The Fertile Crescent, 1800–1914

STUDIES IN MIDDLE EASTERN HISTORY

Bernard Lewis, Itamar Rabinovich, and Roger Savory

General Editors

Israel Gershoni and James P. Jankowski

EGYPT, ISLAM, AND THE ARABS

The Search for Egyptian Nationhood, 1900–1930

Ami Ayalon

LANGUAGE AND CHANGE

IN THE ARAB MIDDLE EAST

Fatma Müge Göçek

EAST ENCOUNTERS WEST

France and the Ottoman Empire

in the Eighteenth Century

Charles Issawi

THE FERTILE CRESCENT, 1800–1914

A Documentary Economic History

Other Volumes are in Preparation

The Fertile Crescent
1800–1914

A DOCUMENTARY ECONOMIC HISTORY

Charles Issawi

New York Oxford
OXFORD UNIVERSITY PRESS
1988

Oxford University Press

Oxford New York Toronto
Delhi Bombay Calcutta Madras Karachi
Petaling Jaya Singapore Hong Kong Tokyo
Nairobi Dar es Salaam Cape Town
Melbourne Auckland

and associated companies in
Berlin Ibadan

Library of Congress Cataloging-in-Publication Data
The Fertile Crescent, 1800–1914.
(Studies in Middle Eastern history)
Bibliography: p.
Includes index.
1. Middle East—Economic conditions—19th century.
2. Middle East—History—1517– I. Issawi, Charles Philip.
II. Series: Studies in Middle Eastern history (New York, N.Y.)
HC415.15.F47 1988 330.956 86-33275
ISBN 0-19-504951-9

2 4 6 8 9 7 5 3 1

Printed in the United States of America
on acid-free paper

To Albert Hourani
and over fifty years of friendship

Preface

This book, the last in the series, is a companion to *The Economic History of the Middle East* (University of Chicago Press, 1966), *The Economic History of Iran* (University of Chicago Press, 1971), and *The Economic History of Turkey* (University of Chicago Press, 1980). It covers Geographical Syria and Mesopotamia—that is, the area within the present states of Iraq (450,000 square kilometers) and Syria, Lebanon, Israel, and Jordan (320,000 square kilometers), plus a small region in Turkey. The reader is reminded that much material relevant to the Fertile Crescent is contained in the above-mentioned books, especially the first. For an analytic overview he is referred to my *Economic History of the Middle East and North Africa* (Columbia University Press, New York, 1982) and to Roger Owen's *The Middle East in the World Economy* (Methuen, London, 1981). Since in all these books little attention has been paid to various aspects of daily life, I am now working on a volume on this subject, covering Egypt and the Fertile Crescent.

As with its predecessors, the primary aim in selecting material for this documentary history has been to include the best and most interesting texts available, but with emphasis on the less accessible sources. Within this framework, five criteria have been applied. First, with a single short exception, no passage from any book or journal in English has been reproduced. Second, preference has been given to unpublished over published material. Third, texts in non-Western languages have been given preference over texts in Western languages and, within the latter group, non-English texts over English. Fourth, priority has been given to reports and articles over books and to older books over more recently published ones. Finally, since the main laws, treaties, and concessionary and other agreements have been reproduced in J. C. Hurewitz, *Diplomacy in the Near and Middle East,* or are available in G. Young, *Corps de droit Ottoman,* no attempt has been made to include such documents here.

Of the 156 selections, 117—almost all the English and French ones—are published here for the first time. The texts cover two centuries, the first having been written in the

1770s and the latest in the 1980s. They are drawn from English, French, Arabic, Russian, German, Hebrew, Turkish, and Italian; all the translations were made by me, except for the Turkish one, which was made by Fatima Müge Göçek, and the Hebrew ones by Dina Le Gall, both of whom are graduate students at Princeton.

Each chapter of the book is preceded by an introductory essay. The selections and introductions have been arranged to provide a more or less consecutive narrative and to bring out the salient features of the branch of the economy studied in the chapter. A few explanatory words or sentences, and cross references, are inserted in brackets. Otherwise, except for some omissions—which are indicated—no attempt has been made to edit the texts or to change the fanciful spelling of Arabic and other words used by the authors. I have followed English usage for the better known names, such as Damascus and Aleppo.

Syria occupies distinctly more space than Iraq in both the selections and introductions of this book, but for this there are good reasons. Its population was larger, its resources more developed, its social level higher; besides, the material available on it is much more abundant.

I have taken the pound sterling (decimalized) as the basic unit of account, partly because most of the source material is British but mainly because the pound was by far the most important currency in international trade and finance. For purposes of conversion, during most of the period under review the pound was equal to about 5 dollars, 10 gold rubles, 20 marks, or 25 francs. A table showing the exchange rate of the Ottoman *qurush,* or piaster, is available in *The Economic History of Turkey* (pp. 329–331), and one showing that of the Persian *kran* in *The Economic History of Iran* (pages 343–345).

I should like to thank A. H. Hourani, Hanna Batatu and Bernard Lewis for their help, Judy Gross and Dorothy Rothbard for typing the manuscript—no mean achievement—and the Dodge Foundation for its support. My wife was helpful as usual. Elizabeth Frierson prepared the Index of Places and Peoples.

Princeton C.I.
March 1988

Contents

VI Industry 367

Syria

Iraq

VII Finance and Public Finance 407

Syria

Abbreviations

A and P	Great Britain, Accounts and Papers
CC	France, Ministère des Affaires étrangères, Correspondance commerciale
FO	Great Britain, Public Record Office, Foreign Office
HHS	Austria, Haus-Hof und Staatsarchiv
IOC	Great Britain, India Office, Bombay, Commerce
IOPS	Great Britain, India Office, Bombay, Political and Secret
US GR 84	United States National Archives, Group 84, dispatches to Department of State
EHME	Charles Issawi, *Economic History of the Middle East* (Chicago, 1966)
EHI	Charles Issawi, *Economic History of Iran* (Chicago, 1971)
EHT	Charles Issawi, *Economic History of Turkey* (Chicago, 1980)
EHMENA	Charles Issawi, *Economic History of the Middle East and North Africa* (New York, 1982)
EI	*Encyclopaedia of Islam*
EI2	*Encyclopaedia of Islam,* 2nd edition
IJMES	*International Journal of Middle East Studies*
JEH	*Journal of Economic History*
JESHO	*Journal of the Economic and Social History of the Orient*
MEJ	*Middle East Journal*
D.S.	*Devlet Salnameh*
MEEP	*Middle East Economic Papers* (Beirut)
/	Fiscal or Muslim years (e.g., 1878/79)
()	Figure estimated, e.g., (20).
II,2	Form used for cross-references within this volume (e.g., II,2 refers to chapter II, selection 2).

The Fertile Crescent, 1800–1914

I

The Fertile Crescent in the Middle Eastern Economy

The Fertile Crescent has always been in close touch with the other parts of the Middle East: Turkey, Iran, the Arabian peninsula, and Egypt. Indeed the ties binding it to each of those subregions have usually been stronger and more numerous than those between any other two.

With the Arabian peninsula there was, first of all, the blood tie. For millennia, the Fertile Crescent has been periodically replenished by waves of peoples and tribes migrating from the desert and settling in the steppes or sown areas of Syria and Iraq. In addition, the beduin tribes, following their camel pastures and the availability of water, travel each year hundreds of miles between their winter quarters in the peninsula and their summer abodes in the crescent. The nomads and seminomads supplied the settled areas of Syria and Iraq with camels, the essential means of transport in the Middle East; with fine horses, used for ceremony and war; and with various animal products such as goat and camel hair. To give one example, in the 19th century "the purchase of camels was handled by the ʿUqail, an ancient, widespread corporation of camel traders, centered in Baghdad, with representatives in nearly every large tribe."[1] In return, Iraq, and in particular Syria, sold the tribes small quantities of cereals, tobacco, sugar or sugar substitutes such as *qamar al-din* (dried apricot jelly) or *dibs* (grape jelly), and textiles and other manufactured goods. The beduins also played an essential part in transport, escorting (or, in default, pillaging) caravans between Iraq, Syria, and northern Arabia. Of particular importance was the annual *hajj* (pilgrimage) caravan from Damascus to Madina.

Syria's trade with Egypt was far larger and more varied, but Iraq's was very small. At the end of the 18th century, Syria's exports to Egypt were estimated by Girard at 210.5 million *paras* (about £500,000), and its imports at 131.4 million (£300,000). Of this about one-tenth was carried overland, by numerous small caravans, through al-ʿArish and

[1]Pershits, in *EHME*, p. 344; see also Bulliet, *Camel;* J. L. Burckhardt, *Travels, Notes:* Jamali; Musil, *Rwala.*

3

Gaza and the rest by sea, between Damietta and Rosetta on the one hand and Acre, Tyre, Saida and Beirut on the other; in this, as in other trade along the Mediterranean coasts of the Ottoman Empire, European shipping had a preponderant part. But the trade itself was handled mainly by Syrians, many of them Christians, resident in Cairo and linked by family ties with merchants in Damascus (whose population in the 17th and 18th centuries was about 50,000 to 100,000), Jerusalem, and Nablus. Syria imported rice, pulses, linen cloth, and spices, and exported tobacco grown in the Latakia, Tartus, and Tyre regions; olive oil from Palestine; raw silk from the coastal areas and cotton from the interior; and cotton and silk textiles from the main towns.[2]

Southern Syria's trade was oriented toward Egypt, but that of northern Syria and northern Iraq flowed to Turkey. With a population of some 100,000 to 150,000 in the 17th and 18th centuries, Aleppo was the largest city in the Ottoman Empire after Istanbul and Cairo, and was the leading commercial and handicraft center of southwest Asia. In 1775 its total trade was put at 18 million gold francs or about £750,000.[3] Its textiles and other manufactures found markets in southern Anatolia, northern Iraq, and northern Arabia, as well as in Syria itself, and it drew on the raw materials of these regions. Its caravans linked it with Diyarbakr, Mosul, and Baghdad, which in turn sent Aleppo's goods to Armenia, the Caucasus, northern Iran, and India, and supplied it with their wares; in addition, Aleppo was the leading entrepôt for European goods, imported through Alexandretta, and exported manufactures to Europe. An elaborate division of labor prevailed between the main handicraft centers of Asiatic Turkey: thus the *kinjak* or *bogaz* material used by the common people of Turkey for making *kaftans* was woven in Amasya and Malatya, dyed in Aleppo, and finished in Mosul.[4] In some respects Mosul (population of up to 50,000) was a satellite of Aleppo, conducting with it most of its trade and serving as an entrepôt for caravans and goods circulating between it and northern and western Iran. But it also exported, eastward and westward, both its own handicraft wares and the raw materials produced in the surrounding region.[5]

Baghdad, with a population fluctuating between 20,000 and 50,000, was also linked, by the ancient Silk Road, to Hamadan and Tehran. Persian goods were sent on from Baghdad by river to Basra and thence shipped or, more frequently, moved by caravan to Aleppo and Damascus. In return, Indian goods from Basra and European wares from Aleppo and Damascus were forwarded to Iran. Baghdad's production did not, however, match its trade. Writing around 1800, J. B. Rousseau, a distant cousin of Jean-Jacques and former French consul, stated: "Except for dates, tobacco and a few woolen manufactures, Baghdad has no indigenous products for export; its external commercial relations are maintained exclusively by the circulation and exchange of the foreign goods it receives."[6]

Iran had close relations also with Aleppo. In the 17th century much of its raw silk— by far its most important export—was shipped from the Persian Gulf ports, but with the end of the Turco-Persian wars most of it was sent westward, either through Baghdad or from Tabriz through Erzurum and thence to Aleppo, Izmir, or Bursa, where part was used

[2]A. Raymond, *Artisans* vol. 1, pp. 165–191; Hourani, ''The Syrians''; R. Haddad, *Syrian Christians*, pp. 40–46.

[3]EI2, s.v. ''Halab.''

[4]Novichev, in *EHT*, p. 300.

[5]Hasan, *Al-tatawwur*, pp. 89–92.

[6]See details in Rousseau, in *EHME*, pp. 135–136; see also *EI2*, s.v. ''Baghdad.''

for local manufactures and part exported to Europe.[7] Aleppo's prosperity became heavily dependent on Persian silk, and the sharp decline of Persian silk raising, following the collapse of the Safavi dynasty in the 1720s, struck it a heavy blow.

The 19th century witnessed drastic changes in this secular pattern of production and trade. At different times, the various parts of the Middle East were integrated in the world system of commerce and transport. New routes were opened, notably the Suez Canal, and old ones were revived, like the Tabriz–Trabzon road, diverting trade away from certain areas and expanding it in others. Modern harbors were built in some ancient ports, like Alexandria, Izmir, and Beirut, drawing to them the traffic that had previously been scattered in many small places. In a few regions railways replaced caravans, futher concentrating trade. New crops were raised—or old ones expanded—in response to European demand, such as Egyptian cotton, Turkish tobacco, and Iranian opium, and other crops like madder and valonia lost their markets when chemical products took their place. Modern banks gradually expanded their business at the expense of traditional moneylenders. European factory goods competed with Middle Eastern handmade products, and drove many craftsmen out of business. Population grew almost everywhere, and certain cities saw a severalfold increase in the number of their inhabitants. Needless to say, these developments were very unevenly spread over the Middle East, some areas advancing very rapidly and others stagnating or even declining. Their overall impact on the Fertile Crescent was very marked.

The Nile Delta and the Izmir and Istanbul areas, with their large cities and fertile countrysides, were the fastest growing parts of the Middle East. Moreover, both lay on the way to far richer regions—India and the cornlands of southern Russia and Rumania. It was therefore to them that the first European steamships were sent, through the Mediterranean, Black Sea, and Red Sea, and by the 1830s or 1840s they were served by regular British, French, Austrian, Russian, and Turkish lines. Most of these lines went to both Egypt and Turkey, and made calls at many of the Syrian ports. Of these, Beirut soon rose to prominence, and continued to widen its lead, absorbing some of the trade of the smaller towns. But all benefited from the availability of regular communications not only with Europe but with each other, and both local and foreign officials and businessmen found it swifter and more comfortable to travel up and down the coast by steamer than overland. Some of the caravan trade from Palestine to Egypt was also diverted to the sea route, benefiting Jaffa.[8]

In the 1840s several steamship lines were also active along the Black Sea coast of Turkey, linking Istanbul with Trabzon and Transcaucasia. Their effect on the Fertile Crescent was adverse, since they diverted most of northern Iran's trade, including silk, to the shorter Tabriz–Erzurum–Trabzon route. However, since most of the silk had already been shifted from the Erzurum–Aleppo to the Erzurum–Izmir route, the loss was not too great. And by the 1880s Iran's trade was once more turning to the revitalized Basra–Baghdad–Hamadan–Tehran river and caravan route.[9] The latter was, of course, greatly stimulated by the establishment of regular steam navigation between Bombay and both shores of the Persian Gulf in 1862; here, too, the Fertile Crescent benefited from an enterprise designed mainly to serve one of its larger neighbors, Iran.[10]

[7]*EHI*, chap. 3, *EHT*, p. 120.

[8]Farnie, *East and West of Suez*, p. 148.

[9]*EHI*, chap. 3; *EHT*, pp. 124–128; Charles Issawi, "The Tabriz–Trabzon Trade," *IJMES*, January 1970.

[10]*EHI*, pp. 165–177.

The Suez Canal, again intended to facilitate communications with a distant region, bypassed the Fertile Crescent and had mixed effects on it. Iraq gained immensely from the fact that its sea route to Western Europe was reduced from 14,000 miles to under 10,000, putting it within reach of the steamers of that time. Its sea trade multiplied severalfold, and its agriculture was profoundly affected by the expanding demand for its produce. But on Aleppo, Damascus, and Mosul the impact was adverse, since the goods sent through them to Baghdad, and the Iraqi products exported to Europe, went instead through the canal; between 1869 and 1871 the caravan trade through these cities fell by four-fifths, but recovered some of this loss later. Damascus also suffered from the fact that much of the goods, and most of the pilgrims that it sent to Arabia took the sea route, as did some of the traffic between Istanbul and Arabia though Baghdad.[11]

The extensive railways built in Egypt, and somewhat later in Turkey, had no noticeable effect on the Fertile Crescent. They were linked with the Syrian railways, through Haifa and Aleppo, respectively, only at the end of the First World War and with the Iraqi railways in 1940. They do not seem to have either stimulated development or diverted trade. The Hijaz railway, built with funds raised from all over the Muslim world and linking Damascus with Madina in 1908, also had limited economic effects. It failed to win back to the traditional land route the Muslim pilgrims, most of whom continued to go to Hijaz by sea. It also seems not to have increased appreciably Syria's trade with northern Arabia, although it might have done so had the portions south of Ma'an not been blown up during the First World War. Its most important result was internal: the stimulation of grain exports from Hauran to Haifa, along a branch of the main line.

Nor was the Fertile Crescent adversely affected by the agricultural expansion of Egypt, Turkey, and Iran. The decline and disappearance of Syrian cotton may be explained partly by the sharp reduction in domestic consumption, due to the decline of the handicrafts, and partly by the fall in world prices caused by the vast increase in exports from the United States and India. Egyptian cotton was of far superior quality to Syrian, and did not directly compete with it, and Turkey's and Iran's output rose markedly only at the end of the century. Similarly, Lebanon's silk production does not seem to have suffered from the increase in Turkish or Iranian exports, although in this case competition was more direct.[12] Nor was there any industrial competition between the four subregions.

But the general expansion in the Egyptian economy had a certain beneficial impact on Syria. First, one may assume that traditional Syrian exports to Egypt, such as soap, olive oil, and some textiles, were stimulated—although the imposition of an 8 percent duty in Egypt slowed down imports. Second, tens of thousands of Lebanese, Palestinians, and Syrians—the vast majority of them Christians—emigrated to Egypt in search of economic opportunities; by 1914 the total living there was about 50,000, to which should be added several hundreds in the Anglo-Egyptian Sudan. These people played a leading role in trade, finance, journalism, the professions, and government service. It is to be presumed that, like emigrants to the Americas,[13] they sent back home some remittances. It is certain that their patronage did much to launch Lebanon's summer tourist industry.

Turkey's growth was somewhat slower than that of Egypt, and its own minorities—Armenians, Greeks, and Jews—supplied the required business and professional skills.

[11]Farnie, *East and West of Suez*, pp. 146–147.

[12]*EHME*, pp. 446–448; *EHT*, pp. 253–258; *EHI*, pp. 231–238, 244–246.

[13]See II,12 (this volume), and Ruppin, in *EHME*, pp. 269–273.

But some Syrians played a minor part in the expansion of cotton cultivation in the Adana region.[14]

The linkage of the Syrian railways with those of Egypt and Turkey and the building of the Iraqi line during the First World War, as well as the development of transdesert motor transport, grealy facilitated trade and movement of persons between the Fertile Crescent and its neighbors. This was, however, largely offset by the effects of the breakup of the Ottoman Empire. In place of a large free-trade area, there were now the mandatory states of Iraq, Syria, Lebanon, Palestine, and Transjordan flanked by Egypt and Turkey. In spite of the provisions of the Acts of Mandate for preferential tariffs between these states, customs duties rose rapidly, especially after 1930 when Egypt and Turkey recovered their tariff autonomy and the mandates sought to protect their industry and agriculture. Once more the main sufferers were Aleppo, Mosul, and Damascus, which lost markets for their products and transit trade. Beirut, however, managed to overcome the political and other obstacles and establish a commercial and financial network stretching to Iraq, Iran, and Arabia. This more than offset the competition caused by the development of a modern port in Haifa, serving Palestine and some of the southern parts of the Syrian republic.

The period following the Second World War saw further disintegration, in the form of the closure of the frontier and cessation of trade between the Arab countries and Israel and the breakup of the customs and monetary union between Lebanon and Syria. But a new, very powerful, force making for increased economic transactions between the Fertile Crescent and its neighbors was now at work: oil. Already in the 1930s and early 1940s the laying of pipelines from the oil fields of Kirkuk, in northern Iraq, to Haifa and Tripoli had resulted in the erection of refineries in those two cities, and with the building of the Trans-Arabian pipeline and further large pipelines from Iraq through Syria other refineries were set up in Saida, Homs, Banias, and Zarqa in Jordan. Lebanon and Palestine also received tiny loading fees on oil shipped from Tripoli and Haifa, and after the War the four transit governments levied small transit fees on both the Iraqi and Arabian oil passing through them. These fees were raised sharply in the 1950s,[15] and by 1970 were bringing in about $55 million to Syria, $15 million to Lebanon, and $5 million to Jordan.[16] Further developments, including a huge rise in revenues, the shutting off of the pipelines by Iraq in 1976, and the construction of an all-Iraqi pipeline to carry Kirkuk oil to the Persian Gulf and of another to transport it to Dortyol, in Turkey, will not be discussed here.[17]

Far more significant were the indirect effects of the enormous increase in oil production and revenues in the gulf. Already in the 1930s Lebanon, and to a lesser extent Syria, benefited from the expansion of the Iraqi economy, handling a substantial proportion of Iraq's foreign trade, exporting to it some of their own products, sending to it teachers and other personnel, and receiving Iraqi tourists and students. After the Second World War such exchanges multiplied severalfold, covering not only Iraq but the Arabian oil countries and, for a while, Iran. A study of a trade matrix of the Middle East indicates that by far the densest portions are those showing exchanges between Lebanon, Jordan, and Syria on the one hand and the Arab oil-producing countries: Iraq, Saudi Arabia,

[14]*EHT*, p. 243.

[15]Issawi and Yeganeh, *Economics,* pp. 137–139.

[16]*Petroleum Press Service,* June 1970.

[17]See E. Penrose, *Iraq,* pp. 441–446.

Kuwait, and the other states. Lebanon, Jordan, and Syria are also the only countries for which intraregional trade is a significant proportion of total foreign trade—say 10–20 percent of imports and 30–50 percent or more of exports by the mid-1960s. Moreover, between them they have sent several hundred thousand persons, including Palestinians, to the gulf, first in small numbers to staff the oil industry and then on a far larger scale to supply a very wide range of skills needed by the rapidly expanding economies. Large amounts of capital flowed from the oil countries to Lebanon, for deposit in banks or investment in real estate or other enterprises. And, like other Arab countries, all three states were the recipients of grants and loans from the numerous development funds set up, singly or jointly, by the oil-rich Arab states, and they are also participating in some joint Arab projects. Thus, although the Fertile Crescent's economic relations with Turkey, Egypt, and now again Iran, are at present slight, its ties with the Arabian peninsula have become very close and its economic future is, more than ever before, bound up with that region.

II

General and Social Developments

General Developments

In contrast to the preceding centuries, which had been marked by stagnation and, in certain respects, decline, the period under review saw distinct progress.[1] Population grew, modern schools were opened and books and newspapers published, the cultivated area was extended, mechanical transport was introduced, foreign trade multiplied severalfold, the rudiments of a financial system emerged, and, after a sharp decline in the handicrafts had been followed by stabilization and recovery, a few industrial enterprises were built or projected. Progress was perceptibly greater in Syria—which had started the period at a somewhat higher level—than in Iraq. In both parts of the region the interwar period saw continued development, which accelerated after the Second World War.

In Syria the second half of the 18th century was a period of stagnation, or even decline. At a time of rising prices the value of British imports from Syria decreased sharply and the far larger French trade also fell.[2] In 1785 Volney noted that, in the Aleppo *pashalik,* whereas the tax registers contained the names of 3200 villages, only 400 were actually paying taxes—a statement that probably gives an unduly somber picture: ''Those of our merchants who have been resident for twenty years have seen the depopulation of the greater part of the vicinity of Aleppo.''[3] In 1847 the French consul reported that the ʿAnaza tribe had reached the gates of Aleppo and had been fought off by its inhabitants,

[1]For an excellent overall view, see Owen, *Middle East,* chaps. 1–3, 6–7, and 10–12.

[2]See tables in ibid., pp. 6–7.

[3]Volney, *Travels,* vol 3, p. 44.

after devastating the wheat and barley fields.[4] In 1860 the British consul in Aleppo reported:

> The commencement of ruin to this rich country dates about eighty years back when the Anezi Arabs, driven out of Central Arabia by a famine, appeared in swarms on the eastern limits of the Syrian plains. The villages have since then gradually receded before the tide of devastation which in two places, near Acre and between Latakia and Tripoli, has at last reached the sea. Its progress has been more rapid of late years, on account of the great increase of the flocks and herds of the Arabs . . . I have seen this year twenty-five villages plundered and deserted.

A year later his colleague in Damascus stated that, because of tribal raids and insecurity, "within the Pashalik of Damascus there are more than 2000 ruined and deserted villages of which about 1000 were cultivated and have been deserted within the memory of man."[5] In Aleppo, further adverse factors were the series of earthquakes—especially the one of 1822, which devastated the town—prolonged factional strife, and the diversion of trade to Persia through the Black Sea, bypassing Syria, in the 1830s.[6] Writing in 1857 the British consul stated that the city "reached perhaps its lowest point twelve years ago, when a reaction took place and a growing commercial activity has since then been observable"; another report stated that between 1847 and 1857 tithes had doubled, because of the increase in cultivation.[7]

The Egyptian occupation (1831–1840) saw an interruption of this stagnation. Ibrahim pasha both enforced order and tried to promote development (II,1) agriculture expanded (V, Introduction), and trade increased (III, Introduction and III,9). However, the Egyptian withdrawal was followed by renewed deterioration.[8] Concurrently, European competition was forcing many craftsmen out of business (VI, Introduction).

The first part of the region to recover may have been Palestine, where conditions seem to have been relatively good in the second half of the 18th century.[9] By 1851 the British consul in Jerusalem was reporting general improvement, evidenced first by "the great increase of revenue actually levied in the province within the last three years"; this was due to "the extension of agriculture, confessed by all, and the augmentation of the trade of Jaffa." Second, there was "the rebuilding of villages from utter heaps of desolation and the improvement of others which have not ceased to be inhabited. This is mostly the case in Christian villages . . . as Bethlehem, Ain Karim, Deir Diwan, Ram Allah, and Latron. But not exclusively. . . . I know of no place in Palestine that has deteriorated within my knowledge of nearly six years." Third, in Jerusalem "the sources of money expended in buildings, particularly by the convents, are very considerable . . . nor should I omit the difficulty experienced by Europeans in finding a house for residence." Finally, "the number of European and American travellers to Palestine is

[4]Geofroy to Guizot, 10 May 1847, CC Alep, vol. 31.

[5]Skene to Bulwer, 12 May 1860, FO 78/1538; Rogers to Bulwer, 10 June 1861, FO 78/1586; for a more detailed account of the effects of the Beduin incursions see V, Introduction (this volume), and Gibb and Bowen, *Islamic Society,* vol. 1, pt. 1, pp. 166–167; also the excellent study by Lewis, *Nomads,* pp. 1–57.

[6]See Charles Issawi, "The Tabriz–Trabzon Trade," *IJMES,* January 1970, and *EHI,* pp. 92–116.

[7]"Report on Aleppo," 1857, FO 78/1389; see also two reports on Aleppo in A and P 1859, vol. 30.

[8]Report of 14 June 1858, FO 78/1388; Lewis, *Nomads,* pp. 38–46.

[9]Amnon Cohen, *Palestine,* pp. 184–188.

steadily augmented.''[10] In 1880 the British consul in Beirut reported: ''Of the outlying districts, I may remark that the state of Jaffa seems the most satisfactory.'' By 1856 the consul in Jaffa had reported: ''all around Jaffa for three miles are gardens, with spring water, and large cisterns in every garden, which make it ever green, even in the midst of summer.''[11]

At the same time Beirut was rising rapidly, to become Syria's leading seaport, and in 1847 conditions in Lebanon were reported to be improving by the French consul, who added ''Druze feudalism is disintegrating, bit by bit.''[12] However, this disintegration led to the bloody communal clashes of 1845 and 1860, which took a great toll in lives and property (II,2). The powers intervened and established the Règlement Organique of 1861, which gave Lebanon a privileged status, exempted it from many taxes, and produced increasing prosperity until 1914 (II,15). Already in 1872 the British consul traveling in the Dayr al-Qamar area ''was greatly and agreeably surprised to observe the improvements that had been effected during the last three years''; carriage roads had been built and the government departments were working well.[13]

The 1860 clashes also provoked a massacre of Christians in Damascus (selection 2) and disrupted its trade and textile industry (VI, Introduction). However, here too recovery was quite swift, although in 1866 the country suffered from the triple effects of cholera, locusts, and the world depression.[14]

The Latakia district continued to be very backward. An Austrian consular report of 1838 describes the misery of the inhabitants, who often had to sell their girls to officers.[15] A British report of 1874 dwells in detail on the very restricted cultivation of the plains, the poor state of roads and bridges, the low level of living of the villagers, and their almost total illiteracy: ''The depopulation of these plains and of the neighbouring mountains has been gradually taking place during the last few centuries.'' In the last 50 years emigrants had gone to Adana; tobacco planting was hurt by the ''Régie'' (V, Introduction), and the trade of Latakia was further restricted.[16]

In the 1870s crop failures (see prices in VII, 1) and falling export prices caused hardship (there was a severe shortage in Damascus in 1878 and in Aleppo in 1880—see also selection 7)[17] but, throughout Syria, an upward trend in agriculture,[18] handicrafts, and foreign trade seems to have prevailed. Foreign capital, mainly French, was invested in railways and ports (IV, Introduction). Emigration to the Americas gathered momentum (selection 12), producing a reverse flow of remittances that helped the balance of pay-

[10]Finn to Canning, 7 November 1851, FO 78/874.

[11]A and P 1880, vol. 73, ''Beyrout''; Reply to Questionnaire, FO 78/1419.

[12]Report in CC Beyrouth, vol. 5, p. 346.

[13]Eldridge to Rumbold, 30 October 1872, FO 78/2228.

[14]Eldridge to Lyons, 30 October 1866, FO 78/1927; see also A and P 1865, vol. 53, ''Damascus.''

[15]Dispatch of 14 February 1838, HHS 67, 1838, I–VI.

[16]A and P 1875, vol. 75, ''Beyrout,'' pp. 372–383.

[17]Rousseau to Waddington, 17 March 1878, CC Damas, vol. 6; A and P 1878, vol. 73, ''Damascus''; Henderson to Layard, 10 March 1880, FO 195/1305.

[18]A and P 1880, vol. 74, ''Damascus.''

In 1872 the British consul reported that in the Balqa region of Transjordan ''considerable progress had been made; a larger tract of land was under cultivation than was the case in 1866, a sure sign of greater security to life and property; the people too seemed to be better clothed and fed,'' although the 1870 and 1871 crops had been partial failures. Many parts subject to beduin raids were now secure and appeared ''in a comparatively flourishing state'' (Eldridge to Rumbold, 29 April 1872, FO 27/2228).

ments and introduced new ideas. Other sources of foreign exchange were remittances to Jews in Palestine, tourism, and the expenditure of foreign missionary or philanthropic institutions; among the latter were a fine set of colleges and schools—see below.

An increased interest in economic matters among Syrians is also perceptible. In 1868 the Syrian *Majlis* (Council), sitting under Reshid pasha, passed numerous resolutions including a carriage road from Ma'arra through Hama, Homs, and Balbeck to join the Beirut–Damascus road; repair of bridges; registration of mortgages and a cadastre; extension of telegraphs; improvement of glass factories in Damascus and 'Akkar; authorization to open banks to lend to farmers at 12 percent; garrisoning of Palmyra, Salt, and other towns to check beduins, and forcing the latter to settle and cultivate the land.[19] Mention should also be made of the beneficial effects of Midhat pasha's governorship (1878–1880).[20]

There were setbacks, some rather severe, as in the Aleppo region in 1895 during the Armenian massacres. In 1899 the French consul complained of the prevailing anarchy. The Kurds, having finished off the Christians, were now attacking Muslims: "The population gets poorer yearly, the poor suffer and the middle class becomes more and more wretched."[21]

In all this Syria followed the general Ottoman trend. Around 1880 the pace of development of Anatolia and Rumelia began to quicken perceptibly, as a result of many factors: the absence of major wars between 1878 and 1912; better fiscal and financial management, largely because of the supervision exercised by the Public Debt Administration; the inflow of foreign capital into railways and other infrastructure; a new interest by the government in economic development, manifesting itself in more favorable legislation and the taking of many measures to aid industry and agriculture; and increased private initiative, particularly by the minorities, in economic matters.[22]

In Iraq the timing was somewhat different. The second half of the 18th century was later to be looked upon as a prosperous period, thanks to the diversion of trade from Bushire to Basra, the firm and enlightened rule of Sulayman pasha "The Great" (1780–1802), and, after the evacuation of Basra in 1780, the end of the Persian threat to that town.[23] But the prosperity was only relative: tribal disturbances continued, and the very small volume of the East Company's total sales in Basra and Bushire in FY 1780/81–1789/90 (about £65,000 and £27,000, respectively) shows the low level of commercial activity; the losses incurred by the company made it want to close down its establishments in the gulf.[24] In the early decades of the 19th century conditions deteriorated further. Among the reasons for this were the European wars, which affected trade in the Mediterranean; increasing Wahhabi raids; tribal disturbances, which disrupted communications (selection 22); the usual toll of plagues and floods (selections 23–25); and the extortionate policy of the pashas.[25] The efforts of Dawud pasha (1817–1831), perhaps inspired by the example of Muhammad Ali of Egypt, to develop the country (selection 27) had very few

[19] FO 78/2051.

[20] See, for example, his transport schemes, A and P 1880, vol. 74, "Beyrout."

[21] "Report on Trade," 1899, CC Alep, vol. 39.

[22] *EHT*, passim; Eldem, *Osmanli*, passim; Osman Okyar, "A New Look at the Problem of Economic Growth in the Ottoman Empire, 1800–1914," unpublished paper, Hacetteppe University.

[23] Longrigg, *Four Centuries*, pp. 177–220.

[24] *EHI*, pp. 82–89.

[25] *EHME*, pp. 135–136; see also Al-Husri, *Al-Bilad*, pp. 44–52.

results and the Mamluk régime was easily overthrown by the Ottoman government after it had been enfeebled by the disastrous plagues and floods of 1822 and 1831 (selection 24).

Little improvement seems to have taken place during the first few decades of Ottoman rule.[26] Most governors were incompetent. Some were venal: in 1861 the instances of bribery proved against the late governor, Mustafa Nuri pasha, amounted to 2,249,425 piasters and those withdrawn or not proved to 1,495,500 piastres (see also selection 29).[27] Their main objective seems to have been to bring the country under central control, to increase revenue, and, by imposing conscription—in Mosul in 1835 and in Lower Iraq in 1870—to make Iraq contribute to imperial defense. The power of the Kurdish chiefs and other notables in northern Iraq was gradually broken, but no success was achieved in either conciliating and settling or subduing the tribes of Lower Iraq. Repeated expeditions with inadequate forces resulted only in destruction of crops and livestock and further alienation of the tribesmen. In 1854 the British consul was informed that the country between Basra and Suq al-Shuyukh "is now so infested with robbers and pirates as to be almost impassable and here again Shaikh Mansur [the leader of the Muntafiq tribes] and the Governor of Bussorah mutually accuse each other."[28] In April 1849 Rawlinson reported that in North Kurdistan "the mountains have risen pretty generally against the Turkish power," in southern Iraq the Banu Lam "have taken the field in considerable number," in the northern desert the Shammar "have agreed to direct their united efforts" against the pasha, and Baghdad itself was infested by gangs of plunderers; "some allowance must always be made for the natural turbulence of the Kurds and Arabs—but undoubtedly the immediate crisis has been produced by the character of [Najib's] administration, which sacrifices all other objects to the sole consideration of accumulating money." By May the Arabs on the Hindiyya canal, from whom 21,000 purses had been raised, "found themselves suddenly reduced from a state of comparative affluence to complete destitution" and revolted, plundering public granaries and other property. By July the insurrection had spread, and "the navigation of the Tigris has been almost entirely suspended."[29] In 1852 "Reshid pasha's expedition [against the Muntafiq] has at length completely failed," although he had used 10,000 regular and irregular troops and had beaten the tribesmen in all engagements; he had therefore had to retreat from Diwaniyya: "It only remains to add that H.E.'s wanton spoliation and butchery of the tribes who sought his protection at Hillah has already had the effect of raising the Arabs generally to the West of Baghdad."[30]

In 1856 conditions in the Muntafiq were still very bad. The Turks would either have to "overwhelm their country with troops" or "withdraw their garrison from Sook esh Shiookh and abstain from interference in their affairs"; the policy in recent years "has contributed so much to the ruin of the agriculture and commerce of these parts and has changed tribes of hard working agriculturalists and labourers into systematic murderers and thieves."[31] In the north, Kurds and "Hamidiya" irregular cavalry harassed the population until the First World War (IV,16 and 17).

[26]For this period see Longrigg, *Four Centuries,* pp. 277–297; Marr, *Modern History,* pp. 22–28; and, more generally, Vaucelles, *La vie en Irak* pp. 64–88.

[27]Dispatch of June 1861, FO 195/676.

[28]Jones to Rawlinson, 26 July 1854, FO 195/442.

[29]Rawlinson to Canning, 25 April 1849, 23 May 1849, and 16 July 1849, FO 195/334.

[30]Rawlinson to Rose, 2 June 1852, FO 195/367.

[31]Taylor to Kemball, 17 April 1856, FO 195/521.

Even good intentions did not produce results:[32]

> It is not of course pretended that the Turkish Authorities have ever been insensible to
> the neglected state of the districts bordering on the Euphrates:—as from time to time
> reported to H.M.'s Embassy, every Governor, on his appointment, since Nejib Pasha,
> has planned and undertaken the works necessary to retain the command of the water of
> the River, and to regulate its distribution for purposes of irrigation; but their efforts
> have been unskillful or ill judged, or the open or secret opposition of the Khezzail and
> Montefig Sheikhs seeking to evade the direct Turkish control has prevailed; the issue
> has been failure, and the sums expended, aggregating an enormous amount, have been
> so much money thrown away.

Rashid Gozlikli pasha's rule (1852–1856) has been described as "honest, vigorous and
liberal."[33] Namiq pasha (1861–1868) "effected great reforms," paid the arrears of the
garrison and kept it in good shape, stopped peculation in the military, and got surplus
revenue; he strongly disliked European interference (see also VII,22).[34] Midhat pasha
(1869–1872) was perhaps the greatest Ottoman reformer of the 19th century. His activity
covered many aspects of government, economy, and society, but his achievements were
not commensurate with his efforts (selections 31 and 32; VII,23).

In the meantime, worldwide forces were beginning to change Iraq. Trade with the
Indian Ocean area was steadily growing (III, Introduction). In 1848 a British consul had
reported that Basra "fifty years ago had a population of 60,000 souls—it is now a mere
hamlet."[35] However, the establishment of a line of steamers between Bombay and Basra
and the introduction of steam navigation on the Tigris (IV, Introduction) stimulated a
revival. By 1866 "the native-born inhabitants of Bussorah are very few, and the greater
part of the traders and labourers are immigrants from Persia and the Arabian coast of the
Persian Gulf, attracted hither by high wages and cheap living."[36] The opening of the Suez
Canal in 1869 started a new chapter in Iraq's history, making it accessible to steamers
from Europe, and the volume of foreign trade greatly increased (III and IV, Introduction).
This trade was not significantly affected by the persistence, or recrudescence, of piracy in
the gulf, which continued until this century.[37] Foreign demand for Iraqi grain and dates
(V, Introduction) induced an extension of cultivation and the settlement of nomads. In
1878, along the Tigris above ʿAmara, "The nomad Arab population have taken to erect
'churds' or mechanical means of irrigation"; it had been observed that when they did so
"they become more settled, build houses and forsake their predatory habits," for exam-
ple, the Muntafiq, "who are reported not to have committed any crime in the way of
robbery etc. since they were permitted to acquire land by purchase on the Euphrates. But
those Arabs are subject to the caprices of the Pashas and recently there has been nearly a
formidable revolt on an attempt being made to dispossess them of their lands; indeed half
the disorganization and want of progress in Arabia [i.e., Lower Iraq] arises from this

[32]Kemball to Bulwer, 22 April 1863, FO 195/752.

[33]Longrigg, *Four Centuries,* p. 283.

[34]Kemball to Bulwer, 28 June 1865, FO 195/803A.

[35]Rawlinson to Canning, 14 April 1848, FO 195/318.

[36]A and P 1867, vol. 62, "Bussorah."

[37]For incidents see dispatches of 27 December 1887, FO 195/1580, 12 August 1891, FO 195/1762, and several
in 1900, FO 195/2074.

question of land tenure" (see also V, Introduction).[38] The linking of Iraq with Istanbul and India by telegraph in the 1860s and the laying of a network in the country also contributed to greater order and economic progress. The administration slowly improved, as did the fiscal system. Population grew and a few modern schools were opened. Nevertheless at the beginning of this century Iraq was only slightly more developed than it had been in 1800, and it compared poorly with the other Ottoman provinces.[39]

In the decade preceding the First World War progress accelerated noticeably. The Ottoman government became much more interested in development and, after customs duties had been raised in 1907, had more funds available. The Germans were attracted to Iraq as an outlet for the Berlin–Baghdad railway and as a potential supplier of cotton and oil. The British shared the craving for oil, had other interests to protect (e.g., the river steamers), and were further drawn into Iraq by the desire to block, or at least partly control, the railway. The ensuing diplomatic controversies were gradually resolved and implementation began. A master plan for irrigation was drawn up by Willcocks; the Hindiyya barrage was built and work started on other schemes (V, Introduction). The river fleet was expanded (IV, Introduction). A railway was laid down between Baghdad and Samarra (IV, Introduction). War interrupted these schemes, but they were taken up again and gradually carried out in the following 50 years.

Population

The study of the economic and social history of the Fertile Crescent in the 19th century is severely handicapped by the paucity and unreliability of statistics. Almost all the figures in this book are derived from European writings; almost all of these, in turn, were obtained from Ottoman officials and are no better than their sources. Mainly for fiscal purposes, the government collected a good deal of data on population, landholdings, customs dues, tax revenue, and other subjects. Some of the figures, as well as other information, are to be found in the *Salnamehs* (yearbooks) for various provinces that began to be issued in 1846/47 and, with the necessary adjustments, can be used as a starting point by the statistically minded historian. Censuses, of various degrees of comprehensiveness, were carried out in 1831, 1844, 1881–93, and 1906–1907. Some of these have been published or analyzed and summarized by various scholars; most of them cover the Arab provinces, but the figures given are less reliable than those for Anatolia or the European provinces.[40]

The first Official Statistical Yearbook was the *1313 [1895/6] Istatistik,* but earlier figures, derived from official sources, are given by Vital Cuinet. Very recently, a thorough and comprehensive statistical compilation has been published by Justin McCarthy. A good deal of information is to be found in the records of the *shar'i* courts (see VII,11).[41] Much more lies buried in the Ottoman archives in Istanbul, more specifically, *The*

[38] "Report on Trade," 1878–79, FO 195/1243.

[39] For a more detailed account see Longrigg, *Iraq,* pp. 1–66.

[40] Enver Ziya Karal, *Osmanli imparatorlugunda ilk nufus sayimi, 1831* (Ankara, 1943), see *EHT,* pp. 19–22; Kemal Karpat, "Ottoman Population Records and the Census of 1881/2–1893," *IJMES,* May 1978; Stanford J. Shaw, "The Ottoman Census System and Population," ibid., August 1978.

[41] Also Abdul-Karim Rafeq, "Les registres des tribunaux de Damas comme source pour l'histoire de la Syrie," *Bulletin d'Etudes Orientales,* 1973.

Longrigg and Batatu mention the following major ones in Baghdad: 1689, 1719, 1799, 1802, 1822, and, most terrible, 1831, which was followed by a devastating flood (selection 24). Deaths in Hilla, Hindiyya, and other places were extremely numerous.[48] There was also an outbreak of plague in Mosul that was said—no doubt with much exaggeration—to have carried off 100,000 persons and left 17,000 houses deserted.[49]

There were further outbreaks of plague in the period under review. In 1867 there was a mild epidemic in Baghdad. In 1876–1877, out of 18,000 Jews in that city, 1130 (6.3 percent) died. A British physician, who had already listed some 4394 deaths, pointed out that his figures represented the same percentage of Baghdad's estimated population of 70,000 and was "much nearer the truth than 1,560, the official returns for Baghdad given by the Sanitary Commission." Since about half the population had left the city, the mortality rate was in reality twice as high.[50] The physician stated: "I have on former occasions repeated, and the same holds good now, that not only is the quarantine, as conducted in this province, useless but by collecting together unwashed masses without any sanitary care it tends to spread the disease it was established to check."[51] The plague also broke out in 1881, 1882, and in Basra in 1910, but none of these epidemics seems to have been very serious.[52]

Cholera was an even greater threat. In Baghdad in 1846, it attacked some 20,000 persons among an estimated 80,000, and killed 6000, and there were a few victims in 1847.[53] The French records show cholera outbreaks in Baghdad in almost every year in 1851–1861, and again in 1865 and 1869.[54] The 1851 epidemic took over 2000 lives in Baghdad and the 1858 outbreak in Basra nearly 600.[55] The 1869 epidemic, brought in by Iranian pilgrims, claimed a few hundred victims in Karbala and elsewhere.[56] There were further outbreaks in 1889 and 1893; the former was described as "the worst since 1831" and spread to both Mosul and Basra.[57] Cholera broke out again in Baghdad in 1899 and in Basra in 1910, but both epidemics seem to have been relatively mild.[58]

Modern medicine had made little impact on Iraq by 1914. British physicians, working for the East India Company, were sent to Basra and Baghdad and vaccination started in the 1820s (selection 28), but the numbers treated were small. In January 1879 the clinic in the British Residency in Baghdad served some 3500 patients.[59] In 1890

[48]See also Longrigg, *Four Centuries*, p. 266; Batatu, p. 15; Haider, "Land Problems," p. 112, Fraser, *Travels*, vol. 1, pp. 234–254; for a comprehensive study of the plague in the Ottoman Empire in 1700–1850 see Panzac, *passim*.

[49] Botta to Guizot, Report on Mosul, 18 May 1843, CC Mossoul, vol. 1.

[50]Dispatches by Nixon, 31 May 1876, FO 195/1076, and Colvill, 4 September 1877, FO 195/1142; see also A and P 1877, vol. 83, "Bagdad."

[51]Report by Colvill, 6 March 1876, FO 195/1076.

[52]Longrigg, *Four Centuries*, p. 316; A and P 1911, vol. 96, "Basra."

[53]Answers to Queries by Dr. Hyslop, 27 January 1848, FO 195/318; cholera first came to the Middle East from India in 1821, see Panzac, *La Peste*.

[54]Pellissier to Drouyn, 17 September 1866, CC Bagdad, vol. 12; Rogier to La Valotte, 6 December 1869, CC Bagdad, vol. 13.

[55]Rawlinson to Canning, 23 September 1851, FO 195/367, and Rogers to Kemball, 26 January 1858, FO 195/577.

[56]Herbert to Elliot, 15 September 1869, and 30 September 1871, FO 195/949.

[57]Pognon to Spuller, 25 August, 16 September, and 18 November 1889, CC Bagdad, vol. 14.

[58]Longrigg, *Four Centuries*, p. 316; A and P 1911, vol. 96, "Basra."

[59]A and P 1878/79, vol. 72, "Baghdad," which contains a medical report.

Cuinet mentioned six pharmacies in Mosul, one of which was run by nuns.[60] By 1914 foreign missionaries had established small hospitals and dispensaries, including ones in Baghdad, Mosul, and Basra by a Protestant mission; some foreign physicians were practicing and there were some government inspectors and physicians, but their action was confined to the main cities.[61]

Syria saw distinctly more progress, although here too epidemics were devastating, for example, an outbreak of the plague in Syria in 1840–1843 and, in Aleppo, of cholera in 1822, 1832, 1837, and 1848, the last claiming 3500 lives; in 1851 cholera was reported in Damascus, in 1865 (selection 4), and again in 1875, all over Syria.[62] There were outbreaks in Beirut in 1883, in Damascus and Aleppo in 1890, and in Jerusalem in 1902. According to the British consul, in the 1912 epidemic 10,000 lives were lost in the Damascus *vilayet,* compared to the official estimate of 4000.[63]

However, medical facilities were far more widespread than in Iraq. In 1845 Damascus had, in addition to two institutions (Muslim and Christian) for lepers and a lunatic asylum—all of which had been functioning since time immemorial—a military hospital opened by the Egyptians.[64] By 1854 Jerusalem had Prussian, Latin Patriarchiate, and French Jewish hospitals, and there were also British services.[65] In the 1870s the Syrian Protestant College (later American University of Beirut) began to graduate physicians from its medical school, and in the 1880s St. Joseph University followed (see below). In 1903 the government opened a medical school in Damascus. In 1848 the French consul had reported that there were only three European physicians in Aleppo, and another two or three Syrians who, however, were not properly trained.[66] In 1895 Palestine had 23 hospitals (17 in Jerusalem) with some 700 beds; Beirut had 6, Aleppo 2, and there were military hospitals in Damascus, Homs, and Hama; there were 50 physicians in Beirut.[67] By 1914 Syria had several score European and Syrian physicians, the latter having received a very good medical education abroad or in the country.

As regards the other Malthusian checks (i.e., war and famine), after the Turco-Egyptian wars of 1831–1832 and 1840, there was no large-scale fighting in Syria. However, the 1845 and 1860 communal struggles (selections 2 and 3) took many lives and destroyed much property. There were also numerous expeditions to impose government authority in Jabal al-Druze. Moreover, Syrian and Iraqi conscripts served in the Ottoman army. No famines are recorded until the terrible one in Lebanon during the First World War, but there were severe local shortages in 1878. As reported by the French consul in Damascus, "During the last three days the Muslim population—the one that eats nothing but bread—has been besieging the doors of the Serail, crying famine. Yesterday several

[60]Cuinet, *Turquie,* vol. 2, p. 820.

[61]Longrigg, *Iraq,* p. 37; see description of Sanitary Service in Cuinet, *Turquie,* vol. 3, pp. 11–13, and of Basra mission by Zeigler, "Brief Flowering."

[62]Answer to Queries, 27 May 1859, FO 78/1449, and Despréaux to Bastide, 19 July and 12 August 1848, CC Alep, vol. 31; Wood to Palmerston, 21 January 1851, FO 78/872; dispatches of 22 July and 4 August 1875, CC Beyrouth, vol. 9. Gerber lists the following plagues in Aleppo: 1669/70, 1685/86, 1720–1723, 1761/62, 1786/87, 1813/14, 1826/27, and 1846/47; according to Qasatli (*Kitab al-Rawdah,* pp. 90, 93), 30,000 persons died in Damascus in 1852 and 10,000 in 1865.

[63]Richards to O'Connor, 2 December 1912, FO 195/2122.

[64]Memorandum of 22 February 1845, CC Damas, vol. 2.

[65]Finn to Clarendon, 27 July 1854, FO 78/1024.

[66]Despréaux to Bastide, 29 July 1848, CC Alep, vol. 31.

[67]Cuinet, *Turquie,* vol. 2, p. 184; idem, *Syrie,* pp. 56, 119, 446, 450, 553.

hundreds of women invaded the Governor's palace and such was the confusion that recourse had to be had to armed forces."[68]

There seems to have been little migration to or from Iraq, but in Syria both currents were quite large. Emigration from Lebanon began in the 1850s, at first mainly to Egypt, which was growing rapidly. By the 1880s large numbers were emigrating to the New World. Several "push" factors were operating: population pressure, religious and social unrest, and—in other parts of Syria that, unlike Mount Lebanon, were subjected to conscription—the desire to escape military service. The "pull" factors were those at work elsewhere. Between 1860 and 1900 some 120,000 persons emigrated. By 1896 emigration was running at about 5500—mainly to South America. Formerly it had been all Christian, but now the Druzes were also leaving; remittances sent back by emigrants were put at £T. 143,000 a year.[69] In 1900 the American consul stated that emigration to the United States had started in 1878; some 5000 persons were leaving for the States from Beirut and Tripoli each year, and the total number of Syrians there was over 50,000 (see also selection 12).[70] The previous year he had reported that some 500 naturalized Americans of Ottoman origin had returned to their villages in Lebanon.[71] In 1902 the British consul reported that emigration "is always on the increase and has now extended from the Lebanon and Anti-Lebanon to all districts of Syria"; brokers were exploiting the situation.[72]

In 1903 there was an emigration of Christians from Beirut, many from "the most considered Greek Orthodox families," to Egypt and elsewhere because of the feeling of insecurity engendered by the events of September 6 of that year. In 1907 the French consul reported that emigration from Palestine was relatively small—4000 in the previous 10 years. In 1909 total yearly emigration from Syria was put at 10,000, but for the same year a higher figure was given for Aleppo alone, and for 1900–1914 the annual average has been estimated at about 15,000.[73]

In 1911 the United States Immigration Commission pointed out that Syrian immigrants had higher levels of skills than other immigrants: 22.7 percent were in skilled occupations and 20.3 percent in trade.[74]

By 1914 some 300,000–350,000 had left, two-thirds to the United States and most of the rest to South America. The number of Lebanese abroad must have equaled at least a quarter, and probably more, of the population of the Mountain, and nearly half in some districts.[75] Their remittances made a significant contribution to Syria's balance of payments (III, Introduction). No less important were the ideas and skills they transmitted, ranging from literature to politics and commerce. In 1905 the British consul reported that

[68]Rousseau to Waddington, 17 March 1878, CC Damas, vol. 6.

[69]Himadeh, *Economic Organization*, pp. 13–16; "Report on Trade," 1896, CC Beyrouth, vol. 12.

[70]Ravndall to Hill, 4 October 1900, US GR 84, T367.21.

[71]Ibid., 11 April 1899.

[72]"Quarterly Report," June 1902, FO 195/2122.

[73]Richards to O'Conor, 22 October 1903, FO 424/205; A and P 1910, vol. 103, "Beirut" and "Aleppo"; Himadeh, *Economic Organization*, p. 13.

[74]Karpat, "Ottoman Emigration," which contains much information; see also Tibawi, *American*, p. 238.

[75]See Ruppin, in *EHME*, pp. 269–273; see also Safa, *L'émigration libanaise*, Tu'meh, *Al-mughtaribun;* Winder, "The Lebanese"; Karpat, "Ottoman Emigration" puts total emigration from Geographical Syria at 600,000.

returning emigrants from America and elsewhere were stirring a movement against the feudal shaykhs and clergy among Maronites, Greek Orthodox, and others in North Lebanon and Matn.[76]

There were three currents of immigration: Armenians, Caucasian Muslims, and Jews. For centuries a substantial number of Armenians had lived in Aleppo, mostly engaged in trade and handicrafts, and in the towns lying north of it like ʿAintab and Marʿash. In 1857 the number of Armenians in Aleppo city was estimated at 4000 and in 1890 at 5500, and that in the Aleppo *vilayet* at about 48,000.[77] The official returns for 1914/15 give two figures for the Armenian population of the *vilayet:* 40,843 and 49,481, and, for the city, 8000; the discrepancy may be due to the inclusion of Protestants in the second, but not the first figure; the number of Armenians in the rest of Syria was put at 2500. During and after the First World War some 150,000 Armenians took refuge in Syria, and by the Second World War there were some 200,000 in Syria and Lebanon and 4000 in Palestine.[78]

Caucasians were part of the influx of Muslim refugees from the Caucasus, Russia, and the Balkans, who entered the Ottoman Empire in 1876–1878 and most of whom settled as productive farmers.[79] In 1906 the future prime minister of Syria, Faris al-Khuri, then employed by the British consulate in Damascus, put the total settled in the *vilayet* of Syria (mainly in Qunaitra and ʿAmman) at 5540 households, or about 30,000 persons. A further 670 households were settled in the *sanjaq* of Hama,[80] and a larger number in the *vilayet* of Aleppo and the Dayr al-Zur district (selection 9). Some Cretan refugees were settled in the Antioch district (selection 14).

Until the 1870s the number of Jews in Palestine remained small. In 1806 and 1816, respectively, Seetzen put it at 2000 and Buckingham at 4000.[81] For the 1830s estimates range between 6000 and 10,000, of whom some 3000–5000 were in Jerusalem and 1500 in Safad, and these figures showed little change through the 1860s. By the mid-1870s the total had risen to 25,000, of whom 13,000 were in Jerusalem and 8000 in Safad. In 1895 the total reached the 50,000 mark, of whom 28,000 were in Jerusalem, 7000 in Safad, and 3000 in each of Tiberias and Jaffa. By 1907 there were 80,000, and by 1914 over 90,000, of whom 45,000 were in Jerusalem, 10,000 in Jaffa, and 8000 in Safad. The Jews of Palestine were an overwhelmingly urban community, but there were some 12,000 farmers (V, Introduction). However, as late as 1891 a British consul, describing seven Jewish colonies, stated that Jews "do not make good agricultural colonists and were it not for outside support would not prosper. They seem to prefer employing native labour to working themselves."[82] But early in this century Petah Tikva and other successful settlements were founded (see V,22). In 1914–1918 many thousands of Jews left Palestine, and in 1918 there were 56,000 in the country. Throughout the period mortality was very high

[76]Administrative Conditions in Lebanon, 17 October 1905, FO 424/208.

[77]A and P 1859, vol. 30, "Aleppo"; Cuinet, *Turquie,* vol. 2, pp. 114, 164.

[78]McCarthy, *Arab World,* pp. 64–71; Himadeh, *Economic Organization,* p. 23; *idem, Palestine,* p. 10; Hourani, *Minorities,* p. 12.

[79]See Karpat, "Ottoman Population Records."

[80]Report, FO 618/3; for a detailed account see Lewis, *Nomads,* pp. 96–123.

[81]The figures in this paragraph are taken from Eliav, *Ahaavat,* Appendix A, and Ruppin, *Syrien,* p. 11.

[82]Trotter, "Report on Visit," 10 August 1891, FO 195/1723; see also Dan Giladi, "The Agronomic Development of the Old Colonies in Palestine, 1882–1914," in Maʿoz, *Studies,* pp. 175–189.

because of poor living conditions and premature marriages, and death rates may well have exceeded birthrates; it was almost solely through immigration that the community grew.[83]

Very few other foreigners settled in Syria or Iraq. In 1831 the number of Frenchmen—all merchants except for a few missionaries, dragomans, and four physicians—in the Acre consulate was 97 (including 42 persons under 21 years), and there were also 29 protected subjects, mostly Lebanese; 69 were in Beirut, 25 in Saida, 12 in Lebanon, 7 in Acre, 6 in Damascus, 4 in Jaffa, and 3 in Haifa.[84] In 1863 there were 25 Frenchmen in the consulate of Damascus (of whom 8 women and 3 children) and 95 in that of Aleppo (30 children).[85] In 1895 the French consul estimated the number of French subjects in Beirut at 1200–1300, plus those in the interior; Italians were put at over 600, Austrians at 200, Germans at 150, British at 100, Swiss at 50, and there were a few Russians and, he could have added, Americans.[86]

With regard to the British, in 1891 there were 215 British-born and 18 naturalized subjects as well as 171 protected persons (not including 139 Russian Jews) in the Jerusalem consulate.[87] In 1901 there were 59 British-born males and 151 females, and 295 protected subjects in the Beirut consulate, and 81 British-born males and 164 females in the Jerusalem consulate.[88] In 1911, there were 14 British-born males and 19 females in the Damascus consulate.[89] The most important group of Germans was the Templars in Palestine, with some 2000 members (V, Introduction and V,13). The construction of the Baghdad Railway brought a large number of German technicians to northern Syria, and in 1911 the British consul reported that over 200 Germans were registered in their consulate in Aleppo. They had opened both a hospital and a school; earlier there had been German reports of settlers in Marʿash, Urfa, Kharput, and elsewhere along the line.[90] For 1895 the Ottoman government gave the number of foreign residents as follows: *vilayet* of Beirut 2742, of Aleppo 2107, and of Jerusalem 5457.[91] These figures presumably include protected subjects. Altogether, the number of foreigners was incommensurately small compared to their economic and cultural influence.

The same was even more true of Iraq. In 1895 the French consul in Mosul reported that, in the whole *vilayet,* the only foreigners were the Dominican Mission, the Apostolic Delegation (selection 21), and a couple of American pastors.[92] In 1891 there were 77 British-born persons in the Baghdad consulate, including wives and children. Of these, 4 were merchants, 4 engineers, 2 accountants, a banker, and a physician; there were also 5 protected subjects, 4 of them of German and one of Greek nationality. In Basra the figures were 17 (of whom 7 merchants and one physician) and 4, all the latter of Greek

[83]Schmelz, "Some Demographic Peculiarities of the Jews of Jerusalem in 19th Century Palestine," in Maʿoz, *Studies,* pp. 119–141; for occupations and living conditions see Luncz, *Jerusalem,* passim, and Gilbert, *Jerusalem,* passim.

[84]Dispatch of 1 January 1831 and Table in CC Beyrouth, 1 bis.

[85]List in CC Beyrouth, vol. 9.

[86]"Report on Trade," 1895, CC Beyrouth, vol. 11.

[87]Return in FO 195/1727.

[88]Returns in FO 195/2075; FO 195/2106.

[89]FO 195/2370.

[90]Young to Lowther, 24 October 1911, FO 195/2366; Cartwright to Grey, 1 June 1907, FO 424/212.

[91]McCarthy, *Arab World,* p. 61; no figures are given for Damascus.

[92]Report, 30 April 1895, CC Mossoul, vol. 2.

nationality.[93] In 1901 there were 35 British-born males, 20 females, and 16 minors in Baghdad; they included 6 engineers, 5 merchants, 3 physicians, 2 nurses, 2 bankers and an accountant, a goldsmith, and a photographer. In Basra there were 18 males and 7 females and 37 British Indians.[94] In 1911 the figures were, Baghdad 49 males and 24 females, Basra 35 and 16, and Mosul 3 and 3.[95] The number of other western foreigners was negligible, and the total European and American population was put at about 200; however, in 1895 there were some 33,000 Iranians and other Asians, almost all in the Shiʻi Holy Cities of Karbala and Najaf.[96]

Groups, Classes, Sects

The political, economic, and cultural developments that took place in the 19th century produced significant changes in the social structure. The imposition of order over greater areas made it possible to push back the frontier of cultivation in both Syria and Iraq (V, Introduction). This process not only opened new lands to sedentary cultivation but also accelerated the settling down of nomads. In addition, beduins were adversely affected by certain developments in transport. The diversion of trade to the Suez Canal reduced the volume of caravan traffic across the Syrian desert and Sinai, and the North Arabian caravans were also probably affected. The building of railways took away some business from nomads (IV,7 and 8). It is also possible that sales of camels and horses by nomads to the sedentary inhabitants were reduced,[97] although this may have been offset by increased sales of livestock products to the growing urban population (V,18). Hence the proportion of nomads in the total population sharply decreased. In Iraq, according to Hasan's estimates, it fell from 35 percent in 1867 to 17 percent in 1905; more accurate figures for 1930 put it at 7 percent.[98] In Syria the same trend probably held. In 1843 it was reported as generally believed that in the area between Damascus, Aleppo, and Baghdad there were some 500,000 beduins, of whom 200,000 were known as *ahl al-shimal* and 300,000 were ʻAnaze; around 1930 the proportion of nomads in the Republic of Syria was 13 percent, far less in Lebanon, 6 percent in Palestine, and probably near 50 percent in Jordan.[99]

The most important change in the class structure was the strengthening of the landlords and merchants. Both benefited from the extension of cultivation, the rise in the value of land and farm products, and the increasing monetization of agriculture (V, Introduction). Both were also helped by increased order and the greater security enjoyed by property; in particular the Land Code of 1858 (V, Introduction) established titles to land on a much firmer base. Both were also able to take advantage of the opportunities offered by the expansion of foreign trade (III, Introduction), specialization in cash crops

[93]Return 5 April 1891, FO 195/1721.

[94]Returns in FO 195/2096.

[95]Returns in FO 195/2368.

[96]Great Britain, Foreign Office, *Mesopotamia*, pp. 11–12; McCarthy, *Arab World*, p. 61.

[97]See Pershits, in *EHME*, pp. 342–349; on the process of sedentarization of the Muntafiq, see Fraser, *Travels*, vol. 2, pp. 97–104; on Bedouins in Iraq in the nineteenth century, see Nieuwenhuis, pp. 121–68.

[98]*EHME*, p. 157.

[99]Consul to Guizot, 21 December 1843, CC Damas, vol. 1; Himadeh, *Economic Organization*, p. 12; idem, *Palestine*, p. 35.

(V, Introduction), and the introduction of mechanical transport (IV, Introduction). The Ottoman army and administration also enabled some individuals to rise to the upper levels of the social scale.[100]

In Syria, by the end of the 19th century, a few dozen families of very large landowners, each holding several villages, had emerged. As Philip Khoury has pointed out, they replaced—and were often the result of a merger between—the two formerly prominent groups: the religious-based *ulama* and the military *aghawat*. In Damascus there were the 'Azm, 'Abid, Yusuf, Mardam, 'Ajlani, Bakri, and other families.[101] In Aleppo there were the Jabri, Hananu, Qudsi, Rifa'i, Kikhya, Ibrahim Pasha, Kayyali, and other families.[102] The leading landowners of Homs were the Atasi and Druby families and of Hama the 'Azm, Barazi, and Kaylani. In Huleh the beduin Fa'ur chiefs held much land, in the Biqa' there were the Harfush and Himadeh, in South Lebanon the As'ad, and in 'Akkar the Mir'abi.[103] A small number of merchants, some Christian like the Sursuq of Beirut or the Far'un and Skaf of Zahle, also acquired large estates in foreclosure for debt or by purchase. Practically all these landlords were absentees, renting out their estates to sharecroppers or administering them through bailiffs.

The shift of economic activity from the interior to Beirut favored the merchants of that city, particularly the Christians. By the middle of the century the latter had forged ahead of their European and Muslim rivals (III,9). In addition to trade, many were engaged in banking and insurance, or acted as agents of foreign shipping lines; they also invested in the rapidly appreciating real estate. The main merchant families of Beirut were the Sursuq, Bustros, Trad, Fraij, Tuwayni, Medawwar, and Abela among Christians and the Bayhum, 'Itani, and Barbir among Muslims.[104] In Aleppo there were the Sayim al-Dahr, Mi'marbashi, Rabbat, Lian, and others, and in Damascus the Humsi, Asfar, and Shamiyya among Christians, the Quwwatli, Haffar, Jallad, and Sukkar among Muslims, and the Farhi, Lanyado, and 'Ads among Jews.[105]

The handicraftsmen, who had played such an important part in traditional urban life, suffered greatly from foreign competition. Their numbers seem to have declined sharply but then may have picked up somewhat (VI, Introduction). Their incomes were subjected to heavy pressure and in all probability declined. Their guilds slowly disintegrated. But they continued to constitute a significant urban force that could be called upon in a political crisis and played their part in the nationalist movement of the interwar period. Another petit bourgeois group was the product of the educational revival (see below); the graduates of the modern schools earned their livelihood as government officials or employees of the few banks and other large firms, or else as physicians, pharmacists, journalists, and teachers. Because of the very limited extent of industrialization, the urban working class was very small and weak. The peasantry seem to have been little affected by the various developments in the economy; many failed to register their claims to the land they had been cultivating and to which they were entitled under the Land Code, but they continued to farm it as sharecroppers. The lack of population pressure probably

[100]Ruth Roded, "Ottoman Service as a Vehicle," in Warburg and Gilbar, *Studies*, pp. 63–94; on the Haifa elite see Joseph Vashitz, "Dhawat and Isamiyyun in Haifa," in idem, pp. 95–120.

[101]Khoury, *Urban Notables*, pp. 18–52; see also Schatkowski-Schilcher, *Families*, pp. 136–156.

[102]For the earlier period, see Meriwether, "Notable Families"; Marcus, *Social Realities*.

[103]Gilsenan, in Khalidi, *Land Tenure*, p. 460.

[104]Fawaz, *Merchants and Migrants*, pp. 88–96.

[105]Khoury, p. 119.

meant that sufficient land was available for all those in a position to farm it, but any statement on this subject must remain highly tentative.

Developments in Iraq were roughly similar, but with more emphasis on landowning and less on urban activities. The expansion of agriculture and the alienation of land from tribesmen brought into being a class of very large landowners, several of whom eventually came to hold tens of thousands of hectares.[106] They covered all the main regions and were drawn from Arabs and Kurds, Sunnis and Shi'is. In the north there were such tribal families as the Jaf Begzadeh, al-Yawir, and al-Farhan, representatives of the old ruling families such as Baban, heads of religious orders like the Kakai and al-Talabani families, and merchant families that had acquired land, like the Sabunji. In the center were such tribal families as al-Amir, al-Yasin, al-Qassab, and al-Sa'dun, and merchant families, like the al-Chalabi, al-Khudayri, al-Damirchi, and Pachachi. In the south there were tribal *shaykhs* such as the 'Atiyya, al-Shahad, and al-Sha'lan families, and tribal *sadah* (descendents of the Prophet) such as the Abu Tabikh and al-Mgutar families.

Mercantile and financial activities were much less developed than in Syria and, to a much greater degree, they were dominated by foreigners. And within the Iraqi community the Jews became predominant.

In 1839–1840 two British firms were established in Baghdad and, as late as 1857, in spite of the arrival of one Swiss and two Greek firms, "except the two British firms . . . , There are no foreign [i.e., non-British] merchants who are engaged in the direct trade with Europe."[107] By 1879 "The Jewish Mercantile Community of Baghdad have nearly all the trade with England in their hands whereas the native Christian merchants trade mostly with France"[108]; trade with Britain was many times greater than that with France (III, Introduction). In 1909 there were 54 Baghdad importers who had branches in England; all were Jewish.[109] The Jewish business community included such internationally famous names as Sassoon, Zilkha, Haskiel, and Kadoorie. In Basra in the 1870s the export of dates was carried out by six European and six local firms, most of the latter being Muslim, and the same was broadly true of grain and wool.[110] A petition of Basra merchants in 1891 was signed by five Britons, three Muslims, two Greeks, and one Syrian, and in 1908 there were two Greek firms.[111] A list of the main establishments in Iraq engaged in the import–export trade around 1908 shows seven foreign names, five Jewish, and one Muslim.[112]

On the whole, Muslim merchants concentrated on internal trade. Many of them were descended from or related to Arab tribal families, including the Ghannam, Qassab, and Shawkat families. A few had connections with the handicrafts, like the Muluki and Kubbah. Some of the most prominent were of Syrian, Najdi, or Persian origin, like the Shahbandar, Pachachi, Zaibaq, Ghannam, and Charchafchi.[113]

Except for the *sarrafs* (moneychangers), all banking was carried out by foreign

[106]See the discussion in Batatu, *Old Classes,* pp. 53–361, and tables on pp. 58–62, on which the following account is based.

[107]Kemball to Redcliffe, 26 December 1857, FO 195/577.

[108]Trade report, 1878/79, FO 195/1243.

[109]List in Ramsay, Note, FO 195/2308.

[110]Hasan, *Al-tatawwur,* pp. 139–162; Batatu *Old Classes,* pp. 252–256.

[111]Petition of 20 June 1891, FO 195/1722, and Crow to O'Conor, 18 January 1908, FO 195/2274.

[112]See details in *EHME,* pp. 184–185.

[113]Batatu, *Old Classes,* pp. 259–260.

establishments (VII, Introduction and VII,25). The liberal professions were much less developed than in Syria, and "the lawyer's profession in Baghdad, Basra and Mosul is monopolized by the Christian races."[114] The civil service was staffed mainly by Muslims. To a much greater degree than in Syria, Iraqis served as officers in the Ottoman army.[115]

The main shifts in the relative position of the principal sects is apparent from the preceding account. The non-Muslim minorities, who lived mainly in the cities, took full advantage of the increased educational opportunities, concentrated on the expanding sectors of the economy (i.e., trade, finance, mechanical transport, professions), and received much help from their coreligionists abroad, and often foreign protection as well.[116] In Lebanon the Christians came to dominate trade, finance, the professions, and the silk industry, and in Palestine they became prominent in trade and tourism. In 1860 the British consul in Jerusalem reported: "The principal native exporters and merchants are Moslems," Christians were "generally dealers in merchandise of both local and foreign goods"; "artizans of the better kind are all Jews and Christians"; the "bulk of landed and house property is in the hands of Moslems."[117] In Syria, the Jews, who in the 1830s had been rather important in the trade of Damascus, and quite significant in Aleppo,[118] lost ground to Christians. Christians were also prominent in the professions; however, their former predominance in handicrafts was weakened by the events of 1860 (VI, Introduction). In 1861 the British consul stated: "Most of the trade and manufacture of Damascus was in the hands of that portion of its inhabitants who are now dispersed." However, his colleague in Aleppo declared that "all the proprietors in the country are Mussulmans. Almost all the traders in the towns are Christians. Almost all the cultivators are Mussulmans . . . almost all the manufacturing population are Christians." In 1879 the French consul in Damascus reported that the Christians of Damascus and Hama were poor but those of Homs well off; his British colleague stated: "The wealth of the city and of the country around, which was formerly possessed by some 50 or 60 individuals, Moslems, Christians and Jews, is now chiefly centered in the hands of a dozen Moslem families, the majority of whom form part of or are connected with the official *entourage* of the local government"; some Christians, and more Jews, had been hard-hit by the government's default (VII, Introduction).[119] Except in Mount Lebanon, land remained in Muslim hands.

In Iraq, as noted, Jews—and, to a much lesser extent, Christians—became predominant in trade, finance, and the professions. A slight improvement also took place in the position of the Shiʿis, since the authorities showed greater tolerance while the Land Code strengthened the hold of the Shiʿi tribal *shaykhs* and *sadah*. A breakdown of the property held by the very large landowners in 1958 shows that 44 percent belonged to Shiʿi

[114]"Report . . . by George Lloyd," London 1908, p. 7 in IOPS/3/446.

[115]Batatu, *Old Classes*, pp. 319–323; Szyliowicz, "Changes in the Recruitment," in Maʿoz, *Studies*, pp. 249–283.

[116]For a fuller account, see "The Transformation of the Economic Position of the Millets in the Nineteenth Century," in Issawi, *Legacy*, pp. 199–230.

[117]Finn to Russell, 19 July 1860, FO 78/1521.

[118]See figures given by Bowring, *Report*, pp. 80, 94, tabulated in Issawi, *Legacy*.

[119]Rogers to Bulwer, 20 August 1861, FO 78/1586; "Report on Aleppo," 4 August 1860, FO 78/1538; Gilbert to Waddington, 14 August 1879, CC Damas, vol. 6; A and P 1880, vol. 74, "Damascus."

Arabs, 31 to Sunni Arabs, and 24 to Kurds[120]; before the First World War the Shi'i share may have been somewhat smaller.

The most striking regional development change in Syria was the shift from the interior to the coast. The population of the seaports grew much faster than that of the inland cities (see below). Two regions in particular made great economic and social progress: Mount Lebanon and parts of Palestine. In both, farmers benefited from the increased production of cash crops for export (V, Introduction, V,6). Lebanon, and to a lesser extent Palestine, was the main source of emigration, and it was to them that the bulk of remittances from emigrants was sent (selection 12, and III, Introduction). Both developed lucrative services, notably tourism. Finally, both were the main scene of foreign missionary and educational activity, a factor that had an enormous impact on their economic and social development (see below, and selection 11). This is strikingly brought out by the contrast between the tiled stone houses of Mount Lebanon and such small towns as Bethlehem, Ramallah, and Nazareth and the flat-roofed mud brick houses of the interior, and also by their superior hygienic standards and much higher rates of literacy.

Another important shift was from northern to southern Syria. This was partly attributable to the developments just noted, but also to the relative stagnation of Aleppo, which in the 17th and 18th centuries had been by far the leading city (III-5). This in turn was due to the devastating earthquake of 1822, the civil strife in the first decades of the century, the disturbances of 1850, and the Armenian massacres of 1895. Another contributing factor was that railways were built in the north much later than in the south, a failure that was only just being remedied at the outbreak of the First World War. It is noteworthy that the few modern factories that were set up were built in Damascus, Beirut, and (by Jewish immigrants) in Palestine, not in Aleppo (VI, Introduction).

Little is known about regional developments in Iraq, but two trends may be discerned: a shift from the countryside to the towns, especially Baghdad, and from the north to the south. The growth of trade, the development of the bureaucracy, the increase in taxes levied on farmers and spent in the towns (VII, Introduction), the appropriation of some tribal land by city people, and the loosening of the ties between tribesmen and their *shaykhs*—some of whom became absentee landowners (V, Introduction)—all of this raised urban incomes in comparison to rural ones. Concurrently, overland trade with Syria and Turkey stagnated, whereas the development of steam navigation in the gulf and on the Tigris greatly facilitated sea commerce and pulled away much business. It would seem that by far the greater part of the land reclaimed for cultivation lay in the center and south of the country. And, although the figures are far from reliable, it appears that in 1860–1914 the population of Mosul remained constant, whereas those of Baghdad and Basra grew.

Urbanization

At the beginning of the 19th century the Fertile Crescent—and more particularly Syria—was one of the most urbanized parts of the world. Table II.3 indicates that the urban population of Syria was over 250,000, or perhaps 20 percent of the total number of

[120]Batatu, *Old Classes*, p. 62.

Table II.3 Approximate Population of Cities[a]

	Year				
	1800	*1840*	*1860*	*1890*	*1914*
Damascus	100	100	100	165	220
Aleppo	100–150	70	100	130	200
Beirut	6	10	60	100	150
Homs	(10)	NA	NA	60	80
Hama	(10)	30–40	NA	45	70
ʿAintab	NA	25	NA	40	70
Tripoli	NA	15	NA	30	50
Latakia	NA	NA	NA	20	25
Saida	6	NA	NA	11	12
Jerusalem	9	13	20	40	80
Jaffa	3	5	6	(20)	40
Acre-Haifa	9	12	13	20	30
Gaza	8	12	15	20	30
Nablus	8	8	10	15	30
Hebron	7	8	10	15	25
Baghadad	80	(70)	90	145	200[b]
Mosul	50	80	45	60	70[b]
Basra	5–50	24	10	18	80[b]
Najaf	NA	NA	20	NA	40[b]
Karbala	NA	NA	30	65	50[b]
Hilla	10	NA	20	30	30[b]
Kirkuk	15	8	25	30	20[b]

Sources: EI2, s.v. "Akka," "Baghdad," "Basra," "Bayrut," "Dimashk," "Ghazza," "Halab,"
"Hamat," "Hilla," "Hims," "al-Khalil"; McCarthy, *Arab World;* Gibb and Bowen, *Islamic Soci-*
ety, vol. 1, p. 281; Cuinet, *Turquie*. With regard to Syria: Beirut, see Fawaz, *Merchants and Mi-*
grants; Palestine to 1880, Ben-Arieh, *Population;* Volney, *Travels;* Bowring, *Report*, pp. 7, 87, 114;
Ruppin, *Syrien*, pp. 9–10; Cuinet, ibid.; Gerber, "The Population." With regard to Iraq: To 1860,
Buckingham and travelers and consuls (Rousseau, Chesney, Fraser, Kemball), cited in Haider, "Land
Problems," p. 338; FO 78/1418, 1419; A and P 1867, vol. 67, "Baghdad"; 1890, Cuinet, ibid.;
1919, Great Britain, Foreign Office, *Mesopotamia*, pp. 14–15; Akrawi, "Curriculum Construction,"
p. 15.

[a]In thousands. Numbers in parentheses are estimates. NA, Not available.
[b]1919.

inhabitants and that of Iraq over 200,000, or perhaps 15–20 percent; both figures are very
high by the standards of the time.[121]

Many factors account for this. The fact that most of the recipients of rural rents and
taxes lived in the cities and spent their incomes there increased the purchasing power of
urban markets—and correspondingly diminished that of rural ones—causing a concentra-
tion of craftsmen, merchants, and others in the cities. The handicrafts of such towns as
Aleppo, Damascus, Baghdad, and Mosul served a market well beyond the borders of
present-day Iraq and Syria (VI, Introduction). Rural insecurity increased the attraction of
the cities, and many town dwellers cultivated lands outside their walls. Moreover, in
times of famine peasants fled to the towns in the accurate belief that the government

[121]For comparative figures and a general discussion see "Economic Change and Urbanization in the Middle
East," in Issawi, *Legacy*, pp. 289–307; see also Gerber, "The Population."

would not let townsmen starve, for fear of riots, and would secure provisions from the countryside in one way or another, even if it meant rural famine. Finally, transit trade brought considerable revenue to the towns situated on the main routes (III, Introduction), and pilgrimage played an important part in the economy of Damascus (IV,8), Jerusalem, Najaf, and Karbala.

Although the figures in Table II.3 are far from accurate, some estimates being shaky and numbers fluctuating sharply because of plagues and other catastrophes, they suggest that, until close to the end of the 19th century, the large towns—Aleppo, Damascus, Baghdad, and Mosul—showed little growth. The main reasons for this were probably the decline of handicrafts (VI, Introduction) and the diversion of trade routes (III, Introduction). On the other hand, the ports—especially Beirut but also Jaffa, Haifa, Tripoli, and Basra—developed very rapidly, a phenomenon that had its counterpart in other Middle Eastern countries. Many smaller towns also seem to have grown quite fast, such as Homs, Hama, Jerusalem, and, perhaps, Karbala. By 1914, Syria may have had an urban population of 1.2 million, or somewhat over 25 percent of the total, and Iraq of 500,000, or over 15 percent. The slow rise or constancy of the urban ratio at a time when it was rising in most parts of the world is due to the high rate of population growth, which raised the denominator, and the absence of industrialization, which meant relatively few opportunities in the cities and slower immigration into them, thus preventing the numerator from rising faster. It was not until the Second World War that the cities of the Fertile Crescent, and those of the Middle East in general, began to grow very rapidly.

The growth of the population of the main cities—Beirut, Damascus, Aleppo, Baghdad, and also Jerusalem—led to the development of new quarters outside the city walls. In Aleppo, in 1888, attempts were made to "create new quarters outside the city, composed of small houses, giving a revenue of 3 or 4 percent—but such attempts have not been successful, either from a sanitary or pecuniary point of view." In 1890 the British consul in Jerusalem mentioned "the springing up of a large suburb of well built and handsome houses to the west of the city"; the rise in the price of land from 600 to 800 percent in the previous twenty years; "superior hotel accommodation; good European shops, etc."[122]

Beirut led the way in providing urban amenities. In 1875 a British company, with a capital of £144,000, completed a waterworks system, piping water from Nahr al-Kalb, 14 kilometers away; by 1887 it had 2000 customers and a gross revenue of £11,000 and a net revenue of £7000. In 1896 the respective figures were 3000, £14,000, and £9000; the company was later acquired by French interests.[123] A French gas company started operations in 1888, but its first years were difficult because of the competition of kerosene; in 1909 it began supplying the town with electricity.[124] In 1908, a Belgian company laid down 16 kilometers of electric tramways.[125] Meanwhile, in 1905 a Belgian company,

[122]Moore to White, 15 February 1890, FO 195/1690; A and P 1889, vol. 81, "Aleppo"; for Aleppo, Damascus, and Baghdad see *E12*, s.v. "Halab," "Dimashk," "Baghdad"; for Aleppo see Marcus, *Social Realities*, Meriwether, "Notable Families," Sauvaget, *Alep*, and selection 18 (this chapter); For Beirut see Fawaz, *Merchants and Migrants;* For Jerusalem see Gilbert, *Jerusalem;* more generally, Abdel Nour; Raymond, *Grandes villes.*

[123]A and P 1875, "Beirut"; Verney and Dambmann, *Les puissances,* pp. 447–448.

[124]Verney and Dambmann, *Les puissances,* p. 451; A and P 1910, vol. 103, "Beirut."

[125]A and P 1909, vol. 98, "Beirut."

with a capital of £240,000, received a concession to supply Damascus with electricity—generated by the Barada River at Tekiyya, 35 kilometers away, the first hydroelectric installation in the Middle East—and to lay down 8 kilometers of tramways; by 1907 electricity was being supplied and streetcars were operating on 5.6 kilometers.[126] Baghdad got piped water shortly before the First World War. As for Jerusalem, numerous schemes were put forward for waterworks and electric lighting and streetcars, and in 1913 a concession was granted to a French syndicate, but the outbreak of war prevented implementation.[127]

Education

The educational level of the region was extremely low. No figures are available until the 1930s, but it is unlikely that, in 1914, the literacy rate in Syria, for those 10 years old or over, can have been more than 25 percent and in Iraq over 5 percent. In 1932 the literacy rate in Mount Lebanon was 60 percent; in the rest of the Lebanese republic it was lower, the overall figure being 53 percent. In the State of Syria, the overall literacy rate was 37 percent, ranging from 49 percent in the Alexandretta region, 45 in the *sanjaq* of Damascus and 42 in Homs, to 37 in the *vilayet* of Aleppo, 20 in the Euphrates region, 18 in both Hama and Hauran, and 3 in the Jazira; no figures are given for Latakia but they must have been very low: Generally speaking, women's literacy rates were one-half or less than those of men.[128] However, the 1930 figures refer to the *total* population; they should therefore be raised by about one-third to exclude children under 10. Among Palestinian Muslims the male literacy rate (7 years and over) in 1931 was 25 percent and the female 3 percent (Christians 72 and 44 percent and Jews 93 and 73 percent),[129] and in Transjordan it must have been far lower. In Iraq the first reliable figures, for 1947, put the rate (5 years or over) at only 11 percent—18 percent for males and 3 percent for females.

For Syria, earlier observations, are available. In 1845 an American missionary stated that in Maronite Kisrawan "from one-fourth to one-third of the adult males can read," but far fewer women had received any education. In 1848, among Aleppo Christians, some boys could read and write Arabic but "a young woman who knows how to read and write is a rarity." And in 1875 a British consul reported that in the villages in the coastal plain between Tripoli and Latakia "the only person who can read is generally, besides the sheik of the village, the resident agent of the Tripoli or Latakia money lender, who owns the village or who advances money upon crops."[130] In 1839 Bowring stated that "the Syrian population is generally more instructed than the Egyptian, and its condition, on the whole, is happier," but went on to say: "An estimate of the general want of instruction may be formed from the fact that the demand for books is so small in Syria that I could not find a bookseller in Damascus or Aleppo. I was told no scribe could

[126]A and P 1906, vol. 129, "Damascus"; ibid. 1908, vol. 117.

[127]A and P 1909, vol. 98, "Jerusalem"; ibid. 1913, vol. 95; Morgan to Secretary of State, 11 August 1910, FO 195/2351; see also Gilbert, *Jerusalem*.

[128]Himadeh, *Economic Organization*, pp. 11–12.

[129]Himadeh, *Palestine*, p. 36.

[130]Tibawi, *American*, p. 118; Despréaux to Guizot, 18 March 1848, CC Alep, 31; A and P 1875, vol. 95, "Beirut."

now get his living in copying mss. for sale." However, a few books printed in Cairo were finding their way to Syria.[131]

The schools available to Muslims were religious, where children were taught to read the Quran; according to Bowring, one was to be found in "every parish or mosque district" in the principal towns. There were also higher religious schools, the nature and low quality of whose curricula may be judged from that of al-Azhar University in Cairo, the apex of the Muslim educational system.[132] The Egyptians opened two modern schools, one in Damascus with 600 pupils and the other in Aleppo with 450, but neither survived their withdrawal. In 1845 an American clergyman wrote: "I saw no girls' school anywhere in Palestine except in the Protestant mission schools. The women, donkeys and camels bear the burden throughout the East."[133]

The minorities were better provided for. Thanks to close contacts with Rome dating from the 16th century, the Maronites and Greek Catholics had printing presses and numerous colleges for monks and primary schools, mainly in Lebanon but also in Aleppo and Damascus. The Greek Orthodox and Jews also had schools in Aleppo, Damascus, Jerusalem, and Beirut. By 1879, native and foreign ecclesiastical schools in Damascus "gave ample and sufficient facilities for primary instruction for all [Christians], and that, too, either gratis or purely nominal. . . . On the other hand the Jewish community, perhaps the poorest of all . . . is left pretty much without education of any kind."[134]

In addition, there were the foreign mission schools: Franciscan (mainly Italian) in Palestine and, after 1831, French Jesuit in Lebanon; in 1875 the latter opened St. Joseph University in Beirut, and Catholic nuns also founded many schools for girls. The Protestants followed, the Americans opening their first school in Beirut in 1824 and the British one in Jerusalem in 1849 and another in Jaffa in 1850; by 1887 there were 22 British schools in the Jerusalem consulate, and in the Beirut consulate there were 81 schools with 249 teachers, 2093 boys and 3281 girls, quite a large proportion of the pupils being Muslim or Druze.[135] Following numerous other American schools, the Syrian Protestant College, later renamed American University of Beirut, was founded in 1866.[136]

Russian Orthodox schools began in 1882, first in Palestine and then in Lebanon and Syria, and by 1905 there were 77 in Lebanon and Syria with over 9000 pupils; several of their graduates went on to Russia for further education. At the outbreak of war there were 14 German Protestant schools, in Palestine and Beirut. There were a few very good Jewish schools in Jerusalem. Some of the foreign high schools were excellent, such as 'Antura and Aleppo (French), Brummana and Bishop Gobat (British), Ramallah, Aleppo

[131]Bowring, *Report*, pp. 105–110; Tibawi, *American*, pp. 66–71.

[132]Dunne, *Introduction*, pp. 41–84; see also Tibawi, *Islamic*, pp. 19–50.

[133]Bowring, *Report*, pp. 107–108; Tibawi, *Islamic*, p. 64; Durbin, *Observations*, vol. 2, p. 22; for the work done by women in villages see Wilson, *Peasant*, Ch V–VII.

[134]A and P 1880, vol. 74, "Damascus"; for details see Hitti, *Syria*, pp. 674–677; idem, *Lebanon*, pp. 453–470; Harik, *Politics and Change*, pp. 160–166; Bowring, *Report*, pp. 105–110; Tibawi, *American*, p. 118; Philipp, *Syrians*, pp. 84–85; Hanf, *Erzeihungwesen*, p. 65; Pernot, *Rapport;* Qasatli, *Kitab al-Rawdah*, pp. 118–120, describes schools in Damascus, giving numbers and subjects taught; for the Armenians, see Sanjian, *Armenian*, pp. 78–84.

[135]Tibawi, *American*, pp. 32–33; idem, *British*, passim; Moore to White, 20 July 1887, and Eyres to White, 7 February 1887, FO 195/1581.

[136]S. Penrose, *That They May Have Life*, passim.

(American), Nazareth (Russian), the Prussian girls' school in Beirut, and the Alliance Israélite in Jerusalem.[137]

The government also began to play a more active part, with the Public Education Law of 1869.[138] Selection 11 of this chapter shows the situation in the *vilayet.* of Damascus in 1885; comparable data are not available for Aleppo, but in 1880 there were, in the city, five foreign Catholic schools with 120 boys and 240 girls; seven national Catholic schools with 585 boys and 100 girls; one Greek Orthodox school with 120 boys; five Armenian schools with 240 boys and 55 girls, in addition to an advanced college and three other schools in 'Aintab with 980 pupils; and two Jewish schools with 80 pupils. In 1890 a secondary school, with accommodation for 300 boys, was opened in Aleppo.[139] In 1895 there were, in the provinces of Aleppo, Syria, Beirut, Jerusalem, and Dayr al-Zur, 1562 elementary (*ibtidaiya*) schools with 48,900 Muslim pupils (42,200 boys and 6700 girls), 8 preparatory (*i'dadiya*) schools with 700 Muslim pupils, all male, and 29 secondary (*rushdiya*) schools with 2150 Muslim pupils, nearly all boys.

In 1907 the *vilayet* of Aleppo had 710 Muslim schools, with 19,000 pupils, 250 Christian with 8000, and 30 Jewish with 2000. In 1909 that of Syria (i.e., Damascus) had 89 government schools with 5900 pupils, 131 communal schools with 4000 students (500 Muslim, 500 Druze, and the rest Christian), and 89 foreign schools with 10,500 pupils (1100 in Jewish and the rest in Christian schools).[140] In 1903 a medical college was opened in Damascus, with an entering class of 38.[141]

By 1913 the number of pupils in state elementary schools had risen to 29,500, and there were 51,000 in private schools[142] These figures do not include mosque schools nor those in Mount Lebanon; in 1900 there were 330 schools in Lebanon,[143] and the number of pupils may have been of the order of 20,000. In 1924 the number of students in the Lebanese republic's public schools was 8000, in private schools 53,000, and in foreign schools 7000; in Syria the figures were 25,000, 27,000, and 2000, respectively.[144] Assuming that about one-eighth of Syria's population, or about 560,000, were 7–12 years old, some 15 percent of Syria's school-age population attended school in 1913, the percentage for boys being perhaps 25; however, a disproportionate number of students were Christians or Jews. By Middle Eastern standards Syria, and more particularly Lebanon and Palestine, was very well provided with education; its press was developed: 50 dailies, 15 weeklies, and 20 monthlies or quarterlies in 1914.[145]

[137]Hopwood, *Russian Presence,* pp. 136–157; see also Foreign Office Handbook, *Syria and Palestine,* pp. 53–56, for breakdown of foreign schools. The dates of foundation of schools and other institutions in Jerusalem between 1838 and 1900 may be traced in the maps in Gilbert, *Jerusalem,* pp. 29, 58, 106, 140, 172, and 204. For the Alliance and other Jewish schools, see K. Grunwald, "Jewish Schools under Foreign Flags in Ottoman Palestine," in Ma'oz, *Studies,* pp. 164–174.

[138]Kazamias, *Education,* passim; Shaw and Shaw, *History,* vol. 2, pp. 111–113, 249–252.

[139]"Population of Aleppo Vilayet," 28 August 1880, FO 195/1305; A and P 1892, vol. 82, "Aleppo."

[140]For details see Longworth to O'Conor, 15 April 1907, FO 424/212, and Devey to Grey, 13 September 1909, FO 424/221.

[141]Richards to O'Conor, 10 December 1903, FO 195/2144.

[142]For breakdown, see McCarthy, *Arab World,* pp. 117–127.

[143]See breakdown in "Report on Lebanon," FO 195/2075.

[144]Akrawi and Matthews, *Education,* p. 351.

[145]Pernot, *Rapport,* pp. 228–229; for details see Tarrazi, *Tarikh.*

Even by these standards, however, Iraq was very much less fortunate. It too had its religious schools, culminating in the colleges of Najaf and Karbala that attracted students from many foreign Shi'i communities,[146] but almost no modern ones. In Mosul, the Dominicans had a mission (selection 21) that taught a small number of Catholics. In 1870 Midhat pasha opened the first state schools. In 1885 a British consular report lists the schools in Iraq.[147] In Baghdad there were three military schools, two primary with 260 pupils who were taught Turkish, Persian, and Arabic, and one secondary with 10 teachers and 30 students, the language of instruction being Turkish. There were also two civilian primary schools, with 102 pupils who were also taught Turkish, Persian, and Arabic, and a crafts school with 69 pupils. In the area of private education, there was one Catholic French school for boys and another for girls, an Alliance Israélite school, founded in 1864,[148] and an Armenian school. In Basra there was one government school, with 30–40 pupils, a national Catholic school for boys and one for girls with nearly 40 pupils each, and a Jewish school with 30 pupils. In Mosul there was one primary school with 81 pupils and two elementary ones with 522; the Christians had 25 schools with 1513 pupils and the Jews one with 110. These figures do not, of course, cover the mosque schools. In June 1896 a British Protestant school opened in Baghdad, with 26 Iraqi and 10 European boys and girls, and had 61 pupils registered for the following October. There were also boys' schools run by Protestant missionaries in Mosul and Basra.[149] In 1898 a girls' primary school was founded in Baghdad. By 1913 "government maintained, besides military schools, a free primary school at every Qadha headquarters."[150] Teachers' training colleges were founded in Baghdad, Mosul, and Basra. In 1908 a law school was opened in Baghdad. In 1913, 818 pupils were attending secondary schools, and 472 of these were in the primary classes. There were also 160 primary and elementary schools, with 321 teachers and 6655 pupils (5899 boys and 756 girls). Of these, 3571 pupils were in Baghdad *vilayet*, 950 in Basra, and 2134 in Mosul. In 1920 there were 8400 pupils in Iraqi government schools.[151]

The impact of this educational development was slight. In Mosul, there was only one Muslim who knew a foreign language.[152] According to a well-informed observer,[153]

From perhaps a half percent in 1850, some five to ten percent of townspeople were literate by 1900. Of publishing, book production, or generally readable literary output there was nothing save the dull official newspaper. . . . The professional classes—lawyers, doctors, military officers—had acquired a modicum of specialized knowledge reaching no standard admissible in Europe; in other branches of applied knowledge—agriculture, engineering, economics—there was nothing, or almost nothing to show.

[146]For a vivid picture, see Mottahedeh, *The Mantle,* passim.

[147]"Table of Public Educational Institutions," FO 195/1509.

[148]See details in Geary, *Through Asiatic Turkey,* vol. 1, pp. 132–133.

[149]Dispatch of 1 June 1896, FO 195/1935; Zeigler, "Brief Flowering," pp. 4–7.

[150]Longrigg, *Four Centuries,* p. 316.

[151]Akrawi, "Curriculum," p. 130; see also selection 35 (this chapter) and, for further details, al-Hilali, *Tarikh.* Akrawi and Matthews, *Education,* p. 139; for French schools in 1912, see Pernot, *Rapport.*

[152]"Notes on the City of Mosul," FO 195/2308.

[153]Longrigg, *Four Centuries,* pp. 21. 316.

National Income and Level of Living

Any statement about the course of per capita income in Syria must remain highly tenta-
tive, and about the level of living even more so. For we know too little about their major
determinants—agricultural and industrial production, population, income distribution,
and even foreign trade—to hazard more than a guess. Some scholars, such as
Smilyanskaya, Chevallier, and Schatkowski-Schilcher, hint at a general impoverishment,
adducing the drain of specie caused by an adverse balance of trade (III, Introduction), but
such bullionist arguments are not very convincing, although they may well be true for the
1840s and 1865–1880.[154] The opposite argument, of an improvement witnessed by the
large increase in foreign trade (III, Introduction), is somewhat more cogent. The exten-
sion of the cultivated area (with no noticeable rise in yields) and the expansion in most
cash crops (V, Introduction and V,6) point to a significant rise in agricultural production.
Tithes yielded 10–11 million piasters in 1833–1835, during the Egyptian occupation (a
period of heavy taxation), about 35 million in the mid-1870s, about 46 million in 1898, 54
million in 1904, and 65 million in 1910 (VII,7). Since population about doubled over this
period and wheat prices rose somewhat less than twofold (VII,1) it would seem that per
capita agricultural output increased by perhaps 50 percent, or say 0.5 percent a year.

Data on industrial output are scanty. Like those of other countries, Syrian handspin-
ners were unable to compete with machine-spun yarn, and local output fell sharply and
consistently from the 1820s on.[155] On the other hand—and also as in other countries—
weavers were able to adjust to the new situation, using imported yarn (VI, Introduction).
Hence the output of cotton cloth, which had fallen quite considerably, began to increase
again rather quickly after the 1870s. Some other industrial products, such as soap and
tourist goods, also increased (VI, Introduction). However, it is likely that, at best,
industrial output kept pace with population, and more probably it lagged behind.

It is however practically certain that the product of such sectors as transport, trade,
finance, and various services like education and tourism, grew much faster than popula-
tion. So, in all probability, did the government sector.

Another approach is through the estimates of gross national product (GNP) shown
in selection 20. Raising Ruppin's estimates by 10 percent, to take into account Rechlin's
rectifications, gives a per capita income of slightly over £8–10s, or say $42. This agrees
substantially with Eldem's estimate of about £T. 10.5 for 1913 and compares with about
$45 for the Ottoman Empire and $50 for Egypt.[156] In both countries these figures were
reached only after a steady rise over several decades, which may indicate a similar
increase in Syria. On the other hand, we can recall Bowring's statement, quoted earlier,
that compared to Egypt, Syria's "condition, on the whole, is happier."[157] The improve-
ment may therefore have been smaller.

Another indicator is the trend of real wages. Table II.4, based on averages of the
available figures in selection 19, shows that between 1840–1858 and 1910–1914 wage
rates rose by about 2.5 times, while the cost of living probably less than doubled (VII,
Introduction, Table VII.2). This suggests a distinct rise in real wages for both skilled

[154]Smilyanskaya, in *EHME*, pp. 226–247; Chevallier, "Western"; Schatkowski-Schilcher, "Ein Modellfall."

[155]See estimates for Ottoman production in Pamuk, "Decline."

[156]*EHT*, pp. 6–7; Eldem, *Osmanli*, p. 305; Hansen, "National."

[157]Bowring, *Report*, p. 105.

Table II.4 Nominal Daily Wages in Syria, 1840–1914

Time Period		Occupation			
	Mason	Carpenter	Common Laborer	Agricultural Laborer	Unweighted Average
1840–1849	100	100	100	100	100
1850–1858	103	127	111	165	127
1873–1878	146	211	195	—	184
1900–1914	253	—	292	278	274

Source: Selection 19 (this chapter).

artisans and common laborers. The increase is in line with, though perhaps smaller than, that for Turkey.[158] However, a breakdown by subperiods shows that the increase in real wages came after the 1870s; until then, wages seem to have lagged behind the rise in prices. This observation agrees with the British consul's remarks regarding both the lowness of wages and the generally depressed situation in the late 1860s and 1870s (selection 7). Comparison between the two pieces in selection 6 also points to a deterioration between the 1830s and 1870s. Since there is no reason to believe that the share of labor rose, at the expense of other classes, the increase in real wages probably indicates a similar rise in per capita income in 1880–1914.[159]

Information on changes in the level of living is even scarcer. No data are available on food, but trends in imports of three items of wide consumption are significant. That of sugar rose from £14,000 in 1836–1837 (and £8000 in 1844–1846) to £72,000 in 1873–1877, £136,000 in 1893–1897 and £607,000 in 1913; the corresponding figures for coffee were £12,000 (£20,000), £48,000, £89,000, and £127,000, and for rice £17,000, £93,000, £64,000, and £218,000. In addition, the price of all three products fell by over 50 percent in 1873–1913, no earlier figures being available. The increase in the import of both cotton cloth and yarn may also indicate a greater availability of clothing.[160]

Housing improved in the new quarters of several towns and also in many villages in Lebanon and a few in Palestine, and some towns, notably Beirut, benefited from new amenities (see above). Famine and plagues diminished and greater security prevailed. Education became much more available, and so did modern transportation in large parts of Syria. In 1897 Anis al-Maqdisi traveled from his village to Batrun by mule, took a carriage to Beirut and the railway to ʿAlay, and then another carriage to his boarding school in Suq al-Gharb.[161] A few years earlier he would have traveled most of the way by mule. Similarly, the introduction of certain foreign products made life easier. In 1900 the British consul reported that in Damascus petroleum was "used universally for lighting and, in many of the well to do houses, for cooking purposes" (see selection 18), and in

[158]*EHT*, pp. 37–43; Boratav et al., "Ottoman Wages."

[159]"30 or 40 years since, when the land was undoubtedly much poorer than now, the wealth of the country was more equally divided and much less poverty existed. . . . The bulk of the agricultural population live upon bread, cheese and treacle with, when irrigation is possible, fruit and vegetables. In the overcrowded cities and towns bread with a little fruit and olives can be had for a penny in ordinary times, while for double that sum a varied repast at one of the cheap cook-shops with which they abound is obtainable" (A and P 1880, vol. 74, "Damascus").

[160]Kalla, "Foreign Trade," pp. 79 and 266–271; Pamuk, "Decline."

[161]Anis al-Maqdisi, *Maʿal-zaman*, p. 16.

1903 his colleague noted: "Bicycles are very popular in Aleppo, the roads in the immediate neighborhood being good."[162]

In one respect the living conditions of the upper and middle classes changed drastically: the adoption of European dress, furniture, and housing. In the small town of Latakia "at the beginning of each season the big shops of Paris send catalogues to their clients and in 1913 536 postal packets arrived containing about 30,000 francs worth of clothing." In Damascus in 1904, the British consul noted that little progress had been made in the previous 20 years. "At the same time a distinct, if slight, improvement may be remarked in the desire for betterment evinced by the natives generally, certainly in the towns if less so in the rural districts. This is tantamount to a wish for more European goods and sometimes for a better quality of those to which they are already accustomed." Among these were bicycles: "Three or four years ago there was scarcely a 'wheel' to be seen; but now [1910] there are about 150 in Damascus and the demand is increasing."[163]

Information about Iraq is much scantier, but the trend in output is easier to determine. Between 1864–1868 and 1911–1913 (available figures), exports of dates rose by 7 times, of wheat by 15, and of barley by 267 times.[164] This implies a large increase in agricultural output, far outstripping the doubling of the population. Handicraft output probably declined (it almost certainly did not increase), and practically no modern industry rose to take its place. Modern transport was of little importance and so were services, except for the pilgrimage to Najaf and Karbala (III, Introduction), but the government sector expanded. Altogether, it seems highly probable that per capita income increased.

Given the distribution of land in Iraq (V, Introduction), it is certain that a large part of the increment accrued to landowners and tribal *shaykhs,* and a further share went to merchants and others. However, judging by the sharp increase in imports of goods of wide consumption, there was also a rise in the level of living of the masses. Annual imports of sugar went up from £14,000 in 1864–1870 to £81,000 in 1894–1899 and £263,000 in 1910–1913, or 19 times. The corresponding figures for tea were £4000, £20,000, and £21,000, or 5 times; available figures on prices show a sharp drop in both tea and sugar.[165] In 1899 the British consul stated: "Tea cannot be said as yet to be ousting coffee, but its consumption is certainly extending. Only the cheapest Indian teas are in demand."[166] The huge increase in textile imports, which must have been much greater than the decline in local production, also points in the same direction: £39,000, £500,000, and £1,002,000, or 26 times; available figures show no significant trend in prices.[167]

Table II.5 shows an increase in wages—in some occupations sharp, in others slight or negligible—between 1870 and 1908. Figures are lacking on the cost of living, and the only relevant data are wheat and barley prices in Baghdad (see VII-28). Putting aside such abnormal years as 1870 and 1913, these prices show little significant change between the

[162]"Quarterly Report," 26 April 1900, FO 195/2075; A and P 1904, vol. 101, "Aleppo."

[163]Consul General Beirut, 1 April 1914, FO 368/1140; A and P 1905, vol. 93, "Damascus"; A and P 1911, vol. 97, "Damascus."

[164]Hasan, *Al-tatawwur,* pp. 510–511.

[165]Ibid., pp. 538–539, 642–643.

[166]A and P 1900, vol. 96, "Basra."

[167]Hasan, *Al-tatawwur;* chap. III, Introduction, Table III.7 (this volume).

Table II.5 Daily Wages or Earnings in Baghdad[a]

Occupation	Year			
	1855	1870	1908	1911
Baker	10.7–13.5	6.75–11.25	7.5–10	8–12
Carpenter	NA	5–8	20–40	30–60
Carpenter apprentice	2.7	2–3	5–7	5–8
Coppersmith	7	11.25–22.5	15	15–20
Shoemaker	16	6.75–15.75	15–20	15–20
Tinsmith	8–10.7	6.75–22.5	15–20	20–30
Field laborer	NA	4.5–11.25	8–9	8–11
Master mason	10	NA	18–40	30–60
Cook[b]	NA	NA	8–16	14.5–30
House servant[b]	NA	NA	6–8	12–14.5
Nurse[b]	NA	NA	4–6.5	5.5–13.5

Source: Report in FO 83/337; A and P 1909, vol. 98, "Baghdad"; idem 1912–1913, vol. 100, "Baghdad"; Jones, *Memoirs,* pp. 346–351.

[a]In pence, decimalized. NA, Not available.

[b]Monthly wage divided by 30.

late 1860s and the 1900s. In 1908–1913, nominal wages increased appreciably, and real wages may also have risen.[168] The British consul's comments on these figures are that

a feature of the time is a rise in the cost of skilled and unskilled labour at and about Baghdad. . . . The cost of living of all classes seems to have increased in a corresponding degree. The principal causes of the rise in wages are probably the increased commercial activity of the last few years and the higher standard of comfort which general prosperity has brought in its train. Contributory causes are the demand, actual or prospective, for labour by such enterprises as the Mesopotamian irrigation works and the Baghdad Railway; the gradual but constant extension of agriculture, due to pump irrigation; and the effectual inclusion of Jews and Christians in the obligation to military service.

House rents have risen enormously, being in some cases double or even triple what they were a few years ago. The increase in rents affects the lodging of the poor. . . . The principal reasons were the demand for new houses and the dearness of the fuel used in brickmaking.[169]

Shields gives a few figures showing that in 1894 nominal wages in Mosul were higher than in 1845 and concludes:[170]

Steady or rising meat consumption and rapidly rising sugar consumption would seem to indicate a high and probably increasing standard of living. Indeed, wages seem to go up at a rate almost equivalent to rising food prices. However, as is clear from the table below, some workers suffered a decrease in real earnings. All three types of workers could actually spend less of their daily wages on wheat in 1894 than they would have in 1858 for the same quantity.

[168]For developments in Turkey see EHT, pp. 37–38.

[169]A and P 1912–1913, vol. 100, "Baghdad."

[170]Shields, "Economic History," pp. 80–81, 98–99.

In 1911 the British consul in Mosul reported that workers on the railway were being paid 10 piasters a day, "which is considered a good wage"; the cost of hiring a camel was also 10 piasters a day! Shortly after, workers on a canal were being paid 7–10 piasters; "great difficulty is being experienced in obtaining sufficient labour and a strike of the workmen with a view to better pay is intended."[171] In 1912 the consul in Baghdad reported: "The purchasing power of the local population has been increased to some extent by the expenditure in wages of Sir John Jackson, Limited, irrigation engineers, and of the Baghdad Railway Company, and is, moreover, being daily added to by the extension of agriculture due to oil-pump irrigation."[172]

Starting around 1900 and especially after 1905, increased prosperity also raised real estate values in Baghdad, and still more outside it. The main cause was "commercial prosperity, particularly in the Jewish community, and the fall in the rate of interest on investments other than non-moveable property."[173]

A hopeful note is also sounded regarding Kirkuk. "Decent roads are being built, a technical school has been opened in which 100 orphans are taught trades and there is a municipal hospital. Agricultural machinery has been bought and more has been ordered."[174]

As in Syria, but to a lesser extent, consumption became Europeanized. In 1885 it was observed that "when these nomads approach towns like Baghdad, to buy their year's supply of dates, they are very ready to possess themselves of delf [sic] ware and knives and forks, deadly weapons of European manufacture, watches made expressly for exportation, and other things unknown to their fathers." Zinc bathtubs were being used instead of platters of wood at meals, and "household utensils of a still humbler order [!] are also finding their way as soup tureens into the homes of settled Arabs."[175]

As regards the towns,[176]

The people indulge increasingly in European apparel and wares of all descriptions. Their tastes and fashion follow the Continent, not England. This is chiefly due to (1) imitation of the Turks; (2) the establishment of branches in Baghdad by Syrian and Constantinople merchants who deal in German, Austrian and French goods; (3) the indulgence in French and Turkish literature by the educated classes of all ranks; and (4) the cheapness of certain Continental goods.

Surprisingly, in view of Britain's economic influence, "A knowledge of English is very rare in Turkish Arabia, whereas French is talked by a large number of the natives of Baghdad."[177] Other signs of Europeanization are the opening of a cinema in Baghdad in 1911[178] and of two hotels "by Oriental Christians who have been servants in European households, but none of them are first class."[179]

[171]Dispatches from Greig, 12 September and 8 November 1911, FO 195/2369,

[172]A and P 1914, vol. 95, "Baghdad."

[173]Dispatch from Lorimer, 27 October 1911, FO 195/2369.

[174]Hony to Lowther, 7 July 1912, FO 424/231.

[175]A and P 1886, vol. 65, "Baghdad."

[176]"Report . . . by George Lloyd," IOPS/3/446, 1908, p. 9.

[177]A and P 1906, vol. 129, "Baghdad."

[178]4 September 1911, FO 195/2369.

[179]A and P 1914, vol. 95, "Baghdad."

However, a factor that may have worked against the encouragement of European enterprise and the adoption of western ways in Iraq was fear of British encroachment (see VII,22). In 1909 the following conversation was recorded, with an opponent of Willcock's irrigation schemes.

> Pir Ibrahim laughed and said: "we know better. It is the same old story. The drama of Egypt shall be reenacted in Iraq. First comes the irrigation scheme, which entails the services of 25,000 coolies and agriculturalists from India. Then, all of a sudden, it will be discovered that it will be no good to make the soil productive unless there are the means of exporting the superabundant produce to profitable markets. To achieve this purpose railways must be established. This means more Indians, say 10,000 to 15,000 as railway employees, etc. Then there is the question of money, for the Turkish government is insolvent. Sir William Willcocks obtains permission to raise a loan in England. Either the British government or the British people find the money. The loan is raised, irrigation and railway schemes are completed. New schemes crop up and the loan is never repaid. Military intervention becomes imperative; India is near, and occupation follows and Mesopotamia becomes Egypt!"[180]

[180]Confidential memorandum by A. R. B., FO 195/2310; see also *II*-33.

1

Syria under Egyptian Rule, 1831–1840

CURRENCY REFORM

[Document 4058, Muhammad 'Ali pasha to Ibrahim pasha, 25 Muharram 1251 (24 May 1835), vol. 3, pp. 9–10.]

Refers to Ibrahim pasha's request for minting coins and 1500 silver purses of 5- and 10-piaster pieces, to alleviate the shortage of coins circulating in Syria.

He then informs him that he has reflected on what has befallen the country because of the difference in the rates of European, Istanbul, and Egyptian coins, arising from the fact that greedy people export the finer, more valuable Egyptian coins abroad, appropriating the difference in value. He has therefore instructed the members of the *majlis* (council) and others to look into the matter of regulating the currency; they have done so and deliberated several times, but without result, since they apparently would rather see a general loss [to the public] than the partial loss that would befall the Treasury. Hence His Highness, without further consultation, has ordered the Mint to issue the various silver coins, on the basis of the French riyal [5 franc?] and gold coins on the basis of the doubloon, that is, 4 percent below their silver or gold content [i.e., 96 percent fineness], so that there would be no profit in exporting them. He is herewith sending to Ibrahim

From Asad Rustum, *Al-mahfuzat al-malakiyya al-misriyya* (A Calendar of State Papers from the Royal Archives of Egypt), Beirut, 1940–1943.

pasha specimens of these coins so that Ibrahim may send him the registers pertaining to them. He will then send back the registers and coins so that Ibrahim may issue the required coins from the 1500 purses which the *Khazindar* (Treasurer) recently sent him. The said coins should be of the specified weight and fineness—except for the silver coins, which were struck slightly smaller than their older counterparts; if Ibrahim pasha wishes to, he may alloy them with copper, so that they reach the legal weight, and if he prefers he need not issue them at all.

('Abdin, register 212, no. 22)

ATTEMPT TO DEVELOP IRON AND COAL MINES IN LEBANON

[Document 4783, Ibrahim pasha to Sami bey, 1 Sha'ban 1252 (11 November 1836), vol. 3, p. 172.]

This document forwards a report presented to him by Muhammad 'Arif effendi on the smelting of Lebanese iron and proposing that, in view of the failure of metallurgists in Lebanon to smelt that ore, it be smelted in Bulaq.

It appears from the report by *qaimmaqam* Muhammad 'Arif effendi, "supervisor of mining in Jabal al-Duruz," that he went on an inspection tour and visited the coal mines in Qurnayil and Bizibdin and the iron mines near Shuwayr and made some attempts to smelt the Shuwayr iron by means of the coal, but that the experiments did not give satisfactory results.

('Abdin, register 254, no. 277)

LAND OWNERSHIP AND TAXATION

[Document 485, Muhammad Sharif pasha to Sami bey, 5 Shawwal 1252 (14 January 1837), vol. 3, pp. 185–188.]

In accordance with His Highness' orders, he reports that the government does not own all land in Syria. Most of the land consists of "private ownership, *timars, ziamets,* and *waqfs,* whose holders are in charge of levying tithes on them." In Syria tithes are not levied on a uniform basis on all land; some are content with one-tenth, but others take a ninth, or an eighth, or a seventh, or a sixth, or a fifth. He goes on to say that the government appoints some officials to collect tithes from these villages, and they do the weighing and measuring.

> In some places tithes are not collected; instead, the crops are divided in equal parts and a certain amount, estimated by experts in proportion to the village crops, is taken, by arbitration (*bism faisali*), in lieu of tithes. After the names of the persons from whom the aforesaid amounts have been taken are entered [in the registers], and the kinds of crops and amounts due to the government have been noted, the villages carry these products to storehouses where they are weighed and delivered.

He goes on to say that other villages settle their tithes in the way described above, part being paid in cash. "There are also villages from which crops are not taken; instead, specified sums of money (*bism maqtu'*) are collected from them."

Table 1.1 List of Receipts[a]

Locale	Receipts	Expenses—salaries and other	Net receipts
Jaffa (17 Jumada al-ula 1251 to 27 Jumada al-ula 1252, full Year)	306,401	5,550	300,851
Saida (same period, expenses not shown)	1,783	NA	1,783
Acre, Haifa, Tantura, and 'Atlit (full year)	298,341	3,296	295,045
Tyre (15 Dhi al-Qaʻda 1250 to 25 Dhi al-Qaʻda 1251)	24,691	1,180	23,511
Beirut (17 Jumada al-ula 1251 to 27 Jumada al-ula 1252)	68,311	6,134	62,177
Junieh (above-mentioned period)	12,741	2,422	10,320
Tripoli (full year)	56,636	3,230	53,406
Latakia (full year)	23,954	1,903	22,051
	792,860	23,715	769,145

[a]Paras, shown in original, rounded to nearest piaster. NA, Not available.

Accompanying this dispatch is a list of receipts (Table 1.1) from the *tasrih,* a tax on certain localities, reproduced verbatim.

As for receipts from *tasrih* in Gaza, between 1 *Rabi ʻal-Thani* 1251 and *Rabi ʻal-awwal* 1251, receipts amounted to 125,798 piasters and salaries and expenses to 1,414 [*sic*— read 4,445?], leaving net receipts of 121,354 piasters.

Thus net receipts for *tasrih* on the Syrian coastlands amounted to 769,145, as shown above. And since the rumors and gossip spread by European communities concern the above-mentioned parts, I have enumerated them one by one. No objections were raised by the Europeans concerning Gaza; nevertheless, since returns were available, I have included them for your information.

(ʻAbdin, register 254, no. 351)

REORGANIZATION OF CUSTOMS ADMINISTRATION

[Document 4,949, Baqi bey to Sami bey, 8 Muharram 1253 (26 April 1837), vol. 3, pp. 221–224.]

This [accompanying] letter is followed by the text of the "New Regulations," namely:

In accordance with the Exalted Order, on Monday 5 *Muharram* 1253, the undersigned met in the Sublime Court and exchanged views on the subject of drawing up regulations for the Customs Administration; the opinions that were approved follow:

It is evident to the people high and low—as is also certain to wise and clear-sighted men—that the main part of the thoughts of His Khedivial Highness is directed to procuring the means of improving the conditions of the subjects and people and helping the poor and weak and that all his noble hopes aim at raising the level of the country and ensuring the happiness of the Faithful. At present, the established practice is that customs duties on goods in internal trade are levied at all the ports and main towns (*banadir*), being paid on arrival at each customs house. His Highness, with his usual overflowing compassion and pity for his subjects, the people and the poor, issued his Noble Order for the establishment of regulations abolishing the repeated levying of customs duties in the ports and main towns of the Egyptian territories, Syria, Hijaz, and the Island of Crete. Such dues should be levied only once; thus, when a trader reaches the first port or town, a duty will be charged on his goods—but only once—and a note of receipt of payment (*tadhkirat takhlis*) will be delivered to him which, as long as he carries it, will allow him to proceed to any place he chooses

without paying any additional customs duty. In accordance with this Noble Order, a meeting of certain eminent persons was held in the Sublime Court, the views of distinguished people were heard, and the following measures were recommended:

In view of the fact that the Order of His Khedivial Highness concerning this matter aims first at relieving merchants and second at reducing prices of imported goods by lowering the custom duties levied on them, and in view of the fact that this act of public benefit is conducive to increasing the well-being of the subjects and people, the following means to this end should be taken:

Since the customs houses of Alexandria, Rosetta, Damietta, Yanbuʿ al-bahr, and Jidda are the principal customs of Egypt and Hijaz, these customs houses should remain as they are. As for the others, their supervisors, clerks, and employees should be dispensed with, only one clerk being assigned to the Governors (muhafiz) of Qusayr and Suez, whose function it will be to examine the notes of receipts of payment in the hands of merchants who bring their merchandise to those two ports; any merchant who does not have such a note of receipt (raftiyyah) will have to pay customs duties. And since, according to the present policy, the customs house of Bulaq will be abolished, and since His Khedivial Highness intends, by his present Order, to increase the people's well-being and prosperity, customs duties should not be collected at Bulaq, Old Cairo, Alexandria, Rosetta, Damietta, and Suez on the products of Egypt that are brought by merchants for sale in the markets of those towns. The customs house of Old Cairo should also be abolished, a supervisor and clerk being appointed there only for formalities concerning goods imported from Sudan. That same supervisor will be put in charge of the customs houses of Bab al-Nasr and Bab al-Futuh, which are the channels for Syrian goods that enter by land without notes of receipt of payment. As regards the Syrian customs houses of Gaza, Jaffa, Haifa, Acre, Tyre, Saida, Beirut, Tripoli, Latakia, Alexandretta, Tarsus, and Adana, they should remain as they are. And since in the ports of Latakia and Alexandretta customs duties are not levied in the same way as in other customs houses, only a small mururiyyah (transit) tax being taken and customs duties on goods imported into those two ports being levied on their arrival at Aleppo, it is necessary also to keep the customs house of Aleppo as it is, for the levying of customs duties on goods and produce arriving there from Latakia and Alexandretta or from Baghdad or Anatolia without notes of receipt of payment. The customs houses of Damascus, Nablus, Hebron, Homs, and Hama should be abolished. And just as no customs duties should be levied on Egyptian produce sold in Egyptian ports and towns, as mentioned above, none should be levied on Syrian products and crops sold in the interior of that country.

And since all customs houses in Syria are operated by tax farmers (multazimun) and do not have officials appointed by the government, and since it is necessary that such customs should be, as from the beginning of the year, run by the government so that it may be in charge of their operations and revenues, it will be necessary to appoint a sufficient number of officials in those customs houses that will not be abolished. Should someone be desirous of farming the customs on suitable terms, they should be conceded to him on such terms. A supervisor and one or more clerks should be appointed at all those places whose customs house have been abolished (i.e., Damascus, Nablus, Hebron, Hama, and Homs); their function will be to examine the notes of receipt of payment of merchants bringing their goods from other places and to levy duties on goods whose owners do not have such receipts.

When the Council examined the customs tariffs, it appeared that some goods pay a duty of 15 percent and others a higher or lower duty, whereas some goods pay not more than 3 or 4 percent. Moreover, not all customs houses follow the same rule, some taking 10 percent on goods that, in others, are charged 5 percent. In some

customs houses duties are assessed on packages, in others on loads, and in others on pieces. And since it is judged necessary that customs duties be levied only once, and since it is evident that at present there are discrepancies due to the fact that the customs houses do not follow the same rules—some charging too much and others too little—it became incumbent on the Council to deal with this matter too. And since the reason for having all customs houses operate according to one rule is to promote trade in all parts and smooth the paths leading to its prosperity and to treat all merchants on the same footing of equality in their relations with the customs, (following European princi- ples)—which will benefit merchants and promote trade—the Council recommends that duties in all customs be levied according to the same method, paying the same specified percentage on the same basis everywhere. The question of increase or decrease concerns internal trade alone and any measures taken to facilitate such trade will have beneficial results in promoting the progress of the state (*mulk*) and people. Hence the Council recommends that duties on goods and produce of Islamic coun- tries—that is, internal trade, in a broad sense, consisting of imports from or exports to customs in countries administered by the Khedivial Government—be valued, at first, at current prices, and a uniform duty of 3 percent levied on them. Should a merchant not agree to the price at which his goods were valued and wish to pay the duty in kind, his offer must be accepted and no further duty levied on his goods, as mentioned above.

Since the Council does not know which of the customs houses in the Island of Crete should be kept and which abolished, it refers this matter to the above-mentioned authority for consideration and action.

[Signed] Director of Egyptian Accounts, Basilios Ghali; Supervisor of Board of Schools, Mustafa Mukhtar; Supervisor of Royal Advisory Council (*al-shura al-mal- akiyya*) 'Abd al-Baqi; Head (*mamur*) of Khedivial Office (*diwan*), Muhammad Habib; Governor of Syria, Muhammad Sharif.

('Abdin, register 255, no. 16)

EXPORT OF CURRENCY

[Document 5257, Muhammad Sharif pasha to Sami bey, 19 Shawwal 1253 (17 January 1838), vol. 3, pp. 313–314.]

I have received Your Excellency's letter regarding the currency that Europeans and natives send abroad, asking us to indicate the types of coins exported, their destina- tion, and the difference in their rates in Aleppo and the places to which they are sent. Upon receiving Your Excellency's letter, I wrote to Ismail Bey, Governor of Aleppo, asking for information and got this reply. They send them by messenger to Istanbul, whence bills are sent to Europe; or else the coins are shipped on steamers to Europe. His letter was accompanied by a list of the rates of coins in Aleppo and Istanbul, which I enclose for presentation to His Khedivial Highness. . . . [There follows a list of 11 Ottoman and European coins; for most the rate (expressed in piasters, i.e., *qurush*, at the rate of 109.5 per pound sterling) on 21 *Sha'ban* 1253 in Istanbul was 6 to 7 percent higher than in Aleppo, but for some the difference was only 1 to 2 percent.]

Rates in Europe, on coins shipped there by steamer, are determined by fineness and weight.

('Abdin, register 255, no. 302)

ATTEMPT TO REGULATE CURRENCY

[Document 5667, Muhammad Sharif pasha to Husayn pasha, 17 Dhi al-qaʿda 1254 (2 February 1839), vol. 3, pp. 468–472.]

After his repeated unsuccessful attempts at enforcing Muhammad ʿAli's order fixing rates for various coins in circulation in Syria at the same levels as those prevailing in Cairo, and describing the strict penalties imposed, including the beating of traders, he goes on to say:

We called together most of the traders and bore heavily on them and told them that coins should be exchanged at the rates fixed in the Proclamation and that since they were the persons principally involved in the circulation of coins they should form an association (*rabita*) for that purpose, otherwise they would suffer grave consequences. They left us, promising to discuss such an association and inform us. Shortly after, they presented to us a petition bearing 62 signatures and seals of the principal merchants of Damascus, the gist of which follows.

To begin with they beg for a delay of a specified duration to enable people to settle debts and outstanding transactions; at the end of that period the instructions in the Proclamation will be followed. They then were so bold as to explain the reasons that prevented others from forming an association to implement the instructions in the Proclamation, namely:

First, the only activity of the country is the handicraft production of *aladja* and cotton cloth, which are sold mainly in Turkey and the surrounding regions; in return, coins are brought back from these parts. These coins are the new ones current in these regions. that is, the gold *mamduhi*, the *rubʿiyya zarifa*, the *tilak riyal*, the *qamari riyal*, the *beshlik*, and the halves and quarters of these coins. Since these coins also constitute the main currency in circulation here, if their rates should be reduced merchants will have to stop dealing in them and business activity will stop.

Second, the old currency is continually being sent to Europe and Istanbul, and after a time it will become rarer and no other currency will be available to take its place.

Third, the small silver coins—*qurush,* and half and quarter *qurush*—are used for petty purchases and for change (*takamil*), and meet the needs of the poor, the handicraftsmen, and people high and low; should their [official] rate be reduced, as is decreed in the Proclamation, they will be withdrawn from circulation and disappear, and cheating and distress will result from their absence, since there is no substitute currency.

Fourth, this country is not like European countries, whose industries are sufficient to bring in currency from all parts [of the world] and which are not subject to distress since their currencies are, generally, soundly minted and of uniform fineness, with no adulteration. If the provisions of the Proclamation are enforced, the Faithful subjects will be impoverished and their condition will deteriorate. Since they will not have a currency in which to transact their business, they will face ruin—and God forbid that this should happen. Therefore, they beg that the present currency be maintained, so that the condition of the people may be preserved from deterioration and ruin.

These are the excuses they offer. And since the currency at present in circulation and used in all parts of Syria is that of Istanbul—Egyptian currency being little used— if we should force them to follow the rates fixed in the Proclamation, one may apprehend that in future conditions will deteriorate. It will then be said that they complained and described the ruin that would befall them and that no one listened to them. We therefore judged it best not to reply to them until such time as we had written

to Your Excellency on this matter and received a reply. We have therefore written this letter and are enclosing the petition from the aforementioned merchants, which if you think it suitable, you may present to His Khedivial Highness.

[The enclosed petition contains, almost verbatim, the arguments given above. Most of the 62 signatories were Muslims, but a certain number were Christians or Jews.]

('Abdin, register 256, no. 295)

2

The Costs of Civil Strife, 1845–1860

LEBANON, 1845, 1860

Memorandum communicated by the Porte to the representatives of the Five Powers relating to the claims of the Maronites and Druzes, and to the government of Deir-el-Kamar (FO 406/8, translation from Turkish into French).

We have now received the dispatches of H.E. Assaad pasha, Mushir of Saida, who submits to the Sublime Porte the following arrangements. The claims of the Maronites of Mount Lebanon against the Druzes, having been verified by the Provisional Council, amount to 16,000 purses [of 500 piasters each]. For their part, the Druzes have counterclaims that amount to 2600 purses. Whatever be the amount of the claims, it is understood that the Druzes do not have the means to pay even the 16,000 purses. Liquidation of claims should therefore proceed as follows.

The 16,000 purses will be regarded as the cost of settlement of the losses sustained by the Maronites. The Druzes will produce the stolen goods which they are believed to hold, whether hidden or not. Goods that have been used since they were taken and the value of which has depreciated, will be returned to their owners at prices determined according to their present condition. The sum of 2600 purses, representing the approximate estimated value of the losses suffered by the Druzes, shall be deducted from the above-mentioned cost of settlement, and shall also be slightly reduced as part of the settlement. After that, the balance due shall be paid on suitable terms. . . .

Extract from Plan for Settling the Losses of Personal Chattels (Pertes Mobilières) that occurred during the preceding events (1860) in Mount Lebanon (FO 406/11, translation into French).

. . . At this time the evaluation amounted to 300,000 to 400,000 purses, of which 160,000 represented the losses suffered by the Druzes. The balance was reduced to about 86,000 purses.

Upon the arrival of the late Shekib pasha, on his Extraordinary Mission for the affairs of the Mountain, a Council was formed consisting of priests and notable Chris-

From FO 1845, 406/8, 406/10, 406/11.

tians, deemed trustworthy because of their past. The latter further modified the estimates submitted to them, and decided on a final figure of 61,000 purses.

The Sultan's government granted the treasury of Saida 10,000 purses to be debited against the latter figure, and decreed that the Druzes pay a further sum of 3000 purses; thus 13,000 purses were allotted, village by village, among claimants, each of whom, upon establishing his claim, received the quota due to him. We give here below a list of the losses of personal property suffered at that time. . . .

From the Minutes of the Five-Power Commission (FO 406/11).

. . . The question of the indemnities in the Mountain has already begun to be carried out. Six million piasters in cash (*argent*) have been distributed, out of the total of 20 million to 22 million to which the indemnities regarding personal property approximately amount. Wood has been requisitioned wherever it was available and has been used to rebuild houses. Twelve hundred beds have been distributed to the neediest and 200,000 *dirhams* of silkworm eggs have been sent to various parts of the Mountain. Thus, some 8 million to 9 million piasters worth have already been paid, that is, over a third of the indemnities for personal property.

[The Report of the Anglo-American Relief Committee in Beirut of 23 August, 1860 stated that 7000 persons were receiving aid, the large majority being Maronites; some 20,000 had fled to Kisrwan, but some were drifting back, asking for aid. The amount expended to date was £543-10-0, or 65,232 piasters (FO 406/10). The total number killed in Lebanon was estimated at 6000 (FO 406/10).]

DAMASCUS, 1860

Memorandum by Mr. Robson, an Irish Presbyterian Missionary in Damascus (enclosed in Dufferin to Russell, 23 September 1860, FO 406/10).

. . . The work of the plunderers was complete. Nothing to be found in the Christian quarter was left if it seemed worth carrying away. Many had concealed some of their more valuable effects under the floors or in secret recesses, closets, presses, or holes in the wall, or by throwing them into wells; most of what was thrown into wells was preserved, but almost everything else was discovered and taken away. The shops in the bazaars were plundered, but the khans were not attacked, and the property which Christians had in them was not disturbed. The Consulates of England, France, and Prussia, owing to their situation in the Moslem quarter, to their being guarded, and to other special circumstances, were not plundered. Besides these, a house in the Moslem quarter in which an Englishman lived, escaped.

About 1500 houses were robbed; one private and unguarded house was left untouched. Some 200 houses adjacent to or among Moslem houses were plundered and greatly injured, but not burned. All the rest of the quarter, to the number of 1200 or 1300 houses, with all the churches, schools, convents, workshops, and khans, is now heaps of ruins. In many places, in pulling down walls and cutting down ornamental trees, there are traces of laborious efforts to destroy even what the fire spared. The lowest and perhaps the most accurate estimate of the loss of property is between 300,000 and 400,000 purses, equivalent to £1,250,000 to £1,500,000. To this might well be added the loss resulting from the compulsory idleness of the whole Christian population while the settlement of affairs is pending.

The number of persons murdered will never be exactly ascertained. Of hundreds, it is only known that they disappeared. The survivors are so scattered, and so occupied with other cares and anxieties, that it would be almost impossible to make an accurate list of the missing. An estimate may be made of the number of males in Damascus on the day of the insurrection, and of the probable proportion which the murdered bore to survivors. The number of Christian males resident in the city were about 8000 to 9000, and of refugees from the surrounding country from 2000 to 3000. Thus the whole number of males would be between 10,000 and 12,000, and of this one-third may be deducted for children under fourteen years of age. Of the remaining 7500 to 8000, probably more than a third, or about 3000 were murdered. This is the lowest estimate yet given, but it is perhaps within a few hundreds of the truth. . . .

[This estimate agrees with the one submitted by the French Member, 150 million piasters, or about £1,250,000, based on a detailed estimate of losses reproduced in FO 406/10. The Commission judged the estimate "very moderate," and "Fuad pasha himself was the first to accept it as the basis of the indemnity," but there was much discussion as to the mode of payment (Dufferin to Bulwer, 27 February 1861).]

Protocol of the Twelfth Meeting of the Syrian Commission, held at Beyrout, November 21, 1860 (FO 406/10, in the original French).

The President [Fuad pasha] read a new proposal submitted by a Christian of Damascus regarding the extraordinary tax that is to be imposed on that city. It rests on the following basis.

There are in Damascus:

13,356	Muslim houses
7,600	Shops or coffee houses
58	Public baths
73	Mills
22	Khans
669	Gardens

[Imposing a tax of 1000 piasters per house, 750 per shop, 10,000 per bath, 2000 per mill, 15,000 per khan, and 2000 per garden would give 21,450,000 piasters; adding a contribution of 13,550,000 from wealthy people would produce a total of 35,000,000, the amount that had been proposed by the Ottoman Plenipotentiary at a previous meeting. "The moderate wealth of the inhabitants of Damascus may perhaps surprise your Excellency, but with the exception of perhaps five or six individuals the most wealthy inhabitants do not enjoy an income of from more than £700 to £1000 a year" (Dufferin to Russell, 23 November 1860, FO 406/10).]

3

Peasant Uprisings in Lebanon, 1840s–1850s

After the events of 1845 there was a slump in the peasant struggle. Its next upsurge began in the second half of the 1850s.

The period between the two waves of the people's movement was marked by intensive socioeconomic development of the country. It is enough to mention the following facts: between the 1840s and 1860s Beirut's population rose from 10,000–12,000 to 40,000; silk production increased by one and a half times. In 1845, in the village of Bteytar, the first silk-reeling factory was set up,[1] but by 1860 there were five or six such factories.[2] In the 1850s, the first bank was established in Beirut (with English capital), and local entrepreneurs opened the first hotel.[3] In 1858 a French company began building the first carriage road in Syria, between Beirut and Damascus.[4] During those years European shipping companies established regular sailings along the Lebanese coast. All this indicates the development of bourgeois relations and the gradual inclusion of Lebanon in the international market.

The development of capitalist relations was accompanied by the rise of bourgeois strata and by the differentiation and ruin of the peasantry. It is not fortuitous that in the 1850s emigration of peasants from Lebanon began and swiftly gained greater amplitude: in 1858, 5000 emigrants left from five Maronite villages alone.[5]

The consequences of the inclusion of the country in the international market were not slow in making themselves felt. During the years of the Crimean War, when the demand for Syrian products in the west rose, exports of agricultural products and grain from Syria and Lebanon to Europe increased, which had favorable effects on the peasant economy. But as soon as the war ended, there was a slump—a consequence of the world commercial crisis. Prices of agricultural raw materials fell sharply, and the demand for Syrian and Lebanese produce in foreign markets greatly declined. In 1858 grain harvests were poor. In the winter of 1857/58, there were natural calamities, resulting in much destruction in Damascus and central Syria. Everywhere, the already narrow internal markets were further restricted. Local and even foreign goods went without an outlet. The number of bankruptcies among the bourgeois merchants rose. The misery of the masses and their discontent with their conditions were intensified.

The 1840s and 1850s also saw greater activity in the social and cultural life of Lebanon; this was particularly marked in Beirut, which had become the economic, social, and cultural center of the country. The rise in Beirut's population was accompanied by the development of bourgeois layers (owners of commercial companies, merchants, brokers) and those of the intelligentsia (teachers, clerks, journalists, men of letters).

From I. M. Smilyanskaya, *Krestyanskoe dvizhenie v Livane v pervoi polovine XIX v*, Moscow, 1965, pp. 148–151, 209–212.

[1]D. Chevallier, "Aux origines des troubles," p. 52.

[2]K. D. Petkovich, *Livan i livantsy*, p. 169.

[3]J. L. Farley, *Two Years in Syria*, pp. 36, 54.

[4]The Beirut Newspaper, *Hadiqat al-Akhbar*, reported that the project for this road came from a Beiruti merchant, M. Mudawwar (*Journal Asiatique* 11, 321, 1858).

[5]M. Jouplain, *La Question du Liban*, p. 368.

In the winter of 1847 the first cultural-educational organization in Syria, the "Syrian Society for the Study of Science and Art," was founded in Beirut; in 1852 it published the "Transactions of the Syrian Society." It had correspondents in Damascus, Tripoli, Saida, and Haifa. Ten years later, following its dissolution, it was replaced by the "Syrian Scientific Society"; at first the latter did not receive official recognition because of friction with the Turkish authorities.

The social composition of these organizations was characteristic: like a mirror, they reflected the changes in the social structure of Syria and Lebanon. A prominent part was played in them by Butrus Bustani, a teacher, publicist, and man of enlightenment, who came from a feudal-clerical family; Nasif al-Yaziji, a teacher and publicist from a family connected with the court and who had spent his youth at the court of Amir Bashir II; Mikhail Mishaqa, a physician and publicist, from a merchant family; Ibrahim Trad, also from a merchant family, and others.

These organizations called for a reformation of the life of Lebanese society through the spread of education. They engaged in the popularization of natural science by discussing questions relating to education and upbringing. Sociopolitical themes are only dimly reflected in their work; nevertheless, Butrus Bustani, in his discourses defending women's education, expressed—albeit darkly—a thesis on the equality of people. Thus, in the domain of ideology, the preconditions for the emergence of a bourgeois world view were prepared.

On 1 January 1858, the first sociopolitical newspaper, *Hadiqat al-Akhbar,* appeared in Beirut. Its editor was Khalil al-Khuri, an employee in a trading company; the paper was financed by a Beiruti merchant, Mikhail Mudawwar. The newspaper set for itself the goal of "propagating knowledge and news of all kinds and promoting the progress of education."[6] It contained political, commercial, and literary sections and gave the greatest attention to economic questions (e.g., the development of trade, irrigation projects, construction of roads).

In 1858, a Lebanese historical chronicle was published in Beirut, Tannus al-Shidyaq's *Kitab akhbar al-ʿain fi Jabal Lubnan.* Its author, too, had connections with the Syrian men of enlightenment [see VII,4].

All of this bears witness to the birth in Lebanon of new forms of social life, which could not but reflect themselves in the internal political situation of the country. Among the different layers of the people, an antifeudal and anti-Turkish mood gathered strength.

The Hatti Humayun of 1856, which proclaimed the equality of Ottoman subjects, aroused among the people hopes of abolishing feudal dependence and of destroying feudal privileges in the apportionment of taxes.[7] By the end of the 1850s, these illusions began to dissipate, strengthening the general discontent. The situation was complicated by the economic crisis. In various regions of Syria and Lebanon agitation began to break out. The introduction in Syria in 1859 of a new tax on Christians "in lieu of military service" was met by further agitation. In Damascus, poor Christians refused to pay the new tax, declaring themselves ready to provide recruits but lacking the means of supplying money. The Turkish government sent troops to Damascus and made many arrests, chiefly in the Maydan quarter, where the poorer inhabitants dwelt. In the Latakia region the peasants rose against their feudal rulers. In Nablus there was an anti-Turkish agitation. Peasant

[6]*Journal Asiatique* 12, 312, 1858.

[7]In 1859, in their complaints about the oppression of the feudal lords, the peasants referred to Hatti Humayun.

villages around Damascus were in ferment.[8] In Lebanon, the growing discontent of the *fallahin* led to the Kisrwan uprising, the most significant in the history of the peasant movement in the country. . . .

The study of the antifeudal peasant movement in the period between 1782 and 1860 makes it possible to represent the logic of its development by the following outline.

The events of 1782 and 1784 and the uprising of 1820 were still traditional peasant riots, confined to demands concerning taxes and led by dissatisfied feudalists. The feudal epoch witnessed an endless number of such riots.

The uprising of May–July 1840 was a turning point in the history of the popular movement. It did not contain any new principles in the matter of demands but was incomparably broader in its scope and social composition than previous insurgencies, bourgeois as well as feudal elements participated in its leadership, and, finally, the demands of the insurgents had a new basis—the struggle for liberty and justice against tyranny. Although the leaders of the uprising did not advance a program of political reforms, their call for the elimination of tyranny contained a condemnation of all systems of government; this had an ideological influence on subsequent events.

The participation of the peasants in the expulsion of the Egyptians, their arming by the Turkish government, the change in the situation in Lebanon, the sharpening of social contradictions because of the attempts of the Druze feudalists to restore their rights and privileges—all these resulted in a profound discontent among Lebanese peasants and townsmen, directed not only against Turkish fiscal policy but also against the claims of their own feudalists. Peasants gathered in large groups, declaring their unwillingness to pay any taxes, drawing up manifestos refusing to submit to the judicial and administrative power of the feudalists, and killing rent collectors.

The specific conditions of Lebanese life, and in the first place the diversity of the religious composition of the population, intensified the contradictions, in a period of serious social crisis, between two religious groups, the Druzes and the Maronites. Religious antagonism accentuated the deepening social contradictions and allowed the separate political and social groups to use it in their political interests.

The social meaning and character of Druze–Maronite clashes in 1841, 1845, and 1860 changed. In 1841 the Druze feudalists, in their attack on Maronite peasants and townsmen, sought by armed struggle to suppress the antifeudal fermentation and overthrow Bashir Qasim, the spokesman for the centralizing tendency in internal policy, to give scope to the triumph of feudal reaction.

The Druze–Maronite clash of 1845 bled the popular struggle in central and southern Lebanon, the concessions made by Shakib Effendi weakened the contradictions, and the peasant movement temporarily subsided.

At the end of the 1850s it started again in northern Lebanon where, thanks to the experience of the preceding years, it underwent rapid development; it started as an expression of discontent with the feudalists' arbitrariness and claimed equality, and it concluded with the expulsion of feudal lords and the division of lands. In Kisrwan a peasant republic emerged that embodied the ideals of the Lebanese peasantry that had already been partly expressed in 1841: taxes were not collected, feudal jurisdiction was abolished, the whole population enjoyed equal rights, and the agrarian problem was solved by the taking and redistribution of the feudalists' land.

[8]AVPR (Russian Foreign Policy Archives), "Embassy in Constantinople File (*Fond*)" case 21, 11. 301, pp. 388–395.

It appeared possible that the insurgency would spread to the whole of Lebanon. But Lebanon still lacked the socioeconomic and political preconditions for a bourgeois transformation. The bourgeois elements had not yet formed themselves into a class, they lacked class solidarity, and their interests were limited. The rural upper strata of Kisrwan, which was half bourgeois and half feudal in its social essence, was satisfied with the removal of the rule of feudal lords but not with the agrarian reforms of Tanyus Shahin and his circle and sought reconciliation with the authorities, which led to splits in the ranks of the insurgents. The comprador merchants of Beirut, who were ready to exploit the agitation in Lebanon to obtain concessions from the Turkish government, were not inclined actively to support the insurrection. In central and southern Lebanon, class contradictions were unable to overcome religious antagonism, which allowed various forces skillfully to provoke the Druze–Maronite clashes of 1860 and use them as an instrument for the suppression of the antifeudal movement. All this doomed the Kisrwan uprising to failure.

Notwithstanding its defeat, however, the peasant movement of the 1840s and 1850s had important consequences for the economic and social life of Lebanon. At first (i.e. in the 1860s–1870s), there was a spread of small peasant ownership, a rapid growth in silk-reeling factories, an increase in differentiation among peasants, and a rise in emigration. All of these changes indicated the activation of the process of the birth and development of capitalist relations. In the field of political organization, the events led to the recognition of Lebanese autonomy. Finally, the antifeudal movement in Lebanon promoted the development of sociopolitical ideas, the rise of the movement for enlightenment, and a renaissance in the field of literature.

4

Cholera, 1865

. . . For several months previous to the appearance of cholera in Beirut, in 1865, diarrhea and dysenterie [sic] affections had been unusually prevalent; the first cases were of a malignant type, proving rapidly fatal; but on becoming epidemic, the disease was more amenable to treatment. It was introduced from Egypt, by steamers some of whose passengers died en route, in the quarantine, and in the streets and houses of the town.

The first death occurred June 28. The highest mortality per day was 35, the total number of deaths was probably less than 2000 during the three months' visitation. But it should be remarked that out of the population of 80,000 about 60,000 fled to the mountain villages, where, with but few exceptions, they spent the summer in safety, and that provision was made in tents outside of the city limits for hundreds of those that remained. With Beirut as its starting point in Syria, the cholera spread slowly up and down the coast, its general course was northward, sometimes skipping a seaport, as Latakia, and generally following low and marshy ground, but here no law can be traced as Jerusalem and

From Johnson to Seward, 28 July 1866, US GR 84, Miscellaneous Correspondence, Beirut, 1864–1867.

Nablous, lying thousands of feet above the sea lost ten percent of their population, while the dirty town of Tiberius on the Sea of Galilee was scarcely touched.

Sidon [Saida], less than 30 miles south of Beirut, was not infected till Aug. 18, the malady being delayed in its progress, perhaps, by the river which flows to the sea midway between, and by the quarantine on the southern bank. From Sidon down the coast to Jaffa, where it was most fatal, and on to Jerusalem and Nablous, and so through Palestine, the cholera can be traced with distinctness.

The Lebanon range of mountains, which run along the Syrian coast, probably served as a protection for a time for the interior towns, for the upper villages of the mountain were not infected, though some few deaths were reported among the fugitives in the quarantine stations; and although the cholera appeared in Damascus on the 2nd of August it does not appear to have been introduced from Beirut, 60 miles distant, notwithstanding the daily communication between those towns through the French Diligence line over the mountains.

The U.S. Vice Consul reports that the cholera was brought into Damascus by the Guards of the Pilgrims who opened the packages of clothing they had plundered from the dead and that it first appeared in the locality inhabited by them known as the market of Saroja, in Akrad el Saleheah. The duration of the disease was 60 days, and the mortality in the districts of Damascus, Hamah and Hums is estimated at 10,000.

Generally the epidemic lingered longest in towns that suffered least, but it was most fatal at Aleppo where its duration was greatest. The Vice Consul reports that it was brought there by fugitives from the coast towns, and increased by the arrival of 30 putrid bodies brought by pilgrims for burial.

The disease reached that place August 15, raged highest in September, declined in October and became sporadic in November.

Out of a Moslem population of 70,000, eight thousand died; of 15,000 Christians 800 died; of 6,000 Jews 200 died. At Aleppo, as at Damascus, those who maintained a strict quarantine in their houses were not infected.

The infection spread successively to Antioch, Aintab, Killis, and the neighboring villages.

At Adana (Cilicia) the introduction of the cholera was distinctly traced to the family of Kozan Oglu, one of whose women died on the night of the arrival, October 8, overland in company with Ali Riza Pasha, the Governor General, from Payas, where the disease appeared Sept. 30. From Adana the infection extended its ranges through the province, reaching Tarsus October 17 and Mersine (the port of Adana, and but a few miles distant) on the 13th of November.

Cholera was first brought to Syria in 1832 by Moslem pilgrims from Hejaz. It did not rage severely then, except at Hums, where owing to the presence of the Egyptian and Turkish camps, the mortality rose to 248 per day—nor at any subsequent visitation, until 1848, when the infection was introduced into Damascus by Moslem pilgrims from the North. Dr. Meshaka, U.S. Vice Consul at Damascus, states that cholera is most fatal when it comes from the north.

The mortality was everywhere greatest among Moslems, who, as a people disregard epidemics and sanitary measures for their prevention; and few, even among the rich, seek for medical aid from educated physicians. Cleanliness of the person is prescribed by their creed but they are in general neglectful of house drains and sewerage, and most offensive deposits are allowed to accumulate before the doors of the poor.

It is stated that the greatest number of deaths occurred among their females, and

that, *enceinte* most speedily perished. Women, certainly were more exposed to the foul air of their filthy abodes, than the men who went out daily to labor in a purer atmosphere.

It may also be remarked that the mortality was greater in walled cities of the interior, though of greater elevation than in the seaports where the houses are much scattered, in the gardens; and that the cholera was generally preceded by the cattle plague.

I have learned from the English Consul General that on the arrival from Egypt of an infected steamer, which was permitted to perform a three days' quarantine off Beirut, almost the entire crew of a British corvette laying at anchor to windward, suffered severely from diarrhea. The officer in command went out to sea for the benefit of his men, who entirely recovered after leaving the infected harbor.

The Consular Agent at Caipha reports that the villagers of Karabash, dipped their cholera patients in an adjacent stream, pulling them through the water in a state of nudity, by their hands and feet, and that in almost every case this treatment proved successful.

In conclusion I beg to observe that from what I have seen I have been led to conclude that villages of high elevation are comparatively free from infection, and are not favorable to its development and duration; and that quarantines to be efficacious should be located several miles distant from population centres.

The cholera is no doubt a product of India, and is carried by pilgrims, through rapid steam communication, to Mecca, where the immense crowds of half-famished devotees, already sickened by the putrid remains of sacrifices, furnish circumstances favorable to the rapid increase and spread of the poison.

Table 4.1 Mortality from Cholera in Syria, 1865[a]

Place	Population	Death from cholera	Date of appearance	Duration
Jerusalem	20,000	2,000		
Jaffa		2,000		
Nablous		2,000		
Caipha	4,000	300		
14 Villages of Caipha	10,650	596		
Acre	9,500	530		
13 Villages of Acre	26,975	157		
Tyre	3,600	75		
42 Villages of Tyre	15,648	428	Aug. 18	Nov. 18
Sidon	13,480	441		
Beirut[b]	80,000	1,200	June 28	Sept.
Damascus, Hamah, and Hums[c]		10,000	Aug. 2	Sept. 30
Tripoli and villages		1,577		
Latakia	No cholera			
Alexandretta				
Aleppo	91,000	9,000	Aug. 15	Nov. 1
Tarsus and villages	25,000	5,314	Oct. 17	
Adana and villages	30,000	5,073	Oct. 8	
Tiberius	10,000	32		
3 Villages of Tiberius	1,675	11		
Nazareth	8,900	52		
2 Villages of Nazareth	5,075	285		

[a] In one village, Berg Rahal (Metowali), out of a population of 48, 42 died of cholera.

[b] Actual population at date of the epidemic 20,000.

[c] Hamah, of Damascus, lost one-fourth of its population.

A quarantine on all vessels arriving at Jeddah and Bussorah, and all pilgrims at Suez, might do much towards stifling this scourge in its infancy or, at least, to confine it to the country in which it is indigenous.

It is to be hoped that the cholera conference now in session at Constantinople may accomplish this, if not more; else it is to be feared that the visitation of this dreadful plague will become annual in Europe and possibly in America.

I submit herewith a table [Table 4.1] of such statistics as I have been able to obtain through the Agencies of this Consulate.

[Signed] Johnson

5

Education in Lebanon, 1869

. . . Mainly through the efforts of missionaries some social reforms are in operation. The condition of the industrial arts has slightly improved and some measures have been introduced tending to the development of natural advantages.

The population of Syria, exclusive of bedouins, is estimated at 1,500,000 including 150,000 in Damascus, 100,000 in Aleppo, 20,000 in Jerusalem and 80,000 in Beirut. Previous to 1860, in Beirut, there were but 4 girls' schools and 19 boys' schools, while from 1860 to 1869 there were established 23 girls' and 29 boys' schools, making a total of 52 schools in the last nine years against 23 in the previous century. Of those, the Catholics, Greek-Catholics and Greeks have 26 boys' schools with 1749 pupils and 11 girls' schools with 920 pupils, total 2669; the Protestants have 8 boys' schools with 609 pupils and 16 girls' schools with 1060 pupils, total 1679; the Moslems have 11 boys' schools with 702 pupils; the Jews have 3 boys' schools with 100 pupils, making 48 boys' schools with 3170 pupils and 27 girls' schools with 1980 pupils—a grand total of 75 schools with 5150 pupils or 6 percent of the whole population.

The Lebanon district with a population of 450,000, two-thirds of whom are Christian has 5 high schools with 480 students, all but one sustained by foreign aid, also 21 primary schools with 32 teachers and 800 pupils under control of a Scotch society at an annual expense of $4000. A London society expends $10,000 per annum on Syrian schools. The annual expenditure of United States funds for the support of its missions is about $100,000, while the value of its mission real estate will not fall much below that sum. . . .

From U.S. Consul to Johnson, 31 December 1879, US GR 84, Miscellaneous Correspondence, Beirut 1869–1872.

6

Working-Class Conditions, 1838, 1873

CONDITIONS IN 1838

The condition of the labouring classes is, comparatively with those in England, easy and good. They feed on mutton, at 3 piastres per oke, several times a week, bread daily, sometimes rice pillaus, and always bulgur pillaus: bulgur is a preparation of wheat, husked and bruised, or half ground, after having been moistened and dried; their pillaus are made either with butter, olive or sesame oil; leben or joghuourt, cheese, eggs, olives, various dried fruits and abundance of vegetables, beet-roots, turnips, and radishes preserved in brine or vinegar, and for winter use. Their clothing is not very coarse; the fine climate permits them to wear light cotton and other similar apparel, and in the short winter they are generally well covered. Their lodging is good; generally each family has a separate house. The prices of lodging vary according to locality; lodging generally in Syria for all classes is cheap comparatively with most other countries. . . .

In Syria a great portion of the labour is done by females. They are constantly seen carrying heavy burthens, and, as in Egypt, a large portion of their time is employed in fetching water from the wells for domestic use. They bring home the timber and brushwood from the forests, and assist much in the cultivation of the fields. The Christian women of Palestine go unveiled. They are a robust, and generally speaking a very handsome race. Many of them wear ornaments on their foreheads, consisting of wires or round plates of silver overwrapping one another like a coat of mail or the fins of fish.

CONDITIONS IN 1873

. . . The bazaars are filled with poor articles from Birmingham and Sheffield; with the merchandise of Manchester, and the cheap manufactures of France and Germany; but little is seen of Syrian manufactures, which are used only by natives and are no longer exported.[1]

The wages of a Damascene workman average 45 to 60 cents per day, according to the nature of his work. He lives on bread, rice, fruit and vegetables. He consumes a great quantity of olive oil. Meat is a luxury which he can rarely afford. The cheapness and abundance of fruits and vegetables enable him to obtain them at a low price and save from his wages enough to purchase his clothes and for other expenses.

He can hire a house containing four or five rooms for $1.25 to $1.50 per month, such as it is, built of mud and stone. The streets where he lives are narrow and filthy. He is exposed to the heat during summer and to the cold during winter; he is also exposed, for want of all sanitary precautions, to every kind of epidemic that prevails.

Thus it will seem that the life of the Damascene working man is not better than that of his countrymen dwelling in the other purely oriental cities. There is a more numerous

(1838) From John Bowring, *Report on the Commercial Statistics of Syria,* reprint, New York, 1973, pp. 49–50 (originally published, London, 1840). (1873) From US GR 84, Miscellaneous Correspondence, T 367 11.
[1]Earlier in the report the consul had stated that before 1860 there had been 3000 looms in Damascus, whereas now they were said barely to reach 1300.—ED.

class of laborers worthy of mention, the assistant-workmen, the carriers of stone, mortar etc., their wages vary from 20 to 37 cents per diem. They lead a life necessarily lower than that of their master-workmen in all that regards food, clothing and lodging. If the laborer is unmarried, he occupies a room with comrades similarly circumstanced; if he is married he hires a room for himself and family at about 3 to 4 cents per day, or $1 per month, sometimes for less. The furniture consists of an "abba" or coarse cloak, a carpet rug, a mat and a few kitchen utensils. The bed is a blanket in winter and a mat during summer.

A mussulman of this class, if a bachelor, lodges in the Khans, which costs him from 1 to 2 cents a night. He takes his meals at one of the numerous "bakals," eating houses for the lower classes, with which the city abounds. If married, he hires a room, and cooks in the open air. The working men of Damascus are simple-minded, contented with their lot, without ambition, happy when they have earned a few piastres to go and spend them at the coffee shops. . . .

7

Problems of Development of Syria, 1878

. . . For better elucidation of the remarks I have now the honour to offer, I think it better to attempt a slight retrospect of Syrian trade during the past few years, dating from 1863–5—the period when Syria attained the zenith of her modern prosperity, from which she has slowly but surely declined. The exceptional prosperity of that time was brought about by bountiful harvests in Syria, aided by extraordinary high prices in Europe for its chief products, namely, cotton, silk, cereals, and sesame seed, &c.; thus permitting the importation and the ready sale at remunerative prices of very large quantities of British and other European manufactures, even at the greatly enhanced values to which such had attained in consequence of the American War.

The decay since 1865 has arisen, apart from the disadvantages under which the country chronically labours in matters appertaining to its civil government, chiefly from occasional bad harvests, low prices in Europe when a surplus proved available for export, and the stagnation and want of confidence engendered by war at home and abroad; all of which circumstances have tended year by year to diminish the power of consumption of European manufactures and generally to impoverish the people.

In July, 1876, I made incidentally the following remarks in my report upon the revenues and taxation upon Syria and Palestine.—

Syria must be said to be dependent solely upon the natural products of the soil, the few native manufactures it still possesses being sufficient only for the local wants of the poor and for the small demand in respect to the better description in adjacent countries where alone, from their peculiarly Oriental character, they command a sale.

Its chief products available for exports, such as cereals, olive oil, silk, and sesame seed, are inferior in quality, save in the one article of silk, to those raised

From "Report on Syria," FO 78/3070.

elsewhere, and therefore have a sale in times of dearth only in other countries. Since the epoch of the Franco-German War, trade and commerce in Syria have been slowly but surely declining, and although within the last three years bountiful harvests have blessed her soil, unremunerative prices in Europe and the Levant have left her with a surplus produce unsold, causing distress among the peasantry, consequent limitation of power of consumption of European and native manufactures, and producing stagnation in trade throughout the country. Another great element in the causes which have reduced Syria to her present unprosperous condition is the Suez Canal. Although benefiting the world at large, the revolution it has wrought in the markets of Europe, in bringing within easy reach the produce of the far East, has proved ruinous to Syria: notably in the articles of silk and sesame seed. Prices of these products have declined from one-half to two-thirds when compared with those of a few years ago, and little sale exists even at this reduction. Of the silk spinning factories of the country, one-third remain closed. Cotton which averaged in production between 1868 and 1872, 20,000 bales, is now almost neglected, and the present quantity raised suffices only for local wants. In consequence, the value of real estate, both urbane and rural, has diminished in like proportion, and this depreciation, one of nearly 50 percent during the last two years, is being maintained. The cities and towns of the country dependent wholly upon commercial activity and prosperity for their support have suffered considerably, the number of failures which have occurred and are still occurring, being ample evidence, while the rural population struggling at the best of times for bare subsistence is in no better condition.

No surer proof of the present distress can be adduced than in low wages which labour commands at this moment in the towns, and in the amount of want prevailing despite the great cheapness of food. A year ago, unskilled labour commanded from 1s. 2d. to 1s. 4d. a day, now from 8d. to 10d. The master carpenter and mason received 3s. 4d., now 1s. 8d. and 2s. 4d.; their assistants 1s. 4d. to 1s. 8d., now 1s. to 1s. 2d. In the silk factories of Beyrout and the Lebanon unskilled female labour is paid at 2d. per day; male, 5d. and 6d., while numbers of girls and boys are glad to earn 1d. per diem; all this without food, and for work extending from sunrise to sunset. But happily bread is cheap; good wheaten flour selling at 7½d. per 5½ lbs., while ordinary flour can be bought from 5d. to 5¾d. per 5½ lbs. Vegetables and fruit, again, are exceedingly cheap, and thus the poor can live at little cost.

Owing to the manifold vexations and impediments in the way of the employment of capital in agricultural enterprise, production is limited to the efforts of those the lowest in the social scale, whose total lack of education and means reduces cultivation to narrow limits and to the most primitive methods; and the condition of these tillers of the soil partakes largely of the general decay of the country. The small credits formerly obtainable by them from the capitalists of the towns for carrying on their operations, have in the majority of instances been stopped, owing to the difficulties in securing repayment. Consequently many villages are becoming depopulated, and their inhabitants departing to other less settled districts, leaving their debts and obligations behind them.

Efforts made by wealthy native Christians and Europeans to employ capital in agriculture have been invariably met by great obstacles, the apparent impossibility of getting incontestable title deeds being one of the many, although such documents may have emanated from the highest authority in the land. Actions of ejectment have invariably followed such efforts, to which the fact of the Government itself being often the seller, opposed no bar. In consequence, although in the settled districts of Syria waste lands are said to be unknown, still large tracts are practically in this condition, owing to the wants of the fellaheen or peasant cultivators, and to the obstacles in the way of introduction of capital.

This state of things will go far to explain the anomaly which the country presents, in the crowding together in the towns, of masses of the inhabitants, the large majority of whom are sunk in poverty, or at least living a hand to mouth existence, competing with each other for bare subsistence, and contributing by their numbers to the impoverishment of the whole; while, on the other hand, large tracts of cultivatable land lie around sufficient to support an enormous population, but cultivated by its few wretched denizens in a manner and under conditions which give them merely a bare living for their labours.

Beyrout, a city of some 65,000 inhabitants, the centre of trade and finance in Syria, and the residence of the wealthiest among the European native Christian and Jewish dwellers in the land, presents no more cheering aspect. The financial embarrassments of the Government have caused serious losses to nearly all the better classes, holders as they are of Turkish and Egyptian bonds. Owing to the present financial and commercial disorganisation and stagnation, real property finds few purchasers, even at reduced prices, rents fall in proportion, owing to the general impecuniosity, and expenditure is reduced to its narrowest limits, even in a country where the acquisition of wealth leads to no corresponding outlay, causing again distress among the poor, who are dependent upon the wants of their richer fellows for support. Credit is stopped, confidence being totally wanting, while imports are declining and exports almost nil.

Although the bankers and merchants of Beyrout are the richest and most numerous in Syria, their wealth is not great. From ten to fifteen possess capital of 10,000l.; beyond that sum are seven or eight. The greater part of their capital again is locked up in real estate, at present almost unrealisable, or in bonds of nominal value. In Damascus the rich Christians and Jews can be counted upon the fingers. They are all large holders of local government stock, the nominal value of which is 50 percent below that of a year ago, but there are no buyers; and many of them are often embarrassed for the want of a little ready money. The large Moslem proprietors on the other hand are sufferers by depreciation in value of produce, their chief wealth, and the actual financial state of Damascus is at as low an ebb as that of Beyrout.

In the small seacoast and inland towns of Syria, the inhabitants of which are dependent upon the agricultural districts around them for their means of support, the low prices of produce and the little or no commercial activity prevailing, operates most disadvantageously, and general stagnation is the natural result. The small local manufactures, suitable only for local demands and for the rude wants of the surrounding peasantry, suffer from the lack of means at the command of their sole customers.

The wealthier residents, who exclusively employ their little capital in lending money to the agriculturists, have most of them their means locked up in advances, which the poverty of the cultivators increased by the necessary stoppage of their credits and consequent curtailments of operations, leave little hope of being satisfied.

In the Hauran, the granary of Syria, where the full burdens of Imperial taxation cannot, as yet, be introduced, grain is a drug, and no means exist in many districts of bringing it to market, save in paying in kind the half of the produce as the cost of transport. No efforts are being made to utilise such resources by the making of roads, and thus increasing the tax-paying powers of the community.

Such being the present condition of the country, induced by lack of security, encouragement and protection, and increased at the present moment by the general state of trade and commerce throughout the world, it will be evident that the limits of taxation have been reached, and that, moreover, the tax-paying power of the community has decreased enormously during the past one or two years. And indeed this opinion would seem to have been accepted, as no attempts (save the introduction of the tobacco régie and the stamp duties, the former of which has proved disastrous alike to

the Treasury and the people) have been recently made to increase taxation. In conclusion, it would appear that, although under the present system of taxation, its burdens, if distributed according to the intentions of the law, would press no heavier upon rural than upon urban interests, the practical effect of the present mode of perception is to cause the chief onus to fall upon the former, the backbone of the country; thus retarding development, and crushing the little vitality which exists. On the other hand, the acquired wealth of the land, centralised exclusively in the cities and towns, is, from circumstances which may appear herein, exempted from its full share of taxation. . . .

I may here mention that although Syria has made great progress, when a comparison is instituted over a great number of years, and the wealth of the country has undoubtedly increased, the latter has become centred in the hands of a few, leaving the bulk of the people much worse off than before. And again, this acquired wealth of the land is, on account of the impossibility of finding any safe employment for it in Syria, kept almost exclusively in Europe, where it lies at the present moment totally "unproductive." . . .

8

Tribes in the Syrian Desert, 1880

. . . I left Aleppo on the 6 of September to visit the Arab tribes and returned on the 17 of October. . . .

The nearest to Aleppo of the Bedouin tribes are the Ferdoon, Leheb, and Shehemih. These have latterly been induced to cultivate the soil although still retaining their tents for the purpose of moving to short distances in summer in search of pasture for their sheep and cattle and of returning in autumn to reap their crops while they remain stationary in winter to grow others. They have entirely abandoned their warlike and predatory habits having sold their mares to purchase oxen for tillage and submitted to Turkish rule. They pay their taxes regularly, and no idea of political independence being possible for them such aspirations cannot be said to exist among them. The strength of each of these tribes numerically may be computed as averaging two hundred tents with five persons to a tent.

The Hadideen are a much more powerful tribe also located near Aleppo without ever migrating to any great distance and equally peaceful and submissive. They do not cultivate land, but they have given up breeding horses and camels, and devote themselves exclusively to the tending of sheep which belong in a great measure to the inhabitants of Aleppo. A partnership is thus formed, the produce being divided between the owner and the shepherd in a ratio of two-thirds for the former and one-third for the latter. The number of Hadideen tents exceeds a thousand. This tribe is remarkable for honesty in all its dealings and written contracts of partnership are almost never required by the people of the town who trust their flocks to the care of its members.

The small remnant of a once powerful Bedouin tribe called Mowali has adopted the practice of husbandry to a certain extent but it still adheres to its lawless habits, plundering

From dispatch to Granville, 3 November 1880, FO 195/1305.

villages, attacking caravans, and making war on other tribes when favorable opportunities occur. This tribe formerly occupied a paramount position in the Syrian desert and was dislodged from it by the first invasion of greater tribes from Central Arabia in a season of unusual drought which obliged them to seek cooler grazing ground towards the north. The Sheikh of the Mowali bears the hereditary title of Bey conferred on him by Sultan Amurath III when passing through the province of Aleppo on his way to Egypt and in like manner originated his family name of Abu Risheh or Father of the Plume, that Sultan having taken the Aigret set in diamonds from his own fez and attached it to the head-kerchief of the Mowali Sheikh. Although very brave and extremely turbulent the Mowali tribe cannot be regarded as likely to give any trouble to the Turkish authorities first on account of its numerical weakness, consisting now of no more than five hundred tents, and secondly because in all its movements it takes its cue from the greatly superior Anizeh tribes; whose only ambition is to maintain their predominance over the Shammar tribes of Mesoptoamia and the Anizeh tribes of Southern Syria without harbouring the faintest aspiration after independence or self-government.

In the valley of the Euphrates there are five small tribes, the Weldi, Affadli, Sebha, Aghudat and Bagara which are completely under the control of the Turkish authorities, and which though in some degree nomadic, never extend their migrations beyond a few miles to the north or south according to the requirements of their livestock. The Weldi breed cattle and sheep; the Affadli buffaloes and cattle; the Sebha camels and sheep with a few horses; the Aghudat camels and horses; and the Bagara cattle alone.

The number of these nomadic Arabs may be calculated at between four and five hundred tents in each tribe. They pay their taxes regularly and are quite peaceful and submissive to the Turkish government.

The Asmarr tribe occupies a line of hills stretching, in a south westerly direction from the valley of the Euphrates to the summer pastures of the great Anizeh tribes between Palmyra on the East and the towns of Hama, Homs and Damascus on the West.

The Asmarr are the worst of the Arab tribes as regards character and habits being inveterate robbers.

They have neither mares nor dromedaries but they travel great distances on foot, and very rapidly to purloin animals from the Arab camps at night and to sell them in the nearest villages on the skirts of the Syrian desert.

No traveller can escape them scotfree if passing within their reach unprotected by a strong escort of Anizeh arabs. In other respects their mode of life is simply pastoral and their flocks of sheep cover a vast tract of country in their wanderings to seek fresh pasturage. With all their lawlessness, not unaccompanied by a sort of wily bravery in their conflicts with other Arab tribes, they display a wholesome dread of the Turkish rifle and they always take to flight at sight of the smallest detachment of regular troops, concealing themselves among rocks and ravines inaccessible to cavalry. The whole strength of the Asmarr tribe cannot exceed a thousand tents. It appears abundantly evident from the above mentioned particulars that it cannot be considered as possessed of the least political importance, being neither mounted nor armed and being formed of the outcasts of desert society, without merits of their own, as without influence on others.

Having thus taken a cursory view of the smaller tribes which never go to any great distance from Aleppo and which hold a comparatively insignificant position in the Syrian desert, I come to the consideration of the State and feeling towards the Sultans government of its predominant Anizeh population.

I found these great tribes covering the whole territory which lies to the East of Hama and Homs and to the west of Palmyra. They consist of three principal divisions. The Fedan, the Sebaa and the Jelas. . . .

9

Sanjaq of Dayr al-Zur, 1881

AGRICULTURE, VILLAGES

. . . As may be supposed from the above description on the Right Bank away from the Euphrates the extent of cultivated land is quite insignificant. The few villages scattered about such as Sokhna, Tudmor, etc. are poor miserable decaying places. Their inhabitants are mainly occupied in extracting Potash from the desert weeds. This potash is sent to Orfa, Aleppo, etc.—and there used in the manufacture of soap. A handsome profit is made in the transaction. I was told that formerly these villages were much larger and that the Bedouins have ruined them. Judging from the number of deserted houses there is probably some truth in this statement but even in their most prosperous time they can never have been much to boast of as generally the supply of water is both scanty and of indifferent quality and the villages are separated from each other and the coast by miles of waterless plain.

In the actual Euphrates valley there are many villages. In some the people reside during winter in mud hovels going into tents in the summer. In others tents are used all the year round. In the Khabour, Jaghejak, Rumela and other districts stretching East to the Tigris and North nearly up to the Taurus tents are in general use. In these districts the cultivation is very superior in extent to any to be seen on the Right Bank altho very far indeed to what it might become under an intelligent government and with cheap transport to the coast. Of late years in some districts such as the Khabour, Rumela, etc. I am indeed told the acreage under cultivation has fallen off. The Jibour Arabs a tribe of Fellahs residing in the Khabour district report that some 10 years ago the district was fairly well cultivated and that there were 20 to 30 water wheels then for every one to be seen now. The reasons given for this contrast between the past and the present are 1) Arbitrary and excessive taxation, 2) the plundering of officials, 3) raids from Bedouins, 4) robberies and murders by the Chechian and Kara Boulak Emigrants who came into the country after Sheikh Shamyl's defeat by the Russians and were established at Ras-el-Ain. 5) Last year's famine.

What I saw during my ride through that and other districts fully corroborates their statement. In many places along the Khabour wild corn is growing in profusion along the river bank and deserted villages are frequently passed. The soil both in that and many other districts of the so-called desert is singularly rich. So much is this the case that even under the present miserable attempts at agriculture the yields are frequently astonishing,

From "Report on the Sanjak of Deyr," by Captain D. H. Stewart, 14 July 1881, FO 195/1368.

30 & 40 fold being by no means uncommon. In the vicinity of Orfa on a farm owned by a European the yield in some cases has been as high as 70 fold. Wherever water can be had for irrigation the results are always fine. Hence the great value of the Khabour River the water of which might easily be made available for irrigating thousands of acres.

CROPS (VARIETIES)

The chief crops grown in these and other districts are (1) corn [wheat], (2) millet, (3) barley, (4) rice near Ras-el-Ain, (5) maize. At Orfa, cotton, castor oil, lentils, flax, a species of pea for cattle feeding called by the natives julban and sesam are also grown. In that district till within the last 3 years the silk worm has been reared. In the Sinjar grapes and figs are extensively grown and the latter exported. This year the harvest promises to be everywhere very good but I am told the area under seed is rather less than usual. The reason given for this is, that to prepare land for seed it has to be ploughed over some 3 or 4 times, hence a good supply of yoke cattle are necessary. Unfortunately many died last year.

HERDS

What however the desert is especially adapted for is grazing. Of this the Bedouin takes full advantage. It is a sight quite unique in its way to see the number of animals coming towards the camp about sunset. Far as the eye can reach the country appears alive with herds of camels and sheep. Towards the East near Mosul the buffalo puts in an appearance. It is almost needless to remark that all products derived from milk are exceedingly abundant. The Sinjar district is said to be singularly well suited for sheep. They come to maturity very early and are exceedingly fertile.

TENURE OF LAND—DIFFERENT CLASSES

There are 5 Systems of Land tenure to be found in the desert.

(1) Mirié (Belonging to a Prince). Land thus held is purchased from the Government and on the condition that if after the lapse of 3 years it is not cultivated it is to revert to the Government. There is a great deal of land held under this tenure but the condition under which it is held is generally a dead letter. Within the last two years many of the Aleppo notables have as a speculation purchased for merely nominal sums large tracts of Mirié Land.

(2) Memlooke (Possessed). Mirié land becomes Memlooké directly it is broken up. In the desert there is but little of this kind of tenure. Near Aleppo the extent of Memlooké land is increasing. The owner can will it as he likes.

(3) Metrooké (Abandoned). Uncultivated grounds. In the desert owing to their immense extent they represent no money value.

(4) Muat (Dead). Barren Lands, grazing grounds, roads, commons. Extensive tracts of this class of land are to be found in the desert. Many of them such as commons, village grazing grounds etc. are by law unsaleable.

(5) Evkaff (Pious Foundation). But little of this kind of tenure is to be found.

Besides the above different classes of holding there is not far from Bab a large Imperial farm (Chiftlik Humayun). The value of the tithe alone from this farm is

£T.40,000. The Constantinople Parliament directed that this Chiftlik should be sold but the order was never carried out.

In theory the above are the different systems of land tenure. Practically it is very different. When the population is so scanty and vagrant and so abundant it has but little if any value. Practically all a Fellah has to do is to select the most convenient unoccupied piece of land he can find and set to work to till it. It then becomes his by right. Probably in some cases quarrels may occur for lands favorably placed near springs, camps, etc. In such cases I believe the Sheikh has a voice in deciding the matter. In other cases I am told where the original owner has not sufficient cattle to work up all his land the Sheikh sometimes sells off a portion of it to some wealthier person. The Sheikh himself is generally an extensive owner and employs labourers. The following is the salary paid by a Sheikh of my acquaintance. An annual sum of Piastres-200, a suit of clothes, a pair of shoes and enough corn for the labourer's family.

TAXATION

Similar to other parts of Turkey the conduct of the tax gatherer and the system of levying affords frequent causes for complaint. In the Sanjak itself the Tithe System is apparently not adopted or at any rate very partially and the crop tax is arbitrarily (Mustesna) and roughly estimated by the government collector and the head of the Village or Sheikh who ride around the crops and assess each owner. It is evident what a field for peculations this system affords. Another complaint is that as the tithe is generally collected in money the collector frequently estimates its money value at double or more its real market price. The tithe is not usually farmed but is collected by government officers frequently military men. In the Khabour and Euphrates district the tax is sometimes paid on the water wheel instead of on the crop, each water wheel being assessed at 18 Chumbuls of corn. On the Euphrates the water is mostly raised from the river by a pair of bullocks lifting a leather bucket as in India. The tax or tithe on this style of irrigation is 9 Chumbuls.

(A chumbul of wheat = 80 okes = 213 lbs.)

(A chumbul of barley = 64 okes = 170 lbs.)

Many of the inhabitants complained of this system of collection although I could not clearly make out for what reason. They said it had been condemned by the Aleppo Commission. In most of the neighbouring districts the tithe is collected as elsewhere i.e. in kind. To collect the tithe the crop is divided into 10 heaps. The government officer or Multezim chooses any one of the heaps he fancies. Afterwards should the field happen to be part of a Chiftlik (property) the owner chooses 4 heaps and is followed by the farmer who also chooses 4. The last heap is equally divided between the proprietor and the farmer.

Besides the tithe the peasantry pay the usual sheep and goat tax $3\frac{1}{2}$ piastres and the camel tax, 10 piastres. They also pay an Emlak verghisi or property tax, i.e. on houses or tents, gardens, etc. As yet the system of sending valuers round has not been introduced and each village and community is assessed at a certain lump sum which the Sheikh assisted by the Elders apportions off among the villagers. According to the old law each house, garden, etc. should be assessed at 4 per 1000 on its building value, purchase price, etc. and 40 per 1000 on its letting price or rent—This has recently been changed the tax on rent (sic) and has done away with it and it has been decided that houses, etc. valued above 20,000 piastres are to pay 8 per 1000, those under 20,000 piastres, 4 per 1000. So far as

my experience goes of places where property has been valued the result has been that the people as a whole have had to pay more. It is very unlikely that the valuer would be such a fool to his own interests as to diminish the revenues the government receives—the only gainers are the wealthy or those who can bribe, with the natural consequence that the poor are losers.

At Deyr I hear that the Verghi or tax on trades, profits, etc. has recently been introduced. This tax is meant to correspond with the Oshur or tithe which the peasantry pay.

Of the rascality and venality of the officials it is superfluous to write. Perhaps as the district is a wild one and the inhabitants especially ignorant—they are able to rob with greater uniformity than elsewhere.

As for the Bedouins they are supposed to pay a camel tax of 10 piastres per head. The collection of this tax is difficult, the Bedouin not paying unless he is overawed. As the government has no means of estimating the number of camels, the Sheikh's word has more or less to be taken on trust. The tax can only be collected during the summer when the Bedouin comes North for pasture. The Bedouin is also supposed to pay a tax of 1 medjidieh on each camel he sells.

The Yezedees of the Sinjar are another wild tribe that only pay their taxes according as the local government for the time being happens to be strong or weak. For instance Mutto a powerful Yezedees Sheikh has paid no taxes for the last three years. This year as there happens to be some soldiers in the town of Sinjar—he is anxious to pay and make good arrears. Similarly with the other wild tribes.

RACES, TRIBES

The Deyr or Zor Sanjak is essentially an Arab district. On the other hand its Northwest, north and northeast boundaries form a line of demarcation beyond which are several races and religions. East of the Sinjar the Kurd puts in an appearance. In some villages Arabic is spoken and in others Kurdish. Along the Northern line at Orfa, Nisibin etc. there is a mixture of Arab, Turk, Armenian. . . .

REVENUE AND EXPENDITURE OF DEYR SANJAK

Formerly before the Sanjak was reduced in size, its total average revenue was estimated at £T.70,000. Of late years it has lost by curtailment of territory revenue to the amount of £T.40,000 so that now its annual income including the sheep tax (£T.7000) does not exceed £T.30,000.

Its expenditure is about £T.30,000 estimated as follows:

(1)	Salaries of Officials	£T.7,000
(2)	Gensd'armerie	13,000
(3)	Garrison (Nizam)	8,000
(4)	Secret service fund	1,500
		29,500

The Gensd'armerie is put down at 390 men of whom 290 are mounted. This is the paper strength. The actual strength is probably far less.

The Garrison is estimated at 550 Infantry of whom 200 are mounted on mules. At

present the far larger proportion of these men altho charged to Deyr are actually serving about Aleppo.

It is evident from the above that the Sanjak after defraying expenses has little or no balance to transmit.

10

Agriculture and Industry in Hama Region, 1883

The author starts by pointing out that the official figures on population are absurd; his own estimate is 216,000, or a little over, of whom 40,000 are in the town of Hama and 30,000 in Homs. On the basis of the tithes, he puts the (gross) value of agricultural production at 10 million francs and that of livestock products at 6 million. This suggests that total agricultural production per capita may have been about 80 francs, or a little over £3.

. . . Agricultural practices are the same here as everywhere else in Syria. No improvement has been made in the primitive plough, which seldom weighs over 4 kilograms and barely grazes the soil. The draught animals are even more defective than in other regions and are very diverse: small and large oxen harnessed together, oxen and horses or mules or even an ox and a donkey, sometimes two donkeys—not infrequently one even sees harnessed camels. It should be added that the reason for the poor state of the draft animals, and of their diversity, is the successive epizootic diseases of which the country has not yet got rid and which have destroyed the herds of oxen which were formerly so numerous in this region.

Manure is not used by peasants for agriculture. When it is not used as a fuel it is stacked outside the villages, forming rich reserves for the future.

Interest rates on loans to agriculture range from 24 to 40 percent. One can easily see that in a country where foresight is not one of the farmers' characteristics, the latter are always at the mercy of the usurer and end up by being dispossessed of their property.

The peasants' food differs according to districts. In the Ansariyeh mountains almost their only food is a horrible black bread made with the flour of white maize; in the plains yellow maize and barley are more commonly used and provide a more bearable bread. To bread, peasants add a few onions and, seldom, rice or other vegetables. During the season of heavy work they add to this simple food milk products or *burghul*—wheat that is boiled and then cracked. Wine and intoxicating drink are almost unknown to the rural population. One cannot say as much for the inhabitants of the towns of Hama and Homs, where arak and the use of hashish have made great progress among the better-off Muslims.

Cereals consumption is put at one *shumbul* per inhabitant per annum. This measure of capacity is equivalent in Hama to about 320 cubic decimeters, with an average value of 28.30 francs for wheat, 12.26 for barley, and 15.10 for maize.[1] The upkeep of a farm

From "Report on the Mutasarriflik of Hama," by P. Savoye, 15 March 1883, CC Beyrouth, vol. 9, 1868–1888.

[1]Since weights and measures vary between Hama and Homs, and even between villages, I have not attempted to give their ratios.

servant is reckoned at 180 francs per annum. An ox's annual consumption is valued at 50 francs, a mule at 100, and a horse at 150; these figures do not include the value of the chopped straw given to livestock at will; straw fetches a price only in years of dearth.

The maximum yield of wheat is 16 : 1 and of barley 20 : 1; average yields may be put at 6 or 7 : 1 or 9 to 11 : 1, according to districts.

In Northern Syria farmers let their land lie fallow one year in three, and they alternate barley and wheat cultivation. They generally have three ploughings for summer crops and two for winter. Practices for other crops do not deserve mention; they do the least possible and leave it to Nature to ensure that they thrive.

Cottage industries are very limited. The women spin the wool and cotton required for making overcoats, girdles, and coarse cloth for family use.

Industry. The only significant industry of Hama and Homs is the weaving of fabrics used only by Orientals, the main markets being Egypt, Hijaz, Yemen, Smyrna, and Constantinople. In spite of the activity and prosperity that these native industries enjoy, one can foresee their disappearance unless they transform themselves. Having been created to serve tastes and habits that are disappearing as civilization permeates the East, they must either perish or transform themselves along with the transformation of dress, which seems necessarily to precede that of mores.

I also believe that one of the causes of the prosperity of weaving in Hama and Homs must be the decrease of this industry in certain parts of the Ottoman Empire, where the dearness of labor makes it no longer possible to produce at a profit.

Until recently, the silk used by the looms of Hama and Homs came from the Djabal Ansariyeh, whose output is no longer sufficient today. The cotton yarn that this region formerly exported to Europe is now brought in from England and Germany; the yarns produced by native industry are more expensive and less regular and are used only to make the coarse cloth worn by peasants or for some special nonexported goods. It would be easy to endow this industry with economic means, which would give it real advantages by preparing it for a transformation that would allow it to survive; but routine, which shackles progress, is stronger here than elsewhere.

The town of Homs has today over 4000 looms with an annual production of 9 million francs; employment is about 12,000, both in those looms and in other small handicrafts connected with them. The skill of the Homs weavers was already known in ancient times, and the silk and gold fabrics that are still made here were highly appreciated.

The weaving industry of Hama is fairly new; it is only recently that the looms making bath towels, silk and cotton, and fluffy cotton reached their present stage of development. Similarly, the making of *Hamdiehs,* a satinlike cloth, is only a few years old. I have been assured that 30 years ago the number of looms in Hama did not exceed 400, whereas today it is close to 1000. Annual output is over 1 million francs, and about 3000 persons are employed in weaving and its various ancillary crafts. . . .

11

Education in Syria, 1885

. . . Before the arrival of Midhat Pasha, as Governor General of Syria, education in Damascus was in a very unsatisfactory condition, owing to the want of proper efforts on the part of the Government, and to the apathy and discouragement shown by the people. The "Rushdieh" Schools, which had been inaugurated some years previously, and which promised much for the success of education, had become small primary grammar schools, under the direction of religious sheiks, in which the Koran was taught. The children of some of the more wealthy classes were educated at home, and each mosque had one or two schools attached to it for small children, where learning the Koran by heart, and a little reading, were all the instruction given. Schools for girls did not exist.

On the appointment of Midhat Pasha in 1878, he directed his attention to the subject of education, and caused several new primary Public Schools to be opened in Damascus, and also established an Industrial School; and since then the question of public instruction has received more attention on the part of the Authorities. At present there exist 77 primary or elementary schools in the city of Damascus for boys, the average number of pupils being 2929, and 25 schools for girls with an average attendance of 906 pupils, 2 "Rushdieh" boys' schools, one of them being a Military School, with 346 pupils, 1 "Idadieh" (Preparatory) School, and 1 "Sultanieh" (Industrial) School for boys, with 78 and 96 pupils respectively. This will give one school for every 1448 Mussulman inhabitants. In the rest of the Sandjak there are 94 Mussulman Schools with an average attendance of 1880 scholars. In the Mutaseriflick of Homs and Hamah, with a Mussulman population numbering 150,000, there are 83 schools with 369 pupils, and in the Hauran, whose population (non-Christian) is 18,200, there is 1 school with 32 pupils. A detailed list of the Mussulman Government Schools, within this Consular District, is given in the Appendix.

In the Primary and "Rushdieh" Schools, the Koran, reading, writing, a little grammar, and a smattering of Turkish and Persian are taught at present, the teachers in the Primary Schools being generally Sheiks of the Mosques. The Military School in Damascus is kept up exclusively for the education of young men of good parentage, who are desirous of entering the military service as officers, but no Christians are admitted to it. The Industrial School established by Midhat Pasha in 1879, was intended to promote the teaching of different trades and professions, and promised at first to be a successful undertaking, but of late it has been somewhat neglected and the average attendance is inconsiderable. Mussulman boys as a rule are not sent to any of the Foreign or native Christian schools, although in one or two instances Mussulman parents have been known to place their sons for a short while at the Jesuit or Lazarist Schools, as day scholars, with the object of learning the French language, but these have been rare exceptions. Neither are Mussulmans in the habit of purchasing any books printed in Arabic at the Foreign printing presses; and the agricultural population may still be said to be without the means of education. Female education, although now looked upon as necessary, is still in a backward condition, on account of the restraints which the Mohamedan religion places

From "Report on Education within the Consular Districts of Damascus," FO 195/1514.

upon the liberty of women, and of the early age at which Mussulman girls are sought in marriage.

The different schools established in accordance with the law on Public Instruction are maintained by Government contributions, by special endowments, donations and legacies, and by a municipal tax of 6 percent, levied on the property tax, which is collected from all creeds without distinction, Christians and Jews being made to contribute on the plea that the Schools are Government secular schools. The teachers in the "Rushdieh" Schools receive from £2 to £6 per month. Some of the small schools attached to the mosques, and the few private schools that exist, are supported by the pupils paying a fee of about 1s. per month. . . .

At present, the Irish [Presbyterian] Mission has in Damascus two ordained Ministers, and two ladies in charge of the girls' school. The first school of this mission for boys was established in Damascus in 1847, and one for girls was opened in 1855. Afterwards Schools were opened in the surrounding villages in compliance with petitions from the inhabitants. At the present time there are twelve schools in the different villages in the vicinity of Damascus in addition to the two schools in Damascus. Two are in the village of Rasheya, on the western side of Mount Hermon, and five others in the neighbourhood of Rasheya; one in Bludan in the Anti-Lebanon, and four in the villages of Yabrud, Nebk, Deir-Atyeh and Kuryetein, to the North of Damascus. The number of pupils in the boys school in Damascus is 97, of whom 9 are boarders, and in the girls' school there are 88 day pupils and 16 boarders. In the different villages the number is 414, making an aggregate of 615 pupils in all the schools of whom about 170 are girls. The subjects taught are Reading, Writing, Arithmetic, Geography and Arabic Grammar in the village schools, and in the Damascus boys' school instruction is also given in Algebra, Geometry, Trigonometry, Natural Philosophy, Rhetoric, and in the English and Turkish languages. In the girls' school, Physiology, English and French, vocal music and music on the piano are taught. Five teachers are employed in the Boys' school and six in the girls' school in Damascus, and one in each of the 12 village schools, or twenty-three in all.

The British Syrian Schools for Female education, which were founded in 1860, by the late Mrs. Bowen Thompson in Beyrout, opened a branch, under the auspices of that lady, in Damascus in 1868, in response to a petition from the people of Damascus. A few years before in 1863, a school was established at Hasbeya, on the western slopes of Mount Hermon, and in 1870, another branch school, was opened for Mussulmans in the Quarter of Damascus called the Meidan. Lately a school has been opened at Baalbec for the instruction of the inhabitants of that place, who belong for the most part to the Mohamedan sect called Metualis. At present there are in Damascus two schools for boys and girls, a school for Mussulman girls only, and a Blind School. With the exception of the school exclusively for the Mussulman girls, these schools are attended by Mohamedans, Druzes, Jewesses, Oriental Christians and Protestants. The Damascus Schools are under the management of two English ladies, with a staff of 12 native teachers, and the attendance of pupils is about 440. In Hasbeya, the attendance is 174 pupils, and the school is under the direction of one English and three native teachers; and in the Baalbec School, where there is also a European lady as superintendent, the number of pupils is 81. The subjects taught in these schools are Reading, Writing, Grammar, History, Geography, English, French, Needle-work and Singing.

The Church Missionary Society has for its field the District of the Hauran and Transjordanic Palestine. In the Hauran there are seven schools, all in Druze villages, except Kharabah, which is a Christian village. These schools are only granted to the

natives on the written request of the chief of the village, who provides a room for the school, and proper accommodation for the School-master. In Transjordanic Palestine there are five schools belonging to this mission, of which three are at Es-Salt, where there is likewise a church and a Dispensary. The attendance averages about 30 pupils in each school, and the teaching is confined to the elementary branches of education.

The Society for the Propagation of Christianity amongst the Jews has one school in Damascus in the Jewish quarter, attended by 41 scholars, but the attraction of children to this school is difficult, on account of the opposition of the Jewish Rabbis, who are entrusted with the religious education of the Jewish male children. The ''Alliance Israelite'' has lately established a school in Damascus, and, being a purely Jewish Society, has obtained a fair attendance of pupils of both sexes in its school. At present the number is 120 boys and 62 girls. French and Arabic are the languages taught, and the subjects of instruction, in both these languages, are Reading, Writing, Arithmetic, Geography, Rhetoric, etc. This school promises to be successful in promoting education amongst the Jewish Community, who have hitherto been unprovided with a good school of their own for their male children, although some of the Jewish girls have been in the habit of attending the Foreign Christian Seminaries.

The different missions under French protection, and the native Christian Communities have numerous schools in Damascus, and the neighbouring districts, and in all the schools of the former the French language is taught. The attendance is good, and the instruction in the elementary branches of education is well conducted. The Sisters of Charity have a boarding school in Damascus for girls. The Jesuits have of late made great efforts to establish schools in the Hauran, and in the barren volcanic region of the Ledja, inhabited principally by Bedouins. Altogether this society has eight schools in the District of Damascus and Homs and Hamah, with 685 pupils, and is active in taking measures for opening new ones. The Lazarists have one school in Damascus for male children with 250 pupils; the sisters of Charity have three with 525 pupils; and the Franciscans one with 45 pupils. Of the native Christian Communities the Greek Catholic is the largest, and has

Table 11.1 List of Ottoman (Government) Schools in the Sandjaks of Damascus, Hamah and Hauran

| | Primary schools | | | | "Rushdieh" schools | | | |
| | Boys' Schools | | Girls' Schools | | Boys' Schools | | Girls' Schools | |
Sandjak	Number	Pupils	Number	Pupils	Number	Pupils	Number	Pupils
Damascus								
Damascus[a]	77	2929	25	906	2	121	1	225
Bekaa	37	693	—[b]	—	—	—	—	—
Baalbec	2	55	—	—	1	50	—	—
Dumeyr	37	700	1	28	1	25	—	—
Hasbeya	1	30	1	34	—	—	—	—
Wad-el-Ajam	12	240	1	25	—	—	—	—
Hamah								
Hamah	46	479	—	—	1	30	—	—
Homs	33	720	2	110	1	30	—	—
Hauran								
Kuneitra	—	—	—	—	1	32	—	—

[a]also one "Idadieh Boys' School with 78 pupils; one "Sultanieh" Boys' School with 96 pupils.
[b]None.

Table 11.2 List of Schools Belonging to Native Christian and Latin Communities in Sandjaks of Damascus, Hamah and Hauran

	Greek Catholics				Jesuits				Lazarists				French Sisters of Charity			
	Boys' Schools		Girls' Schools		Boys' Schools		Girls' Schools		Boys' Schools		Girls' Schools		Boys' Schools		Girls' Schools	
Sandjak	No.	Pupils	No.	Pupils	No.	Pupils	No.	Pupils	No.	Pupils	No.	Pupils	No.	Pupils	No.	Pupils
Damascus																
Damascus[a]	3	465	1	70	1	120	—	—	1	125	—	—	1	25	2	500
Baalbec	1	—[c]	—	—	—	—	—	—	—	—	—	—	—	—	—	—
Nebk[b]	1	40	—	—	—	—	—	—	—	—	—	—	—	—	—	—
Yabrud	1	50	—	—	—	—	—	—	—	—	—	—	—	—	—	—
Malula	1	30	—	—	—	—	—	—	—	—	—	—	—	—	—	—
Muarra	1	30	—	—	—	—	—	—	—	—	—	—	—	—	—	—
Hamah																
Hamah	1	90	—	—	—	—	—	—	—	—	—	—	—	—	—	—
Homs	1	155	—	—	1	180	1	40	—	—	—	—	—	—	—	—
Hauran																
	8	330	—	—	5	345	—	—	—	—	—	—	—	—	—	—

[a]Also one Franciscan Boys' School with 45 pupils; one Maronite Boys' School with 50 pupils; one Syrian Boys' School with 70 pupils; one Greek Orthodox Boys' School with 180 pupils.

[b]Also one Syrian Boys' School with 60 pupils.

[c]None.

many Schools throughout the country. A list of all these schools will be found in Tables 11-1 and 11-2.

As far as Christian Sectarian education is concerned ample opportunities are given to the inhabitants of this District for the instruction of their children, and even Mussulmans occasionally send their daughters to some of the Foreign Schools, but, as already stated, this is rarely the case with their male children. On the other hand the native Government Schools are, owing to faulty organisation, ill-paid teachers and a spirit of fanaticism, in a backward condition. No Christian or Jew would send his son to an Ottoman School, knowing that the instruction would be inadequate, and that, if the child were admitted, he would probably suffer a certain amount of persecution. This contrast between the progress of the Foreign and the native Mussulman Schools has been viewed with jealousy of late years by the Ottoman Authorities, and the promotion of education under the auspices of the different Christian missions is discountenanced. To obtain permission to open or build a school, in connection with any mission, is now almost an impossibility, every excuse and delay being sought to avoid granting the requisite authorization. As long as the principles of Ottoman rule remain theocratic in their nature, based on Koranic precepts, they will be incompatible with the enlightened views of modern times, and with the progress of civilization.

12

Syrian Emigrants to America, 1904

. . . The statement made in the Syrian publication in regard to the Syrian emigrant is somewhat inexact. The Syrian emigration has been confined almost entirely to the district of the Lebanon the inhabitants of which are nearly all of the peasant class. There are indeed a number of old families of high standing and influence in the Lebanon, but they have contributed hardly a man to the emigration, I may therefore confine my report to the above-mentioned peasant class. Owing to the extreme rockiness of their land and the difficulty experienced in winning the soil to cultivation they have developed a careful if crude ability to till the soil which would seem to make them most valuable additions to our rural population if they could be persuaded to take up this line of work. Unfortunately they have no inclination to take up the work that one would naturally expect of them. As shown by declarations made by returned citizens practically all are ''merchants'' and that this in the majority of cases means peddlers can be verified by any one who remembers the familiar Syrian figure tramping the dusty roads in the rural districts of America. Practically no one of these emigrants came from Beirut or other commercial points and the percentage of those educated in American schools in Syria is also very small. The type of Syrian most easily Americanized would seem to be those who have been brought under American influence in this country, as for instance in the American College in Beirut where American instructors administer American methods. How small a proportion of these educated Syrians go to America may be gathered from the fact that out of a total of 842 graduates only 37, or less than four and one half percent have gone to America. A detailed account of this number is given below:

Graduates of Collegiate Department with no given vocation	13
Physicians (including one on P.I.Staff)	8
Pharmacists	6
Merchants	5
Clergymen	2
Students	2
Teachers	1
Total	37

The average Syrian in America seems to live as cheaply and meanly as possible in order to accumulate money to send or bring back to his native land. Judging by the number who return to their former homes to build houses and purchase land it would seem that the height of their ambition is to become land proprietors in their native haunts. It is a commonplace observation among Syrians and foreigners that all houses built with tiled roofs in the Lebanon districts from which the emigration flows have been built with American money. When it is considered that there is hardly a village in the most remote parts of the Lebanon that has not at least 2 or 3 new houses with tiled roofs and that even whole villages have been thus constructed—the amount of money diverted from America

From Magelssen to Loomis, 12 September 1904, US GR 84, Miscellaneous Correspondence, Beirut.

and permanently invested in Syria can be easily recognized. Some slight clue as to the amount of money sent home by Syrians residing abroad can be gathered from the statement of the Imperial Ottoman Bank that between £400,000 and 500,000 come annually from said sources. All this shows the general tendency of the Syrians to withdraw money from the countries in which they are sojourning. How large a proportion of this amount comes from the United States I cannot say, but I have reason to believe it is large.

Regardless of the restrictions placed upon these naturalized people by Turkey a large number venture, nevertheless, to return to their former home. During my term of service in this consulate covering a period of more than 5 years I have had exceptional opportunities to study this particular class of people to which the editor of the Syrian newspaper refers in his letters. More than 330 have in that time been placed on our Register as American citizens. I have personally conversed with the majority and I have never in the course of the conversation failed to question them as to the purpose of their return to Turkey. Not one of this number has stated that his visit has been prompted by a desire to establish trade agencies or business, but they have almost invariably replied that they have relatives to visit or property to dispose of. Quite a considerable number comes to find wives and in some instances it has been stated that ill health has compelled them to return. In connection with this paragraph it might be well to draw the attention of the Department of State to the fact that when registering these Americans in the Consulate we have observed that a very considerable majority have left the United States immediately after securing their certificate of naturalization and passport.

The statement that these naturalized Americans come back to establish trade agencies is untrue. American consuls in Syria do know "that American hillside plows are to be seen on the slopes of the Lebanon and that American reapers, harvesters and harrows are to be seen on the coasts of Syria." And they also know that these agricultural machines have not been imported by, or for, naturalized Americans of Syrian birth. There is in Syria one naturalized American of Syrian birth who enjoys the distinction of having imported American goods to these regions. According to his statement his importations for the fiscal year ended June 30, 1904, amounted to $5093, and consisted of cotton goods, boots and shoes.

Owing to the friendly relations existing between this Consulate and the local authorities we are able to assist Syrian-Americans who possess the required papers i.e. passport and certificate of naturalization, to land as such when they arrive in this port and we also facilitate their embarkation at the termination of their visit in spite of the fact that their American citizenship is not officially recognized by the Ottoman Government.

In regard to their protestations of patriotism I regret to report that a very large number of these naturalized citizens cast aside the cloak of American citizenship when they sail from the United States for the purpose of visiting Syria. They provide themselves with Turkish passports in New York or Marseilles presumably for the reason that the Turkish consuls acting on the instructions of the home Government refuse to acknowledge the validity of their citizenship certified to by such passports and therefore decline to grant the visas. The acceptance of a Turkish passport may therefore be due to the ignorant belief that American consuls in Syria "either will not or have not the power to protect them." . . .

It has been found that of the Syrians who come to the Consulate for one purpose or another not many have been able to speak the English language with ease; in some instances they have utterly failed to understand even the simplest routine questions. . . .

13

Report on the *Vilayet* of Aleppo, 1890

ESTIMATE OF POPULATIONS

. . . The population of the Vilayet is estimated as approaching one million. The Salnamé, or annual official register of the province, for 1889, gives the population as 776,745, but in detailing that of the region's cazas it only arrives at a total of 554,483, the populations of entire districts being left blank.

In 1879 however new estimates was taken by the government for the purpose of assessment of taxes which seems to approach accuracy as near as possible. The numbers then given were as follows:

Turks, Arabs, Circassians, Kurds and other Moslems		712,964
Nuzariehs or Sabians		40,000
Druzes		35,000
Yezidis		10,000
Jews		10,410
Christians		
Gregorian Armenians	77,397	
Roman Catholics	11,679	
Greeks	12,504	
Greek Catholics	10,257	
Syrian Jacobites	2,778	
Syrian Catholics	3,000	
Maronites	2,484	
Latins	813	
Protestants	11,265	131,877
Total		940,251

The Jewish population is very largely confined to the city of Aleppo. The Europeans, chiefly resident at Aleppo and Alexandretta, can hardly number more than 400 souls, leaving out the larger numbers of native Arab Jews at Aleppo who by some means or other have acquired in years gone by, and still retain, a foreign nationality.

The populations of the principal cities and towns are as follows: Aleppo 116,000; Orfa 65,000; Aintab 45,000; Marash 30,000; Antioch 20,000; Killis 15,000; Idlib 12,000.

LANGUAGES

With the city of Aleppo going north the use of the Arabic language ceases and that of Turkish begins; the latter being the only language spoken by the inhabitants of Killis, Aintab, Marash and their districts; at Orfa, however, the Arabic again appears, and both languages are spoken. The agricultural population of the settled districts being mainly

From "Report on the Vilayet of Aleppo," by Consul Jago, June 1890, Aleppo, FO 195/1690.

Kurd, the Kurdish language predominates among this class. The bulk of the Christian inhabitants of the Vilayet consists of Armenians (Gregorian, Protestant, and Roman Catholic), the majority of the first being confined to immigrants from Armenia who after a stay of a few years as petty traders, bakers and servants, return to their country with their earnings, few settling in the province.

TRADE AND COMMERCE

Trade and Commerce are almost exclusively in the hands of the Christians and Jews, the Moslems devoting themselves to agriculture. The Suez Canal gave the death blow to the commercial prosperity of Aleppo, and of recent years considerable stagnation, want of confidence and curtailment of credit have prevailed. Referring, however, to the Returns of Imports and Exports at Alexandretta, the port of Aleppo, the loud complaints one hears on all sides respecting the condition of trade hardly seem to be borne out, and may probably be explained by the ever-increasing number of merchants and traders among the Christians and Jews, produced by the non-existence of industrial and agricultural enterprise, and the great and suicidal competition in trading, their only occupation, which cut profits down to starvation point. Those returns of trade during the last five years were as follows [see III,1]: . . .

Taking into account the large quantities of foreign merchandise imported from other Turkish ports where they have already paid duty and which consequently do not figure in these returns, and the now free export of native manufactures to Turkish ports, the aggregate of trade, inwards and outwards, cannot fall far short of three millions sterling. As regards exports the high and ever-fluctuating cost of transport to the coast by camel, the only means available for grain, has caused the export of cereals, the chief product of the country, to well nigh cease. In 1885, grain to the value of £252,000 was exported; since then the annual value has never exceeded £90,000. It is satisfactory to note that England, as regards imports at least, ranks for over two-thirds of the total amount.

NATIVE COTTON AND SILK MANUFACTURES

The native manufacturers of Aleppo, formerly of considerable importance, have diminished during the last thirty years to the extent, it is alleged, of nearly thirty percent. Various causes have contributed to this decline which has been gradual, but of late years has been accelerated by the impoverishment of the populations of Asia Minor and the Sudan, the chief customers, by war. The recent abolition of the 4 percent internal duty on manufactures passing between Turkish ports has caused the Anatolian demand to revive. On the other hand the imposition of 8 percent in Egypt has been disastrous, and from 700 to 800 looms working in this trade, the number is said to have been reduced to 70 or 80 in consequence. [Table 13.1] gives the description and value of native manufactured goods at Aleppo.

About fifteen percent of manufactures are consumed in the province; the rest being exported to Syria, Anatolia, and other Turkish ports. The manufactures of Aintab, formerly insignificant, now rival those of Aleppo and form the chief industry of that town— 2,500 looms work, and the artisans are held to be more painstaking and skilful than those of Aleppo. Marash also contains about 900 looms. At Killis, the industry is small. Taking the Vilayet as a whole the annual value of her cotton and silk manufactures is said to be nearly half a million sterling. The use of aniline colours has been prohibited by the

Table 13.1 Industrial Output and Wages

Description of goods	Number of looms	Average value per pieces of 4 ½ to 6 ¾ yards (s.)	(d.)	Total annual value £	Daily earnings of workman, piece work
Cotton Manufactured	1500	1/5	¼	56,000	8 d. to 11d
Cotton & Silk Manufactured	650	2/10	½	49,000	1/– to 1/2
Silk Manufactured	900	5/9		135,000	1/3 to 1/5½
Silk and Gold	50			25,000	1/3
Satin	35			5,000	
Total	3135			270,000	

municipalities of Aleppo, Aintab, and Marash, but in the first city the law is not strictly enforced, and yellow and dark green are sometimes used.

All the above manufactures are made from English and other foreign yarns, the bulk, however, English. Native yarn, spun by women by hand, is used in small quantities for the manufacture of native calico which, dyed with indigo, is sold to the Bedouins and peasants for skirts and other garments. Owing to the thickness of the thread and consequent coarseness of the cloth none is consumed by townspeople, although much more durable and cheaper than English calico.

The cotton grown in the Vilayet of Aleppo is unsuited by reason of shortness of staple for weaving by European machinery, and an effort made some years since near Antioch for yarn spinning and cotton weaving with English machinery resulted in the ruin of the speculator. More recently the military authorities, in virtue of orders from Constantinople to clothe the troops with native cloth, have endeavored to persuade native capitalists to enter again or make speculations but without success. Failing such the soldiers are now employed in weaving cloth, making socks, and boots, etc., the cotton yarn used being obtained from the Mill recently erected at Tarsous, and which is working successfully.[1]

Should the proposed increase in the import duty on foreign cotton and silk manufactures take place, it will doubtless go far to increase the manufacture and consumption of native made stuffs.

AGRICULTURE

Agriculture is conducted in the primitive manner of past ages, and no serious attempt is made to encourage such or to introduce a better system. The agricultural classes remain, as ever, the poorest in the land. In the plains of Antioch, Killis, Idlib, Aintab, and Orfa cultivation is seen at its best the inhabitants being noted for their skill, but elsewhere it is of the most slovenly and disheartening description, consequent on the poverty and indolence of the tillers, and the paucity of their numbers when compared with the extent of land they attempt to cultivate. In the rich plains I have mentioned land seldom remains fallow, being sown alternately with winter and summer crops. Manure in any form is never used, not being procurable; and it speaks volumes for the fertility of the soil which after centuries of cropping still yields abundantly. Despite all this the conditions of the

[1]See EHT, p. 310.

peasant is wretched in the extreme. In the long settled and fertile districts I have named between 10 and 15 percent of the population cultivate on their own account, the remainder through poverty allying themselves with some city usurer or influential man of the nearest town in the following terms: this city associate or partner advances money and seed to his peasant without interest for purchase of cattle, labor at harvest, etc., the latter supplying labour and cultivation. The produce is divided nominally between the two after the government tithe has been taken, but practically the former to guarantee his debt, agricultural debts being practically not recoverable by law, the ally takes all, first recouping himself for money advanced, seed at his own prices, and for his share, and then returning to the peasant what remains, if any. This system results in the peasant being almost always indebted to his city partner, and being left with little more than sufficient for the bare support of himself and family. On the other hand the peasant defrauds his associate to the best of his ability. Thus the relations between the two are those of never-ending disputes and wranglings, but the law never interferes, leaving the two parties to fight out their differences, each side endeavoring to protect himself by every means in his power. But the city partner being always a man of some local influence, besides holding the purse strings, comes best out of the contest.

The government, instead of assisting and encouraging, aggravates the position of the peasant by its deliberate action and to its own detriment. Take the matter of the tithe for instance. The cereal harvest takes place in May or June, but the tithes are never finally sold until three, four, and even five months afterwards, chiefly from the hope of securing better prices; the grain remaining on the threshing floors, exposed to rain, and often to accident by fire during the long hot summer months.

Although the peasant cannot thresh or remove his grain from the threshing floor, nothing prevents him, his cattle, and friends from living on it during the long interval which elapses between the cutting of the harvest and the sale of the tithe. This state of things has always prevailed despite the complaints and prayers of the suffering peasantry.

AGRICULTURAL BANK

The institution of an agricultural bank to make advances to the peasantry and so rescue them from the usurer, is not a success. Peasants prefer to borrow, as before, at 20 or 30 percent from the usurer with the facility the law gives them of preserving their land when unable to pay, agricultural debts practically not being recoverable by law, than borrowing from the government at a moderate rate with the certain risk of being deprived of their land in case of default of payment. Besides this the almost insuperable difficulties placed in their way by the regulations of the bank effectually bars their availing of its assistance. For instance, a peasant desiring a loan, large or small, has to dance attendance at least a month at Aleppo, following up his petition through the various departments through which it has to pass, feeing each petty clerk at every stage to ensure its progress. He must besides procure certificates from the land offices that he owes no arrears of taxes to the government, certificates difficult to obtain owing to the confusion in the land registers and to the fact that he almost invariably does owe arrears.

All those formalities have to be gone through no matter how small the loan required, and as no government clerk moves unless paid, loss of time and money are at once essential and fatal to the operation.

No more than £200 has been advanced by the bank since its creation. Its capital, taken from the extra tithe hired for the purpose, amounts now to about £5000, i.e. the

amount standing to its credit in the government books, but not cash, which is only obtainable after great difficulty and delay. Loans are limited to £50 but as few peasants possess land of such value they are restricted to £3 to £10.

DIRECTOR OF AGRICULTURE

The recent arrival of a Director of Agriculture from Constantinople with instructions to establish a model farm for the education and encouragement of the peasantry demonstrates the ignorance prevailing at Constantinople of the first necessities of the peasant at the present day which are not education but some cheap means of communication with the coast to create a sale for his produce. At present no renumerative sale exists; the country is full of grain, harvests are most abundant, but the produce remains unsold and rotting in granaries. Not a single European agricultural machine of any kind exists in the country. Although both the Director of Agriculture and of the Agricultural Bank have offices assigned to them in the Government House their duties are nil and their salaries obtained with difficulty.

ROADS

Besides the carriage road from Alexandretta to Aleppo opened a few years ago at an immense cost and now yearly falling more and more into ruin, despite subscription for repairs extorted from the citizens, tolls levied, and forced labour employed here and there towards ostensible repairs, a road has been made from Killis to a junction on the Alexandretta–Aleppo road, and another from Antioch to a similar junction near Khan Karamut. An attempt has been made to construct a carriage road from Marash to Aintab of which three miles have been traced out, and the works then suspended. Another from Aintab to Killis, begun four years ago, stops eight miles from the former town.

All those roads, even if completed, are however useless for any practical purpose. They are metalled, it is true, after a fashion, large and small stones from the nearest river bed being used, but the metalling is never rolled and in consequence traffic by them is carefully avoided whenever possible both by beasts and carriages which naturally prefer to follow the tracks through the fields on either side.

Nothing better illustrates the present condition of the government of the country than those expensive and futile attempts at road making. They appear to be begun simply to furnish matter for a report to Constantinople, and to extort money locally and are then even if completed after their fashion, abandoned to their fate.

So much for the long settled and fertile districts of the Vilayet. . . .

14

Agriculture and Textiles of Damascus, 1879

Raw Wool. There are four main markets for wool in the Vilayet: Homs, Hama, Damascus, and Zahleh. The amount sold each year at Homs and Hama may be put at 1500 quintals of 100 *ratls* each, or 45,000 kilograms, at Zahleh 500 quintals or 15,000 kilograms, and at Damascus 3000 quintals or 90,000 kilograms. Of these 150,000 kilograms, the *vilayet* keeps 15,000 for local industries, which mainly make various kinds of overcoats and other articles for personal use. The rest of the wool goes to Europe; that part originating in Homs and Hama is shipped from Tripoli, and that from Damascus, Zahleh, and its neighbourhood through Beirut. . . . It is the desert Arabs who mainly supply Homs and Damascus. . . .

(Gilbert to Waddington, 27 April 1879, *ibid*)

Madder. Formerly this plant was quite widely grown in the villages of Nabk, Dayr Atiyeh, and Yabrud, all three of which lie north of Damascus. Annual output ranged between 200,000 and 300,000 kilograms, whereas today, for lack of outlets in Europe, it falls below 100,000.

Madder is harvested here after two years. However, should the peasant not be obliged to make money as quickly as possible—which unfortunately seldom happens—he can delay pulling out the roots until four years after planting; this would provide him with crops of higher quality and greater weight without imposing on him the work required for sowing another time.

Of the present production of madder Damascus keeps some 35,000 kilograms for its dyeing plants; the rest is sent to Aleppo, Smyrna, Cyprus, and other towns in Turkey. Merchants buy madder at 6–7 piasters an *oke*, or 1.20–1.40 francs. They pay 85 piasters (17 francs) for transport and 1 percent customs duty per quintal of 200 *okes*, or 256 kilograms.

Apricot Stones. Some 400,000 *okes*, or 512,800 kilograms, are packed in crates containing 50–60 *okes*, or 75 kilograms, sold in Damascus for 4–4½ piasters an *oke*. The larger part is sent to Marseilles, bearing the same transport and other costs as madder.

Wheat. Annual output of this crop harvested in the villages and districts directly dependent on the Mutasarriflik of Damascus is put at 600,000 *djefets* or Constantinople *Kiles*, each equal to 25 *okes* or 36 liters. According to an estimate based on the total population of this city, 35,000 *djefets* are used for local consumption, the rest being sold to Beirut and the Lebanon.

Sesame. It is planted in the lower plateau and in some villages in the Anti-Lebanon, south-west of Damascus. Annual production is estimated at 12,000 hectoliters. One-third is consumed locally and the surplus carried to Beirut, for shipment.

Silk. Finally, the quantity of *silk* produced in Djabal al-Shaykh (Mount Hermon), the highest peak of the Anti-Lebanon, together with that harvested in the main production centers of the mountain (i.e., Hasbayya and Rashayya), is 1100–1200 kilograms, all of which is consumed locally.

From "Report on Agriculture of Vilayet of Damascus," 27 March 1879, CC Damas, vol. 6, 1878–1889.

[There follows an account of the main textile handicrafts of Damascus, which may be summarized as follows:

> *Aladja,* a silk and cotton cloth (selection 13); 1200 workmen; output 100,000–120,000
> pieces, 5–6 meters long, 20 inches wide; sold at 90–150 piasters each (i.e., 18–
> 30 francs).
> *Dima,* cotton cloth; 2000–2500 workmen; output 300,000 pieces, 5–6 meters long, 20
> inches wide; sold at 3–6 francs a piece.
> *Kaffiyeh,* headdress; 100 workmen; output 13,000 pieces; sold at 12–120 francs a
> piece, depending on silk content.
> *Mabrum,* cloth; 3000 workmen; output 300,000 pieces; sold at 2–4 francs each.
> *Banbazahr,* cloth; 60 workmen; output 5000 pieces; sold at 8–12 francs each.
> *Malaf,* cloth; 60 workmen; output 5000 pieces; sold at 18 francs each.
> These articles are sent mainly to Egypt, Constantinople, Asia Minor, and
> Mesopotamia.]

15

Lebanon, 1900

. . . The agricultural products of the mountain consists chiefly of silk cocoons, olive oil, wheat and barley, grapes, and other fruits, vegetables, and dairy produce, valued at 1,072,726*l*, as follows:

Cocoons	£572,727
Olive oil	118,182
Wheat and barley	181,818
Grapes, &c.	109,090
Dairy produce	
Vegetables	90,909
Total	1,072,726

The value of the silk produce represents about 3,000,000 okes of cocoons, at about 3 to 5 fr. per oke[1] or 3,000 bales of silk weighing respectively 100 kilog. The whole of this produce is exported to France. The production in the districts of the vilayets adjoining the Lebanon may be estimated at about one-half of the latter.

The cultivation of the mulberry tree is universal throughout the Lebanon, and has in many places supplanted that of the olive and vine.

Olive trees are grown chiefly in the northern and southern districts where the soil is more fertile, but the cultivation of this tree is stationary. They yield a good quality of oil, which is employed either for local consumption and the manufacture of soap, or for exportation to Asia Minor and Egypt.

From "Report by Consul-General Drummond-Hay on the General Condition of the Lebanon," FO 195/2075.
[1] 1 oke = 1 lb. 14 oz.

Lebanon grapes are famous for their excellence, and especially those grown in altitudes of from 3,000 to 4,000 feet. The fruit is largely consumed by the natives, forming, with a wafer-kind of wheaten bread, and goats' milk cheeses, their staple nourishment during the grape season.

The chief industries are silk spinning, silk and cotton weaving, wine and spirit manufacture, the preparation of oil and soap, the weaving of carpets and goats' hair saddle-bags, and basket-work.

There are 6,965 spinning wheels in the silk factories and 1,113 oil and wine presses. (See Appendix, Annex I.)

Red and white wines, mostly sweet, a spirit called arrack, flavoured with anisette, and a syrup made from grapes, but resembling molasses, are fabricated in considerable quantities, and consumed in the mountains, Beirout and neighbourhood.

Silk looms are scarce, and only employed for the manufacture of furniture-stuffs, usually of plain bright yellow hue, or striped with red.

The cotton industry is more important, and is capable of development; the principal looms are in the villages of Bekfaya and Beit Shebab, in the Caza of Metten, and of Zouk in Kesrawan.

It is estimated that about 1,000,000 pieces are manufactured yearly, valued at 80,000l. The textures and patterns are chosen to suit native requirements for wearing apparel. They are consequently firmly woven with fast dyes, and are in these respects superior to the foreign article.

Zouk, a village adjoining Djouny in the Kesrawan, is famous for its gold and silk thread looms, from which is produced a cloth of gold and silver, which is a specialty of the Lebanon.

This material had a large demand in the days of rich Eastern costumes, prior to the adoption of European fashions. It is now woven into table and cushion covers, which are very handsome when the dyes employed are not too vivid.

Grain bags and saddle bags made of goats' hair are manufactured principally in the villages of Shehin and Battha, in Kesrawan. These bags are commonly used by muleteers and camel drivers; they are very durable, and owing to their firm texture are almost waterproof.

Carpets and "abbahs," or cloaks are manufactured at Baaklin and other villages in Shoof, where there are about 1,000 looms for carpets and 18 for abbahs.

The carpets have a close thick pile resembling those of Smyrna, to which, however, they are very inferior. The favourite designs are in black and other colours on a dark red ground.

Abbahs are made of pure wool, and are finely woven as a protection against rain and cold; the popular colours are black, yellow, brown, and black and white stripes. Druses, as a rule, don the black abbah, especially the Elders of the community, commonly known as "Akkala."

When the census of the male population of the Lebanon was taken in 1862 before establishing the poll tax, it was estimated at 99,834 souls (see Annex II), of whom over half were Maronites, about one-eighth Druses, and a similar proportion Greek Orthodoxes, the remaining fractions being divided between Greek Catholics, Mussulmans. Metwalis (Shiah rite), besides an insignificant number of Protestants and Armenians, &c. The population, including both sexes, may be roughly estimated to have been about 220,000 in 1862, and to have increased now to about 300,000. A fresh census has not been taken,

but there is a general opinion among the Lebanese that a considerable increase has taken place during the past thirty-eight years. A trustworthy estimation of the present population is rendered difficult owing to the emigration to America and other parts of the world that has taken place during late years, and although a considerable portion of the emigrants possess property in the Lebanon, and continue to pay the land and poll taxes, there is no Department in the Local Government which controls the movement. It began to take serious proportions about twenty years ago. Opinion as to the number that have emigrated during that period varies considerably between the figures of 50,000 and 100,000. I am inclined to place the number at 60,000, and to deduct from it one-third as representing those who have returned to their homes. Besides emigrants to foreign countries, there are about 20,000 who have left during the above-mentioned period and settled permanently in the adjoining vilayets, and especially in the Cazas of Baalbec, Tyre, Sidon, and Tripoli, the town of Beirout, besides Egypt and Cyprus. The total exodus from the Lebanon may therefore be estimated at 40,000 to foreign countries and 20,000 within the Ottoman Empire, making a total of 60,000 souls in thirty-eight years. Many people believe that the actual population exceeds 400,000. This would, no doubt, have been the case if emigration had not taken place, but the fact must be taken into consideration that the Lebanese exist chiefly on agriculture, and that the country under such conditions can never support more than a limited number of inhabitants. Many emigrants to America and the British Colonies are successful, and settle down in their adopted homes, but there are numerous instances of persons returning to the mountain after a comparatively short absence, having amassed sufficient capital to thrive upon in their native country.

The Lebanon has undoubtedly benefited largely by emigration, judging from the heavy sums of money that pass through the hands of Beirout bankers, which, I have ascertained from reliable sources, amount annually to about 200,000l., representing either moneys for the support of families left behind, or to be used as investments in property for those who intend returning to their homes. There are now indications in all parts of the Lebanon of the beneficial effects of the movement. Hamlets with every sign of poverty and misery, have been transformed into flourishing villages, surrounded by carefully terraced plantations.

Emigration was at first limited to Christians, but it has been extended to Mussulmans and Druses. These, however, are unable to travel with their families, and consequently they, with rare exceptions, repatriate themselves after a time. The moral effect of emigration on the Lebanese is usually good, as travelling widens their mental outlook and brings them into contact with more advanced nations. . . .

There are three printing offices in the Lebanon, two at Baabda and one at Djouny, and four newspapers are published weekly, the "Rawdat" and the "Arrs" by Maronites, the "Libnan" by a Greek Orthodox, and the "Suffa" by a Druse. The "Rawdat" and the "Libnan" are employed by the Local Government for the insertion of official notices and publications.

The construction of roads is one of the most prominent benefits derived by the Lebanon from the Organic Statutes of 1861. The endeavours of the earlier Governors-General to promote the opening up of the province by roads met with little success, as the natives clung to their ancient traditions, and were opposed to schemes which they believed would weaken their mountain fastnesses, which had hitherto been the main protection against their foes. After several years of peaceful administration, and the civilizing benefits accruing therefrom, the inhabitants began to realize the utility of the few roads

that had already been made, but they required twenty-five years to arrive at that conclusion. The mountain has now a network of roads in all districts, even to villages over 4,000 feet above sea-level.

Their total length (the Beirout–Damascus not included) is $414\frac{9}{10}$ kilom., besides $261\frac{1}{2}$ kilom. under construction, and 169 kilom. projected (see Annex III).

Taking the population of the Lebanon at 300,000, and the length of roads constructed and under construction at $676\frac{2}{5}$ kilom., there are about $2\frac{1}{4}$ kilom. to each 1,000 inhabitants. The Metten, which is the most progressive district in the Lebanon, contains over half the length of roads in the whole mountain, and is followed next in that respect by the Shoof.

The only exit from the Lebanon by road over the passes to the Bekaa on the eastern slopes has hitherto been by the "Beirout–Damascus," but one of those now under construction will shortly open up another pass between Mounts Sunnin and Keneisy to Zahlé, and among the projected roads another will cross the mountain south of Djezzin to the Bekaa.

When a road is required, the inhabitants of the district address a Petition to the Governor-General, who refers it to the Council of Administration. The latter then examine the project, and, if approved, the funds necessary for the works are assessed by competent engineers, and charged to the inhabitants of the district interested in the undertaking. In many instances these charges are graduated according to the relative distances of villages from the projected road.

Repairs are controlled and managed by the Local Government, and the funds for that purpose are derived from a tax of $\frac{1}{4}$ of a medjidié (about 1 fr.) per male of the population. . . .

The census of the male population, and the cadastre of all cultivated lands, were taken in 1862, as required by Article 16 of the Statute. The lands were assessed at 125,078 drachms, as shown in the annexed statement of the cadastre. A poll tax of $8\frac{3}{4}$ piastres (1s. 7d.) was levied on each male, and a land tax of 21 piastres (3s. 8d.) on each drachm of the cadastre, or estimate of the annual productive value of land according to the following calculations: twelve loads of mulberry trees, twelve keili[2] of oil, and a plot of land requiring twelve "muds" of seed, were respectively assessed at 1 drachm, or taxed at 21 piastres.

Orchards, vineyards, and other plantations were assessed at 1 drachm for every lot valued at 4,320 piastres, and mills, khans, shops, and all industrial establishments were assessed at the rate of 1 drachm for every 360 piastres estimated revenue.

In accordance with Article 15 of the Statute, the fixed tax on the Lebanon was raised from 3,500 "purses"[3] to 7,000 to meet the expenses of the Administration, and this revenue was secured by the above-mentioned taxes, which amount annually to about 3,500,000 piastres (31,818l.), as shown in Annex IX. It was also stipulated by the same Article that should the expenses strictly necessary for the Administration exceed the revenue the excess would be covered by the Imperial Treasury, and that the "Bekaliks" or revenues from the Imperial domains in the Lebanon, being independent of the taxes, were to be collected by the Local Government and credited to the Imperial Treasury. When the Administration was started in 1862, the revenue being found insufficient, a subsidy of £T. 20,000 was granted by the Imperial Government to meet the deficit. Each

[2] 1 keili = 2 muds; 1 English quarter = $14\frac{3}{4}$ muds.

[3] A "purse" = 500 piastres.

successive Governor down to Rustem Pasha succeeded in diminishing the grant, and during the latter's Governorship it was reduced from £T. 12,000 to £T. 6,000, and, finally, after the war with Russia in 1878, was suppressed altogether.

This was effected:

1. By a gradual increase in the judicial fees;
2. By the "Mahmoulats" taxes, derived from charges on goats and sheep;
3. By fines, carriage and gun licences, and the Tombak dues; and
4. By a tax of $\frac{1}{4}$ of a medjidié imposed on all tax-payers in the seven cazas for the repairs of roads in the mountain.

In 1880, after the Imperial subsidy was abolished; the revenue of the Lebanon from the poll and land taxes, the Imperial domains, sponge fisheries, and judicial fees amounted to 3,928,256 piastres, and the expenditure to 4,541,089 piastres, with a deficit of 612,833 piastres, which was placed to the debit of the Imperial Government.

The Mahmoulats of that year amounted to 285,400 piastres. These taxes were, and always have been, kept separate from the Budget, and the same rule applies to the taxes that have been since raised to meet expenses for the construction and repairs of public buildings, bridges, and roads.

In 1899 the revenue, minus the supplementary taxes, was 4,102,677 piastres (37,297l.), and the expenditure 4,104,697 piastres (37,315l.). The deficit of 2,020 piastres was covered by a credit for that amount from the proceeds of the Mahmoulats. The receipts from the latter and other taxes not included in the fixed revenue amounted to 1,243,603 piastres (11,304l.), and the expenses to 984,915 piastres (8,953l.), showing a surplus of 258,688 piastres (2,351l.) under this heading.

A comparison of this Budget with that of 1880 shows an increase in the present day of 1,132,624 piastres in the revenue, including the supplementary taxes, and a decrease of 436,382 piastres in the expenses of the Administration. The latter was effected by reducing the strength of the police force, as already stated, from 1,400 to 963 men of all ranks to cover a part of the deficit caused by the cessation of the Imperial subsidy.

The revenue from the "Bekaliks," or Government lands, situated in North Lebanon varied during the past twenty years between 330,000 piastres and 397,000 piastres. The sum of 59,140 piastres deducted from the fixed revenue of 1899 represents the estimated produce of an extensive olive plantation near Tripoli, called the "Monassera," which was included in the cadastre, and valued at 3,000 drachms. The inhabitants of Tripoli disputed the claim of the Lebanon to the land at the time of the survey, and as the question remained in abeyance, the taxes have never been recovered by the Administration.

The sponge fishery dues were at 70,000 piastres in 1880, and now amount only to 1,200 piastres, owing to the emigration of fishermen, but the judicial fees have increased from 12,000 piastres to 229,900 piastres since the creation of new judicial fees, and especially those derived from criminal cases. . . .

16

Mutasarriflik of Hama, 1911

. . . In respect of goods imported to Homs and Hama, it should be remarked that 75 percent come from Beyrout, 15 percent from Tripoli, 10 percent from Damascus; now of the above 75 percent from Beyrout, about nine-tenths at least are reshipped by sea to Tripoli, and thence brought by camel, or horse or mule, to destination, owing to the rather heavy quay duties, and costliness of the railway freight, with the disadvantage of transfer at Rayak from narrow to broad gauge, not to mention the (hitherto remarked) want of sufficient customs accommodation at Beyrout.

Already the presence of the new railway is felt, in diminishing and killing this transport by animals. Camels of the neighbourhood are being sent to Egypt where they obtain a better price than in Syria. . . .

Besides the weaving industries of these towns (there may be some 2000 looms) and various articles which are exported to Damascus and Egypt, the chief products are wool exported abroad to the value of £30,000 from Hama, and £10,000 from Homs; and barley, wheat, butter, mainly sent to Beirut and surrounding districts [Table 16.1].

The cereals of all this region are unusually poor and unpromising from Baalbek northwards; the severe winter has occasioned this loss, whereas round about Damascus, and in the Hauran and to the South they are above the average. Doubtless Homs and Hama will have next to no barley and wheat export this year.

During my journey I chanced to meet the Régie Nazir of Damascus, who was engaged on a project for lessening the consumption of contraband tobacco in these parts in concert with the Régie Directors of Beyrout and Aleppo: it would seem that the Régie tobacco sold is a ridiculously small quantity and this mainly of the lowest quality averaging less than £T. 300 p.m. for the town and district of Homs, because contraband is introduced from Lattakia in vast quantities, whereas but little comes from Lebanon. In the Vilayet of Syria very little tobacco is grown at all.

Emigration is continuing throughout this Vilayet on a larger scale than before, as a hundred insignificant items indicate, and all the gain by natural increase or even more is thus carried off and the population of these fertile lands remains nearly stationary. I found this specially the case at Homs and Hama, where many peasants resort from surrounding districts. As the United States restrict the influx by various laws and conditions, Brazil is becoming more and more frequented by Syrians. . . .

A small ice factory is found at Hama which can produce up to three tons a day, and supplies of this article are sent by train to Homs where none is found.

A project for carrying water from the Orontes into the town and houses of Homs was entertained and not unlikely of fruition some three years; an aqueduct was to bring the river water from a point some five miles distant at a cost of £45,000, but the plan fell through. The municipality give some attention to paving lighting and cleaning the streets, though their revenue is only about £3,000 p.a. so that Homs compares rather favourably with most Anatolian or Syrian towns.

From Devey to Lowther, 24 May 1911, FO 195/2370.

Table 16.1

	Hama	Homs	Total
Barley	£90,000	£90,000	£180,000
Wheat	£27,000	£30,000	£57,000
Butter	£24,000	£6,000	£30,000
	£141,000	£126,000	£267,000

I did not hear of any projects for utilizing water power for electrical purposes in the neighbourhood, though such may occur some day in relation to the fairly large lake of Homs, and the swift Orontes (R. Assi). . . .

17

Tourism in Lebanon, 1914

SUMMER RESORTS

. . . Lebanon is the natural summer resort for Syria, Mesopotamia, Karamania [southern Turkey], and Egypt. . . .

There are 5 First-Class Hotels, which afford all comfort to their patrons, and 80 Medium Class Hotels, scattered all over the area of the Mountain. Recently, the scope of summer tourism has greatly expanded, tripling the size of such villages as ʿAley, Bhamdun, Sawfar, Bayt Mery, and Dhuhur al-Shuwayr during the last 20 years.

The [direct] income derived by the Mountain from summer tourism is estimated at 20 million piasters. The price of land in some of these villages has risen enormously; 20 years ago a square meter of land was worth 10 *paras* to one piaster, in such places as ʿAley, Bhamdun Station, Sawfar, Bayt Mery, and Dhuhur al-Shuwayr; today it fetches 20 to 100 piasters.

Emigration from Lebanon has helped the development of tourism, for the great attachment of Lebanese to their homeland has led them generally to use their savings to purchase real estate and build houses in their village of origin, which has added to the comfort and amenity of the housing available to tourists.

Among the benefits of travel has been the broadening of the mind of the Lebanese and their awareness of development issues such as that of transport, which plays an important part in the life of Lebanon. Hence, in the last 30 years or so, we have seen the Lebanese busy building roads and bridges. The scope of their work becomes apparent when we recall that Lebanon is the only Ottoman province that has a network of roads, totaling 1200 kilometers, for an area of only 400 square kilometers of arable land. This was achieved through the funds accumulated by Lebanese abroad, by dint of saving. One can only admire their effort and energy. But if the Lebanese individual has understood the importance of roads, the old Administration of Roads and Bridges has greatly diminished

From Ismaʿil Bey Haqqi (ed.), *Lubnan: mabahith ʿilmiya wa ijtimaʿiya*, Beirut, 1918 (reprinted, Beirut, 1970), vol. 2, pp. 531–535.

their utility because of failure of upkeep and the deficiency of most roads in the way of poor layout and bad construction, making it difficult for motor cars to pass over them because of the weakness of their walls and the narrowness of their curves.

The future of the Mountain undoubtedly lies with summer tourism; Lebanon will become for the East what Switzerland is for the West. . . . Incomes from tourism have risen continuously, doubling in 20 years, even though the necessary means of encouragement were not provided. If public measures aiming at this end were taken, income from tourism would increase to an extent that would make it a source of much wealth for the Mountain. Among the necessary measures, the most important is the use of motor cars, the improvement of old roads, and the building of new ones facilitating circulation.

We should not forget that tourists are well-off people, who like ease and comfort. There is no means of transport for short distances that is easier and more pleasant than cars, especially in the Lebanese mountains, which capture the heart with their beauty and variety of scenery. Moreover, the utility of cars is greater in mountains than in plains; this may surprise the reader, but it is as evident as mathematical truths and is proved by experience. Here is an example: Suppose a commercial vehicle with a horse power of 40, capable of carrying 12 passengers, as is common, and suppose the objective is to travel from Beirut to Junieh, a distance of about 25 kilometers. It is difficult for the car to accomplish this journey in less than 40 minutes, i.e., at an average speed of 37.5 kilometers per hour, because of the twists and turns in the road and especially because of the continuum of villages in most places; this forces the driver to reduce speed and makes it impossible to use the full 40 horsepower of his car without danger save in exceptional circumstances. The same journey in a carriage drawn by horses of average strength would take at least 120 minutes, i.e., the car would save two-thirds of the time.

Take now the same example in mountain roads, and assume that the same car goes from Beirut to Sawfar, a distance of about 25 kilometers. This journey would take 50 minutes, at an average speed of 30 kilometers per hour, for the power of the motor makes such a speed—and more—possible, and there is no harm in proceeding so fast in the mountains, because villages are far from each other; the full force of the motor car can be used without danger. The same journey by carriage would require at least five hours, i.e., 300 minutes, and would moreover need strong horses. The car therefore reduces time by the ratio of 300 to 50, i.e., six times. Hence, the car is more useful in mountains than in plains. This is the reason why 'Aley, Bhamdun, and Sawfar have attained their present importance, for the passage of the railway through them has greatly reduced distances and ensured the comfort of passengers. . . .

18

Economic and Social Innovations in Aleppo, 1853–1914

Appearance of Cigarettes in Aleppo. In 1270 A.H. (1853/54) the use of cigarettes reached Aleppo. At first people objected to smoking them, then most took them up and stopped using waterpipes. Previously they had been extravagant in their water-pipes, . . . the mouthpiece of which sometimes cost 1000 piasters or more because among its parts were rings studded with diamonds or other precious stones. . . . We discussed the craft of waterpipe makers in Part One of this book.

Consumption of Tomatoes in Aleppo. In the same year a vegetable known as "Frankish eggplant," or *banadora* [Italian *pomodoro*], made its appearance in Aleppo, its seeds being brought from Egypt by a trader. It was successfully planted but Aleppines did not at first take to it, some being repelled by it; and some simple-minded people, when seeing it or hearing it mentioned, would exclaim "There is no God but God and Muhammad is His Prophet," in the belief that it was a forbidden vegetable invented by the Franks. The few who ate it restricted themselves to cooked green tomatoes, avoiding ripe red ones, which they declared to be unwholesome and causing disease. But with the passage of time people got accustomed to eating tomatoes and avoided green ones—except as pickles—and developed a great predilection for ripe tomatoes, making tomato juice for winter to season their food, which seemed to be insipid without some juice. . . .

Opening of Telegraph Line. In 1278 (1861/62) or the previous year, work began on bringing the telegraph line to Aleppo and some of its dependencies. When told that it could transmit news from one town to another, however distant, in the twinkling of an eye, simple-minded people refused to believe this; they maintained that the news was transmitted by an evil spirit dwelling in the wire. . . .

Use of Petroleum in Aleppo. In 1280 (1863/64) the use of petroleum in lamps reached Aleppo. At first people avoided it, claiming that its smell was harmful to the chest and that the brilliance of the light hurt the eyes—But after a short period people realized the advantages of petroleum, and all other means of illumination were given up. . . .

Publication of "Al-Furat" Gazette. In 1284 (1867/68), the official weekly gazette, "Al-Furat," began publication in both Turkish and Arabic; it was the first newspaper in Aleppo. Its 50th issue appeared in three languages, Turkish, Arabic, and Armenian, but after the 100th issue it was issued only in Turkish and Arabic. . . .

The Salnameh of the Province. In the same year the first *salnameh* [annual alma-nac] of Aleppo was published. . . . At first it was of small size and printed on lithograph, but it became larger and more comprehensive. . . .

Beginning of Work on Alexandretta Road. In the same year work began on paving the road to Alexandretta. Each adult male had either to supply four days' work or to pay a cash equivalent of 10 piasters for each day . . . [pp. 388–396].

Publication of Newspaper. In 1294 a private Arabic newspaper, "Al-Shahba," began publication . . . [p. 404]. In 1297 (1878/79) another newspaper, "Al I'tidal,"

From Kamil al-Ghazzi, *Nahr al-dhahab fi tarikh Halab*, Aleppo, 1923–1926, vol. 3, pp. 388–535.

began publication; one of its two sides was in Arabic and the other in Turkish . . . [p. 406].

Opening of Main Road. In 1301 (1883/84) the great road known as "Jaddat Bab al-Faraj" was opened . . . [p. 407].

In 1303 (1885/86) the paving of the Alexandretta road was completed and it was officially inaugurated . . . [p. 409].

[*Building of New Quarters.* The following new quarters of Aleppo were started in this period: Al-Ghazalat, 1278 (1861/62); Al-'Aziziya, 1285 (1868/69); Al-Jamiliya, 1304 (1886/87); and Al-Talal, 1310 (1892/93)—see pp. 390, 401, 413, 421.]

Draining of Swamps of Alexandretta. In 1317 (1899–1900) work started on draining the swamps of Alexandretta. A big dam, 500 meters long, was built on them; it had been planned for 950 meters, but the necessary energy was lacking and the swamps remained as they were . . . [p. 449].

Crafts School and Drilling Rig. In 1319 (1901/2) a Crafts School was opened for carpentry, sewing, shoemaking, weaving, and knitting of stockings. The initial outlay was met from the receipts of the theaters and the permanent costs from a levy on meat imposed a few years before under the name "Levy for refugees from Crete." I was appointed as director of the school, established the crafts, organized operations, and held the post for four years.

In the same year a rig for drilling wells like artesian wells arrived, with two operators in charge. They started work in Jaddat al-Khandaq, between Bab al-Nasr and Suhrawardi, and drilled two wells. But shortly after the wells dried up and the operators left, with their rigs . . . [p. 455].

A New Tax. In 1322 a new tax called *personal werko (vergi)* was imposed. Each able-bodied adult male was to pay each year an amount fixed according to his wealth; the lowest rate was 15 piasters a year and the highest 200 piasters. As for government officials, 2 days' pay was to be deducted each month if their salary was below 500 piasters and 24 days' pay if it was over 500 [*sic*] piasters [But in the face of popular opposition the tax was repealed] . . . [p. 465].

Arrival of Trains. On 20 July 1906 a locomotive reached the Aleppo–Hama railway station drawing behind it maintenance wagons—the first to arrive at Aleppo . . . [p. 466].

Street Lights, etc. In 1325 (1907/8) the Municipality bought from the Lux factory about seven lamps and placed them in the main public squares. They were the first of their kind in Aleppo and are referred to by the people as "electricity."

In June the government established in the secondary school a place for breeding silkworms, open to anyone who wished to breed such worms. It promised the winners bonds (*bunut*) and cash. Silkworm breeders from Aleppo and Antioch flocked to that place and the winner obtained the promised prize.

In September the government organized a horserace in the racetrack and offered prizes ranging from £T2 to 25. . . . This was the first time the Ottoman government had organized a horserace in the tracks . . . [p. 468].

Mechanical Mills. In the same year a large European mill, with a motive power of 58 horsepower, for cleaning, grinding, and sifting grain was installed in Khan Aqyol. It was worked by coal gas made out of mineral coal or charcoal, and was the first of its kind in Aleppo. A year earlier a mill of 45 horsepower, worked by petroleum, had been set up in Barriyat al-Maslakh; earlier several other such mills had been established in Aleppo and

other places and, together with ice-making factories, they are spreading fast . . . [pp. 468–469].

 Baghdad Railway. In 1330 (1911/12) trains began moving on the Baghdad line from the old station in Karm al-Khanaqiya in the direction of Raju. . . .[1]

 Arrival of Aeroplane. In May 1914, for the first time, an aeroplane appeared in the sky above Aleppo. The plane came from Istanbul and was piloted by two Turks of tender youth called Sadiq Wasim and Fathi. [They went on to Damascus but, on their way to Cairo, crashed and were killed near the Jordan.] . . . [pp. 535–536].

[1]See *EHME*, pp. 254–255; *EHT*, pp. 147–150, 188–194.—ED.

19

Men's Daily Wages in Syria, 1820–1915

Year	Place	Mason	Carpenter	Common laborer	Agricultural laborer	Handicraftsman	Source
				Wage (piasters, decimalized)			
1820s[a]	Aleppo	4–5	NA	1.5–2	1	NA	Bowring, *Report*, p. 124
1836	Aleppo	8–10	NA	4	4.5	NA	Ibid.
1838	Aleppo	8	8	NA	NA	5–20	Ibid., p.82
1838	Damascus	8–12	9–15	5–7	NA	10–12	Ibid., p. 51
1838	Beirut	14–15	14–15	5–6.5	NA	NA	Ibid.
1825	Aleppo	5	NA	2	NA	NA	CC Alep 28
1837	Aleppo	7–10	NA	3.5–6	NA	NA	Ibid., 28,29
1847	Aleppo	NA[b]	9[c]	NA	NA	NA	Ibid. 31
1835	Lebanon	NA	NA	8[d]	NA	NA	FO 226/11
1832	Saida	NA	NA	3.3	NA	NA	CC Beyrouth, 1 b
1835	Saida	6.5	6	2–3	NA	NA	Ibid.
1836	Saida	6.5	6	2–3	NA	NA	Ibid., 2
1837	Saida	10	10	4	NA	NA	Ibid.
1839	Saida	10	NA	3	NA	NA	Ibid.
1840	Saida	11	NA	3.5	NA	NA	Ibid., 4
1841	Saida	11	NA	3.75	NA	NA	Ibid., 2,4
1842	Saida	11	NA	2.3–3.75	NA	NA	Ibid.
1843	Saida	11–12	NA	3.8–4	NA	NA	Ibid., 5
1845	Saida	11	NA	4.1–4.25	NA	NA	Ibid.
1846	Saida	10	NA	4.6–4.75	NA	NA	Ibid.
1849	Saida	8	8	3–5	NA	NA	Ibid., 6
1850/51	Saida	9	9	3–4	NA	NA	Ibid.
1846	Beirut	(6–11)[e]	(6–11)	(3–4.5)	NA	NA	FO 78/1419
1846	Jaffa	(7.5)	(6)	(2–2.5)	(2–2.5)	NA	Ibid.
1851	Alexandretta	NA	NA	NA	(3)	NA	Ibid.
1853	Diyarbakr	7	7	2	NA	NA	A and P 1865, 53
1854	Diyarbakr	9	9	4	NA	7	Ibid., 1859, 30
1853	Aleppo	NA	NA	(5)	(3.5)	NA	FO 198/13
1856	Jaffa	15	12	4–5	(4–5)	NA	FO 78/1419
1856	Diyarbakr	6–9	6–9	3	NA	NA	Ibid.
1856	Aleppo	11	11	4–7	(3)	NA	Ibid.

(*continued*)

Men's Daily Wages in Syria, 1820–1915 *(Continued)*

Year	Place	Wage (piasters, decimalized)					Source
		Mason	Carpenter	Common laborer	Agricultural laborer	Handicraftsman	*Source*
1856	Mosul	10	9	3	NA	NA	Ibid.
1856	Tripoli	9–11	9–11	3	NA	NA	Ibid.
1856	Mar'ash	NA	NA	7	2.5–6	NA	Ibid.
1856	Antioch	9	11	3	2.5	NA	Ibid.
1856	Urfa	(8)	(8)	(5)	3–6	NA	Ibid.
1856	Alexandretta	11–14	11	4.5–5.5	5–5.5	NA	Ibid.
1856	Latakia	9–11	7–9	4	NA	NA	Ibid.
1856	'Aintab	7	7	3	NA	NA	Ibid.
1856	Beirut	8–14	8–14	4–6	4–6	NA	Ibid.
1858	Alexandretta	15	15	8	NA	12	A and P, 1859, 30
1858	Antioch	11	8.5	3	3	NA	FO 78/1418
1858	Diyarbakr	8	8	3.5–4	1.5–5	NA	Ibid.
1858	'Aintab	5.5	5.5	3	(4)	NA	Ibid.
1858	Mar'ash	NA	6.5	2.5–3.5	2.5–6	NA	Ibid.
1858	Urfa	(6)	NA	(4)	3–6	NA	Ibid.
1858	Aleppo	11	11	3.5–7	3	NA	Ibid.
1858	Mosul	10	9	4	NA	NA	Ibid.
1858	Beirut	NA	8–14	4–6	NA	NA	Ibid.
1858	Jaffa	15	12	4–5	4	NA	Ibid.
1858	Latakia	NA	NA	2.5–3	NA	NA	Ibid.
1858	Tripoli	9–11	9–11	3–4.5	3–4	NA	Ibid.
1863	Jerusalem	NA	NA	NA	5.5	NA	FO 195/771
1863	Diyarbakr	13	NA	4.5	NA	NA	A and P, 1865, 53
1869	Aleppo	NA	NA	NA	NA	7	Ibid., 1870, 66
1869	Beirut	NA	NA	NA	NA	6–20	Ibid.
1873	Damascus	NA	NA	5.6–10.14	NA	12.6–16.8	US GR 84, T367.11
1876	Aleppo	13.5	13.5	6	NA	NA	A and P, 1877, 83
1877	Syria	20	20	8–10	NA	NA	FO 78/3070
1878	Syria	10	14	6–7	NA	NA	Ibid.
1878	Damascus	NA	NA	NA	NA	9–11	A and P, 1878/9, 72
1880	Beirut	(22)	24	(10)	NA	NA	Ibid., 1880, 73
1882	Beirut	NA	NA	4–6	NA	NA	Ibid., 1883, 73
1885	Jerusalem	NA	NA	NA	6.8	NA	Ibid., 1886, 60
1886	Beirut	(16–26)	(16–26)	(11–17)	NA	NA	Ibid., 1887, 86
1888	Lebanon	NA	NA	NA	7–8	NA	CC Beyrouth, 10
1888	Hama	NA	NA	NA	(4–5)	NA	Ibid.
1895	Damascus	NA	NA	NA	8	NA	Cuinet, *Syrie*, p. 338
1900	Damascus	15	NA	7	NA	NA	A and P, 1912/13, 100
1903	Palestine	NA	NA	NA	6.5	NA	Ibid., 1904, 101
1905	Jaffa	NA	NA	NA	6.5	NA	Ibid., 1905, 93
1905	Jaffa	NA	NA	NA	(6)	NA	Auhagen, *Beiträge*, p. 78
1905	Damascus	30	NA	7.5–11	NA	NA	A and P, 1906, 129
1906	Damascus	20–25	NA	12	NA	NA	Ibid., 1912/13, 10
1910	Aleppo	NA	NA	NA	NA	8–12	Weakley, "Report," p. 66
1910	'Aintab	NA	NA	NA	NA	4–8	Ibid.

(continued)

Men's Daily Wages in Syria, 1820–1915 *(Continued)*

Year	Place	Mason	Carpenter	Common laborer	Agricultural laborer	Handicraftsman	Source
					Wage (piasters, decimalized)		
1910	Lebanon	NA	NA	NA	6–7	NA	Ibid., p. 58
1912	Damascus	30–35	NA	15	NA	NA	A and P, 1912/13, 10
1914	Palestine Jews	NA	NA	NA	6.8–10.8	NA	Ruppin, "Syrien," p. 84
1914	Gaza	NA	NA	NA	NA	4–8	Ibid., p. 138
1914	Syria	11–43	NA	NA	NA	NA	Ibid., p. 160
1915	Homs	NA	NA	NA	NA	4.5–6.5	Ibid.

[a]"Formerly," that is, presumably before Egyptian conquest.

[b]Not available.

[c]Wage given as 12, including apprentice.

[d]Coal miners.

[e]Figures given in parentheses are estimates.

20

Gross Value of Production in Syria, 1913

VALUE OF ANNUAL PRODUCTION OF GOODS IN SYRIA

. . . In order to give a verified overview of the value of goods produced in the country (including remittances from abroad but omitting incomes derived from trade), we reproduce here, as a supplement to our investigation into the productive powers of Syria, the estimates made by Ruppin (pp. 20–23)[1] on the total value of the annual output of goods (in millions of francs).

I. *Agriculture.*
 (a) Annual food and fodder crops (cereals, pulses, root crops, vegetables, sesame) 450
 (b) Annual cash crops (tobacco, cotton, hemp, aniseed, fennel, cummin) 10
 (c) Tree crops
 (i) Olives 30
 (ii) Vines 30
 (iii) Sericulture 25
 (iv) Oranges, lemons 15
 (v) Other fruits (pistachios, almonds, apricots, figs. etc.) 10 110
 (d) Wild-growing plants (liquorice, galls, buckthorn berries) 5
 (e) Produce of animal husbandry (meat, milk, wool, etc.) 100
 (f) Poultry and agriculture 20

 Total 695, say 700

II. *Forestry.* Output consists almost solely of firewood, charcoal, and edible pinecones, and may be estimated at, at most: 5

From Wilhelm Rechlin, *Syriens Stellung in der Weltwirtschaft* (Greifswald, 1920), pp. 112–115.

[1]A. Ruppin, *Syrien.*—ED.

III. *Fisheries.* (estimated) 10
IV. *Mining and Quarrying.* (partly estimated) 2
V. *Factory Industry, or Handicrafts.* Producing for foreign markets: 30
VI. *Handicrafts.* 30
VII. *Communications.*
 (a) Transport (railways, sailing ships, transshipment in ports, transport by carts and pack
 animals) 45
 (b) Pilgrim and tourist traffic 10 55
VIII. *Remittances of Money from Abroad.*
 (a) Remittances to relatives or poor people
 (i) To Lebanon and neighboring areas 30
 (ii) To Palestine (mainly Jews) 10
 (b) Remittances for charitable Christian religious purposes 10 <u>50</u>

 Grand Total 882 million francs

This total may be at a rough estimation, broken down as follows:

Vilayet of Aleppo	222 million
Vilayet of Damascus	350 million
Vilayet of Beirut	210 million
Mutasarriflik of Lebanon	50 million
Mutasarriflik of Jerusalem	50 million

For three of the latter estimates, viz. for the *vilayets* of Damascus and Beirut and for the *Mutasarriflik* of Lebanon, I can give a counterestimate, based on the German Beirut Consular Report for 1911. This report gives the average annual production of these three districts, but mostly as overall figures, with the breakdown of individual products by *vilayet* and with regard to I. Agricultural Production, II. Animal Husbandry, and III. Raw materials for industry, in which the *Vilayet* of Beirut is particularly deficient [in figures]. Nevertheless, this calculation shows that Ruppin's figures may be regarded as too low rather than too high. The synopsis shows the following figures: [Table 20.1]

Table 20.1 Value in Thousands of Marks

	Damascus	*Beirut*	*Lebanon*
Wheat	44,100	31,140	1,800
Barley	26,070	6,600	300
Maize	30,730	2,100	35
Fodder, etc.	22,000 ?	2,000	1,000
Fruit	7,000	7,000	7,000
Horned cattle	170,000	4,000	6,000
Camels	3,000	500	500
Sheep and goats	34,000	4,000	2,0000
Horses	4,000	2,500	500
Hides and skins	800	200	200
Olive oil	1,000	3,000	3,000
Silk	3,000	6,800	17,000
Tobacco	200	400	400
Wool	4,000	1,000	2,000
Total	349,900,000 marks = 437.5 million francs	71,240,000 marks = 89 million francs	41,735,000 marks = 51 million francs

21

Mosul, 1750–1800

The author of the following selection, Domenico Lanza, was born in 1718, entered the priesthood in 1749 and, after studying in Rome, was sent to the Dominican Mission that had been established in Mosul in that year. He had two tours of duty there, in 1754–1761 and again in 1764–1770, serving in the interval in the mission in Kisrwan, in Mount Lebanon. The date of his death is unknown, but must have occurred after 1775.

Father Lanza left two manuscripts on Mosul. The longer one, Relazione istorica della nostra Missione di Mussol, *is not extant. The other is in the archives of the Dominican Order in Rome. During the 1848 revolution it was lost, but later retrieved from the shop of a butcher who intended to use it for wrapping meat. In 1895 a copy of the manuscript was given to the Dominican monastery in Mosul. The portions dealing with the history of Mosul were translated into Arabic and published by Father Rufail Bidawid under the title* Al Mosul fi al-jil al-thamin ʿashar hasab mudhakkirat Domenico Lanza *(Mosul, 1951); from it (pp. 9–15, 34–37) the following paragraphs are taken.*

The population figure given by Lanza seems highly exaggerated; if correct it would imply that Mosul had more inhabitants than Cairo and many more than Aleppo.[1] But the general impression he gives of sharp fluctuations, due on the one hand to plagues and famines and on the other to rebuilding, is probably accurate. Similarly, his account of the main economic activities presents a true picture of the situation at the end of the 18th century and the beginning of the 19th.

In the 1790s Olivier gave the following description[2]:

> Mosul is one of the great markets of the Orient. Most of the fabrics, drugs and Indian wares that come to Basra and Baghdad pass through it, going on to Constantinople or spreading out in the interior of Asia Minor. The same holds for the coffee of Mocha and Persian goods. It also serves as an entrepôt for gallnuts, gum tragacanth and the wax of Kurdistan, as also for cotton from neighboring regions. In Mosul very good morocco leather and much cotton cloth is made, for the use of the local population. Some of these are sent to Aleppo, along with gallnuts and gum tragacanth, for sale to French merchants who ship them to Marseilles. Mosul has given its name to the cotton cloth known as muslin, because it is from this town that the first specimens reached Europe. They were carried there from India, through Persia or the Persian Gulf.
>
> Aleppo sends on to Mosul the European goods the latter needs, and also *abas* made in Syria. Old copper is also brought there from Syria, Mesopotamia, Anatolia, Armenia and Kurdistan, being sent on to Baghdad and Basra and then shipped to India.

POPULATION OF THE CITY

Mosul is still very extensive, in spite of the vicissitudes and destruction that have befallen it; its population is so numerous that recently [1743] it was able all alone to fend off the

From Domenico Lanza, ''Compendiosa relazione istorica dei viaggi fatti dal P. Domenico Lanza dell'Ordine dei Predicatori da Roma in Oriente dall'anna 1753 fino al 1771.''

[1] For the 1790s, Olivier gave the following estimates: 7000–8000 Christians, 1000 Jews, 25,000 Arabs, 15,000–16,000 Kurds, and about as many Turks, or say 70,000 in all (*Voyage*, vol. 1, p. 268)—ED.

[2] Ibid., p. 273.—ED.

huge army of Tahmasp Quli Khan [Nadir Shah], the King of Persia, in virtue of its strength and large numbers, without requiring the help of an Ottoman army.

The older inhabitants have often told me that, in their time, almost half of the city consisted of uninhabited ruins and that the population was about a third less than now. The cost of living was very cheap, and clothing was rough and low in price and the only sellers of goods and textiles were a few Christians. Christians did not differ from Muslims in their customs and dress, and there were no distinguishing marks between Christians and Muslims. However, when, at the beginning of this century, war broke out between the Sublime Porte and Persia, the Ottoman armies started to come, successively, to Mosul. Many of the inhabitants of Mosul were driven off to the wars, mixed with Turks and foreigners, picked up their bad habits and manners, and acquired a taste for softness in their dress and luxury in their food and social intercourse. They then began to trade and practice the various crafts and in a few years the city expanded, its population grew and its wealth increased, and it soon became no less important in the eyes of the Turks than it was in those of the Persians. Finally, when Tahmasp Quli Khan invaded this country with a large army in order to capture Mosul, large numbers of Arabs, Kurds, Turks, and Christians fled to it from neighboring villages. After this celebrated siege the city remained congested with people. Most of the Turks joined the army, at the same time engaging in trade or practicing a craft; their numbers increased to an amazing extent and so did their wealth, and they became more arrogant and vainglorious than the Turks of other cities.

Contrary to accepted opinions, this city has a very large population and can be considered among the important cities of the Empire. After I had resided in it and circulated in its various quarters, on different occasions, and contemplated all its constituent parts, I realized the huge size of its population and asked Father Francis [Corradino Turriani] and several other persons what was, in their opinion, the number of inhabitants; our consensus was that it exceeded 300,000, but it was not possible to make an exact count.

I will not mention the reasons on which we based this estimate; suffice it to say that during the plague that broke out after my departure [his final departure, in 1771] the *wali* [governor] instructed the guardians of the city gates to count, as was their practice, the number of funerals that went out of the city walls. He found out that, by the time the plague was over, more than 100,000 persons had been buried outside the city. To this should be added the numerous persons who were buried in cemeteries inside the city, especially Christians who have their own graveyards adjoining the church near the Temple. This is what our friars in Mosul wrote to me, adding that the city was still sufficiently populous but that the inhabitants were in great distress.

Whatever their number may be, the inhabitants of Mosul lack culture and elegance, for most of them are Turks and Kurds who gradually settled in the city. Some became traders and *aghas* [gentlemen], while others till the soil or employ others to till it. Some are associated with highway robbers, spying for them, and others are employed in various occupations. Almost all belong to one of the *ortas* [regiments of Janissaries], taking refuge in them in times of distress and relying on them to preserve them from harm.

The city's Jews are poor and are believed not to exceed 400. As for the Christians, their number is said to be 6000 but I believe it is greater; they are engaged in trade, dyeing, and other occupations and their wealth is moderate. They belong to two sects, Jacobites and Nestorians. In this city Christians suffer less injustice than in other regions of the Ottoman Empire, but they are not immune from various humiliations. Catholics are more subject to attacks than others because of their having departed from the customs and

rites in which they were born, which renders them subject to being denounced to the Ottoman authorities by the other inhabitants. When I left, their number was about 1000 in the city and somewhat more in the surrounding villages.

ECONOMIC CONDITIONS

No one should be surprised at the abundance of grain in Mosul. Little of the land is used for agriculture, especially those parts lying near the desert, which cannot be cultivated by the inhabitants for fear of nomad raids; hence they confine their ploughing to the portions adjacent to the city. But the land lying along the river is entirely cultivated, as is that of the numerous villages on the opposite bank. These lands are very fertile—surpassing the imagination—and their produce is therefore sufficient to meet the needs of the *wilaya* [province], nay exceeds them and may be sufficient to meet the needs of neighboring *wilayas*. But from time to time they are attacked by swarms of locusts that descend on the crops and eat all the wheat if it is still green; if, however, it is ripe the damage is smaller.

Essential foodstuffs are usually cheaper in this *wilaya* than in others—especially bread, grapes, plums, cotton, and other such items—and their price is very low because of the large amounts that are brought to it from Kurdistan. Other fruits are rare, because they are brought in from distant places and in small quantities, except for *shamzi* and watermelons and other fruits that abound locally.

TRADE

In Mosul there are goods imported from Persia, India, and Europe, and from other regions of the Empire. But the particular trade of Mosul is, in addition to grain, cotton fabrics, of which it exports a large quantity each year to various parts. One can say that the whole city profits to a large extent from this kind of trade. For in the villages where water is abundant much cotton is planted. This, however, does not meet local needs, hence many people travel to the regions of Kurdistan to carry it back to Mosul and its villages. The women then spin it and the men weave it into various forms, others fulling and bleaching it, others dyeing and printing it with various designs, and still others transporting and selling it. Thus almost all work on cotton.

Trade in textiles is flourishing and the profits made by the city are very abundant. The money earned by the inhabitants in this trade is used to import, from various countries, the materials required for their work, and they sell them in the neighboring *wilayas* of Kurdistan and Iran, and return laden with the produce of these countries, purchased at low prices, then proceed to Aleppo and other places and sell them at high profits.

Gallnuts are abundant in the mountains of Kurdistan. Larger quantities are carried by the Mosulis to Aleppo for sale to Europeans and the purchase of woolens and other cloths, indigo, and other European goods with the proceeds. The value of the indigo imported each year from Aleppo to Mosul exceeds 1 million piasters [see also III,17]. I believe all of it is consumed in this city, for dyeing various fabrics.

It may be noted that, in addition to its own branches of trade, Mosul benefits from its central geographical location between various regions. Arabs come to it from the desert and Kurds from the mountains, to buy what they need. To travel from Mosul to Persia requires only the crossing of the mountains. To Baghdad there is an easy way by land and an easier one by river, and from Baghdad one can proceed to Basra and India, as do many merchants. The caravans that come to the Ottoman Empire from Persia and India pass

through Mosul; similarly the goods that are carried from the northern highlands to the southern lowlands go through it.

For all these reasons, the wealth of Mosul is considerable. It would have been greater if its government had been more orderly and had it not been the victim of the tyranny of governors whose only concern is to find out who are the men of wealth and where their wealth lies, in order to seize part or the whole of it. . . .

THE YEAR 1757: THE FREEZING OF THE RIVER TIGRIS

These disturbances eventually subsided, after a few persons had been killed. Winter came and the cold was so severe that the river Tigris froze over completely in those parts and caravans passed over it without fear for 20 days. I believe there is no record of such cold in the history of this country, whose climate is warm and where water very seldom freezes. Because of this terrible cold many animals, both wild and domestic—which constitute an important source of the wealth of this country—died. There followed a rise in the price of foodstuffs in Diyarbakr and Mardin and the surrounding regions which was greater than that in Mosul. For Mosul did have food, although its price was high; hence people flocked to it in large groups, in quest of food, and the city was filled with poor people—its own and those of surrounding villages and those of distant regions. The state of poverty and suffering in which they found themselves, which forced them to sell all their belongings at the lowest prices, stirred one's pity and compassion.

What was heartbreaking is that their wretchedness drove fathers to sell their children and husbands their wives in order to prolong their own lives for a short while, only to lose it soon after, dying in the pangs of hunger aggravated by the severity of the winter. Their corpses remained exposed on the streets, unburied, until some charitable person would dispose of them, usually throwing them into the Tigris. Many Turks, moved by these pitiful sights, distributed a large amount of bread and other food among the poor, who would crowd at the gates. During the whole of that winter everyone helped those in need.

When, at the end of February, the winter was over and grass began to grow again, the Pasha ordered the poor who had come from outside the city to leave it, in order to alleviate its misery. Those wretched people went off without provisions, some in the direction of Baghdad and others in that of Qara Cholan [in Sulaymania]. They began to eat grasses, like beasts, and—the strength of many having been sapped by what they had endured in winter—they started dying of hunger, with the grass in their mouths, and the wilderness was covered with innumerable corpses.

LOCUSTS AND THE GREAT FAMINE

The situation having somewhat improved because of the departure of foreigners, and part of the original inhabitants too, people ate what they could find and awaited the harvest. At that point they were struck by an invasion of a huge number of locusts, who ate up all the crops in a few days. Thereupon a large number of the inhabitants left the city and the adjoining villages, some taking refuge in Baghdad and others in the adjacent provinces or Persia or further afield. Once more one could see the fields covered with the corpses of the fugitives. As for those who stayed in the city, every day large numbers died, corpses lying in the streets to be eaten by dogs or dragged away and thrown in the river. In addition to this, malignant fevers spread throughout the year 1757, filling the houses with the sick and the graves with the dead.

Those whose means allowed them to did not hesitate to spend money to obtain what was necessary for maintaining their relatives, going to Qara Cholan and Persia and elsewhere—or sending people there—to fetch grain. But what is certain is that in the fall and winter of that year no one sold grain openly. This was because of the greed of the rich, who hid and cornered grain in order to sell it at the right moment, and the injustice of those who got hold of grain by force. It was only seldom that people sold it in their houses, even at exorbitant prices.

As a result, robberies were numerous and of daily occurrence; the robbers did not leave one house or shop unplundered. They even attacked our [the Dominican] house and stole a few vessels from the kitchen. But the truly heartrending, amazing, and pitiful thing was to see fathers selling their sons and daughters to any one who came and husbands selling their wives and other dear ones—and not only Muslims but Christians too. . . .

22

Iraq in 1800

The following passages from dispatches from and to Harford Jones (later Sir Harford Jones Brydges, British envoy to Iran and author of several books), Resident of the East India Company in Baghdad, gives a picture of the unsettled condition of Iraq, the difficulty and slowness of transport, and the general ignorance concerning the country. They are based on three journeys from Basra to Hillah by way of the Euphrates. The first discusses the possibility of sending an army to Syria, through Iraq, to fight the French.

. . . The Western bank of the Euphrates, from Coorna where the two rivers unite to Samawat, is cultivated and abounds with villages, except in some particular parts of it; the Eastern bank, or rather boundary of the stream, is generally speaking the edge of a marsh extending between the two rivers. Above Samawat commence the shallows which end near Lemlum and from thence to Hillah there is a partial cultivation on each side of the river. From Hillah to Beer (please observe, my Lord, I speak only by hearsay) the country is nearly desert and the river in many places from large rocks laying in the bed of it forms a sort of fall. Between Bussora and Samawat where the Western bank of the Euphrates is cultivated the country is intersected by very large creeks made for the purpose of affording irrigation to the cultivated country, which would frequently oblige an army to make considerable detours into the desert and to lose sight for a day or two of the transport boats proceeding up the stream. Within the same sphere the Western bank is for a very long distance, probably fourscore miles, a factitious one, and here the rice swamps extend from the river to a very considerable distance. The shallows, the whole of which I conceive are a distance of thirty or forty miles across, owe their origin to the drains made by the Chesaal [Khaz'al?] Arabs from the river for the purposes alike of the cultivation of rice and of defence and security against the troops of the Pashaw. The passage through them

From Jones to Elgin, 28 November 1800; Jones to Resident Basra, 25 October 1800; IOPS Bombay 381/17; Tooke to Jones, 27 March 1801, IOPS Bombay 381/23; Manesty to Government Bombay, 4 March 1802, IOPS Bombay 8 381/31.

often presents a frightful marsh overgrown with reeds and sometimes little streams of a few feet wide, and not deeper than mid-leg. They are only passable in a sort of canoe called mushoof and the falls between Hillah and Beer have been represented to me as serious obstacles in navigating against the stream. . . .

Provisions. That the country from Baghdad to Bussora does not supply wheat and barley enough for its own consumption is a fact evident from the immense importation at both these places of grain from Curdistan etc. but it produces rice and dates in a far greater quantity than is consumed. Livestock, though dear from other causes, is abundant enough but the mass of it is in the hands of the Arabs who move from place to place [Therefore, an army would have to bring with it its own supplies]. . . .

It does not admit of a doubt that provided the Public Packets reach Baghdad from Bussora in five or six days, that they will always reach Constantinople before those dispatched by way of Aleppo. For instance the Tartar I last dispatched arrived at Constantinople on the thirteenth day after his departure; had his packet therefore been delivered to me in five or six days, Mr. Tooke would have received it in eighteen or nineteen days after its dispatch by you.

The avoiding to submit both Packets, original and duplicate, to the risk of the desert is certainly worthy of the stress you lay on it, but from Bussora to Samawat is generally considered as being under the government of the Shaik of the Monteficks, with whom I know your influence to be so great that I conceive little danger is to be apprehended to the public dispatches between Bussora and that place—the only serious risque therefore, in my humble opinion, that the Arab Messengers will be exposed to is between Samawat and Meshed Aly and Hillah, and this considering how frequently the Government Chocodars (Courriers) have been plundered and robbed in passing through the Chesaal Country is not on average greater than that to which the Express Chocodars are exposed to, who pass from Samawat to Hillah. . . .

I have procured [a Tartar] from the Ogiack named Abdul Hamed, an old man on whom I have little hope of dispatch but he is in a manner forced upon me. I have paid him his full hire to go and return, and he is promised one hundred piastres for every day he diminishes of twenty-five in performing the journey [from Constantinople] to Bagdad and the sum of five hundred piastres each for the 16th and 15th day whereby in reaching Bagdad in fourteen days he will be entitled in all to 1900 piastres and if he reaches in fifteen days complete he would be entitled to 1400 in all. He shall depart tomorrow morning as it is now too late to cross to Scutary and set off. . . .

. . . report . . . the total loss of the ship Active to the eastward of the Bar of Bussorah River . . . may prove a danger to other ships. . . .

The loss of the Active revives in my mind an idea which I once entertained of erecting a pillar near the mouth of the river, the which could it be seen from the mast head of vessels from without the Bar might by its bearings direct them without danger or difficulty into the proper channel. The expense of building such a pillar would not prove a heavy one whilst its utility would be generally experienced. . . .

23

Plagues in Iraq, 1689–1877

. . . In 1689 the plague spread in Baghdad and afflicted its inhabitants for some five months. Its severity and the large number of its victims caused Baghdadis to nickname it *"Abu tabar"* (He of the hatchet). Some sources estimate its victims at 100,000, in the course of three or four months. It is believed that the infection spread to Baghdad from Mandali, following a great famine caused by lack of rain that began in Mosul and its adjacent parts and spread from there to central and southern Iraq. The influx of people into Baghdad because of the famine brought the plague to it.

The plague returned to Baghdad the following year, 1690, and was even more virulent and deadly. It lasted over three months and its victims were put at 1000 a day; many people died because of it. The infection then spread south, reaching Basra and killing its inhabitants by the thousands. It is said that the number of victims in Basra exceeded that in Baghdad, so much so that the people could not bury their dead. . . .

At the end of 1737, the plague broke out in Mosul and remained until the following year. It was deadly in its effect, killing 1000 persons or more each day. Two years later this plague spread to Baghdad, killing many of its inhabitants.

In 1772, the plague reached Baghdad from Istanbul and hovered over it for about six months. The Mamluk *wali*, Umar pasha, fled the city and camped near A'zamiya for over two months. 'Abd al-Latif Abi Talib al-Shushtari relates in his *Travels* that 70,000 perished in the first stages of this plague, those who died later being uncounted. It is known that several Iraqi and foreign (including Iranian) families were wiped out by this epidemic. Conditions deteriorated greatly because of the plague: security broke down, trade ceased, and eventually circulation almost stopped. Nevertheless, the infection spread to Basra and Bushire and to villages and the desert too. Among those who perished was a large number of competent officials, on whom everyone relied for the conduct of the affairs of the province. Hence, in many departments transactions stopped for a long time and the government's business suffered.

The Italian traveler Sestini,[1] who visited Baghdad in 1781, states that the outbreak of this plague reduced the population to not more than 25,000, carrying off two-thirds of the inhabitants. Many quarters were still deserted at the time of his visit. Among the victims was the Bishop of Babylon, who was buried in the church. In the winter of 1785, there was a drought which led to a great shortage because the previous year too the rains had failed. Prices in Baghdad rose horrendously, a *wazna* of wheat costing 8 piasters and one of barley 6. The *wali*, Sulayman pasha al-Kabir, was forced to distribute the stocks of foodstuffs among the inhabitants at low prices, but this does not seem to have had much effect and people remained agitated. They rose up and attacked the palace and had to be repelled by force of arms, the ringleaders being punished. At the end of that year the plague spread, adding to the misery. It lasted several months and disappeared only after it had taken many innocent lives.

In the last year of the 18th century a frightful plague broke out in Diyarbakr,

From Ja'far al-Khayyat, *Suwar min tarikh al-Iraq fi al-'usur al muzlimah*, Beirut, 1971, pp. 197–205.
[1]Sestini, *Voyage de Constantinople à Bassora en 1781*, Paris, l'an VI.

99

carrying off 20,000 persons according to contemporary estimates and leaving, it is said, 1000 houses with no survivors in them. From there it moved to Sulaymaniya and the surrounding region, at the time of Ibrahim pasha Baban, the son of Ahmad pasha, killing 18,000 people. Three persons were buried in each grave, and many remained unburied and were eaten by dogs, which consequently became more ferocious and started attacking people, killing 40 persons. The pasha was forced to mount a special expedition to destroy the dogs.

In 1800 the plague broke out in Mosul, spreading to most of its quarters; some 150 of its victims died each day. Prices of foodstuffs consequently rose, because of the interruption of caravans coming to the city from Baghdad and the Kurdish regions. Dates sold for $4\frac{1}{2}$ dirhams per *ratl* and raisins and figs for 3 dirhams. . . .

In the first year of the 19th century the plague broke out in Baghdad too, eliminating many signs of life in it.

Two years had not passed before the plague struck Baghdad again, in 1803. It lasted over three months and caused much destruction in the city and its surroundings, killing thousands of people. . . .

But the greatest and deadliest of plagues was the one of 1831 [see II,24]. . . .

The bad luck that had afflicted unhappy Baghdad in this period showed itself in another outbreak of plague in 1833. This was a slight epidemic whose victims numbered only 5000. It recurred in 1834, claiming 7000 victims. This time the plague came from Kermanshah in Iran; the person responsible for it was the *wali* of Baghdad, Rida pasha, who chose not to stop travellers coming from Kermanshah because of his desire to get the dues paid by visitors—and this in spite of the warnings of the British Resident, who had pointed out to him the grave consequences. The small number of victims in those two outbreaks was due to several causes. One was that the population of Baghdad and the other towns had fallen to a very low level. Another was that this time the inhabitants were allowed to leave the city and flee to the countryside at the outbreak of the epidemic, unlike 1831 when they were prevented from doing so. Whole districts and communities fled, carrying their belongings with them as soon as the symptoms of the disease appeared. All the Jews left their congested quarters and Divine Providence protected them, so that they suffered no harm.

The last three plagues, with their deadly consequences and frightening reports, are probably the ones whose story Baghdadis still relate and refer to on occasion, calling them "the plagues of Baghdad."

This, however, does not mean that Baghdad and its surroundings were henceforth immune from plagues. Severe plagues broke out in Iraq from time to time until the 20th century, but they were not of such frightening intensity. Our sources[2] mention that in 1847 the plague broke out in Basra, following a cholera epidemic the previous year, and claimed among its victims M. Raymond, the French vice-consul. It then spread north, along the Tigris, reaching Baghdad and claiming the French consul among its victims. This same consul states that this time the advance of the plague was particularly marked on the west bank of the Tigris and that it spread in the swamps, reaching Hillah where it claimed 8 to 10 victims a day. In one suburb of Basra, with a population of not over 4000, 12–15 persons were stricken each day.

[2]See the book by the French Ambassador, Pierre De Vaucelles, *La vie en Irak il y a un siècle*.

The plague also appeared in Baghdad at the end of March, coming from Hillah.[3] It first appeared in the Bab al-Shaikh quarter, the one where it had first begun in 1831, at the time of the aforementioned Great Plague. Dr. Colvill, the physician of the British Residency in Baghdad, who was a member of the International Sanitary Commission, requested the *wali* of Baghdad to close all schools for a month. By April all the districts between Baghdad and the Arabian Gulf, except for ʿAmarah and Basra, were stricken with the plague. By the end of April the number of victims in the district of Baghdad alone was 2500. It should be mentioned that a violent dispute broke out between Dr. Colvill and the *wali*, ʿAbd al-Rahman pasha, who was not convinced of the need for preventive measures to stop the spread of the disease, which forced Colvill to present his resignation to the Ministry of Health in Istanbul. However, the *wali* stopped the telegram, changed his conduct, and completely cooperated with Colvill. . . .

Colvill was opposed to the confining of people in one place, proposing that they be allowed to disperse and flee from infected areas. He experimented with this approach the following year when the plague reappeared in Baghdad. He started with the Jews, asking the Grand Rabbi to request them to disperse and go to the suburbs or camp in the open. His suggestion was followed and in the course of two weeks some 15,000 out of the 18,000 Jews in Baghdad had left. Many Muslims and Christians did likewise, and within a month two-thirds of the population of the city had departed. When, in the summer of 1877, an accurate count was made, after the danger of the plague was over, it was found that the number of its victims was 4394, of a total population of 70,000. Of the Jews who had left, only 20 died, whereas over half those who had remained in their homes perished. . . .

[3]See a detailed article by Joseph Malone, ''Surgeon Colvill's Fight Against Plague and Cholera in Iraq, 1868–1878,'' American University of Beirut, *Festival Book* (Beirut, 1967), pp. 163–183.

24

Plagues and Floods in Baghdad, 1822 and 1831

THE FLOODS OF 1237 AND 1247

During the governorship of Daud pasha (1232–1247 A.H., 1816–1831 A.D.), which represents the end of Mamluk rule in Baghdad, two great floods occurred, the first in 1237 (1822 A.D.) and the second in 1247 (1831 A.D.). It so happened that the plague broke out during the two floods, increasing their danger. The late Father Anastas al-Karmaly quotes

From Ahmad Susa, *Fayadanat Baghdad fi al-tarikh*, vol. 2, Baghdad, 1965, pp. 367–374.

from The History of the Carmelite Mission in Baghdad and from the records kept in their monastery, the following description of the first of these floods.

In 1237 A.H. (1822 A.D.) misfortunes and tribulations piled upon Baghdad. First, the enemy advanced to take the city from Daud pasha and fighting broke out, engaging all the inhabitants of Baghdad. Secondly, the plague spread, leaving no time for those who were burying the dead to perform the duties due to their loved ones; many were struck down while carrying out such ceremonies, died instantly and were buried where they fell—even inside the city or in their own houses or cellars. To make matters worse, the Tigris rose exceptionally high, damaging the summer and winter crops and water settled in the orchards for many days, turning brackish and killing trees and palms and other vegetation that does not tolerate excessive moisture. The flood then burst out on every side, pouring into the city whose inhabitants were [by then] insufficient in number to take the necessary measures for preventing the waters from rushing on and breaking the dykes; buildings fell on those who had escaped the plague, ruin engulfed all households in Iraq and the few survivors were reduced to the direst poverty.

The truth is that this catastrophe was one of the greatest in the history of Baghdad since its founding; for it consisted of three disasters, each worse than the other and each devastating to the inhabitants, and they came in succession, each destroying what the other had spared; hence, that year has left a memory which has not been forgotten and which is, indeed, indelible.[1]

As for the second event, the flood of 1247 (1831), he quotes from the records of the monastery what follows:

1822 was not unique in the history of Baghdad, for very similar events occurred in 1831. On the 20th of March a virulent plague broke out and by April the number of those dying of it approached 2000 a day and on some days was greater, falling lower on some others. What is however certain is that the number of deaths caused by this sinister disaster was over 200,000 in less than two months.

And in the spring of that year the twin rivers rose unusually high (the simultaneous overflow of both Tigris and Euphrates occurs very seldom). After the waters had covered the plains surrounding Baghdad and risen a few yards, the dykes broke and the water entered the city, and destroyed an incalculable number of houses which fell on their owners and occupiers, turning into graves instead of dwellings. As though these two disasters, the plague and the flood, were insufficient, robbers and looters spread in the city, breaking into houses and stealing what they found in the way of jewels, ornaments or other valuable household goods. When they discovered such jewels on unburied corpses they broke the limbs on which they were displayed and coolly walked off with them. . . . Then came the war, after the flood, and dislodged all living and inanimate beings and thus ruin fell on Baghdad and its neighboring villages and districts. Some old men still remember the horrors of that year, with details that make the hearer shudder.[2]

[1]Op. cit. [Al-fawz al-murad fi tarikh, Baghdad, Baghdad, 1329 (1911)], p. 6.
[2]Ibid.

Another description of the flood runs as follows:

In April the plague reached Baghdad, and by the 10th of that month 7000 persons had died of it. What made matters worse was the scarcity of food and the refusal of the water-carriers to deliver water to the inhabitants, causing general misery. In addition, the flood struck Baghdad on April 21st, surrounding the city, drowning thousands of persons, and making it impossible to transport food to the people. Five days later the city's northern dyke and part of the fortress broke and the waters rushed in and submerged 2000 houses in one hour; within 24 hours the palace and 7000 houses had been reduced to ruins and Daud pasha's thoroughbred horses were seen to be wandering in the city. After two days the waters began subsiding and by the end of the first week in May the threat of the plague and flood had disappeared and the survivors began to bury the dead . . . and Daud pasha recovered from his attack of plague.[3]

The British missionary Antony Groves has left us the most accurate account of the plague and flood of 1830–1831. He was residing in Baghdad at the time and continued to pursue his work, noting in his diary the events of that fateful period in the history of the city. According to this diary the first cases of plague appeared by October 1830, but were concealed. The epidemic reached its peak at the end of March 1831, and 7000 persons perished in 15 days in the eastern part of the city, where the *wali*'s palace and the houses of the notables were located. By the 24th of April, 30,000 persons had perished, and the daily average of deaths continued to range between 1000 and 1800; on the 26th of April, 5000 persons died.

At the same time the flood of the Tigris began; the waters rose and broke the dykes in the upper parts of the city, submerged the lower parts and reached the city walls, which crumbled in many places. The waters rushed into the city, submerging the whole Jewish quarter and demolishing part of the fortress wall. The peak of the flood was reached on April 28, 1831, destroying over 7000 houses and carrying away the sick and the dead; that day 1500 persons perished. As for those who endeavored to flee from the city, they ran into the waters that had covered the surrounding areas and were forced to seek refuge in the higher spots where they remained stranded, unable either to return to the city or to move away, and thus died of hunger and cold. The other refugees were mercilessly plundered by robbers.

The *wali*, Daud pasha, having lost the last of his European-style soldiers, tried to flee to Kut in the boat of the British consulate, but the captain and crew of the boat ran away, some meeting their death. Of the pasha's special hundred Georgian guards, only four remained: The pasha left his house open and the doors of the granaries unlocked, and the people took what they could carry in the way of foodstuffs. The waters submerged the pasha's stables and his thoroughbred horses broke their tethers and roamed in the streets of the city. But Daud pasha escaped the plague, as did the missionary Groves. No one remained of the family of Daud pasha to prepare his food, but an old woman neighbor took pity on him and cooked for him. At that time Ali Rida pasha [who had been sent by the Sultan to retake Baghdad] camped around the city, and Daud pasha was compelled to surrender it to him without a fight.

At the end of the first week in May the danger of famine and flood disappeared. The

[3]Ibid., p. 102.

survivors started burying the dead, some being thrown into the rivers for lack of graves. The *muazzins* came back to their minarets, food reappeared in the markets, the scattered livestock was rounded up, and things returned to normal.[4]

BAGHDAD'S POPULATION BEFORE AND AFTER THE 1831 FLOOD

Foreign travelers give divergent estimates of the population of Baghdad before and after the flood and plague. In his diary covering the plague and flood, Groves states that over half the inhabitants perished in less than two months; he then returns to the subject and says, after more careful observation and verification, that two-thirds of the inhabitants had died. Since he had estimated the population before the plague and flood at 80,000, the survivors would have numbered about 27,000.[5] Wellsted, who visited Iraq in 1830–1831, stated that Baghdad's population had fallen to 20,000.[6] The British traveler Fraser, who visited Baghdad shortly after the plague and flood, reported that its population had fallen from 150,000 to 80,000 souls.[7] Among the travelers who visited Iraq after the plague and flood was Southgate, who was there in 1837 and put the population at 40,000.[8] Eloy, who visited Baghdad in May 1835, put the city's inhabitants at 50,000 before the disasters and 20,000 after.[9] Chesney, the head of the British mission that surveyed Iraq's rivers in 1835–1837, estimated the population at 110,000 before the disasters and 65,000 after.[10] The German tourist, Mrs. Pfeiffer, who visited Iraq in 1848, stated that the population of Baghdad ranged from 50,000 to 60,000.[11] A few years later, the British traveler Grattan Geary visited the city and stated that in ordinary times its population was estimated at 80,000.[12] In 1890 Mrs. Bishop visited Iraq and put Baghdad's population at 120,000.[13] Richard Coke stated that Buckingham, who had visited Baghdad 14 years before the flood, put its population at 80,000, a figure that rose to 150,000 under Daud pasha; he believes that it fell to 50,000, i.e., that 100,000 persons perished during the plague and flood.[14]

[4]Antony N. Groves, *Missionary Journal of a Residence at Baghdad 1830 and 1831* (London, 1832). . . .

 J. R. Wellsted, *Travels to the City of the Caliphs* (London, 1840).

 J. Baillie Fraser, *Travels in Kurdistan, Mesopotamia, etc.,* in 2 vols. (London, 1840) (see vol. 1, pp. 233–254).

 Aucher Eloy, *Relations de Voyages en Orient de 1830 à 1838.* Iere partie (Paris, 1843). Notes sur Daoud Pasha, pp. 218–220, 325–330.

 Travels of Dr. and Madame Helfer in Syria Mesopotamia, Burmah and other Lands, in 2 vols. (London, 1818) [*sic,* 1878], vol. 1, pp. 268–270.

 Joseph T. Parfit, *Marvellous Mesopotamia, the World's Wonderland* (London, 1920), p. 230.

 Richard Coke, *Baghdad, the City of Peace* (London, 1927), p. 259.

[5]William Heude, who visited Baghdad in 1817 (i.e., at the beginning of Daud pasha's governorship), put the city's inhabitants at 200,000 [*A Voyage up the Persian Gulf,* London, 1819].

[6]See note 4, above.

[7]See note 4, above.

[8]H. Southgate, narrative of a *Tour through Armenia, Kurdistan, Persia,* etc. (London, 1840), vol. 2, p. 178.

[9]See note 4, above.

[10]Op. cit. [*The expedition for the survey of the rivers Euphrates and Tigris,* London, 1850].

[11]*Voyages d'une Femme autour de Monde,* par Mme. Ida Pfeiffer. Traduit de l'Allemand par W. de Suchaw, 2eme Ed. (Paris, 1859).

[12]*Through Asiatic Turkey,* by Grattan Geary (London, 1878), vol. 1, p. 130.

[13]*Journeys in Persia and Kurdistan,* by Mrs. Bishop (London, 1891), Letter II, Jan. 9, 1890, p. 28.

[14]See note 4, above.

25

Flood of Tigris at Baghdad, 1840–1907

Year	Duration of flood in days	Governor	Observations
1840		Lazali Rida Pasha	Tigris and Euphrates; bursting of dykes and causing losses
1845	40	Najib pasha	
1849	50	Churbanli 'Abd al-Karim pasha	
1853	30	Rashid pasha	
1857	40	Sirdar 'Umar pasha	
1862	30	Namiq pasha	
1865	60	Namiq pasha	
1874	30	Radif pasha	A great flood
1876	20	'Abd al-Rahman pasha	
1877	60	'Akif pasha	A great flood
1880	60	Taqi al-din pasha	
1884	30	Taqi al-din pasha	
1885	40	'Asim pasha	
1888	40	Sirri pasha	
1891	120	Hasan pasha	A great flood, with large losses
1894	120	Hasan pasha	A great flood, with large losses
1898	60	Namiq pasha	
1901	30	Faidi pasha	
1905	60	Hazim bey	
1907	[125]		Tigris and Euphrates, a great flood

From Ahmad Susa, *Fayadanat Baghdad fi al-tarikh,* vol. 2 (Baghdad, 1965), pp. 384–419, based on Ottoman *salnamehs* and other sources.

26

Piracy on the Euphrates, Disturbances at Basra, 1820

. . . the fact is that a river piracy exists in the Euphrates on an extended scale; they have committed depredations on the boats of the merchant vessels, who while taking a cargo of dates at different points on the river, at various distances from Bussora, are still obliged by their means to keep up a daily communication with their commissioners and agents who remain in towns.

From Taylor to Rich, 20 November and 21 November 1820, IOPS Bombay, 385/1.

Complaints have been made to me on this head by Masters of the merchant ships and the HCC [Honourable Company's Cruiser] Psyche once succeeded in taking a pirate boat but the crew deserted her and swam naked to the shore, the boat was detained and when the owners came forward to claim her, their property was delivered to them at the particular intercession of the *Musallim* [Governor] and on a promise of their future good behaviour.

Similar acts have nevertheless since been repeated by others and among these the event herein described.

I have used every endeavour to discover the perpetrators and to recover the plunder, but hitherto without effect, which has at length induced me to address the Moontifik Shaikh whose control extends over almost every tribe on both banks of the river except the Chaab Arabs. . . . There is little doubt that the Moontifik Shaikh encourages these piracies, by neglecting to punish them and by directly participating in their gains. If therefore he continues to tolerate them nothing will secure our shipping in the river from further attacks but the severe public example of burning every boat of this description, which three or four cruisers would effect with ease. . . .

After the first attack of the Najadeh on Bussora they made a semblance of offering a pecuniary expiation of 4000 [*sic*] *lacs* [400 million] of piastres to the Pacha of Bagdad which their agent at HC's [Honourable Company's] Court had the address to reduce to half this amount, but on his being despatched to Zobeir to collect the fine they wholly disavowed him and sent him in disgrace into Bussora.

On the arrival of this news at Bagdad, instead of punishing the insolence of the Najadeh and complying with the just call for military by the *Musalim,* a Turk of some rank named Ghalib Agha was despatched with powers to renew the treaty for a pecuniary fine, and even to diminish its amount. If the sum formerly offered could not be procured, Ghalib Agha could procure a payment of only 12,000 piastres.

On the knowledge of this second disaster the Pacha was induced to send a force of four hundred Turkish and Kurdish horse which within this week, aided [by] three or four thousand Arab auxiliaries the *Musallim* has collected from the tribes around Bassora, have sustained a signal defeat from the Najadeh, who had come before the town in defiance and who themselves lost in the action one or two of their principal men.

The enemy fortunately retired from before the walls, and the *Musallim* is still increasing his force by the addition of Turkish and Arab troops in order to strengthen himself sufficiently to besiege Zobeir the Najadeh town, and put an end to their hostility.

The troops which are now in Bassora are under no control; they plunder the inhabitants, which has destroyed all public confidence; this connected with the shallowness of the Tigris and the want of safety on its banks has put an end to trade altogether and kept the town in an indescribable confusion and alarm. . . .

27

Iraq under Dawud Pasha, 1817–1831

. . . Among his most important projects in this connection was the digging of the al-Nil canal, which had been originally dug by al-Hajjaj ibn Yusuf al-Thaqafi in 82 A.H. (709 A.D.) and which starts from the Euphrates, near al-Hilla. Dawud pasha mobilized 5000 men and completed it in 1242 (1826). He was also interested in irrigation machines that facilitated the farmer's labor, and when an Iranian proposed to him a water-lifting device he gave the necessary orders for implementation, and when that was successfully achieved the vizier recompensed the originator of the project and called the machine *charkh Yusuf* (Yusuf's wheel) in honor of Dawud's son, Yusuf.

His plans for the economic renaissance of Iraq were comprehensive, and not confined to providing irrigation water and extending the cultivated area. He tried to raise the level of industry, which had fallen very low. Naturally, his projects aimed at utilizing Iraq's agricultural raw materials by founding cotton and woolen textile factories.[1] Woolen textiles were sold, competitively, in Iraq by Britain and France.[2] It is true that these industries were largely designed to meet the needs of his army and its new units. This was what was needed by the province in those circumstances, viz., swiftly meeting the needs of the military forces created by the reforming pasha without consideration—at first—of the implementation of an industrial program designed for the people. Hence we see Dawud bringing technicians from Europe, and the necessary instruments for building a rifle factory.[3] This drive to industrialize was due only to the fact that Dawud felt his power shaking beneath him because of his fear of the Sultan's intentions, of the numerous revolts occurring in the country, and of the fact that he had stood almost alone in the war against Iran.

Iraq was rich in minerals and raw materials required by many industries, but ignorance prevented their exploitation. Thus Chesney mentions the discovery of valuable minerals and industrial materials that were not being used, such as bitumen and petroleum, which was coveted at that time by both Britain and France,[4] and sulfur,[5] as well as copper and lead; these minerals were already then attracting the interest of Europeans.

One would have expected Iraq's trade to be small, given the weakness of its agriculture; however, Iraq was a pathway between East and West and an important point for the distribution and consumption of European and Indian goods, which caused it to continue in a fairly flourishing economic condition. The credit for raising Baghdad from a small trading center to a great eastern emporium goes to Sulayman Abi Layla (1749–1761) and Sulayman al-Kabir (1780–1802).[6] Hence, in the first quarter of the 19th century trade made great progress. Each year, six vessels carrying the British flag entered

From 'Abd al-'Aziz S. Nawwar, *Dawud basha, wali Baghdad*, Cairo, 1967, pp. 286–296.

[1]Sulayman Faiq, *Baghdad Kuleh*, p. 38.

[2]Olivier, *Voyage*, vol. 4, pp. 436–437.

[3]Faiq, loc. cit.

[4]Chesney, *Expedition*, vol. 1, p. 108; Olivier, loc. cit.

[5]Al-Munshi al-Baghdadi, *Rihlat*, pp. 55; Rich, *Narrative*, p. 55.

[6]Groves, *Journal*, pp. 244–245.

Basra, instead of two, in addition to Arab ships; this was due to the facilities offered to the British and Omanis. Indeed, in 1815 Basra received 15 vessels from Bengal and Bombay, with an average tonnage of 300–400. These ships carried Bengal muslin, spices, drugs, rice, American sugar, silk, shawls, chinaware, lace, lead, instruments for cutting, tin, perfumes, incense, and indigo.[7] Indigo used to come in abundance to the Ottoman Empire from San Domingo, but from the end of the 18th century that trade decreased and it was replaced by indigo from Lahore, in India [see III,16]; this indigo was re-exported from Baghdad to Iran, Kandahar, and Turkey. Basra also received 30,000 *okes* of cotton yarn each year and shipped them on to Baghdad, Mosul, Damascus, and Aleppo. It also received ships from Muscat and East Africa, laden with slaves, coffee, and amber, and ships from Bahrain carrying pearls and gum.

Caravans continually came to Baghdad from Tibet, Kandahar, and Iran, carrying fruit and tobacco, which were re-exported to Damascus, Aleppo, and Istanbul, as well as shawls. For although tobacco was grown in large quantities in the neighborhood of Baghdad, its quality was inferior to that of Iran, but a small amount was exported to Istanbul. The same caravans also brought shawls.

Other caravans came from Senneh, Zuhab, Sulaymaniya, Kirkuk, Diyarbakr, Aleppo, Urfa, and Mardin; all of these met in the markets of Baghdad and exchanged goods. Those from Aleppo were particularly important, since they included goods from Europe; among the main ones were confectionary and textiles.

Iraqi goods played their part in trade activity. In the second decade of the 19th century the value of such goods was about 350,000 piasters; Iraq's potential would have made it possible to increase this amount fourfold, if only the government had paid attention to the ways of developing production and the tribes had settled and become more productive.

Transport costs to Bengal equaled 4 percent of the value of goods, to Bombay 3 percent, to Musqat 2 percent, and to Bushire 1 percent. Horses, bred around Baghdad and in Najd, were one of the leading Iraqi export items to India. The Sublime Porte realized the importance of horses for military purposes and issued a *firman* prohibiting their export from Ottoman ports, but this trade brought such profits to the *mutasallim* [governor] of Basra, and consequently to the pasha of Baghdad, that it continued to flourish. Dates from Basra formed a very large part of Iraq's exports; they went to Kermanshah, Hamadan, Musqat, and India. Each year 250 medium-sized boats (60 tons) entered Basra, to carry dates and 1500 horses to India.[8]

There was another commercial activity that came to Iran, connected with the principal Shiʿi shrines, in Najaf and Karbala, which were visited each year by an estimated 12,000–15,000 pilgrims.[9] Sunni pilgrims from India also came to visit the shrine of al-Imam al-Aʿzam [Abu Hanifa, in Baghdad].[10] This influx contributed to increasing commercial activity in Iraq and increased the amount of currency in the country, whereas the Indian trade, in particular, was in Britain's favor and caused an outflow of currency through British merchants.

[7]Buckingham, *Travels in Mesopotamia*, vol. 2, pp. 201–205; idem, *Travels in Assyria*, vol. 2, p. 169.

[8]Ibid. *Travels in Assyria*, vol. 2, pp. 170–173, 180; idem, *Travels in Mesopotamia*, vol. 2, pp. 201–203; Ainsworth, *Personal Narrative*, vol. 2, p. 110; Olivier, op, cit., vol. 4, pp. 440–448; Fontanier, *Voyage*, vol. 1, pp. 142–143; Dupré, *Voyage*, p. 180.

[9]Fontanier, op. cit., vol. 1, p. 323.

[10]Gibb and Bowen, *Islamic Society*, vol. 1, pt. 1, p. 305.

At any rate, the Indian trade was the most extensive and the duties it paid had been agreed upon between the East Indian Company and the *walis* of Baghdad at 3 percent of the value of the goods, payable in Basra on sale. This gave great scope for manipulation, especially as British traders succeeded, through consuls in Baghdad, in securing particular privileges. Thus they had the right to discharge their goods in the warehouse of their Agency, or in any other spot, without sending them to the customs house; this privilege doubtless gave British traders the opportunity to avoid payment of duty on all their merchandise by smuggling part of it. Moreover, the bills of lading which the British presented to the *mutasallim* of Basra were accepted without scrutiny. British ships were also allowed to proceed upstream, past the customs house, a privilege not granted to Arab ships flying the British flag.

Ottoman subjects and nationals of states that had no agreements or treaties with the Porte paid the official duty of 7.5 percent, which in fact amounted to 9.5 percent because of the rise in prices in 1816. The duty was calculated either per bale, or box, or by weight—in which case it was known as *saqt*—or by length, in which case it was known as *sagh;* a fee of one piaster was deducted per bale.[11] Some goods were exempt from duty, such as coins, gold, and silver.[12] The British did not pay duties when exporting wheat and dates, because these were considered to be consumption goods.[13] Duties were not uniform, varying from one commodity to another; what was uniform, however, was that the balance of trade was always in Britain's favor.[14]

When Dawud came to power, the British enjoyed great privileges, due not only to the Capitulations granted by the Sultan but also to the culpable leniency of Sa'id pasha, the *wali* of Iraq, who gave the foreigners commercial opportunities which they did not enjoy in their own colonies. In consequence, the Treasury suffered from a lack of resources, and Sa'id himself became insolvent. These privileges were not confined to the British; it is noteworthy that the other country enjoying vast privileges was Musqat, Britain's ally and its right hand in the Arabian Gulf. The *wali* Sa'id granted the sultan of Musqat, al-Sayyid Sa'id, the right to send three ships to Basra and discharge their goods without payment of duty; this privilege was so exorbitant that the pasha demanded its modification, and both sides agreed that the sultan of Musqat would pay 1000 *tumans* a year [about £80] in lieu of duty on the goods carried by those ships—a sum not equal to one-tenth of the profits made by the Sultan.[15] (See III,19.)

Trade became more active during his rule and would have become still more so but for the catastrophes of 1830 and 1831. The digging of canals [including one between the Tigris and Euphrates] was not the only measure taken to stimulate trade; Dawud paid great attention to ensuring the safety of highways and the facilitating of transport by land and water, an example being his punishment of the 'Afk clan for interfering with river navigation in certain areas. This attention was aimed at increasing government revenues from this vast trade and also expanding the national income.

[11]Su'ad al-'Umari, *Baghdad,* pp. 41–42, 47; Dupré, op. cit., vol. 1, p. 189; Wadi al-'Atiya, *Tarikh al-Diwaniya,* p. 20.

[12]Buckingham, *Travels in Assyria,* vol. 2, pp. 169, 181–182; 'Umari, op. cit., p. 38.

[13]Dupré, loc. cit.

[14]Buckingham, *Travels in Assyria,* vol. 2, p. 187.

[15]Ibid., p. 188.

Duties on trade in Baghdad were estimated at 1 million piasters and in Basra at 1.5 million.[16] Yet customs duties were only one of the taxes levied in the *wilaya*.

(A) Shar'i Taxes

(1) *Al-jizya* [poll-tax on non-Muslims]

(2) *Al-'ushr* [tenth] on agricultural produce[17]; some sources state that it equaled one-fifth in Basra.[18]

(3) *Zakat al-ghanam* [animal tax][19]

(4) Customs duties[20]

(5) *Baj*, or tolls on goods levied by officials appointed by the pasha; in mountain passes it was known as *Khawa*.[21] Sometimes local chiefs levied this tax on their own, as at Zahu.

(6) Tax on shops and taverns and houses

(7) Tax on cultivated lands[22]

(8) Sums paid by the governors of cities[23]

(B) Irregular Taxes

These were levied by the pasha, or *shaykh*, or *mutasallim*, or headman of the village when making improvements or in need of funds.[24]

Generally speaking, taxes were collected through *iltizam,* that is, an individual would be granted the right to raise a specified sum from a specified territory in return for an obligation to pay the pasha an annual amount. Naturally, some *multazims* would collect more than their due, hurting the people; but it has also been proved that, at the end of his rule, Dawud collected taxes harshly, causing Jews to flee from Iraq to Musqat.[25]

Mardin rose up against its governor, who introduced new taxes and raised those on merchants.[26] The currency depreciated, the 2-piaster piece becoming worth 1 piaster, and the *dirham* fell in a ratio of 8 : 10 (in 25 *Dhi al-qa'da,* 1244 [1829]).[27] Currency depreciation was one of the means used by the pashas to increase their revenues. The increase in taxes reached large proportions and caused some people to request the British authorities to mediate in reducing them.[28] These developments were due to the fact that Dawud pasha undertook his reforms after the end of the Iranian war and needed money to train his new army, buy factories, bring in trained instructors, and dig canals and ditches. But Dawud did not differ from most Oriental rulers of that time, who exploited their country's resources without seeking to develop its hidden potential. And yet the Oriental ruler of that time, who saw the enormous gap between him and Europe, had no choice but to leap

[16]Dupré, op cit., vol. 1, pp. 187–189.

[17]Rich, *Narrative,* vol. 1, p. 35.

[18]Al-Sufi, *Al-Mamalik,* p. 214.

[19]Al-'Umari, op. cit., p. 43.

[20]Al-Sufi, op. cit., pp. 214–215.

[21]Al-Munshi al-Baghdadi, *Rihlat,* pp. 39–43.

[22]Ibid., p. 58.

[23]Al-Sufi, op. cit., pp. 214–215.

[24]Rich, *Narrative,* p. 52.

[25]Abd al-Salam al-Mardini, "Tarikh Mardin," (unpublished mss.), p. 157.

[26]Ibid., pp. 157–158; Wellsted, *Travels,* p. 15.

[27]Sarkis, *Mabahith,* vol. 2, p. 220.

[28]Groves, op. cit., p. 50.

forward and hurry—which was one of the causes of the superficiality of reforms in the East and among the reasons why the countries were so heavily burdened in the course of creating a very expensive military force.[29]

Treasury revenues under Dawud were far higher than under his predecessors; in 1828 they amounted to 24,000 purses, after deduction of expenses—a figure attained by no previous pasha.[30] Chesney gives the following list of government revenues:

(1) From exports of dates and cotton and house rents, 1.5 million dollars.
(2) From grain crops, particularly in the Baghdad and Hilla areas, 4 million dollars.
(3) 10 percent tax on animals, 3.5 million dollars; or a total of 9 million dollars. Chesney estimates the revenue that could be derived by the pasha from the production of petroleum at 3.5 million dollars.[31]

In view of Iraq's economic activity and its distance from the capital, the Porte authorized the pashas of Baghdad to strike coins; Baghdad had a mint and a *masrafkhaneh*. But coins struck in Baghdad were not allowed to circulate elsewhere. During Dawud's rule, Baghdad was authorized to mint coins in 1235 (1819/20).[32] The amount to be minted was restricted to 50,000 piasters, and further minting after 1235 was prohibited, yet coins have been discovered which had been minted in Baghdad in 1255 (1839/40).[33]

[29]Dupré, op. cit., vol. 1, pp. 160–161.
[30]Ahmed Lutfi, *Tarikh,* pt. 1, p. 293.
[31]Chesney, *Expedition,* vol. 1, p. 110.
[32]Al-ʿAzzawi, *Tarikh al-Iraq,* vol. 6, p. 300.
[33]Ibid.

28

Request for Physician and Arms in Baghdad, Introduction of Vaccination, 1824

(Taylor, Political Agent Basra, to Government Bombay, 16 July 1824, IOPS, Bombay, 385/51)

. . . I have the honour to lay before you some requests lately conveyed to me from the Pacha with regard to which he appears anxious to receive favourable replies.

His highness' first wish is to have a medical man attached to his person at Bagdad. He endeavoured to prevail upon Dr. Lamb while passing through his capital to remain but without success. I expostulated to H.H. making such offers to a British subject without previous referral to me, when a strong application was made through the Native Agent [in Baghdad] to this effect.

This application having been repeated, I conceived my duty to submit it to Government, assuring them, however, at the same time, that I have not been able to induce him to

From IOPS, Bombay, 385/51, 383/32.

fix any certain or well-defined salary. Should Government determine to comply with his request, which I think may be done with safety and great gratification to him, no dependence can be placed on H.H. except for occasional presents to the gentleman named to this office.

If this request be taken into consideration I beg leave to suggest that it offers an invaluable opportunity for introducing the system of vaccination into the Pachalik on the most extended scale adopted in India, as well as for placing near H.H.'s person a diplomatic assistant to this Residency who might by adroitness and presence of mind prove of the highest utility to the Agency at Bussora.

The influence of the national character appertaining to such a coadjutor at Bagdad would undoubtedly be useful, and with the aid of the Native Agent already there, some representative advantages might be secured. With any native potentate indeed the character of European medical attendance generally becomes absorbed in relations of diplomatic nature. . . .

The second request of the Pacha regarded a supply of arms and accoutrements complete for one thousand infantry privates, viz. musquets and bayonets, butt belts, cartouch boxes, bayonet scabbards, brushes, prickers, turn-screws and flints in proportion.

To meet this request, I have the written engagement of H.H.'s Intendant of the Treasury that they shall be paid for on delivery at Bussora, with all charges accruing. I have every reason to believe that the state in which H.H. finds himself pressed by his enemies that he will not only be thankful for the supply but be ready to pay the charges, in order to be in possession of the arms as quickly as possible.

[Both requests were refused, on the grounds that too close an involvement would be undesirable; the experience of the Residency in Baghdad from its opening in 1798 until the departure of Rich in 1821, "every year produced some unpleasant discussion with the Government and internal interference on our part which involved us in difficulties."

On 5 January 1812 Rich had written to Bombay: "H.E. the Pasha having applied to me to provide him with 200 carbines, I shall be happy if you can make it convenient to spare them from the store. It has been usual for us to supply the Pashas of Bagdad occasionally with musquets and carbines, but this is the first time I have made any request of the kind for H.E. since his accession to the Government." The sending of the carbines, if they could be spared, together with an invoice, was approved on 14 March.

IOPS, Bombay, 383/32]

(From Medical Board, Bombay, 23 October 1824, IOPS, Bombay, 385/51)

I am directed by the Medical Board to acknowledge receipt of your letter of the 13th instant, enclosing paragraph 3 of a memorandum delivered in by the Assistant Surgeon at Bussorah, regarding the establishment of a Native Assistant at Bagdad for the purpose of propagating vaccination in that city, and conveying the request of the Honourable the Governor in Council that they would state the extent of the vaccinating duties of the several stations in the Gulph of Persia. As it appears from the report of the Assistant Surgeon at Bussorah that the people in Bagdad are anxious to enjoy the advantages of vaccination, the Medical Board are of opinion that under such circumstances a steady well-educated Native Vaccinator would confer great benefit on the people of that city, and tend to extend the practice of vaccination in countries where it is now unknown.

In reference to the extent of the practice of vaccination at the different stations in the Gulf of Persia, I am directed by the Medical Board to state that it has as yet made little, or

no progress in that quarter. In proof of this the last monthly return of persons vaccinated from Bussorah amounted to only 27, the last from Bushire to 31 and the last from the surgeon in charge of the Mission in Persia to 25, while no return has been lately received from Muscat, where a native vaccinator is stationed.

[A vaccinator was sent to Baghdad—and in 1827 another to Isfahan.]

29

Pashalik of Baghdad, 1851

. . . There is probably no province in the Turkish Empire which might be governed with more ease and at a less expense than the large Pashalic of Baghdad. There is certainly no province which affords greater facilities for the development of industry and the extension of trade. On the one hand the Arab tribes of Mesopotamia are naturally unwarlike. Great provocation can alone rouse them into hostility; while sustained misgovernment can alone render that hostility formidable. On the other hand if any moderate degree of security existed, the country is so rich, the influx of visitors is so great, the means of transport afforded by those magnificent rivers, the Tigris and Euphrates, are so ample and so excellent, that commerce *must* flourish and peace and happiness must follow in its train.

Yet with all these advantages the Pashalic of Irak is now almost a desert. It has been the misfortune of the country for the last 9 years to be subjected to all possible abuses of Government. The rapacity and corruption of Nejib Pasha, who held the province in farm for about 6 years, not only arrested all progress, but actually forced trade backwards, and led to general impoverishment and in some cases to the depopulation of districts.

The utter incompetence of his two successors brought the authority of the Govt. into contempt, and the headstrong violence of the present Chief, seeking with insufficient means to reestablish absolute power, has put the finishing stroke to the calamities of the country. Namik Pasha inaugurated his Government by acts of severity which were totally uncalled for; he then goaded the tribe chiefs, one by one, into a hostile confederation against the Government; and he has since—by exhibiting sometimes military weakness, by countenancing at other times measures of perfidy and scenes of cruelty which it would be shocking to relate, and by maintaining throughout a violence of language and haughtiness of demeanour which to the Bedoins of the desert are of all things the most insupportable—so completely excited and exasperated the Arab population of the province, that it would require perhaps a force of 50,000 men to put down opposition and restore general tranquillity. . . .

From Rawlinson to Malmesbury, 21 June 1852, FO 195/367.

30

Conditions along Proposed Telegraph Route, 1856

(Kemball to Redcliffe, 29 December 1856, FO 195/521)

. . . I would beg Your Lordship to observe that there is scarcely a mile of this extensive space beyond the immediate limits of the larger towns, which can be said to be under the real control of the Turkish Authorities; and even in what are termed the settled districts, where their Authority is recognized, that Authority must be measured by their present ability to enforce it, but can seldom be exercised with effect either to prevent local disorder, or to punish the disorderly acts of the inhabitants, too often attributable to their own interference with the Government of the Sheikhs, or to their attempts to increase the rates of tribute at which the tribes are assessed.

The administration of the Province is in fact a system of compromise.

The Government, if the dominant race, a mere handful of foreigners exclusively of the military class, can be so designated, has no direct relations with the people; and the latter, in order to supply the place of law, order and security are united into communities under the rule of one family, to whom is resigned the charge of the Interior and fiscal economy of the tribe.

In the struggles for power constantly ensuing between the members of the ruling family, Turkish Policy finds its opportunity and the Government persists or yields, while disturbance is more or less protracted, according as its selection may have been well or ill judged, and its power or influence sufficient to secure the ascendency of its nominee.

In the case of the Great Bedouin tribes the Shammer, the Anezeh, and the Dhefyr a weak Government has no resource but to purchase their forbearance by the assignment of monthly salaries to the Chiefs, the suspension or cessation of which is the sure prelude to the plunder of Villages and Caravans, and the interruption of the neighbouring lines of communication. When troubles arise in the body of a Bedouin tribe and even in the quietest times, the Government is powerless to prevent the levy of blackmail or to procure the restitution of plunder. . . .

[I] entertain the best hope of success from a course of liberal and conciliatory conduct towards the Arabs themselves. My experience of these people leads me to believe that where no temptation to plunder exists, they are sufficiently prone to keep their engagements, and this disposition might be confirmed and sustained by such inducements as it would be politic to hold out to them.

Occasional presents to the ruling sheikhs, through whose territory the wires should pass, would of course be necessary, but my dependence would be mainly placed on the services of some member of his family, or of some influential, though minor Chieftain of the tribe to whom a monthly salary, say from £5 to £12, must in each instance according to circumstances be assigned. The rule amongst Arabs that travellers if escorted by a member of the tribe should be considered safe from molestation, is in the general case faithfully observed and would equally operate in favor of the Telegraph.

From FO 195/521.

After mature consideration I am disposed to regard the line through Mesopotamia from Mosul to Baghdad and so to Kalaa-Derwish on the Hye, opposite to Koot, as in most respects preferable; though I must confess that from the last point I am unable to indicate with precision, the course that should be followed.

That part of the Country having been little travelled by Europeans I am ill informed at present of the extent of the marshes which spread over its surface during the high season or whether at all times one might travel dry shod in a direct line from Kalaa-Derwish even to Sook esh Shiookh. . . .

(Kemball to Frere, 21 February 1856, FO 195/521)

[The Bedouins who, because of their] mode of life are little amenable to control, and who acknowledge the Authority of the Turkish Masters to the extent and for the period only that it can be immediately enforced. That this difficulty is not however insuperable is sufficiently illustrated by the freedom of transit enjoyed by a Bi-Monthly Dromedary Dawk maintained for many years past by the British Government over one of the worst Desert Tracks between this city (Baghdad) and Damascus. The Packets are repeatedly opened for the purpose of examining their contents; but care being always taken to exclude valuables of any kind or description, it is rare indeed that they are subjected to wanton destruction. British influence, or rather the mere prestige of the British name, would assuredly never suffice to check the propensity of the Arab to plunder, yet when nothing tangible is presented for its gratification, his forbearance may be purchased at no very exorbitant price. . . .

31

Midhat Pasha's Projected Reforms, 1869

His Excellency addressed the assembly [at the Government House (Serai)] telling his audience that he had come hither with an earnest desire to benefit the country and enrich the people—that he proposed to introduce many changes and reforms which he hoped would be beneficial, changes, which perhaps they might not at first altogether approve but which they would appreciate when they had experienced the advantage that would accrue to them therefrom.

He commenced his career by the abolition of the following taxes, which are said to have been peculiarly local and have proved obstructive and oppressive,

1st: Ihtisab, or Octroi duty levied on all produce brought into the City-Gates for sale in the market,

2nd: Kalibiyeh, a tax on the native craft on the rivers,

3rd: Khumus Hatib, a tax of 20 percent on fuel brought to the city on rafts and in boats,

4th: Roosbukar, the tax on the irrigation wheels of the Arab cultivators.

From Herbert to Elliot, 26 May 1869, FO 195/949.

In lieu of these taxes he has established one of 10 percent on the produce of gardens and field.

His Excellency is organizing several new Councils (Mejlises) of which the numbers are to be paid, instead of as heretofore working gratuitously with the opportunity of making what they could, a source of corruption and trouble.

He has introduced the Walayet System, and I have the honor to forward a copy (with translation) of a communication which has been addressed to the foreign Consulates on this subject.

His Excellency has deputed an Officer, Serri Effendi, to reopen an old canal called "Kenanieh" from the Euphrates into the "Saglawieh" canal, which falls into the Tigris, with the view to forming a channel of communication between the two great rivers, to be conducted by means of small steam vessels which it is proposed to bring from Europe for the service.

He has also deputed a steamer to proceed up the Euphrates to endeavour to arrange for the ultimate opening of the navigation of that river, with which object he proposes to remake the embankments of the Jezair territory, and so confine the water of the river to its own bed, and prevent the inundations which yearly immerse large tracts of country to the South, and reach even to the town of Bussorah.

These inundations convert the whole of that country into a tract of unhealthy and unproductive marsh while the loss of the water from the bed of the river renders the latter unnavigable.

His Excellency's mind seems earnestly bent on various schemes for the improvements of the country.

He at once recognises the two great wants; Viz: Security of property; and means of communication with the world (from which the country is at present excluded) and of the transport of produce.

He contemplates the construction of a Railway hence to Kerballa as a step in this direction in connection with the navigation of the Euphrates; the importation of several Steamers for river and Sea navigation—so as to connect the province with Suez; of machinery for cleaning the river channels; and also for various manufactures, as well as for irrigation.

32

Midhat Pasha's Reforms, 1869–1872

. . . *Printing Press and "Al-Zawra" Newspaper.* Both of these were set up by the government, as had been done in other provinces [see II,18], since it was difficult to establish them. The *vizier* [Midhat] wanted a record of his activities and therefore established *Al-Zawra*, of which the first issue appeared on 5 *Rabiʿ al-awwal* 1286 (1869). It lasted during his tenure of office and continued almost until the [British] occupation. The government published news so as not to have it distorted, and recorded government

From ʿAbbas al-ʿAzzawi, *Tarikh al-ʿIraq*, Baghdad, 1937–1956, vol. 7, pp. 171–260.

activities. The government had recommended bringing in a press before this *wali* took office.

The press printed not only the newspaper but other publications, including *salnamehs* (almanacs) and official publications [The author refers to his book, *Al-tibaʿa wa al-matbuʿat fi al-ʿIraq*] . . . [p. 171].

Weights and Measures. Midhat pasha tried to reform and verify weights and measures. On 10 *rabiʿ al-awwal* 1286 he ordered that the *huqqa* (*oke*) equal 400 *dirhams* and that 10 *huqqas* constitute a *mann*, 10 *manns*, a *wazna*, and 10 *waznas* a *taghar*. But his wishes were not fulfilled; he was not trying to invent a decimal system but to facilitate international transactions and failed in this purpose.

The government issued a law dated 20 *Jumada al-akhira* 1286 on the new weights and measures . . . prohibiting the use of the old ones as from March 1290 *Rumiyya*, i.e., after two years. . . . I have explained all this in detail in the chapter on weights in my book *Al-nuqud al-ʿIraqiya*. But the project failed and people continued to use the weights to which they were accustomed until the end of the Ottoman era.

Currency. The vizier tried to reorganize currency according to the wishes of his government but did not succeed. The coins in use were innumerable in their variety, including both Ottoman and foreign. No attention was paid to strict orders, for people did not want to depart from their accustomed ways and economic needs. Iranian coins were widely used and so were Ottoman and foreign. . . .

No coins were minted in Iraq after 1262 (1845/46), and the ones in currency did not have constant ratios. The *beshlik* was regarded as equal to 5 sound piasters (*qurush sahiha*) but actually exchanged for 6 piasters and 10 *paras* and for 25 piasters of unsound money, *metalik*. The same was true of the *shami*, regarded by the state as equal to 9 piasters and 30 *paras* but actually exchanged for 10 piasters. The injustice caused by the difference between the two prices is evident. The same was true of Iranian coins and the manipulation of their exchange rates. The *Kran* was equal to 3 piasters and 30 *paras* but did not stay at that rate.[1] . . . [pp. 174–176]. [See VII, Introduction.]

Crafts School. In view of the large number of *madrasas* (mosque schools), the *wali* decided to convert one of them into a school for crafts. . . . The school was opened at the beginning of 1287, and its students [recruited from among Muslim orphans] were assigned to the different branches: smithcraft, weaving, shoemaking; they numbered 144 and were lodged in tents pending the completion of the buildings . . . some were chosen to work in the printing press.

The people of Baghdad, Basra, and other places contributed large sums of money to this school. And if only the *walis* who succeeded Midhat pasha had done their duty by this school it would have produced satisfactory results. . . . The years and days passed by, and the school is still in a primitive state and has not taken any steps toward reform. And if some trained people have graduated from it, that is because of their own personal efforts, not because of any improvement in the methods of teaching . . . [pp. 178–179].

Paving of Streets. The government began paving *Suq al-Balanjiya*, known today as *Al-Mamun* street, as an experiment, but stopped there . . . [p. 179].

Steamship Lines. The government therefore bought, at a cost of £T. 33,500, a steamer to which the name "Babil" was given, with a horsepower of 350, displacing 1700 tons and capable of providing sleeping space for 280 passengers. It was tested by the British War Office. . . .

[1] *Al-Zawra*, No. 9; Lutfi, *Tarikh*, vol. 8, p. 91; ʿAzzawi, *Al-nuqud al-ʿIraqiya*.

It was also decided to acquire another steamer of the kind known as "Midhat pasha" class, which sailed on the Danube, for use between Qurna, Basra, Kuwait, Bushire, and Bahrain. [Three other smaller ships were bought: "Niniveh," "Najd," and "Ashur."] These three ships and the "Babil" sailed between Istanbul and Iraq once every three months, and also went to England, on a regular schedule. Among their greatest needs was coal, which the government bought in England. They also required ports in Aden, Musqat, and Bushire, and agents in those places to manage their affairs. It was also necessary to set up in Aden a depot of 8000–10,000 tons of coal for use by the ships. . . .

An Ottoman administration was set up for these ships, known as "Uman-Uth-mani." Its reputation for good management spread to the neighboring countries, and it made a monthly trading profit of £T. 1000.[2]

But if we look at what happened after Midhat pasha, we see that this Administration suffered from mismanagement and deterioration and eventually disappeared. This occurred only because his successors did not give it the necessary attention . . . [pp. 188–190].

Dredging of Euphrates. Midhat pasha hoped to use the Euphrates for carrying heavy goods and promoting trade and the exchange of merchandise. He tried to go by boat from Birejik but was prevented by the sinking of the boats. The Euphrates is a big river and suitable for navigation between Maskana and Basra [see IV,15]; the greatest obstacle lay in the stretch between Hit and 'Ana, mainly because of the remains of old buildings and waterwheels (*kurud*) in the river. Midhat pasha went there himself and ascertained that it was capable of improvement. The next year Shakir Bey, the official in charge of Public Works in the province of Baghdad, went there with two boats equipped for the purpose and accompanied by engineers and experts to survey all aspects of the Euphrates. The necessary investigations were made and information collected, and it was shown that the Euphrates could be improved and put to use. Work began on removing obstacles, starting with Hit and proceeding to the Failawi islands, Jibba, and Allus. However in most parts the current of the Euphrates is powerful and swift, and no means were found to slow it to the required degree. The ships drew little water but could not exceed the speed of 12 miles an hour. The government therefore decided to order a ship with four wheels and a greater speed, like the ones used in Austria for rivers with powerful currents. But this required much time and was accomplished only after Midhat had been removed from Iraq. When the ship reached Iraq it was called "Maskana" and sailed for some time between Baghdad and Maskana, being the only one to do so.[3] The subsequent fate of this ship is unknown, as is the date of its retirement. The scheme was completely unsuccessful . . . [pp. 190–191].

Hospital for Foreigners. Baghdad had over 150,000 inhabitants, and included many foreigners but did not have one hospital, physician, or pharmacist. [Contributions were raised and a hospital established] . . . [p. 199].

Date Tax. The tax on crops was a fifth or a tenth, assessed by estimation. But with date palms, expenses of cultivation are great and the produce does not ripen all at once, making it more difficult to collect samples; hence, estimation was used, but it was only approximate, [and farming out the tax resulted in inequities].

Hence, under Midhat pasha, the government—estimating that an average tree did

[2]See Ali Haidar Midhat, *Tabsere-i ibrat*, p. 89.
[3]Ibid., p. 91.

not yield more than 20 *huqqas* of fruit a year worth an average of 20 *paras* each for ordinary dates—resolved that places that paid a tenth, like Baghdad and its surroundings, would pay 2 *huqqas* or 40 *paras*. Payment in cash was easier for both government and taxpayers and involved less expense and fraud. This decision was well received. They urged that that basis should be followed for five years, after which adjustments might be made if prices went up or down. And the people of the district (*qada*) of Khalis, who paid a fifth, asked to be included in this arrangement, paying 2 piasters per tree instead.[4]

[In Basra the date tax was levied by estimaters, whose decisions were arbitrary.] The system of estimation was therefore abolished; instead the government levied a tax of 15 piasters a year on each *dunum*. This tax was levied on all land, including uncultivated patches; this led farmers to plant trees to fill such patches. And whereas the revenues of Basra had been 48 "loads" (*himl*) of coins, after two years they rose to 70 loads and more . . . [pp. 203–204].

River Steamers. The government bought the steamer "Al-Rusafa," which was assembled, reached Baghdad, and sailed between Baghdad and Basra, returning to Basra on 3 *Shawwal*. The "Basra" navigates the Euphrates, and the "Baghdad" is used to explore the river north of Baghdad and study its clearing. . . . The "Rusafa" is used only for carrying mail. These ships have been added to the "Babil" and the other two ships, expanding the scope of the River Boats Administration. And the Naqib of Basra, Sayyid 'Abd al-Rahman, recently bought a small boat, the "Fayha,"[5] and then handed it over to the government; it has been put under the River Boats Administration.

Al-Zawra also stated that the "Babil," which the government bought in Europe, reached Basra and sails between that town and Jidda during the pilgrimage season; it charges a low price, in contrast to the British who monopolize the business: 4000 piasters in first class, 2500 in second, and 1200 in third. The journey takes 15 days.[6] . . . [pp. 228–229].

Tax on Cotton ('ushr). The government has given cotton special consideration, taking a tenth of the crop and not a fifth, quarter or third—and in some places even a half—by way of tax. For that is a heavy burden, especially since it trying to encourage its cultivation. It has announced that it will levy a tenth of the produce[7] . . . [p. 239].

Horse-Tramway to Kazimiya. Kazimiya may be considered a suburb of Baghdad, from which it is not distant [7 kilometers]. It contains the tomb of two Imams, Musa al-Kazim and Muhammad al-Jawwad, and is full of visitors, residents, and people who work there. It is in constant touch with Baghdad. . . .

For these reasons the Tramway Company was constituted; its shares sold briskly, 748 being taken up in 10 or 12 days, because of the eagerness and encouragement shown, and more being sold since.[8]

Construction was completed, and for this credit is due to the *wali*, who in this way saved people a lot of inconvenience. The line has been in use from its inception to the present day. The Company was liquidated in May 1941. . . .

The Company was established with the encouragement of the *wali* and the guarantee of the government. There were 6000 shares of 250 piasters each, or a total capital of 1.5

[4]*Al-Zawra*, No. 13, 1 *Jumada al-akhira* 1286.

[5]Ibid., Nos. 31 and 35.

[6]Ibid., No. 31, 16 *Shawwal* 1286.

[7]Ibid., No. 38, 5 *Dhi al-hijja* 1286.

[8]Ibid., No. 46, 6 *Safar* 1287.

million piasters. . . . Only 1000 shares were [initially?] subscribed. Annual profits were 18–20 percent, some of which was paid to shareholders and the rest used to redeem debt. The Company eventually had 5000 shares, a figure that was maintained . . .[9] [pp. 240–241].

Land Tenure Reform. [pp. 245–253; see V, Introduction and VII,23; see also *EHME,* pp. 163–178].

Nahrawan Dam. The *wali* built a dam on the Nahrawan Canal at Zalli(?), at the confluence of the Nahrawan and the Diyala River. The place had been used before for a dam that had broken down, at Abi 'Arruj. The project failed because of the materials used, which could not withstand the powerful current . . . [p. 254].

New Factories. The army had grown and its needs increased. In Midhat pasha's time there was an Army Corps of 7000 men, whose number grew to over 12,000 because of conscription and voluntary enlistments. The needs of such a large number could not be met by the local handicrafts, and difficulties arose. The textile factory was therefore founded, producing 300 meters of woolen cloth and 400 of thick cotton cloth a day. The factory was known as the *'Abakhana.* . . . As for the mill, it ground and baked 2000 *okkas* of flour a day. Midhat pasha brought from Europe for this purpose motors of 70 horse-power, with all the necessary accessories. He bought these in France for £T. 2,000 and had an engineer sent to supervise the work.[10]

Because of the Franco-Prussian war of 1870, these projects were delayed till after the removal of Midhat pasha. Eventually the machines were brought in by way of Basra, but no one competent to run them was found and they rusted.

When Husayn Fawzi pasha was in command of the Sixth Army Corps, he brought these over to Baghdad and erected the necessary buildings for them, and they started operations. That is all that is known about them[11] . . . [p. 260].

[9]*Tabsere-i ibrat,* p. 94.

[10]*Al-Zawra,* No. 18, 6 *Rajab* 1286; idem, No. 145, 30 *Safar* 1288.

[11]*Tabsere-i ibrat,* p. 95.

33

Economy of Mosul, 1884

The demand for European goods here is extremely small and the supply proportionately limited. Merchants who import small quantities of goods from the Continent cannot naturally buy them as cheaply as those who give large orders, and so it has come about that Mosul traders find that they can buy their small stock cheaper from the large wholesale houses in Aleppo and Baghdad than if they imported direct from Europe. In the latter case it would be necessary for them to have established agencies in the principal commercial centres on the Continent, which the smallness of the demand for such goods would

From Report by Vice-Consul Richards on the Trade and Commerce of Mosul for the Year 1884, A and P 1884–1885, vol. 79.

hardly render worth their while. The great distance which separates this town from the coast, and consequently the long lapse of time before goods reach their destination must also be taken into consideration. Goods imported from England direct are, at the lowest computation, three months en route, and it not unfrequently happens that five or even six months elapse before they reach their destination. In the meanwhile prices have undergone a change, and what was a fairly profitable transaction three or four months previously may eventually prove to be ruinous. For these and other reasons direct importation of European goods has altogether ceased of late years, while the amount of such goods sold here is considerably less than it was even six or seven years ago. The reason of this is that whereas formerly there was a very considerable trade done here, both in European and Turkish goods, with Persia and the district towns of Kerkook and Suleimaniyé, these places are now supplied directly from the Baghdad market. As regards exports to Europe they consist chiefly of wool, mohair, skins, hides, and gall nuts, in which there is an approximate annual export trade of the value of 100,000*l.*, three-quarters of which goes to Great Britain alone. . . .

But it is sheep-rearing which is undeniably the most profitable commercial enterprise in this part of Mesopotamia, the country being especially suited for grazing, whereas for agricultural purposes the soil is too sandy and thickly covered with stones. The sheep tax realised 51,000*l.* in this province last year, which, on the calculation of 3 pias. per sheep (the amount of the tax), gives 1,700,000 as the number of sheep in this vilayet. But when it is considered that the Arabs, at least those of them who are genuine nomads, pay no tax, although they are all large sheepowners, and that many of the wilder Kurdish tribes are similarly exempt, it will be seen that 3,000,000 is by no means an overestimate of the number of sheep in this province. A great many are exported yearly to Syria and Egypt, while the greater part of the wool is sent to Europe. The Mosul mohair is not of course to be compared with that of Angora, but yet a great deal of it finds its way every year to European, mostly British, markets. The best gall nuts come from Rowanduz and the Hakkiari district, the green being far more highly esteemed than the white.

Owing to the recent discovery of several petroleum springs in the neighbourhood of Kerkook, it may fairly be conjectured that the demand for that oil from America will be very much less in the future. At present it is being utilised for street lighting purposes, but it is considered that with the refining appliances now in use, there will shortly be a good supply of oil available for household purposes. Coal, too, has been discovered within the last year at Selahiyyé (Küfri), in the district of Kerkook, which appears to be likely to prove productive if the mine be properly worked. There is also a large coal mine at Kerboul, a village in the sub-district of Djezireh, which has been worked in a somewhat desultory fashion for the last 15 years. Sometimes it is taken in hand by the Government, but more often the latter contracts with some native merchant for the delivery of the coal in Baghdad at so much the oke. During the last year this was the case, the contract being in the hands of a merchant of Mosul, who agreed to deliver the coal in Baghdad at 290 pias. (about 2*l.* 6*s.*) the ton. But I am informed that the business has proved anything but profitable, owing to the extremely deficient means of carriage, and that the contract will not be renewed this year. . . .

An agricultural savings bank (Caisse d'Epargne Agricole) has also been established here during the past year, with a view to affording relief to the peasant population in rescuing it from the payment of usurious interest on loans advanced by the native merchants in the towns. This bank lends to those in need at the rate of 1 percent per month, with a lien on the borrower's land for twice the amount, such loans not being made for a

period exceeding a year. . . . I am given to understand that the experiment so far is not generally considered a success.

The horse export trade during the past year was far from being so profitable as it usually is. For some reason or other unknown the greater number of those landed at Bombay have failed hitherto to meet with purchasers, while others have been disposed of at considerable sacrifice by owners who despaired of getting a good price. At Mosul the price of horse flesh has fallen in consequence very considerably.

As regards the completion of public works undertaken during the past year, beyond the building and repairing of a few bridges, very little has been done until quite recently, when the main road to Zakho was begun. . . .

34

Floods in Iraq, 1894

Every spring, when the snows melt in Armenia and Kurdistan, the Tigris rises some twenty feet or more, and from a sluggish stream is transformed into a raging torrent. This year the rise has been about 24 feet above low water mark—the highest since 1849 and higher than in 1831, when 7000 buildings fell in a single night in Bagdad, burying the inmates under the great mass of crumbling brick. The water reached several feet up on the wall of the house I occupy, the outer wall of which was partially destroyed and threatened to fall, my Sardab (cellar) filled, and I could sit at my office window with hook and line and catch all the fish I wanted. To save city property it became necessary to make several breaks in the river bank above here and let some of the water into the desert, and then strengthen the wall around the city with stakes, mats and earth, at which thousands of men and boys were engaged for many days. A similar rise in the Euphrates caused a number of Crevasses in its Eastern bank which allowed the water to overflow the country and empty into the Tigris, the bed of which is on a lower level, at Bagdad, so that the waters of the two rivers mingle as high up as here, and Mesopotamia is traversed in boats. From Sit Zobeida's tomb (Sit Zobeida was wife of Harun-al-Rashid) in West Bagdad there is nothing but water to be seen (clean horizon) in direction of the setting sun, while looking Hillah-wards one sees a few low islands here and there marking the sites of ancient mounds. Truly "The sea is come up over Babylon: she is covered with the multitude of the waves thereof" (Jer.LI.42). From the wall of East Bagdad the view is similar, and where a few weeks ago flocks of sheep were grazing, hundreds of boats are now engaged in the transportation of men, beasts and merchandise. The crops are destroyed, but fortunately the low price of wheat has kept the granaries full of last year's harvest. Thus famine will be averted. But as the waters recede they will leave a mass of putrescent matter to poison the air, and pestilence is sure to follow. . . .

From Sundberg to Uhl, 10 May 1894, US GR 84, Miscellaneous Correspondence, Baghdad.

35

Baghdad in 1908

. . . It has already been mentioned that the Tigris passes through Baghdad and divides the town into two sections, al-Karkh (right bank) and al-Rusafa (left bank). In this chapter we will try to describe each of these two shores.

Al-Karkh, where the palace of the caliphs and the most interesting monuments were formerly located, is today in a state of ruin. Apart from a few recent buildings set up by some notables, only one-floor houses are to be found; they are inhabited by poor natives, most of them farmers, camel drivers, weavers, and porters—some 20,000 inhabitants in all. Of the ancient monuments, all that remains is the tomb of Princess Zubayda, wife of the caliph Harun al-Rashid, that of the prophet Yusha (Joshua), the mausoleum of Shaikh Ma'ruf al-Karkhi and that of the Ibn Muqla, and the mosque of Shaikh Sandal. Among more recent buildings, the foreigners' hospital and the ironworks known as Demir-hane, built by Midhat pasha [selection 32], stand out. The old hospital has been converted into a school for young Muslims and the Demir-hane into barracks for sailors. In addition, on the site of the old Bab al-Sham (Damascus gate) there is a building used as the station of the streetcar line joining that quarter to Kazimiya, and which also goes back to Midhat pasha [selection 32]. There are also four or five public baths, six large and small mosques, and a cereals market. The government has, in that quarter, a storehouse for cereals derived from the crops on its estates.

Bridges. This section of the town is linked to the other by two bridges, a very old one in the center of the city and another, upstream, near the Bab al-Mu'azzam gate, formerly known as Bab Khurasan. These two bridges, which are of primitive and defective construction, are held up by wooden barges coated with bitumen and fastened to buoys by iron chains. They do not resist well the river current and require constant repair. Formerly, no dues were paid for crossing the bridge, but when Midhat pasha built the second one he imposed dues. These bridges are farmed out each year, by auction. The city bridge brings in £T. 1200 (about 30,000 francs) a year and that of Bab al-Mu'azzam £T. 800–1000.

There is also a bridge that links the little town of Kazimiya to that of Mu'azzam, a league upstream from the city, and another, a league downstream, at a place called Grara. These two bridges, like all those in the province, are farmed out by the government to private individuals who levy tolls. All these bridges are about 200 meters long, but of different widths. The broadest, in the center of the city, is about 8 meters wide; it is also the best kept bridge. The revenue from the farming out of the bridges is earmarked for the three municipal districts of the city, two of which cover al-Rusafa (left bank) and the third al-Karkh (right bank).

From Habib Chiha, *La Province de Baghdad*, Cairo, 1908, pp. 163–165, 102–105.

Population. The population of Baghdad's city may be put at 150,000, of whom 20,000 live on the right bank and 130,000 on the left; they consist of:

Sunni Muslims	40,000
Shi'i Muslims	50,000
Christians	7,000
Jews	53,000
	150,000

In the absence of an official census, it is very difficult to give exact figures. The above are based on the best estimates of competent persons living in the province. . . .

Schools. In Baghdad the Muslims have several schools, of which the main ones are the government schools. The primary military school, known as *Rushdiya 'Askariya,* has about 150 pupils. The preparatory military (*I'dadiya 'Askariya*) takes students graduating from the former schools, and has about 150 pupils; young men graduating from this school and obtaining its certificate are admitted to the higher military school in Constantinople and, after three years, obtain their commission. These two schools are organized on the same pattern as military schools in the other provinces.

There are also two civilian government schools, a primary one (*Rushdiya Mulkiya*) with about 150 pupils and a preparatory one (*I'dadiya Mulkiya*) with no more than 60–70 pupils.

The Arts and Crafts school, founded by Midhat pasha, is one of the most useful institutions in the country [but see Selection 32]. Children of the lower classes, especially orphans, are admitted to it to learn a craft, such as shoemakers, carpenters, smiths, or weavers. A shop, in which the furniture and other products made by the pupils are exhibited for sale, is annexed to the building.

There are also some 40 small schools in the city, where summary instruction is given; a schoolmaster teaches children to read and write Arabic.

As for Christian schools, the Catholics have several for teaching children of both sexes. In the first place one should mention the French college run by the Carmelite Fathers, which includes two schools where education is absolutely free. The first takes in small children, who are taught the first notions of Arabic and French. The second has a fuller program that includes the study of Arabic, Turkish, French, and English. . . . The second Catholic boys' school is that of the Alliance Catholique, which is run by native priests, under the supervision of the Syrian archbishop. The number of children in Catholic schools is about 1300.

Monsignor Henri Altmayer, ex-Archbishop of Baghdad and Apostolic Delegate in Mesopotamia, founded at his own expense a large school for girls. This school, run by French sisters of the Presentation, has greatly flourished. In it girls of all communities are taught French, Arabic, music, drawing, and handiwork. The services rendered by this school to the country deserve particular notice. Monsignor Altmayer also founded in Baghdad a shelter for 3- to 6-year-olds which, too, is run by the same sisters.

The Gregorian Armenians have two schools, one for boys and the other for girls. The girls' school has some 30 pupils; in it Armenian and French are taught. Though managed by laymen, this school is under the supervision of the Armenian clergy. The boys' school has about 80 pupils, who are taught Armenian, Turkish, and French.

The Jews have, in their quarter, a large school—that of the Alliance Israelite—

where Arabic, French, and English are taught. This school is managed by a special commission consisting of French teachers. A few years ago a new school for girls, with a French headmistress, was founded. The Jewish community also has a large number of small primary schools, run by rabbis who teach the Talmud and Hebrew; in some of them pupils are taught to read and write Arabic.

Baghdad has only one small public library, with about 500 volumes mostly donated by the city's notables. Most of the books deal with religious subjects. . . .

III

Trade

Except in 1832–1840, when Syria was under Muhammad Ali's rule and integrated in the Egyptian economy (II,1), it had the same tariff structure as the rest of the Ottoman Empire. The same was true of Iraq, both under the Mamluks and following the Ottoman reconquest. This meant low customs duties on imports, fixed by the Capitulations at 3 percent on goods from Europe, but in fact sometimes higher (selections 15 and 16). Moreover, the rise in prices in the 18th and early 19th centuries had further reduced the weight of these duties. Exports were also supposed to pay 3 percent, but a shortage of revenue led both the central authorities and local rulers or governors to supplement this with additional taxes, prohibitions, and monopolies (selection 7). European merchants found these restrictions burdensome and in 1838 the Anglo-Turkish Convention, or Treaty of Balta Liman, was signed. It prohibited all monopolies, allowed British merchants to purchase goods anywhere in the Empire without payment of any taxes other than import or export duty (or its equivalent in internal duty), and imposed duties of 3 percent on imports, 12 percent on exports, and 3 percent on transit. In addition to the import duty, British merchants agreed to pay another 2 percent in lieu of other internal duties paid by importers. Following Muhammad Ali's defeat, the convention was applied to Syria as well as to Egypt. The other powers soon acceded to it, and their consuls ensured its implementation.[1]

The treaty increased Ottoman revenues and facilitated exports, thus benefiting the agrarian interests that had supported it. But it also exposed the handicrafts to greater competition from European machine-made goods (VI, Introduction), a factor further

[1]For more details and analysis, see *EHMENA*, pp. 17–19; *EHT*, pp. 74–75, 88–100; Owen, *Middle East*, p. 91; and Charles Issawi, "Notes on the Negotiations Leading to the Anglo-Turkish Commercial Convention of 1838," *Mémorial Omer Lutfi Barkan* (Paris, 1980), pp. 119–134; for the text of the convention, see *EHME*, pp. 39–40.

aggravated by the sharp decline in freight rates (IV, Introduction). Moreover, the government's need for funds was greater than ever, and customs duties were the most elastic tax at its disposal. Hence, after negotiations that started as early as 1843, in 1861–1862 new conventions were signed raising import duties from 3 to 8 percent, and reducing export duties from 12 to 8 percent, with a further reduction of 1 percent a year until such time as they reached 1 percent. Most internal duties were abolished by 1874, but an 8 percent duty continued to be levied on goods seaborne from one Ottoman town to another; in 1900 it was reduced to 2 percent and in 1909 abolished except for a few goods. Repeated Ottoman demands for further increases, starting in 1875, were finally successful when, in 1907, a rise in import duties to 11 percent was agreed upon, followed in 1914 by one to 15 percent. By then the government was using the tariff for development purposes, exempting tools, machinery, and fertilizers from duty.[2]

Value and Quantum of Trade

Attempts to calculate the value and quantum of the region's trade meet with almost insuperable difficulties. First, no series are available on trade by land; yet there is every reason to believe that until the 1840s or so it was distinctly greater than sea trade (see selection 6 for Damascus, selection 5 for Aleppo, and selection 16 for Baghdad). Moreover, in the course of the century the land trade of Syria did not increase, and may even have declined.[3] This means that the overall growth in the region's trade was considerably smaller than that shown in Table III.1 and selection 14.

Second, trade returns are available only for the main ports, and even there not for every year. Third, the available returns are not consistent or reliable. In some exports of specie are included, in others not. Only dutiable goods are shown, and nondutiable goods such as raw tobacco, cigarettes, wine, and salt (which were handled by monopolies) are omitted.[4] Fourth, methods of valuation were often changed, making the returns inconsistent; moreover, the cumbrousness of the customs procedure produced both corruption and error.[5] Fifth, the British and French consular figures for the same year often differ greatly. Sixth, there is good reason to believe that both exports and imports were undervalued; for example, in 1851 the French consul declared that much silk was exported in contraband and that the farmer of the customs underestimated imports in order to hide his profits.[6] Finally, no price deflators are available, to convert nominal values into real ones.

No attempt has been made to adjust for all these errors, except that, in Table III.1,

[2]*EHT*, pp. 75–76, 318–320.

[3]In 1833 Damascus received, by caravan, 18.5 million francs worth of goods, of which 16.2 million came from outside geographical Syria. This was ''double what the whole of Syria received in the way of European merchandize'' (*Douin*, pp. 254–255). The statement regarding the stagnation of Damascus' land trade is not contradicted by the fact that, between 1882–1884 and 1910–1911, its total trade rose by 3.3 percent a year, a rate far more rapid than that of Beirut. For, by the 1880s, the bulk of Damascus' trade was conducted through the seaports.

[4]Ruppin, *Syrien*, pp. 190–191.

[5]Ibid., pp. 188–190; A and P 1889, vol. 103, ''Beirut.''

[6]''Report on Trade,'' 26 July 1851, CC Beyrouth, vol. 6.

Table III.1 Sea Trade of Main Syrian Ports[a]

Year	Port	Imports	Exports	Total
1784[b]	Alexandretta	(200)	(208)	(408)
	Tripoli	(16)	(20)	(36)
	Saida and Acre	(120)	(144)	(264)
	Total	(350)	(400)	(750)
1825	Alexandretta	220	108	328
	Beirut	112	80	192
	South Syrian ports[c]	236	160	396
	Total	(500)	(300)	(800)
1833[d]	Alexandretta	140	80	220
	Latakia	120	72	192
	Tripoli	25	22	47
	Beirut	440	240	680
	Tyre	4	16	20
	Acre	3	13	16
	Jaffa	7	5	12
	Total	739	448	1187
	Total	293	482	775
1844[e]	Alexandretta	227	106	333
	Beirut	977	634	1611
	Jaffa	NA	52	NA
	Total	(1350)	(850)	(2200)
1855–1857[f]	Alexandretta	504	315	819
	Tripoli	103	163	266
	Beirut	1473	1596	3069
	Jaffa	NA	123	NA
	Total	(2200)	(2200)	(4400)
1861–1863[g]	Alexandretta	790	443	1233
	Beirut	1301	796	2097
	Saida	64	21	85
	Jaffa	NA	200	NA
	Total	(2400)	(1600)	(4000)
1871–1873[h]	Alexandretta	1203	732	1935
	Beirut	1240	615	1855
	Jaffa	138	247	385
	Total	(2800)	(1800)	(4600)
1884–1885[i]	Alexandretta	1558	998	2556
	Tripoli	769	286	1055
	Beirut	(2000)	791	2791
	Jaffa	280	125	405
	Total	(4600)	(2200)	(6600)
1895–1897[j]	Alexandretta	1708	1115	2823
	Latakia	60	100	160
	Tripoli	398	679	1077
	Beirut	1609	743	2352
	Saida	31	50	81
	Acre-Haifa	160	60	220
	Jaffa	280	322	602
	Total	4246	3069	7315

(*continued*)

Table III.1 (*Continued*)

Year	Port	Imports	Exports	Total
1900–1902[k]	Alexandretta	2283	1122	3405
	Latakia	97	NA	NA
	Tripoli	442	357	799
	Beirut	1412	626	2038
	Acre-Haifa	200	80	280
	Jaffa	405	249	654
	Total	(4900)	(2600)	(7500)
1910–1912[l]	Alexandretta	1251	1122	2373
	Tripoli	880	320	1200
	Beirut	1857	633	2490
	Haifa	399	328	727
	Jaffa	1087	707	1794
	Total	(5500)	(3200)	(8700)
	Total 1910–1911	6600	3320	9920
	Total 1908–1912	5920	3673	9593

[a] In thousands of British pounds: Unless otherwise stated, all figures are from selections 1–4; figures in parentheses are estimated. NA, Not available.

[b] *EHME*, pp. 33–37; figures for French trade have been multiplied by two.

[c] "South Syrian ports," from Polk, *Opening*, p. 162; it is likely that this includes Beirut.

[d] Figures, including first total, from Douin, *Boislecomte*, p. 269; those for Tyre, Acre, and Jaffa refer to 1825 and those for Latakia and Tripoli to 1832; second total from Bowring, *Report*, (p. 135) who gives breakdown on p. 71.
MacGregor, *Statistics* (vol. 2, p. 250) gives the following totals, including trade with Egypt and Turkey:
 1835—exports £280,000, imports £480,000.
 1836—total trade with Europe £1,033,000, coasting trade £448,000.
 1837—£752,000 and £373,000, respectively.
 1838—£890,000 ad £657,000, respectively.

[e] Jaffa, 1843.

[f] Average of available figures; Tripoli from A and P 1859, vol. 30, "Tripoli."

[g] Average of available figures; Saida from Labaki, *Introduction*, p. 189.

[h] Average of available figures; exports from the *vilayet* of Syria (i.e., from Latakia, Tripoli, Beirut, Saida, Tyre, Acre, Haifa, and Jaffa) averaged £422,000 in FY 1868/69–1870/71, the 1870/71 figure being exceptionally low because of poor harvests and stoppage of shipments to France during the war; imports in those years averaged £1,181,000 (A and P 1872, vol. 58, "Syria").

[i] Average of available figures; Tripoli from Labaki, *Introduction*, p. 189.

[j] Average of available figures.

[k] Figures for Latakia, Tripoli, and Haifa from Kalla, "Foreign Trade," p. 256, and refer to 1898–1902.

[l] Figures for Tripoli and Haifa for 1912 from Ruppin, *Syrien*, p. 196; total for 1910/11 from idem, p. 188, for 1908–1912 from Kalla, "Foreign Trade," p. 256.

estimates have been made for the missing ports. At best, it gives only orders of magnitude and an indication of trends.[7]

With regard to the overall increase, between 1825 and 1910/11 imports rose by 13.2 times, exports by 11.1 times, and total trade by 12.4 times. Deflating by the British export and import price indices[8] suggests increases in real terms of about 31.8 times for imports

[7] For other, sometimes very different figures, see Kalla, "Foreign Trade," pp. 254–259, and Labaki, *Introduction*, pp. 182–199.

[8] See export and import price indices in Imlah, *Economic*, pp. 94–98.

or at a compound rate of about 4.1 percent per annum and 19.0 for exports or 3.5 percent. Taking the somewhat more reliable figures for 1833 as base, by 1910/11 imports had risen by 8.9 times, exports by 7.4 times, and total trade by 8.4 times. Again, deflating by the British indices gives a real increase of 14.0 times in imports, or at a compound rate of 3.5 percent, and 10.2 in exports, or 3.1 percent.

The rate of increase was far from uniform throughout this period, however, being influenced mainly by developments in European markets. During the Revolutionary and Napoleonic wars, trade sharply declined, that of France—which had accounted for about half the total—being practically wiped out; but British trade revived slowly after 1808. In real terms, the figures for 1825 were almost certainly lower than those of 1784.[9]

The period 1825–1833 was one of rapid expansion, caused partly by the upsurge in world trade and partly by the establishment of Egyptian rule and the growth of trade with Egypt (see below). Taking Boislecomte's figures, both imports and exports increased by just under 50 percent in nominal terms, and slightly more in real terms—or at some 5.5 percent per annum. This upsurge continued in 1833–1844, in spite of the withdrawal of the Egyptians. Imports rose by 83 percent, exports by 89, and total trade by 85 percent in nominal terms; and since British prices showed almost no change, these figures may be taken to represent the increase in real terms, which again averaged about 5.5 percent.

The figures for 1855–1857 reflect the expansion in exports caused by greater demand for grain during the Crimean War. Imports rose by 63 percent and exports by 159, while total trade just doubled; in real terms the figures were about 50 percent for imports and 125 for exports; for total trade the increase was about 80 percent, or about 6 percent per annum.

The low figures for 1861–1863 reflect the disruption caused by the 1860 disturbances and also, presumably, the decline in textile exports from Britain due to the "cotton famine" created by the Civil War in the United States. Exports fell by 27 percent and in spite of the rise of 9 percent in imports, total trade declined by 9 percent. The rest of the 1860s was a period of prosperity, and the figures for 1871–1873 show a rise of 17 percent in imports, 11 in exports, and 15 in total trade; since prices showed little change, these figures may be taken to represent real increases.

In the late 1870s and early 1880s the upward trend accelerated; by 1884–1885 imports had risen by 64 percent, exports by 22, and total trade by 43. In real terms, the increases may have been about 75, 25, and 50 percent, or about 3.5 percent per annum for total trade. The next decade registered much slower growth; in 1895–1897 imports stood 8 percent lower; exports were, however, 40 percent higher and total trade 10 percent. Prices fell in this period, and the real increase in total trade was about 1 percent per annum. The figures for 1900–1902 showed a rise of 12 percent in imports, a decline of 15 percent in exports, and an increase of 3 percent in total trade; the last was offset by the rise in prices.

The first decade of this century (to 1910/11) once more witnessed rapid growth: 35 percent in imports, 28 in exports, and 32 in total trade; in real terms the figures were some 10 percent less, or, say, 3 percent per annum for total trade. In the years 1911–1913, wars disrupted trade, which fell off in both nominal and real terms. It will thus be seen that, during the first half of the period, growth was much more rapid than in the second, which

[9]*EHT*, p. 86; Wood, *History*, pp. 179–195; Bailey, *British Policy*, pp. 74–76; Owen, *Middle East*, pp. 84–87; for price indices see Schumpeter-Gilboy and Gayer et al., in B. R. Mitchell and Phyllis Dean (eds.), *Abstract of British Historical Statistics* (Cambridge, 1971), pp. 331–332.

is not unreasonable; however, the unreliability of the figures precludes pressing this conclusion too far.

For Iraq's seaborne trade, the first reliable figures are those for 1844–1846 (in selection 13). The earlier figures seem too high in view of the unfavorable conditions prevailing in the first decades of the 19th century (chap. II). Moreover, the much more reliable figures in selection 15 show an increase in the trade of Bombay (by far Basra's most important partner) with the whole gulf of almost four times between 1801–1803 and 1855–1857, or at a compound rate of 2.5 percent per annum; using British export and import prices as deflators, the annual increase in real terms may have been 5–7 percent.

As for Basra, between 1845–46 and 1869–70, imports rose by 20 percent (or 0.75 percent per annum), exports by 136 percent (3.6 percent), and total trade by 69 percent (2.2 percent). In the interval, British export prices showed practically no change and import prices rose by 16 percent; in other words, the real increase in total trade may have been about 60 percent, or 2 percent per annum.

The opening of the Suez Canal in 1869 gave a great stimulus to shipping (chap. IV) and trade in the gulf. Between 1869–70 and 1912–13, imports rose from an average of £152,000 to £3,264,000, or 21.6 times (i.e., at a compound rate of 7.5 percent per annum); exports from £218,000 to £2,593,000, or 11.9 times (i.e., at 6 percent); and total trade from £370,000 to £5,862,000, or 15.8 times (i.e., at 6.6 percent).[10] Since both British export and import prices fell by 20 percent in this period, the real rates of increase may have been about 9, 7.2, and 8 percent, respectively.

A breakdown into two almost equal subperiods, 1869–70 to 1891–92 and 1891–92 to 1912–13, shows a marked slowdown. In the first, imports increased by 6.5 times (i.e., at 8.9 percent per annum), exports by 7.6 times (or 9.7 percent), and total trade by 7.2 times (or 9.4 percent). Moreover, British prices fell by about 25 percent in this subperiod. The rate of growth in the 1880s was far more rapid than in the 1870s.

In the second subperiod, imports increased by 3.3 times (or at 5.9 percent a year), exports by 1.6 times (or 2.3 percent), and total trade by 2.2 times (or at 3.9 percent); British prices remained steady in the subperiod. It should be added that in the 1890s trade was sluggish but that in the decade preceding the First World War imports rose much more rapidly—partly because of the import of construction materials and machinery for various development schemes (chaps. IV and V, Introduction)—and exports also picked up; between 1901–2 and 1912–13, imports rose at a rate of 8.9 percent a year, exports at 8.5, and total trade at 8.7 percent. In view of the very small rise in British prices, these figures may be taken to represent real growth.

Considering land trade, some information is available on Baghdad, by far the most important commercial center. In 1864/65–1868/69, exports to Iran averaged about £5500, or 2.1 percent of the total (£260,000), the remainder paying "duty at the port of shipment," presumably Basra.[11] Exports to Syria and other Ottoman provinces, for which no figures are available, may have been somewhat higher than those for Iran. However, imports from Iran were much larger, averaging £165,000 or 72 percent of the total (£230,000). Imports of both European and domestic goods from Syria were also quite large. In 1878/79 imports from Iran amounted to £103,000, or 22 percent of the total, and exports to £184,000, or 43 percent. A large part of the import trade with Iran

[10]See also tables in Hasan, *Al-tatawwur*, pp. 114 and 223.
[11]A and P 1870, vol. 64, "Baghdad."

consisted of goods for reexport.[12] In 1908 imports from Turkey averaged £43,000 and from the Persian Gulf £27,000, or a combined total of less than 2 percent of imports, and even here the figures probably refer to ports in the two areas. Exports to Turkey were £54,000, or about 7 percent of the total. In 1907/08 the transit trade with Iran was, for imports, about £900,000, and for exports about £300,000; in 1908/09 it was about £1,100,000 and £280,000, respectively. In 1913 the U.S. consul put Baghdad's transit trade with Iran, though Kermanshah, at $7 million for imports and $1.35 million for exports.[13] Mosul's trade was largely with Iran, Syria, and Turkey, but the amount was small (selection 14).

Balance of Trade and Balance of Payments

Available figures (Table III.1) indicate that in the 19th century Syria's sea trade consistently showed an import surplus, except during the Crimean War boom; this is in marked contrast with previous centuries, when Syria seems to have had an export surplus in its trade with Europe and to have hoarded specie.

Imports regularly exceeded exports in the two major ports, Beirut and Alexandretta, and also in Jaffa. Tripoli generally had an export surplus, and the few available figures for Saida also show a surplus. For the country as a whole, exports seem to have covered about 60 percent of imports in both the first 20 years (1825–1844) and the last 20 years (1895–1912); the intermediate period saw a slightly higher coverage, exports amounting to about two-thirds of imports.[14] However, it should once more be stressed that the unreliability of the figures introduces a large margin of error into such calculations. Moreover, it is probable that a substantial portion of the goods imported by sea were reexported by caravan to Iraq, southern Anatolia, and northern Arabia, thus partially offsetting the deficit.[15] Nevertheless all observers agree that, in the first half of the period, there was a large deficit in Syria's trade and that a considerable amount of specie was shipped abroad.[16]

After about 1860, certain invisible items helped to offset the import surplus and reduce the deficit on current account. First, there was the growing expenditure by pilgrims and tourists, primarily to Palestine but also to Lebanon (II,12) and Damascus. In 1896 the British consul reported that some of the tourist traffic to Egypt—which had greatly increased since the British occupation—was spilling over into Palestine and was now averaging 2000–3000 a year; five good new hotels had sprung up in Jerusalem and three in Jaffa. In 1899 the number of tourists in Jerusalem was put at 2300 (two-thirds British and American) and of Christian pilgrims at 13,400, of whom 7500 were Russians. In

[12]A and P 1878/79, vol. 72, "Baghdad"; see also Hasan, *Al-tatawwur,* pp. 89–90, 128–129, 216–217, and 253, and *EHI,* pp. 120–121.

[13]Report in FO 195/2308; A and P 1911, vol. 96, "Baghdad"; "Report on Political Conditions," US GR 84, C8.9, vol. 5.

[14]For a fuller discussion that, however, does not cover Alexandretta or Jaffa, see Labaki, *Introduction,* pp. 200–225; see also Kalla, "Foreign Trade," pp. 30–40.

[15]Himadeh, *Economic Organization,* pp. 199–200.

[16]See Chevallier, *La société,* pp. 192–199; A and P 1859, vol. 30, "Aleppo"; however, this outflow of specie gradually diminished, and in Aleppo in 1900–1913 there was actually a very small inflow, see Kalla, "Foreign Trade," pp. 38–39.

1906, some 1200 tourists visited Damascus and spent there about £12,000; in 1909 about 1200 American tourists visited Beirut.[17] Ruppin gave the following figures for 1912: European and American tourists 5300, Christian pilgrims 24,000, and Muslim pilgrims 20,000 (IV,8), with a combined annual expenditure of 10 million francs (£400,000).[18]

Second, there were the remittances sent to Jews in Palestine by Jewish associations, and capital brought in by immigrants. Ruppin put the total at 10 million francs a year.[19] To this should be added a small amount sent to the German settlers in Palestine (II, Introduction).

Third, there were the remittances sent by emigrants to the Americas, primarily to Lebanon (II, Introduction). In 1906 the British consul estimated the annual amount received by the province of Damascus at £150,000; a Lebanese economist put the amount received by *mutasariflik* of Lebanon at 90 million piasters, or about £800,000. Ruppin put the total at 30 million francs (£1,200,000), of which 15 million was sent through banks in Beirut, 12 million through banks in Tripoli, and 3 million through banks in Homs.[20]

Fourth, there were the sums sent by Christian philanthropic organizations for the upkeep of schools, churches, hospitals, and other institutions in Palestine, Lebanon, and elsewhere; the total was put at 10 million francs a year by Ruppin.[21]

Finally, there was the annual expenditure by the Ottoman government of some £100,000 for the Hajj caravan (IV,8). The total received from the above-mentioned sources was, in the years immediately preceding the First World War, about £2.5 million a year, which just offset the deficit in the balance of trade. In previous decades these receipts had been much smaller, but so was the import surplus.

Another item that can only be mentioned, not quantified, is transactions between the provincial governments in Syria and the central government in Istanbul—and for a short period, Cairo. In the 1830s and 1840s there was a deficit, which was covered by transfers from Cairo and Istanbul (VII,6). By the late 1870s, Syria was transferring funds to Istanbul (VII, Introduction). On balance, this item must have shown a debit in Syria's accounts.

Looking at the capital account, Table III.2 gives the main European investments in Syria (in millions of francs).[22] To this may be added a very small amount invested in various industries, banks, and commercial houses. Labaki judges that an annual inflow of 10 million francs a year seems reasonable and that the profits made on these foreign investments averaged about 19 million francs a year. It seems likely that, in the years 1890–1912, Syria's current account may have been close to a balance and that any deficits that may have been incurred were covered by capital inflow.

Very little can be said about the balance of trade or payments of Iraq. The available figures on Basra seem to indicate a persistent import surplus until 1869 (selection 13). This was aggravated by the fact that Baghdad's imports from Iran far exceeded its exports to it, and there is no reason to believe that this deficit was offset by an export surplus in

[17]A and P 1896, vol. 89, "Jerusalem"; 1900, vol. 96, "Palestine"; 1908, vol. 116, "Damascus"; Ravndall to Gottschalk, 28 March 1910, US GR 84, C8.5.

[18]Ruppin, *Syrien*, pp. 330–332.

[19]Ibid., p. 18.

[20]A and P 1908, vol. 117, "Damascus"; Ruppin, *Syrien*, pp. 15–16; see also *EHME*, pp. 269–273; in 1896 remittances were put at £T. 143,000 ("Report on Trade," 1896, CC Beyrouth, vol. 12).

[21]Ruppin, *Syrien*, p. 18.

[22]Monicault, *Le Port de Beyrouth*, p. 32; Labaki, *Introduction*, pp. 219–223.

Table III.2 Major European Investments in Syria

Project	Amount invested (millions of francs)
Beirut–Damascus road	4.2
Port of Beirut	13.5
Jaffa–Jerusalem railway	20.5
Damascus–Muzayrib railway	10.6
Beirut–Damascus railway	26.5
Rayak–Hama railway	31.7
Hama–Aleppo railway	27.6
Homs–Tripoli railway	15.7
Beirut–Mamaltain railway	5.7
Baghdad railway (Syrian portion)	17.0
Beirut waterworks	9.0
Damascus streetcars and electricity	6.0
Beirut streetcars	8.4
Beirut gas and electricity	9.0
	205.9

Baghdad's trade with Syria or Turkey. In 1846 the British consul stated that Baghdad had a deficit in all directions, amounting to at least 4 million *krans,* or £200,000; in addition, some £50,000 was remitted annually to Istanbul. Specie was therefore being drained.[23] The few data on Mosul (selection 14), however, show a small export surplus that may have reduced the country's deficit.

As regards invisibles, there was one very large credit item, the expenditure by Persian pilgrims in the Shi'ite Holy Cities of Iraq. In 1875, a British consul reported that 100,000 pilgrims used to come each year and estimated that their average annual expenditure was just over £1 million, which probably more than offset the total deficit in merchandise trade. In 1800, such expenditure had been put at £100,000 and in 1846 at £125,000. The Iranian government tried to divert this pilgrim traffic to the Persian Holy Cities of Meshad and Qum, and seems to have had some success, but in 1905 some 95,000 Iranian pilgrims came to Iraq and in 1910 about 55,000.[24] There was also probably another debit item, the remittance of revenue to Istanbul (VII, Introduction). In the absence of significant immigration to or from Iraq, or tourism or foreign capital investment, it may be assumed that other invisible items were negligible.

After the opening of the Suez Canal, Basra's exports surged and almost invariably exceeded imports. For the period 1870–1907, available figures show an average export surplus of about £130,000, or 16 percent of imports. This surplus may not have sufficed to offset the deficit in Baghdad's trade with Iran and the one shown by the few available figures for Mosul in 1884–1897. However, pilgrim expenditures must have been an important balancing item. Starting in 1908, however, Basra's trade shows a large import surplus. This was due partly to a change in methods of customs valuation but mainly to the large increase in imports of construction materials and machinery for the irrigation works and railways. Mosul's trade showed a large surplus in these years.

A significant debit item was the transfer of funds to Istanbul, not only by the

[23]Rawlinson to Canning, 3 February 1846, FO 195/237; the same was true of trade between the Gulf and India in 1802–1806, see Milburn, *Oriental Commerce*, vol. 1, p. 123.

[24]See *EHI*, pp. 128–129, and document reproduced; the 1846 figure was given by Rawlinson—see note 23.

provincial governors but also by the Saniyya Administration, which received large revenues from the lands registered in the name of the Sultan; but counterbalancing that there was considerable government investment in irrigation.[25] Foreign capital investment and tourism continued to be negligible but pilgrim expenditure was large.[26]

Channels of Trade

The channels of Syria's trade are traced by geography. Two sets of high mountain ranges stand between the cities of the interior and the coast, and it is through their gaps that trade has always flowed. For northern Syria the main port was Alexandretta, with its excellent natural harbor. To it flowed most of Aleppo's trade, along a road through the gap formed by the 'Afrin River. A small part of Aleppo's trade, however, passed through Latakia, along a road crossing the Orontes ('Asi) at Jisr al-Shughur and continuing along the Nahr al-Kabir River. Aleppo was the great emporium of northern Syria, its trade radiating into southern Anatolia, Kurdistan, and northern Iraq (selection 5).

The outlet for central Syria, with its two towns of Homs and Hama—and also for northern Lebanon—was Tripoli. The road from Homs to Tripoli, which was short and with a relatively low gradient, passed through the gap between Lebanese and Ansariya mountain ranges.

Southern Syria had two main ports, Saida and Acre, both serving as the outlets of Damascus and Hauran. The road from Damascus passed through the Biqa' valley skirting the Anti-Lebanon range, and then bifurcated, one branch reaching Acre through the gap between the Lebanese and Judean mountains and the other going north to Saida through Marj'uyun. Acre, which had quite a good natural harbor, was also the outlet for northern Palestine. Damascus was the terminus of the caravans to Baghdad and of the pilgrimage caravans to Mecca and Madina (selection 6 and IV,8).[27]

In addition, Beirut served a small Lebanese hinterland, Jaffa was the port of Jerusalem, and Gaza, besides providing an outlet for southern Palestine, was a station on the coastal caravan route to Egypt.

The most striking features of the period under review were the spectacular rise of Beirut in the 1830s, at the expense of Saida and Acre; the recovery and subsequent slowdown of Alexandretta; and the upsurge of Haifa in the last 20 years preceding the First World War.

In the 18th century Beirut, under its amirs from the Mountains (i.e., until 1775, when it was taken over by the pasha of Acre), enjoyed a reputation as a pleasant, healthy, and tolerant place. However, its business was not large enough to justify the establishment of a European trading house, although European ships called there to unload Egyptian rice and textiles and to take Lebanese silk.[28] The withdrawal of French firms from the Levant during the Revolutionary and Napoleonic wars, however, gave the local Christian merchants their chance, and they soon established new channels of trade with Europe (selec-

[25]For a more detailed account, see Hasan, *Al-tatawwur*, pp. 404–414.

[26]In 1919 "the capital value of the railways, steamers, ports and buildings built by British capital, whether public or private," mostly during the First World War, was put at "£10 million at least"; that of the oil fields was estimated at £50 million (Dispatch of 22 July 1919, FO 371/4149).

[27]For the markets and *Khans* of Damascus, see Qasatli, *Kitab al-Rawdah*, pp. 97–100, 110–111.

[28]Charles-Roux, *Les Echelles de Syrie*, pp. 79–80.

tion 7). By 1825 Beirut was handling most of the trade of Damascus, at the expense of Saida, but its position was not yet completely secure (selection 6). A few years later its leadership was uncontested. Under Egyptian rule, Beirut's trade greatly increased and its situation improved further. One factor was that Damascus now became more accessible to Europeans. Several European houses were opened, but most of the trade was handled by Lebanese, mainly Christians, who had been allowed by Muhammad Ali to become consular agents for foreign powers (selections 7–10). The establishment of steam navigation lines (IV, Introduction) further increased its importance, since they used Beirut as their main coaling station. So did its designation as the provincial administrative center, first by the Egyptians and then by the Ottomans, thus attracting foreign consuls to the town.[29] Ingenuity also helped. In 1846 the local farmers of the customs allowed importers to pay only 3.5–4 percent duty, while getting receipts for 5 percent, and thus diverted trade from other ports where the full 5 percent duty was levied.[30]

In 1851 the French consul stated that Beirut had become "the center of commerce and all the European houses are established in that town"; however, except for silk, exports were all sent through other ports, "particularly Jaffa whose trade, in the last few years, has shown a notable increase."[31] The 1860 civil disturbances (II,2) at first disrupted Beirut's trade but eventually greatly strengthened it by driving thousands of refugees from the Mountain and Damascus, which increased both its total population and its active Christian component.[32] The building of first a road (in 1863) and then a railway (in 1895) to Damascus largely overcame Beirut's main handicap, the steepness of the mountains lying between it and the interior. And in 1893 Beirut inaugurated the only modern port in the Levant between Smyrna and Port Said (IV, Introduction). The city's progress is illustrated by the growth in its population (II, Introduction) and trade (selection 2). Another index is the increase in foreign firms. In 1849, there were 5 British (and 2 Ionian and Maltese) and 14 French houses in Beirut.[33] In 1910 the U.S. consul reported that, in the Beirut consular district, there were 7 German firms, 4 French, 4 British, 3 Italian, 2 Austrian, 2 Belgian, 2 Swiss, and one American, "most of them engaged as import commission agents and bankers."[34] However, the bulk of trade had long since passed into Lebanese, mainly Christian, hands (selection 9).

The figures in Table III.1 show that, between 1833 and 1871–1873, Beirut's imports rose by 2.8 times, or at 2.7 percent per annum, and its exports by 2.56 times, or at 2.5 percent; between 1871–1873 and 1910–1912, the rise in imports was 1.5 times, or at 1.1 percent, and in exports 1.03 times, or at 0.1 percent. Table III.1 also shows that Beirut's dominance in Syria's trade reached its peak in the middle of the century, when it accounted for about three-quarters of the total. Its share then fell to 40 percent in 1860–1885 and 30 percent thereafter. This was partly due to the increase in the trade of Alexandretta and Jaffa. But even in the narrower range of "the coast ports from Haifa to Latakia," Beirut's share of exports fell from 60 percent in 1892 to 46 percent in 1901,

[29]Guys to Minister of Foreign Affairs, 20 March 1836, CC Beyrouth, vol. 2; Fawaz, *Merchants and Migrants,* pp. 21–26.

[30]"Trade Report for 1846," CC Beyrouth, vol. 5.

[31]Report of 26 July 1851, CC Beyrouth, vol. 6.

[32]Fawaz, *Merchants and Migrants,* pp. 28–60; Labaki, *Introduction,* pp. 182–204.

[33]Replies to circulars, FO 83/111; for figures on the rest of the Ottoman Empire and other countries see *EHT,* pp. 100–101.

[34]Ravndall to Gottschalk, 28 March 1910, US GR 84, C8.5.

although it remained as the "distributing centre for the whole district." The main reason for the decline in exports was stated to be "the excessive rates charged by the railway and port companies"[35] (IV, Introduction). This helped to divert trade to Tripoli and Haifa, whose communications with the interior were improving.

Alexandretta's trade reflects the vicissitudes of Aleppo. In the 18th century that city had been by far the largest and most active in the Fertile Crescent (selection 5). In addition to the agricultural produce of its large hinterland, extending deep into present-day Turkey and Iraq, and the products of its handicrafts (VI,3), Aleppo derived its commercial importance from its transit trade with Iraq and Iran. In 1846, before conditions were drastically changed by steamships and the Suez Canal, a French consul estimated the time required for and cost of transporting textiles from Switzerland to Baghdad as follows: Switzerland–Trieste 20–25 days, 3–4 percent; Trieste–Beirut by sailboat, 25 days, 1.5 percent; Beirut–Aleppo 10 days, 1 percent; Aleppo–Mosul–Baghdad 50–60 days, 4.5–9 percent—that is, altogether 4 months and 12–14 percent, including commissions of agents in Beirut and Trieste (1.5–2 percent). By contrast, the journey from Trieste to Bombay, around the Cape, took 6–7 months and cost 12–15 percent, and the insurance costs were also higher.[36]

The second half of the 18th century and first decades of the 19th, however, saw a sharp decline in Aleppo's activity.[37] A very important factor was the collapse of Iran's silk production and the diversion of much of its exports of silk through the gulf, instead of overland to Aleppo and the Mediterranean.[38] Another was the fighting between political factions, which greatly hurt the city's economy. As a result, whereas around the middle of the 18th century there had been 28 British firms in Aleppo, by 1792 British interests were represented only by the consul (selection 9). In addition, all French houses closed down after Napoleon's invasion of Egypt.

In 1822 a severe earthquake caused much damage. This was soon followed by the influx of machine-made textiles from Europe, which hurt the handicrafts (VI, Introduction).

Aleppo's trade recovered during the boom resulting from the Crimean War, when grain exports soared. In 1857, abundant crops in Europe caused a fall in the price of cereals; the severe crisis that followed resulted in a drain of currency and a suspension of business.[39] However, the rise in exports of cotton and other commodities during the American Civil War lifted foreign trade to a record level in both money and real terms (selection 1). Another crisis followed in 1866.[40] During this period an important shift occurred: in spite of the anti-Christian riots of 1850, native Christian and Jewish merchants took over most of the trade at the expense of Europeans. In 1855 the French consul reported that the *rayas*, "being less oppressed, have been able to enter into direct contact with Europe"; the European firms had been forced to push into the hinterland—to Urfa, Diyarbakr, Mosul, and Baghdad.[41] In 1859 the British consul noted the same phe-

[35] A and P 1902, vol. 110, "Beirut."

[36] Report for 1846, CC Beyrouth, vol. 5.

[37] See Davis, *Aleppo;* Masson, *XVIII^e siècle;* Paris, *Histoire du commerce; EI2*, s.v. "Halab"; Bodman, *Political Factions*, passim.

[38] See *EHI*, pp. 12–13, 82–91.

[39] A and P 1859, vol. 30, "Aleppo."

[40] A and P 1866, vol. 69, "Aleppo"; 1868/69, vol. 60, "Aleppo."

[41] Grasset to Drouyn, 14 January 1855, CC Alep, vol. 31.

nomenon and in 1872 reported: "A few years since, five [British] houses existed; not one remains."[42]

At this point a new factor began to affect Aleppo's trade adversely: the opening of, first, the Egyptian railway and then the Suez Canal. Already in 1863 the U.S. consul had reported: "Since imports have entered the country by Basorah, the Persian Gulf, by Moussal and Mesopotamia, the imports of Aleppo of sugar, coffee, indigo and dyestuff have much diminished."[43] In 1879 the British consul stated that the canal had diverted Iraq's exports away from Aleppo; instead they were being floated down the river and shipped from Basra. Some of Baghdad's import trade had also been diverted, but "the greater part of the import trade of northern Mesopotamia and Kurdistan still passes through Aleppo."[44] Aleppo adjusted to the new situation and, presumably thanks to the increased output of its northern hinterland, its exports rose until 1908 and with them its imports. Between 1833 and 1871–1873, Alexandretta's imports rose by 8.59 times, or at a compound annual rate of 5.7 percent, and its exports by 9.15 times, or 6.0 percent; between 1871–1873 and 1906–1908, the increase was 2.11 and 1.99 times, or 2.2 and 2.0 percent.

Jaffa's trade expanded rapidly. Between 1825 and 1871–1873 imports rose by 19.71 times, or at a rate of 6.6 percent a year, and exports by 49.4 times, or at 8.7 percent. Between 1871–1873 and 1910–1912 the increase was 7.88 times, or 5.4 percent, and 2.86 times, or 2.7 percent, respectively. The rise in exports was due to greater shipments of grain, olive oil, soap, and, increasingly, oranges. The rise in imports is to be explained by the development of Jerusalem, by Jewish and to a lesser extent German immigration, and by the tourist trade. Jaffa also absorbed much of the caravan trade to Egypt.

Saida's trade, on the other hand, declined. In 1862, imports were only £21,900 and exports £64,000, and in 1897 they were only £33,000 and £48,000,[45] figures well below those for 1784.

Tripoli's trade expanded rapidly, imports rising by 30.76 times, or at 7.0 percent, between 1833 and 1884–1885, and exports by 13.0 times, or at 5.2 percent. After that the rate of increase fell sharply: between 1884–1885 and 1910–1912 imports rose by 1.14 times, or at 0.5 percent, and exports by 1.12 times, or 0.4 percent.[46] The linking of Tripoli to the interior by road in 1883 does not seem to have had much effect on trade (IV, Introduction).

Finally, Haifa's trade developed very rapidly in the 20 years preceding the First World War, when it took over Acre's trade and became the main port for northern Palestine. Between 1895–1908 and 1910–1912, its imports rose by 2.49 times, or at 6.3 percent, and its exports by 5.47 times, or at 12.0 percent. Here too, as in Jaffa, Jewish and German immigration played an important part, and the extension of the Hijaz railway to Haifa in 1905 diverted to it some of the exports of grain from Hauran.

Iraq's trade has always followed the course of its rivers, from Mosul to Basra. At Baghdad three routes radiated from this axis: the ancient Silk Road through Khaniqin and Kermanshah to Tehran, the caravan route to Damascus (IV,1), and the one to Aleppo.

[42]A and P 1859, vol. 30, "Aleppo"; 1872, vol. 58, "Syria."

[43]"Report on Alexandretta," 1863, US GR 84, T367.5.

[44]A and P 1878/79, vol. 72, "Aleppo."

[45]Labaki, *Introduction*, p. 189.

[46]Ibid., pp. 188–191.

From Mosul, a route ran west to Aleppo, through Mardin and Urfa, another north, through Diyarbakr and eventually to the sea at either Samsun or Istanbul, and a third east through Arbil and Ruwanduz to Tabriz.

In the period under review there were large changes in the relative importance of these routes. Iran's trade shifted dramatically: whereas traditionally it had followed mostly an east–west axis, linking Tabriz with Erzurum, Hamadan and Kermanshah with Baghdad, and Mashad with Afghanistan and Central Asia, through Herat or Kandahar, by the end of the 19th century most trade flowed in a north–south direction: to Russia overland from Tabriz or across the Caspian and to India and Europe through Bushire and other gulf ports. The importance of trade through both Baghdad and Mosul was greatly diminished, although there was a revival of the Baghdad route in the 1880s.[47]

As for the caravan trade with Syria, following the high degree of security prevailing under Egyptian rule, conditions greatly deteriorated. In 1842, a caravan was robbed of 500,000 piasters worth of goods, two days from Damascus.[48] In 1857 the ʿAnaza plundered the Damascus caravan near Hit, taking 10 million piasters worth; as a result the route remained closed for over two years.[49] In 1861 several pilgrim caravans and one with merchandise worth £5000–6000 were pillaged in Iraq.[50] In 1866 the Baghdad–Aleppo caravan was robbed of £6000 worth, by the ʿAnaza, and in 1871 the Shammar robbed the Mosul–Aleppo caravan.[51] As late as 1901 the Ghiyath plundered the Baghdad–Damascus caravan, "right under the nose, so to speak, of Husrev pasha."[52] In addition, the opening of first the Egyptian railway and then the Suez Canal diverted much transit trade from Iraq. Together with the introduction of steam navigation on the rivers (IV, Introduction), it also pulled much trade away from the caravans and toward Basra. The same factor also operated on Mosul's northern trade, since it became much cheaper to ship goods to Basra and then through the canal than to send them to Samsun or Istanbul. At the same time the improvement of communications in Turkey pulled away some trade from Mosul and toward the Turkish seaports on the Black Sea or Mediterranean. Altogether, a much smaller proportion of Iraq's trade went through the various land routes in 1913 than it had a century earlier.

As regards the organization of trade, foreign merchants—as well as Jews and Christians enjoying foreign protection—had an immunity (which they sometimes abused) against the arbitrariness of officials that, together with their overseas connections, enabled them to attain a predominant position. In 1839/40 two British firms were established in Baghdad and in 1859/60 two Greek and one Swiss firm, which carried on the import trade with Europe. However, by 1879, "The Jewish Mercantile Community of Baghdad have nearly all the trade with England in their hands whereas the native Christian merchants trade mostly with France. There are only two English merchant firms in Baghdad."[53] In spite of the establishment of another two British firms by 1888,[54] the import trade

[47]See *EHI*, pp. 73–74; *EHT*, pp. 120–127.

[48]Consul to Guizot, 21 March 1842, CC Damas, vol. 1.

[49]Misk to Clarendon, 31 August 1857, FO 78/1298; "Report on Trade," 1859, FO 78/1450.

[50]Kemball to Bulwer, 18 December 1861, FO 195/676.

[51]Kemball to Lyons, 17 October 1866, FO 195/803; Herbert to Elliot, 17 July 1871, FO 195/949.

[52]Richards to O'Conor, 2 April 1901, FO 195/2097.

[53]"Trade Report" 1878/79, FO 195/1243; see also A and P 1878/79, vol. 72, "Baghdad."

[54]A and P 1889, vol. 72, "Baghdad."

remained firmly in Jewish hands up to and beyond the First World War.[55] However, when it came to the export trade of Basra, "by far the greater portion . . . is in the hands of our countrymen, or of Indian subjects of Her Majesty,"[56] and there were some Iraqi or Persian Muslims as well.

Direction of Trade

Until the 19th century the trade of both Syria and Iraq was conducted mainly with their neighbors (Turkey, Egypt, Iran, and Arabia) and with each other (chap. I). Iraq also traded extensively with India, as it had done since antiquity, and Syria with Europe; from the 17th century its main partner was France, which may have accounted for half the total, the other half being shared by the Netherlands, Britain, and Venice.[57]

During the Revolutionary and Napoleonic wars French trade with Syria was cut off, and gradually replaced by British. The British ascendancy lasted until the First World War, but was slowly reduced by the successive emergence of competition from Egypt, France, Austria, Germany, Italy, and others. France soon regained its predominance among export markets and kept it until 1914, and after. These trends come out clearly in selections 1–4.[58]

In 1838, when Syria was closely tied up with the Egyptian economy, Egypt supplied 31 percent of imports and took 41 percent of exports. It was followed by Turkey (18 and 16 percent), France (14 and 22 percent), Tuscany (19 and 11 percent), Britain (15 and 2 percent), and Austria (3 and 3 percent).[59]

By 1855, however, a pattern had been established that was to last, with minor changes, until the First World War: Britain had 32 percent of Beirut's imports and 10 percent of its exports, France 28 and 21, Austria 29 and 38, Egypt 9 and 8, Turkey 0.2 and 8, Tuscany and Sardinia 2 and 9, and the United States 0.2 and 5.[60] In 1858 Britain supplied 65 percent of Aleppo's imports and took 5 percent of its exports, France's share was 10 and 32, Austria's 7 and 1, Turkey's (including Egypt?) 6 and 56, and Tuscany and Sardinia's 12 and 6.[61]

In 1880 Britain and its possessions supplied 62 percent of Aleppo's imports and took 5 percent of its exports; the share of France was 14 and 22 percent, of Turkey 11 and 41, of Egypt 4 and 25, of Austria 5 and 1, and of Italy 2 and 2.[62]

Figures for 1910, a normal year, show that Britain and its possessions supplied 36 percent of the combined imports of Alexandretta, Beirut, and Jaffa, and took 10 percent of their exports. The share of France was 9 and 32 percent, of Turkey 16 and 23, of Egypt 3

[55]See Issawi, "Transformation of the Economic Positions of the *Millets*" in Braude and Lewis, *Christians and Jews,* pp. 269–270; see also II, Introduction.

[56]Consul-General to Ambassador, 27 August 1887, FO 78/4106.

[57]*EHME,* p. 37.

[58]For a much more extensive treatment see Kalla, "Foreign Trade," pp. 22–30; Labaki, *Introduction,* pp. 227–261; Verney and Dambmann, *Les puissances,* pp. 481–626.

[59]Table in Bowring, *Report,* p. 135; in 1833 the Egyptian share was much smaller and the British larger, see table in Douin, p. 269.

[60]Kalla, "Foreign Trade," p. 25, citing Hasani, *Tarikh suriya,* p. 194; both also give figures for 1844–1846.

[61]"Report on Trade," FO 78/1452; the figure refers to "Turkish ports."

[62]A and P 1880, vol. 73, "Aleppo."

and 22, of Austria 9 and 1, of Italy 8 and 2, of Germany 7 and 1, of Russia 5 and 2, and of the United States 1 and 6.[63] It will be seen that Syria's trade was less concentrated than it had been half a century earlier, and an index of concentration—which, however, errs in comparing Beirut to the whole of Syria—shows a decline in both imports and exports.[64]

The most important development was the emergence of German, and renewed Austrian, competition in the 1890s. Both British and French consular reports contrast unfavorably the attitude of their merchants and manufacturers with those of the Germans and Austrians, for example, from Beirut: "English merchants could probably compete advantageously . . . if they sent commercial travellers with patterns to push their goods, and if they had trustworthy agents on the spot acquainted with the peculiar business habits of the country. The Austrians and Germans are the most active in this respect; English commercial travellers are never seen here"; and from Aleppo: "owing to foreign competition and the want of enterprise of merchants at home, we are gradually losing all share in [import trade]. Germans and Swiss send out suitable and cheaper goods."[65] For his part the French consul complained that French merchants were not trying hard enough; their rivals, especially the Germans and Austrians, took great care to "flatter the tastes of their clients," going as far as to create, upon request, new items appropriate to the Oriental way of life"; their commercial travelers were excellent and carefully studied the market; they quoted c.i.f. prices instead of f.o.b. at the factory or at best Marseilles, etc.[66]

United States trade with Syria was small. Around 1850, merchants from Boston, New York, and Philadelphia established direct contact with Syria, taking wool and supplying some sugar; in 1859 the U.S. consul reported: "American commerce with Syria is yet in its infancy and is principally confined to the wool trade. Wool is taken in exchange for lumber, which is in very great demand and yields a heavy profit. House furniture also finds a ready market."[67] Soon after, the United States started supplying kerosene and for a while had a virtual monopoly, but in the 1880s Russian oil entered the market and in the last prewar years provided 50–60 percent of the total, compared to 20–30 percent for the United States, the balance coming from Rumania and Austria.[68]

Until the Suez Canal made direct maritime contact with Europe possible (IV, Introduction), Iraq's trade was mainly conducted with India (see selection 16). In 1845–1846, imports from India accounted for 68 percent of Basra's total trade and exports to it for 74 percent; moreover, imports from India seem to have consisted mainly of goods made in that country (selection 22). On the import side, however, European goods carried from Syria or Turkey, and Iranian goods featured prominently in the trade of Mosul and Baghdad (selections 1, 3, and 5).[69]

By the 1860s British goods were entering in larger quantities, overwhelmingly by way of India. Taking the average for 1864/65 and 1865/66, imports from India and Britain accounted for 83 percent of Basra's imports, and about 99 percent of its exports went to those two countries. However, the last figure does not include goods on which

[63]Ruppin, *Syrien,* pp. 193–194.

[64]Kalla, "Foreign Trade," pp. 25–29.

[65]A and P 1893/94, vol. 91, "Beirut"; 1897, vol. 94, "Aleppo"; see also *EHT,* p. 87.

[66]"Trade Report" 1895, CC Alep, vol. 38.

[67]"Trade Report" 1853, CC Beyrouth, vol. 7; Johnson to Cass, 30 September 1859, US GR 84, C8.

[68]Ruppin, *Syrien,* p. 221; see also *EHT,* pp. 138–143.

[69]See also *EHME,* pp. 135–136.

duties were levied in the interior before arrival at Basra; the balance was with Iran and gulf ports. A breakdown suggests that the bulk of the exchange was with India rather than Britain.[70] In 1903, however, the British consul estimated that 43 percent of goods imported to Basra and Baghdad were of British origin and 17 percent Indian and Colonial. As regards exports, in 1903 Baghdad exported to Europe and America £652,000 and to India and China £71,000 worth of goods.[71] As for Mosul, deducting trade with Baghdad and Kurdistan, in 1897, Britain supplied 37 percent of imports and took 50 percent of exports, India 4 and 10, France 8 and 16, Syria 6 and 23, and Turkey 36 and 3 percent.[72]

At this point two new competitors entered the scene. On the one hand, exports to the United States—mainly of dates and liquorice—rose markedly and, together with Russia, it supplied oil until production began in Iran. On the other, imports from Germany, carried by ships of the Hamburg–Amerika line, rose dramatically, causing much anxiety in British circles (IV, Introduction).[73] Nevertheless, at the outbreak of war Britain was still by far the major supplier and market. In 1913 it provided 45 percent of Baghdad's imports and took 33 percent of its exports. India's share was 20 and 4, the United States 0.3 and 18, France 3 and 19 (mainly wool), Germany 5 and 6, and Austria 9 and 3.[74] This pattern did not change appreciably until Iraq began to export oil in 1935.[75]

Composition of Trade

There was no fundamental shift in the composition of Syria's exports, but significant changes are brought out in Table III.3.

The main items in the "agricultural products" column are wheat, barley, cotton, tobacco, and sesame. Cereals reached a peak in the 1880s but then suffered from the worldwide fall in prices caused by greatly expanded exports from the Americas, Russia, and India. Raw cotton exports, important in earlier centuries, gradually dwindled because of greater competition and a decline in production (V, Introduction). Tobacco exports were reduced by the action of the state monopoly (V, Introduction). Sesame, exported mainly from Jaffa and Haifa to France and Austria, became the leading item in this group.[76]

From the 1880s on, by far the leading fruit exported was citrus, grown in Palestine and the coast of Lebanon and sent to England, Russia, Egypt, and Turkey (V, Introduction).[77]

Pastoral products consisted mainly of livestock and butter exported from Alexandretta to Egypt, and wool and hides to Europe and the United States. Growing exchanges with the beduins led to larger quantities being offered for sale (V,18).

The main wild products were sponges (V,2), gallnuts, saffron, and liquorice.

[70]A and P 1867, vol. 67, "Basra."

[71]A and P 1904, vol. 101, "Basra," "Baghdad."

[72]A and P 1899, vol. 103, "Mosul"; the import figure for France covers continental Europe.

[73]See also *EHME*, pp. 350–355.

[74]A and P 1914–1916, vol. 75, "Baghdad."

[75]For further information see Hasan, *Al-tatawwur*, pp. 128–137, 253–261.

[76]Ruppin, *Syrien*, pp. 197–198; Labaki, *Introduction*, p. 326.

[77]Ibid.

Table III.3 Syria: Percentage Shares of Export Classes

Time period	Agricultural products	Fruits	Pastoral products	Wild products	Cocoons and raw silk	Processed and manufactured
1835–1837	16	NA[a]	1	2	69	11
1844–1846	10	NA	14	17	27	33
1873–1877	21	1	29	4	31	14
1878–1882	31	5	19	3	23	20
1883–1887	42	4	12	6	25	12
1888–1892	20	5	19	4	33	18
1893–1897	17	8	17	4	33	20
1898–1902	19	8	16	5	33	19
1903–1907	19	8	19	3	33	17
1908–1912	22	11	19	4	26	18
1913	19	16	20	2	25	18

Source: Kalla, "Foreign Trade," p. 41. (Earlier figures are partly estimated; see breakdown on pp. 260–265.)

[a]NA, Not available.

Sponge exports diminished because of the emigration of divers to the United States, and gallnuts and saffron because of the competition of synthetic dyes.[78]

Silk continued to be the largest single product (V, Introduction and V,6 and 7) and was sent from Beirut and Tripoli, mainly to France. The decline in the 1870s and 1880s shows the impact of the *pébrine* disease and of competition from the Far East. The share of cocoons in relation to raw silk rose steadily but remained a small fraction (V, Introduction).

The last column consists mainly of cotton and silk textiles, produced by the handicrafts of Aleppo and Damascus (VI, Introduction and VI,2,3, and 6) and exported mainly to Egypt and Turkey. Another important item was soap, made from olive oil and exported from Tripoli and Jaffa, also to Egypt and Turkey.

As pointed out by Labaki, a comparison of the figures for 1833 with those for 1910 shows a marked "primarization" of exports. Raw products, such as textile fibers, livestock, cereals, and fruits, which accounted for 30 percent of the total in 1833, rose to 67 percent by 1910, while processed goods fell from 42 percent to 17 percent. On the other hand, with the appearance of citrus, sesame, soap, wine, and various handicraft products, exports had become slightly more diversified.

The shift in Syria's imports is more pronounced, as may be seen from Table III.4. However, this table is less accurate than the one on exports, and should be used with even greater caution.[79] A perusal of Kalla's breakdown and of Labaki's analysis comparing 1833 with 1910 brings out the following changes[80]:

First, there was a sharp decline in textiles and clothing, from a peak of over 80 percent around 1880 to 34 percent in 1913. It should be noted that in some years cotton yarn was included under this heading; available figures show a sharp increase in this item from £25,000 in 1836/37 (£120,000 in 1833 according to Boislecomte), to £900,000 in 1913. Given the great reduction in yarn prices between these dates,[81] this represents a

[78]Labaki, *Introduction*, p. 337.

[79]Labaki, *Introduction*, pp. 327–343.

[80]Kalla, "Foreign Trade," pp. 266–275; Labaki, *Introduction*, pp. 303–323.

[81]Imlah, *Economic*, p. 105; and see Table III.7 below.

Table III.4 Syria: Percentage Shares of Import Classes

Time period	Food, drink, tobacco	Textiles and clothing	Fuel	Other consumer goods	Intermediate goods	Capital goods
1836–1837	13	58	NA[a]	NA	29	NA
1844–1846	5	56	NA	9	30	NA
1873–1877	11	76	1	NA	11	NA
1878–1882	8	82	1	NA	8	0.4
1883–1887	8	79	2	NA	11	0.5
1888–1892	6	76	1	0.3	16	0.5
1893–1897	11	65	3	1	19	0.6
1898–1902	11	65	3	1	21	0.4
1903–1907	13	48	4	2	32	2
1908–1912	16	40	7	3	33	2
1913	19	34	9	2	35	2

Source: Kalla, "Foreign Trade," p. 44 (see breakdown on pp. 266–275).

[a]NA, Not available.

very large increase in volume and testifies to the continued vitality of the handicrafts (VI, Introduction).

Second, most of the increase in the "food, drink, tobacco" column is accounted for by Syria's traditional imports (sugar, spices, rice, and coffee), to which were now added some small items such as tea and preserved food and, in some years, flour.

The increase in the "fuel" column is due to rising imports, starting with the 1870s, of oil products and, to a small extent, of coal. The latter was used by the railways and utilities. Most of the petroleum consisted of kerosene, for illumination and cooking (II,8).

The distinction between the last three columns is blurred. The rise in the level of living in Lebanon and a few other places and growing westernization led to the importation of wood, tiles, glass, cement, and other construction materials; of preserved and other foodstuffs; of hardware, glassware, and pharmaceuticals; and of various articles of dress. Intermediate goods included, in addition to yarn, metal, chemical, wood, and leather goods. The figure for capital goods in the table omits machinery and transport equipment which, in 1910, accounted for 3.6 percent of total imports; including construction materials, Labaki estimates capital goods at 10 percent of total imports.[82]

It will thus be seen that the bulk of Syria's imports consisted of consumption goods. Only at the very end of the period did it begin to import the capital goods that could increase its productive power and diversify its economy.

The changes in the composition of Iraq's exports from Basra may be seen in Table III.5. It covers the six main items that together generally accounted for two-thirds to three-quarters of the total. Other exports included seeds, liquorice, butter, and goat hair. The first striking aspect is the absence of any nonagricultural products; however, a very small amount of handicraft goods (shoes, soap, textiles) was exported from Baghdad and Mosul.

Within the agricultural group, there is a marked shift from pastoral to farm products. This reflects the increasing sedentarization of nomads (II, Introduction) and the vast extension of cultivation and growth of output (V, Introduction). Particularly marked are the rise in wheat and barley exports; they increased, in volume, by about 14 and 250

[82]Labaki, *Introduction*, pp. 311–312.

Table III.5 Iraq: Percentage Shares of Main Exports

Time period	Dates	Wheat	Barley	Wool	Hides	Animals
1864–1871	48	6	1	7	NA	2
1872–1879	6	2	NA	34	1	20
1880–1887	9	NA[a]	NA	NA	NA	NA
1888–1895	24	11	5	20	1	4
1896–1903	21	2	10	16	3	1
1904–1911	17	4	11	12	3	2
1912–1913	18	5	24	9	2	3

Source: Hasan, *Al-tatawwur*, p. 119.

[a]NA, Not available.

times, respectively, between 1864–1871 and 1913.[83] Their price also rose over this period—that of barley twice as fast as that of wheat (Table III.9)—reflecting strong international demand following the opening of the Suez Canal.

Dates, which accounted for about half Basra's exports before the opening of the canal, saw their share drop to less than a fifth. But in absolute terms there was a sevenfold increase. The price of dates had a downward trend.[84]

Exports of wool also increased appreciably, by about 13 times, but that of hides at first fell and overall rose only one-third. The price of hides rose markedly, which perhaps indicates that the constraint on expansion came from the supply side, while that of wool fell over most of the period. The number of horses exported to India rose 40-fold, in spite of strong competition from Australia.[85] Carpets were imported from Iran to Baghdad and reexported, mainly to the United States, but also to Britain and elsewhere; in 1913 exports amounted to £83,000.[86] As regards imports, Table III.6 indicates the main trends in Basra's trade. The share of food, drink, and tobacco declined slightly, from over to under a quarter of the total. The main items in this group were coffee, sugar, spices, tea, and alcoholic drinks. All of these showed a large absolute increase (e.g., sugar from 4000 tons in 1892–1895 to 10,000 in 1912–1913 and tea from 13 to 85 tons). Tea began to replace coffee as the common beverage.

The share of textiles rose to over two-fifths of the total. The sharp decline in 1912–1913 was due not to a drop in value or quantity but to the large rise in total imports. Household goods included kitchen utensils, glassware, furniture, soap, chemicals, and pharmaceuticals, all of which were being used in much greater quantity with the rising levels of living of certain classes and the westernization of tastes.

Capital goods include not only machinery and transport equipment but gunny bags and wooden crates for packing grain and dates, respectively. The sharp rise in the decade preceding the First World War is a consequence of the irrigation and transport works carried out in this period (IV, Introduction and V, Introduction).

The "raw and semiprocessed materials" column includes dyes, tanning materials, metals, wood, building materials, and fuels. Petroleum imports rose sharply; at first only American and Russian oil competed in the Iraqi market, but by 1913 Anglo-Persian was

[83]Hasan, *Al-tatawwur*, table on p. 103.

[84]For a description of date packing see Wratislaw, *Consul*, pp. 150–155.

[85]Hasan, *Al-tatawwur*, pp. 111, 113.

[86]A and P 1914–1916, vol. 75, "Baghdad."

Table III.6 Iraq: Percentage Shares of Imports

Time period	Food, drink, tobacco	Textiles and clothing	Household goods	Capital goods	Raw and semiprocessed materials
1864–1865	28	30	5	0.3	25
1887	32	23	5	5	10
1889–1895	22	45	3	6	21
1897–1903	23	38	6	6	18
1904–1911	24	43	5	9	14
1912–1913	23	29	4	8	31

Source: Hasan, *Al-tatawwur*, p. 241.

supplying over half the total, from its nearby Abadan refinery. This column also includes yarn, but the amount imported was small, averaging £72,000 in 1911–1913.[87] Overall, comparing consumer and producer goods, the table shows that it was only in the immediate prewar years that the share of the latter rose significantly.

Terms of Trade: Trade and Development

Data on Syria's net barter terms of trade are fragmentary but suggestive. The largest series concerns silk, which accounted for the bulk of exports from Beirut and for a quarter to a third of Syria's total exports (Table III.3). As Table III.7 shows, between the 1840s and the First World War the price of silk and cocoons about doubled while the price index of British exports (which may be taken as a proxy for that of Syrian imports) fell by about one-third. Between the 1840s and 1880, the price of British cotton cloth (which accounted for nearly half of Syria's imports) fell by more than a quarter. It should be added that between 1824 and 1835 the price of silk had risen by about 2.5 times,[88] while British export prices had fallen by one-sixth, cotton cloth by one-third, and cotton yarn by one-quarter.

The terms of trade reached a peak following the Crimean War and another in the late 1860s, and fell to their lowest point in the mid-1870s, after which there was a slow and irregular recovery until the First World War.

With regard to other export products, the series on the price of wheat and barley in Aleppo, the main exporting center, show a slight upward trend between the 1840s and the First World War (VII,1), but it is unwarranted to use these domestic prices as an indicator of export prices. Table III.8, which measures the overall terms of trade of Aleppo, shows a distinct improvement in the period covered. However, it is likely that there had been a deterioration in the 1870s and 1880s, perhaps following an improvement in the 1840s to 1860s.

With regard to individual commodities exported from Aleppo, between 1881–1882 and 1913 the price index of cereals and cottons declined and that of wool and hides rose. Sesame, oranges, and olive oil from Jaffa also rose in price between 1874–1877 and

[87]A and P 1914, vol. 95, "Basra." In Mosul in 1910–1914, yarn imports averaged nearly £30,000—Shields, "Economic History," p. 72.

[88]Chevallier, *La société*, p. 225; between the 1830s and 1840s the price of cocoons rose by about 2.5 times—see Ducousso, *L'industrie*, p. 108.

Table III.7 Beirut: Price of Raw Silk and Cocoons and Terms of Trade

Year	Raw Silk (francs/kg)	Cocoons (francs/kg)	Index (1880 = 100)	Index of British export prices (1880 = 100)	Index of price of British cotton manufactures (1880 = 100)	Terms of trade (3/4 × 100)
1836	24	NA	NA	160	196	NA
1839	22	4.5	79	138	163	57
1841	22a	NA	NA	124	148	NA
1842	24a	2.8	49	114	132	43
1843	15.7	NA	NA	112	125	NA
1845	23	3.2	56	118	127	47
1848		1.4b	25	106	108	24
1849		2.2b	39	101	106	39
1850		2.8b	49	101	112	49
1851		3.3b	58	99	108	59
1852		5.1	89	98	108	91
1854		4.4	77	109	106	71
1855		4.1b	72	106	103	68
1856		7.8	137	108	105	127
1857		10	175	112	109	156
1858		5.2	91	109	106	83
1859		7.8	137	112	112	122
1861		5.6	98	111	109	88
1862		6.7	118	117	128	101
1863		5.3	93	129	168	72
1864		5.8	102	141	190	72
1865		9.3	163	135	171	121
1866		7.8	137	139	174	99
1867		9.3	163	131	147	124
1868		10.0	175	122	132	143
1869		8.3	146	121	135	121
1870		7.9	139	119	128	117
1872		8.1	142	131	129	108
1873		7.3	128	135	127	95
1874		3.8	67	128	120	52
1875		4.4c	77	120	118	64
1876		3.4	60	111	108	54
1877		5.4	95	106	107	90
1879		6.4c	112	96	99	117
1880		(5.7)*	100	100	100	100
1881		5.1	89	96		93
1883		5.1	89	94		95
1884		5.9	104	91		114
1885		5.2	91	87		105
1886		6.7	118	84		140
1887		5.3	93	83		112
1888		4.3	75	83		90
1889	NA	4.1d	72	85		85
1890	NA	4.8d	84	88		95
1891	NA	4.8d	84	88		95
1892	46	3.8d	67	84		80
1893	54	4.6d	81	84		96
1894	39	3.8d	67	79		85
1895	39	4.2d	74	76		97

(continued)

Table III.7 (*Continued*)

Year	Raw Silk (francs/kg)	Cocoons (francs/kg)	Index (1880 = 100)	Index of British export prices (1880 = 100)	Index of price of British cotton manufactures (1880 = 100)	Terms of trade (3/4 × 100)
1896	37	3.9	68	77		88
1897	37	3.9	68	77		88
1898	34	5.3ᵈ	93	76		122
1899	51	5.1ᵈ	89	80		111
1900	48	3.8	67	92		73
1901	40	NA	NA	87		
1902	44	NA	NA	83		
1903	49	5.8	102	83		123
1904	41	4.4	77	84		92
1905	43	4.7	82	84		98
1906	50	5.3	93	89		104
1907	59	5.9	104	93		112
1908	51	4.8	84	90		93
1909	53	5.1	89	87		102
1910	42	4.9	86	90		96
1911	NA	4.2	74	92		80
1912	NA	NA	NA	93		NA
1913	NA	NA	NA	97		NA

Sources: Silk and cocoons: except where otherwise specified, Ducousso, *L'industrie,* pp. 108–112; Chevallier, *La Société,* pp. 227–233; and Labaki, *Introduction,* pp. 129–135. British prices from Imlah, *Economic,* pp. 94–98, 105.

ᵃDispatch of 29 May 1841; "Trade Report," 1842; CC Beyrouth, vol. 3.

ᵇ"Trade Report," 26 July 1851, CC Beyrouth, vol. 6; idem, 1853, CC Beyrouth, vol. 7; Chevallier's figures are equivalent to 1.8, 3.2, 3.5, 4.2, and 4.7, respectively.

ᶜDispatch of 2 November 1875, and Delaporte to Waddington, 10 September 1879, CC Beyrouth, vol. 9, give 3 and 4.4, respectively.

ᵈSomewhat lower figures are given in the "Trade Reports" for 1894, 1896, and 1899, CC Beyrouth, vols. 11 and 12 (e.g., 3.2 for 1893 and 1899, 2.9 for 1896).

*Figures in parenthesis are estimates.

1913.[89] Overall, Syria's terms of trade seem to have improved during the period covered in this book; like other primary producing countries, however, it suffered during the great depression of the 1870s.

The same may also have been true of Iraq, as may be seen from Table III.9, which covers some 50–60 percent of exports. Here the improvement seems quite steady, and considerable. No earlier figures are available, but it seems likely that Iraq's export prices rose in the 1850s and 1860s,[90] and that the cost of its textile imports fell appreciably.

Foreign trade played an important part in the economy of both Syria and Iraq. On the eve of the First World War imports and exports combined stood at about $12 a head in Syria and $10 in Iraq, figures lower than those for Egypt but comparable to Turkey,

[89]See tables in Kalla, "Foreign Trade," pp. 264–265.

[90]For grain see VII,28; date prices rose by 10–20 percent between 1861/62 and 1865/66—see A and P 1867, vol. 67, "Basra." In 1878 Geary (*Through Asiatic Turkey,* vol. 1, pp. 103–104) reported that "of late the price of dates has gone up six-fold owing to the better markets which the opening of the Suez Canal has made accessible," which is no doubt a great exaggeration.

Table III.8 Aleppo's Terms of Trade[a]

Year	Export index	Import index	Terms of trade	Index of cotton goods imports
1891	93	112	83	115
1892	89	102	87	101
1893	83	101	82	95
1894	93	102	91	98
1895	96	101	95	97
1896	101	114	89	99
1897	95	102	93	93
1898	97	96	101	92
1899	98	99	99	95
1900	100	112	89	113
1901	100	109	92	111
1902	100	100	100	100
1903	105	113	93	120
1904	106	107	99	102
1905	108	103	105	97
1906	115	104	110	98
1907	115	97	118	91
1908	121	102	118	91
1909	125	102	123	91
1910	128	106	121	92
1911	124	105	119	92
1912	118	101	117	82
1913	123	101	122	86

Source: Kalla, p. 68.

[a]Note: 1902 = 100.

Table III.9 Iraq's Price Indices[a]

Time period	Dates	Wheat	Barley	Wool	Hides	Unweighted index	Index of British export prices	Terms of trade (6/7 × 100)
1864–1871	105	68	38	54	37	60	135	44
1872–1879	75	75	NA[b]	69	59	70	122	57
1880–1887	65	56	51	38	48	52	95	55
1888–1895	83	53	23	32	71	52	88	59
1896–1903	74	30	41	27	81	51	86	59
1904–1911	70	71	68	56	87	70	93	75
1912–1913	100	100	100	100	100	100	100	100

Sources: Hasan, *Al-tatawwur,* p. 103, 111; Imlah, *Economic,* pp. 94–98.

[a]Note: 1912–1913 = 100.

[b]NA, Not available.

Greece, Russia, and Japan.[91] In Syria imports may have amounted to some 15 percent of GNP, and exports to 8 percent, again fairly high ratios, and the Iraqi figures may have been of the same order of magnitude.

Foreign trade acted as an engine of growth in agriculture; it was directly responsible for the extension of grain cultivation in Iraq and Syria and the growth of silk production in Lebanon (V, Introduction). It also attracted the foreign capital that built the railways and ports. In Lebanon the process went one step further, with the establishment of silk-reeling factories (VI, Introduction).

In the industrial sector, however, the impact of trade was adverse, since it destroyed a large part of the handicrafts both directly through competition and indirectly by turning consumers' taste to western-type goods (II, Introduction). Moreover, trade did not, as in some other countries, serve as a "highway of learning," and did not develop skills that could be transferred to other fields. The ancillary services it required were, in the main, performed by foreigners. Very little of the income it generated was invested in other branches of the economy. Finally, it did not stimulate local industry by inducing import substitution. For all these reasons, its impact on the economy remained strictly limited in the period under review, and even after.[92]

[91]League of Nations, *Statistical Yearbook 1928*, Geneva, 1929.

[92]For a much more extensive treatment, see *EHMENA*, pp. 41–43; Labaki, *Introduction*, pp. 303–343; and Hasan, *Al-tatawwur*, pp. 167–205, 279–291.

1

Trade of Alexandretta (Aleppo)[a]

Time period	Imports			Exports			Source
	Total	United Kingdom	France	Total	United Kingdom	France	
1775			341			366	Guys, *Esquisse*, p. 155
1776–1787			71			109	Masson, XVIIIe siècle p. 16
1784			102			113	*EHME*, p. 36
1787			59			152	Charles-Roux, *Les Echelles de Syrie*, p. 196
1783–1792[b]			250			139	Guys, *Esquisse*, p. 155
1815–1822[b]			125			62	Ibid.
1824	(100)[c]		(60)	(70)		(50)	CC Alep vol. 28
1825	220		150	108		93	Ibid.
1830	299		18	13		12	Ibid.
1835	(110)	97	2	(36)	19	12	Bowring, *Report*, p. 71
1835–1840[b]			49			43	Guys, *Esquisse*, p. 155
1837	180	165		22	2		FO 78/341
1841–1846[b]			32			39	Guys, *Esquisse*, p. 155
1842		142			12		FO 78/539
1844?	227	142	21	106	10	36	Guys, *Statistique*
1847	344	309	30	80	20	38	CC Alep, vol. 31
End of 1840s	252	143	34	121	10	41	Guys, *Esquisse*, p. 16
1851[d]	324	146					FO 78/1221
1852	165			22?			FO 78/1389
1853	188			263			Ibid.
1855	685	445		271			Ibid.
1856	482	300		410			Ibid
1857	344	206		263			A and P 1866, vol. 69
1858	534	346	51	364	20	116	FO 78/1452
1859	468			385			Ibid.
1860	457			306			Ibid.
1861	1,032			312			Ibid.
1862	555			380			A and P 1867, vol. 67
1863	784			636			Ibid.
1864	2,081	1,617		699	95		Ibid.
1865	1,353	1,250	13	593	75	250	Ibid.
1866	1,276	1,203	9	539	61	230	Ibid.
1870	1,816			708			CC Alep, vol. 35
1871	1,476	860	34	660			Ibid.
1871	775			284			A and P 1872, vol. 57
1872	1,516	940	28	780			CC Alep, vol. 35
1873	1,043	(800)		424			FO 78/3070 and A and P 1879, vol. 72

(continued)

Trade of Alexandretta (Aleppo)[a] (*Continued*)

| Time period | Imports | | | Exports | | | Source |
	Total	United Kingdom	France	Total	United Kingdom	France	
1874	1,161	(500)		1,090			Ibid.
1875	1,346	(400)		880			A and P 1879, vol. 72
1876	978	(200)		776			Ibid.
1877	514			421			Ibid.
1878	2,250	1,390	369	1,099	79	326	Ibid.
1879	1,776	1,131	252	1,004	39	225	A and P, 1880
1880	1,277	792	179	836	41	183	A and P 1881
1881	1,703	1,015	268	894	54	193	A and P 1882
1882	1,664	951	201	1,043	49	239	Ibid. 1883
1885	1,558	810	239	998	41	122	A and P 1887, vol. 86
1886	1,671	890	229	1,022	48	157	A and P 1888, vol. 103
1887	1,619	878	207	885	86	150	Ibid.
1888	1,693	925	198	1,052	178	144	A and P 1890, vol. 77
1889	1,765	962	203	981	95	191	Ibid.
1890	1,716	951	155	696	46	148	A and P 1893/94, vol. 91
1891	1,800	1,027	192	736	45	149	Ibid.
1892	1,800	1,068	117	866	68	123	A and P 1894, vol. 88
1893	1,883	913	182	933	73	138	Ibid.
1894	1,829	885	164	952	69	117	A and P 1897, vol. 94
1895	1,413	835	68	1,077	60	203	Ibid.
1896	1,659	814	104	1,131	87	245	A and P 1898, vol. 99
1897	2,051	1,034	123	1,136	98	234	Ibid.
1898	2,332	1,361	109	959	47	206	A and P 1900, vol. 96
1899	2,164	1,159	111	931	109	163	A and P 1901, vol. 85
1900	2,082	999	98	1,185	113	186	A and P 1902, vol. 110
1901	2,429	1,274	121	1,220	118	167	A and P 1903, vol. 79
1902	2,337	1,288	122	961	99	146	A and P 1904, vol. 101
1903	2,404	1,341	116	1,322	140	183	A and P 1905, vol. 93
1904	2,170	1,121	141	1,561	118	172	A and P 1906, vol. 129
1905	2,487	1,310	147	1,393	102	211	Ibid.
1906	2,394	1,189	136	1,466	113	257	A and P 1908, vol. 116
1907	3,326	1,198	173	1,448	95	224	Ibid
1908	1,891	907	191	1,467	82	221	A and P 1910, vol. 103
1909	2,226	1,063	215	1,309	73	195	A and P 1912/13, vol. 100
1910	1,399	548	171	1,301	25	189	Ibid.
1911	1,145	445	121	1,044	14	178	A and P 1913, vol. 73
1912	1,210	573	88	1,020	20	133	Ibid.
1913	930	365	62	932	10	141	A and P 1914, vol. 95

[a]In thousands of pounds.

[b]Average.

[c]Figures in parentheses are estimates.

[d]Exports plus imports.

2

Trade of Beirut[a]

Year	Imports			Exports			Source
	Total	United Kingdom	France	Total	United Kingdom	France	
1824			25			19	CC Beyrouth, vol. 1
1825	236		75	160		54	Ibid.
1826	112	14	56	80	19	25	CC Beyrouth, vol. 2
1827	203		54	149		49	Guys, *Esquisse*, p. 229
1833	448		53	235		39	Ibid.
1834	480		68	323		108	Ibid.
1835	482		67	283		65	Ibid.
1836	660		111	362		107	Ibid.
1837	470		82	254		68	Ibid.
1838	617			403			Chevallier, *Société*, p. 196
1841	790		123	615		109	Guys, *Esquisse*, p. 229
1842	1,136		136	640		80	Ibid.
1843	886			672			Ibid.
1844	977		179	634		123	Ibid.
1845	872	208	116	641	7	56	Ibid. FO 78/1580
1846	631	350	151	403	7	65	Guys, *Esquisse*, p. 229; FO 78/1580
1847	366	535 (sic)		234	7		Chevallier, p. 197; FO 78/1580
1848	381	304		240	15		Chevallier, p. 197; FO 78/1580
1849	914		135	716		116	CC Beyrouth, vol. 6
1850	997	419	256	719	50	300	Ibid, vol. 5
1851	895	287	183	631	23	269	Ibid.
1852	834	272	151	811	53	321	CC Beyrouth, vol. 7; FO 78/1117
1853	954	226	147	874	42	252	FO 78/1298
1854	838	261		1,056	30		Ibid.
1855	1,430	455		1,565	97		Ibid.
1856	1,370	519		1,608	43		Chevallier, p. 197; FO 78/1149
1857	1,618	276		1,614	67		FO 78/1539
1858		433			31		Ibid.
1859		362			8		Ibid.
1860		364			3		FO 78/1586
1861	741	432		340	11		FO 78/1670
1862	1,861	(500)[b]	641	1,251		334	CC Beyrouth, vol. 7
1863			(600)			(250)	Ibid., vol. 8
1866		490					A and P 1872, vol. 58
1867		544					Ibid.
1868	(1,100)	514					Ibid.
1869	(1,200)	580					Ibid.

(continued)

154

Trade of Beirut[a] (*Continued*)

Year	Imports			Exports			Source
	Total	United Kingdom	France	Total	United Kingdom	France	
1870	(900)	617					Ibid.
1871	1,240	556		530			Ibid.
1872	1,158	590	282	699			A and P 1874, vol. 66
1873	1,323	697					FO 78/3070
1874		563					Ibid.
1875		472		440			Ibid.
1876	1,194	635		919			Ibid.
1877	723	450					Ibid.
1878		709					A and P 1879, vol. 72
1879		770					A and P 1880
1881		752					A and P 1883, vol. 73
1882		919					Ibid.
1884		1,082		848			A and P 1887, vol. 86
1885		1,170		733			Ibid.
1886		1,030					A and P 1888, vol. 103
1887		994					Ibid.
1888	2,088	959					A and P 1893/94, vol. 91
1889		1,136		(900)			A and P 1890, vol. 77
1890	2,588						A and P 1893/94, vol. 91
1891		1,057					Ibid.
1892	2,800	1,260					A and P 1894, vol. 85
1893		968					Ibid., vol. 88
1894	2,052	894		720			A and P 1897, vol. 94
1895	1,520	780	135	652	18	496	Ibid.
1896	1,720	824	158	797	21	602	A and P 1898, vol. 88
1897	1,588	758	120	781	40	616	A and P 1899, vol. 103
1898	1,403	714	115	724	24	575	A and P 1900, vol. 96
1899	1,580	848	92	1,052	39	850	A and P 1901, vol. 85
1900	1,352	802	61	605	31	446	A and P 1902, vol. 110
1901	1,545	895	81	541	18	420	Ibid.
1902	1,340	714	75	731	39	577	A and P 1904, vol. 101
1903	1,259	750	64	692	83	531	A and P 1906, vol. 128
1904	1,426	875	55	954	76	780	Ibid.
1905	1,538	954	48	924	115	701	A and P 1907, vol. 93
1906	1,698	984	85	1,020	127	765	A and P 1908, vol. 117
1907	1,694	820	130	1,029	160	770	A and P 1909, vol. 98
1908	1,693	710	145	919	175	638	A and P 1910, vol. 103
1909	1,656	665	130	792	110	568	A and P 1911, vol. 96
1910	2,153	934	150	823	71	672	A and P 1912/13, vol. 100
1911	1,920	902	130	551	41	432	Ibid.
1912	1,498	749	121	526	32	424	A and P 1914, vol. 95
1913	2,175	1,015		631	14		Ibid.

[a]In thousands of pounds.

[b]Figures in parentheses are estimates.

3

Trade of Damascus[a]

Year	Imports			Exports			Source
	Total	United Kingdom	France	Total	United Kingdom	France	
1880	315	177					A and P 1883
1882	459	218		443			Ibid.
1884	368			307			A and P 1884/85, vol. 78
1885	712	379	62	365	9	47	A and P 1887, vol. 86
1886	626	292	70	289	10	49	A and P 1888, vol. 103
1887	398	201	46	341	13	46	Ibid.
1888	611	234	67	338	14	42	A and P 1890, vol. 77
1889	671	354	64	453	17	50	Ibid.
1890	526	223	58	216	15	12	A and P 1893/94, vol. 91
1891	542	239	72	358	18	14	Ibid.
1892	611	271	63	425	17	13	A and P 1894, vol. 88
1893	678	285	52	457	17	10	Ibid.
1894	615	237	56	401	17	11	A and P 1895, vol. 100
1898	675	314	35	302	14	15	A and P 1899, vol. 103
1901	855	305	29	307	5	21	A and P 1905, vol. 93
1902	776	232	30	307	26	21	Ibid.
1903	825	280	24	387	34	15	Ibid.
1904	784	264	28	405	39	27	A and P 1908, vol. 116
1905	872	279	24	386	38	30	Ibid.
1906	920	307	29	643	40	45	Ibid.
1907	929	322	29	639	39	50	A and P 1910, vol. 103
1908	853	290	36	657	40	51	Ibid.
1909	969	311	49	1,005	63	44	A and P 1912/13, vol. 100
1910	950	253	44	980	81	47	Ibid.
1911	926	260	46	996	93	48	Ibid.

[a]In thousands of pounds.

4

Trade of Jaffa[a]

Year	Imports		Exports		Source
	Total	United Kingdom	Total	United Kingdom	
1841			65		CC Beyrouth, vol. 5
1842			52		Ibid.
1843			52		Guys, *Esquisse*, p. 3
1849			229		Ibid.
1850			237		CC Beyrouth, vol. 5
1851			303		Ibid.
1853				15	FO 78/963
1857			123		FO 78/1296
1858			101		FO 78/1387
1859			50		FO 78/1449
1860			117		FO 78/1537
1863			200		A and P 1864, vol. 61
1873	138	25	247	24	FO 78/3070
1874	114	27	208	21	Ibid.
1875	111	19	258	61	Ibid.
1876	231	37	436	31	Ibid.
1877	199	30	119	7	Ibid.
1879	231		188		A and P 1880, vol. 74
1880	219		227		A and P 1881
1881	246		249		A and P 1882, vol. 71
1882	281		280		A and P 1883
1884	271		117		A and P 1884/85, vol. 78
1885	288	52	133	24	A and P 1887, vol. 86
1886	241	46	120	26	A and P 1888, vol. 103
1887	232	40	186	42	Ibid.
1888	253	46	204	50	A and P 1889, vol. 81
1891	288	22	401	100	A and P 1893/94, vol. 91
1892	343	50	258	72	A and P 1894, vol. 88
1893	350	53	333	70	A and P 1895, vol. 100
1894	273	43	286	53	A and P 1896, vol. 89
1895	276	29	283	41	Ibid.
1896	256	28	373	56	A and P 1898, vol. 99
1897	307	32	309	60	Ibid.
1898	322	31	307	61	A and P 1899, vol. 103
1899	390	35	316	66	A and P 1901, vol. 101
1900	382	38	265	77	• A and P 1902, vol. 110
1901	426	40	278	75	Ibid.
1902	406	36	203	70	A and P 1904, vol. 101
1903	440	38	322	90	A and P 1908, vol. 116
1904	473	43	295	92	Ibid.
1905	464	45	368	114	Ibid.
1906	660	65	500	145	Ibid.
1907	809	74	484	160	A and P 1911, vol. 96
1908	803	80	556	164	Ibid.
1909	973	321	561	158	A and P 1912/13, vol. 100
1910	1002	129	636	173	Ibid.
1911	1170	146	711	185	A and P 1914, vol. 95
1912	1090	155	774	190	Ibid.
1913	1313	170	745	200	Ibid.

5

Trade of Aleppo, 18th Century

We have already pointed out the importance and the particular character that the factory (*échelle*) of Aleppo derived from its connections with other regions, some of them very distant. The main caravans that came or went from Aleppo were those of Diyarbakr, Mosul, and Baghdad. They took from Aleppo those European goods that could be sold in the markets to which they went and brought in raw materials and manufactured goods from their points of departure. In addition, Diyarbakr, Mosul, and Baghdad served—to the benefit of Aleppo—as intermediaries between it and much more distant regions: Armenia and the Caucasus, northern and western Persia, Iraq, the Persian Gulf, and Hindustan. For the caravans that plied between Aleppo and Diyarbakr were linked with those between Diyarbakr and Bitlis, Erzurum, Van, Erivan, and Tiflis. Those between Aleppo and Mosul were linked to the caravans between Mosul and Urmia, Tabriz, Hamadan, and Tehran. And the Aleppo and Baghdad caravans were linked to other caravans, and to riverboats, that circulated between Baghdad and Basra, from whence goods were transshipped, by oceangoing vessels, to the Persian Gulf, the Indian Ocean, and the Bay of Bengal.

The French East India Company kept—at least during the second half of the 18th century—an agent at Basra, and so did the English Company. British ships called at Basra, from Surat or Bombay, or even from Madras and Calcutta.

One should not assume that the mechanism of trade ensured frequent or rapid communications. With regard to maritime relations between Basra and the western and eastern coasts of Hindustan, the timing of the ships' journey was determined by the monsoon, and its length depended on the numerous circumstances affecting such a long voyage. But one can understand what disturbance was caused to the inland and overseas trade centered on Aleppo by the Turco-Persian wars, whose military operations took place precisely along the frontier stretching from the Caucasus to the Persian Gulf; or by the civil wars pitting Persians against Persians, or even by the Perso-Afghan struggles. We have given ample evidence on this subject.

As for goods, Aleppo was also a stopover point for Europeans going to Persia. . . .

Aleppo was also a channel for correspondence, information, and views. The French consul in Aleppo sent on the dispatches from the Court to its agents—when there were any—in Persia, the infrequent correspondence of the Catholic missions in that empire, and the envelopes sent by the East India Company to its representative in Basra. However, the dispatches of the Court or company to our establishments in Hindustan seldom took this route: the normal course was that of the Cape of Good Hope. During the second half of the century, some use was made of the Suez–Red Sea route. Conversely, our consuls in Aleppo often gathered news in Persia and transmitted it to Versailles. . . .

Thus it was through the French consul at Aleppo that the Court of Versailles was kept informed of English commercial activity in the Persian Gulf and of the first manifestations of the British Indians' political and military activity on the two shores—

From ''Annex VII, Note sur les relations d' Alep avec l'intérieur de l'Asie,'' in F. Charles-Roux, *Les Echelles de Syrie et de la Palestine au XVIIIᵉ siècle*, Paris, 1928, pp. 200–202.

Arabian and Persian—of that gulf. During the Seven Years' War and the Anglo-French
War of 1778–1783, the first news of what had happened in India—between the French
and English or between the English and their Hindu enemies, such as Haidar-Ali and
Tippoo Sahih—often reached it through the same route.

The usual intermediaries in the trade between Basra and India, and between Persia
and the Turkish towns from whence caravans set forth for Aleppo, were generally Arme-
nian merchants. They also provided the channel through which passed the news that was
most often transmitted to the French consul at Aleppo by his informers. Sometimes the
Court deliberately appointed to the Aleppo Consulate persons who were already knowl-
edgeable about trade and business in India, Iraq, and Iran. Thus Pedro de Perderiau, who
was appointed to that post in June 1768, was a foreign agent of the [French] East India
Company at Basra. . . .

6

Trade of Damascus, 1825

Thanks to its location, Damascus must be regarded as the leading commercial city in Syria
and Palestine, being the trade entrepôt of the East Indies, Persia, China, and the whole of
Arabia Petraea and Felix. The large output of its workshops, consisting of silk and cotton
fabrics, is sold in the whole Ottoman Empire, and from many places in that empire people
came to Damascus to buy not only its products but also those of French industry.

[The same year a "Trade Report" (8 March 1826, CC Alep, vol. 18, 1825–1829)
put the value of goods brought to Damascus by caravans across the desert at 18,528,000
francs and went on to say: "before the introduction of European calicoes into the Levant,
Damascus workshops employed 20,000 persons. They imported Indian yarn through
Baghdad. But now that work has diminished by half, the population has sunk into poverty
and the consumption of second quality woollens (*draps Londrins seconds*) is almost
zero."]

The misfortunes that have befallen Aleppo—first the Civil War between the Janis-
saries and the *Ashraf,* then the rebellion of the Janissaries against the pasha and, still more
important, the earthquakes that destroyed part of that beautiful city—have been favorable
to Damascus; a large number of Turkish, Armenian, and Jewish merchants left Aleppo to
establish themselves in Damascus.

A few years ago European products had a very small outlet in Damascus, but now it
is the largest consuming city in Syria. For the goods that are brought to it from the coast,
through Beirut, are insufficient and, in order to supply its own market, Damascus is
obliged to fetch, at great expense, from Constantinople, Smyrna, and Egypt, the colonial
produce and manufactured goods of Europe; these are mostly carried by land, which
appreciably raises their cost. Nevertheless the manufacturers of Damascus prefer to sup-
ply their workshops with cotton yarns and cochineal from Smyrna, at a higher cost than
those brought directly from Europe through Beirut, for the following reason: they pay for

From *Mémoire sur le Commerce de Damas,* by Beaudin, 20 January 1826, CC Alep, Vol. 18, 1825–1829.

the former by supplying the products of their own workshops, whereas they have to pay in cash for all their purchases coming directly from Europe through the coast.

The same is true of other items such as caps, woolens, cotton cloth, silk, braids, and, in general, all the valuable goods that are bought for Baghdad, Persia, India, and China; the Smyrna, Constantinople, and Egyptian merchants who sell these goods are willing to accept cash payment for one-quarter of their value, taking the rest in tobacco from Persia and Baghdad, Indian muslins, cotton fabrics, cashmeres, pearls, sword blades, etc., all of which are suitable for consignment to Egypt, Smyrna, and Constantinople.

[An enterprising French firm located at Beirut or Saida, and prepared to take losses for some time, could sell European goods to Damascus and take back local and Indian wares.]

Although at the moment Beirut is regarded as the port of Damascus, I would rank Saida higher in several respects. In all seasons, the Saida–Damascus road is more passable than the Beirut road. Lodgings can be had at very moderate prices and warehouses almost for nothing, especially in the French *Khan;* they are also safe from danger in times of disaster, which are not so very infrequent in Turkey. Animal products cost at least one-third less than in Beirut, and living expenses are therefore lower. I believe the Saida roadstead to be as good as that of Beirut; anchorage being far from town, communications are easy and less costly.

7

Emergence of Beirut, 1827

. . . In this report I will attempt to prove:

(1) That trade has definitely established itself in Beirut;
(2) That the port (*échelle*) of Acre has for long been regarded only as a fortified town whose governor takes umbrage at any foreigner who settles in it because he wants to be the only monopolist of the products of his territory;
(3) That the port of Saida has imperceptibly fallen into decay and no longer offers the least resources to the industry of French traders and shippers.

Because of its location, its good roadstead, and the wealth of its inhabitants, Beirut has always been a port with great commercial potential; but for a very long time it was held, as a fief, by the princes of the Mountain, and as the latter were continually harassed in their possessions of it by the pashas of the Porte—whose covetousness it aroused—Europeans could not settle in it. This port's trade became significant only when the French withdrew from Tripoli, their last refuge in Syria, at the time of the invasion of Egypt; a few years earlier the notorious Djazzar had reintegrated it in immediate dependence on the *Pashalik* of Acre. Prompted by the rise in prices of European goods during the last war, its

From "Memorandum on Trade of Beirut," 15 January 1827, CC Beyrouth, Vol. 1, 1821–1828.

merchants began to buy them in those places where they knew that trade had hitherto carried them—hence their first contacts with Larnaka, but especially with Constantinople and Smyrna, from which they could carry their goods by land after the numerous dangers to which the belligerents had subjected shipping prevented them from continuing to load them on neutral vessels.

As trade is a practical science, practice and experience made those traders eager to go back to the original sources, and they turned directly to Europe as soon as the general peace had opened European ports to them. They therefore established direct contacts with the markets of Marseilles, Genoa, Livorno, Malta, and Trieste, to which they also sent their native products, according to need. Some Syrian merchants even went to live in Europe, thereby presenting their countrymen with the advantage of being able to correspond with them in their own tongue. . . .

As a result of all this, there is no one in Syria who does not understand perfectly well the ratios of the various French weights and measures; who is not completely cognizant of our commercial customs, of the terms of transactions, and of the discounts that are granted in various sales; or who does not know that there are certain goods for the export of which the [French] King's Government grants bounties. Thus today it would be very difficult for a French merchant or ship's captain to take advantage of those people, who make an accurate reckoning of the various goods and know exactly what they ought to pay for them. But if the initiation of this throng of small merchants into the secrets of our manufactures was at first harmful to the interests of some French residents of the Levant, it must nevertheless be considered as having been very favorable to the sale of the industrial products of our kingdom. Your Excellency will see that it is because of the expansion of the trade of the inhabitants of Beirut that French merchants came to establish themselves in this town and consequently gained some benefit. Before, and even after, 1814 there was only one European merchant in this port, yet Beirut was already considered to be the most active trading port of the [Syrian] coast; from this one can infer that it was not precisely the establishment of European trading houses that gave Beirut its importance. Its beginning goes back to the time of the expulsion of the French from the *pashalik,* which occurred a few years after the reunion of the government of Beirut with that of Acre; however, for some time Damascus continued to make its purchases from the French firms in Tripoli. But the dealings of the Arab merchants of Beirut spread only slowly. . . .

Your Excellency will judge the strength of the competition to which the French are subjected by foreign and native merchants by comparing their respective numbers and means. For this purpose, I have put two asterisks next to the names of those who transact a large volume of business and one asterisk next to those whose trade is smaller; the other names indicate those merchants who are in the process of withdrawing or who carry out little business:

[The list of names shows: 5 Turks (i.e., Muslims), all with two asterisks; 15 Christians, 6 of them with two asterisks and 5 with one; 4 Austrians, 2 with two asterisks and 2 with one; 2 British, both with one asterisk; 1 Russian, with two asterisks; and one Sardinian, with no asterisk.] That is, in all 34 firms trading with Europe, and mainly with France. In addition, in the territory of Beirut and notably in Kisrwan, there are several firms trading with Marseilles.

Comparing the returns on the trade of the *Pashalik* of Acre with France, would it not appear that business has merely shifted its place and changed hands but that the total volume has, more or less, remained the same? Indeed one finds, My Lord, in the Memoir

on the Levant published in 1784 that trade with Syria (Tripoli, Saida, and Acre) amounted to 1,198,403 *livres* for imports and 1,604,020 for exports.[1] In the one for 28 January 1802, the average imports of Saida are put at 1.5 million francs and its exports at 1.8 million. My own observations, over three years, show the following results for Beirut: [see selection 2]. This would prove the statement made earlier that trade has by no means declined since 1784. . . .

[1]See *EHME*, pp. 31–37.—ED.

8

Trade of Beirut, 1838

. . . At present, Beirut has 67 business firms of which 11 are French or French-protected, 8 English, 14 of various nationalities, and 34 belong to local people, both Christians and Muslims.

Imports amounted to 15,429,824 francs, showing an increase of nearly 4 million over 1837; exports came to 10,069,047 francs, having risen in the same proportion. Since my predecessor did not include in exports the value of the specie shipped on British steamers, I have followed his example, for it is impossible accurately to determine that figure, and moreover that trade is carried on by various nations. It is, however, estimated that the export of specie in 1838 amounted to some 600,000 francs on each English steamer leaving Beirut every month.

Your Grace will observe that in 1838 exports to France exceeded imports from that country. This increase is due to shipments made by Syrian merchants, who were indebted to French traders in Marseilles and who had to repay some of the credits that had been extended to them in previous years.

Otherwise, Beirut's trade for 1838 does not give rise to any particular remarks. At present business is paralyzed by the prevailing circumstances and by the fear of events to which they may give rise. With good reason, European merchants apprehend difficulties in recovering the sums due to them, both in Beirut and in the Mountain, and which are estimated at over 2 million francs.

This year, the silk crop in Beirut is rather poor, but the cereals crop has been abundant in the whole of Syria.

From "Report on Trade," 20 June 1839, CC Beyrouth, Vol. 2, 1836–1840.

9

British Trade and the Rise of Beirut, 1830–1860

In the second half of the eighteenth century, British trade with Syria had fallen off sharply. A draft report by the British consulate general in Constantinople, dated 2 December 1831, on establishing a consular service in the Levant, describes the situation as follows[1]:

> In Turkey, foreign trade now confines its principal operations to the cities of Constantinople, Smyrna, and Alexandria . . . Aleppo, which was before the Middle of the last century the most considerable emporium in Turkey, is now a place of comparatively little commercial importance. The trade began to decline shortly after the above-mentioned period, and in the year 1792 the Levant Company finally dissolved the respectable Establishment which they had previously supported there, the Consul in fact being then the only English resident in the city, whereas in former times there had been as many as twenty-eight British merchants attached to that factory. The towns in Syria have been of late supplied with British manufactures from the establishments at Alexandria, but the consumption does not appear to have been sufficiently extensive to encourage any of the trading houses in that city to form branch establishments on the Syrian coasts.
>
> The decrease of trade at Aleppo has been attributed to various causes. The gradual cessation of the demand for the Persian market, after that country began to receive foreign supplies from the East India Company's establishments by the Euphrates, must be considered the principal cause, and to it may be added the failure of demand in England for articles which formerly were exported from Syria.

The report ends by suggesting the establishment of a consulate at Tarsus, and possibly at Kaisari.

Until Napoleon's expedition to Egypt put an end to its commerce, France had been by far the leading trader in Syria. In 1789 there had been twenty French firms in Syria which sold goods worth 4 to 5 million francs and bought 5 to 6 million, that is, more than twice all other nations combined. Revival was slow after 1815.[2] . . .

The revival of British interest in Syria was partly motivated by the increase in trade, and the growing realization that the country offered a large potential market for British manufactured goods and a source of supply of cotton, grain, wool, and other raw materials, as well as a transit route to Iraq and Iran. But perhaps a more powerful cause was apprehension regarding Muhammad Ali's designs on the Levant. Leaving aside the broader political issues, both British government and traders were completely opposed to the system of monopolies he had established in Egypt, and were able to put so much pressure on him and the Sultan that, after his defeat in 1841, he had to give up his monopolies and other forms of administrative protection. But in one important respect British trade bene-

From Charles Issawi,'' British Trade and the Rise of Beirut, 1830–60,'' *IJMES* 8:91–101, 1977.
[1]FO 781/1.
[2]CC Smyrne, vol. 43, Memorandum "Etat du Commerce et de la Production de Syrie," September 1, 1839.

fited from the Egyptian occupation of Syria. In the words of the British consul in Beirut, N. Moore[3]:

> Whatever effect the Egyptian System of Government may have had in some respects—and its injurious tendency can neither be denied or concealed—one benefit has accrued under it to the natives—viz. the greater security to property than existed under the government of the Turkish pachas—to which may be added the perfect safety with which travellers of all nations may explore the country. The taxes and imports of this government are heavy, but they are defined.
>
> The consequence of this security of property has been an augmentation in the sources of wealth, and this again has been followed by the usual effects, an increased attention to the comforts and conveniences of life—this especially observable with respect to articles of dress—usually the first visible mark of an improved state of society. Many coarse articles which a year or two ago were eagerly sought after on account of their cheapness are now neglected and a more elegant material is required, whilst the ordinary stuffs of the country, laboriously and expensively manufactured, are gradually falling into disuse.

The other main beneficiary of the Egyptian occupation was the town of Beirut, which developed along with the expansion of British and French commerce. Some overall figures show the growth of its trade. [See selection 2]. . . .

By 7 February 1834, Farren was able to state[4]:

> Previous to my appointment not an English cargo or vessel had arrived at the port of Beyrout direct from home—not a British commercial house existed in any part of Syria. . . . Since my appointment British vessels from 120 to 150 tons each have arrived direct from England with British manufactures and colonials and there are on their passage now two from London and one from Liverpool.
>
> The produce of this country after being gradually sent to England indirectly as part returns, is now coming so fully into play that two British vessels have lately been freighted home direct—a third (bearing these despatches) also returned with a full cargo of madder roots, wool, silk and skins and produce is now ready to be shipped by the first occasion.
>
> Three British establishments are formed at Damascus and the same at Aleppo in direct trade with England, and an English merchant is now here making arrangements for a fourth, and others I hear are in contemplation—a branch of one of those houses has already been settled at Baghdad.

The account is confirmed and amplified in the 1835 Commercial Report from Beirut mentioned earlier.[5]

> Beyrout till within the last few years almost unknown even by name in England and entirely so as a mart for British manufactures and colonial produce, is now transformed from a third-rate Arab town into a flourishing commercial city—the residence of Europeans of various nations. It is the shipping port of Damascus and of a considerable

[3]"Commercial Report," 16 November 1835, FO 78/264.

[4]FO 78/243.

[5]See note 3.

part of Syria and the market for the sale of large quantities of English manufactures and colonial produce. Its direct trade with England has within the last 4 or 5 years almost annihilated that which previously existed for imports of British manufacture betwixt Syria and the French and Italian ports. . . .

A breakdown of the trade figures shows that the main items from England were cotton yarn and piecegoods, coffee and sugar, and the main exports cotton, wool, raw silk and madder and other dye stuffs. A list of British merchants in the Beirut consulate in 1834, including Acre, totals 15, of whom 7 bore English names while the others were Ionians, Maltese and other British subjects.[6] The effect of the increase in the population of Beirut and the influx of foreign merchants was to push house rents sharply up: on 29 September 1835, the British consul certified that "the rents of houses in Beyrout have not only undergone an increase of 500 percent in the last few years but are also scarce on account of the great demand of Europeans who begin to establish themselves." The consular house in Beirut paid an annual rent of 900 dollars.

The next few years saw a brisk increase in the activity of the port of Beirut. . . .

In 1848[7] the value of British goods imported to Beirut was put at an average of £150,000 a year. This was paid for as follows: specie and bullion carried in British ships, £50,000; silk reeled by British and French establishments, £20,000; bills on England drawn by the different consulates, missions in Palestine, and travelers, £20,000; specie sent to Egypt for purchase of bills on England, £40,000; and bills drawn through France. It is notable that invisible items such as expenditures by travelers, missions, and consulates had already begun to make significant contribution to Beirut's balance of payments. There was no important change in the composition of imports, except for the addition of coal for use by the steamers calling at Beirut (see below); on the export side, the main change was the increase in shipments of grain.

By 1849 the consul could state: "Beyrout is a thriving commercial town, having usurped the foreign trade possessed by Sidon [Saida]; in 1845 above 365 new houses were built in Beyrout; it is now the port for the centre of Syria and Damascus, and the chief point of communication of Syria with Europe; two British and one Austrian commercial steamers come here once and two French government packets twice a month."

British trade with Syria as a whole was also growing, though not so rapidly. In 1836, the combined imports of Tripoli, Latakia, Alexandretta and Tarsus, which served Aleppo and northern Syria, amounted to £351,000 and their exports to £190,000; the British share was £151,000 and £14,000 respectively, and the French £36,000 and £56,000.[8] In 1842, the imports of Alexandretta amounted to £179,000 and its exports to £73,000; the British share was £141,000 and £12,000, respectively; total imports through Latakia and Tripoli were £228,000 and exports £122,000.[9] [See selection 1]. . . . In 1855, British imports to Syria were put at about £1,200,000, "a fifth of which found its way to Baghdad and Persia, thro' Aleppo and Damascus, leaving about one-eighth of the whole imports in warehouse at the end of the year."[10]

[6]Farren to Palmerston, 29 July 1834, FO 78/243.
[7]"Report on Trade," 1848, FO 78/802.
[8]FO 78/316.
[9]FO 78/539.
[10]FO 78/1221.

What were the factors accounting for this upsurge in British trade? Quoting from the "Report on the Trade of Beirut" for 1855:

> 1. The encouragement afforded by late Laws in England to the exportation of corn from Syria which has enriched the population thus affording them increased means of paying for foreign goods.
> 2. The rivalry amongst the Levantine merchants in London engaged in the Syrian trade, especially the firms of Spartali and Lascaridi, who have given unusual facilities to their correspondents, thereby enabling them to sell British goods in Syria nearly as cheap in England.
> 3. The partial transit of British goods to Persia, via Syria, already alluded to.
> 4. The diminution in the importation of cotton manufactures from Switzerland owing partly to the improvement in and cheapness of prints from Manchester and other fancy goods from Glasgow, which have superseded, in a great degree, Swiss manufactures during the past year.
>
> In regard to exports it must be stated that altho' the result of the harvest in 1855 was less favorable than was anticipated, the rise in price compensated for the deficiency.

To this should be added a fact noted as early as 1843: Britain had replaced France as the main importer of colonial goods.[11] As for the general expansion in Beirut's trade, three factors should be noted: the favorable effects on both exports and imports of the Anglo-Turkish Commercial Convention of 1838; the development of steam navigation; and the expansion of silk production. . . .

The first steamers were used mainly to carry mails, specie and passengers, not goods, but they soon began to take increasing amounts of merchandise and in his report for 1854 the consul put the amount of British goods imported by screw-steamers at £136,000, as against £125,000 by sailing ship. By 1866, steamships accounted for 280,000 of the total of 400,000 tons entering Beirut.[12] This shift did not benefit Beirut only by increasing its trade. For quite a few years, it was the only port between Alexandria and Smyrna served by steamers, for example, in 1844 the consul at Aleppo stated that no steamers called at Tarsus, Alexandretta, Latakia, and Tripoli.[13] In addition to attracting trade to Beirut, this made it the coaling station of the Levant coast. In 1843, two shiploads of coal amounting to 681 tons were imported for the use of the Austrian and Turkish steamers, and by 1854 twenty-one sailing ships brought 6900 tons of coal for use by the French and Austrian steamers.

The growth in Britain's commercial, religious, and political activity led to an increase in the number of British subjects, including Ionians and Maltese, residing in the area falling within the jurisdiction of the Beirut consul, from 75 in 1843 to 163 in 1846, 227 in 1849, and 282 in 1851.[14] By then the consul could announce that a chapel had been provided for Anglican services, at an expense of about £25. And by 1861 there were 80 British-born subjects (i.e., excluding Maltese, Ionians, etc.) in Beirut.[15] In 1843, there were 24 British subjects in Aleppo, 3 in Alexandretta, 31 in Latakia, and 4 in Tripoli, a

[11]See note 9.
[12]D. Chevallier, *La Société*, p. 184.
[13]FO 78/580.
[14]FO 78/580, 78/661A, 78/802, and 78/912.
[15]FO 195/700.

total of 62 in the Aleppo consulate.[16] But the number of British commercial houses in Beirut does not seem to have increased commensurately—a list for 1842 shows only 6, plus two Maltese houses,[17] and a petition from the "British bankers and merchants" of Beirut in 1858 contains only 7 signatures.[18] This compares with 14 French firms in 1849.[19] In Aleppo, the number of British houses fell from 5 in 1842 to 3 in 1848 and in Damascus from 7 to 6.[20]

The fact is that the increase in British trade seems to have been carried out mainly by Lebanese firms engaged in direct trade with England. A list compiled by the British consul in Beirut on 27 December 1848[21] is worth reproducing, since it includes most of the merchant families that dominated Lebanese trade and finance until World War II, when a new wave of contractors, merchants, and industrialists arose: Naqqash Brothers, Niqula Farajallah, Antun Qutta, Mansur Eddeh, Bishara and Elias Farajallah, Barbir Brothers, Francis and Antun Misk, Niqula Jahel and Son, Yusif Sayyur and Co., Thabit and Co., Tubiya and Asfar, Jurjus ʿId, Niʿmatallah Khury, ʿAbdallah Khury, Yusif Daghir, Mikhail Saliba, Butrus Kabbabeh, Antun Nasrallah, Nawfal Brothers, Bustrus and Nephews, ʿUmar and ʿAbdallah Bayhum, Ahmad al-ʿAris, Rizqallah and Ibrahim Trad, Niqula Sursuq and Brothers, Habib Dahan, ʿAbdallah Hanna and ʿAwdeh, Dabbas and Fayyad, Sursuq and Jammal, Fiʿany Brothers. The consul adds: "These twenty-nine houses are the most respectable native merchants at the place. Their agents in England are: Spartali and Lascaridi in London; P. Hava and Co. in London; N. S. Francopolo and Co. in London; Paul Cababé in Manchester." In other words, two of the agents in England were already Lebanese, the others being Greek.[22] It should also be noted that of the 29 names, only three are Muslim and none Jewish—the Christian ascendency in Lebanese trade and finance was clearly established. [See also selection 7]

This phenomenon was noted with some sorrow by a British vice-consul in his report on the trade of Beirut during the year 1871[23]:

British Commercial Establishments

These, in Syria, as in all other parts of the Levant, are decreasing in number. Beyrout possesses, at the present moment, five English houses, but in no other part of the country is an Englishman to be found engaged in commerce. In Aleppo, where a few years since, five houses existed, not one remains.

In Damascus, English and European trade in general is represented by a couple of German commission houses. The competition of the native has driven the Englishmen off the field.

Equal, if not greater, facilities given by the home manufacturer, cheaper modes of living, and consequent requirement of a smaller profit, looser ways of doing

[16]FO 78/580.

[17]FO 78/754.

[18]FO 195/587; some 5000 Christian pilgrims visited Jerusalem each year in the 1850s, Finn to Clarendon, 27 February 1854, FO 78/1032; the pilgrim caravan to Mecca cost the Ottoman government £ 70,000, Wood to Clarendon, 25 November 1854, FO 78/1029.

[19]FO 78/802.

[20]Ibid.

[21]See note 17.

[22]Similarly, the Dahdah family opened a trading office in Marseilles (D. Chevallier, p. 206).

[23]A and P 1872, vol. 58, "Syria."

business in many instances, have all combined in the face of the increased import trade with Great Britain, to enable the native to compete successfully with the Englishman.

The growth of a commercial bourgeoisie in Beirut and other towns was perhaps the most striking economic and social result of the expansion of trade with Europe. Another, hardly less significant, effect was the ruin of the Syrian and Lebanese handicrafts. [VI, Introduction] . . .

By the early 1860s Beirut had taken shape. Swollen by the refugees fleeing the mountains and interior after the 1860 upheavals, its population had grown to about 50,000, compared with less than 10,000 in 1830. Its foreign community had also grown: in 1858 a petition was signed by 37 European bankers and merchants resident in Beirut, including the manager of the newly opened branch of the Ottoman Bank.[24] It was linked to Damascus by the road built by a French company[25] in 1859–1863, the first one of its kind in the Ottoman Empire, and by a telegraph line. Its communications with Europe were regular and abundant: "Now the mails leave London for Syria every Friday via Marseilles and every Monday via Trieste; while English steamers run regularly between Beirut and Liverpool,"[26] and in 1861 204 French, Austrian, Russian and British steamers called at Beirut.[27] Emigration to America, which was to have such a profound impact on Lebanon's economy, society, and culture, was getting into its stride. The agrarian revolts of 1858–1860 had broken the traditional feudal structure. The Anglo-American missionary and educational activity of the previous thirty years was about to bear its finest fruit, the Syrian Protestant College founded in 1867 and later expanded into the American University of Beirut; concurrently French schools were being set up and would be followed by St. Joseph University. And at the top of this economic and social structure was an enterprising and prosperous commercial bourgeoisie, born of and sustained by the expanding foreign trade and its ancillary activities.

[24]See note 18.

[25]The company reserved 2000 shares for local investors in Beirut, Aleppo, and Damascus, which were immediately taken up.

[26]J. L. Farley, *The Resources,* p. 209.

[27]"Report on Trade," 1861, FO 78/1690.

10

Trade and Handicrafts of Aleppo, 1855

. . . The Gross Returns show that the Trade in Imports and Exports had nearly doubled every year since 1851, and that all the elements for a farther increase exist; and only require favorable circumstances, and increased facility in the means of Transport to the Coast, for their development; particularly the Exports in Grain, which have been considerable during the last two years; in the preceding years not a single quarter was exported.

In a country where accuracy is unknown and where the Government itself depends

From "Report from Mr. Acting Consul Barker on the Trade of Aleppo with Europe and Turkey for the Year 1855," 31 March 1856, FO 78/1221.

on the Custom House Officers for information, who are generally unwilling to give any, as the Customs are farmed annually to the highest bidder, our means of obtaining correct data are very limited. I have been guided by the general knowledge common to all the Mercantile community; which I have confronted with what I have been able to learn from the Custom House, and have arrived at the following results.

The Imports from Great Britain in Manufactured Goods and in two or three other Articles form in quantity about two-thirds of the whole trade. The French, Italian, German and Swiss, make up the remaining one-third—But some of the French and Italian goods are of greater value; as for instance cloth, silk stuffs etc. each bale of which is worth about £150 so that the British Trade in value would be reduced to one half: In Colonials the French and Italians Import in quantity and value about as much as Great Britain. Again the Trade of the whole line of Coast from Constantinople to Alexandria, amounts to as much as the French, Italian and Swiss Trade, which would give us a fair proportion one-third in value, as the amount of the imports from Great Britain.

The following approximate statement will show the increase since 1851. . . .

The Export Trade in grain has been increasing rapidly with the high prices in Europe since 1851, but the great impulse has been given to it by the demand at Constantinople to supply the Allied Armies and the increased consumption in the Capital; and were the means of transport to the Coast available, the whole of Mesopotamia would pour in incalculable supplies at prices far below those of the same articles in the Black Sea. Upwards of 50,000 quarters of grain belonging to different purchasers still remain in store to the East of the Euphrates, and double that amount remain in store unsold for want of the means of transport to Alexandretta. Were roads made from Mesopotamia to the Coast, the influx of Trade would well repay the expense, for at present Camel and Mule Carriage are scanty and the charges very heavy. During the year 1855 the rate of Carriage hire from Aleppo to Alexandretta has varied from piasters 100 to piasters 200 per 5 Cwt. which is equal to 18/5 to 26/5 [sic] on the quarter of wheat and from £3.6.8 to £6.13.4 on the ton of goods. Whereas the prices of grain in Aleppo has ranged from 25/- to 30/- shillings per quarter of wheat and 11/- to 14/-shillings per quarter for barley. At Orfa Wheat has been selling from 10/- to 18/-shillings a quarter, and barley at half the prices, although they are the best grown in the country.

As soon as the high prices of grain in Europe admitted of exports being made the restrictions which previously existed were removed by the Porte, and an increased amount of Cultivation was immediately the result. Before a year had elapsed hundreds of animals, camels, horses, and asses, were seen day and night conveying grain to the coast, pursuant to contracts, and the succeeding year a still greater number were engaged in this business, and there is no doubt were roads made that the agriculture of the whole of the interior would increase so rapidly, that the produce would be sold at very remunerating prices. . . .

Aleppo has ever been celebrated for its manufactures, which are sent to all parts of the East on account of their strength and durability, which formed a very considerable branch of trade until the Egyptian occupation of Syria; but during the whole of that domination to 1840 this trade was much depressed. A reaction took place on the restoration of Syria to the Porte, but the Revolution in 1850, again put a stop to all enterprise, and Aleppo has since 1850 been gradually recovering from that unfortunate event.

Table 10.1 will show the number of looms at present at work and the quantity of goods manufactured annually.

The Internal trade of Aleppo is considerable and I think has been generally underrat-

Table 10.1

Articles	Style and texture	Number of looms	Number of pieces	Value in piasters per piece	Total value (000 piasters)
"Chitara"	Cotton and silk stuffs	2,500	1,200,000	25	30,000
"Gazlieh"	Cotton stuffs throughout	1,000	600,000	11	6,600
"Cottonee"	Cotton and silk satined	500	120,000	75	9,000
"Alagia"	Silk and little cotton	400	134,400	60	8,064
"Agabanee"	Cotton embroidered with silk	50	12,000	50	600
"Sawa-ee"	Silk and gold thread	100	9,600	200	1,920
"Checkmak"	Silk and gold thread with cotton	50	7,200	100	720
"Atlass"	Silk satins	15	3,600	70	252
"Foutah"	Cotton and silk aprons	50	48,000	10	480
"Boshieh"	Silk handkerchiefs	25	24,000	20	480
Girdles	Cotton and silk colored	20	4,800	20	96
Ditto	Cotton, colored	50	24,000	8	192
"Kham"	Cotton cloth not dyed	200	134,400	20	2,688
"Abee"	Woven wool and cotton	100	28,800	25	720[a]
"Mandeel"	Black cotton handkerchiefs	300	192,000	30	5,760
Ditto	Colored cotton handkerchiefs	300	96,000	20	1,920
	Total	5,660	2,638,800		69,492

[a]Shown erroneously as 520,000 and the total as 69,292,000.—ED.

ed, of late years the trade of Damascus and that of the South of Syria and Palestine has not progressed in the same manner as Aleppo; perhaps the depression mentioned above may have contributed to stimulate enterprise on the reaction taking place or perhaps other causes attendant on the fluctuation of trade such as the establishment of Steam communication, may have been gradually bringing the wants of the inhabitants of Mesopotamia to this city.

Certainly population has not been increasing at all, nor has kept pace with the increased demand. I have endeavored in the following table to show the movement of the internal trade of Aleppo with Turkey and with Europe, at the close of the year 1855, obtained from the most authentic sources to be found in this country.

[A set of tables, omitted here, shows the internal trade of Aleppo, which totaled 134.9 million piasters or £1.08 million. Of the textiles enumerated in Table 10.1, and some additional ones, with a total value of 70.7 million piasters, about 10 percent were "consumed in Aleppo and the rest sent to Turkey and Mesopotamia"; soap for 5.8 million piasters was sent to Mesopotamia and Asia Minor and gold and silver thread for 5 million to Turkey. Among the main goods entering Aleppo were pearls for 5 million piasters, "the greater part exported"; silk stuffs from Damascus for 2.7 million piasters, "the greater part sent to Mesopotamia"; raw silk from Antioch and Latakia, Persia, Bursa, Beirut, Hamah, Amasya, and Cyprus, 1050 sacks worth 6.7 million piasters, "the great part consumed"; and 200,000 head of sheep from Erzurum, worth 10 million piasters, "consumed one-half in Aleppo and one-half in Damascus."

The bulk of exports to Europe, aggregating 79.3 million piasters or £634,000, consisted of grain from the Aleppo region, which also exported a small amount of cotton; galls, madder, and goat hair came from Mesopotamia, and a small amount of silk cocoons from Antioch.]

Beside the want of means of transport to the coasts, the unhealthy climate of its Port Alexandretta and the depreciation in the value of the piastre are circumstances which operate unfavorably to the development of the trade of Aleppo. . . .

11

Trade of Jaffa, 1899

IMPORTS

Iron. The total import amounts approximately to 1000 tons of which over 75% is Belgian and the rest English and Swedish in about equal proportions. The consumption of Belgian iron is fully double what it was ten years ago, while English and Swedish remain stationary. The reason for this is two-fold, (1) the difference of cost, and (2) the purposes for which the Iron is required. The cost of Belgian is £7.10.0 per ton delivered in Jaffa against £9.10.0 for English. Again, Belgium Iron is used for building; while the higher priced, but better, English and Swedish are used for making horseshoes and agricultural implements. Thus, it will be seen that while building Iron has a growing demand, that used for agricultural purposes remains in "status quo," a fact sufficiently suggestive. It may be remarked that Belgian Iron was hardly known in these markets fifteen years ago; now it has practically monopolised the trade, almost to the exclusion of English. The cause of this is cheapness combined with suitability of quality.

Timber. The imports represent a value of about £20,000 annually and have increased about 50% during the last ten years. It is imported chiefly from Odessa; a small quantity only of a better kind used for window-frames and doors coming from Adalia. About one-half of the quantity from Odessa is sawn into planks for orange boxes and the rest is used for building purposes.

Zinc. Imported from Belgium and France value £500 annually.

Tiles. Imported from Marseilles value annually £1500.

The demand for these two items is increasing in proportion with other building materials.

Petroleum. Annual import from Batoum, which has increased about 50% within ten to fifteen years, is now fifty to sixty thousand cases, for distribution throughout Palestine.

Canvas Bags. For shipping cereals. Imported from Bombay; about 100,000 annually. Stationary.

Rice. About 50,000 bags Indian, and 25,000 Egyptian.

Sugar. 100,000 bags chiefly from Trieste.

Coffee. 10,000 bags; 75% from Marseilles; 25% from Aden.

The import of these articles of food has increased quite 50% during the last ten or fifteen years and is progressive.

Clothing. Ready made, and piece cloth for European mode of dress, imported chiefly from Trieste. £40,000 annually.

From Irwin and Hordern to Dickson, 28 January 1899, FO 195/2062.

Calico. Printed and plain, with other materials for native mode of dress. Cottons from Manchester. Cloth from Germany principally. £60,000.

Leather. For boots and shoes, imported from France and Italy, value about £80,000 annually.

The demand for these articles of clothing may be said roughly to have doubled within the last ten or fifteen years, and is progressive.

Sundries. Lastly, all kinds of hardware and crockery which is imported chiefly from Trieste, and the demand for which keeps pace with the other wants of the people.

EXPORTS

Olive Oil. The yield one year with another is about 20,000 tons, and is nearly all manufactured into soap. Very little oil is exported. The value in soap represents approximately £60,000 annually; the surplus, after local consumption, goes to Egypt.

Darri Seed, Sesame, and Beans. There is a small export trade in these cereals; sesame going principally to France. But the cultivation remains stagnant, not to say decreasing.

Wheat. No surplus for export.

Oranges. The development which the cultivation and export of this fruit has acquired during the last ten or fifteen years is remarkable. The present value of the exports is about £60,000, and as fresh gardens are being planted every year this sum may be considerably increased as time goes on.

The foregoing remarks lead us to the following conclusions: First—The absence, with the exception of some cottons, of imports of English goods. Second—The relatively considerable amount of stuff imported for building purposes, food, and clothing; showing an increasing and active population. Third—The marked disproportion between this growing population with its wants, and everything connected with the products of agriculture. This is the more striking when we consider that it is a purely agricultural country.

The first is easily explained. This country will not buy anything but cheap goods, and profits are so cut up, that English firms will not bother with the small details, nor the trouble required in order to obtain very inadequate results. Add to this the credit which must be given, often very risky, and you have a business which does not attract Englishmen.

The second is attributable to the character of the native, who is frugal, thrifty, industrious, and will live and even build some sort of a house out of profits on which ordinary people would starve.

Much might be said in explanation of the third, but it would involve entering into matters which exceeds the limits of the present report. It may, however, be said briefly that with a better system of government, the prospects for the prosperity of Jaffa might be very encouraging.

A few words in conclusion about the Port of Jaffa. It is an open roadstead, the most exposed of any on the coast, and during the occasional stormy weather in the winter months is practically inaccessible for shipping. A line of English steamers calls three times a month, chiefly for orange cargoes. Besides this there is a coasting steamer belonging to English owners in Alexandria, which calls for oranges and other cargo more or less regularly. Other English trading steamers call from time to time casually. During the season there are two or three steamers, under the English flag, chartered for tourists. French, Austrian and Russian steamers call regularly, carrying the mails and cargo.

12

Trade of Baghdad[a]

Year	Imports		Exports		Source
	Total	United Kingdom	Total	United Kingdom	
1828	900		1260		CC Baghdad, vol. 10
1840	459		225		FO 195/237
1844	120–240		55		CC Baghdad, vol. 10
1845	400		105		Ibid.
1846			137		Ibid.
1864	282				A and P 1870, vol. 64
1865	255				Ibid.
1866	199		24		A and P 1872, vol. 57
1866			360		CC Baghdad, vol. 12
1867	175	24	33		A and P 1872, vol. 57
1868	165	32	33		Ibid.
1869	181		53		Ibid.
1870	286		50		Ibid.
1871	406	200	125	36	CC Baghdad, vol. 13
1874	873	400	877		Ibid.
1874	452		42		FO 95/1243
1875	211		230		CC Baghdad, vol. 13
1876	276		208		FO 195/1142
1877	452		295		Ibid.
1878	463		426		FO 195/1243
1884			371[b]		FO 195/1509
1887	762[b]		484[c]		A and P 1889
1888	813[b]		525[c]		Ibid.
1890	760[b]		476[d]		A and P 1893
1891	915[b]		565[d]		Ibid.
1892	847[b]		286[d]		Ibid.
1896			604[d]		A and P 1897, vol. 94
1897	1,183[b]		523[d]		A and P 1898, vol. 99
1898	1,271[b]		638[c]		A and P 1900, vol. 96
1899	1,417[b]		662[c]		A and P 1902, vol. 110
1900	1,495[b]		639[c]		Ibid.
1901	1,439[b]		551[c]		Ibid.
1902	1,984[b]		575[c]		A and P 1904, vol. 101
1903	1,924[b]		723[c]		A and P 1906, vol. 128
1904	2,014[b]		607[c]		Ibid.
1905	1,610[e]		696[c]		Ibid.
1906	1,858		847		A and P 1909, vol. 98
1907	2,312		710		A and P 1910, vol. 103
1908	1,912	931	556		Ibid.
1909	2,153	1,201	765	256	Ibid.
1910	2.736	1,319	854	330	A and P 1912/13, vol. 100
1911	2,661[f]	1,200	747	284	A and P 1914–1916, vol. 75
1912	2,823[f]	1,415	981	286	Ibid.
1913	2,914[f]	1,314	756	246	Ibid.

[a]In thousands of pounds.

[b]Europe and India.

[c]Europe, America, India, and China.

[d]Europe and America.

[e]Europe, India, and China.

[f]Excluding materials for Baghdad railway, valued at £367,000 in 1912.

13

Trade of Basra[a]

	Imports		Exports		
Time period	Total	United Kingdom	Total	United Kingdom	Source
1813	(500)[b]	400–480			CC Bassorah, vol. 3
1822	(500)				CC Baghdad, vol. 9
1844	123				CC Baghdad, vol. 10
1845	112		58		Ibid.
1845	139		88		FO 195/237
1846	114		96		FO 78/704
1851[c]	146		94		FO 195/647
1855[c]	119		55		Ibid.
1851–1855[c,d]	129		73		Ibid.
FY 1858/59	418	24	158		Ibid.
FY 1858/59[c]	203		131		Ibid.
1864	267		81		A and P 1867, vol. 67
1865	313		90		Ibid.
1866	325		82		FO 195/803A
1867			480		CC Baghdad, vol. 12
1869	118		218		A and P 1872, vol. 57
1870	185		217		A and P 1884/85, vol. 79
1873	144	26	214	60	FO 78/3070
1873	144	24	216	60	CC Baghdad, vol. 14
1874	147	22	200	55	FO 78/3070
1874	148	20	200	56	CC Baghdad, vol. 14
1875	179	31	399	119	FO 78/3070
1875	180	32	308	120	CC Baghdad, vol. 14
1876	202	32	287	112	FO 78/3070
1876	204	32	288	112	CC Baghdad, vol. 14
1877	209	31	543	112	FO 78/3070
1877	208	32	544	124	CC Baghdad, vol. 14
1879	880	144	1,552	472	Ibid., vol. 10
1887	511		973		A and P 1890, vol. 77
1888	842		1,010		Ibid.
1889	960		1,117		Ibid.
1890	921		1,376		A and P 1893/94, vol. 91
1891	1,144		2,025		Ibid.
1892	839		1,114		A and P 1894, vol. 88
1893	684		765		Ibid.
1894	1,156		864		A and P 1897, vol. 100
1895	1,399		1,091		Ibid.
1896	1,064		1,173		A and P 1898, vol. 99
1897	719		1,020		Ibid.
1898	1,178		833		A and P 1900, vol. 96
1899	1,190		1,136		A and P 1902, vol. 110
1900	1,264		1,562		Ibid.
1901	1,278		1,152		A and P 1903, vol. 79
1902	1,276		958		Ibid.
1903	1,255	(540)	1,297		A and P 1904, vol. 101
1904	1,261		1,306		A and P 1906, vol. 129
1905	1,388		1,505		Ibid.

(continued)

Trade of Basra[a] (*Continued*)

| Time period | Imports | | Exports | | Source |
	Total	United Kingdom	Total	United Kingdom	
1906	1,512		1,644		A and P 1907, vol. 93
1907	1,880		1,970		A and P 1910, vol. 103
1908	2,412		1,784		Ibid.
1909	2,360		1,504		Ibid.
1910	2,635		1,669		A and P 1913, vol. 73
1911	2,856		2,526		A and P 1914, vol. 95
1912	2,638		3,247		Ibid.
1913	3,899		1,939		Ibid.

[a]In thousands of pounds.

[b]Figures in parentheses are estimates.

[c]India only.

[d]Average.

14

Trade of Mosul[a]

| Year | Imports | | Exports | | Source |
	Total	United Kingdom	Total	United Kingdom	
1845	(100)[b]				CC Mossoul, vol. 1
1853	320		420		Ibid.
1861	(300)		(360)		Ibid.
1862	133		370		Ibid.
1863	218		366		Ibid.
1864	168		320		Ibid.
1865	200		162		Ibid.
1866	185		168		Ibid.
1884	563	90	252	79	A and P 1884/85, vol. 79
1892			350		CC Mossoul, vol. 2
1896	855	77	253	91	A and P 1879, vol. 94
1897	563		223		A and P 1899, vol. 103
1906	137	18	487	185	A and P 1908, vol. 117
1907	133	16	508	195	Ibid.
1909[c]	147	42	572	164	A and P 1912/13, vol. 100
1910[c]	142	38	609	177	Ibid.
1911[c]	165	43	343	164	Ibid.

[a]In thousands of pounds.

[b]Figures in parentheses are estimates.

[c]The U.S. consul ("Trade Report," Mosul, 1912, US GR 84, C8.9) gave the following figures (in thousands of dollars):

	1909	1910	1911	1912
Exports	1,212	1,247	1,127	1,155
Imports	587	571	659	720

15

Imports and Exports of Bombay with Persian Gulf and Arabian Gulf (Red Sea), 1801–1858[a]

FY	Persian Gulf	Arabian Gulf	Aden	Suez
1801/02	1,684	705		
	1,216	304		
1802/03	1,829	2,425		
	1,640	1,773		
1803/04	2,388	1,648		
	1,167	1,331		
1804/05	2,230	3,984		
	1,372	1,921		
1805/06	2,904	2,604		
	2,154	1,504		
1806/07	3,375	1,461		
	1,765	311		
1807/08	1,971	1,605		
	1,705	1,071		
1808/09	3,099	914		
	1,985	1,107		
1809/10	3,095	1,715		
	2,039	1,140		
1810/11	2,712	736		
	1,182	1,053		
1811/12	2,302	1,593		
	2,223	911		
1812/13	1,429	1,580		
	1,995	1,070		
1813/14	1,436	1,387		
	1,719	1,424		
1814/15	2,546	2,182		
	1,758	1,820		
1815/16	3,700	2,499		
	2,131	1,490		
1816/17	2,827	3,647		
	1,515	2,878		
1817/18	3,756	4,202		
	1,932	2,589		
1818/19	5,235	3,693		
	2,336	2,294		
1819/20	2,994	3,025		
	2,038	2,780		
1820/21	3,577	3,477		
	2,900	1,638		
1821/22	3,398	2,640		
	3,380	1,975		
1822/23	3,686	2,751		
	3,094	2,207		
1823/24	3,951	2,414		
	4,171	1,655		

(continued)

Imports and Exports of Bombay with Persian Gulf and Arabian Gulf *(Continued)*

FY	Persian Gulf	Arabian Gulf	Aden	Suez
1824/25	3,562	2,404		
	3,730	1,674		
1825/26	3,182	2,651		
	4,353	1,727		
1826/27	3,480	1,866		
	4,249	1,269		
1827/28	3,206	1,400		
	3,366	514		
1828/29	4,511	988		
	4,512	660		
1829/30	4,034	1,488		
	5,562	890		
1830/31	3,638	1,649		
	4,560	1,101		
1831/32	2,380	1,224		
	3,602	862		
1832/33	1,561	1,236		
	2,736	884		
1833/34	3,348	1,837		
	3,129	1,186		
1834/35	2,856	1,830		
	2,187	1,143		
1835/36	4,004	1,844		
	3,868	1,654		
1836/37	3,560	1,884		
	3,500	1,265		
1837/38	3,602	1,777		
	3,733	2,397		
1838/39	2,997	1,522		
	2,414	1,629		
1839/40	2,896	1,695		
	2,881	1,647		
1840/41	3,355	2,245		
	3,743	1,993		
1841/42	3,680	2,037		
	4,277	1,804		
1842/43	3,105	2,131		
	4,960	1,507		
1843/44	3,145	1,624		
	5,317	2,055		
1844/45	3,353	2,413		57
	4,572	1,814		26
1845/46	3,988	2,294		78
	4,100	2,576		66
1846/47	3,908	2,532		119
	5,027	2,671		133
1847/48		7,115		188
		7,886		102
1848/49		7,429	426	158
		6,780	1,392	166
1849/50		8,150	548	287
		7,264	777	346

(continued)

Imports and Exports of Bombay with Persian Gulf and Arabian Gulf *(Continued)*

FY	Persian Gulf	Arabian Gulf	Aden	Suez
1850/51		8,100	1,548	1,148
		6,312	562	261
1851/52	6,738	1,850	4,570	232
	5,154	1,646	544	205
1852/53	6,150	1,462	6,069	669
	5,770	1,849	706	322
1853/54	5,902	1,348	1,466	560
	5,071	1,795	553	564
1854/55	6,117	1,970	1,910	1,809
	5,674	2,324	987	252
1855/56	6,817	1,582	14,174	17,163
	5,914	1,827	861	492
1856/57	5,695	1,629	6,066	43,921
	6,630	2,254	1,472	1,005
1857/58	7,969	2,330	6,079	39,791
	6,432	2,240	1,553	501

Source: India Office, Bombay Commerce, Range 419, vols. 39–106.

[a]In thousands of rupees. For each year and each locale, the top one of the two figures represents imports, the bottom one exports. Figures for FY 1801/02 and 1806/07 exclude Surat; those for FY 1802/03–1826/27 include Surat. It is possible, though improbable, that Surat is excluded in subsequent years; its trade with the Persian Gulf was very small but with the Arabian Gulf was of the same order of magnitude as Bombay's.

16

Trade of Iraq, 1790s

At present almost all goods that come from the Persian Gulf are carried from Basra to Hilla, and from there they have to proceed, by land, to Baghdad; they take this route because it is easier to sail the Euphrates upstream than the Tigris. Dues payable at Basra are 7.5 percent for nationals, irrespective of religion, and 3 percent for Europeans. On leaving that town for Baghdad they are not inspected, but are subjected to seven tolls if they take the Euphrates route. The first, paid on leaving Basra, is of 5 piasters; the last, of 3 piasters, is paid at Hilla; the others are lower. Europeans pay only half. Boats sailing up the Tigris avoid five tolls, paying only the ones at Basra and Qurna, but they take that route only when the water level is very high; in such cases they enter the Euphrates at Qurna and, 20 leagues further on, take a canal named Hay (serpent) which gets them to the Tigris.

On entering Baghdad, merchandise belonging to nationals, no matter what its provenance may be, is charged 8.5 percent if it is classified as "heavy merchandise," and 5 percent if it is designated as "precious merchandise." Dues are assessed at current prices. "Heavy merchandise" includes metals, coffee, tobacco, pepper, and sugar—in

From G. A. Olivier, *Voyage dans l'Empire Othoman, L'Egypte et la Perse*, Paris, L'An VI, vol. 4, pp. 432–449.

other words, all bulky goods. "Precious merchandise" refers to cloth, irrespective of quality or value. Europeans pay 3 percent on all goods.

On leaving Baghdad, goods are not inspected or taxed. Goods going to Basra by the Tigris or Euphrates are not subjected to any tolls, but the Arabs exact some presents. On arrival at Basra they pay 7.5 percent, like those coming from the gulf. On leaving Basra for Persia, Musqat, or India, they pay 5 percent. Europeans never pay more than 3 percent.

Caravans from Aleppo to Basra, across the desert, pay the same dues. Those from Damascus almost always go to Baghdad and, for some time now, all those from Aleppo have done the same. No dues are paid in the desert, but the heads of the caravans always give some presents to the Arab hordes they meet on the way.

EXPORTS

Not only Europe is obliged to pay, in gold and other metals, for the rich and abundant products it obtains from India. In Turkey, too, the same channel drains almost all the metals it obtains from Europe. Payment for the merchandise obtained through the Persian Gulf is made in Venetian, Dutch, and Hungarian sequins, in old Turkish sequins, and in old piasters. By this route over 10 million Turkish piasters are drained away. This sum would have been much larger were it not that, as we will see below, Turkey supplies India with some valuable goods. The money that passes to Persia is estimated at 5 million piasters, and the European goods that are sent by the Turks in payment for those brought from Persia and India at 1 million.

India receives, through Baghdad, much ingot copper (*cuivre en pain*) from the mines of Asia Minor and also a very large quantity of old copper, brought from Syria, Mesopotamia, Anatolia, and Kurdistan.

Gallnuts are another important article; much is sent to India. Some opium and gum tragacanth are also brought from Asia Minor. Baghdad, Kirkuk, and Mosul also export some bales of madder, known as *foua*.

A good deal of dates is sent to Kermanshah, Hamadan, and northern Persia, and also a small amount of rice. From Basra dates, rice, and sometimes wheat and barley are shipped to Musqat, Surat, and the Gulf of Cambay.

The writing pens used by Persians and Turks are made out of reeds that grow east of the Shatt al-Arab; a large amount is also sent to India.

Horses bred by the Arab tribes living west of Basra and Baghdad are highly valued in India. A large number is shipped each year to Surat and Gujarat.

EUROPEAN MERCHANDISE

Satins, velvets, gold and silver cloth from Lyon, *moiré* silk, etc., are used in Turkey; they are often brought to Baghdad, from whence they spread to Persia and as far as Kandahar.

Woolen cloth from France is sent to Persia and up to Kandahar; the most sought-after qualities are *londrins seconds*,[1] made by factories in Languedoc. When the European were established in the Persian Gulf and Isfahan, a large amount of woolens and other European manufactured goods was sold. Under Kerim Khan [reigned 1751–1779] the English still sold, in Basra and Bushire, woolens worth 1 million [francs], destined for

[1]Woolens made in imitation of those of London and intended for the markets of the Levant.—ED.

Persia. Today they sell almost no woolens, for the following reason: in the past the English government forced the East India Company to buy, from factories in England, a certain amount of woolens, which were sold at a loss in Bandar Abbas. Having lost this agency, the Company sent its woolens to Bushire and Basra. As long as English cloth was being sold at a loss, other countries could not compete. But ever since the company recovered its freedom of action in this respect, the price of woolens has greatly increased in Basra and the gulf ports, and it became possible to sell French cloth at a lower price.

There is no doubt that the French, whose cloth is less expensive—and of a quality more highly valued in these regions—will be able, someday, to develop the full potential of this branch of commerce. For this it would be necessary to have agencies in Basra. Ships sent from France could carry woolens, hardware, Lyon cloth, etc., to Musqat, Basra, and the ports of Persia. They could load back either foodstuffs from Basra to Musqat or copper and dates to Surat, or else bring back merchandise to Europe. They could also carry foodstuffs and mineral tar or bitumen from Hit to l'Ile de France [Mauritius].

Braids from Lyon are widely consumed in the Ottoman Empire; only a small amount is sent on to Persia, but much is used in Baghdad. In Constantinople, attempts have been made to imitate the most widely used qualities, but it proved impossible to make them as beautiful or to produce them as cheaply.

Needles constitute an important item, and many are sent to Persia; the most common kinds are the most sought after, since they are less expensive.

Watches and hardware are not sold fast, and only a few are imported.

Bar iron, steel, nails, tin, white lead, red lead, brass wire, brass sheets, and thin sheets of yellow and white brass from Nurnberg, known as *lametta,* come to Baghdad by land and from there are carried to Persia and, sometimes, to India.

Glassware from Venice is sent, by this route, to India and Persia. Glass from Bohemia—bottles, plates, *nargiles* (waterpipes), drinking vessels, jars for jam, gilded glasses—are bought in the whole of Turkey. Much goes to Persia through Baghdad and Basra.

Sometimes a small amount of cochineal is sent from Marseilles to India, via Aleppo. Worked coral also takes the same route; the most beautiful kinds go to India, and the less beautiful to Persia; those that are decayed are bought by the Arabs.

Amber that is transparent and has a beautiful yellow color, is highly valued in Persia, Arabia, and India; it constitutes an important item of trade in Baghdad. Opaque kinds are used in the whole of Turkey, mainly for pipes; only small amounts of this kind go to India and Persia.

IMPORTS

Sugar. American sugar, being superior to that of India, is always preferred when its price is not too high. Nevertheless much sugar is imported from Batavia and Bengal for consumption in Baghdad and Arabia, and some also goes to Persia.

Coffee. Each year some 5000–6000 bales of coffee reach Basra and Baghdad for consumption in Mesopotamia, Kurdistan, and Armenia; little goes to Persia. Quite often some is sent to Aleppo and Damascus.

Tobacco. Persian tobacco, known as *tombak,* is brought from Isfahan and Shiraz to Baghdad, from whence it is carried to Damascus, Aleppo, and Constantinople. The same kind is also raised in very large quantities around Baghdad and is sent all over

Turkey. The tobacco of Shiraz is considered as the highest quality and that of Isfahan as the second; Baghdad tobacco is regarded less highly. Exports of the last-mentioned are put at 10,000 bales at a price of about 50 piasters a bale, which equals 1 million francs of our currency. Transport to Constantinople doubles the price. This kind of tobacco is very strong, and used only for *nargiles*. Its smoke would be too acrid if it were not softened by the water-filled bowl that separates the tobacco in the tube from the pipe. *Tombak* is acrid only because the tobacco plant is allowed to grow almost to maturity. Not only the leaves but the sides, the stalk, and the whole plant are used. The tobacco is of the same species as that cultivated in Europe and in the whole of the Levant.

Indigo. For the last 10 or 12 years, American indigo having become much scarcer and much more expensive than formerly in Turkey and Persia, cultivation of the plant from which it is extracted has increased prodigiously in Lahore, Multan, and in the area around the Gulf of Cambay. The indigo from these places is almost as good as that of San Domingo. Part of this merchandise is carried to Surat; the other goes overland through Kabul and Kandalas and is marketed all over Persia and in the whole of Asian Turkey. [See selection 17.] One may presume that this branch of industry will soon be lost for Europeans and that the indigo made east of the Indus will meet the needs of the Ottoman Empire and Persia. Recently, some has also been produced at Shushtar, northeast of Basra. We have already mentioned that much is produced in Egypt. . . . [Drugs . . . *Salep.* . . . Rhubarb. . . . Senna. . . . Myrobolan. . . . Terebinth]

Spices. Pepper, cinnamon, cardamom, zedoary, galingale, ginger, and nutmegs are also imported in large quantities from India and sent on to Aleppo, Damascus, and Constantinople; a small amount is distributed in Asia Minor. A small quantity of ginger and nutmegs preserved in sugar is also imported. . . . [Gum elemi. . . . Musk. . . . Ambergris]

Cashmere Shawls. Each year Persian caravans bring to Baghdad shawls from Kashmir worth 1 million piasters, which are sold all over Turkey. They are often carried to Constantinople by the Tartars whom the pasha sends [see IV, Introduction]. Persia also exports Kirman shawls; they are neither as fine nor as beautiful as those of Kashmir; Kashmir shawls are made of down interposed with hair of Tibet goats and Kirman shawls with hair of Kirman goats. In Baghdad the former cost 150–200 piasters and the latter 20–25.

Silk, Silk Fabrics. Basra and Baghdad import silk from Gilan, Bengal, and China; almost all is sent to Aleppo and Damascus, Baghdad's own consumption being very small. Bengal silk is the most beautiful; then comes Gilan silk, which is preferred to that of China, the latter being stiffer and coarser. Arbil, Kirkuk, and the whole of the southern part of Kurdistan supply Baghdad with a very small quantity of silk, which is used in workshops. A very large quantity of pure-silk fabrics, or of silk and cotton cloth, is imported from Surat and Gujarat; they are plain or striped, with silk flowers or gold or silver flowers. Silk cloth, plain or striped, is also imported from Bengal, for reexport to Arabia.

Silk and cotton fabrics—plain or striped—made in Damascus and Aleppo are marketed all over Turkey; Baghdad and Basra receive only the amount needed for their own consumption and that of their immediate surroundings.

Cotton, Muslin, Linen Cloth. The best cotton—the finest and most suited for the making of beautiful muslin—is harvested in the kingdom of Bervoidje, near Surat; a large amount of raw cotton of this kind is brought to Basra. Some 30,000 *okes* of cotton yarn are also imported, and sent on to Mosul, Damascus, and Aleppo. Usually it is sold at 20

piasters an *oke,* for a total of about 1.2 million francs. Devil(?), a port near the north of the Indus, supplies Basra and all the Persian Gulf towns with coarser cotton that is used to make cloth for shirts and, more especially, cloth for sails. Much sailcloth is made with such cotton in the Bahrain Islands. Southern Persia also sends a kind of cotton more beautiful than that grown along the Tigris, for the use of workshops in Baghdad, Aleppo, and Damascus.

A large amount of muslin comes from Bengal; also much very fine cotton cloth and some closely woven cotton cloth, white or printed, or varying qualities and prices. They are exported by Madras and made in Dianaum(?), above Masulipatam; in France they are known as *Perses,* because the first ones were brought from Persia. Calicoes from Sadras, Madras, and Pondichery are also imported in fairly large quantities by Basra; the white ones go to Turkey and the printed ones to Persia.

In Surat thick linen cloth—blue, white, or red, but most often blue—is made and sent to Basra for use by the Arabs.

Pearls. In the Persian Gulf, from Gran [Kuwait] to Cape Musandam and around the Bahrain Islands, a very large amount of pearls is fished; in an average year the output amounts to 2 million piasters or 4 million francs.[2] The most beautiful, largest, and most valuable—about three-quarters of the total value—are sent to India and China. The rest is sent to Basra, and marketed all over Turkey; hardly any go to Persia. It is from Bengal that some pearls, small and round, are brought to Europe.

[2]See *EHME,* pp. 312–316.—ED.

17

Indigo Imports, 1801

The following passages are taken from "Copies of two papers given to me by two very intelligent and respectable merchants here," that is, in Baghdad. The first is in very good French and the second in somewhat shaky French. They give an idea of the magnitude and ramifications of the traditional trade in an important item.

For a long time, until the year 1776, Basra, Baghdad, Kirkuk, and Kurdistan used two kinds of indigo, carried from Surat in long leather bags that were sold by the bag, without weighing, for all were of equal weight; the price of that first kind was 50 percent higher than that of the second.

In order to judge the quality, a hole was pierced at the top of the bag, and the sellers would not allow a second hole to be made; but because numerous cases of fraud were discovered in these bags—which sometimes contained at the top the ordinary quality, in the middle a much poorer one, and at the bottom a much inferior quality—the bags lost their reputation and no one wanted to buy them. Each year 300–350 bags were brought to Basra, the first quality selling at 300 piasters and the second at 200.

From Jones to Government, Bombay, 24 April 1801, IOPS Bombay, 381/23.

Merchants started importing indigo from Surat in bales, which were opened wide for inspection, after which the price was set. But when Zeman Shah ascended the throne [1793], the routes from Kandahar, which had long been closed, were reopened and the indigo of Redegat was carried from Persia to Baghdad. This comes in three varieties: the first is known as *crouta,* the second as *champoury,* and the third as *poucqui.* Each bale of these three varieties contains three qualities, the difference in price between each being about 5 percent. *Crouta* sells at about 50 percent above *poucqui,* and *champoury* falls in between. Indigo is highly regarded in Baghdad, Kirkuk, Mosul, and Kurdistan, and after the Revolution in France it spread to Diyarbakr, Tokat, Caesarea [Kayseri], Smyrna, Damascus, Aleppo, and Erzurum. As a result, Surat indigo is no longer needed for these places; nevertheless a small amount is imported each year, for the use of Baghdad and Mosul.

In 1794 Bengal indigo began to be carried to Basra; its quality was about 7 percent higher but it soon deteriorated and at present is equal to *crouta* and sells at the same price. Last year *crouta* was sold in Baghdad at 73 piasters a *batman* of 2400 *drams, champoury* at 50, and *poucqui* at 47 piasters. At present, because of the siege of Kandahar by the brother of Zeman Shah, these indigos are sold at 10 percent more, cash down. Since the Revolution in France 1 million piasters worth of indigo are sold in Baghdad each year; before the Revolution annual sales were about 600,000 piasters, for Damascus, Aleppo, Caesarea, Smyrna, Diyarbakr, Tokat, and Erzurum used American indigo.

When, among the indigo exports of Baghdad, someone raises a question regarding any quality of indigo, a piece of the dyestuff is taken, weighed, and then burned, upon which all the indigo is consumed in dark blue smoke; when this thick smoke stops, the piece is taken out of the fire and reweighed. The same is done with other pieces of indigo; the one that has decreased the most is regarded as the best quality, since it contained the most indigo—for what remains is pure earth. The indigo that used to be carried in bags was so adulterated that, using this method, it was found to contain only 12.5 percent indigo and 87.5 percent pure earth.

Among all the items that constitute the basis of the trade of Baghdad, indigo is one of the most important and essential; its import (*extraction*) through Baghdad has greatly increased since the outbreak of the present war—a development that has almost wiped out the importation of this article from America—and after that consumption of our indigo has spread all over Anatolia and almost into Rumelia.

We have here several kinds of indigo, all products of the East Indies, part of which comes to us by way of Persia, passing through Kandahar. These are Kroujia indigo, which we call *lahori,* a product of Kroujia, a district between Lakuahor and Delhi; there is the indigo of Multan, or Linegiate, which is called *giampouri* or *poucqui,* of different qualities with somewhat different prices; and in addition there are other varieties that reach us by sea from India. The above-mentioned *lahori* is the very best variety, which is at present sold at 85 piasters, cash down, which has risen as high as 145 piasters in times of dearness, and which last year was sold at 85 piasters, on one year's payment. None of these prices are stable, prices rising or falling—as for other items—depending on the amount that is brought here and on consumption. In peacetime this kind of indigo was quoted at 65 piasters, which then amounted, effectively, to about 63 piasters and which is about the current price, given the increase in money in this country; but as consumption increased the amount planted also probably increased, which has brought it about that present prices correspond to peacetime prices. . . .

Lahori indigo being the very best, those varieties that come to us from Bengal, by

sea, are usually sold at 5 to 8 piasters less than it; multan indigo, or *poucqui,* is sold at almost half the price of *lahori.* It has often happened that Lahori fetched 80 piasters and *poucqui* 45–48; but the indigo that comes from Surat is sold at a still lower price than *pouki* [*sic*]—8–10 piasters a *mann* of Baghdad of 2400 *drams,* or 6 *okkas.* Thus, taking the price of *lahori* or kroujia at 80 piasters, that of Bengali should be 72–75, *pouki* or multan 45, and Surat 35 to 38, more or less—that is the difference in price between them.

 Lahori indigo incurs great costs to get to Kandahar, where the usual price is 14–16 rupees per Ievrisi *mann,* the measure used in that country, 2.25 of which equal 1 *mann* of Baghdad of 2400 *drams;* often, when this price is paid in Kandahar, little profit is made.

 Here are the costs that indigo incurs between Kandahar and Baghdad, reckoned in rupees and Ievrisi *manns:*

Transport from Kandahar to Herat, usually 0.5 rupee per *mann;*

Duty at Herat, 4 rupees per load of 60 *manns;*

Transport from Herat to Yazd, 1 rupee per *mann;*

Duty at Tabas, 60 rupees per load—a customs duty;

Duty at Yazd, 2 rupees a load;

Transport from Yazd to Baghdad, 60 rupees a load;

Duty at Kermanshah, 60 rupees a load.

 All these figures, which are more or less accurate, can be more or less reduced, depending on the weather, (*sont susceptibles de plus ou moins d'économie selon le temps*); hence, *lahori* indigo bought at 16 rupees in Kandahar and sold at Baghdad for 80 piasters, breaks even (*fait la parité*), reckoning the rupee at $1\frac{7}{8}$ current piasters, and not taking the lapse of time into consideration; I do not speak of costs incurred in Baghdad, which are of little account for the seller.

 Consumption of all these kinds of indigo may amount to about 50,000 Baghdad *manns* a year, more or less; during the present war it is necessary to have all these varieties for different kinds of work.

 This item is essential in all Asia, where it is consumed in large quantities, since in many places poor people dye their shirts (*chemises*) blue; indigo from America having become scarce and dear during the present war, Indian indigo has met all needs.

 The lowest (*le plus commun*) kind of indigo is used at Baghdad for the dyeing of coarse cloth, and at Cucheter, near Baghdad, an indigo is made which sells at 15 piasters a *mann* and is employed, along with the other kinds of indigo, for certain uses.

 There is no doubt that the costs incurred in importing Kroujia indigo by way of Kandahar are immense, and could be reduced by competition using the sea route; the difference in costs alone would constitute a handsome profit for whoever managed to do this. One could even sell advantageously in Persia, by delivering this commodity more cheaply than that brought from Kandahar.

18

Complaints of Imam of Musqat regarding Basra Customs, 1801

[The Imam of Musqat sent the following to the Pasha of Baghdad]

The reduction of the Customs is a reciprocal mark of friendship between the Governor of Bussorah and Muscat not confined to the Imam alone for he remits the duties on the Mussallum's [Governor's] goods as the Mussallum remits them on his, it is no innovation but a matter of long standing between the two Governments.

Every year a list is sent with the goods to Bussorah which is in the hands of the Mussallum and if the Bashaw of Bagdad will require it from the Mussallum the Bashaw will perceive that the amount excused in some years, 6000 and never exceeding 10,000 piasters, except last year when Muhammed Khullul went as Ambassador with a retinue to the Bashaw in Ibrahim Mulla Aaly's ship, when it amounted to 24,000. Muhammed Khullul then made handsome presents to both the Bashaw and Mussallum.

The account of the Bashaw in making the reduction 20,000, 30,000 and 40,000 piastres is greatly exaggerated without the Mussallum may have reckoned [*sic*] on a tyrannical custom of his appraising the merchant's goods double the market price and collecting the customs on his own arbitrary valuation and also by an exaction of 10 dollars on a Bengal bale and 4 dollars on a coffee bale over and above the legal duties which makes the customs (farmed by the Mussallum himself) amount to 15 percent to some, to others who are favoured both Jews and Mussulmans they are only 3 percent, while the legal duty is only 8 percent on the amount of sale; these exactions are not made at Muscat on the Bussorah merchants and the Muscat merchants in return should be free of them.

It is the wish of the Imam to continue on good terms with the Bashaw of Bagdad but the communication between them can only subsist on equal terms and therefore if the Bashaw is not pleased to permit matters to continue on the present footing he is very willing to drop all communications whatever with Bussorah without being less the Bashaw's friend and will willingly agree that the Bussorah vessels shall not frequent his ports nor his subjects Bussorah. . . .

From David Seton, Company Resident Musqat to Government, Bombay, 18 February 1801, IOPS Bombay, 381/20.

19

Tariffs in Iraq, Aleppo, and Constantinople, 1810

Statement of Turkish import duties collected at Bagdad on native property according to the regulations of the Customs House of the present day, viz.:

On Bengal goods of all descriptions whatsoever	5 percent
On Surat, Guzerat and Scind piecegoods of various description	5 percent
On Cambay goods	5 percent
On Surat Leree and Sermasoot [sic] goods	5 percent
On cotton yarn called Inhend [Terbund?]	5 percent
On cotton yarn called Shajree [sic]	8½ percent
On Guzerat Leree, Taffeneck and Gomasoot goods	3 percent
Indigo	⅝ of a piaster per chest
Pepper, sugar, sugar candy, sandalwood, blackwood, iron, iniger, tin, lead, stick lac, coffee, cinnamon, cardamom, nutmegs, cassia, cloves, etc.	8½ percent

The note respecting the practice at the Bussora Custom House applicable to Bagdad.

Statement of the Turkish duties collected at Aleppo on the receipt there of native property from Bagdad and Bussora, viz.:

Bengal goods, shawls, Surat goods, Guzerat goods, Scind goods, 42 piastres per camel load.
Indigo, ditto
On coffee 40 piastres on 500 lbs. weight

Statement of the Turkish duties collected at Constantinople on the receipt there of native property from Bagdad and Aleppo, viz.:

On Bengal goods, shawls, Surat goods, Cambay goods, Guzerat goods, Scind goods	5 percent

Statement of Turkish import duties collected at Bussora on native property according to the regulations of the Bussora Custom House of the present day, viz.:

On Bengal goods of all descriptions whatsoever	7½ percent
On Surat, Guzerat and Scind piecegoods of various descriptions	7½ percent
On Cambay goods	7½ percent
On Surat Leree and Germasoot [sic] goods	5½ percent
On cotton yarn called Terbund	5½ percent
On cotton yarn called Shagzree [sic]	8½ percent
On Guzerat Leree, Toffeneck and Germasoot [sic] goods	3½ percent
Indigo	9⅝ piasters per chest

From Manesty, Resident at Basra, to Bombay Government, 20 December 1810, IOPS Bombay, 383/14.

Pepper, sugar, sugar candy, sandalwood, blackwood, iron, iniger, 8½ percent
 tin, lead, stick lac, coffee, cinnamon, cardamom, nutmegs,
 cassia, cloves, etc.

NB: These customs are collected on a valuation sometimes very exorbitant and always exaggerated whilst with respect to the Surat Leree and Germasoot and the Guzerat Leree and Germasoot and Teffureck [sic] goods the customs, now apparently moderate, have been reduced to prevent smuggling and to encourage their owners to convey them to the Custom House, although they there suffer exceedingly by the selection therefrom of the choice pieces by the Musallam [Governor] and Customs Master at their own prices.

Statement of Turkish duties collected on the despatch to Bagdad of native property from Bussora:

On all descriptions and kinds of goods per bale or package piasters to 1 [sic]

20

Trade of Basra and Baghdad, 1814

27 February 1814. . . . The Jonas, laden with 100 Arabian horses and dates, left for [Bombay]. This year, Arabian horses are very eagerly demanded in India. Mr. Colquhoun [the British agent] bought 300, and the merchants of this port who deal in this business have purchased as many. Prices have therefore considerably risen, and the least one pays is 450 piasters, fine horses fetching up to 3000. Transport costs are fixed: to Bombay 675 piasters a head and to Bengal 900; this does not include a customs duty of 63 piasters a horse in Basra, nor the cost of feed and other expenses. . . .

22 March 1814. Four months ago, in the vicinity of China, an American frigate captured three British ships, whose cargoes have been estimated at 2,440,000 francs. . . .

20 November 1814. The ships of Abdallah lbn Djabir having met, in the Gulf of Hormuz, a *daw* that had recently left for Bombay carrying 60 horses belonging to Mr. Colquhoun, attacked and captured it after three days of fighting. Learning later at Cinas [Shinas?], where they landed, that the horses belonged to the English Agent at Basra, these brigands hastened to charter another *daw,* for 5700 piasters 'ayn, and sent them on to their original destination, accompanied by two Arabs from their tribe. . . .

INFORMATION ON EUROPEAN TRADE
WITH THE DEPARTMENT OF BAGHDAD

Since we have been in charge of the consulate at Basra, no French vessel has entered this port; the same was true during the time of our predecessor; hence it is clear that there is no direct trade between France and this country. French commercial relations with Baghdad

From "Commercial News Bulletin on Basra," 17 February 1814 to 26 January 1815, CC Bassorah, Vol. 3, 1813–1816.

are almost nonexistent. Imports of French goods to Baghdad consist of woolens, caps, Dutch diamonds, braids, coral, velvet, golden velvet, silk lustrines, spangles, purl, satin, moiré silk, gauze, crepes, cochineal, vermillion, paper, tinsel, hardware, lancets, clocks, and taffetas. The sum of these imports, whether by way of Constantinople or Aleppo— those being the only entrepôts of European trade with Baghdad—does not amount to 3 million [francs] per annum. In return Baghdad sends, to both Aleppo and Constantinople, Indian and Persian goods and pearls from the Persian Gulf. Exports of the last-named and cashmere shawls to Constantinople are put at over 8 million [francs] a year; we do not know the amount of these two articles that reaches France.

Two obstacles contribute to the diminution of French trade with this department; one topographic, and of necessity irremediable, and the other arising from the avidity of the Turks who instead of protecting trade thwart it. The first of these is that Baghdad is 500 leagues distant from Constantinople and 200 from Aleppo; the second is the multiplicity of customs duties, of which here is a description.

French goods reaching Constantinople are withdrawn from the customs on payment of a duty of 3 percent. The French merchants sell them on the spot to local traders who, to send them to their correspondents in Baghdad, must first pay an export duty of 4 or 5 percent. In Diyarbakr they pay a further duty of 5 percent. On reaching Baghdad goods sold by weight pay 8.34 percent and those sold by measure 5 percent.

Through the entrepôt of Aleppo, goods brought by French ships from France to Aleppo are unloaded in Cyprus, Alexandretta, or Latakia, where they pay no customs duties but only very small dues. When they have reached Aleppo, the European merchants of that city withdraw them on payment of a 3 percent duty and sell them to local traders who send them on to Baghdad by camel caravans, through the desert. The latter also pay an exit duty of 4–5 percent.

This example shows that the duties paid on merchandise by the time it reaches Baghdad are: through Constantinople four, totaling over 17 percent, and through Aleppo two (one might say three, since the dues paid at Latakia or Alexandretta, although light, are nonetheless a charge on trade), and amounting to over 9 percent.

It may seem strange, from this account, that the goods that come through the entrepôt of Constantinople, traveling 500 leagues[1] and paying customs of over 17 percent while those that come through Aleppo travel only 200 leagues[2] and pay only over 9 percent—it may seem strange, I repeat, that the merchants of Baghdad do not give up the former entrepôt in favor of the latter. And yet the Constantinople's trade at least matches that of Aleppo, if indeed it does not exceed it. The reason is that there is only one caravan each year from Baghdad to Aleppo and from the latter to Baghdad, whereas from Constantinople here, and vice versa, communications are very frequent, goods going and coming almost each month, either by caravan or by Tartar. A merchant who loads for Constantinople may expect to receive his returns (*échanges*) within a few weeks; if he loads for Aleppo he will receive them only after a year. What he gains in time more than offsets the difference in cost noted above.

The only way of overcoming the second obstacle with regard to both entrepôts would be to have French establishments in Baghdad, which would undertake themselves

[1]Constantinople caravans consist of mules. The carrying load is 100 *okes* (40,000 *drams*) and the cost from Constantinople to Baghdad is 300 piasters. By Tartar [post], each *oke* (400 *drams*) costs 10–15 piasters.

[2]A camel carries 200 *okes* (80,000 *drams*), the cost being 100–120 piasters.

to trade in French goods. They would pay duty only once (see articles 37, 39, and 57 of the Capitulations) at the rate of 3 percent.

Both these obstacles face English trade as well, but the amount of such trade through Constantinople and Aleppo is insignificant. It is from India that the English pour their goods into Baghdad, by way of Basra, and from there flood the whole East. These goods consist of vitriol, sugar, indigo, pepper, cinnamon, nutmegs, cloves, aloe wood, incense, camphor, ginger, sandalwood, sal ammoniac, bezoar, tin, and also muslins, cotton yarn, embroidered muslins, dyed cloth, cotton fabrics, silk fabrics, and silk and gold fabrics. In return Baghdad sends to India Venetian sequins, Spanish dollars, copper worth 2 million piasters, and 1 million piasters worth of coral, tinsel, blades, dates, gallnuts, yellow amber, emeralds, horses, and hardware. The value of English goods brought into the Department of Baghdad by English, Persian, and Arab vessels entering Basra is estimated at over 12 million [francs]. The reasons for the huge size of these imports are:

1. The advantage derived by the English from the geographical protection of the place, that is, being able to send their goods by water, an advantage that reduces the cost of transport to a very small amount.
2. The advantage accruing to Indian goods of paying not more than two customs duties, one in Basra and one in Baghdad.
3. The great esteem in which these goods are held here, arising from the fact that they meet no competition. For agricultural (*territoriale*) goods this advantage arises from the fact that no country other than India produces them; for manufactures it is because our own similar goods, which equal or even surpass them, are not imported here. . . .

As for the agricultural produce of this department—in the way of cereals, it covers exactly the consumption of the inhabitants.

21

Trade of Baghdad, 1824

. . . With regard to trade, the last war was very harmful. Caravans coming from Persia to Baghdad are today much smaller than before. They have become accustomed to taking other routes. Much business is now transacted in the towns along the Persian Gulf: Shiraz, Basra, Bushehr, etc., but in that vicinity one should note that everything takes place at the will of the English; in the whole of the Persian Gulf and Arabian Iraq the English are solely dominant. They alone have influence on what takes place in these countries; no one disputes their victory. Hence the company's Resident, who lives in Basra, often causes much anxiety to the pasha of Baghdad. He could easily impede Mesopotamia's trade and stop goods from coming up the Tigris and Euphrates. Daud pasha does not like the English, but he fears them and with good cause; his main revenues are derived from the

From an unsigned letter, 28 April 1824, CC Baghdad, vol. 9, 1822–1830.

duties he levies on goods from India. Currently, caravans from Damascus, Aleppo, Mosul, and Persia bring him little profit. The desert Arabs on the one hand, the Kurds on the other, are in an almost continuous state of war, and therefore communications between these towns are greatly obstructed. Caravans, messengers, Tartars are stopped and robbed or escape only by submitting to extortion and paying arbitrary dues that ruin everybody.

At present nothing interesting is happening in Arabian Iraq, the country being fairly quiet. Transport vessels go up and down the Tigris and Euphrates without difficulty, there are no contagious diseases as in recent years, and each person is carrying on his private business. . . .[1]

[1]The previous year a "Report on the Trade of the Pashalik of Baghdad" (9 February 1823, CC Baghdad vol. 9, 1822–1830) estimated the Pashalik's imports of British goods through Basra at 10–12 million francs. Arab ships were bringing in coffee (from Yemen). But, because of a dispute between the government and the Resident of the East India Company, trade had diminished.

22

Merchandise Trade and Money Transactions of Basra, 1845–1846[a]

Merchandise Trade of Basra[b]

Imports from		Exports to	
India		**India**	
1845	1,865		1,446
	(indigo 660, *dhotis*[c] 427, cashmere shawls 80)		(horses 1,175, dates 180, *ghee*[d] 20)
1846	1,909		1,567
	(indigo 624, *dhotis* 202, cashmere shawls 120)		(horses 1,300, dates 120, wool 49)
Bahrein		**Bahrein and Persian Gulf**	
1845	768		233
	(pearls 750)		(rice 90, wheat 84, dates 45)
1846	132		220
	(pearls 125)		(wheat 100, rice 68, dates 42)
Persia		**Persia**	
1845	174		116
	(tobacco 40, *hinna*[e] 34, limes 20)		(*dhotis* 50, dates 32, European long cloth 21)
1846	168		143
	(tobacco 45, *hinna* 43, limes 11)		(*dhotis* 60, dates 36, sugar 25)

From tables compiled by Henry Rawlinson in FO 195/237 and FO 78/704.

Merchandise Trade of Basra[b] (*Continued*)

Imports from	Exports to
Baghdad	**Baghdad**
1845 137	2,009
(Damascus silk 35, bitumen 26, galls 17, *chigins*[f] 75)	(pearls 750, Mokha coffee 124, cashmere shawls 80, dates 68, indigo 65)
1846 194	1,654
(bitumen 35, European chintz 22, wool 21)	(indigo 606, coffee 159, pearls 125, cashmere shawls 120, *chigins* 105)
Suq al-Shuyukh	**Suq al-Shuyukh**
1845 629	478
(wheat 264, *ghee* 128, rice 120)	(*dhotis* 252, coffee 83, *hinna* 27)
1846 664	346
(wheat 221, rice 166, *ghee* 157)	(*dhotis* 120, coffee 86, pepper 12, British iron 12)
Jidda and Mokha	**Jidda and Mokha**
1845 248	144
(coffee 248)	(dates 126, *'abas*[g] 18)
1846 234	138
(coffee 234)	(dates 126, *'abas*[g] 12)
England Direct	**England Direct**
1845	
1846 70	45
(illegible)	(skins and tallow 15, wool 14, galls 10)

Summary of Merchandise Trade[b]

	Imports from		Exports to		Balance	
	1845	*1846*	*1845*	*1846*	*1845*	*1846*
India	1,865	1,909	1,446	1,567	−419	−342
Bahrein and Gulf	768	132	233	220	−535	88
Persia	174	168	116	143	−58	−25
Jidda and Mokha	248	234	144	138	−104	−96
England		70		45		−25
Total sea trade	3,055	2,513	1,939	2,113	−1,116	−400
Baghdad	137	194	2,009	1,654	1,872	1,460
Suq al-Shuyukh	629	664	478	346	−151	−318
Total land trade	766	858	2,487	2,000	1,721	1,142
Grand total	3,821	3,371	4,426	4,113	605	742

Money Transactions of Basra, 1845[b,h]

Received from Baghdad in Kerans against the Bahrein pearls:	750	Sent to India in old coins:	229
		Sent to Bahrein in kerans:	535
		Sent to Persia in kerans:	58

Money Transactions of Basra, 1845[b,h] *(Continued)*

Received from Baghdad in old coins sent by the Jew Sarrafs of the former place to profit by the exchange:	277	Sent to Suq al-Shuyukh in Kerans: Sent to Mokha and Jidda both in old coins and in kerans:	151 54
Total	1,027		1,027

[a]Balance met by coins or bills.

[b]Given in thousands of *Kerans;* in 1845 and 1846 the rate of exchange was 1 pound sterling = 22 *kerans.*

[c]Loincloths.

[d]Clarified butter.

[e]Henna, orange-red dyeing leaf.

[f]Turbans.

[g]Woollen cloaks.

[h]In addition, the following amounts were transmitted by bills in 1845:

To India:	182	From Baghdad:	293
To Mokha and Jiddah, through Gran (Kuwait):	50	From Baghdad in bills on India obtained from the sale of horses:	543
	232		836

23

Slave Trade, Basra, 1847

British Consulate
Baghdad—April 28, 1847

Sir,

I have within these few days received several letters from Bussorah on the subject of the African Slave—at that place, from which I proceed to make such extracts as appear to be of statistical or political value.

1. There is not at present a single boat belonging to either of the Turkish ports of Bussorah or Koweit, which is employed in the African Slave trade—the vessels which supply the Bussorah market with slaves are exclusively those of the independent Arab Chiefs of the Persian Gulf, and the number of such vessels which annually enter the Shut-il Arab varies from 50 to 100. This, however, does not include the Slave trade of Mohamarah, which is principally carried on by vessels from the Persian Coast.

2. The average import of slaves into Bussorah is 2000 head—in some years the numbers have reached 3000, but for the year 1836, owing, it is supposed, to the discouragement which the traffic has sustained from the Imam of Muscat, no more than 1000 Slaves were imported.

3. Of the slaves imported, one half are usually sent to the Muntefik town on the Euphrates, named Sook-ess-Shookh, from whence they are spread over all Southern Mesopotamia and Eastern Syria; a quarter are exported direct to Baghdad and the remainder are disposed of in the Bussorah market.

From Kemball to Welles, FO 195/272.

Table 23.1

	Shamiis	£
Abyssinians		
Male	From 120 to 200 =	9 to 15
Female	From 160 to 300 =	12 to $22\frac{1}{2}$
Nubians		
Male	From 200 to 250 =	15 to $18\frac{3}{4}$
Female	From 250 to 350 =	$18\frac{3}{4}$ to 26
Bombassis		
(Negroes)		
Male/female		
Female	From 60 to 180 =	$4\frac{1}{2}$ to $13\frac{1}{2}$

4. The duties on Slaves, amounting to 3. Shamiis a head, are usually farmed by the Governor of Bussorah to some of the local officers for an annual sum of 6000 Shamiis, equal to about £450.

5. The Slaves are divided into 3 classes, Abyssinians, Nubians and Bombassis, and the usual prices in the market are as [in Table 23.1].

6. It is understood at present that there are about 2500 slaves collected at Muscat, waiting for an opportunity of shipment to the Euphrates in vessels sailing under the flag of the independent Arab Chiefs—they may be expected in the river during the summer, and should they be prevented from ascending the Shat-el-Arab to Bussorah, they will run into the Haffan Creek and land their Cargoes at Mohamruh.

The Governor of Bussorah has given orders to the Guard Ship in the river, to seize any boats belonging to Bussorah or Koweit which may be found with slaves on board for sale, and to send the said boats to the former port to be confiscated and sold; but there is no prohibition at present against the passage, up the river, of Arab and Persian vessels with similar cargoes.

The Mohammedan population of Bussorah, however, expecting that such a prohibition will follow, are in great consternation; for not only will a lucrative traffic be lost to them, but a great portion of the lands, date groves and gardens of the place will be thrown out of cultivation, as slave labor has been hitherto extensively employed in agriculture, and an annual supply of 500 fresh hands is supposed to be barely sufficient to meet the ravages of the pestilential climate of the lower Euphrates.

24

Trade of Mosul, 1858

. . . For the last few years the report of British and other European goods have [*sic*] decidedly and steadily been on the increase. The Mountaineers, villagers and Arabs who formerly consumed Native Manufactured goods, have now turned their attention entirely to British and European Manufactures on account of cheapness, variety of pattern, and

From Rassam to Alison, 29 May 1858, FO 195/647.

brightness of color. All description of Manchester and Glasgow cotton goods are the staple articles of the place; the whole population both rich and poor adopt them for apparel and household furniture. The population during the last few years has increased considerably and consequently the consumption of goods has increased equivalently.

EXPORT TRADE

Moossul is of importance on account of its productions sufficient for local consumption and exportation; the soil is rich, and large crops of wheat and barley are raised without manure; the husbandman merely scratches over the soil, sows his seed and reaps a pretty abundant harvest. The grain raised here is more than sufficient for local consumption and the consumption of a large portion of the Bedween Arabs, yet only a small portion, comparatively speaking, is cultivated; a great part of this Province laying [sic] between the Tigris and the Euphrates a distance of about 120 miles in breadth and about 240 in length is waste except here and there a few strips, in fact hardly more than 9 miles West of Moossul pretends to be cultivated owing to the want of security and protection from the nomade [sic] Arabs.

Sheep's Wool

The export of Sheep's Wool for the last few years has considerably increased, the rich herbage of Mesopotamia is well adapted for the pasture of Sheep, goats and camels; and there is not the least doubt if the tribes could be kept in a peaceable state and forego their love for plunder and fighting, and give their whole attention to the improvement of their flocks the Merino Sheep might be introduced with success, which would tend to better their conditions, as well as give a great impetus to export Trade in this Article. Wool is a great support to the trade of Moossul, it throws cash into the place which otherwise would be drained of currency by the increased Import of British and European goods.

Gall Nuts

The second standing article of Export trade, is the Gall Nut, a wild production gathered from the Oak tree which grows in abundance in the Mountains of Kurdistan. Some years the pluck is very considerable amounting to about 3000 Cantars, and then again it is very trifling not exceeding from 400–500 Cantars. This article formed the chief support of the poor Kurds, who frequently barter them for Manufactures. It is a valuable product attended with no expense in raising; at the time of the pluck whole families go out to collect them.

Cotton Wool

Cotton Wool is also a staple product of this Province; at present however only sufficient for local consumption is raised, because the Farmers find that if they extend their cultivation they choke the Market and prices fall very low. The soil of Moossul is well adapted for the growth of Cotton, it needs no manure and water is abundant which can be turned into any direction with little labour.

The extension of this article depends upon the encouragement and stimulus given to the Agriculturists, and under some scientific and enterprizing director large tracts of land might be sown with this article and in the course of a short time it would become as valuable an article of export as Sheep's wool is at present to the province.

Products such as Sesema [sic], Rice, Pulse, and Tobacco grow luxuriantly but are not raised to a very large extent. . . .

25

Trade, Shipping, Currency, and Prices in Basra, 1859

During the commercial year which ended the 31st August 1859, the value of the commerce of Basreh has been enhanced to an extent unprecedented for some years past; judged partly by Account and partly by Estimate.

In doing this however, it must be borne in mind that, in consequence of the loose and irregular manner in which all Accounts, having reference to the various sources of its Import and Export channels, are kept at the Custom House, the figures given in the following tables are not to be received as literally accurate, but so trifling is this inaccuracy that, properly speaking, it is hardly worth being taken into consideration from its insignificant influence over the general results of the year, computed not only from the Record of Imports and Exports, but also from the duties levied on these.

Various causes have led to this general improvement of the trade of Basreh, as also to its fluctuations in the old and recognized channels during the past year, each of which will be taken into consideration in its proper place.

In the foreign trade, the improvement is most marked, especially in its Imports. Without adverting to those from England, in which there is but little change from that of former years, it becomes necessary to call attention to the Entries from France and Belgium, in so far as they are connected with measures undertaken by the Turkish Government for the amelioration and improvement of the productive power and commerce of the interior.

Towards this end, a sailing vessel and two small River Steamers with a quantity of Machinery and an irrigating Pump were procured from Europe during the course of 1858. The sailing vessel, of about six hundred tons, was to be employed in the Foreign trade of the country, and the steamers in that of the interior, under the auspices of the Turkish Government. The time which has elapsed since these schemes were first put in force is too short to allow of an authoritative opinion being expressed as to their eventual results, although judging from the manner in which matters have hitherto been managed, the success of the whole undertaking may very seriously be questioned.

The enterprise in the hands of competent private individuals on the spot and acquainted with the wants and capabilities of the country, would, I have no hesitation in asserting, be in so far as regards the steamers, a successful speculation; for if properly developed the trade between this and Baghdad is sufficient to give a fair return for the outlay necessary to establish an undertaking of this nature. In other respects the Importations from France and Belgium hardly affect the commerce of the town.

As regards India it will be observed that the Imports, particularly of British Manufactures, has [sic] been eminently successful this year, the gross value exceeding by 904,499 Shamies the general average attained between 1851 and 1855, before or after which I am not possessed of Documents to carry the comparison further. In the years in question, the Indian Branch of the Import Trade assumed in 1851 its maximum value of 1,769,100 and in 1855 its minimum of 1,444,443 Shamies, the average being 1,559,845.

From Report, 28 April 1860, FO 195/647.

This improvement is attributable to the increased demand which has arisen in Baghdad for Articles of European Manufacture via Bombay, in consequence of the risks with which the route between Baghdad and Aleppo is surrounded and by which, previous to 1858, a large portion of goods were received. In the latter year however the Baghdad Merchants were severe sufferers by the loss of a large caravan en route from Damascus, since which the trade by that channel has not been so extensive as it was previous to that event. The influx of spice into the country especially from India for the purchase of Dates, Horses and Mules, on a scale not before surpassed, has likewise tended to foster to its present dimensions this branch of the trade of Basreh, in which Persia has likewise largely participated; the value of her Imports being 921,216 Shamies against 338,138, the average from 1851 to 1855; the principal item of Importation being Grain which figured for 608,000 Shamies, or about two-thirds of the whole, and nearly treble that of former years, during which Basreh was principally supplied from Baghdad and Sook-esh-Shiookh. However for the period now under review, no supplies were drawn from Baghdad, and by comparison but little from Sook-esh-Shiookh or its vicinity in consequence of which Basreh was rendered more dependent than ever on foreign supplies.

As far as relates to Arabia including Bahrein, Muscat and Yamen there is nothing in the present Report, or which distinguishes it from that of former years calling for particular comment. Neither does the trade between Basreh and Baghdad call for further remark; as the causes which led to its augumentation have been already noted.

It therefore only remains to enter into a few particulars with reference to the Export branch. That to India as being the most conspicuous, and to which all others are subordinate, was in the year now under consideration highly satisfactory, during which the value of the following articles of Export was:

Dates	Shamies	1,000,000
Horses	Shamies	510,000
Mules	Shamies	80,000
		1,590,000

The average of the five years already quoted being:

Dates	Shamies	658,000
Horses	Shamies	222,500
Mules		—

During which the Range was as follows:

Dates	Maximum in 1851	880,000
	Minimum in 1855	500,000
Horses	Maximum in 1855	258,000
	Minimum in 1853	172,400

The Export of Dates to Muscat and the coasts of the Persian Gulf has no feature to distinguish it, the value being about that of former seasons. To Baghdad there has [sic] however been exported Dates to the value of 75,000 Shamies, in place of an average of 12,050; the increase being required to make up for the deficient harvest.

By referring to the foregoing table of British shipping which entered inwards at

Basreh during the last year it will be seen that the aggregate amount of tonnage was $5510\frac{1}{2}$ tons. Taking the average annual Entries for the last seven years during which the maximum was 2018 tons and the minimum 1272, the difference in favor of the present year is nearly 3900 tons. The value of the Imports for the same time and by the same means, was 754,000 Shamies Eyni; but what proportion this bears to their annual average value for the previous seven years, I am not in a position to state with certainty but if it is estimated at double the amount it may be considered as under than over the mark.

Of the ships from London, two are annual. Those for the present year contained General cargoes for the Baghdad market valued at 296,000 Shamies. The third from the same Port, was loaded with Telegraph Wire and Stores on account of the Turkish Government the value of which is not set forth.

The two ships from Bombay were chartered for the voyage to Basreh by Native Merchants at that Port as a speculation. Their freight inwards, of which the value is given, consisted principally of Piece Goods, Indigo, Sugar, Metals, Earthenware, etc., etc., for the local and interior Markets; nearly two-thirds of which was consigned to Merchants and Agents at Basreh for the first on their own account, and for the latter on account of their constituents in the interior. The remaining third was to be bartered for Dates for the Indian Market. The cargo of the Steamer was similar to that of the Ships just mentioned but was wholly consigned to parties at Basreh.

Both in numbers and amount of tonnage the entries at Basreh of Bugalows or native craft under English colors has been nearly treble that of former years and the aggregate value of their cargoes in proportion.

From this list it appears that the amount of British tonnage which cleared outwards from Basreh, during the year ending 31st August 1859 was 4650 tons with Exports to the value of 362,000 Shamies, viz.:

This remarkable increase in British tonnage during the last year is to be attributed to two causes viz. the great demand which was anticipated in India for Dates so soon as the season would admit of their importation, and for which an unusually large number of vessels were engaged. Besides this the disturbed state of the country in vicinity of the Persian Port of Mohammerah situated on the Shat-el-Arab about twenty-five miles south of Basreh, rendered it impossible for vessels to resort to that place, where, in previous years, a considerable number had loaded for the Indian market. They had therefore to repair to Basreh.

Without these causes operating in favor of English Shipping of a large tonnage I do not think they would, for the present at least, be able to enter into remunerative competition with the Native craft usually engaged in the trade between this and India.

The latter, even when under English colors, are almost always owned by Natives connected with or interested in parties resident in this country or in the Ports of the Persian Gulf; and who in consequence generally take care to secure freight for the vessels in which they or their friends are concerned, and as these Vessels are sufficient in number for the trade of the Country in ordinary seasons and as it now exists the appearance of one or two large Vessels to participate in its profits manifestly can only do so to the disadvantage of the regular traders, who on this account, and to render competition unprofitable when such arises will carry cargo at a rate which would not be remunerative to English shipping casually participating in the trade of the place either between this Port and India or vice-versa. As an instance in point, the sailing vessel already referred to as having been procured from Europe by the Turkish Government for employment in the Foreign trade of the Port was laid on for Bombay but it was only through the instrumentality of the local

authorities that a cargo could be procured for her, the Merchants if left to their own choice in the majority of instances preferring country vessels in which they are nearly all interested either as owners or agents. After discharging her cargo at Bombay attempts were made to procure return freight, but so unsuccessfully in consequence of the Shippers of Merchandize being at full liberty to exercise their own discretion in the selection of the means of transport that although the rate of Freight was gradually lowered until it was below that usually charged by the country Craft, yet barely a hundred tons of Goods could be procured, although every thing was in her favor, both as regards speed of transit and Security of cargo from injury. . . .

The Shamie Eyne being the coin by which most of the monetary transactions at Basreh are regulated, and the only one in general circulation amongst the Arabs between this and Baghdad during the date season, the following table [not included here] shows the relative value which the various other monies current at Basreh during the past year bore to this coin. Although the whole of those mentioned are in circulation yet the proportion which one denomination bears to another is extremely fluctuating and uncertain as well seasonally as annually and depends in a great measure on contingent causes which cannot always be foreseen or accounted for. During the period embraced in the table, all Gold Coins whether Gazie, Mutbuck or Pound Sterling were scarce and hardly to be observed in circulation, in consequence of the great demand which existed for them at Baghdad; but the want of a currency of this description is unfelt at Basreh either as a Medium in local transactions or for making Remittances. In transactions of the first description, the Mohamed Shah Kerans and Shamies Eyne and Reige are preferred. For Remittances to India, Mohamed Shah Kerans, German Crown or Spanish Dollars are the coins generally selected for this purpose. With Baghdad nearly all Remittances are effected in Mohamed Shah Kerans.

I am unable to compare in a satisfactory manner the difference in the value of the Shamie Eyne during the year now under review with that of previous years, but taking the average rate of Exchange obtained from former Reports from 1852 to 1855 inclusive, during the season from 1st September to 31st December as given in the table, the value of the Shamies Eyne in proportion to that of other coins between which I have been unable to make the comparison has, as will be observed, increased in a remarkable degree.

This is to be attributed in a slight degree to the slow but gradual decrease from loss of the amount in circulation, which is never made up by a further issue; again the Dealers from India, Persia and Arabia in their anxiety to obtain money of this denomination at the earliest date to enable them to make their purchases with as little delay as possible are often obliged to compete one with another for the amount which is procurable at the moment in Basreh and without which their business would be at a standstill; for in no other money but this will the rural producers transact business.

RICHARD ROGERS
Vice Consul, Basreh

26

Value, Quantity, and Price of Main Exports and Imports, 1864–1958

EXPORTS

. . . Careful consideration of Table 26.1 shows that the increase in the total value of exports in the earlier period, 1864–1913, was due—where agricultural produce was concerned—to the rapid increase in quantity. For, except for barley, the price of agricultural exports was stable, or slightly falling. The slow growth in the total value of agricultural exports in 1919–1939 was, however, due to the fall in prices, since quantity rose appreciably. [As for fluctuations during and after the Second World War] the slow growth or decline during the war was due to the decrease in the quantity available for export, in spite of the rise in price. The increase in the value of exports after the Second World War was caused by the rise in both price and quantity—except for the period of the Korean War, 1950–1953, when the rise in price was the main factor. . . .

The fall in the price of Iraqi wheat relative to that of barley in the period 1896–1925 is due to the increased amounts of good-quality wheat sent by America, Russia, and the Balkan countries to the markets of continental Europe and Britain. It was also due to the great improvement in means of transport and cheap communications and storage, all of which affected the Iraqi producer who did not enjoy the economies of large-scale production. This led him to restrict his output of wheat to what was required for local consumption, exporting only the surplus. On the other hand, the expansion of dairy production, especially in Britain, raised the demand for Iraqi barley, which is of high quality compared to both Iraqi wheat and the barley of other countries. . . .

We now come to the price and quantity of animal products, the most important of which were wool, hides, live animals, hair, *mar'az*, and melted butter. Table 11 shows us the quantity and price of exports of wool and hides.

The quantity of wool exported rose from the relatively low figure of 300 tons a year in 1864–1871 to its peak of 12,600 a year in 1896–1903. This occurred in spite of the drop in price from 38.6 dinars per ton in 1864–1871 to the low price of 19.6 in 1896–1903. This shows that the great rise in the value of exports (Table 9) in the earlier period was due mainly to the increase in quantity, except for the 10 years preceding the First World War, when the price of wool per ton rose to 71.6 dinars in 1912–1913. This high price was not regained until 1933–1939, when prices began to rise slowly to 75 dinars. The quantity exported continued to increase, in spite of the decline in price in the interwar period, from 3800 tons a year in 1912–1913 to 5600 in 1933–1939.

During the Second World War the price of wool rose to 123.5 dinars per ton and the quantity exported to 6100 a year. After the war, the increase in the value of wool exports was, however, almost solely due to the rise in price, which reached 224.6 dinars in 1952–1958; the quantity remained constant or fell, to 5400 before the [Iraqi] revolution of 14 July 1958.

From Muhammad Salman Hasan, *Al-tatawwur al-iqtisadi fi al-'Iraq,* Saida-Beirut, n.d., pp. 102–105, 109–115, 227–232.

Table 26.1 Quantity and Unit Price of Export of Dates and Grain, 1864–1958[a]

Time period	Dates				Wheat				Barley			
	Quantity		Price		Quantity		Price		Quantity		Price	
	000 tons	Index	Dinar per ton	Index	000 tons	Index	Dinar per ton	Index	000 tons	Index	Dinar per ton	Index
1864–1871	101	15	8.1	105	14	7	6.3	68	3	1	3.7	38
1872–1879	60	9	5.8	75	17	9	7	75				
1880–1887	105	15	5.0	65			5.3	56			5.0	51
1888–1895	510	74	6.4	83	246	182	4.9	52	339	44	2.2	23
1896–1903	545	80	5.7	74	118	62	2.8	30	367	47	4.0	41
1904–1911	673	98	5.4	70	154	81	6.6	71	468	61	6.6	68
1912–1913	685	100	7.7	100	190	100	9.3	100	772	100	9.7	100
1919–1925	1,518	221	9.6	125	386	202	6.9	74	505	69	7.7	79
1926–1932	1,408	205	8.2	106	249	112	7.2	77	1,047	136	4.5	46
1933–1939	1,640	240	5.7	74	403	212	4.5	49	1,871	243	3.2	33
1940–1945	1,237	166	15.1	196	64	34	22.2	239	1,469	190	17.2	177
1946–1951	2,218	324	20.5	226[b]	188	99	46.8	503	3,097	401	31.7	224[c]
1952–1958	2,400	350	14.5	181	112	59	20.0	215	3,437	445	18.9	195

[a]Index 1912–1913 = 100.
[b](sic)—read 266.
[c](sic)—read 327.

The relatively slow rise in the quantity of wool exported in the 1930s, and the stability and subsequent decline after the Second World War, was caused by the rise in local demand due to the establishment and expansion of modern woolen weaving factories.[1] . . .

In contrast to other Iraqi agricultural and animal exports, the quantity of hides exported declined but their price rose sharply—from 2500 tons in 1864–1871 to 3300 in 1912–1913—in spite of a marked decline between these two dates and a rise to 3400 in 1904–1911. The price tripled, from 6.2 dinars per ton in 1864–1871 to 17 in 1912–1913. . . .

The initiation and expansion of the boot and shoe and saddle industry in the 1930s was responsible for the relative decline in the quantity of hides exported. . . .

IMPORTS

. . . In spite of this [lack of data and diversity of units of measurement], it is possible to obtain some information on the relative importance of the quantity and price factors in determining the value of imports of such consumer goods as tea, sugar, and textiles, which usually accounted for over half the value of imports. Table 26.3 provides an estimate of the effect of changes in the quantity and price of these goods in 1892–1895 to 1952–1958.

Generally speaking, changes in the value of imports were attributable to changes in quantity. But it is useful to study changes in quantity and price for each of these goods.

First, the quantity of tea imported rose sharply from 13.2 tons in 1892–1895 to 84.3 in 1912–1913, while its price dropped from 400 to 214 dinars per ton. The 4.5-fold

[1]See Part 5, section 3.

Table 26.2 Index Numbers of Quantity and Unit Price of Agricultural, Livestock, and Total Exports (Other than Petroleum), 1864–1958[a]

Time period	Agricultural exports		Livestock exports		Total exports	
	Quantity	Price	Quantity	Price	Quantity	Price
1864–1879	14	90	38	62	16	100
1880–1887	17	64			13	64
1888–1895	145	29	99	47	135	32
1896–1903	109	45	132	35	113	42
1904–1911	97	76	141	62	103	71
1912–1913	100	100	100	100	100	100
1919–1925	58	177	256	73	113	164
1926–1932	74	131	130	84	89	109
1933–1937	119	83	113	94	117	83
1938–1939	100	100	100	100	100	100
1940–1945	62	345	129	149	82	235
1946–1951	93	453	216	337	128	217
1952–1958	123	355	166	245	142	219

[a]1912–1913 and 1938–1939 = 100.

Table 26.3 Value, Quantity, and Unit Price of Imports of Tea, Sugar, and Textiles, 1892–1958

Time period	Tea			Sugar			Textiles		
	Value (000 dinars)	Quantity (tons)	Price (dinars per ton)	Value (000 dinars)	Quantity (tons)	Price (dinars per ton)	Value (000 dinars)	Quantity[a]	Price[b]
1892–1895	4	13	400[c]	59	3,945	15[d]	349	252	27
1897–1903	23	53	254	96	5,848	16[e]	440	175	24
1904–1911	23	96	234	127	11,956	12[f]	870	302	29
1912–1913	18	84	214	235	9,755	24	887	279	22[j]
1922	490	1,800	272	2,380	62,600	38	5,127	NA[i]	NA
1926–1932	279	1,957	147	676	28,792	24[g]	1,668	65	25
1933–1939	279	2,699	104	410	38,685	11[h]	1,746	93	32
1940–1945	695	2,502	269	794	28,401	30	2,996	56	251
1946–1951	2,428	6,439	276	3,308	61,098	54	8,003	69	278
1952–1958	6,011	16,061	394	6,304	127,871	50	9,193	98	227

[a]Hundred bales, 1892–1913; thousand square yards, 1929–1958.

[b]Dinars per hundred bales, 1892–1913; per thousand square yards, 1929–1958.

[c]1889–1895.

[d]1894–1895.

[e]1897–1898; 1899–1903.

[f]1904, 1910–1911.

[g]1929–1932.

[h]1933–1937.

[i]NA, Not available.

[j]Read 32 (see text).

increase in the value of tea imports is therefore attributable to the increase in quantity, which rose 6-fold in that period. The relative decline in the quantity of tea imported in the interwar period was not due to a rise in price, which was low. It was due partly to the fact that tea in transit to Iran (about half the total) was included in the figures for 1922—whereas the later figures are net of transit—and partly to the decline in purchasing power caused by the world crisis of 1929–1933. . . .

Second, the quantity of sugar imported rose appreciably in the period before the First World War, from 3945 tons in 1892–1895 to 11,956 in 1904–1911, while its price fell from 15 to 12 dinars per ton. In the immediate prewar period the quantity of sugar fell and its price rose. After the war, both quantity and price rose sharply, imports reaching 62,000 tons (including transit to Iran) and price 38 dinars per ton. After that both quantity and price fell to 38,685 tons and 11 dinars in 1933–1939. . . .

Third and finally, the increase in the value of textile imports in the earlier period is attributable to a rise in both quantity and price. For whereas the quantity rose from 25,300 bales in 1892–1895 to 27,900 in 1912–1913, the price advanced from 27 dinars per hundred bales to 32. Again in the interwar period the same rise in the value of textile imports from 1,668,000 dinars in 1926–1932 to 1,746,000 in 1933–1939 was accompanied by an increase in quantity from 65 million square yards to 93 million and an advance in price from 25 to 32 dinars per thousand square yards [sic]. . . .

[Some of the figures are inconsistent, e.g., for tea in 1897–1903 and for textiles in 1933–1958.—Ed.]

IV

Transport

The transport system of the Fertile Crescent experienced more change during the period under review than any other branch of the economy. In 1800 the means of transport by both land and sea were essentially the same as they had been for hundreds, or even thousands, of years. By 1914 almost all sea trade was carried in steamers; a rapidly expanding network of railways and telegraphs had been laid down, and automobiles, telephones, and even airplanes had made their appearance.

Navigation

The volume of shipping was small until the 1830s. In 1784, 40 French ships—with an aggregate tonnage of probably 6000—sailed to the ports of Alexandretta, Syria, and Palestine, but French shipping was practically wiped out during the Napoleonic Wars and recovered very slowly.[1] In 1803, 46 Austrian ships—probably aggregating 7000 tons— called at Egyptian ports, and this level was maintained during the first half of 1804; the volume of ships going to Syria must have been roughly equal.[2] In 1824, 19 British ships—with a probable aggregate tonnage of 3000—called at Beirut; this level was maintained, with fluctuations, through the 1820s.[3] The aggregate tonnage of country craft was probably higher. In 1833 Boislecomte stated that Syria had 150–200 ships, mostly built in Tripoli. However, fear of requisition by Muhammad Ali was leading to the putting of these ships under foreign flag (*dénationaliser*).[4]

[1]*EHME*, p. 36.
[2]HHS, Tuerkei, vol. 2, p. 135.
[3]FO 616/1; Bowring, *Report*, p. 52.
[4]Douin, *Boislecomte*, p. 262.

Under Egyptian rule, Beirut's navigation rose sharply. In 1835-1837 an average of 390 ships aggregating about 50,000 tons entered the port; of this some 30,000 was Egyptian, followed by Greek 5500, French 5200, Sardinian 3900, Austrian 3000, British 1700, and other shipping.[5] As regards other ports, in 1837 shipping entering Alexandretta aggregated 3300 tons, Latakia 10,200, and Tripoli 4100; of this the bulk was under the Ottoman flag, that is, probably Egyptian.[6]

No figures are available for the 1840s, but by 1850 the total for Beirut had risen to 1573 ships and 126,000 tons.[7] Into Beirut in 1851 came 3351 ships aggregating 219,000 tons; in 1852 there were 4506 ships, aggregating 242,000 tons. Of the latter tonnage, 38,000 was French and 30,000 British; Ottoman vessels, engaged in coastal shipping, accounted for two-thirds of the total but their average displacement was only 33 tons, compared to nearly 200 for European ships.[8]

The upward trend continued until 1866 when Beirut's navigation averaged about 400,000 tons (see breakdown in selection 4). In 1867, under the impact of the world depression, the total fell to 296,000.[9] This level seems to have been maintained throughout the 1870s, the average for 1871-1879 being about 310,000 tons.[10] After that, however, there was a great upsurge: by 1884 the total had reached 448,000; it was 534,000 in 1890 and 950,000 by 1896.[11] For 1902-1904 the average was 1,180,000 tons,[12] and in 1911-1912 an average of 1,383,000 tons of steamers with cargo and 50,000 of sailing ships entered Beirut; of the former, 377,000 were French, 342,000 British, 197,000 Austrian, and 194,000 Russian.[13] In 1913, the aggregate tonnage of all ships entering Beirut was 1,799,000; they took and landed 246,000 tons of merchandise.[14]

Concerning the other ports, by 1858 shipping entering Alexandretta had risen to about 100,000 tons, by 1878 to 185,000 tons, by 1885 to 292,000, by 1898 to 401,000, and by 1911 to 580,000.[15] In Tripoli the totals were 62,000 tons in 1857, 484,000 in 1891, and 521,000 in 1905.[16] In Jaffa, in 1863, total tonnage was 98,000; it was 202,000 in 1876, 604,000 in 1898, and 1,090,000 tons in 1912.[17] Finally, shipping at the port of Haifa grew rapidly, from 97,000 tons in 1892 to 270,000 in 1902 and 697,000 in 1912.[18]

[5]Bowring, *Report*, p. 55; the Egyptian figure is partly estimated and the total figures are inconsistent with those given on p. 53.

[6]Dispatch of 10 February 1838, FO 78/341.

[7]"Report on Trade," 26 July 1851, CC Damas, vol. 3.

[8]"Report on Trade," 5 July 1853, CC Beyrouth, vol. 5.

[9]Rousseau to Moustier, 10 July 1868, CC Beyrouth, vol. 9.

[10]A and P 1872, vol. 58, "Syria"; A and P 1874, vol. 66, "Beirut"; Dispatch 31 March 1876, CC Beyrouth, vol. 9; and A and P 1878-1879, vol. 72, "Beirut."

[11]See table in Verney and Dambmann, *Les puissances,* p. 343.

[12]A and P 1905, vol. 93, "Beirut."

[13]A and P 1912-1913, vol. 100, "Beirut."

[14]A and P 1914, vol. 95, "Beirut"; Monicault, *Le Port de Beyrouth,* pp. 26-28.

[15]A and P 1859, vol. 30, "Alexandretta"; A and P 1878-79, vol. 72, "Aleppo"; Verney and Dambmann, *Les puissances,* p. 373; and A and P 1912-1913, vol. 100, "Aleppo."

[16]A and P 1859, vol. 30, "Tripoli"; Verney and Dambmann, *Les puissances,* p. 368; A and P 1905, vol. 93, "Beirut."

[17]A and P 1864, vol. 61, "Jaffa"; A and P 1877, vol. 83, "Jaffa"; Verney and Dambmann, *Les puissances,* p. 354; A and P 1913, vol. 73, "Jerusalem."

[18]Verney and Dambmann, *Les puissances,* p. 359; A and P 1905, vol. 93, "Beirut"; A and P 1914, vol. 95, "Beirut."

The development of Jaffa, Beirut, Tripoli, and Haifa was greatly stimulated by the railways terminating at those ports (see below), and the growth of the Palestinian ports was also helped by German and Jewish immigration.

This great increase in navigation was due to steamships. The first steamer came to Beirut from Istanbul in September 1835, and in August 1836 another reached Alexandretta, from London, to pick up mail sent by the Chesney expedition. By 1837, British steamers were calling regularly at Beirut, from London via Malta and Alexandria.[19] In 1837 also, two lines that were to dominate the trade of the Levant started operations: the Austrian Lloyd from Trieste and the Messageries (successively Royales, Nationales, Impériales, and finally, in sheer despair, Maritimes) from Marseilles.[20] The latter reached the Syrian ports only in 1845.[21] The size of their ships rose slowly, for the Lloyd from an average of 254 tons in 1836 to 397 in 1850, 526 in 1860, and over 1000 in 1874. Concurrently their unit cost was declining: from £47 per ton in 1836 to £24 in 1870. Of the two the Austrian line was by far the better managed. In 1853 the French consul reported that the Austrians were more punctual and had 40 ships, many brand new, whereas the French had 18, many old and not working properly. However, the two companies got on very well and both were highly profitable: the Messageries had declared a profit of 28 percent and its shares had more than doubled in value and the Austrian was also prosperous.[22] In 1842 the Peninsular and Oriental line started services from Southampton to Istanbul and Beirut,[23] but gave up the latter after a few years; however, many British steamers called at the Syrian ports, regularly or sporadically. In 1844 the Fevaide Osmaniye line was founded and in 1856 a Russian line linking Odessa to the Syrian ports started operations.[24] The situation in 1859 is described in selection 3. Italian, Greek, and other lines also made their appearance. By 1878, the British consul in Beirut was reporting that mail from England, via Brindisi, was taking only eight or nine days, a figure that was not substantially reduced until the advent of airmail.[25] As regards goods, for some decades steamers charged much higher rates than did sailing ships and were therefore used only for valuable items or where speed was essential.[26] But by the 1870s, sailing ships had become confined to the coastal trade and a few bulk goods like coal.

The changes brought about by the development of steam navigation may be judged by examining the declarations of British captains to their consulate in Beirut, protesting excessive delays. In 1851, when the usual burden of sailing ships was 140–150 tons, and the average time of sailing for 11 ships from Liverpool to Beirut (about 5000 miles) was 41–42 days, the fastest took 27 and the slowest 67 days. In 1856, the average for four propeller-driven steamers was 28.5 days, the fastest taking 21 and the slowest 40 days; most of these steamers were around 350 tons, but one, with a burden of 824 tons, took 28 days including stops at Gibraltar, Malta, Alexandria, and Alexandretta. In 1858, three

[19]Dispatch of 25 September 1835, CC Beyrouth, vol. 1 ter.; 29 August 1836, CC Beyrouth, vol. 2; 24 May 1837, CC Beyrouth, vol. 2.

[20] See *EHT*, pp. 161–163.

[21]Chevallier, *Société* p. 183.

[22]Report of 24 February 1853, CC Beyrouth, vol. 5; see also Finn to Malmesbury, 28 December 1852, FO 78/914.

[23]Dispatch of 31 December 1847, FO 78/715.

[24]*EHT*, pp. 137, 167; for details see Labaki, *Introduction*, pp. 176–179.

[25]Eldridge to Derby, 1 May 1878, FO 195/1201.

[26]See figures for 1850 in *EHT*, p. 163.

steamers averaged 24.7 days, the slowest taking 31 days (including stops at Alexandria and Alexandretta) and the fastest 19 days.[27] Their tonnage ranged between 700 and 800. By the beginning of this century, the average tonnage of British ships calling at Beirut had risen to 1000 and the journey from Liverpool had been reduced to about 15 days. Similarly, in 1846, the journey from Trieste to Beirut by sailing boat took 25 days.[28] By the beginning of this century it took about 5 days by steamer.

Even before the advent of steamers and the increase in the size of ships had reduced rates, the cost of shipping to Syria the light and valuable goods exported by Europe was not excessive. In 1851 a French consular report put the freight by sailing ships on a crate of 60 pieces (2500 yards) of Swiss cloth, worth 4062 piasters, from Marseilles to Beirut at 45 piasters, plus 9 piasters for the lighter and porters at Beirut; the addition of 4 percent for customs and stamp duties and 7.5 percent for brokerage, commissions, and storage, brought the total costs to 504 piasters.[29]

However, freights represented a larger fraction of the value of exports. In 1835, the freight charge from Beirut to France was stated to have been, ordinarily, 5 francs per quintal of 100 pounds, or 110 francs per metric ton; however, the scarcity of ships had pushed it up to 8–10 francs.[30] In 1842, freights from Palestine to Marseilles on French sailing ships were put at 4–5 francs and on foreign ships at 3–3.5 francs per 100 kilograms (worth 42 francs) or 30–35 francs per ton.[31] In 1859, freight from Alexandretta to Marseilles was £6.5 per ton for pressed wool and cotton and £3.5 for galls; to Liverpool it was £8 and £4.5, respectively, and about £3 for grain.[32] In 1862, the freight for grain and metals on steamers from Beirut to Europe was 10 francs per 100 kilograms or 100 francs per ton; first-class merchandise (e.g., silk) paid 49 francs per quintal and second-class (e.g., cotton in bales, pressed wool, tobacco, and fruits) 20 francs.[33] During the 1870s, freights fell sharply as a result of both improvements in steam navigation and the world depression: in 1878 freights from Alexandretta were stated to have dropped by 50 percent because of greater competition between British, French, and Italian steamers, and insurance rates also fell in the same proportion.[34] In 1887 the freight on oranges from Jaffa to London was 8–9 francs per 100 kilograms and to Liverpool 7 francs.[35] In 1893 the Prince Line offered to carry textiles from Liverpool to Beirut for 18 shillings per ton, as against the prevailing rate of 25 shillings.[36] By 1897, freight from Latakia to France was 10–12 francs per ton for cereals, and to Great Britain 13–14 francs; for other merchandise it was 41 francs.[37] In 1909 freight on grain from Jaffa to British ports was 9–11 shillings, or 11–14 francs per ton.[38] It may be noted that freight on wool to the United

[27]FO 616/4.

[28]Report for 1846, 26 June 1846, CC Beyrouth, vol. 5.

[29]Report of 1 May 1851, CC Beyrouth, vol. 6.

[30]"Trade Report," Beirut, 1835, CC Beyrouth, vol. 2.

[31]"Trade Report," Beirut, 1842, CC Beyrouth, vol. 4.

[32]A and P 1859, vol. 30, "Alexandretta."

[33]"Report on Commerce," Beirut, 1862, US GR 84, T367.4.

[34]"Report on Trade," Alexandretta, 1878, CC Alep, vol. 36.

[35]A and P 1888, vol. 103, "Jerusalem and Jaffa."

[36]A and P 1894, vol. 88, "Beyrout."

[37]"Report on Trade," Latakia, 1897, CC Beyrouth, vol. 12.

[38]A and P 1910, vol. 103, "Palestine."

States was put at $1\frac{1}{2}$ to 2 cents per pound in 1854 but at 1 cent in 1869.[39] This decline in freight rates, which appreciably helped Syria's exports, was in line with world trends and those prevailing in the eastern Mediterranean. For example, around 1900, cereals from Smyrna to London paid 7–20 francs per ton, to Liverpool 14–20, and to Marseilles 10–20.[40]

In the early modern period the condition of Syria's ports had deteriorated, mostly because of silting (e.g., Jaffa, Tyre, Latakia, and Suwaydia—the port of Antioch) but also because of the deliberate blocking of Beirut and Saida by Fakhr al-Din in the 17th century, to keep out the Ottoman fleet (see selection 2). Except for a small jetty built in Beirut in 1835, no attempt at port improvement has been recorded. Weather permitting, ships anchored offshore discharged their goods onto lighters and left them in the open or under rudimentary sheds. The following description of Alexandretta applies to other ports:

> There are but two miserable jetties in the place for loading and discharging cargoes of the several vessels arriving here, and these were erected some years since by a few Austrian sailors, the Turkish Government not having expended one para in their erection or repair; and, although they are at present in a state of dilapidation, no steps have been taken to put them in repair, which, if not done previous to next winter, or new ones erected in their room, the shipping will have no place to load or discharge their cargoes.
>
> The lighters employed in the conveyance of goods from ships to the shore, and vice versa, are of the most wretched description; and it often happens that bales of valuable manufactures are landed on the beach saturated with salt water, which damage occurs in the transit of the goods from the ship, from the leakage of the lighters.
>
> The goods, when landed, are rolled by porters from the jetty to the magazines of the agents (who are employed by merchants at Aleppo and the interior to forward the same), often through wet, dirty streets, there not being as much as a hand-truck in the town to transport the goods, although most of the warehouses where they are stored are a long distance from the landing place, and I have repeatedly seen bales of Manchester goods lying on the beach exposed at night to wind and rain.[41]

Similarly, in Beirut, because of the lack of a breakwater, in winter discharging was suspended "for days together—and is attended with great risk of total loss or considerable damage"; moreover, there was "the want of sufficient warehouse room at the custom-house for goods landed, where there is neither shelter from rain nor protection from the waves which in squally weather inundate the locality."[42] Matters had not improved by 1885: "Steamers have frequently to wait two or three days before they can discharge, and then only are able to land their goods on an open quay."[43] Shipwrecks were frequent. In 1859, five out of seven British ships riding at anchor off Beirut were lost, in 1869 a French steamer was cast ashore and in 1911 a British steamer sank off Jaffa.[44] Proposals

[39]"Reply to Circular," July 15, 1854, US GR 84, T367.2, and "Commercial Report," 1869, T367.7.

[40]For details see Verney and Dambmann, *Les puissances,* pp. 628–631; also *EHT,* pp. 170–171 and sources cited.

[41]A and P 1859, vol. 30, "Alexandretta."

[42]Report for 1858, FO 78/1449.

[43]A and P 1886, vol. 66, "Beirut."

[44]Report for 1858, FO 78/1449; Monicault, *Le port de Beyrouth,* p. 20; A and P 1912/13, vol. 100, "Palestine."

to build a modern port at Beirut were put forward in the 1860s (see selection 4). By then, in spite of the fact that its natural harbor was poor (unlike those of Alexandretta and Haifa) and that—in contrast to Tripoli and Haifa—goods to and from it had to cross two high mountain ranges to get to the interior, Beirut had clearly established its lead over other ports (see III, Introduction). Other favorable factors were that the town was an administrative center, that its population was eager to have an improved port, that its immediate hinterland was thickly populated and produced silk, that the rocky substratum of the harbor provided good foundations for modern installations, and, finally, that in 1858 it was joined to Damascus by Syria's only modern road (see below); it may be added that the road company played an important part in forming the port company.[45] The latter was founded in 1888, with a share capital of 5 million francs, which was progressively called up in 1888–1894; in addition, it took over 5 million francs worth of the debentures issued by the Beyrouth–Damas–Hauran railway company in 1892. In 1895, new shares were issued, raising the capital to 6.1 million, of which French capital contributed 4.9 million.[46] Construction started in 1890 and was completed in 1895, but the new port began to be used in 1893. It consisted of an 800-meter breakwater with a 350-meter jetty, enclosing an area of 23 hectares, of which 3 hectares were bordered by quays, at a total cost of 10.9 million francs. Various improvements were made by 1914, and the port was repeatedly enlarged and improved in the interwar period and after the Second World War.[47]

The company immediately ran into the opposition of the lightermen. A compromise was reached that preserved the latter's monopoly and allowed them to charge 5 piasters for each lighter, adding 20–25 percent to the cost of carrying goods from ship to shore; no such dues existed at Smyrna or "any other port in the world." In the words of the British consul[48]:

> It is perhaps necessary to explain that in the port of Beirut shipping agents are not free to use their lighters. Could they do so and employ large lighters or barges carrying from 20 to 50 tons the tax though illegal would be a trifling one. But the agents are by the custom of the port compelled to take lighters in rotation, according to a list kept by the Captain of the Port. Those lighters are from 3 to 5 tons capacity, many of them old and leaky and goods are often injured in transit, from the water oozing through the bottom of the lighters.

In addition, port dues were higher than at Smyrna, because of different conversion rates for the *majidiya* (see VII, Introduction) and other charges, and merchants complained that trade was being diverted to Tripoli and Haifa. In 1895 the company therefore requested, and was allowed, a reduction in the dues it charged.[49] Nevertheless, as late as 1908 the British consul estimated that the cost of landing six bales of cotton yarn at Beirut was 137.65 piasters (just over £1 at current rates), of which 42 represented port dues; at

[45]Monicault, *Le Port de Beyrouth*, pp. 19–20; dispatch of 5 November 1833, CC Beyrouth, 1-bis.

[46]Thobie, *Intérêts et impérialisme*, pp. 177, 383.

[47]Ibid., pp. 172–177; Monicault, *Le Port de Beyrouth*, pp. 19–20.

[48]Trotter to Currie, 3 May 1894, FO 195/1843; see also A and P 1894, vol. 88, "Beirut."

[49]Jago to White, 13 April 1893, FO 195/1720; "Report on Trade," 1894, CC Beyrouth, vol. 11; idem, 1895.

Alexandretta it was 53.40 piasters (9s.2d.)[50] In 1912 a settlement was reached with the lightermen and porters.[51] However, the company's gross receipts rose steadily, from 581,000 francs in 1896 to 812,000 in 1904, 1,155,000 in 1910, and 1,119,000 in 1913. Dividends were paid out from 1903 on; over the whole period up to 1913, gross profits averaged 2.53 percent a year and distributed profits 1.35; for 1901–1913 the figures were 4 percent and 2.55.[52]

With regard to the other ports, in 1912 work started on the building of a modern harbor at Alexandretta, but little was done pending the completion of the railway link with Aleppo (see below).[53] A concession was also granted to the Hijaz railway for a modern port at Haifa[54] and a harbor was planned for Jaffa, but no progress had been made at the outbreak of war. The creation of a "Lebanese port" at Junieh was discussed but successfully opposed by the Beirut port company.[55]

In the gulf navigation was sparser than along the Levant coast and increased more slowly. In 1842–1845, entries into Basra averaged 22,600 tons; for 1843 the figures were 162 ships and 22,300 tons.[56] In 1864/65 and 1865/66, an average of 11 steamers (all British), aggregating 8000 tons, and 1018 sailing ships of all nationalities aggregating 86,000 tons entered the port; except for 4 sailing ships that came directly from England, all were engaged in the gulf or Indian trade.[57] In 1884, 117 steamers, aggregating 160,000 tons (of which 101 aggregating 137,000 tons were British), 4 square-rigged sailing ships aggregating 2000 tons (probably from Java) and 320 small craft, under the Turkish, Persian, British, and French flags, aggregating 32,500 tons entered Basra.[58] No progress was registered in the next two decades, the figures for 1900 being 135 steamships aggregating 167,000 tons (of which 130 with 162,000 tons were British) and 717 sailing ships aggregating 35,000 tons.[59] After that, however, traffic picked up: for 1910 the total was 313 steamers and 208,000 tons (185 British with 169,000 tons) and 348 sailing ships with 16,000 tons.[60] In 1913 traffic stood at its peak: 195 steamers aggregating 328,000 tons (163 ships and 255,000 tons British) and 250 sailing ships aggregating 19,000; the British share of steam tonnage, which had stood at a peak of 97 percent in 1900, had fallen to 84 percent (see also selection 20).[61]

Commercial steam navigation in the gulf began in 1862, with the establishment of a service from Bombay, through Karachi, to the ports on both sides of the gulf. This was

[50]A and P 1909, vol. 98, "Beirut."

[51]Monicault, *Le Port de Beyrouth*, p. 20.

[52]Ibid., p. 22; A and P 1914, vol. 95, "Beirut"; see Thobie, *Intérêts et impérialisme*, pp. 378–379, for table.

[53]A and P 1913, vol. 73, "Aleppo"; A and P 1914, vol. 95, "Aleppo."

[54]A and P 1914, vol. 95, "Beirut."

[55]Thobie, *Intérêts et impérialisme*, pp. 379–383.

[56]"Report on Trade," 1845, CC Baghdad, vol. 10.

[57]A and P 1867, vol. 67, "Basra."

[58]A and P 1884, vol. 85, "Basra"; a table, showing the breakdown for 1871–1874, is given in the report.

[59]A and P 1902, vol. 110, "Basra."

[60]A and P 1911, vol. 96, "Basra."

[61]A and P 1914, vol. 95, "Basra."

awarded to the Burmah Steam Navigation Company, which changed its name to British India Steam Navigation Company (BISN). At first there was a six-weekly service, but this was soon increased to a monthly, fortnightly, and finally weekly service.[62] However, it was the Suez Canal that brought large numbers of steamers to the gulf, by reducing the distance between London and Bombay from about 12,400 miles round the cape to 9500 and between London and Basra from 14,000 miles also to 9500. From Marseilles and Trieste the journey to Bombay was cut by about 60 percent.[63] Moreover, coaling was far easier in the Mediterranean and Red seas than on the African coasts.[64] As a result, in 1870 the British Resident in Muscat reported the following developments: the first steamer from England direct, through the canal; the first of an intended line of Turkish steamers (see II,32); two steamers from Jiddah; and two Persian steamers plying between the gulf and India.[65] By 1884, steam had reduced the duration of the journey between Basra and Bombay to 18 days, and goods were being delivered from England in 40 days[66] instead of about five months.

A sharp reduction in freight charges ensued; for example, the rate from London to Bombay fell from £2 in November 1869 to £1.25 in February 1870.[67] One can assume that there was a similar pressure on freights to and from Basra and further pressure during the depression of the 1870s, when world freights fell considerably. In 1869 the French consul reported that, because of the competition of Indian, Persian, and Arab ships, the BISN had reduced its Basra–Bombay first-class passenger fare from 390 to 290 rupees and its freight per ton from Bombay to Basra from 130 to 40 rupees, and from Basra to Bombay to 22.5 rupees (£1.5). In 1872 he reported that, whereas in 1867, 40 percent of exports of wool from Baghdad to Europe had gone by sea, around the cape, and the rest overland, through Alexandretta, now all went through the canal, being transhipped at Port Said for Marseilles or London. This was cheaper and quicker and made it possible to use bigger bales. The freight from Basra to Marseilles was 26 francs (i.e., £1.1) per bale of 160 kilograms; adding 24 francs for freight from Baghdad to Basra brought the total up to 50 francs, or £2 (i.e., far less than through Alexandretta).[68] In 1879 it was reported that some Jewish merchants at Baghdad had started a bimonthly line to England, competing with the BISN and reducing freights, and that a Persian line of steamers occasionally sailed to Bombay.[69] In 1874 a French line, Nicol Company, established a service, but according to the French consul, its rates were exorbitant: 30–35 rupees to Bombay and 50 rupees (£3.3) to Marseilles.[70] Other lines, including a Russian one, started calling at Basra (see selection 18), but until 1906 the main British ones completely dominated the market. For example, in 1903 rates from London to Basra fell to a low of 10–15 shillings per ton (compared to £1.1 in 1900), but the three principal companies combined to raise

[62]For details, see *EHI*, pp. 166–170.

[63]Farnie, *East and West*, p. 138.

[64]Fletcher, "Suez Canal."

[65]Report, A and P 1871, vol. 51, reproduced in *EHI*, p. 170.

[66]"Report on Trade," 1884, FO 195/1509.

[67]Farnie, *East and West*, p. 99.

[68]Rogier to La Valotte, 1 March 1869, CC Baghdad, vol. 13; Rogier to Rémusat, 23 December 1872, CC Baghdad, vol. 13.

[69]"Trade Report," 1878/79, FO 195/1243.

[70]"Report on Navigation," 4 January 1875, CC Baghdad, vol. 13.

them to £1 or even £1.75; similarly, rates to Bombay, which had fallen from 10 rupees to 4–8, were raised to 14 rupees.[71] In the words of a British official[72]:

> Up till 1906 British shipping had a practical monopoly of all trade entering and leaving the Gulf ports. There was, it is true, a Russian line which had a nominal monthly service to the Gulf, but it was in no sense competitive as regards British trade, and was moreover not very successful in its own trade. In the date season a few non-British ships under special American or other charters called at Basra,[73] but apart from this it may be said that all British goods entering or leaving Gulf Ports were carried in British bottoms. In 1906, however, the Hamburg–Amerika line started a series of services to the Gulf and, in spite of initial losses, maintained their services, so that in five years they had increased their import trade by 100 percent. From that time onwards, working in close connection with the German firm of Wönckhaus, established at various points in the Gulf, their success has been phenomenal.

This they did by quoting rates of 17.5 shillings to Hamburg and Antwerp, that is, 10s below those of the British lines.[74] According to the same British official,

> The British shipping lines, who commenced by being scornful, became alarmed when they realized that the German company had come into the Gulf to stay; and British merchants, who at first had seen in the competition of the Hamburg–Amerika line a silver lining to the cloud of previous high freights soon realized that the Hamburg–Amerika line had not come there in order to serve the interests of the old established British houses but rather to carry German goods with which to out-trade the British merchants in all the Gulf markets.
>
> In the short space of ten [sic] years they have succeeded in wresting practically the whole of the sugar traffic, formerly exclusively in British hands, from the British lines, and are making serious inroads into much of the general traffic formerly emanating from Great Britain and now coming from Antwerp and Hamburg. Perhaps the shortest and most convincing evidence as to the hold which the Hamburg–Amerika line had acquired in the first ten years of its competition will be shown in the nature of the agreement come to between the Conference of British lines (which in itself was formed to oppose the German line) and the Board of the Hamburg–Amerika, recently before the commencement of the war. The agreement provided two main things: (a) an agreement of freight rates from Europe to the Gulf and (b) an agreement that the British lines should not load at Hamburg or Antwerp, on condition that the German lines should not load at English ports."[75]

Because of this competition, freight charges remained low until the outbreak of war, for example, 17–22 shillings for grain to London and 5–14 rupees to Bombay in 1911, and 25–30 shillings for grain and 30–35 shillings for dates to London in 1913.[76] (See also selection 18.)

[71]Crow to O'Connor, 20 January 1904, FO 78/5461; A and P 1902, vol. 110, "Baghdad"; A and P 1903, vol. 79, "Basra"; A and P 1904, vol. 101, "Basra."

[72]"Notes on the Economic Situation in the Persian Gulf and Mesopotamian Markets," by Captain George Lloyd, IOPS, 11/59, B240, 1916. See also *EHME*, pp. 350–355.

[73]In 1902 two steamers loaded direct for the United States (A and P 1903, vol. 79, "Basra"—editor's note).

[74]Diary, 6 August 1906, FO 195/2214.

[75]Captain George Lloyd, "Notes" (see note 73).

[76]A and P 1912/13, vol. 100, "Basra"; A and P 1913, vol. 73, "Basra."

In spite of all this increase in shipping, practically no improvements had been made at the Port of Basra. Already in 1879 the British consul had complained that, because of silting, the channel of Basra was becoming shallower, impeding navigation.[77] A dredger brought out by the Ottoman government in the 1870s "has been rusting for thirty years."[78] Ships sailing down the Shatt al-Arab encountered a first bar at Muhammara (18 miles below Basra) that could be crossed by deeply laden steamers only at high water. Five miles from the river mouth were the outer bar, with 9 feet of water at low spring and 19 at high spring tides, and the river bar, with 7–9 and 17–18, respectively. "Ships drawing more water often force their way through the bars, driving through the soft mud, of which they are composed, to the depth of 2 feet or 2½ feet. Deeply laden vessels often take two tides to cross the two bars, as they get over one bar on top of the first tide and have to wait for the top of the next tide to cross the other bar." Four buoys, installed and kept up by the BISN, were the only improvements in the river or port.[79]

In 1911 the British consul stated that a lightship had been installed, greatly helping navigation, but that no dredging or clearing had been carried out since he had arrived in 1903.[80] The installation of a corrugated roof on the customs house was an occasion for rejoicing.[81]

At the outbreak of war conditions were still the same: "There were no port facilities of any kind: all vessels lay out in the stream and discharged into the country boats or small lighters belonging to local firms, and after their cargoes had been passed through the Turkish customs these boats off loaded to river steamers and flats for conveyance up the Tigris."[82] (See also selection 18.) However, "owing to natural causes," the river had deepened and "[o]cean steamers in some cases can now load to 20 feet. . . . Under these improved conditions the number of steam lighters kept in the port has been reduced to four, with an aggregate registered tonnage of 2310 tons and a total carrying capacity of 4000 tons. About 20 percent of the British ships leaving the port in 1912 completed their cargoes outside the bar by means of steam lighters."[83] It was only when the British occupied Basra, in 1914, that a modern port was built.

Inland Transport

Land transport had not changed since late antiquity, when camels began to replace carts in Syria and paved Roman roads fell into disuse.[83a] Goods were carried by camels, mules, or donkeys. In 1860, a report stated that the best mules could carry 170 kilograms, average mules 136, camels the same or less, and donkeys 91 kilograms.[84] The figure for camels is low compared to those given for other parts of the Middle East (i.e., 200 kilograms or

[77]Turner to Robertson, 16 January 1879, FO 195/1242; according to Sir W. Willcocks, the silt came mainly from the Karun, since the Tigris, Euphrates, and Karkha left almost all their deposits in the marshes (Report, 31 March 1911, FO 406/37).

[78]Matthew to Lowther, 31 October 1911, FO 195/2369; see Geary, *Through Asiatic Turkey,* vol. 1, p. 87.

[79]A and P 1893/94, vol. 97, "Basra."

[80]Consul to Lowther, 22 Decembrr 1911, FO 195/2369.

[81]A and P 1912/13, vol. 100, "Basra."

[82]"Note," by India Office, 14 May 1919, FO 371/4149.

[83]A and P 1913, vol. 73, "Basra."

[83a]Bulliet, *Camel,* chap. 1 and passim.

[84]Memorandum by Lt. Col. Burnaby, enclosed in Dufferin to Russell, 8 October 1860, FO 406/10.

over).[85] But Syrian pack animals may have been inferior: "In winter, when the splendid Bactrian camels are brought down from the highlands of Anatolia . . . the cost of transport between [Aleppo and Alexandretta] is reduced to 40s. per ton weight, but in summer when the service is performed by the weak and sickly Syrian camels and mules, the cost of transport often rises to 50s. or even 60s. per ton." At that time annual traffic on that road was estimated at 40,000–50,000 tons, rising to 66,000 in 1896–1898.[86]

In addition, pack animals were scarce. The above-mentioned report states:[87]

> Syria, in its prosperous state, found it difficult to supply 2000 mules for the allied armies during the Crimean campaign, and suffered on account of this abstraction; today there is an unusual scarcity of these animals, inasmuch as the Druzes have taken with them all theirs, as well as all or most of those that belonged to the Christians, as a means of transporting their material and their families towards the Hauran.

Moreover, the government frequently commandeered pack animals, often together with their drivers.[88] Hence, in the absence of any improved roads whatsoever, transport costs were very high and weighed particularly heavily on agriculture. Moreover, traffic was slow, usually moving at under 5 kilometers an hour. Mules and donkeys traveled in small groups, but the desert caravans numbered 1000–2000 (see selections 1 and 13).

A few examples are illustrative. In 1838 goods sent by mules or camels from Alexandretta to Aleppo (125 kilometers away) cost 80–100 piasters per *qantar*, or £3.1–4 per ton, and in 1857 £3 per ton, or almost as much as the freight to England; wheat that cost 35 piasters per *shumbul* at ʿAintab paid a freight of 25 piasters to Alexandretta, 160 kilometers away.[89] In 1858–1859 the average price of wheat in England was about £10 per ton; in 1860, the rate from Aleppo to Alexandretta was 90 piasters per *qantar* or about £3.2 per ton.[90] In 1871 wheat from Aleppo to Alexandretta cost 25 piasters per *shumbul* and "may cost twice as much from the villages near Orfa" (some 230 kilometers away) to Aleppo; at that time the normal price of wheat in Aleppo was 50 piasters (see VII,1). Similarly, in 1888 freight to Alexandretta equaled 50 percent of the price in Aleppo and the freight from London to Alexandretta was only 50 percent of that from Alexandretta to Aleppo.[91] At the latter date *dura* (white Indian corn) cost 10 piasters per shumbul for transport from Dayr al-Zur to Aleppo (about 340 kilometers) at a time when the price in Aleppo was 12 piasters, leaving only 2 for the grower. Liquorice root cost five times as much for transport from Antioch to Alexandretta (some 60 kilometers) as from Alexandretta to New York.[92]

[85]See Bulliet, *Camel*, p. 281; *EHME*, p. 5; *EHI*, pp. 195–196; *EHT*, pp. 177–179; and *EHMENA*, pp. 52, 58–60, which also have figures on costs of transport; in 1856, camel loads varied from 180 to 250 kilograms in Mosul, and 250 in Palestine and Diyarbakr, to over 300 in Aleppo and 400 in Urfa; corresponding mule loads were 110–150, 200, 150, and 250 (Replies to Questionnaire, FO 78/1418 and 1419); in Palestine in 1909, camel loads were put at 300 kilograms and mule loads at 140 (A and P 1910, vol. 103, "Palestine").

[86]A and P 1883, vol. 73, Aleppo; Barnham to O'Conor, January 1900, FO 195/2073.

[87]FO 406/10.

[88]For example, in 1886 (Eyres to Thornton, 10 October 1886, FO 195/1548).

[89]Bowring, *Report*, p. 46; A and P 1859, vol. 30, "Alexandretta" and "Aintab."

[90]B. R. Mitchell, *Abstract of British Historical Statistics* (Cambridge, 1971) p. 488; US GR 84, T367.4, "Commercial Report on Aleppo."

[91]A and P 1872, vol. 57, "Aleppo"; A and P 1889, vol. 81, "Aleppo."

[92]Ibid.

In 1882, transport by camel from Alexandretta to Aleppo cost 60 francs (£2.4) per ton, and in 1900 from Aleppo to Alexandretta £2 per ton.[93] It will then be seen that, over the previous 50–60 years, the cost of transport had fallen, whereas that of wheat had risen (see VII,1), which must have facilitated exports.

In central Syria, in 1879 the transport of goods from Latakia to Hama (a three days' journey of about 100 kilometers) cost 100 francs (£4) per ton, compared to 25 francs by sailing ship to Genoa.[94]

Conditions in southern Syria were no better. In 1826 the French consul stated that the cost of transport from Beirut to Damascus (about 125 kilometers) had previously been 12–15 francs per *qantar* of 225 kilograms (£2.1–2.6 per ton) but had now risen to 35 francs (£6.2); rates were higher in winter.[95] In 1838 rates from Beirut to Damascus, by mule or camel, were 80–100 piasters per *qantar* of 504 pounds, or £3.1–4 per ton.[96] In 1857, in summer when the roads were dry, rates were 0.25–0.5*d*. per pound, or £2.3–4.6 per ton.[97]

Rates from Hauran, Syria's granary, were equally high. In 1880 grain worth 4 piasters (per *kaylah*?) there "cost its own worth in transport" to either Damascus (about 100 kilometers away) or Acre (about 140 kilometers) and fetched 14 piastres in Mount Lebanon.[98] In 1899 transport by camel from west Hauran to Acre cost 25–30 francs per ton and from central Hauran 35–40 francs (i.e., £1.4–1.6); from Beisan to Acre it cost 18 francs and from Nazareth 10 francs.[99] (See also selections 6 and 7.) Inland rates were also high: in 1838 the cost from Aleppo to Damascus (about 400 kilometers) was 150–160 piasters per *qantar,* and it was 160 in 1860.[100] As for rates across the desert (see selection 1), in 1838 from Aleppo to Mosul (about 700 kilometers), they were 220–300 piasters per *qantar* and to Baghdad (about 900 kilometers) 400–500, or £8.8–12 and £16–20, respectively, and in 1860, 200 and 300.[101]

Conditions were very similar in Iraq. In Mosul in 1895 camel loads were put at 178 kilograms and mule loads at 133; donkeys, which were seldom used, carried 53–67 kilograms. Rates from Mosul to Aleppo ranged from 110 to 250 piasters per *qantar* of 266.6 kilograms (£4–9 per ton), and from Baghdad to Mosul (about 525 kilometers) 120–150 (about £4.2–5.3 per ton) by camel and 150–200 by donkey. Rates had come down considerably because of greater competition and the diversion of trade through the Suez Canal, which had resulted in larger numbers of camels being available; thus, previously, the rate from Mosul to Aleppo had been 400–500 piastres.

In 1878 Geary reported that wheat worth 4 shillings in Hilla cost 6 shillings to transport to Baghdad, a little over 100 kilometers away, and that much grain collected in

[93]"Report on Alexandretta," CC Alep, vol. 37; "Report on Alexandretta," 13 February 1900, FO 195/2073.

[94]A and P 1880, vol. 74, "Damascus."

[95]"Trade Report," Beirut, CC Alep, vol. 28.

[96]Bowring, *Report,* p. 47.

[97]Misk to Clarendon, 31 August 1857, FO 78/1298.

[98]A and P 1880, "Beirut" and "Damascus."

[99]"Report on Prospects of Haifa—Damascus Railway," FO 195/2056.

[100]Bowring, *Report,* p. 47; US GR 84 T367.4, "Commercial Report on Aleppo."

[101]Bowring, *Report,* p. 85; US GR 84, T367.4, "Commercial Report on Aleppo"; for a list of caravans arriving at Damascus in 1825, see Douin, p. 255.

taxes was left to rot in government granaries for lack of transport.[102] In 1888, raisins that cost 43.50 francs in Mosul cost 20 francs to carry to Basra and another 16 to Marseilles. On the 150-kilometer road from Baghdad to Khanaqin, in 1902–1906 rates per ton averaged £2.5, and 30 percent less in the opposite direction; some 30,000 tons traveled eastward each year and 15,000 westward, as well as about 200,000 passengers.[103]

For mail, the Ottomans used both carrier pigeons and the Tatar couriers, who were mounted on dromedaries and were allowed 12–13 days, or a little longer, for the Baghdad–Istanbul route. The British also had a dromedary post. In 1838, their couriers were allowed 24–30 days for the Baghdad–Erzurum round trip, but usually did it in less time, and were paid 2500–3000 piasters. The British service was closed in 1886, but the Ottoman continued until the First World War.[104]

The main difference between the two countries was in their waterways. In Syria, the only navigable rivers were the ʿAsi (Orontes), from Antioch to Alexandretta, and the Euphrates (see selection 10); both could be used by small boats of low draught. In Iraq, however, both rivers were navigable throughout their whole length and, indeed, goods were brought down by rafts from Diyarbakr to Mosul on the Tigris and from Birejik to Faluja on the Euphrates. The consequent savings in transport costs may be illustrated by three examples. In 1864, freight on cotton sent by camel from Baghdad to Aleppo (about 900 kilometers) was about £10–13 per ton, but by sailing craft to Basra (some 570 kilometers) about £1 and by steamship about £2.[105] In 1895 goods sent by *kalaks,* or rafts on inflated skins, from Mosul to Baghdad (see selection 19) took 3–12 days and cost only £0.16–1.3 per ton. And in 1867 the freight on grain from Baghdad to Basra was 150 piasters per *taghar* of 2690 pounds (about £1.2 per ton) on the Tigris and 200 on the Euphrates. This represented 15–20 percent of the price of grain in Baghdad (see VII,28). Much the same rates prevailed on the upward journey, by steamer on the Tigris and sailing ship on the Euphrates.[106]

Modern transport first came to the region on the Mesopotamian rivers. In 1836 an expedition under Francis Chesney carried two steamers across the Syrian desert and sailed them down the Euphrates.[107] Between 1839 and 1842 up to four British steamers, belonging to the East India Company, sailed up and down the Tigris, Euphrates, and Karun, surveying the rivers, carrying passengers and mails—and ready for possible use against Muhammad Ali. In 1841 Captain B. Lynch, who had been in command of this flotilla and

[102]"Report on Mosul," 30 April 1895; Geary, *Through Asiatic Turkey,* vol. 1, pp. 95–96; for the organization of the Baghdad–Aleppo caravan in 1808, see Rousseau, *Voyage,* pp. 40–50.

[103]Siouffi to Goblet, 15 November 1888, CC Mossoul, vol. 2; "Report on roads," 7 November 1907, FO 195/2243.

[104]Grant, *Syrian Desert,* pp. 241–259, Memorandum, 31 December 1838, FO 248/83; Tweedie to White, 24 March 1887, FO 195/1579.

[105]Delaport to Drouyn, 3 February 1864, CC Baghdad, vol. 12; for descriptions of voyages on *kalaks* see Fraser, *Short Cut,* pp. 186–233; Oppenheim, *Mittelmeer,* pp. 193–235.

[106]"Report on Mosul," 30 April 1895, CC Mossoul, vol. 2; Haider, "Land Problems," p. 266; for a description see Batatu, *Old classes,* pp. 228–230; for a table on costs from Mosul to Aleppo and Alexandretta see Shields, "Economic History," p. 49; in 1848, transport costs and taxes raised the delivered price of a wheat load from 40 piasters in Mosul to 95 in Baghdad (Shields, p. 114).

[107]Chesney, *Expedition,* and *Narrative;* Longrigg, *Four Centuries,* pp. 292–293.

who had founded a trading firm in Baghdad in that year, was authorized by the Ottoman government to operate two steamers for the transport of mails, passengers, and goods.[108]

In 1855, the Ottoman authorities formed a mixed government–private enterprise and ordered two river steamers, from Belgium, which started operating in April 1859; plans were also made for the establishment of a line connecting the Red Sea ports with those of the gulf.[109] In response, the Lynch firm was incorporated as the Euphrates and Tigris Steam Navigation Company in 1861; its initial capital of £15,000 was gradually raised to £100,000 by 1914. The annual return on this capital has been put at not less than 20 percent.[110] In 1862 it commissioned its first steamer and in 1865 its second; in addition to passengers and goods they carried mail, receiving a subsidy from the government of India. In 1879 it increased its capital and became closely associated with the British India Steam Navigation Company (see above).[111] Gradually it replaced its steamers by larger and more powerful ones, and in 1907 it was authorized to run a third steamer. In the meantime, in 1865 the government reorganized its own company as the publicly owned Oman–Ottoman Administration; this was bought in 1900 by Sultan Abd al-Hamid's Saniyya Administration and renamed Hamidiyya, but in 1909, after the fall of the sultan, was restored as a government department, under the name of Idareh Nahriye. It too modernized its ships (see selection 14). In 1912 a Basra businessman, Ahmad Ja'far, also ran steamers. The size and shares of the three lines is given in selection 18. In 1908–1912, inclusive, the British line accounted for 52 percent of the traffic and the Ottoman for 48 percent.[112]

In 1909 the American consul reported that the river fleet consisted of 10 steamers and perhaps 400 or more sailing boats; the steamers cost $35,000–44,000 and carried 100–350 tons; barges carried 70–100 tons; and sailing boats, which cost $650–$1700, carried 10–75 tons.[113] Thus, total investment in water transport may have been about $1 million.

All these lines sailed on the Tigris, below Baghdad. Upstream, Ottoman steamers occasionally carried pilgrims from Baghdad to Samarra.[114] As for the Euphrates, following Midhat pasha's pioneering attempt in 1870 (see II,32), in the high flood season beginning in May, Ottoman steamers usually made two journeys upstream to Maskana; in 1910 a service was started to Kufa.[115] Attempts by the government to run motorboats on the upper Euphrates in 1911 and 1912 were unsuccessful.[116]

[108]For the Lynch firm see *EHME*, pp. 146–153; for the diplomatic and legal aspects Nawwar, *Al-masalih*, passim. British merchant ships and armed vessels had been sailing on the rivers since 1769 helping the pasha of Baghdad against Arab tribes; see Memorandum by Pelly, 5 July 1883, FO 424/137, and "Memorandum regarding the Navigation of the Rivers of Mesopotamia," 26 November 1907, FO 424/213.

[109]Nawwar, *Al-masalih*, pp. 109–110.

[110]Hasan, *Al-tatawwur*, p. 412; in 1878 Geary (*Through Asiatic Turkey*, vol. 1, p. 106) put the return at 25 percent for Lynch and 8 for the Turkish steamers; Geary has a vivid description of the *Blosse Lynch*, which carried about 1000 passengers and 300 tons of goods.

[111]See *EHI*, pp. 165–170.

[112]"Draft Agreement," 9 June 1913, FO 424/231.

[113]Simpich to Ozmun, 23 October 1909, US GR 84, C8.9.

[114]A and P 1867, vol. 67, "Baghdad"; Bertrand to Moustier, 22 June 1870, CC Alep, vol. 34; "Trade Report," Baghdad, 1878, FO 195/1243; A and P 1912/13, vol. 100, "Basra."

[115]Young to Lowther, 24 October 1911, FO 195/2366 and 424/229.

[116]Taylor to Kemball, 17 April 1856, and Hector to Kemball, 3 October 1856, FO 195/521.

Relations between the Lynch Company and the government were always uneasy. In 1856 it complained about repeated tribal exactions on its boats.[117] In 1886, during a scarcity of grain, the company offered to reduce its rates by 20 percent if allowed to tow a barge on each of its two steamers; this was granted until May 1887 and then withdrawn. In 1897 it claimed that the irrigation canals cut by the *shaykhs* made navigation on the Tigris very difficult and that loading and discharging facilities at Baghdad were inadequate; earlier, it had declared that the Euphrates was almost useless because "at least 200 miles of its lower portion has been suffered to branch out and form itself into lagoons and marshes."[118] In 1910 it declared that it had 3000 tons of goods accumulated in Basra, and the Ottoman line about 5000, and in 1911 it put the combined total at about 10,000, yet the authorities would not allow it to replace a steamer that needed repairs.[119] The government feared the potential monopoly power of the company and resented the fact that its ships flew the British flag. It was also determined to stop the increasing British penetration of Iraq, in which it saw a political threat. In 1870 the British consul stated that the authorities were "using every means in their power" to drive the British vessels off the rivers.[120]

It was not only the Ottoman authorities who had reservations about Lynch. In 1910 a British merchant claimed that every section of the population of Iraq was opposed to the company, that its service was poor, resulting in much spoilage, and that its freight for grain of £2 per ton was "equal to 50 percent of its cost in the markets of Baghdad."[121]

Competition between the British and Turkish lines kept freight rates below what either, left to itself, would have charged. In 1893 a British report stated that, because of Turkish competition, "freights are now half what they were a few years ago," and that Lynch's profits were smaller than before.[122] They were also low enough to drive out many of the small sailing boats.[123] The steamers also reduced the journey from Baghdad to Basra to 2–3 days, compared with 5–8 days by sailing boat, and from Basra to Baghdad to 4 days, compared with 40–60.[124] However, by international standards, freight rates were high. In 1902–1906 they averaged £1.1 per ton downstream and £2.25 upstream, compared to £1.2 for exports from Basra to England and £1.6 for imports.[125]

It should be added that, just before the First World War, the Lynch Company was involved in two major negotiations: In 1887, 1907, and 1908 it tried unsuccessfully to buy out the Turkish steamers.[126] In 1909, the Turkish government agreed to merge its line with the British one, the new enterprise to be a government administration, with a capital of £322,000 equally divided, and the ships to fly the Ottoman flag. But there was much opposition both in Baghdad and in the Ottoman parliament, and the agreement was not

[117]Consul General to Ambassador at Constantinople, 27 April 1887, FO 78/4016.

[118]Report by captains, 25 January 1897, and Consul General to Currie, 4 September 1897, FO 195/1978; Consul General to Ambassador, 3 February 1888, FO 78/4116.

[119]Wire from Lynch, 26 July 1911, FO 195/2368; Company to Carey, 20 June 1911, FO 424/227.

[120]Herbert to Secretary Government of India, 7 April 1870, FO 195/949.

[121]Letter from Cree, FO 195/2238 and 424/222.

[122]Beville to Mockler, 31 May 1893, FO 195/1799.

[123]A and P 1878/79, vol. 72, "Baghdad."

[124]Hoskins, *British Routes*, p. 427.

[125]Ramsey to Lowther, 10 March 1909, FO 195/2308; for river and sea freights, see "Trade Reports" on Baghdad and Basra in A and P 1901–1913.

[126]"Confidential Print," 22 July 1913, FO 424/239.

ratified.[127] However, the negotiations over the Baghdad railway (see below) also covered river navigation. Agreement was finally reached for the formation of a river transport company jointly owned by the Lynch Company and the Deutsche Bank; this company operated for a couple of years, until the outbreak of war. A larger scheme, involving the Inchcape (Peninsular and Oriental Company) interests, was frustrated by the outbreak of war. After the war the Lynch Company raised its capital to £300,000 and resumed operations.[128]

In Syria, as in Europe but unlike most parts of the Middle East, improved roads preceded railways. In the 1840s the British consul in Damascus, Richard Wood, repeatedly urged the Ottoman authorities to build a road to Beirut, but lack of funds prevented implementation.[129] Rising demand for grain during the Crimean War, however, emphasized the need for improved transport, and in 1857 Comte de Perthuis received a 50-year concession for a road; no other concession for a road to any port between Latakia and Acre was to be granted, but the government reserved the right to build such roads itself. A company with a capital of 3 million francs was formed, construction began in January 1859, and on 1 January 1863 the first convoy reached Damascus. The company ran two 12-seat coaches each day, one from Beirut and one from Damascus, and also small carriages; the 112-kilometer journey took 13 hours from Damascus and 14 from Beirut.[130] Tolls were levied on loaded pack animals using the road. Freight rates were variable: early in 1869 they ranged from 50 to 60 piasters per *qantar* (254 kilograms) from Beirut to Damascus and 85–90 the other way. In that year 12,000 tons and 10,000 passengers were carried, almost equally divided between both directions. By 1894 total traffic on the road had risen to 27,000 tons and 15,000 passengers.[131] In 1892 the company went into liquidation, being absorbed by the railway company (see below). After that the road deteriorated, but shortly before the war it was rehabilitated by the government.

The financial results were quite good. A dividend of 8 percent was paid starting in 1872, and rose to 16 percent in 1880 and after.[132] The road was not highly competitive. In 1869 pack animals, avoiding the road, carried some 5500 tons. However, by the turn of the century, when tolls had been abolished, about 200 carts, carrying 1.25–1.5 tons each, used it regularly, charging freights below those of the railway.[133] The road further widened Beirut's lead over the other ports and diverted some caravans from Aleppo to Damascus.

In Lebanon, the autonomous government built a large network of roads (see II,15). In 1879 the reforming governor Midhat pasha started work on the Tripoli–Homs road, which was eventually extended to Hama, a total of 142 kilometers. The 86-kilometer Jaffa–Jerusalem road was built in 1865; the increase in traffic is shown by the amount for

[127]Nawwar, *Al-masalih*, pp. 207–215.

[128]Ibid., pp. 215–220; *EHME*, pp. 152–153; Draft of Memorandum to be exchanged by Lord Inchcape and Mr. J. Lynch, 1 February 1914, FO 424/251.

[129]See Tresse, "La route," on which this paragraph is based.

[130]See also 'Azm, *Mudhakkarat*, vol. 1, p. 26; in 1884 a round-trip ticket from Beirut to Damascus cost 290 piasters (dispatch of 23 February 1884, FO 78/3648).

[131]"Report on Trade," 1894, CC Beyrouth, vol. 11; A and P 1895, vol. 100, "Beirut."

[132]Elefteriades, *Les chemins de fer*, p. 42; for annual figures on receipts (a little over 1 million francs) and expenditures (about 800,000), see table in idem, p. 409.

[133]A and P 1902, vol. 110, "Damascus"; A and P 1905, vol. 93, "Damascus."

which the right to levy tolls was sold: £450 in 1865 and £1564 in 1887.[134] As late as 1892 the British consul reported that, except on those roads, "wheeled traffic is unknown beyond the vicinity of the large towns."[135] However, by the outbreak of war roads had been built between Tripoli and Saida (125 kilometers), Nablus and Jaffa, Jerusalem and Jericho, Damascus and Homs (200 kilometers), and Saida and Marj'ayun; the Aleppo–Alexandretta road had been improved in 1876 and the stretch to Killis subsequently upgraded. In 1910 there were 15 cars of French make, in Beirut,[136] which circulated in Lebanon (see II,17).

The introduction of carts and carriages did not appreciably reduce freights; for example, on the Homs–Tripoli road both carts and camels charged £1 per ton. But they were much more comfortable, shortened travel time (e.g., Damascus–Beirut, one day instead of three), and made it possible to transport much heavier weights: in Palestine in 1909, 1000 kilograms compared to 300 by camel and 140 by mule.[137]

No similar improvement took place in Iraq, but in 1902 an Aleppo–Baghdad coach service began and became twice-weekly in 1907; coaches took 12 days and carriages 4, passenger fares being £.T. 2.5–4.[138] In 1908 the journey took 9 days, of which about 103 hours were spent in traveling.[139] In 1908 an Englishman drove a car from Aleppo to Baghdad.[140] In 1909 a Baghdad notable imported two cars to Damascus, for a Damascus–Baghdad service, but this was not achieved until 1923.[141]

As part of the general development plans of the Young Turks, in 1910, contracts were made with the Société générale d'Entreprise des Routes de l'Empire Ottoman to lay down 9312 kilometers of roads at a cost of £2 million. Of these, 459 were to have been in Damascus, Beirut, Jerusalem, and Lebanon, and 1173 in Aleppo, Baghdad, Urfa, and Dayr al-Zur.[142]

In the meantime, a network of telegraphs and railways had been laid down. In June 1861 the Beirut–Damascus telegraph line was opened; in January 1863 Beirut was linked to Istanbul, via Aleppo, Diyarbakr, and Ankara, and shortly thereafter Beirut was linked to Alexandria.[143] The telegraph line reached Baghdad at the beginning of 1863 and Fao by January 1865, from whence it was extended to Karachi.[144] In 1909 it was reported that the cutting of the telegraph line between Baghdad and Basra cost the government 52,750 francs a year, "hence a wireless installation would be as profitable to the government as it would be to the commercial interests of the country," but this suggestion was not followed.[145] A harbinger of future developments was the arrival in Aleppo and Damascus,

[134]A and P 1888, vol. 103, "Jerusalem."

[135]A and P 1893, vol. 97, "Beirut."

[136]US GR 84, C8.5, 19 September 1910.

[137]A and P 1910, vol. 103, "Palestine."

[138]Ramsay to O'Conor, 12 September 1907, FO 424/213.

[139]Memorandum by Ramsay, 28 May 1908, FO 424/216.

[140]Ramsay to Board of Trade, 2 December 1908, FO 195/2275.

[141]A and P 1910, vol. 103, "Damascus"; Grant, *Syrian Desert*, pp. 270–289.

[142]"Annual Report," 1910, FO 424/250.

[143]Moore to Russell, 20 June 1861, FO 78/1586; idem, 15 January 1863, FO 78/1752; idem, 26 May 1864, FO 78/1833.

[144]FO 195/752; *EHI*, pp. 152–154.

[145]Ramsay to Lowther, 5 March 1909, FO 424/219.

during the spring of 1914, of two successive, ill-fated Turkish military airplanes on their way to Cairo.[146]

Railways

Various schemes for a railway from the Mediterranean to Iraq, or even India, were proposed in the 1850s (see selection 2),[147] but they were obviously uneconomical and were abandoned. The first railway in the region was the narrow-gauge (1.0 meter), 87-kilometer Jerusalem–Jaffa line, opened in 1892 by the French-owned "Société des chemins de fer ottomans de Jaffa à Jérusalem," constituted in 1889 with a capital of 4 million francs and debentures of 10 million.[148] Construction costs were about 110,000 francs per kilometer. Initially results were poor, partly because both the Jerusalem and Jaffa stations were some distance from the towns, and much traffic still went by camels and carts; in 1903 the freight on coal from Jaffa to Jerusalem was 14s. 6d. per ton, the same as by camel.[149] However, after suspending operations in 1894, the company reorganized and traffic gradually increased, for passengers from 81,000 in 1894 to 76,000 in 1903 and 183,000 in 1913, and for freight from 11,000 tons to 26,000 and 183,000; gross receipts rose accordingly from 513,000 francs to 779,000 and 1,310,000. It was not until 1910 that 5 percent was paid on debentures, the dividend on shares peaking at 2.8 percent; the average return on capital has been put at 2.4 percent.[150] Two passenger trains circulated daily in each direction, at a speed of 23 kilometers per hour, and a cargo train ran every night. In 1916 the Turks, and in 1918 the British, widened the gauge, and after the war the line became part of the Palestine Railways.

A British line designed to link Acre with Damascus was begun in 1892 but abandoned in 1898 after only 8 kilometers had been built. However, it spurred a French group to rush its project for the "Compagnie des chemins de fer économiques de Beyrouth–Damas–Hauran en Syrie," constituted in 1892.[151] In 1893 it acquired the concession for a Damascus–Aleppo–Birejik line, with an extension to connect with the future Baghdad line at Telek, and changed its name to "Société ottomane des chemins de fer de Beyrouth–Damas et Biredjik sur l'Euphrate." The original nominal capital of 10 million francs was raised in 1893 to 15 million. Another 60 million of debentures was issued, which brought in 31.2 million. Construction costs were fairly high. The 103-kilometer Damascus–Muzayrib line, opened in 1894, cost about 8 million francs, or about 80,000 per kilometer, including rolling stock. The 147-kilometer Beirut–Damascus line, opened in 1895, part of which consisted of rack-railway because of the high altitudes and steep gradients, cost 19.1 million francs, or about 130,000 per kilometer, including rolling stock. Both were narrow-gauge lines (1.05 meters).

Operations began with one service each day, from Beirut to Damascus. The rolling

[146]ʿAzm, *Mudhakkarat*, vol. 1, pp. 16–18.

[147]See also *EHME*, pp. 137–145.

[148]For details see Verney and Dambmann, *Les puissances*, pp. 253–260; Thobie, *Intérêts et imperialisme*, pp. 158–161 and 330–331; *EHME*, p. 236.

[149]A and P 1895, vol. 100, "Jerusalem"; A and P 1903, vol. 101, "Palestine."

[150]A and P 1905, vol. 93, "Palestine"; A and P 1914, vol. 95, "Palestine."

[151]For details see Elefteriades, *Les chemins de fer*, pp. 37–104; Verney and Dambmann, *Les puissances*, pp. 241–253; Thobie, *Intérêts et imperialisme*, pp. 165–172 and 318–331; *EHME*, pp. 250–251.

stock consisted of 8 engines, 20 passenger cars, and 73 trucks; by 1902 there were 15 engines and 130 cars and trucks. There was a passenger and a passenger and goods train daily between Damascus and Rayak; the Damascus–Muzayrib line was serviced four times a week.[152] The journey from Muzayrib to Damascus was cut from 2.5 days to 3 hours but that from Damascus to Beirut only from 13 to 9 hours.[153] Gross receipts rose from 2,389,000 francs in 1896 (943,000 from 220,000 passengers and 1,446,000 from 220,000 tons of freight), to 3,057,000 in 1903, and 4,241,000 in 1913.[154] But a loss was reported each year; for example, in 1899 gross receipts were about 2.5 million francs, operating expenditures 1.25 million and interest on debentures 1.6 million, leaving a deficit of 350,000 francs.[155] Freight rates were high (12–20 francs per *qantar* in 1884), and carts continued to present a lively competition—accounting for about one-fifth of traffic to Beirut in 1900—and camels went on transporting grain from Hauran; moreover, the fact that the railway terminus in Beirut was over 1 mile from the harbor constituted a further handicap. The company's shares, issued at 500, had by 1897 fallen to 120.[156]

The company therefore went into liquidation and in 1900 was reorganized by the Régie génerale, the Ottoman Bank, and other French banks; once more the name was changed to "Société Ottomane du chemin de fer de Damas–Hama et prolongements."[157] The government offered a guarantee of 15,000 francs per kilometer of operating line (to be reduced to 12,500 when connection was made with the Baghdad line), but insisted that the railway be of standard gauge (1.435 meters). This meant transshipment at Rayak, the meeting point of the old and new lines. By 1902 the railway had reached Hama (188 kilometers) and, after agreement had been concluded with the Baghdad railway, Aleppo (another 143 kilometers) in 1906. In 1909 the Homs–Tripoli standard-gauge line (103 kilometers) was built, without government guarantee. The old line was also connected with the Port of Beirut. To finance these lines, in 1901, 1905, and 1909 debentures were issued for a nominal total of 107,202,000 francs, bringing in 76,928,000. In 1914 the outstanding share and bond capital was 150,200,000 francs, of which 116,741,000 had been in fact received; of this, 70 percent was French capital.[158] Construction costs were 59,364,000 francs for the Rayak–Aleppo line, or 179,000 per kilometer, excluding rolling stock, and 187,000 francs including it, figures not too different from those for the Baghdad railway.[159]

There was a daily service between Rayak and Aleppo and another between Homs and Tripoli. No data on the size of the rolling stock or the volume of freight or passenger traffic are available. However, it may be taken that practically all exports from Beirut, Tripoli, and Haifa (which were about 300,000–350,000 tons) were carried by rail, as was a large proportion of imports (about 100,000 tons). As regards Aleppo, in 1907 the British

[152]A and P 1895, vol. 100, "Damascus"; A and P 1903, vol. 79, "Damascus"; *EHME*, p. 256.

[153]Elefteriades, *Les chemins de fer,* pp. 46–47.

[154]"Note sur la situation économique," August 1897, CC Beyrouth, vol. 12; Elefteriades, *Les chemins de fer,* p. 137 which gives figures for 1901–1913.

[155]Richards to Bunsen, 22 October 1900, FO 424/200.

[156]Elefteriades, *Les chemins de fer,* p. 136; "Quarterly Report on Damascus," 26 April 1900, FO 195/2075; "Report on Beirut," 6 August 1901, FO 195/2122; A and P 1897, vol. 94, "Beirut"; A and P 1898, vol. 99, "Beirut."

[157]See details in Elefteriades, *Les chemins de fer,* pp. 51–79; Thobie, *Intérêts et impérialisme,* pp. 318–323.

[158]Elefteriades, *Les chemins de fer,* p. 114; Thobie, *Intérêts et imperialisme,* p. 329.

[159]*EHME*, pp. 255–256.

consul reported that, because of high freight rates, its traders had reverted to sending goods by camel to Alexandretta instead of by railway to Tripoli; however, by 1911 he was stating that the railway had diverted half the trade of the Aleppo *vilayet* away from Alexandretta.[160]

Gross receipts for the Rayak–Aleppo and Homs–Tripoli lines rose steadily from 209,000 francs in 1902 to 2,627,000 in 1910 and 5,064,000 in 1913. This fell far short of expenditure, and a total amount of 22 million francs was paid by the government as kilometric guarantee—a sum about equal to gross receipts on the guaranteed lines and 30 percent of gross receipts on all lines; however, these ratios fell sharply in the last prewar years. This made it possible to meet charges on debentures and to distribute between 1.5 and 2 million francs a year to shareholders and owners of bonds with variable income, a very low rate of return.[161]

The Hijaz railway was promoted by Abd al-Hamid II to carry pilgrims to the Holy Cities, to raise his prestige among Muslims, and to facilitate control over Arabia, where several anti-Turkish rebellions were under way and which was increasingly threatened by the British. The necessary funds were obtained by donations from all over the Muslim world and by special taxes. Military labor was extensively employed, which partly explains the very low cost per kilometer of 62,000 francs, or a total of 95 million for the 1528 kilometers actually built.[162] The original intention was to purchase the Damascus–Muzayrib railway and start construction from Muzayrib, but the high price demanded by the French company (7 million francs) persuaded the government to build a parallel line with the same gauge, 1.05 meters. Work started in 1901, and by 1904 Ma'an (459 kilometers away) had been reached and by 1908 Madina (1320 kilometers away).[163] A branch from Dar'a to Haifa (160 kilometers) was built, in 1905, facilitating construction of the main railway and providing an outlet to the sea; its average cost was higher than that of the main line, 78,500 francs per kilometer. Another projected branch, from Ma'an to 'Aqaba, was not built because of the border dispute between Turkey and the British in Egypt. The planned extension to Mecca also had to be given up because of repeated beduin attacks, the opposition of the Sharifian authorities in Hijaz, and the Young Turk revolution and subsequent wars.[164]

Except for the stimulus given to agriculture in Transjordan, the economic results of the main line were meager, but the total number of passengers rose from 246,000 in 1908/09 to 361,000 in 1912/13,[165] and travel time was reduced to little over two days. The Haifa branch, however, diverted a considerable amount of grain from Beirut to Haifa, whose exports and imports showed a steady growth. Before and during the First World War several small branches were added to the Haifa line, but in 1917–1918 the main line was put out of commission by Arab guerrillas, with technical assistance from

[160]A and P 1908, vol. 116, "Aleppo"; A and P 1912/13, vol. 100, "Aleppo."

[161]See Elefteriades, *Les chemins de fer,* pp. 115–117 and 137, and Thobie, *Intérêts et impérialisme,* pp. 323–324 and 759 for details.

[162]*EHME,* p. 256.

[163]Ibid., pp. 252–253; *EI2,* s.v. "Hidjaz Railway"; for interesting details on construction methods and problems see memorandum in FO 424/213.

[164]See dispatches, 25 May 1908 (FO 424/215), 28 January 1909 (FO 424/218), and 27 March 1909 (FO 424/219); *EI2.*

[165]Landau, *Hejaz Railway,* p. 16.

T. E. Lawrence. Since then the section to Maʿan has been in operation but the rest is still unused, despite numerous attempts to restore the line.

The Baghdad railway cast a long shadow over Syria, delaying the granting of concessions to the French and causing them to abandon their projected lines from Aleppo to Alexandretta and to the Euphrates.[166] But an agreement on 1 October 1903 allowed the French to push their line to Aleppo, and another on 15 February 1914 resolved all outstanding issues: the German line was to run from Aleppo to Maskana on the east, and Alexandretta on the west, as well as to Ras al-ʿAin and thence Mosul and Baghdad, while the French were to build a line from Homs to Palmyra and Dayr al-Zur, on the Euphrates. The French lines were never built, but the Baghdad line from Aleppo reached Jarablus (203 kilometers away) in 1912, and a branch from Toprakkale, near Adana, reached Alexandretta in 1913. Difficult terrain and the war greatly slowed construction of the line from Anatolia to Aleppo, and the first train reached Aleppo only on 9 October 1918, a few days before the armistice with Turkey. In 1914–1915 a 120-kilometer line between Baghdad and Samarra was built. During the war the British laid down a railway from Basra to Baghdad and from Samarra to Baiji. In the interwar period the Iraqi lines were extended and connection was made with the Syrian and Turkish railways, the first train leaving Baghdad for Istanbul in July 1940.[167]

Streetcars also came into use during the period under study. In 1880 Midhat pasha inaugurated a 3.5-kilometer line from Tripoli to its port; the scheme was financed by a local company with a capital of 200,000 francs, actual costs being somewhat higher.[168] In 1894 the ''Société des tramways libanais nord et sud de Beyrouth'' was launched with a share capital of 1,750,000 francs and bonds of 2,025,000. It aimed at laying a line from Tripoli to Saida (138 kilometers), but in fact only 63 kilometers, from Jebail to Damur, were built. Unable to compete with coasting vessels, it led a precarious existence, was liquidated, and eventually reduced its operations to the Beirut–Maʿmaltain stretch of 19 kilometers.[169] Belgian electricity and tramway companies were founded in 1906 for Beirut and 1907 for Damascus; the latter had a capital of 6 million francs. In both, returns remained very low.[170]

A look at Syria's railways reveals grave defects. There was no overall coordination of the various lines. Some essential lines, such as the one from Aleppo to Alexandretta and to the Jazireh, were not built, although definite plans for construction were finally drawn up and would probably have been implemented but for the war. There was considerable duplication (e.g., between the Muzayrib and Hijaz railways and between the Haifa and Beirut lines). The diversity of gauges necessitated costly transshipments at Rayak. Rates were high, and in many sections the railways could not compete with camels or

[166]See *EHT*, pp. 188–194; *EHME*, pp. 248–257; and the works by Chapman, Earle, Hecker, Helfferich, Rohrbach, Williamson, and Wolf, in Bibliography.

[167]*Geographical Handbook, Iraq*, pp. 579–583; in 1866 plans were made for a railway from Baghdad to Karbala, the ground was surveyed and a Belgian firm engaged, but the outbreak of the Austro-Prussian war delayed the project and the removal of Midhat pasha caused it to be shelved (see Geary, *Through Asiatic Turkey*, vol. 1, pp. 153–154).

[168]Blanche to Eldridge, 16 February 1880, FO 195/305.

[169]Thobie, *Intérêts et impérialisme*, p. 336; Elefteriades, *Les chemins de fer*, pp. 141–153; Himadeh, *Economic Organization*, p. 181.

[170]Eldem, *Osmanli*, p. 42; A and P 1908, vol. 116, ''Damascus''; A and P 1908, vol. 117, ''Damascus''; A and P 1910, vol. 103, ''Damascus.''

carts. Finally, large losses were made, some of which had to be covered by costly guarantees.

But the benefits should not be ignored. Greater and greater volumes of goods and passengers were carried. Traveling times were sharply cut, and comfort and safety increased. New areas were served, and the Baghdad and projected French railways promised a much brighter future. On 25 May 1912 the correspondent of the *Daily Telegraph* reported that the tariff announced for cereals by the Baghdad railway was only 22 *paras* per ton-kilometer; for truckloads traveling not less than 900 kilometers it was only 9 *paras* (i.e., a ton carried from Takrit, in Iraq, to Alexandretta would cost only 25 shillings). One has only to compare this figure with the freights given earlier to see the great improvement the railways were bringing about.

1

Damascus–Baghdad Caravans, 1847

The journey from Damascus to Baghdad is always made by caravan. The number of caravans that leave Damascus and go through Palmyra is most irregular; at present they all go through Aleppo, because this road presents less danger from the Arabs. When security prevailed in the desert, there were some 12–15 departures each year by way of Palmyra, and as many coming back.

Generally speaking, caravans from Baghdad to Damascus are one and a half times as large as those from Damascus to Baghdad. The former carry indigo, shawls, pearls, waterpipe tobacco, Turkish-style pipes, gallnuts, drugs, and reeds for making pens. The number of camels ranges from 1500 to 2000, sometimes more. The latter carry calicoes (*indiennes*), English manufactures [textiles], hardware, woolens, fezzes, Damascus cloths, paper, cochineal, ropes, sometimes sugar, etc. These caravans consist of 800 to 1200 camels [each].

One cannot say that at any given time of year departures are more frequent or the amount transported greater than at any other; the season has nothing to do with it, everything depends on trade needs and especially on the fear or confidence the route evokes, for only too often one learns of the plundering of a caravan by beduins in the desert. . . .

[A summary of the description of the stages of the route is:

Damascus–Adra:	1 day
Adra–Khan al-Taifet:	1 day
Khan al-Taifet–Ksayr:	1 day
Ksayr–Qaryatain:	1 day
Qaryatain–Palmyra:	3 days
Palmyra–Djub al-Ghanam:	4 days
Djub al-Ghanam to Rihane:	2 days

From "Itinéraire de Damas à Baghdad par Palmyre," 1847, CC Damas, 1845–1848, vol. 2.

Rihane–'Anah:	3 days
'Anah across Euphrates:	1 day
From there to Shaykh al-Habib Nagiar:	3 days
Shayk al-Habib–a spring:	3 days
Spring to Tal al-Eshenna:	1 day
Tal al-Eshenna–Tigris:	1 day
Tigris–Baghdad:	1 day
	26 days

Add three days in 'Anah, to carry the caravan across the Euphrates, two days at the next stop, two days waiting for the customs officer at Tal al-Eshenna, giving a total of 33 days.]

2

Ports of Syria and Projected Railway to Basra, 1856

Beirut, September 15, 1856

. . . The first port on the south is *Jaffa,* the ancient Joppa, which however can hardly be called a port, all vessels of any considerable size and steamers being obliged to anchor at least half a mile from the town in the open roadstead while a dangerous reef running a few rods from the wall of the city, a little harbour which only the smaller crafts can enter. The city and adjacent fruit gardens contain a population of about 20,000. The products of the Plain of Sharon, extending about 100 miles along the coast from Mount Carmel to the borders of Egypt and running on an average about 15 miles back, are brought to the port of Jaffa, consisting principally of wheat and barley, wool, and fruits. The oranges and lemons of Jaffa are very abundant and thought to be the best in all the East. They are also exceeding cheap, a hundred of the largest size oranges being sold for 25 cents.

The port of ancient *Cesarea,* about 40 miles north of Jaffa, though once crowded with shipping is now entirely filled up with sand and *décombres* and this once magnificent city has itself utterly disappeared.

Caiffa, or *Haifa,* at the foot of Mount Carmel, is a walled town containing 5000 inhabitants and protected by Mount Carmel which rises back of it, affords a safe roadstead for vessels of considerable burden. The cotton of Nablous and Safet, the wheat and barley of the plain of Esdraelon and the region about the Sea of Galilee are brought to this port and the wool of the adjacent region.

Acre, the ancient Ptolemais and St. Jean d'Acre, only two miles north of Haifa, and situated on the Bay of Acre contains at present a population of about 10,000. The harbor is nearly filled up with sand and the considerable wool, cotton and grain is carried on in smaller vessels, a brig not having entered the port, as has been stated, for 30 years.

From US GR 84, American Consulate in Beirut, Dispatches to State and Treasury, January 12, 1855–December 31, 1863.

Soor, the ancient Tyre, . . . is now a miserable village of 2000 inhabitants and its port being utterly filled up with sand and the old town perished and almost nothing is being done in commerce.

Saida, the ancient Sidon, famous like Tyre in the history of commerce has a population of 8000. The present port is small and almost filled up with sand but the commerce of the city is still considerable, having so good a route of communication with Damascus and rich plain on which it is situated.

Beirut, the ancient Berytus, has only a roadstead but the adjacent Bay of St. George into which vessels may run on the approaching of a storm, affords considerable protection to the larger vessels. This city is the most flourishing of any between Smyrna and Alexandria. In 1820 it contained only 8000 to 10,000 inhabitants, now the number is estimated at from 30,000 to 60,000 and is more rapidly increasing than ever before. So many Europeans and Americans settled here and so much intercourse by trade and travel is_____with the outside that the city has assumed much of a civilized and Christian aspect. Its flourishing condition arises from its direct communication with Damascus by roads over Lebanon and from the production of the innumerable towns and villages of Lebanon and also of the rich wheat-growing plain of Bekaa being brought to this port. The last year 126 English vessels visited this port bringing mainly Manchester and Birmingham manufactures and carrying back principally wool, silk, wheat and barley. Three lines of large steamers have been established within a few months between Beirut and Liverpool, in addition to the two Austrian and one French which existed before. A Bank has been recently established by an English company and the Turkish government has lately ordered the building of a harbour.

Tripoli, or Trablous, is situated about 50 miles north of Beirut and contains a population of about 20,000. It has nothing but a roadstead in which harbour vessels ride pretty safely. It is surrounded by plantations of oranges, citrons, and mulberry trees, and exports raw silk, cotton, dry fruit, water of orange flowers, sponges and nut-galls.

Lattakeia, 50 miles further north, the ancient Laodicea of Syria, is situated upon an elevated point of land and is one of the ports of Aleppo, being at the same distance from it as Skanderoon. The port is half filled up, the entrance narrow, and only vessels of 100 tons burden can find safe anchor. The population is estimated at 8000. The principal articles of exportation is a kind of tobacco raised in this vicinity which is regarded as the most delicate in the world, and derives its name from the place. Cotton, nut-galls, silk and wax are also exported to some extent.

Skanderoon, Iskanderoon, or *Alexandretta,* the two first words in Arabic signifying the same as the latter, *Little Alexandria,* at the northern boundary of Syria is a miserable village of less than 1000 inhabitants. Situated on the seashore and surrounded by a wide extent of marshland and bog, whose waters exhale pestilential miasmas in the summer, it is dangerous for permanent residents; at the same time, it is the best port in all Syria. The Bay at the head of which it is situated is about 30 miles long by 15 wide, whose anchorage is the_____while the high mountains protect it from winds from the east and southward. Skanderoon is a place of importance as being the depot of the immense amount of merchandise brought from Europe to supply Aleppo, Diarbekir and Mosul and the vast country around. The warehouses are often insufficient to receive the bales of goods which are piled up in the open air. The exports are wool, cotton, nut-galls, seseame, silks, wax and madder.

Suadia, the ancient Seleucia, and the port of Antioche of the Seleucidae, is entirely

filled up with sand and *décombres* of all kinds and for a long time has ceased to be regarded as a port.

Suadia and Alexandretta are becoming points of vast importance from an enterprise recently projected and which at present seems likely to be accomplished. Not only is it among the boldest ideas ever conceived, but carried out will work out one of the greatest changes in commerce and civilization. It is nothing less than the construction of a railroad from Seleucia along the Orontes and by Antioch to the banks of the Euphrates; and crossing the river thence to Bussorah at the head of the Persian Gulf which will connect with a steamboat line uniting Bussorah with Karrachee on the western coast of India where in turn it will connect with railroads and canals running the length and breadth of India. The distance from Seleucia to the Euphrates is about 100 miles and the whole distance from the Mediterranean to the Persian Gulf by the proposed route is about 900 miles. This route will be much shorter than that by the Suez Canal and the time of travel be reduced more than one half—by 20 days out of 39.

Should this road be completed an enormous field will be opened for commercial enterprise in which Americans at present have no part. . . .

3

Steam Navigation along the Syrian Coast, 1859

. . . One of the boats of the Messageries Impériales arrives every alternate Tuesday from Marseilles, touching at Malta, Alexandria and the Syrian ports, Beyrout, Tripoli, and Lattakia; remains here a day and then leaves for Marseilles touching at Mersine, Rhodes, Smyrna, Syra and Malta. Another boat of the same company arrives from Marseilles every Saturday following the proceeding [preceding?], touching at Malta, Syra, Smyrna, Rhodes and Mersine, and after a day's stoppage, returns to Marseilles via Lattakia, Tripoli, Beyrout, Alexandria and Malta.

The Austrian Lloyd's steamer arrives every alternate Monday from Smyrna touching at Rhodes, Adalia and Mersine, and leaves the same day for Lattakia, Tripoli, and Beyrout, returns by the same route the following week, and leaves the same day for Smyrna, touching at the above-mentioned ports.

A Russian steamer from Odessa, touching at Constantinople, Smyrna, Rhodes and Mersine arrives every alternate Sunday leaves the same day for the Syrian ports and Jaffa, returns to Alexandretta by the same route on the following Saturday and leaves the same day for Odessa, taking the same route as on her downward passage.

The arrival of the French Bazin Company's boats is uncertain, as they wait at Marseilles for a full cargo and generally touch at Cyprus, Beyrout, Alexandretta and Mersine.

From Report by Vice-Consul Sankey, 10 January 1859, Alexandretta, FO 78/1452.

The arrival also of the Turkish boats is uncertain from defects in the administration and navigation.

About four English steamers per month arrive from Liverpool laden with manufactures and Colonial produce.

All the Companies with the exception of the English and Bazin have coal depots at Alexandretta, on which they only indent, when bad weather has caused delay at sea. The Russians have also established a depot at Caiffa.

The boats of the Messageries are the most regular and carry the European Mail but have experienced considerable loss by the starting up of new Companies who take passengers and goods at very low rates and underbid each other in every way. It is a custom now to send criers about the bazaar to tout for passengers and freight, declaring that such and such a boat will take passengers and goods for so many francs less than any other. There is therefore, no longer any possibility of keeping up a fixed tariff and many steamers have lately embarked cargoes at prices that will not even pay their coaling expenses.

The Russian steamers are allowed one Rouble per mile for expenses by their government, and are commanded by captains of the Imperial Navy, officered from every grade of the regular naval and military services and manned from the men of war. The boats are very powerful and well fitted up, and passengers receive great attention on board.

The prices at which they take passengers and goods, would rather militate against the belief that the Russians have started boats as a speculation.

The Turkish company has fine boats the use of which is given them by the Government as also the coal, and received in exchange a certain percentage on the profits.

Being commanded and officered by Turks from the regular army and navy they assume, in a short time more the appearance of pig styes than modern steamers.

They take passengers from Constantinople to Beyrout sometimes for 100 piastres and the captains and officers compete with even their own Agents, taking passengers and goods which the Agent has refused.

It is almost needless to add that these never appear in the ship's manifest but become the captain's and other officer's perquisites. It is now the intention of the Sultan's government to take the whole concern entirely into their own hands.

As may be expected their errors in navigation are frequent, and amusing to all but passengers and shippers.

One boat from Alexandria was two whole days looking for Cyprus and came in to Alexandretta without having found it.

Another boat from Beyrout left for Tripoli and the captain desired that the boat might be turned on arriving at a certain point, and then retired to his berth. The next morning saw the boat again at Beyrout, the boat having certainly been turned, but in the wrong direction.

Sometimes, 4 or 5 steamers arrive here at once and then the several agencies are more like public auction rooms than anything else. This is a fine time for passengers and shippers, who generally manage to pay an almost nominal freight. It is evident that the Russian boats will eventually do away with those of other companies, as they seem to be careless of expense or profit, and seem to be started as a naval nursery.

At this season the arrival of their boats is uncertain, as the mouth of Odessa harbour is blocked up with ice. Sebastopol is intended as their headquarters when the repairs have been completed.

The English Steamers bring very valuable cargoes, the "Araxes" having landed in one voyage about the value of £200,000.

With all these arrivals and departures of Steamers and the consequent amount of traffic we have only a few crazy planks for a jetty which it is impossible to approach unless in perfectly calm weather, and steamers requiring coal cannot ship more than 20 tons per day.

The wages for labourers are high, but there seems a total absence of enterprize both amongst the Europeans and natives. The merchants and factors could construct a good jetty by subscribing 500 piastres each, but as they are also consular agents calling themselves Vice Consuls, are of course on the worst of terms and will insist on dragging the unfortunate flags of the countries they may happen to represent, into all their petty trading quarrels and disputes about a few bushels of sesame seed.

Vituperation in public is not uncommon, and gives the natives a very low idea of European dignity.

"Sir" how dare you sequester the merchandise of H.M. the King of so and so, etc.

These Consular Agents appointed by their consuls or Consuls General call themselves V. Consuls and from seniority take precedence of Her Majesty's Vice Consul, who is the only paid officer and placed there entirely for the public service. . . .

4

Project for Port of Beirut, 1868

The activity of the port had greatly diminished in the last few years; until 1866 the tonnage of shipping had been about 400,000 (of which 280,000 were steamships, 60,000 sailing ships, 20,000 local coastal trade, and 40,000 long-distance coastal trade), but in 1867 it was only 267,000 tons, of which 207,000 were steamships.

. . . The high degree of prosperity of the town of Beirut and the development of its commercial interests, especially since it was linked by carriage road to Damascus, had led the Board of Directors of the Messageries Impériales to study a project for the building of a port designed to increase still further this commercial activity and provide a safe haven for the numerous ships calling at this leading port of the Syrian coast which consists, strictly speaking, of an open roadstead unprotected from the violence of the wind and the heavy seas. For this purpose it commissioned an engineer from the Ponts et Chausées of France, M. Stoecklin, to whom it had previously entrusted the management of the construction of the Suez docks.

Unfortunately, this engineer arrived here at a time when the government was seriously preoccupied with political and financial questions, an unfavorable circumstance which, be it said in passing, made no small contribution to the delaying of the adoption of the idea put forward by the Messageries Impériales. However, M. Stoecklin carried out on the spot serious and practical research which resulted in four different projects. The first

Fom Rousseau to Moustier, 10 July, 1868, CC Beyrouth, vol. 9, 1868–1888.

two were discarded as inadequate and the fourth as too expensive; the third alone seemed to present the best conditions and the greatest chances of success.

This last project, which there is some talk of taking up again today, includes *first* a main pier, 680 meters long, which starting from the northerly tip of the lower town would advance in an easterly direction, through depths varying between 4 and 14 meters; *second* another much shorter pier, starting from the Medawwar point and designed solely to prevent the effect of the undertow from reaching the interior of the port; *third,* landing wharves, either along the shore or along the main pier. The space that would be thus completely sheltered would have the shape of a right-angle triangle with an area of 20 hectares, or very close to that of the old Port of Marseilles. The specifications, which were carefully established, put total expenditure at 5.8 million francs, a sum that could be reduced by about 1 million if the shore wharves, which are perhaps unnecessary for the present traffic, were to be given up.

The plan and specifications were sent to Constantinople where the project was adjourned, in spite of the pressing insistence of the Board of the Messageries Impériales, which undertook to carry out all the work and to advance all necessary funds in return for a government guarantee regarding the payment of interest and amortization of capital.

Various circumstances combined at that time to the provisional rejection of that project, although its soundness was accepted in principle. Thus, on the one hand, to ensure the servicing of interest and amortization, it would have been necessary to create appropriate resources for new needs, whereas the Treasury was neither disposed nor in a state to advance such funds by ceding part of the fiscal revenue of Beirut. On the other hand, the Muslim population of Beirut, which believed that the town's future was guaranteed by the upward trend of business and of real estate values, obstinately refused to impose new taxes to meet new needs. The religious question, with its fatalistic and retrograde consequences, kept on interfering with the financial question. "Every tax," said the Muslims to the Christians who had gathered with them to discuss the matter of the port, "that has to be imposed is an innovation, and every innovation leads to [hell] fire." Such considerations, and other besides, led to the adjournment of the implementation of this project, against which, be it said, no serious objection had been raised.

But matters have greatly changed since then, and ideas of progress have seen the light even in the minds of the most retrograde Muslims and those most attached to routine. The situation and prosperity of Beirut have also greatly changed. A first blow was the transfer of the seat of government of the *vilayet* to Damascus; this was followed by the unfortunate effects of the commercial crisis that has sorely pressed Syria in general, including its most important coastal town. Not only has the upward movement of the trade of Beirut stopped, it has very perceptibly regressed; the prosperity of the town has tended to diminish day by day; a large number of families who had fled to Beirut after 1860 have left it; house rents have fallen by 50 percent and real estate values still more sharply; the credits advanced by European firms to Syrian merchants have diminished in line with the decrease in business activity.

Faced with a situation that was constantly deteriorating, public common sense indicated that the only remedy for such decay lay in the creation of new elements of commercial prosperity, and in the first place in the construction of a port. The principal Muslim notables, whose wealth consists mainly of real estate, and who even more than the native Christians felt the disastrous effects of the situation, were the first to give it their attention and did not hesitate to give up their previous resistance and to proclaim the need for energetic measures to prevent the retrograde movement of that prosperity which they

had thought secure forever. Hence there was agreement and union between the Muslim and Christian inhabitants, who began to reexamine the idea of the creation of a port in Beirut.

Meanwhile, Rashid pasha, the governor general of Syria, who has always been solicitous of the well-being of the country entrusted to his intelligent care, had set up, at the beginning of this year, a municipality in Beirut, choosing its first members from among the principal Christian and Muslim notables of the town. One of the first tasks taken up by this municipality was the implementation of the old port project that had been provisionally given up. A commission was set up by it, consisting of local merchants and real estate owners, and charged with examining the question from the point of view of the plan to be adopted and the financial implications. This commission set to work with praiseworthy zeal and perseverance and after several sessions formulated and adopted the following resolutions: First, the need and urgency of building a commercial port in Beirut, using project No. 3 elaborated in 1863 by M. Stoecklin, engineer of the Ponts et Chaussées.

Second, provision of the resources needed for the servicing of interest on the capital to be invested in these works and the amortization of that capital.

It was assumed that the Board of Directors of the Messageries Impériales, or any other private company that might be formed for this purpose, would undertake to carry out the work and advance the required funds, provided the town of Beirut agreed to pay 5 percent per annum in interest on the capital invested and set aside the necessary funds for amortizing the capital in a space of 15–18 years. . . .

5

Alexandretta–Aleppo–Birejik Road, 1868, 1881

(Bertrand to Moustier, 22 February 1868, CC Alep 1867–1870, vol. 34)

. . . As I have stated in the above-mentioned reports, on 19 July a construction site was opened on the road from Aleppo to Biredjik; a second site was opened on 16th September on the Aleppo–Alexandretta road; finally, on 17th October a third site was opened at Biredjik, starting on the Euphrates and intended to link up with the road from Aleppo. Thus work began on a traced and marked distance of about 12 kilometers, but when operations were suspended [in December] the length of the paved highway that had been completed and opened to traffic was barely 6 kilometers on both sides of Aleppo, and that was broken at many points by gaps that are to be filled by bridges and culverts that have not yet been built.

For six full months of work, this output is certainly far from satisfactory, for at this rate the road, whose total length is 235 kilometers, would not be completed in 20 years. This tiny result can be explained by the fact that instead of the 800–900 workmen who

From CC Alep, vol. 34, 1867–1870; idem, vol. 36, 1879–1882.

could have been continuously employed on the job, the Commission of Ways and Means never put at the disposal of the engineer in charge more than an average of 200 per day; the managerial, administrative, executive, and supervisory personnel, who had been set up to direct a permanent labor force of 800–900 men on average, continued to serve, though idle most of the time, and were paid for six months.

It is very difficult to evaluate accurately the cost of these 6 kilometers of road, but according to the information gathered by the engineer on the works, the *real* cost—at the time when work was interrupted—amounted, in round figures, to some 548,700 piasters, as follows:

Technical personnel	71,700
Supervisory personnel	30,000
Materials and tools	30,000
Requisitioning (*prestation*) in kind	195,000
Workmen's wages	187,000
Administrative expenses	25,000
Sundry	10,000
	548,700

This means that the first 6 kilometers of road completed cost over 91 piasters (21.04 francs) per meter, whereas, based on the first estimates of this project, it was hoped that the average cost would not exceed 10.60 piasters per meter. But Your Excellency may have seen from my Report No. 84 that I never believed that actual costs would correspond to those estimates.

But these works will cost the State and the country much more yet, for they have given rise to numerous malpractices that were denounced to the central government and— I have been assured—have led the latter to send on the spot a commission charged with examining the doings of the administrators and their books.

At first the Government of the Sublime Porte, having decided to build the road in question, had not determined the mode of implementation and hesitated between conceding the works to private industry or having them carried out by the state, with the country's resources. Djevdet pasha, who was inclined to the first alternative, convened the notables and capitalists of Aleppo and invited them to form a joint-stock company that would submit tenders to the government. Meanwhile a French speculator, who claimed to have authorization from some capitalists in Marseilles, made to Djevdet pasha overtures that were listened to all the more favorably because he offered to pay 250,000 francs for the concession he requested; this businessman was urged to raise the amount of his liberality to 300,000 francs, and the deal seemed about to be closed when the central government announced that it would definitely undertake the implementation of the project and sent instructions accordingly to the *vilayet* of Aleppo. The thwarting by the Porte of arrangements that had almost been concluded caused visible annoyance to many people in Aleppo; but it did not take long for Government House (*Serail*) to concoct a new arrangement for the exploitation of the enterprise that had been confided here to native honesty and patriotism. A Commission of Ways and Means was set up, which immediately organized a system of rapine that was carried out with unusual boldness. As soon as work began, the daily lists of men employed on the site were falsified so as to include a number of workers—whether hired or impressed (*prestataires*)—much larger than the

real one. Withholdings were made from wages, with no benefit to the Treasury. Arith-
metic subterfuges were introduced in the accounts. A large number of impressed men
were exempted, on payment for the favor of not being included in the rolls. Attempts were
made to enter in the accounts, as having been executed, works that were not. Both the
making and the supply of materials and tools gave rise to monstrous thefts. Finally, even
the payment of wages, salaries, and honoraria was exploited by the payers, by means of
usurious practices [The Report adds that the chief engineer, Vidal—a Frenchman—had
been opposed to these malpractices. His life had been made impossible, he was forced to
resign, and his salary had not been paid. Later, attempts had been made to have him
recalled by the central government, and after these attempts had failed, because of his
good reputation, they finally succeeded.]

(Destrées to St. Hilaire, 7 November 1881, CC Alep 1879–1882, vol. 36)

[Twenty years ago the provincial government had started work on a carriage road between
Aleppo and Alexandretta.] All the various Valis who followed each other have, in a
greater or lesser measure, put their hands to this Penelope's web. Engineers have drawn
up plans and established specifications, the inhabitants and the Treasury have made large
contributions to the cost of this enterprise, and yet it is still very far from completion. On
the contrary, for lack of upkeep, the work initially carried out is deteriorating. [The
present *Vali* had just put an Ottoman engineer on the job, but since the season of bad
weather would soon set in, nothing would be accomplished.]

(Destrées to St. Hilaire, 21 November 1881, CC Alep, vol. 36, 1879–1882)

Your Excellency is aware that for many years the Ottoman Government has made it
a point to oppose all requests for concessions of works of public utility submitted to it by
foreign subjects, whether for the construction of roads and railways or the exploitation of
mines, forests, etc. Thus hardly two years ago a French company having requested a
concession for a carriage road between Aleppo and Alexandretta was given one only on
unacceptable conditions. Similarly, a Greek merchant, who had discovered in the Taurus
Mountains a chromium mine that seemed to him to be very rich, was not authorized to
excavate there in order to ascertain the extent of his discovery and thus be in a position to
request an exploitation permit. . . .
But recent events have shown that the Turkish Government is not better disposed
toward its own subjects. . . .
A company, including Muslims and Christians, was formed here and submitted to
the Ministry of Public Works in Constantinople a project for the construction of a carriage
road from Aleppo to Alexandretta. In order to exclude from this enterprise any European
elements, whose presence might have given umbrage to the Divan, interested parties had
taken the precaution of inserting in their articles of incorporation one that bound them not
to accept any foreign shareholders in their company. Moreover, the request for concession
put no onerous charge on the Imperial Treasury: neither participation in construction costs
nor guarantee of interest. They asked only the authorization to build the highway at their
own expense and risk, in return for a 50-year franchise that they were willing to reduce if
the Porte found such a term too long.
After waiting for six months, they have just received a counterproposal from the
Ministry of Public Works, suggesting such unacceptable conditions that a clear-cut refusal
would have been better, since it would have had at least the merit of frankness. To bring

out the absurdity of the proposals made to them, it will be enough for me to quote two: (1) The shareholders, while bearing all the risks of the enterprise, may not receive an annual dividend of over 7 percent. They will have to adjust their tariff so as not to exceed that figure. (2) At any time the government will be free to take over the road by compensating the interested parties in the following way: it will determine the average of gross receipts during the first five years and pay the Company, until its franchise runs out, 40 percent of that sum, keeping the 60 percent to cover running costs. Such conditions are more than leonine—they amount to spoliation of the shareholders.

The first is unacceptable in a country where the legal rate of interest is 12 percent and the effective rate 15–18 percent per annum. Where is the capitalist who would be willing to undertake the risks of a chancy business with a maximum of 7 percent? The second adds the last straw to this ludicrous contract by putting the company entirely at the mercy of the State. People have learned from experience how much are worth the promises of a power encumbered with debt like Turkey. By offering to compensate the shareholders at 40 percent of the average of gross receipts during the first five years, the Sublime Porte is aware that it will in fact pay nothing at all. . . .

The bad will manifested in this case has produced here a very poor impression. The natives are discouraged in the highest degree and are persuaded that they have nothing to hope from an administration that ignores so completely the vital interests of the region.

6

Transport Costs, 1883

. . . *Means of Transport.* Except for the carriage road between Beirut and Damascus, the only means of transport in Syria are camels and mules. It is true that there is the Tripoli–Hama road built by Midhat pasha, but it is not yet quite complete and does not have a regular transport service. For the Beirut–Damascus road the official rate, stipulated in the act of concession (*cahier des charges*), is 18 francs per quintal of 200 *okes* (250 kilograms), but this figure is subject to increases or reductions, depending on the season and the abundance or paucity of goods. Rates for transport by pack animals vary from one locality to another and between one day and the next in any given season.

It is therefore impossible to present a table that would be anywhere near accurate on rates—even averages—or on freights paid from the interior to the coast by different articles of produce in Syria. When goods are scarce and mule drivers available in large numbers, one can reckon the cost of transport on the basis of 4 francs for a mule load and 5 francs for a camel load for a day's journey (40–45 kilometers). But in times of plenty two or three times as much may be paid. Sometimes the producers of Hauran, not knowing how to transport their cereals to Acre, give the camel drivers half the load in payment of freight. Now a camel usually carries 250 kilograms of wheat, and makes the journey from Hauran to Acre in three days. If the 250 kilograms carried by his camel sell

From "Report on Trade," 23 October 1883, CC Beyrouth, vol. 9, 1868–1888.

at Acre for 50 francs, the camel driver takes half this amount as hire for his animal and pays the other half to the owner of the wheat.

7

Land Transport in Syria, End of 19th Century

. . . By reducing transport costs, roads (whether railroads or paved roads) impel the farmer to extend the scope of his activity in order to increase his produce. He does this either by ploughing hitherto uncultivated land or by using fertilizers and irrigation and taking greater care of his crops. Why else should he produce more if he cannot benefit thereby? This happened in Aleppo in 1881 when, because of the fall in wheat prices in Europe due to large imports from Russia and Brazil, Syrian farmers could no longer afford the high transport costs due to the absence of easy communications and the consequent need to transport wheat by camel. In Urfa in 1874 the wheat delivered to the government as 'ushr (tithe) was burned by order of the *wali* of Aleppo, Ahmad pasha, in order to save storage costs and in view of the fact that there was no possibility of selling or exporting it abroad because of the high cost of transport.

Before the construction of the Hauran–Haifa railway, the farmers of Hauran paid half their wheat to the owner of the pack animals that carried it to the port; thus, in 1890, whereas the price per ton was 53.18 francs in Hauran, in Zahleh it was 70.91, and in Acre 97.25—we can therefore imagine what remained to the farmer in the way of profit given the low prices in Europe and the payment of taxes to the government. The railway between Haifa and Hauran (Dir'a) reduced transport costs to one-sixth instead of a half,[1] but they could be reduced still further, judging by European railway tariffs. It is enough to examine closely the receipts of the Damascus–Beirut road built by a French company under a concession granted in 1857 to see how much this road met Syria's economic needs. Its receipts doubled within a year and continued in this way until 1869 when they reached 1,031,000 francs, remaining at that level until 1892 (except for 1877 when they did not exceed 892,000), after which they rose to 1,780,000 francs, and continued so until the completion of the Beirut–Damascus railway, which stopped this progress,[2] by reducing the freight per ton-kilometer to 20 centimes, instead of the 56 charged by the road. All these figures show clearly the effect of roads on the quantity of produce exchanged within Syria or with foreign countries.

The government attempted to link Aleppo to its natural port, Alexandretta, and laid a road in 1882, but the technical incompetence of the engineers who built it and lack of maintenance led to its ruin within a short space of time. [See selection 5.] Caravans started taking another route than that of Jabal Barakat and followed the new road only from Wadi 'Afrin[3]; and, in addition to the high transport costs by camel, a large part of the merchan-

From Ali al-Hasani, *Tarikh Suriya al-iqtisadi*, Damascus, 1342 (1923/24), pp. 339–342.
[1]*Recueils consulaires belges*, 1913, p. 220.
[2]Verney and Dambmann, *Les puissances*, p. 215.
[3]Fitzner, *Aus Kleinasien und Syrien*, p. 133.

dise is subject to deterioration because of humidity. This state persisted until 1897. . . .
Hence, after the completion of the railway between Homs, Aleppo, and Tripoli, Aleppo
started sending its goods through Homs and Tripoli instead of through its natural and
nearby port of Alexandretta. And although the freight to Tripoli cost the Aleppo farmers
and traders 30 francs per ton, they preferred this route to the caravan route to Alexandretta
because of its greater security and convenience. . . .

8

Hajj Caravan, 1903

With reference to my dispatch No. 2 of the 7th ultimo I have the honour to report that the
Haj Caravan left Zerka on the 30th ultimo—six days later than usual—the number of
pilgrims being only 90–100 altogether. This extraordinary and indeed unprecedented
paucity of numbers is attributed in part to the existence of cholera here and in the
neighborhood and partly so I am assured, to a growing feel of disinclination to undergo
the extra expense, fatigue, toil and privation which the long wearisome overland journey
to Mecca entails when the same object can be attained, with infinitely less suffering, by
the simple expedient of going round to Jeddah by sea. Whether this feeling is really
becoming general or not it is difficult to say but the fact remains that the number of
pilgrims who take this route is yearly becoming less until, as is the case on the present
occasion, less than a hundred have been found to undertake the journey.

Certain detailed information in connection with the expenditure which the dispatch
of the Mahmal entails yearly on the government having come to my knowledge I venture
to think that your Excellency may find it to be not devoid of a certain interest. The whole
yearly cost of the Haj is from £136,000 to £140,000 of which £100,000 are in the special
charge of the Surra-Emini (Guardian of the Purse) who, this year, is a certain Bâki Bey
Evrak Mudîri (Archivist) in the Sadaret (offices of the Grand Vizier). I should mention
here that the post of Surra-Emini, as perhaps your Excellency knows, is very much sought
after among a certain class of government employees, the holder for any given year being
appointed some years before his actual turn comes round.

The remaining £36,000–£40,000 are assigned to what is known as "Kiler" (liter-
ally, store-room) of the Haj being the stores and provisions of every kind to the purchase
of which this sum is largely devoted.

The whole sum of £135,000 is obtained from different sources which may be
classified somewhat as follows:

Ministry of Finances at Constantinople by order on the	£30,000
Damascus Agency of the Ottoman Bank:	
Evcaf Dairessi at Constantinople (Dairet-awcaf ul-Haremein	35,000
ish-Sherifein):	

From Richards to O'Conor, 10 February 1903, FO 195/2144.

Vilayet of Beirut, through the Ottoman Bank Agency there:	30,000
Vilayet of Beirut, a further sum of:	30,000
to be forwarded to Medina (*so I am informed*) where it is to be picked up by the Surra Emini when he passes with the Caravan on his way to Mecca.	
Vilayet of Damascus, advanced to the Surra-Emini himself:	5,000
Contributed towards the fund of the Kiler:	5,000
Total:	£135,000

As a matter of fact these two last mentioned sums were not contributed from the chest of the Vilayet—which it is well known, is practically empty—but were lent in part by Abdur-Rahman Pasha the Muhafiz-el-Haj and Saʿid Effendi Benna the Muhassebedji (Accountant General) of the Vilayet and in part by the Ottoman Bank here. I might mention that the sum of £35,000 which has been provided by the Department of the Eveaf was brought with him by the Surra-Emini himself; at least this is the only reasonable and at the same time natural way of accounting for the presence of this particular sum. Of the £30,000 already contributed by the Vilayet of Beirut, £20,000 were advanced by the Damascus Agency of the Ottoman Bank in addition to the other sums paid by it as stated above.

Some 14 or 15 years ago when the Vilayet of Syria included the present Vilayet of Beirut and the existing Sanjak of Jerusalem, the whole sum of £100,000 was furnished by this Vilayet alone, the remainder being supplied, as a rule, by the Evcaf Dairessi at Constantinople. But when this Vilayet was separated from that of Beirut the burden of providing annually this sum of £80–100,000 was apportioned more or less equally between them and this system appears to have prevailed down to the present time. This year owing to the large sum (£126,270) which this Vilayet has to contribute from its Tithes towards the payment of the Kilometric Guarantee of the Hamah railway, it has been found impossible for it to provide its usual quota towards the expenses of the Haj—or indeed any sum whatever.

From this main sum of £100,000 the Surra-Emini receives his own salary amounting to £4500 while about £2000 are distributed here among the various Meshaikh el-Turuk (Heads of religious sects or confraternities) dervishes and other persons of reputed sanctity who are traditionally connected with or interested in the ceremonial observances of the Haj. The remaining £93,500 are distributed partly among various Bedouin tribes whose camping grounds lie on or near those parts of the deserts—which the Derb el-Haj (Haj road) traverses, such as the Rowela, Wuld-Ali, Aʿatiyeh, Aʿakil, Sirhan and a great many others, and partly among the Ashraf (the direct descendents of the Prophet living in or near Mecca), the Khadamet-ul-Haram, i.e., the attendants or servants employed in the sacred enclosure round the Caʿaba, and in short all those who are in any way connected with the religious services and ceremonies of the city. Those occupying a similar position in the Haram at Medina are equally sharers in this largesse. It is computed that some 5000 persons in all benefit yearly by this huge dole, which, however, does not in every case bear this character because owing to the scantiness of the revenues of the Vilayet of Hedjaz there are a considerable number of religious and possibly other functionaries whose salaries are paid out of this fund, and who, it may be said, depend on its yearly arrival for their means of subsistence. The Kiler or Commissariat fund, as it may be termed, which ranges in amount from £35–40,000 is controlled and dispensed by Abdur-

rahman Pasha, the Muhafiz or Emir el-Haj. Of this sum £14,000 are given to the Pasha in cash and are spent during the actual journey to and from the Holy Cities, the recipients being all those persons who render services to the caravan such as the supply of water, corn and other fodder for the camels, horses and mules, food for the escort and even for the pilgrims in addition to such stores as they take themselves etc. Extra money presents are also made out of this fund to such dissatisfied Bedouins as consider they have been hardly treated by the Surra-Emini and are therefore likely to give trouble.

The balance Viz. £22–26,000 is spent in Damascus before the departure of the Caravan, in the purchase of all sorts of stores and provisions necessary for the journey, which it should be remembered, lasts 37 days *each way,* and in the payment of the salaries of the Muhafiz himself, his subordinates, the officers in command of the escort and the men of which that body is composed. The Pasha himself receives 81,600 piasters and £120 in lieu of rations. He is accompanied by two "Muzhdéjis" or bearers of good news each of whom gets £450 and rations of the value of £264. These persons are employed for the purpose of conveying to Mecca and Medina votive offerings generally in the form of money, made by the Validé Sultan herself, various inmates of the Imperial Harem and members of noble and wealthy Turkish families residing in Constantinople.

These gifts are made up separately into "Groups" the name and domicile of each recipient being clearly written on each parcel, most of which are destined for persons employed in the Haramein (Mecca and Medina). In addition to the "Muzhdéjis" there is the "Mubeshir" a name which also signifies "Bearer of good tidings," whose special function it is to precede the Caravan by two or three days in order to announce its approach to all concerned. This person receives a smaller salary than the "Muzhdéjis" but of the exact amount I am not informed. There are also three doctors, one surgeon and a cadi who also acts as Mufti, his function being to settle disputes which may arise among the Hajjis, to make out the will of any pilgrim who may die during the journey and act generally as arbiter and referee. The escort, known as "Mowkeb," consists of 300 cavalry soldiers (Nizam) mounted on mules and who, when so mounted and so employed, are known as "Mufraza" (reserved); two cannons in the charge of 16 gunners commanded by a captain (Yuzbashi), 130 Zabtiehs, commanded by their own officers—two Yuzbashis and four Mulazims, and, finally, of 85 mounted Bedouins of the tribe known as "A'akil." The whole escort is commanded by a major (binbashi).

In addition to the purchase of stores and the payment of salaries there are a considerable number of presents consisting of richly embroidered "'abas" (cloaks), high red Morocco leather boots, "Gombazes" (garment enveloping the whole figure), bales of calico and other similarly suitable offerings all of which are bought here out of this sum of £22,000 and bestowed on various Bedouin sheikhs along the line of route. These persons, who are well aware of what it is in the store for them, come to meet the Caravan at some traditionally appointed spot, each man receiving his neatly made up parcel to which his name is attached and going his way as soon as he has got that to which he has been anxiously looking forward for some months.

The "bash kyatib" (Chief Clerk) of the "Kiler"—a certain Yusuf Towwil, who, curiously enough, is a Christian, keeps a list of the names of the recipients of presents— many hundreds in number—throughout the duration of the journey, which he takes himself as far as Terka and there hands over to his deputy, a moslem, to whom he gives minute final hints and instructions before he returns to Damascus. All these presents as well as the tents, stores and other necessaries of the Haj are supplied by contract by Damascene merchants and I am assured that they are usually of a very good quality.

I understand that the first sovereign who instituted the system of the distribution of pecuniary and other presents to the Bedouin along the route of the Haj was Sultan Salim the First. . . .

9

Alexandretta Port and Roads, 1899, 1903

"Report on Aleppo Vilayet," FO 195/2054)

. . . Thirty years ago, when Raif Pacha, our present Vali, was on the staff of Midhat Pacha, Vali of Bagdad, he passed through Alexandretta, which he recalls as a townlet of 2000 inhabitants, who lived in huts erected on piles, at a great distance from the ground, to escape from the miasma of the surrounding swamp. Today, the population is nearly 14,000; the old huts have entirely disappeared; the sea front is occupied by a long line of handsome stone houses and offices; while the streets have been properly laid out and paved.

A Commission, of which Vice Consul Catoni is an active member, was appointed last year to superintend the drainage of the marshes and the work is progressing steadily.

Lastly, preparations are being made for the construction of a breakwater at Alexandretta.

The present carriage road from Aleppo to the coast was inaugurated fourteen years ago by the late Djemil Pacha. Instead of following the old caravan track, which had no difficult gradients, it was made to take a circuitous course to the north for no apparent reason except to increase the profit of the Engineer, its entire length being 157 kilometers. The Vali is now making a new road via Turmeneen (the old caravan route) which will merge into the present road at the Afreen River.

The last section of the road, that over the Beilan Pass, will also be reconstructed, so that the journey to the coast will, altogether, be shortened by something like fifty kilometers, and it will be possible by obtaining relay of horses at Hammami to reach Alexandretta in one day. . . .

("Report on Administration of Aleppo Vilayet," FO 195/2137)

. . . It has been a subject of frequent complaint that the merchants of Alexandretta, having no sufficient storage-room for goods which they have just cleared through the Custom House, and which are destined to be sent into the interior allow these goods to lie about the streets for days together until they find camels to remove them. To obviate this public nuisance the Municipality will erect a large depot for the temporary storage of these goods at a fixed charge per day.

Much progress has been made in the repair, or, I should rather say, reconstruction of the carriage road to Alexandretta. It had been allowed to fall into a more dangerous state, and accidents were frequent during the winter. Sufficient stone material has been

From FO 195/2054, and FO 195/2137.

prepared to relay the road throughout its entire length of 96 miles, and two new iron bridges have been erected over the Blackwater (Kara-Sou) river, in the Amook plain.

At Catmé, 30 miles from Aleppo, the road branches off to Killis, but had remained unfinished for a few miles outside that town, and this portion has now been completed.

A very necessary measure has been adopted with respect to the Khans on the high-road. In future a Tariff of charges is to be posted at the gate of every Khan, the tariff being uniform and fixed by the Municipality of Aleppo. Although the accommodation of a Khan is meager in the extreme, being limited to a bare sleeping room, light fire and coffee, the charges of the Armenian Inn-Keepers are exorbitant. . . .

10

Navigation on the Euphrates, 1903

. . . 2. *Description of Birejik Boats.* Between Birejik and Hit merchandise is carried solely by the flat-bottomed boats, known as *Shakhtúrs,* built at Birejik and no-where else. These boats, which are now so common, do not seem to have existed in Chesney's time; for he makes no mention of them in his exhaustive chapter on Boats and Hydraulic works of the East (Chapter XX, Vol. II). The ferry boats of Birejik are, on the contrary, carefully described by him, and it may, therefore, be assumed that the carrying boats of Birejik did not exist in his time. These boats are oblong in shape, 18 feet long, 8 feet wide, and with a depth, from the gunwale to the flooring, of $2\frac{1}{2}$ feet, which gives a carrying capacity of 360 cubic feet. When fully loaded, they draw about $1\frac{1}{2}$ feet. The total depth of these boats, from the gunwale to the bottom, is 3 feet 8 inches, the bottom consisting of trunks of trees sawn in half, beneath which flat boards are nailed; and a flooring of flat boards is fastened 1 foot above the bottom. The sides and ends of the boats also consist of flat boards roughly nailed together, the interstices being stuffed with rags over which bitumen is daubed. The cost of building a boat of this kind is said to be about $4\frac{1}{2}$ Turkish pounds. One boat carries about 100 cantars of Constantinople, or a little over 5 tons. These boats of Birejik nearly always travel in pairs, fastened together side by side. They are steered by clumsy sweeps, pulled in the bow, and they are so unmanageable that they can only travel in a flat calm. This liability to be arrested by the slightest wind is the chief drawback of these boats. They can, of course, only take merchandise down stream and they are usually broken up and sold for the price of the wood of which they are built at the place to which the goods carried in them are consigned. A certain number, however, are towed empty up-stream by the amphibious inhabitants of Ana. The time taken by boats to descend the river varies enormously. They have been known to go from Birejik to Feluja in time of high water in 12 days. On the other hand, they frequently take as much as 60 days when delayed by wind or when the water is low.

From "Report on Euphrates," FO 78/5324.

3. Through Trade by Boat between Aleppo and Baghdad. The through trade between Aleppo and Baghdad consists mainly of Aleppo soap and cottons. The soap goes by boat from Birejik to Feluja, where it is transferred to the backs of mules for Baghdad; while the cottons go by mule-caravan, which takes 24 days to cover the distance between Aleppo and Baghdad. The total annual weight of this traffic does not exceed 100 tons, of which not more than 30 tons go by boat. The reason why goods from Aleppo are embarked at Birejik, which is 70 miles further up the Euphrates than Meskene, the nearest point on the river to Aleppo, is that there are no suitable arrangements at the small village of Meskene for the embarkation of goods.

4. Local Traffic by Boat. Local traffic on the Euphrates may be divided into two portions, *viz.,* traffic between Birejik and Deir El Zor, and traffic below Deir El Zor. . . .

The total approximate annual river-borne traffic between Birejik and Deir El Zor may be summarised as follows:

	Tons.
From Birejik to Deir	
Grain	5,500
Do. Vegetables, raisins, etc.	60
From Najib and Shaikh Arud to Deir.	
With tribes on bank	
Grain	1,600
Miscellaneous	10
	6,170 [*sic*]

In addition to the above a very large amount of brush-wood (chiefly tamarisk) is made into rafts and floated down to Deir El Zor from the neighbourhood of Abu Hareira. . . .

The approximate average annual weight of river-borne traffic below Deir may be estimated as follows:

	Tons.
Deir to Ana	
Grain	200
Do. Miscellaneous	20
Deir to below Ana—	
(Hadisa Hit and Ramadi) Grain	400
Do. Miscellaneous	50
Country between Meyadin and Abu'l	
Kemal to Ana. Grain	50
Total below Deir (excluding Hit boats)	720

Very little traffic is said to go from the upper parts of the Euphrates to below Feluja owing to the difficulty experienced by the boats built at Birejik in crossing the dam across the river at the mouth of the Hindieh canal; but I was told that a good number of the Hit boats, the cargo of which is not very valuable, go down to Basrah with bitumen and lime.

7. Cost of Freight. The cost of freight for goods conveyed in the Birejik boats may be said to consist in the difference between the cost of the boat at Birejik and the price

obtained by its sale at its destination, added to the cost of the labour of the two boatmen who go with each boat. The freight from Birejik to Deir may be worked out as follows:

Original cost of boat at Birejik 4½ £ Turkish:	4½
Substract price of boat at destination:	2
Net cost of boat	2½
Wages of boatmen for going and returning:	2
Net cost of conveyance of boat load to Deir:	4½ £ Turkish.

Cost per ton (1 boat carries about 5 tons) about 98 Piastres.

Merchants sending goods by these boats buy the boats, hire the boatmen, and send an agent in charge of the goods, despatching separate advices by land to the consignees; so that the wages of the agent should be added to the above amount. The risk incurred by boats owing to the wind and shallows must also be taken into consideration. From all that I could gather, about 3 percent of the boats are wrecked on the journey. . . .

11

Hijaz Railway, 1906

INCLOSURE 2 IN NO. 122: REPORT BY AULER PASHA RESPECTING THE HEDJAZ RAILWAY

Part III. History of the Construction

(Translation.)

On the 1st May, 1900, appeared the Imperial Iradé for the building of the line, and preparations were at once set on foot. As the railway was for a religious object, the money for building it was raised by voluntary contributions from the whole of the Mahommedan world. Besides this money, certain Government revenues—for instance, certain stamp duties, and the proceeds of the sale of the skins of sheep slaughtered at Bairam—were devoted to the Hedjaz Railway. Further revenues for the future are the proceeds of the phosphate beds near Es Salt, on the Hedjaz line, and the sulphur springs near Hamma, on the branch line Haifa–Der'â, the exploitation of which has been handed over to the Hedjaz Railway.

Up to the 1st September, 1905, the total income amounted to 46.7 million francs— about 7.5 million francs per annum. On this date, after the payment of all expenses, the railway still had the sum of 8.25 million francs at its disposal.

From FO 424/210.

At the same time as the preparation of the money, the following preliminaries were arranged for:

1. The organization of the building authorities and of the Directors.
2. The introduction of negotiations for the acquisition of territory.
3. A survey of the whole line for the purpose of making a general plan of building.
4. The procuring of instruments and railway material.

1. For the direction of the construction the following Commissions were formed:

(*a*.) The General Commission for the construction of the Hedjaz Railway, established at Constantinople. The Grand Vizier is the President. Members: the influential and indefatigable Izzet Pasha; the Minister of Public Works; and the Director of the Factories of the Marine Arsenal. Besides these, some officials of the Ministry of Public Works have been appointed as technical advisers. The Commission is charged with the care of finding the moneys required, and decides upon the application of the same. It carries on diplomatic negotiations in acquiring land, appoints engineers and officials, and makes contracts for supplies.

As it is only twenty-two years since Turkey has had an engineering school for civil engineers, and these, through the lack of Government railways, have hitherto had but little opportunity for practical work, there was at first a dearth of experienced engineers. The Commission has therefore for the present imported engineers from abroad, especially from Germany, and bound them by contract. By degrees, however, during the building of the railway, a number of pupils from the engineering schools have become efficient engineers, and are equal to all demands made upon them. At the present moment there are ten foreign and twenty-five Turkish engineers at work on the railway, not taking into account the officers of the engineers.

(*b*.) The Local Commission for the construction of the Hedjaz Railway, with its seat in Damascus.

The President is the Vali of Damascus; the members are the Director-General of the Hedjaz Railway, Kiasim Pasha; the Commanding-General of the 5th Army Corps; and a Notable of Damascus. The technical members are Chief Engineer Meissner Pasha, Director of the Engineering Works of the Railway Construction, and several Turkish railway engineers.

The Commission examines the plans and proposals of the Director-General and lays them before the Constantinople Commission for decision. It also arranges for payment of salaries and wages. At the head of the railway construction was placed the aforementioned Field-Marshal Kiasim Pasha, who has hitherto distinguished himself not only by his talent for organization, but also by his caution and energy. In addition to the troops, the whole of the engineering staff, the contractors and labourers, are under his orders, and it is particularly to his credit that he has managed to avoid friction between the military and civil elements, so that both parties work heartily together to attain this end.

The technical management of the construction was intrusted to Chief Engineer Meissner Pasha, and the choice has proved especially happy, as Meissner has collected much experience during his many years' work on the railways of European Turkey, and to this experience adds an iron energy.

The building of the bridges, &c., was given mostly to Austrian and Italian contractors, and the work was for the greater part carried out by natives, as foreign labour was difficult to get.

The further into the desert the railway advanced, the more difficult became the

question of labour. On this account, and for reasons of economy, Turkish troops were largely employed in the work of construction.

There are now working there:

Railway Battalion, No. 1, with:	1,200 men since September 1, 1900 (till April 1, 1900, only on the survey).
" " No. 2, with:	1,200 since May 1900 (from spring 1904 till September 1905 on the Haifa Railway).
The Sappers Company, 5th Army Corps:	200 men since May 1900.
Detachment of the Telegraph Company, 5th Army Corps:	50 " September 1, 1901,
Two battalions infantry regiment, 33rd Army Corps:	1,000 " " 1, "
Three " " 39th "	1,000 " " 1, "
Four " " 39th "	1,000 " " 1, "
Total:	5,650 men.

The infantry battalions did the earthwork, while the railway troops made the bedding, laid the lines, and did some of the minor masonry work, such as building bridges and culverts. They also supplied the men for the preliminary surveying and surveying companies. . . . (c. Construction, Part IX.)

The sappers were chiefly employed in the railway workshops as mechanicians, locksmiths, smiths, and carpenters. The telegraph detachment laid down the railway telegraph for the Hedjaz and Haifa Railways, and were then placed at the stations as telegraph operators.

2. The most important negotiations which the General Commissions in Constantinople had to carry on were those with the French Company, Beyrout–Damascus–Muserib; and with an English Company on account of the line Haifa–Damascus, which has just been begun, and for which the Company had received the Concession.

It was important that the Company should obtain possession of the line Damascus–Muserib, as they would have then begun the railway direct from Muserib and not Damascus, thus saving the laying down of 120 kilom. of rail for the Hedjaz line. But their efforts were not crowned with success, and the apparently liberal compensation of 7,000,000 fr. was not accepted. Negotiations with the English Company were more satisfactory, which may be attributed to the facts that they were in money difficulties, and that the whole line consisted of the substructure from Haifa to Beisan and 8 kilom. of rail. The Commission bought the Concession from the English Company for 925,000 marks.

With the exception of these two, no other negotiations were necessary for the acquisition of land. The Sultan, as absolute Sovereign, can dispose freely of all the land of his kingdom, and whatever is necessary for Government purposes is requisitioned without permission of the owner. As the construction of the Hedjaz Railway is a religious work, every Mussulman gave up his property with joy in order to contribute to the success of the undertaking.

3. In order to make a provisional trace of the Hedjaz Railway a survey of the whole line was necessary. This was undertaken by the Turkish Engineer, Hajji Moukhtar Bey, soon after the Imperial Iradé for the commencement of the work had been given.

To this end Moukhtar Bey joined a caravan of pilgrims going from Damascus to Mecca, and during the journey he made his observations and took measurements. The results of his survey he has given in a report (see Annex) and in the accompanying map

with sectional profile. His sketch of the line has been corrected as far as Mudewwere (572 kilom.) after the completion of the railway up to this point at the end of 1905 made it possible to take exact measurements. The trace of the line Haifa–Muserib is also the result of exact measurements after its completion.

4. Owing to the lack of native factories, the Hedjaz Railway was forced to get from abroad all necessary material (rails and rolling-stock) with the exception of a few of the carriages which were made in the marine arsenal. Rails and sleepers have been supplied by German, Belgian, and American firms, rolling-stock by German and Belgian firms only.

On account of the transport, the cost of material is, of course, much augmented, but this disadvantage is partially rectified by the fact that, with the exception of lime and cement, the material required for the construction of stone bridges and bedding are to be found of good quality on the spot, and may be taken from the quarries free of cost.

The real work of the Hedjaz Railway began with the laying of the railway telegraph some years after the laying of a Government telegraph line from Damascus, viâ Es Salt and Ma'an to Medina. Shortly afterwards the construction of the Hedjaz Railway itself was commenced, on the section Muserib-Der'a, as the negotiations with respect to the line Damascus–Muserib had not yet been definitely concluded. The work progressed but slowly, so a provisional contract of three years was made with Chief Engineer Meissner in January 1901.

Meissner Pasha's first step was to find suitable assistants and to get the necessary tools, especially measuring instruments. He then began with the military and civil personnel at his disposal, the construction of the line between Muserib Der'a and Damascus Der'a, as in the meantime the negotiations between the General Commission and the French Company had come to naught, and the former had decided to build a line Damascus–Der'a, parallel to the French line Damascus–Muserib. When later on these negotiations were again resumed, unfortunately without result, the work between Damascus–Der'a was again interrupted for a whole year, so that this part of the line could only be opened to traffic in September 1903.

However, the work on the line Muserib–Der'a was continued without interruption, so that the following sections could be opened:

Muserib–Der'a (12.8 kilom.) on the 1st September, 1901.
Der'a Serka (79.75 kilom.) on the 1st September, 1902.
Serka Katramé (123.45 kilom.) on the 1st September, 1903.
Katramé Ma'an (132.60 kilom.) on the 1st September, 1904.

On this day, the anniversary of the Sultan's accession, took place the solemn inauguration of the whole line Damascus–Ma'an, by a special Imperial Mission under leadership of the Minister Tarkhan Pasha.

In connection with the year's pilgrimage to Mecca, the opening of the section Ma'an–Mudewwere (132.2 kilom.) has been planned.

Note. In the course of this summer, 1906, the section Mudewwere–Sat-ul-Hadj has been completed, and it may be expected that at the end of this year the lines will be laid at the station Tebak.)

It is easy to understand that the Hedjaz Railway wished to get an outlet to the sea as soon as possible, as the transport of the immense quantities of building material over the

French line, Damascus–Beyrout proved very expensive. Therefore the construction of the branch line Haifa–Der'a was commenced from Haifa immediately on conclusion of the aforementioned negotiations with the English Company. The original English project by which the line was intended to run from Haifa straight through the valley of the Jordan to Damascus, was changed, so that the railway crossed the Jordan at the town of Beisan, then touching the Sea of Gennesaret near Samach, took its way through the deep romantic valley of the Jarmuk on to Muserib. Already on the 1st September, 1904, the section Haifa–Jordan was opened to traffic. On the 1st September, 1905, the section Jordan–Muserib was inaugurated and thereby was created for the first time a Turkish railway communication with the Mediterranean.

Through its natural position Haifa possesses all the conditions for a good harbour. But in consequence of the strong currents from the west, the sand is banked up and ships are forced to anchor outside the harbour. A jetty 350 metres long, has not yet improved matters. In order to make a usable harbour it would be necessary to build a breakwater 500 metres long, and a quay of about 600 metres. . . .

12

Gulf Shipping in Bombay, 1804

. . . The amazing increase in the shipping and navigation of the subjects of the Imaum of Muscat, to the evident disadvantage of the British shipping in India in general, and of this settlement in particular. . . . Two houses at Surat formerly employed about twenty-five large vessels in the Gulph Trade, the two best of these (Gunjara and Soliman Shah) are now at Muscat, the property of Arabs, and the representative of Chillaby's house, Ty Topal's son-in-law, has about 2000 tons of shipping. And on reference to Statement No. 13 it now appears that of 25 ships employed in the import and export trade of Surat to the two Gulphs [Persian and Arabian, i.e. Red Sea] there are 2 English and 23 Arab ships. . . . It appears that on the trade between Bombay and the Persian Gulph alone the Arab tonnage had increased in the course of four years, from 900 tons which they possessed during the first year to 3918 tons which they were in possession of during the last year and that Arab tonnage had been employed during the last year, on conveyance of our own internal trade during the last season, to the amount of 88,000 bags on which, on a fair calculation it appears that they had gained above 5 lacs [500,000] of rupees. It has also been shown in paragraph 19 of this Report that the Arabs of Muscat had so completely deprived us of the trade of part of the Eastern produce to the Gulphs, that they even brought to our own ports, in their ships, the surplus of what they had imported direct from the Eastern Islands into the ports of the Red Sea. . . .

The shipowners at Muscat are Indians and Persians except four Arabs, Seyd Sultan, Seyd Seif, Seyd Mahomed and Beni Zurafee; the other are men of large capital, attached to Muscat by the convenience for trade and have settled there on account of the encouragement and protection they receive from the government of that place, the moderate duties

From "Report on Trade," 1803–1804, IOC Bombay, 419/2.

they pay, the freedom of trade they enjoy, and the expedition and dispatch they experience in transacting business and clearing at the Customs House. . . .

It is not against the encroachments of the Persians, who bring a large proportion of treasure from the Persian Gulph. It is not against the Arabs or Turks of Bussora, who bring the remainder of treasure from that quarter. It is not against the Arabs of Moculla, Mocha, Hodeida, Jadda, Yambo or Suez and the remaining ports of the Arabian Gulph, that the complaint lies; they possess not a single ship, although the countries and ports mentioned are the only ones from which either the produce and [*sic*] treasure of Persia and Arabia are shipped, they all continue to come to Bombay on Dows (though not in such numbers as before) there to exchange their treasure and produce for the produce and manufactures of India. It is against the shipping of Muscat, which place possessing neither produce nor manufactures nor any other channels through which the treasure of Europe passes to India, must interfere with the trade of these other countries of Arabia, in order to procure employment for their ships, and this interference is itself the subject of complaint. . . .

13

Baghdad–Aleppo and Damascus Caravan, 1850s

The rich caravans from Damascus or Aleppo to Baghdad formerly took the Shamiyeh route, that is, through the great Syrian desert. They came straight to our town, through this vast wilderness, and made the journey in some 20 days, without being molested by the nomadic tribes wandering in it, who allowed them free passage in return for a small fee that was agreed upon and paid in advance.

This state of affairs lasted a long time and ceased entirely only 10 years ago, after two caravans had been robbed and a third completely disappeared. Since then caravans follow the long and costly Sultanieh route (the royal road through Aleppo, Diyarbakr, and Mosul), taking more than two months to reach Baghdad. Through bad faith, the caravan leaders, or *aghels ['uqail],* shut themselves out of that short and convenient road. Let me explain:

At the beginning—and I am speaking of a very distant past—the *aghels,* who belonged to an intelligent and warlike clan originating in Najd (in Arabia), served only as escorts to caravans, defending them against desert robbers. The profession of camel driver was at that time exercised by people from the village of Zubayr—ancient Basra—and by the ʿAbdullah tribe from near Baghdad. Gradually, when the restless tribes of Sbaʿa, Fedʿaan, Amara, and others, were successively pushed out of Najd—their original home—and, with their flocks, came to occupy a large part of the Shamiyeh, the *aghel* escorts were no longer adequate for the protection of the caravans. The latter therefore made friendly arrangements with the nomads, to ensure the security of the road. Relying, with

From ''Report on Caravans,'' 1 October 1866, CC Baghdad, vol. 12, 1856–1867.

good reason, on the traditional respect felt by all the sons of the desert for pledged faith and fraternity, they (so to speak) bought from them a free right of way, guaranteed against all attacks, in return for a small fee on each camel load, and *refieghs* (*rafiq*) from each tribe accompanied them in their journey; the latter were a sort of protective guarantors whose task was to make it clear that the caravans *came as friends*. Between all these various parties, everything was arranged and settled on a purely private basis and on their sole responsibility. The Turkish authorities never interfered, and for good reasons. For, although they surely wished that the caravans that created the wealth of three large provinces of the Sultan should enjoy security in the desert, they judged it prudent not to intervene where one of the two contracting parties belonged to the proud and free tribes of the immense Shamiyeh; for these tribes were then, as they are today and will probably always remain, out of its reach and in a position that is almost independent in fact if not in name.

The fact that the same individuals continued to perform the function of *refiegh* resulted, after a short time and in accordance with desert customs, in endowing certain families in the tribes with a kind of exclusive right to occupy that post; this could be transmitted to heirs and even be indefinitely subdivided, by way of inheritance. The whole of these rights took the name of brotherhood or *Khuwa*, and henceforth those who were formerly known as *refiegh*, and those who participated in whole or in part in the rights of brotherhood, came to be known as *Khuwan*.

Thus, Mr. Minister, came to be formed the brotherhood of the great desert of Syria, that is, the *Khuwa* of the Shamiyeh, which is well known to the peoples living between the Mediterranean and the Persian Gulf. There is no written deed establishing this kind of association. Everything in the past was done by verbal convention, everything till now rests on tradition, but in the desert tradition is sacred.

Let us now return to the caravans. They quickly realized that by faithfully keeping their obligations toward the *Khuwan* (i.e., by punctually paying the small sum agreed upon for each camel load), they could, in security and at any time, cross the desert under their patronage. Little by little the *Khuwan*, of whom many are today powerful *shaykhs* of the Shamiyeh, stopped accompanying the caravans in person, and instead, when they deemed it necessary, supplied them with men whose task was to make them known to the tribes and who took back the old designation of *refiegh*.

This was the state of affairs and, I have been assured, things were going well when the *aghels*—who, as I said earlier, were hired escorts—managed little by little to oust the people of Zubayr and the ʿAbdullahs and replace them almost entirely as camel drivers and leaders of caravans. They thus found themselves alone facing the tribal *Khuwan*, and this was most unfortunate.

For, unrestrained by any control or supervision, whether from the authorities or from the merchants, who gave them, along with their goods a sum covering the cost of transport and the fee owed to the *Khuwan*, the *aghels* thought they could with impunity cheat the desert tribes; their breach of faith and frequent abuse of the confidence they enjoyed led finally to the catastrophes that resulted in the giving up of Shamiyeh route by the Damascus and Aleppo caravans.

But only the *Khuwa* could, and still in the general opinion can, ensure the security of the caravans and travelers in the desert, which no regular troops can penetrate and in which the government cannot exert its power. And this is how, through the *aghels'* fault, it has no longer been able to serve them. . . .

[The report goes on to describe how at first the tribes put up with the *aghels'* failure to pay

them their dues. Then, in 1856, the Fedaans pillaged a caravan and in 1858 the Sba'as robbed another. In 1859 a very large caravan completely disappeared. This greatly upset the merchants, and the *aghels* had, since then, been trying unsuccessfully to patch things up.

Count Léon de Perthuis, representing the Compagnie ottomane de la route de Beyrouth à Damas (see IV, Introduction), had been trying to negotiate a transdesert service.]

14

Government Steamers on Tigris, 1904

I have the honour to report that a telegram has been received from Constantinople by Commodore Yakub Bey, Director of the Oman Ottoman Company, informing him that the Seniye Department (Sultan's Civil List) has purchased the River steamers plant & property, belonging to that Company, & instructing him to place Sassoon Effendi Eskell, the newly appointed Manager of the Seniye steamers in position.

The construction of the two Seniye steamers & four barges, which were landed here in pieces in the summer, is proceeding rapidly. The first vessel will shortly be towed out of dock & completed in the river & is expected to be ready for trial early in March. One barge is also nearly ready for launching.

The new steamers are 210 feet long, 33 feet in the beam, & 6 ft. 6 inches deep. Their draught when carrying a full cargo, 230 tons & 250 passengers, will be four feet six inches.

They are made of the best Siemen Martin's steel, & fitted with electric light & searchlight at the foremast, which will give them a great advantage in river navigation. They have steam heaters throughout.

Each vessel is fitted with two sets of diagonal compound engines, having a coupling in the centre of the shaft, so that they can get disconnected and so arranged that one engine may go ahead while the other goes astern. Each vessel has twin boilers bearing a pressure of 140 pounds to the square inch. The cylinders are 19 inches & 38 inches & 45 inches stroke, & the wheels are of the feathering float type.

The maximum speed of these vessels will be 12 knots per hour and their bunker capacity 45 tons. They will average 10 knots per hour & it is estimated that they ought to reduce the voyage to Baghdad by at least 24 hours.

The four barges are 180 feet long, 25 feet beam, & 5 ft. 6 inches deep. Their loaded draught is 3 ft. 6 inc. & they have a carrying capacity of 265 tons.

It will be seen from the above particulars that the new vessels are first-class modern boats and in every way superior to anything Messrs. Lynch Bros. have now on the river. They surpass the latter in speed & almost double them in carrying capacity, as steamer & barge combined will carry 495 tons as against the 250–300 tons carried by the Mejidie & Khalifah. They are moreover fitted with electric light & searchlight which will give them

From Crow to O'Conor, 20 January 1904, FO 78/5461.

an immense advantage in the tortuous navigation of the river. Lynch's steamers at present only travel at night when there is a moon.

It is evident that the amalgation of the Seniye Steamers with the Oman Ottoman Line, which has now four vessels, the Mosul, Frat, Resafa & Bagdadi, though the last is practically derelict, will present a most formidable combination against Messrs Lynch's Company, & the latter will soon have to fight for its very existence on the river. The Seniye can work 6 boats against their two, and the right of Messrs Lynch to supplement their weekly carrying capacity with a barge, is not unequivocal, and may be called in question at any moment. The Seniye will therefore be able to have two boats always ahead of Lynch's weekly steamer. This is an important consideration in view of the narrowness and incompleteness of the channel and the total inadequacy of the Custom House Wharf at Baghdad, which is too small to berth more than one vessel at a time. Lynch's steamer will probably incur serious delay and their traffic arrangements must necessarily suffer.

At the same time we may anticipate a considerable reduction in the rate of freight from Basrah to Baghdad. Freights are now 35 shillings per ton by the Oman Ottoman Line. The present cost of freight from Basrah to London is 35 shillings, and at one period last year it fell as low as 15 shillings but the three principal companies combined to raise the price. The new element about to be introduced into the competition for the carrying traffic of the river will no doubt be of great public utility.

15

Navigability of Euphrates and Tigris, 1905

. . . Colonel Tweedie, in a report on his journey in Turkish Arabia in 1887, assigns three causes which militate against the navigation of the Euphrates.

1st. The river is affected over its whole course by the fact that unlike the Tigris, it has few affluents. After emerging from the Armenian mountains the only supplementary water it receives during 800 miles of its course is that derived from the Bitikh and Khabour on its left bank and from two smaller streams on its right bank.

2nd. On entering the alluvial deposit of Irak its low and uncared for banks constantly incline it to leave its bed and flow off to the right or west, where large tracts are below its ordinary level. The river at times almost wholly loses itself in the Chaldean marshes—From 350 yards wide at Hit it contracts to 200 yards at Hilla, 185 miles lower down. The river bifurcates a little below Musaiyib, at the head of the modern Hindia canal, and the Government are unable to keep the Hilla branch navigable and this channel runs dry in the low water season.

3rd. The obstruction caused by the methods of irrigation in vogue along its banks affects the medial portion of the river. The running dams of solid masonry, projecting in places from both banks right athwart its bed in order to raise the level of the stream, are a great impediment to navigation.

Colonel Tweedie also states that permanent flooding of the river is caused by the

From Crow to O'Conor, 13 October 1905, FO 195/2188.

melting snows and begins in March and increases to the end of May, when the stream is at its highest. The river remains high for 30 or 40 days and then decreases daily. It is at its lowest from mid-September to mid-October. It increases till December and is then checked by the frost and falls. The course of the river and features of the country are subject to constant fluctuation. Between Hit and Faluja, at the head of the canal system, the right banks are high and no great change is possible, but lower down everything depends on the care bestowed on the artificial embankments of the stream. When the Euphrates breaks through at Faluja and fills the Saglawiya canal, the whole country west of Baghdad is submerged and still greater flooding occurs near Musaiyib, at the head of the Hindia canal. The preservation of the embankments at the point of bifurcation demands constant care. The object should be to allow sufficient water to drain west for the due irrigation of the lands of the Khazail Arabs below Nejef, while the Hilla bed should retain the main volume of the stream and be made navigable to the sea. But it frequently happens that the barrage at the head of the Hindia canal is carried away and, a free channel being opened, the Hilla branch shoals.

The floods on the desert to the west of Basra due, I am informed, to the overflow of the Euphrates, were more severe and more prolonged than usual this year. The waste of water is enormous and the surface covered appeared larger that usual. This was probably due to the severe winter and the increase of snow. On such occasions the only communication with Zobeir is by sailing boat or native ''bellem'' of very light draught. I am informed that the Turks have already spent about 70,000 Turkish pounds on the Hindia barrage but the work seems quite inadequate for the purpose.

The Euphrates enters its delta at Hit where bitumen, sulphur and naphtha springs are abundant and there are good limestone quarries and earth for pottery. Faluja is 80 miles below Hit. The Saglawiya canal terminates $5\frac{3}{4}$ miles above Faluja and starts 5 miles below Baghdad. It has a tortuous course of 45 miles.

The following diagram [omitted] and information taken from the Persian Gulf Gazetteer, now in course of publication, shows how the present canal system affects the river.

The Husainiya canal leaves the Euphrates 2 miles below Musaiyib on the right. Just below this point a former loop of the river, Shatul Atik starts from the left. The river bifurcates 3 miles below the Husainiya canal. To the west is the Hindia canal and to the East the Shatt ul Hilla. About a mile below the point of bifurcation the Shatt ul Atik rejoins the Shatt ul Hilla from the left. The Hindia canal is crossed by a weir or barrage 230 metres long, a short distance below its mouth with an opening in the middle 20 metres wide, where there is no masonry wall overlying the pitching. The Hindia canal carries off practically all the water from the Euphrates. The Shatt ul Hilla is nearly dry and the Shatt ul Atik entirely so. Most of the land enclosed between the Euphrates and the Shatt ul Atik belongs to the Seniye Department. The Daghara canal leaves the river 35 miles below Hilla on the left. The unabsorbed portion of the water drawn off by the Hindia canal flows back into the Euphrates near Samawa, by a channel called Atshan, which issues from the Bahr el Nejef and enters the river from the right bank. For $2\frac{1}{2}$ months in summer the Shatt ul Hilla is quite dry and in winter is said to carry about $\frac{1}{35}$ of the water of the Euphrates. Near Hilla its bed has shoaled to about 12 feet above its old level and the date gardens round Hilla are said to be in imminent danger from lack of water. Between the head of the Hindia canal and Samawa the Euphrates is, owing to the diversion of the water, practically nonexistent, except in the season of the highest flood. The true Euphrates of today is the Hindia canal.

According to Sir William Willcocks, the Euphrates, in its present condition, is navigable from Kurna to Samawa and up the Hindia canal to the barrage for boats drawing 1 metre, throughout the year. From the Hindia barrage, past Musayib and Faluja to Hit navigation is open all the year round to native boats drawing 1.25 metres.

The Tigris enters its delta at Beled about 100 miles north of Baghdad near the ancient weirs of Opis. The Nahrwan and the Dedjil canals drew their water from above these weirs. The ruin of the old irrigation system was due to the Tigris changing its course and the destruction of the weirs. From Beled to Baghdad, 110 kilometres, the strong current renders navigation by sailing boats impossible. Baghdad to Kurna, where the Tigris and Euphrates join, is 740 kilometres; Kurna to Basra 60 kilometres and thence to the bar below Fao 100 kilometres. At Baghdad the river has been known to rise 4 metres a day.

From Baghdad to Kut, 340 kilometres, the river is 300 to 400 metres wide, and its trough about 5.75 metres deep, down to the level of low water. A flood of 6 metres puts the country under 25 centimetres of water, except where it is protected by dykes. The Jeraf el Rogad, Kusseyba, Selman Pak (Ctesiphon) Seyyafiya, Sheresh and Mehdi reaches were all bad in 1904. In the Jeraf el Rogad and Mehdi reaches the water ran in such narrow channels that it was extremely difficult for a steamer and barge to pass. At Kut the Hai canal takes off the right bank of the river and flows due south to the Euphrates. Between Kut and Amara, 260 kilometres, the width of the river decreases from 300 to 200 metres. The reaches are fairly good with the exception of the El Umdug and Seyyed Abbass. At Kut the trough of the river is about 5 metres deep, low water level and decreases downstream. Steamers cannot go alongside at Kut, either opposite the Custom House or Lynch's coal depot, as there is too little water. They have to anchor on the far side of the reach. At Ali Gharbi the trough of the river is 2.50 metres deep and flooding is frequent. At Ali Sharki it is 1.50 metres deep and at Amara 1.25 metres deep. Between Ali Gharbi and Amara numerous overflows and breaches carry off the surplus waters of the Tigris to the swamps between the Tigris and the Hai canal on the right bank of the river. Near Amara to the East the Jehalla or Hidd canal takes off half or more of the volume of water. This canal is about 100 yards wide at its mouth and extends about 15 miles to the East, where it spreads over the marshes and is lost. From Amara to Kalat Salih the river is narrow and winding but the water is deep. There are large breaches and overflows and many canals, which take off a considerable quantity of water. The marshes proper begin at Kalat Salih and the innumerable small canals dug for irrigation purposes contribute to lessen the volume of water and reduce the width of the river to 40 or 50 metres, while the navigable channel is much less. The marshes extend to Kurna but from Ezra's tomb to Kurna the river is much wider and deeper, owing to the water flowing in again from the marshes. Its width increases to 125 metres and its depth is 3 to 4 metres. At Kurna the trough of the river is about 2.50 metres deep, low water level. There are three pontoon bridges across the river between Baghdad and Basra, namely at Garrara, Kut and Amara. The two last are a constant source of danger to safe navigation. The bridge at Kut is not opened sufficiently wide and that at Amara is round a bend and not visible until the ship is close to it and, then, owing to the lights of the town, it is very hard to distinguish whether it is open or not.

In its present condition the Tigris is navigable for steamers and boats drawing from 1 metre to 1.25 metres throughout the year. It is used by 11 steamers including the Comet, the Turkish Gunboat Alus, Lynch's and the Hamidieh boats and many sailing craft, but considerable skill is needed to steer the steamers through the narrow passages and devil's

elbows, which abound between Kalat Salih and Ezra's tomb—In November 1904 the condition of the Tigris was better than it had been for some years. This improvement was not due to any decrease in the fall of the water during the summer but to the existence of better channels and crossings. These were caused by the formation of many islands and sand banks in the bad reaches, which confined the water to a narrower channel and so raked it out better and deeper.

As remarked by Colonel Tweedie, the Tigris affords a fine study of how a vast river will comport itself when allowed to play the prodigal.

16

German Views on Baghdad Railway, 1902

After a short introduction, the pamphlet is divided into three main sections, viz.:

1. Political considerations.
2. The economic basis of the scheme.
3. The route and the districts traversed by the Bagdad Railway. . . .

II. The Economic Basis of the Scheme

The cost of construction of the railway has been calculated at an average of nearly 10,000*l.* per kilom, including inevitable "expenses" peculiar to the East. To provide interest on this an annual revenue of 600*l.* per kilom, would be required, whereas not more than 200*l.* of receipts can at first be counted upon. The Turkish Government would therefore have to provide in the beginning at least 600,000*l.* a year for kilometric guarantee, but could easily do so if allowed to raise the rate of customs duties to 15 percent. *ad valorem.* This, however, will improve as time goes on. Upon the opening of the railway will follow an increase both of population and of revenue. The railway will only pay when the countries through which it passes have again attained the prosperity they possessed in ancient times. As soon as the economic effects of the railway have reached their full development, Anatolia, Northern Syria, Mesopotamia, and the Irak will be able together to export as much grain as the whole of Russia does to-day.

Among the developments to be expected is a large increase in the cultivation of cotton. North-western Mesopotamia and the neighbouring parts of Syria were in ancient times one of the most important centres of cotton cultivation. Climate and soil are still the same, and it is only insecurity and want of communications which now prevent this, or indeed any cultivation. The revival must be initiated by foreign capital, by means of Plantation Companies which would rent large tracts of land from the Turkish Government, either to sub-let to small farmers or to work themselves with native labour. If German enterprise should succeed in meeting the greater part of the German demand for raw cotton from Mesopotamia instead of importing that article from America, it would be

Inclosure in No. 66. Summary of a Pamphlet by Dr. Paul Rohrbach Respecting the Baghdad Railway, dated January 18, 1902 (FO 424/205).

at the same time creating a market for German industrial products; and Germany would have a right to claim preferential treatment for her wares in a country she had opened up and developed by her own capital.

Another source of wealth in the regions traversed by the Bagdad Railway are the naphtha springs, which extend in a broad zone from the Iranian foothills across the Euphrates and Tigris to the Arabian desert. The towns of Kerkuk, Tekrit on the Tigris, and Hit on the Euphrates, belong to this belt. The naphtha springs at Kerkuk and the escape of natural gas in the neighbourhood exceed in volume the similar phenomena observed in the vicinity of Baku before boring was commenced. The only thing to be feared is that foreign speculators may succeed in securing the right to exploit Mesopotamian naphtha before the monopoly can be obtained for Germany. The naphtha question is the more important as there are but few indications of coal on the route of the railway, the only promising field being in the neighbourhood of Eregli, north-west of the passes of the Cilician Taurus.

The great wealth of Mesopotamia and Babylonia will, however, lie in the future, as it did in the past, in the production of grain. Two regions can be distinguished, a northern one in which the rainfall suffices for cultivation, and a southern one in which irrigation is necessary. (On the map attached to the pamphlet the former is indicated by vertical, the latter by horizontal, red lines.) It was so in ancient times also, and all investigations prove that nothing has altered in external natural conditions since those days which would render a return to the former prosperity of the country impossible. Although a large part of the rainfall region is at present desert, it is not necessarily so, as nomadic Arabs often grow small crops of barley there for their horses. With settled conditions the whole of the zone could again be brought under cultivation.

In the irrigation region the conditions are more difficult, but at the same time more promising. The rainfall ceases to suffice for cultivation about the latitude of Kerkuk, and the whole of the sawad, or "black earth," formed by the deposits of the rivers requires irrigation. More than two-thirds of this area, however, have, by over a thousand years of neglect, been reduced to such a condition that only very extensive and costly works could remove the evil. Of the remaining third only a fraction is at present under cultivation, but here European capital could be well employed in irrigation works. The former region, the reclaiming of which would probably have to be deferred for a generation after the Bagdad Railway is completed, includes the marshy districts between the Tigris and the Iranian foot-hills below Kut-el-Amara, and on both sides of the Euphrates from Babylon to Bussorah, also the whole country between the rivers south of Babylon and the broad marshes on both sides of the Shatt-el-Arab. The areas which could at once be dealt with are:

1. The land between the rivers from Feludja to the ruins of Kufa on the Euphrates, and from Samarra to Kut-el-Amarra on the Tigris.

2. The land on the left bank of the Tigris from Tekrit to Bagdad.

3. The ancient irrigation area of the Nihrwan Canal and the Dijala.

For these three areas about 700 kilom. of irrigation canals would be required, which would cost from 1,250,000*l*. to 1,500,000*l*. There is little reason to doubt that irrigation works would yield a profitable return. It can be shown that in the days of Haroun-al-Rashid, about 800 A.D., the population of Mesopotamia was 6,000,000, whereas it is now only 1,500,000. Again, there are records extant of the amount of land tax paid to King Chosru 1 [*sic*] dollar in the sixth century, from which it can be deduced that the grain production of Mesopotamia must at that time have exceeded 10,000,000 tons. This

amount would suffice to feed from 25,000,000 to 30,000,000 people, and if the same figure could again be reached, at least two-thirds of the crop would be available for exportation, even allowing for an increase of the population up to its former level. If a foreign Irrigation Company took the whole matter in hand, it could take payment in kind up to one-fifth or one-quarter of the crop, pay off the Government tithes, and have a margin left which would amply repay the capital outlay. In the districts served by the existing railways in Anatolia a considerable impetus has already been given to agriculture, and the tithes have shown a notable increase. [See *EHT*, p. 193.]

Both the Bagdad Railway itself and the development of the districts through which it will pass are undertakings on a very large scale, from participation in which it would neither be wise nor possible to attempt to exclude non-German capital. There can be no question of creating in any part of the Turkish Empire a field of monopoly for German industry and German influence, and this not only for political, but also for economic reasons.

III. The Route of the Bagdad Railway and the Districts It Will Traverse

The total length of the line from Haidar–Pasha to Koweit will be about 2,500 kilom. (1,550 miles), and it naturally divides itself into five distinct sections:

1. From the Bosphorus to the foot of the Cilician Taurus.
2. From the Taurus to the Upper Euphrates.
3. From the Euphrates to the commencement of the Babylonian Plain below Tekrit.
4. From the latter point to Bussorah on the Shatt-el-Arab.
5. From Bussorah to Koweit.

As regards the first section, the route to the Euphrates via Koniah was not the one originally planned. The first project of a line via Sivas, Kharput, and Diarbekir was, however, relinquished not on political grounds only, but because it would have been quite 200 kilom. longer, and would have encountered great engineering difficulties. The Turkish Government would have preferred the northern route as being of greater strategic value, but the sums required for kilometric guarantee would have been much larger.

The second section is by far the most difficult, and will probably involve the construction of a tunnel several kilometres in length. Curiously enough the Sultan insists in a most decided manner that the railway shall nowhere approach to within less than half a day's march from the coast, for fear of its being attacked from the sea. The Company, however, have maintained their demand to touch Adana, whence an English railway leads to the port of Mersina.

From Jerablus (somewhat south of Birjik on the Euphrates) onwards there are no further serious technical difficulties. It was originally intended to take the line via Urfa, but later it was decided to go straight via Nisibis through the desert to Mosul. The principal reason for this change was doubtless the saving in expense, but it can also be maintained that it is better to go through the very middle of the country, now a desert, which it is hoped that the railway will restore to cultivation. On the whole line from Jerablus to Bussorah there is hardly a single kilometre which cannot be made fertile or has not a promising future in other ways, and there are no engineering difficulties beyond a few marshy tracts of very small extent and the great bridge over the Lower Euphrates.

It is not probable that the connection between Adana and Mersina will suffice for the requirements of the railway, and another outlet to the Mediterranean will have to be sought, possibly at Seleucia, the ancient port of Antioch. The natural route of the trade of

the river basins of the Euphrates and Tigris, towards the west, is the valley of the Orontes, and that part of Northern Syria was formerly most prosperous; indeed, if only German, and not also Turkish, interests were involved, the section between Koniah and the Cilician Plain could be omitted. Two reasons, however, make the completion of the Anatolian line necessary, viz., Turkish military requirements, and the rapid mail route to India.

The whole district from Urfa to beyond Mosul is at present devastated by the Kurdish Hamidieh of the "Generals" Ibrahim and Mustapha, but the railway will doubtless put an end at once and for good to their outrages.

A matter of special interest in regard to the Bagdad Railway is the question of the point where it will reach the Persian Gulf. To enter Persian territory would involve negotiations with another Government; moreover, Muhammerah, as well as Bussorah, is within the bar of the Shatt-el-Arab, and, therefore, not approachable by large ocean steamers. Koweit, on the Arabian coast, offers an excellent and well-known harbour, but it has been said that England has designs upon this place. If Koweit were really to be withdrawn from Turkish suzerainty, and brought within the British sphere of power, this would constitute a severe blow to both European and Turkish interests.

So far as German economic interests are concerned, and even regarding the military requirements of Turkey also, it might be as well not to connect the Bagdad Railway with the Persian Gulf. When the railway is finished to Bagdad, the Syrian ports would be able to compete successfully with Bussorah and Koweit in the export and import trade of Mesopotamia, and a good harbour on the Gulf of Alexandretta will be far easier to obtain than one at the mouth of the Shatt-el-Arab. The Persian Gulf will probably remain under the control of England, and, perhaps, shortly of Russia also, and a German naval station in those waters would arouse much international jealousy. It is most important to prevent England from acquiring Koweit. If she is allowed to do so, she will have obtained control of the third, shortest also, and most rapid route to India and South-Eastern Asia, and will be able to close and open it as she pleases. The Russians, moreover, are slowly advancing through Persia, and if England takes Koweit, they would no doubt retaliate by occupying Bushire or Bunder Abbas. If, however, these two Great Powers establish themselves with large fleets and fortified harbours on the line of the future new road to India, then the influence that Germany could exert on the development of the trade route created by the Bagdad Railway would be far less than if the neutrality of the Gulf could be secured, and the straits of Ormuz kept open for the trade of all nations.

17

Baghdad Railway: British Interests and Views, 1907

. . . British commercial interests in Turkish Arabia predominate over those of every other European country and are as follows:

1. 96 percent of the shipping of the port of Basra.
2. A very large proportion of the export trade, which is carried either direct to the United Kingdom or to other countries in British ships.
3. About 60 percent of the imports, consisting chiefly of British, Indian and Colonial manufactured goods and products.
4. The annual pilgrimage of British subjects and British protected subjects to the Shia shrines. The number of passengers from India and Europe, chiefly pilgrims, who passed through the Lazaretto in 1905 was 11,535.
5. About one-fourth of the river transport from Basra to Bagdad and vice-versa, as represented by the two steamers of the Tigris and Euphrates S.N. Company (agents Messrs Lynch Bros.)

In view of present disabilities, such as the bar difficulty, the impediments to river navigation and what is practically a Turkish river monopoly, British import trade both to the internal towns of Turkey and in transit to Persia would, I think, if assured of commercial fair play, benefit by the Bagdad railway and expand, whether we participate in its construction or not. But as the line starts from Constantinople and connects there with the Central and Eastern European railway systems, it will undoubtedly favour the trade of Eastern and Central Europe and react to our prejudice in those directions. To enable us, therefore, to hold our own with advantage against the competition of land-borne traffic we require increased facilities for our water-borne trade, such as the removal of mitigation of some of the disabilities which now hamper it. If this were done the Bagdad railway would, I think, to some extent, benefit our trade inland from the Persian Gulf and aid its development. A terminus, accessible to ocean steamers, would remove the congestion, which occurs annually when the river falls and obviate the obstruction of the bar at the estuary of the Shatt-ul-Arab, which now strangles our trade at the neck. The line would of course serve to develop new areas of cultivation and our water-borne trade, now artificially cramped and confined, would, unless repulsed by some undue preferential treatment of our rivals, or otherwise interfered with, take its share of the returning prosperity of the country. Composition [competition] between the rail and river transport would undoubtedly have the effect of lowering freight rates from Basra to Bagdad and vice-versa, which are now exorbitant but, as the German Company by Article IX of their Concession, obtains navigating rights on the river during the construction of the line, it seems improbable that, after acquiring the necessary plant and establishing wharves and warehouses at Bagdad and Basra, it will relinquish entirely the advantages of navigation. It may thus acquire complete control of the traffic by water as well as by land. And, in that

From Crow to Barclay, 8 January 1907, FO 195/2242.

case, the present British interest in the carrying trade of the river, which does not exceed one-fourth of the whole, would not appear to have much prospect of further development.

The Germans no doubt calculate, not only that new trade will be developed, but that the course of present trade will be altered. It is expected that British vessels will cease to be the chief medium between Europe and the East, and that passenger traffic with India will be almost absorbed by the Bagdad railway. Kathima, Koweit, Umm-Kasr or Warba would be ten days from Berlin and three and a half or four from Constantinople by the railway. A terminus at any one of these points would be from four to five days steaming from Bombay. The Bagdad railway Company will control the railways, not only of Asia-Minor and Mesopotamia, but also of Syria and Northern Arabia, and the Syrian railway system, now completed as far as Aleppo, will, no doubt, ultimately pass into its hands, as being the more powerful combination. With these advantages it is not unlikely that the course of trade will be deflected and that markets, hitherto supplied from the South and the Persian Gulf, will eventually be inundated with the manufactures of Central and Eastern Europe and that these, encouraged by preferential treatment, will be in a position to supplant sea-borne British goods. In this connection Clause XXIX of the Concession has a sinister significance, for it restricts the opening of the Persian Gulf sections until the trunk line from Konia to Bagdad is open and working. The rights conferred on the Company by other Articles of the concession are of a nature to assure it a monopoly of the economic exploitation of the country through which the line passes, and it is not improbable that British interests will be excluded from participating in the profits of any such development.

As regards the export trade of the districts under consideration, which consists principally of cereals, dates, horses, liquorice, wool, hides, opium, gall-nuts, etc. I do not see that our interests are likely to be seriously affected by the railway. Grain cultivated in regions adjacent to the Tigris and Euphrates, which are situated at a considerable distance from the proposed alignment of the railway, will continue to find its way down the river to Basra, where it is shipped in bulk with comparatively little trouble. Dates, grown in gardens on the river banks, are packed on the spot and placed on board steamers, moored opposite the gardens, which entails a minimum of time and labour. These require no railway to facilitate their export. The horse trade of Bagdad and the surrounding country will benefit by the facilities of the railway transport and will, no doubt, travel direct to the Gulf terminus for shipment to India at less cost than hitherto. Wool, which is now sent from Amara and Suk-es-Shiyukh to Bagdad for pressing, previous to being exported to Europe, will be transported by rail. New areas of cultivation opened under the auspices of the railway will naturally benefit by it and the price of cereals may fall in consequence, which will be to the general advantage.

But, commercial considerations apart, the Bagdad railway has a purely political bearing which deserves examination. British interests in the scheme centre in the Mesopotamian delta and those interests, political as well as commercial, date back as far as 1639, when an English factory was first established at Basra. If the line is built entirely without British participation, our political standing and ascendency, which have been undisputed and predominant over those of every other foreign nation for more than two and a half centuries, will be eclipsed and must disappear, and a legitimate field of political and commercial development will be definitely closed against us. Commercial interests gradually assume political importance in weak States, and the Power which controls the railway will also control the country, by reason of the very nature of the enterprise, which will require adequate protection if the line of communication is to be kept open. German

military police will be as indispensable for the protection of the line in Mesopotamia as Cossacks were for the Manchurian railway. The country is now without a Government in any reasonable sense of the term. The authority of the Turk is limited to a few towns and their immediate neighbourhood, and the Arab tribes are in a chronic state of revolt. The Kurds and Hamidieh cavalry regiments harry the population, Christian and Mussulman alike, with impunity, in Northern Mesopotamia and Mustapha Pasha is said to have established a reign of terror from Diarbekir to Mosul. On the Bagdad Nedjef Zobeir sections of the railway the Montifik Arabs hold the key of the situation and will have to be considered. The civilising influence of the railway must help to restore some measure of order and security in these places, where Turkish misgovernment does nothing but exasperate a semibarbarous people and encourages lawlessness by breaking faith with Arab tribesmen and subjecting them to the caprice and exactions of irresponsible and corrupt officials. German influence will permeate these regions and, stimulated by the cheapness of German manufactures, a current of feeling may set in, hostile if not directly antagonistic, to British interests. These would perhaps be best served if we undertook the task of making some portion of the railway ourselves and if we controlled and managed the Southern sections of the line from Bagdad to Basra and the Persian Gulf, as well as the branch line to Khanikin on the Persian frontier. . . .

18

Shipping in Basra and the Persian Gulf, 1864–1910

[With the foundation of the British India Steam Navigation Company in 1864—see *EHI*, pp. 165–170] the basis was first laid for the stimulation of commercial activity in the Persian Gulf and, finally, for the transfer to the latter of the bulk of trade relations between Europe and Persia and Iraq; contributing factors were the last Russo-Turkish war of 1877–1878, which turned traffic away from the Trebizond–Erzurum route followed by the closing of Transcaucasian transit. [See *EHI*, pp. 92–116, *EHT*, pp. 120–128.]

With the growth of the commercial significance of the gulf and the redirection of traffic to it, the above-mentioned Anglo-Indian company's steamers were no longer sufficient, and soon after, the "Bombay and Persian Gulf Steam Navigation Company" was founded, but direct connections with the ports of western Europe were required. Already in 1887 new steamship companies appeared in the Persian Gulf, the "Persian Gulf Steam Navigation Company," which had direct services between England and the ports of the gulf, and "*Mennier et Cie*," which linked Marseilles with those ports.

Connections between the rest of Europe and the Persian Gulf and Arabian Iraq was partly achieved through the above-mentioned English and French companies—with goods going to London or Marseilles—and partly through the Indian ports of Bombay and Karachi, where they were forwarded by Indian steamship companies to their designated

From Aleksandr Adamov, *Irak Arabskii*, St. Petersburg, 1912, pp. 473–479.

Table 18.1

	1887–1891	1892–1896	1897–1901	1902–1906	1906–1910
Steamships					
Number	110	125	111	153	191
Tonnage	113,365	143,885	131,455	180,400	217,345
Sailing ships					
Number	603	620	566	597	422
Tonnage	40,135	33,260	29,500	33,980	23,175

destinations. Shipping in the Persian Gulf increased from year to year, and already in 1890 a new English company was added to the ones mentioned above, "Gray, Dawes and Co.," which made a voyage every month from London, via Karachi and Bombay. In 1893 the "Anglo-Arabian and Persian Co." began its service, in 1894 the "Clan Line," and in 1895 the "British and Colonial Steam Navigation Co." In 1896 the French company "Messageries Maritimes" joined them, while in 1888 "Mennier et Cie" had ceased to exist. The result was that the growth of shipping in the gulf outstripped to a considerable extent the development of trade, especially exports, for very soon a shortage of return cargo made itself felt and several lines, including the "Messageries Maritimes," discontinued their service to the Persian Gulf ports. Table 18.1 gives an overall picture of steam and sail traffic in the Port of Basra in the last 25 years, from 1887 to 1910.

These figures shows clearly that the dip in the growth of traffic in the gulf at the end of the last century was overcome in this one, when the rapid increase in trade provided cargo not only for existing lines but also for new ones. In 1910 there were eight steamship lines serving the gulf.

A. English Lines

I. From India

(a) "British India Steam Navigation Co.", subsidized by the government to carry mails and nowadays providing two services: one, since 1904 weekly, rapid service for postal connections between the main gulf ports (i.e., Masqat, Bushire, and Basra) and the other a circular one, serving both shores of the gulf.

(b) "Bombay and Persian Steam Navigation Co.", established by Indian merchants and providing a fortnightly service to the gulf ports.

II. From England

(a) "Anglo-Arabian and Persian Steamship Co." or, more briefly, "Strick Line," founded in 1893 and providing a monthly service with a stop at Marseilles.

(b) "British and Colonial Steam Navigation Co.", otherwise known as "Bucknall Steam Navigation Co.", established in 1895.

(c) "West Hartlepool Line," which started its runs to the gulf ports only in 1902.

B. Non-English Lines

I. "Russian Steamship and Commercial Company," established in 1901, with a service to the gulf four times a year.

II. "Hamburg–Amerika Line," which inaugurated its monthly service to the gulf in the autumn of 1906 and since then has sharply increased its activity as the following figures on total annual voyages show: 1906—4; 1907—12, 1908—11, 1909—9, and 1910—12. The Basra agent of this German company is the firm "Robert Wönchkhaus and Co." [See *EHME*, pp. 351–355.]

III. "Austrian Lloyd." It started its runs to the gulf as early as 1897 but only on an irregular basis; the designation of a special agent in Basra and Baghdad, in the person of the firm "Société Anonyme de Commerce Austro-Orientale," established in Iraq shows, however, the desire of the Austro-Hungarian government to put this business on a more solid basis.

The appearance of western European shipping firms in the gulf broke the monopoly of English ships. Whereas in 1900 the number of steamers under British flag constituted 96 percent of gulf shipping, by 1909, as against 138 English steamers entering Basra there were 24 non-English and in 1910 28 compared to 174.

Along with the growth in foreign shipping enterprise, connections between European mercantile centers and the ports of the gulf increased and so did competition in freight rates. Even at the time of the exclusive predominance of the British, commercial flag steamship companies often engaged in a struggle to secure cargo and reduced freights; the appearance of foreign steamship companies in the gulf had a more powerful impact on freight rates to and from European ports and the gulf. At a time when the usual freight rate charged by English steamers for transport from Manchester to Basra was £1 15 shillings a ton, and from Belgian ports not less than £1, the new German line lowered it to £1 from English ports and correspondingly reduced freights for exports from Arabian Iraq. Thus in 1908 freights to London fell to 12 shillings 6 pence, and even in the busy season the transport of dates did not cost over £1; in 1910 a special agreement among all English steamship companies was required to maintain freights during the date season at £1-7-6 per ton, although as recently as 1904 such a figure had been below that charged for such an unremunerative cargo as grain.

Along with steamers, sailing ships also carry the merchandise of the gulf. They sail under various flags, ranging from Turkish and Persian to British and French, the latter belonging to the port of Sur, near Masqat. These ships come to Basra for dates and grain, bringing various goods: the Indian charcoal, wood, and kerosene; those from Zanzibar, timber for construction of ships; those from Masqat, dried fish, lemons, etc.; and those from the gulf itself carry flour, mats, vegetables; only those from the Red Sea usually come in ballast. The tonnage of the sailing ships varies greatly, and one occasionally sees some exceeding 300 tons, but usually those entering Basra are small boats, of not over 100 tons. The development of steam navigation leaves less and less work for the sailing ships and, since the beginning of this century, the number entering the Port of Basra has fallen significantly, as may be seen from the table given earlier.

All this huge commercial fleet, both steam and sail, tirelessly brings to Basra all possible kinds of foreign goods: raw materials, semimanufactured and manufactured articles, which, together with the no less significant exports, pass through that port overseas. This gives Basra the possibility to take a very prominent part in the trade of the gulf, among whose ports it may justly be included because of the navigability of the Shatt al-Arab by seagoing ships. According to Whigham's estimates,[1] in 1901 Basra accounted for 32 percent of the gulf's trade, compared to 24 percent for Bushire, 6 percent for Bandar Abbas, and not over 4.5 for Muhammarah [Khorramshar].

The first place Basra occupies among the gulf's ports in its trade cannot be attributed to the greater convenience it affords, compared to the others. It is true that, in the shallow waters of Bushire and Bandar Abbas, ships unload a mile or a mile and a half offshore, but access to the Shatt al-Arab river, on which Basra is situated, is greatly

[1]H. J. Whigham, *The Persian Problem*, London, 1903, p. 147.

restricted by a bar where only at the full moon and new moon is there enough water to allow access to fully loaded vessels. Hence, to avoid delay and loss of time, ships use steam lighters for unloading on arrival at the Shatt al-Arab and for loading on leaving it. In 1907 there were six lighters, of which five carry the British flag, and which are always necessary. Moreover, as regards additional expenses on cargo, such as fees for carrying them to the customs house, Basra does not enjoy any advantages over other ports, for here too ships cannot moor in the immediate vicinity of the customs house. The unsatisfactory condition of the transport of goods from on board ship to the customs warehouse in Basra leaves much to be desired, especially in that the manager in charge, the *hammal-bashi*— that is, the contractor chosen by the merchants with the assistance of the customs authorities—is responsible for neither the loss nor the spoilage of goods. At the same time the *hammal-bashi* gets a very high remuneration for the transport of goods, viz. 20 kopeks for every chest of tea, 30–40 kopeks per bale of jute, 40–50 per bale of textiles, 10 kopeks per crate of kerosene; in other words, for delivery from the steamer to the customs house and its transport to the warehouses of the latter the contractor takes on each article 10–50 kopeks. Only goods addressed directly to Baghdad are transferred straight from the seagoing steamers to the agents of the riverboats, but this operation costs the recipients of the goods about 1 ruble 20 kopeks per ton. Should the goods be unloaded in Basra and later on forwarded to Baghdad, the above-mentioned expenses double. Among the expenses is the *ardiya,* or warehouse duty, levied on goods lying in the customs ware- houses more than eight days; on average, this duty amounts to 10–30 *paras,* or 20–60 kopeks, per day per place, but for bulky objects it is two to four times higher, depending on their volume.

From all this it is clear that, with regard to the handling of cargo, Basra is in the same situation as the other ports of the Persian Gulf; it owes its predominant share in gulf trade to the large import of European goods going in transit to western Persia through Arabian Iraq and to the no less large volume of exports sent abroad. Thus all the commer- cial activity passing through Basra consists of the following elements: imports of foreign goods, especially for Arabian Iraq; the transit of such goods to Persia; and the export not only of Iraqi-Mesopotamian but also Persian raw materials. . . .

19

Means of Transportation in Iraq, 1912

. . . *The Shipping on the Tigris.* There are three steamer companies plying on the Shat-el-Arab and the Tigris river between Bassorah and Bagdad, namely, the *Idarie Nahrie* with four steamers, the *Euphrates and Tigris Steam Navigation Company* with three steamers and the *Agha Jaʿafar Line* with four very small steamers. The Idarie Nahrie is owned by the Turkish government, the Euphrates and Tigris Steam Navigation is owned by Lynch Brothers of London and the Agha Jaʿafar Line by Mr. Agha Jaʿafar of Bassorah.

From a memorandum by U.S. Consul in Baghdad, 23 July 1913, emended by letter of 9 August 1913, US GR 84, C8.9, 1913, vol. 5, Classes 810–892.

Table 19.1

Lines	Up river	Down river
Idarie Nahrie	18,856	18,270
E. and T.S. Navigation Co.	28,443	29,546
Agha Ja'afar	4,526	4,091
Total	51,825	51,907

The tonnage of freight carried by these three steamer lines up and down river during the year 1912 was as [in Table 19.1]:

The total tonnage moved by the three lines up river in 1912 was 51,825, which represents the approximate importation into Bagdad from foreign countries during that year. The local cargo and the quantity carried by sailing vessels up river are not important. The number of tons carried down river by the three steamer lines was 51,887, while the exports from Bagdad to foreign countries was only 26,362 tons. A large part of the exports of the districts, particularly grain, is carried as local freight to Bassorah and billed for export there; but the tonnage carried down the rivers which does not enter into the exportation from the districts is not important.

The figures above show that the three Lynch steamers carried more freight than the four Idarie Nahrie steamers. This is due mainly to the fact that the Turkish steamers have too deep a draft, thus putting them to a great disadvantage during the time of low water from July to January. As a result, each Turkish steamer during the low water period is compelled to take on less freight, and besides it requires more time to make the trip between Bagdad and Bassorah. The tonnage carried by the river steamers with barges, the length of time required to make the passage between Bagdad and Bassorah and the cause of delay in the transmission of goods up river was described in an article on the Trade of Mesopotamia Valley, published in the DAILY CONSULAR AND TRADE REPORTS for November 17, 1912, page 1061.

Passenger Service. The Turkish and the Lynch steamers on the Tigris and Shat-el-Arab carried [see Table 19.2] passengers up and down river during the year 1912.

All but a few hundred of the passengers are deck passengers who are carried at a rather low rate, approximately $1.65, without food, between Bagdad and Bassorah.

Moving the Material for the Bagdad Railroad Construction. When plans were started for the construction work on the Bagdad Railroad at Bagdad, it was known that the existing steamship companies with the steamers at their disposal could not handle the additional traffic, especially not during the period of low water. An interesting situation has arisen.

The Railroad Construction Company (Gesellschaft für den Bau von Eisenbahnen in der Türkei), a subsidiary company of Philipp Holzmann and Cie. of Frankfurt on the Main, has a concession from the Turkish government to transport material on the Euphrates and Tigris for the construction of the railroad, but it does not use that right directly.

Table 19.2

Lines	Up river	Down river
Idarie Nahrie	30,240	29,630
E. and T.S. Navigation Co.	17,542	17,421
Agha Ja'afar	3,205	3,809
Total	50,987	50,860

For the purpose of owning the special steamers for carrying the railroad material, another company, the *Société des Transports fluviaux en Orient* was chartered under the laws of Belgium in July 1912. (NEAR EAST). The new company issued 5000 shares of stock of a face value of 500 francs each; 2497 shares are held by each of Lynch Brothers and the Deutsche Bank, and one share is held by each of Messrs. Bloss Lynch, F. W. Perry, Sir. G. A. Nickolson, Karl Helfferich, Otto Riefe and C. A. Bishoff. The first three individuals mentioned are connected with Lynch Brothers, Mr. Helfferich with the Deutsche Bank and Messrs. Riefe and Bishoff with Philipp Holzmann and Cie. The Deutsche Bank furnishes the capital for the building of the railroad and is closely connected with the construction company. The Turkish government is interested in the *Société* to the extent that it will receive the steamers and barges when the railroad is completed. The *Société* is authorized to have five steam tugs and 18 barges for carrying the material for the railroad construction.

Up to this time the *Société* has only one steam tug, the *Sririn,* and two barges ready for use. Until five tugs and 18 barges are at hand, Robert Wönckhaus and Company of Bassorah will act as agents for the transportation of the railroad material from Bassorah to Bagdad. For this purpose, Wönckhaus and Company use their own tug, Pioneer, and 8 barges, the Sririn and two barges belonging to the *Société* and two tugs belonging to the construction company. The actual operation of the two tugs of the construction company as well as of the Pioneer is left to Wönckhaus and Company, while the operation of the Sririn is in the hands of Lynch Brothers.

The object of the *Société* is simply to own the tugs and barges used for transporting the railroad material, while Lynch Brothers through the Euphrates and Tigris Steam Navigation Company will operate them. When the five tugs and 18 barges are at hand, Wönckhaus will drop out, the *Société* will lend the tugs and barges to the railroad construction company and Lynch Brothers will be placed in charge of the operation of the same.

During the year 1912, the bulk of the material for the railroad construction was carried from Bassorah to Bagdad by the three regular steamer lines.

Steamer Service between Bagdad and Samarra, north of Bagdad. The firm Istarabadi of Bagdad runs a steamer on the Tigris regularly from Bagdad to Samarra, carrying both freight and passengers. When the water is good, this steamer makes the passage from Bagdad to Samarra in two days and the return passage, with the stream, in one day. The Agha Ja'afar line also runs a steamer occasionally from Bagdad to Samarra during the time of regular pilgrimage in the autumn.

Steamer Service on the Euphrates. In 1912, Lynch Brothers sent one of their steamers on a trip from Bassorah, up the Euphrates, to Hindia, carrying material for the irrigation works. This passage could be made only with a good deal of difficulty.

Feluja to Meskena. The municipality of Bagdad runs two small steamers, provided with barges, regularly from Feluja, one day's journey from Bagdad, to Meskena, due east of Aleppo. The steamers carry both freight and passengers. The passage up river from Feluja to Meskena is made in 8 to 12 days, and down river between these places in 3 to 5 days. These steamers afford the quickest means of traveling between Aleppo and Bagdad, but during the period of low water, the boats are very liable to get stuck, causing indefinite delay. The cost of passage on these steamers between Feluja and Meskena is $22.00 up stream and $17.60 down stream.

Mossayib to Feluja. The municipality of Bagdad also runs a steamer regularly [between] Feluja and Mossayib, on the Euphrates. The trip up river from Mossayib to

Feluja requires from 3 to 5 days, while the trip down river between these two places requires from one to 3 days.

Sailing Vessels, Kelleks, Shakhturs and Gooffas. Sailing vessels are found in large numbers on the Tigris as far north as Samarra, on the Euphrates as far north as Meskena and on the Diala during the high water season as far north as Bakuba. These carry mainly wood, licorice root, charcoal and matting. Small quantities of petroleum are brought every year from Bassorah to Bagdad in sailing vessels.

For carrying material down to Bagdad from as far north as Diarbekir, the kellek is generally used. This is simply a raft supported by inflated skins. For a raft 16 by 16 feet, 100 skins are required. The kellek with a tent or hut on top is the most convenient means of traveling down stream from Mosul or Diarbekir. It requires from 3 to 8 days to float down the Tigris from Mosul to Bagdad, the length of the time depending upon the height of the water.

On the Euphrates, a large flat boat, called *shakhtur,* is used instead of the kellek. Goods are transported down the Euphrates in shakhturs from beyond Birejik. [See selection 10.]

An extremely useful boat in use here on both rivers is the *gooffa,* which is circular in form, 5 to 12 feet in diameter, and covered on the outside with bitumen. The goofa never capsizes, even in the strongest wind.

Railroads. There are now no steam or electric railroads in operation in the district except those used in the irrigation works at Hindia and the railroad construction work near Bagdad. It is said that the Bagdad Railroad between Bagdad and Samarra will be opened for traffic by January or February, 1914.

There is a horse tramway between West Bagdad and Kasimaine, about five miles long, which is used only for passenger traffic. There is also a horse tramway between Kufa on the Euphrates, and Nedjef, six miles in length, which is used for both passenger and freight traffic.

Carriage Service. There is a regular carriage service between Bagdad and Bakuba, north-east; between West Bagdad and Samarra, north; between Bagdad and Moazzem, six miles north; between West Bagdad and Kerbela, and Nedjef, south-west; and between West Bagdad and Babylon and Hilla. These lines are supported mainly by the heavy pilgrim traffic.

Carriage service can always be obtained in traveling between Bagdad and Aleppo and Bagdad and Mosul, but there is no regular service over these lines.

Caravan Routes. The one important means of transport in the district away from the rivers is the pack animal—mule and camel. Mule and camel caravan routes lead from Bagdad in all directions. In 1912, approximately 53,000 tons of freight was imported into Bagdad from abroad. At least 35,000 tons of this was carried to the surrounding territory supplied by Bagdad importers. This tonnage constituted approximately 71,500 mule loads, 130,000 camel loads and 5000 donkey loads. A camel load is to be taken at 400 to 450 pounds, a mule load at 300 to 320 pounds and a donkey load at 225 pounds. The distribution of this freight took place over the following important caravan routes:

1. *The Kermanshah and Hamadan Route.* This route leads through the towns of Bakuba, Khanikin and Kasri Sherin, entering Persia between Khanikin and Kasri Sherin. Approximately 50,000 camel loads and 40,000 mule loads passed over this route to Kermanshah during the year. 10,000 camel loads more went only as far as Khanikin, and 3000 camel loads more only as far as Kasri Sherin.

2. *Route to Mosul.* There are two routes leading to Mosul, one along the west bank

of the Tigris, through the towns of Kasimaine, Samarra and Tekrit, and the other farther east through the towns of Bakuba, Kerkouk, Altoon Kupri and Erbeel. Over the former, approximately 5000 donkey loads and 7000 camel loads were shipped, while over the latter, 3000 mule loads were shipped.

3. *Route to Suleimanieh Sandjak.* Another important route to the north-east is the one through Kerkouk to Suleimanieh, Dooz Khoormatu and Koi-Sandjak, in Kurdistan. This is one of the best agricultural and grazing districts in the eastern part of Turkey and the trade with this district is increasing steadily. Over this route 17,000 mule loads were shipped, including what was sent to supply the localities of Kerkouk, Altoon Kupri and Erbeel.

4. *Route to Kerbela and Nedjef.* These are the largest cities in the Bagdad vilayet next to Bagdad. Over this route approximately 30,000 camel loads were shipped.

5. *Route to Babylon and Hilla.* This route leads south-west from Bagdad a little south of the route to Kerbela. Over this route 15,000 camel loads were shipped.

6. *Route to Mendali and Bedra,* south-east of Bagdad, near the Persian border. Over this route 10,000 mule loads were shipped.

7. *Route to Nasrieh.* This route leads south from Bagdad, across the Tigris near Cteciphon and then south to the Euphrates about 15,000 camel loads are shipped over this route annually.

8. *Route to Aleppo and Damascus.* This route leads via the Euphrates valley through Feluja, Rumadi, Hit, Dier-el-Zor, where the route to Damascus branches off. The route to Damascus leads through Palmyra and that to Aleppo through Meskena. This route is not important for freight, but it is the most important overland route for passengers. About 4500 mule loads of freight pass over it annually.

20

Gulf Steamer Services, 1914

. . . With a view to consolidate British commercial interests against attack, the shipping companies concerned should be organised so as to render the best and most economical service possible as public carriers. Before the war, the British steamer services between Europe and the Gulf, were carried on by vessels belonging to the following Companies:

(1) Ellerman and Bucknall Lines.
(2) Messrs. Strick & Co.
(3) Messrs. Marcus Samuel & Co.
(4) Messrs. Andrew Weir & Co.
(5) The British India Steam Navigation Company (with transhipment in India for Europe).

At the time when competition commenced from the Hamburg–America Line, the rates demanded by British steamers could not be called excessive, having regard to canal

"The Prospects of British Trade in Mesopotamia and the Persian Gulf," 1919, FO 371/4152.

dues, the price of coal in Basrah and the delay and expense involved in lightering cargo over the Fao bar. On other hand, it was argued that the practical monopoly which the British Lines enjoyed had had a prejudicial effect on their service before the Hamburg–America Line commenced operations. The Vice-Consul at Bushire spoke of the British combine as not paying sufficient attention to the wishes and needs of the local traders and prophesied that if a new line, whether British, Russian or German, came into the trade, it would receive strong support because of the dissatisfaction of the trading community with the existing services. The British steamer sailings were reported to be very irregular and information regarding them very difficult to obtain. Complaints were made of their neglect to cater for the trade to and from Europe at the smaller Gulf and Arab Coast Ports and of their failure to provide space for grain from Bushire when grain was available there for shipment.

6. The shipowner's contentions were briefly as follows:
 (1) that the Mesopotamian and Gulf trade was very limited and by no means easy to handle;
 (2) that from a business point of view the trade did not warrant anything beyond the services rendered;
 (3) that the amount of cargo offering at small Gulf and Arab Coast Ports was not sufficient to justify the extra steaming and delay involved in a call;
 (4) that Bushire, as a grain shipping port, had an unenviable notoriety, owing to the habit of the Persian authorities of suddenly placing an embargo against shipments; and
 (5) that, if it was in British interests to nurse the Persian Gulf, it should be done at the expense of the nation and not out of the shipowners' pockets.

The success of the German Line was no doubt largely due to the subsidy received from the German Government, and to profits on carriage of the material for the construction of the Baghdad railway. The German tactics in securing practically the whole of the shipments from Antwerp to the Gulf and Mesopotamia for their own steamers was a further victory and a heavy blow for the British Lines. The service supplied by the Hamburg–America Line was, owing to the subsidy, of necessity an improvement on the British services. The regularity of sailings and the facilities afforded for granting through bills of lading to ports other than those actually called at by the steamer itself were much appreciated.

It may be taken for granted that the subsidy paid to the Hamburg–America Line for the first few years was very considerable, but at the time when the firm of Wönckhaus and Company, were securing practically all the grain in the Mesopotamian and the Persian markets, it is possible that this was done at the cost of the Baghdad railway interest and not from the pockets of the German tax-payer. . . .

V

Agriculture

The agriculture of the Fertile Crescent, which for hundreds of years had experienced hardly any change, was in the period under review subjected to three major influences: the rising demand of the world market for some Syrian and Iraqi products; greater security, which made it possible to extend the area under cultivation; and the impact of the Ottoman Land Code of 1858 on traditional forms of land tenure.

Area, Techniques, Crops

The almost complete absence of figures make it impossible to present a systematic analysis, but some trends may be discerned.

Syria

The second half of the 18th and early years of the 19th centuries saw much turmoil in Syria, including a breakdown of order and beduin invasions. This seems to have caused a marked shrinkage in the cultivated area. In Palestine, a large number of villages were abandoned, some because of malaria; in the Damascus area beduins terrorized the countryside, and in 1861 the British consul reported that the *pashalik* contained "over 2000 ruined and deserted villages, of which about 1000 were cultivated and have been deserted within the memory of man." For Aleppo there is Volney's often-quoted and somewhat misleading statement that only 400 villages paid taxes, compared to 3200 in the registers; and the Hauran and Jabal al-Druze were largely depopulated.[1] However, Lebanon and the area around Acre seem to have enjoyed a certain amount of prosperity.[2]

[1]Hütteroth and Abdul-Fattah, "Historical Geography"; Rafeq, "Economic Relations", p. 655; Rogers to Bulwer, 10 June 1861, FO 78/1586; Volney, *Travels*, vol. 2, p. 44; Burckhardt, cited in N. Lewis, "Frontier"; *EHME*, p. 261; for several of the topics treated in this chapter see N. Lewis, *Nomads, passim*.

[2]See Owen, *Middle East*, pp. 5–7, for general discussion.

Under Egyptian rule the cultivated area was extended and output increased. This was mainly a result of the order imposed (even in such hilly areas as Jabal al-Druze and the Ansarya Mountains), greater security of property, and a somewhat less arbitrary system of taxation. But there were also more positive measures—for example, "Ibrahim Pasha has employed large capitals of his own in agricultural pursuits,"[3] and beduins were encouraged to settle "along the Euphrates, in southern Palestine, along the Jordan Valley and elsewhere, by granting them land and by allowing them immunity from taxation for a number of years."[4] The result was an increase in mulberry plantations and silk production and exports in Lebanon; an expansion of cotton output; the extension of cultivation in the Biqa' and parts of Palestine; and the repopulation of some 170 villages "and a considerable increase of output" in the Aleppo region and a similar number in Hauran.[5]

The withdrawal of the Egyptians in 1841 was followed by a renewed breakdown of order and contraction of cultivation in such locations as Aleppo, Damascus, and along the Jordan.[6] But, sometime between the 1850s and 1880s, depending on the locality, a new and powerful movement of expansion began. Greater order secured by garrisons with improved rifles, the spontaneous settling of beduins, and migration of Druzes and government-sponsored settlement of Circassians and others, rising population pressure (II, Introduction), the effects of the Land Code (see below), increasing interest by city capitalists, growing world demand for agricultural produce and better communications (IV, Introduction)—all of these combined to push the frontier of settlement. For 1850–1950,[7]

The following conservative estimates may be hazarded. In the area of the present Republic of Syria, excluding the Jezireh . . . about 10,000 square miles of new land were ploughed up and about 2000 villages established on this land; in Transjordan, perhaps 1500 square miles and 300 villages. During the same hundred-year period an enormous amount of land must have been brought into regular cultivation, having in the past been at best infrequently used; and hundreds of places developed from hamlets to sizeable villages.

This process may be illustrated by a few examples. In 1850 the British consul in Jerusalem stated that Arabs from beyond the Jordan were cultivating wheat and bringing it to the city.[8] In 1857 his colleague in Aleppo reported a marked increase in cultivation and grain output during the previous 10 years; the amount collected in tithes had risen steadily from £60,000 to 137,000[9]; in Hauran in the 1860s increasing contacts were made between grain growers and European commercial interests.[10] In 1880 the consul in Damascus reported that, during the previous 20–30 years, cultivation had been extended and production increased in Syria; however, methods of production had not improved and the condition of the peasantry was no better, as a result of a combination of poor harvests in

[3]Bowring, *Report*, p. 133.

[4]Owen, *Middle East*, p. 79.

[5]Ibid.; N. Lewis, "Frontier," p. 79; Bazili, *Sirya* pp. 128–129; Qasatli (*Kitab al-Rawdah*, p. 90) credits Ibrahim with introducing rice, indigo, and kermes to Syria.

[6]Owen, *Middle East*, pp. 79–81.

[7]N. Lewis, "Frontier," p. 267; see article for details, and map in *International Affairs*, January 1955, p. 49; see also Owen, *Middle East*, pp. 173–175, for Palestine and 254–256 for the interior.

[8]Finn to Bidwell, 30 September 1850, FO 78/839.

[9]Skene to Redcliffe, 15 July 1857, FO 78/1297, and A and P 1859, vol. 30, "Aleppo."

[10]Schatkowski-Schilcher, "Hauran Conflicts"; idem, *Families*, pp. 75–78.

Table V.1 Cultivated Area in 1909[a]

	Cereals	Vegetables	Industrial and oleaginous	Vines	Total
Aleppo	279	11	13	50	353
Beirut	234	28	30	6	298
Damascus	310	10	1	26	347
Dair al-Zur	37	0.4	0.4		38
Jerusalem	94	4	11	3	112
Total	954	53	55	85	1148
Mount Lebanon					38

Source: Nickoley "Agriculture", in Mears, *Modern Turkey,* p. 285. The totals agree with those given by Ruppin, *Syrien,* p. 356; figures for Mount Lebanon from idem, p. 24.

[a]In thousands of hectares.

the 1870s, conscription, and debt; although the government was trying to protect default-ing debtors, some villages had passed into the hands of officials and moneylenders.[11] In 1882 the consul stated that, in the Biqaʿ, the value of a *faddan* (about 60 acres) of the best irrigated land had risen in 12 years from 2500–2700 piasters to not less than 14,000, and, as a result, waste land had been brought under cultivation; at the same time, in the Jerusalem area waste land was being planted to olives, vines, and other crops.[12] In the *vilayet* of Beirut, cultivation was being extended at the end of the century. Finally, in Lebanon forests were disappearing because of the demand for charcoal and the desire to plant mulberries and other fruits; land had greatly risen in value and large tracts "which were mere rocky wastes in 1861 are now thickly terraced and cultivated."[13] In Transjor-dan the Hijaz railway facilitated settlement and cultivation by Circassian immigrants and others. Official figures on cultivated areas are available only for the very end of the period (Table V.1); as will be argued later, they seem to be distinctly too low.

Methods of production continued to be very primitive.[14] A comparison of the description and illustrations given by K. D. White for Roman ploughs, threshing instru-ments, olive presses, and other agricultural implements with those provided by Latron and Frayha shows them to be practically identical. Land was usually allowed to lie fallow after a cereal crop, sown in the autumn and harvested in spring, but the following rotation was also practiced:

	Year 1	Year 2	Year 3
Field 1	Wheat, barley, chick-peas, etc.	Maize, cotton, ses-ame, etc.	Fallow
Field 2	Maize, sesame, cot-ton	Fallow	Wheat, barley, etc.
Field 3	Fallow	Wheat, barley, vetch, etc.	Maize, cotton, ses-ame, etc.

[11]A and P 1880, vol. 74, "Damascus."

[12]A and P 1883, vol. 7, "Damascus"; A and P 1886, vol. 66, "Jerusalem."

[13]A and P 1897, vol. 94, "Beirut"; Report for 1902, FO 195/2117; "Report on Lebanon," 17 October 1905, FO 424/208.

[14]For a good description see Owen, *Middle East,* pp. 39–40; see also II,10 and selection 8 (this chapter).

Table V.2 Output and Value of Main Crops

Crop	Output (000 metric tons)	Value (million francs)
Food and fodder		
Wheat	1,000	210
Barley	500	75
Sorghum	200	30
Maize	50	6
Leguminous (peas, beans, lentils)	500	65
Sesame	30	12
Potatoes and turnips	200	18
Vegetables	NA[a]	25
Other (rice, vetch, lucerne)	NA	9
		445 [sic, read 450]
Industrial crops		
Hemp	1.5	1.2
Cotton	3	3.5
Tobacco	2.5	5.0
Other	NA	0.3
		10.0
Grand total		460

Source: Ruppin, Syrien, pp. 44–45.
[a]NA, Not available.

The following example from Aleppo is also illustrative: "in spring, chick-peas, lentils, aniseed and vetches; in summer maize, beans, cowpeas, millet, sesame and cotton; in winter wheat, oats, barley, beans and flax."[15] Manure was seldom used, being burned for fuel. Oxen were the main draft animals; cattle and horses were fed on the straw left after winnowing. The British consul in Aleppo adds an interesting bit of information. "Winnowing machines have been introduced, but are very little used. Water and horse mills are employed for grinding flour; the windmill has often been tried, but has always failed in consequence of the continual shifting of the wind, which rushes down the gullies of the neighoring hills." There was little improvement thereafter, and in 1914 (according to data compiled by the late Marwan Buheiry) there were only about 20 steam or oil tractors or threshers in the whole of Syria, one-third being in Lebanon and another in Palestine.

Table V.1 shows that about 83 percent of the cultivated area of Syria was sown to cereals—a figure that has not substantially declined.[16] Ruppin gives the approximate figures shown in Table V.2 for output of field crops in a normal year. In addition, he gives the following data: olives, about 9.6 million trees with an annual product averaging 125 million *okes,* worth 30 million francs (selection 16); vines, 82,000 hectares with an annual crop of 270 million *okes,* worth 30 million francs; mulberries, 28,000 hectares producing 6.6 million kilograms of cocoons, worth 25 million francs (see below); and citrus worth 15 million francs (see below), or a total of about 100 million francs, to which should be added other cultivated and wild fruits such as figs, pomegranates, apples, berries, and various kinds of nuts. With respect to livestock, he gives the following very approximate figures: 4.8 million sheep and goats; 500,000 horned cattle; 270,000 horses, donkeys and

[15]Cuinet, Syrie, p. 335; A and P 1907, vol. 93, "Aleppo"; see also A and P 1859, vol. 30, "Aleppo."
[16]The only available earlier figures refer to Acre and Jersualem in 1863. See EHT, p. 199, and Schölch, in Owen, Palestine, p. 61.

mules; and 180,000 camels; worth about 260 million francs in all. Dairy products were estimated at 36 million francs a year and the total value of the products of animal husbandry at 100 million.[17] This suggests that the total gross output of agriculture may have been about 700 million francs (£28 million) a year.

It may be added that most of the livestock was raised by beduins, and the rest by shepherds grazing their flocks outside the village area (selections 4 and 18). There was no mixed farming, and in 1910 the U.S. consul stated that, in the whole of Syria, there was not a single dairy; butter was being imported from Denmark and Italy.[18] Of course, yogurt and labneh were made all over the country.

Looking at the distribution by provinces, figures for 1909 show that, of the combined area under wheat and barley, 33 percent was in the *vilayet* of Aleppo, 32 in Damascus, 26 in Beirut, and 9 in the *mutasarriflik* of Jerusalem.[19] However, Beirut's share of total output must have been higher, since it included a far greater proportion of such valuable crops as citrus and tobacco, not to mention the silk of Mount Lebanon, which (like the *sanjaq* of Dayr al-Zur) does not seem to be covered in the official returns.

Figures on yields seem to be erroneous. Ruppin's figures for output of cereals divided by his figures on acreage suggest a yield of about 1.5 tons per hectare; yet as late as 1934–1938 the average wheat yield for Syria was only 0.97 metric tons, for Lebanon 0.52, and for Palestine 0.40; for barley the figures were 1.06, 0.88, and 0.29; and in 1922–1933, yields were even lower.[20] Of the two sets of Ottoman figures, the ones on output are much more likely to be correct—since they formed the basis on which tithes were collected (VII, Introduction) and, as pointed out by Ruppin, after deducting 10 percent for seed (a somewhat low figure), 900,000 tons of wheat would supply Syria's estimated population of 4 million (II, Introduction) with only 225 kilograms of wheat a year—and both exports and imports were negligible. This would furnish little over 2000 calories a day.[21] Still stranger is this statement by the British consul in Aleppo in 1906: "The average ratio of seed sown to grain harvested on 1 acre of land is in bushels: wheat, 3 to 30; barley 3 to 45; oats 6 to 90."[22] For the wheat yield is almost as high as the contemporary British one and the barley and oats yield even higher; the wheat figure is the equivalent of over 2 tons per hectare and the barley of over 3.[23] Again, in 1901 it was stated that in Hauran the soil was so rich that half a bushel of wheat seed produced 20–24 bushels of grain per acre, without manure; the figure for barley was 16–32 bushels; however, the soil was planted only once in every four years.[24] It may be taken that yields per hectare for both wheat and barley were close to or somewhat under 1 metric ton.

The main obstacle to extending wheat cultivation, apart from the scanty and unreliable rainfall, was high transport costs (IV, Introduction). In 1857 it was estimated that the cost of growing wheat near Aleppo was only 9 shillings a quarter, but transport to the coast added 17s.6d. At that time, the price per quarter in England was 56 shillings a

[17]Ruppin, *Syrien*, pp. 32–58.

[18]Report, October 1910, US GR 84, C8.5, "Beirut"; for animal husbandry see Wilson, *Peasant*, Chapter 3.

[19]See table in Ruppin, *Syrien*, p. 35.

[20]Food and Agricultural Organization, *Yearbook of Food and Agricultural Statistics*, 1949; Himadeh, *Economic Organization*, p. 78.

[21]Ruppin, *Syrien*, p. 36; Fernand Braudel, *The Structures of Everyday Life* (New York, 1981), p. 130.

[22]A and P 1907, vol. 93, "Aleppo."

[23]See B. R. Mitchell and Phyllis Deane, *Abstract of British Historical Statistics* (Cambridge, 1971), p. 90.

[24]Richards to O'Conor, 3 October 1901, FO 195/2097.

quarter, making export profitable.[25] However, in 1901 the consul in Damascus stated that the peasant could not make much profit unless the price of wheat was 30 piasters a *kayla* (which seems high—see VII,1), or 28 shillings a quarter; but at that time the price of wheat in England was only 27 shillings a quarter.[26]

The main change in agriculture was the increase in the production of cash crops for export. Of these the most important was silk. Silk had been cultivated in Syria, and exported to Europe, since the Middle Ages and by the 18th century silk production had become quite extensive.[27] Parts of Mount Lebanon had specialized in silk so heavily that in 1842 it was judged to be capable of meeting only 50–67 percent of its cereal needs (see also selection 1)[28] By then European merchants had become very active in silk production: in 1837, in the Saida region, they advanced funds and contracted for the following crop at terms "extremely unfavorable to cultivators."[29] In 1833 Boislecomte estimated Syria's output of silk at 400 tons, worth 12 million francs; in 1834 Wood gave the same figure, and in 1838 Bowring put it at 1700 *qantars* (380 tons), of which 700 came from Lebanon, 500 from Antioch, 200 from Beirut, 100 from Tripoli, and 100 from Saida.[30]

Most of this silk was consumed by Syrian handicraftsmen, but some was exported to France or bought by Moroccan merchants. However, in the 1840s a shift to exports began. This shift arose from the decline of Syrian handicrafts (VI, Introduction), the upsurge of demand in Europe, particularly France, and the improvement of quality brought about by the introduction of European reeling methods (VI, Introduction)—all of which more than offset the handicap posed by taxes on exports and greater competition from China.[31] The outbreak of the *pébrine* disease in the 1850s, which sharply reduced silk output in France, and the fourfold rise in silk prices[32] (see also III, Introduction, Table III.7), were a further stimulus and, judging from the value of exports from Beirut in the 1850s (III,2), output probably rose in that decade. The subsequent large increase in production (about fourfold in 1861–1910) is shown in III,17. Quoting a German consular report, Ruppin gives the following breakdown of production of cocoons in 1909: Lebanon and Beirut 2800 tons, Tripoli 600, Suwaydia 600, Arsus 450, Alexandretta 200, Latakia 20.[33]

There was also a change in the composition of silk exports. Traditionally Lebanon shipped silk thread. In 1868–1876 it exported eggs to France.[34] More important was the shift from thread to cocoons, already noted in 1850.[35] For one thing, partially because of

[25]Harrison to Skene, 13 July 1857, FO 78/1297; Mitchell and Deane, *Abstract,* p. 488.

[26]Report, 6 April 1901, FO 195/2097; Mitchell and Deane, *Abstract,* p. 488.

[27]*EHME,* p. 33, 221; Davis, *Aleppo,* pp. 134–172.

[28]"Report on Trade," 17 September 1842, CC Beyrouth, vol. 3; in 1785, according to Volney (*Travels*), Lebanon produced only one-third of its cereals needs (vol. 2, p. 72), but the later figure is likely to be more accurate.

[29]Dispatch by Campbell, 17 February 1837, FO 226/11.

[30]Douin, *Boislecomte,* p. 265; Cunningham, *Early Correspondence,* p. 50; Bowring, *Report,* p. 134. According to Carne (Syria, vol. 1, p. 23), Tripoli "formerly exported 800 quintals a year at about £80 a quintal."

[31]Dispatch of 12 March 1850, CC Beyrouth, vol. 6.

[32]Moore to Secretary of State, 10 October 1856, US GR 84, C8.

[33]Ruppin, *Syrien,* p. 50.

[34]Labaki, *Introduction,* pp. 32–33.

[35]"Report on Trade," 1850, CC Beyrouth, vol. 6.

improved methods of drying that reduced weight by two-thirds, cocoons were very remunerative, yielding a profit of "40, 45 or 50 percent."[36] For another, silk-reeling factories were suffering from the fact that wages were "higher than in France" [*sic*] and the workers less skilled.[37] Nevertheless, the silk-reeling factories continued to process the greater part of the cocoons; around 1913 some 85 percent were reeled and only 15 percent exported in their raw state.[38]

The expansion of demand led to an extension of mulberry cultivation. Already in 1853 a French consul pointed out that, whereas formerly Mount Lebanon and the plains surrounding Beirut had supplied sufficient quantities at profitable prices, it had become necessary to go further afield—to Hasbayya and Antioch, where there was less competition—to obtain cocoons at prices that yielded profits.[39] From Aleppo it was reported that in the Orontes Valley around 1861 not more than 50 cases of silk had been exported, but by 1871 the amount had risen to 300, worth 1.8 million piasters.[40] Again, in 1879 silk production was reported to be spreading in the Alexandretta region; exports had risen from 141 tons worth £71,000 in 1897 to 162 tons worth £83,000 in 1898.[41] But toward the end of the period increasing pessimism was expressed, because of greater Japanese and Chinese competition and the relatively inefficient state of silk production in Lebanon, by officials of both the French and British consulates—the silk expert Ducousso and the poet J. E. Flecker. The latter pointed out that mulberry trees were being replaced by oranges.[42] But in fact it was the cutting down of mulberries for fuel during the First World War, and subsequent competition from rayon, that finished off silk in Lebanon.

Silkworms were raised by farmers, mostly Christians in Lebanon. Until 1840 local eggs were used, after which eggs were imported from Iran, Italy, and elsewhere. In the 1870s the *pébrine* disease struck, but soon Syria was receiving "pasteurized" eggs from the "Institut Séricole" in Bursa, founded by the Ottoman Public Debt Administration in 1888, and from France, and no more outbreaks of disease were recorded.[43] Eggs were supplied to villagers by brokers, who usually also advanced money (at rates of 20 percent or over) and bought part of the crop at prices fixed in advance; a box of 25 eggs normally produced 25–30 kilograms of fresh cocoons. The cocoons were then placed in heated ovens, to stifle the worm, after which they were steamed or put in pans of water to unseal the glue in the cocoon. They were dried and pressed, 3 kilograms of fresh cocoons providing 1 kilogram of dried. After that they were reeled, 5 kilograms of dried cocoons yielding one of thread; about 15 percent was consumed in Syria and the rest sent for export.[44] Over 70 firms were engaged in exporting, of which the 7 largest accounted for 72 percent of the total in 1904–1910; 70 percent was exported by Lebanese firms (almost all Christian) and 30 by foreign firms, mostly French. The large firms had close ties with

[36]Labaki, *Introduction*, p. 42; Dispatch of 4 April 1851, CC Beyrouth, vol. 6.

[37]Dispatch of 14 November 1852, CC Beyrouth, vol. 6.

[38]Ruppin, *Syrien*, p. 50.

[39]Dispatch of 24 February 1853, CC Beyrouth, vol. 6.

[40]A and P 1872, vol. 57, "Aleppo."

[41]A and P 1899, vol. 103, "Aleppo."

[42]A and P 1912/13, vol. 100, "Beirut"; see also Owen, *Middle East*, pp. 250–251; Ruppin, *Syrien*, p. 50.

[43]For details see Labaki, *Introduction*, pp. 32–38; see also *EHT*, p. 256.

[44]Robeson to Secretary of State, 1 September 1883, US GR 84, T367.15.

silk interests in Lyon and with French and local banks. The price of Lebanese silk closely followed that of Lyon.[45]

It should be added that, because of their high value and small bulk and also their proximity to the coast, silk exports were much less handicapped than those of other crops (V,1). In 1890 the cost of moving a bale (100 kilograms) of silk from Kura to Tripoli was only 44.86 francs—mainly in the form of customs and baling; freight to Marseilles cost another 25 francs and insurance 15, for a total of 87 francs,[46] or less than 1 franc per kilogram—compared to a price of 40–50. Silk was also more lightly taxed: Lebanon, where the greater part was grown, was exempt from the tithe, and in other regions the tithe on silk was 12.13 percent, instead of 12.63 on other crops, because of the efforts of the Public Debt Administration to encourage production.[47]

Cotton came to Syria probably slightly later than silk but it too soon became a leading export to Europe and remained so through the 18th century. In addition, it supplied the numerous Syrian craftsmen (VI, Introduction). In 1833 Boislecomte estimated Syria's cotton crop at 2500 metric tons (and another 2500 in Adana), and in 1838 Bowring put it at 2200 in Acre and Nablus and 500 in the Aleppo region (and 2500–3000 in Adana).[48]

These figures probably reflect a rise in production under Egyptian rule. After that, there seems to have been a slow decrease in output. On the one hand, Syria faced greater competition from better, or cheaper, American, Indian, and Egyptian cotton. On the other, there was the decline in Syrian crafts, which shrank the internal market; when they did recover it was by using imported yarns (VI, Introduction). There were also other difficulties. In 1851, the British consul reported that he was endeavoring, with the help of the Ottoman authorities, to introduce American cottonseeds in Damascus, thus making England less dependent on America; a few months later the experiment was declared to have produced far better cotton ("not much inferior to that grown in Florida"), but the "inert character of the natives" rendered them indifferent to improvement.[49] At the same time, however, his colleague in Jaffa was describing the "energy" shown in growing cotton and stating that it had been shipped from Jaffa for the first time but was proving unprofitable because it was bulky and light and needed machines for pressing.[50]

Replies to a questionnaire in 1857 show a general contraction. Jaffa used to export 500 bales annually, but cotton was now being neglected in favor of oranges, wheat, and sesame; inferior seed was being used (although American cotton could be grown) and irrigation practiced.[51] In the Aleppo region 20 years ago three times as much cotton had been grown, but local demand had diminished because of the importing of yarn and insecurity caused by beduins; an acre took 45 pounds of seed and yielded 800 pounds of cleaned cotton; seeds were poor but experiments with Egyptian ones had been successful;

[45]Owen, *Middle East*, pp. 154–155; Labaki, *Introduction*, pp. 38–76; Ruppin, *Syrien*, pp. 49–50; see table on prices in Labaki, *Introduction*, p. 68.

[46]"Notes on Commerce," June 1890, CC Beyrouth, vol. 10.

[47]Labaki, *Introduction*, pp. 70–71.

[48]Douin, *Boislecomte*, p. 265; Bowring's figures (*Report*) are inconsistent, see pp. 13, 14, 58, and 134. In 1842, it was estimated that of the total output of Nablus, Acre, and Samaria, one-third was exported to Europe and two-thirds consumed locally ("Report on Trade," 17 September 1842, CC Beyrouth, vol. 3).

[49]Wood to Palmerston, 21 January and 10 November 1851, FO 78/872.

[50]Kayat to Palmerston, 20 August 1850, FO 78/839 and 2 May 1851, FO 78/874.

[51]Reply to Questions from Cotton Supply Association, Manchester, FO 78/1246.

gins, and presses similar to those in use in Europe and Asia had been adopted in recent years; the produce of Northern Syria was usually over 400 tons of cleaned cotton.[52] In Beirut, "cultivation of cotton has fallen off of late, sesame seed having entirely superseded it in many districts."[53] In the plains between Nablus and the sea probably 15,000 acres were sown to cotton, "but it depends on the amount of rain"; the yield was about 2000 pounds per acre[54]—presumably of unginned cotton (i.e., about 650 pounds after ginning).

The sharp rise in prices caused by the American Civil War led to a large extension in cotton planting, as in other parts of the Middle East (selection 7).[55] In Aleppo in 1862 the price rose from $4\frac{1}{2}d$. per pound to $1s.9d.$; the area under cultivation increased fivefold, and exports to Europe approached 4 million pounds. There was a similar extension in the Lebanese coastal plain, at the expense of cereals; total output reached about 9000 tons worth 9 million francs.[56] But the end of the war led to an equally steep fall in prices—25 percent in one fortnight in Jaffa and back to 6–$9d.$ per pound in Aleppo in 1868—and the cultivated area shrank.[57] Locust attacks further damaged the crops, and the British consul reported that, since "cotton requires a greater outlay of capital than any other crops" and taxes on it were high, the farmers preferred wheat and barley and planted a small amount of cotton only so "that the necessary rotation of crops may be maintained, to keep the land in good order."[58] Cotton was practically given up in southern Syria, but in 1909 successful attempts were made to plant Egyptian varieties in the Jordan Valley.[59] In 1913 output in the Aleppo region was about 2000 tons and in Palestine and Latakia 1000, worth in all some 3.5 million francs.[60]

Citrus fruit has been grown in the coastal plain of Syria since the early Middle Ages, but cultivation expanded only in the 19th century with the opening of export markets, first in Turkey and Greece and then in Britain and Russia. In 1856 Jaffa produced about 20 million oranges; in 1856 it exported 3 million worth £3750 and in 1859 6 million worth £10,000; in 1859 exports from Tripoli were worth £15,000. Small holdings were predominant and rent was paid in money, giving a 10 percent return on capital to the landlord.[61] By 1881, 171,000 boxes (with about 300 units each) worth £50,000 were being exported from Jaffa and in 1887 Beirut, Saida, and Tripoli exported over 30,000 boxes.[62] In 1891 Jaffa exported 270,000 boxes worth £108,000 and, after the establishment of direct steamer lines to England had reduced transport costs and prices rose, 1.3 million boxes in 1911–1913, worth £267,000; in 1912 Tripoli and Saida exported

[52]Ibid., FO 78/1297.

[53]Ibid., FO 78/1298.

[54]Ibid., FO 78/1384.

[55]*EHME*, pp. 416–429; *EHI*, pp. 244–247; *EHT*, pp. 233–243.

[56]A and P 1886, vol. 69, "Aleppo"; A and P 1872, vol. 58, "Syria"; "Report on Trade," 1863, CC Beyrouth, vol. 8; Ruppin, *Syrien*, p. 41.

[57]Kayat to Russell, 15 March 1865, FO 78/1874; A and P 1872, vol. 58, "Syria."

[58]A and P 1868/69, vol. 60, "Aleppo."

[59]A and P 1910, vol. 103, "Beirut."

[60]Ruppin, *Syrien*, pp. 41–42.

[61]Report for 1857, FO 78/1387; Report for 1859, FO 78/1449; A and P 1859, vol. 30, "Tripoli"; Reply to Questionnaire, FO 78/1419.

[62]A and P 1882, vol. 71, "Jaffa"; Report for 1887, US GR 84, T367.17.

220,000 boxes.[63] The number of gardens in the vicinity of Jaffa, averaging 2–3 acres, rose from some 340 in 1880 to about 1000 in 1912. By then about one-third belonged to Jewish planters. Irrigation was provided first by waterwheels and, by 1900, by petroleum pumps. In 1880, the cost of a garden was put at 40,000–50,000 francs and the annual return at 4000–5000.[64] In 1907 a garden of 25 acres was estimated to cost £4348 in installation and maintenance costs and interest up to the end of the fifth year. In the sixth year returns equaled outlay, and from the eighth year on, annual net profit was £320.[65]

Tobacco came to Syria early in the 17th century and was well established around Latakia by the 18th century and in the Saida region around 1800 (selection 3). In 1833 Syria's production was put at 4500 tons worth 6.3 million francs, and in 1843 at 1867 tons worth 1.7 million francs and coming in almost equal amounts from Tripoli and Kura, Latakia, Sour, and Saida (selection 3). A small amount was exported to Egypt.[66] In the 1860s there were some exports to England, in addition to 350 tons to Egypt.[67] But the introduction of a monopoly by the "Régie des Tabacs" in 1874 led to a drastic decline in output and exports; by 1888 production had disappeared from Lebanon, but 200 tons were still exported from Latakia.[68] In 1911 total output was 1300 tons worth some 5 million francs, the bulk coming from Latakia and the rest from Saida and the Lebanese coast; the greater part of the crop was exported to England and Egypt.[69]

Other cash crops were sesame, olive oil, and vines. In 1841–1844, output of sesame in the area of the Beirut French consulate rose from 970 to about 2000 tons, of which about one-half was consumed locally; sesame was very profitable and was replacing cotton and other crops.[70] In 1913 Syria's total output was put at 30,000 tons worth 12 million francs, of which nearly one-half was exported; the crop was profitable, but subject to drought damage.[71] In 1872 output of olive oil in a normal year was estimated at 7500 metric tons; after that there was much planting of olive trees, mainly on the western slopes of the mountains (selection 16), and by 1909 production had risen to 22,000 tons.[72] Vines were also planted in the hills and wine was made in Lebanon (selection 11) and in the Jewish colonies in Palestine.

Looking at other primary activities, in the Beirut *vilayet* in 1902 "The five forests which existed thirty or forty years ago are disappearing," having been cut down for charcoal. In Lebanon, forests used to cover 4 percent of the area but had been considerably reduced to make way for mulberries and other fruit trees. Ruppin estimated the

[63]A and P 1892, vol. 82, "Jerusalem"; A and P 1914, vol. 95, "Jerusalem" and "Beirut."

[64]A and P 1880, vol. 73, "Beirut"; A and P 1901, vol. 85, "Palestine." In 1856 land cost about £10 an acre, having "increased much in value owing to the high prices in produce and owing to better government of late" (Reply to Questionnaire, FO 78/1419).

[65]See details in A and P 1908, vol. 116, "Palestine"; for costs and returns in 1893 see A and P 1893/94, vol. 91, "Jerusalem."

[66]Douin, *Boislecomte*, p. 265; "Report on Tobacco," 1843, CC Beyrouth, vol. 4; Bowring, *Report*, p. 93.

[67]A and P 1872, vol. 58, "Syria."

[68]A and P 1875, vol. 75, "Beirut"; "Report on Trade," 1888, CC Beyrouth, vol. 10; see *EHT*, pp. 249–251; for examples of evasion of the tobacco monopoly see Wilson, *Peasant*, pp. 216–217.

[69]Ruppin, *Syrien*, p. 43.

[70]Reply to Questionnaire, 6 November 1844, CC Beyrouth, vol. 4.

[71]Ruppin, *Syrien*, p. 39.

[72]Ibid., p. 146, where a breakdown is given; for a description of olive cultivation see Wilson, *Peasant*, pp. 226–232.

annual output of forestry at 5 million francs and of fisheries at 10 million. Sponge fisheries were active (selection 2); in 1842 some 43 boats, carrying 215 men and originating in Tripoli, Batrun, Ruwad, and Latakia were engaged, plus a similar number of boats from the Greek archipelago; in 1865 there were 150 boats with a similar number of Greek; output was estimated at 38,000 kilograms worth 600,000 francs.[73] By 1912, however, the number of boats had fallen to 80 and output was worth only 80,000 francs, the Greek fishermen having migrated to the United States.[74]

Iraq

Much less is known about Iraq than Syria, but two facts are clear. First, it had a much greater area of unused but easily cultivable land; second, water transport made it much cheaper to carry heavy produce to the coast—even though, right up to the end of the period, expensive transport prevented the extension of cultivation to many areas (IV, Introduction). Hence, once a modicum of order had been established and markets had opened up for Iraqi wheat and barley, the area under cultivation could be greatly extended and output correspondingly increased. Growing population and the sedentarization of nomads provided the necessary labor force (II, Introduction). Export figures show that this happened after the opening of the Suez Canal (III, Introduction).

The increase almost certainly came from the irrigated zone. Throughout the period under review this area remained subject to the vagaries of the Tigris and Euphrates. Because of the short distance between the mountains from which they derive their waters and the plain, the swiftness of their current, and the great amount of sediments they carry, these rivers kept on changing their course and flooding the countryside.[75] On average, one year out of three saw a flood, and very severe floods occurred periodically (II,26 and 27). Three further points may be noted. First, the peak of the rivers is reached in May, too late for the winter and too early for the summer crops. Second, their high salt content and the intense evaporation of water deposited on the adjacent countryside have produced a great amount of salination and made much land unfit for cultivation. Finally, the silting of ancient canals and destruction of other irrigation works aggravated the problem, by choking off some escapes for excess water. A striking example of a change of course is that of the lower Euphrates: until the end of the 19th century it joined the Tigris at Qurna, to form the Shatt al-Arab, but now the junction is at Qarmat Ali, 50 kilometers downstream, very close to Basra.[76] As for floods, in addition to the terrible ones of 1822 and 1831 (II,24), in May 1874 the Tigris broke its embankment north of Baghdad for the second time in eight years, flooding an area of 25 miles by 3 to 12 miles, and destroying the crops in it; a fortnight later the Euphrates also overflowed, destroying crops. Further, in April 1884 the Tigris surrounded Baghdad with a lake 15 miles by 1–2 miles, destroying crops estimated at £200,000–300,000 and also raising the danger of malaria.[77] In

[73]"Report on Trade," 17 September 1842, CC Beyrouth, vol. 3; "Report on Sponge Fisheries," 3 December 1865, CC Beyrouth, vol. 8; for a detailed description see "Report on Sponge Fisheries," A and P 1874, vol. 66, "Beirut."

[74]Ruppin, *Syrien,* pp. 125–126.

[75]The contrast between Egypt and Iraq is brought out by Willcocks—see *EHME,* pp. 129–130, 191–197.

[76]See map in Great Britain, Naval Intelligence, *Iraq,* p. 62.

[77]Herbert to Elliot, 6 May 1874 and 20 May 1874, FO 195/1030; Plowden to Dufferin, 17 April 1884, FO 195/1030.

1907 the Euphrates submerged the western part of Baghdad and at the same time the Tigris flooded the eastern quarters, causing great damage.[78]

Until close to the end of the period irrigation seems, if anything, to have deteriorated. At the end of the 18th century the Hindiyya canal had been dug, drawing water from the Euphrates to Najaf (selection 27). In 1851 the dike at Hindiyya broke and the Euphrates poured in.[79] In 1858 a new dike was built, to provide additional water and extend the cultivated area, but this was breached by the first flood in 1859. A more ambitious dam, built in 1888–1890, also broke down in 1904. In 1863 the government brought over from Egypt three engineers to study irrigation needs, but they do not seem to have achieved anything.[80]

In the meantime work had been proceeding on the Saqlawiyya canal, a very ancient canal connecting the Euphrates and Tigris 6 kilometers south of Baghdad and providing navigation and irrigation. The discharge of the canal having increased, menacing both Baghdad and the cultivated area, a dam was built in 1847/48. This gave protection to Baghdad but cut off both communications and irrigation. In 1871 Midhat pasha sought to restore the old canal, but faulty work resulted in the Euphrates pouring into the Hindiyya canal and Tigris, and new works had to be built, at considerable expense (selection 29).[81] Further south, the vast swamp between Suq al-Shuyukh and Basra was alleged to "owe its existence to neglect in repairing the embankment which formerly existed to the Euphrates from Suk Esh-Sheukh to Gurnah."[82] In 1886 a 10-kilometer canal was dug below Kut, to draw water to the Dujaila canal and irrigate land recently bought by the Sultan, but it posed the danger of drawing too much water from the Tigris, lowering the level of the river and ruining the 'Amara area as well as hampering navigation.[83]

All this, however did not stop the extension of cultivation. By the beginning of the 19th century systematic cultivation was restricted to the area around Basra, where an ingenious irrigation system operated by the tide watered the palm groves and other fields (selection 28); to Diyala, Hilla, and Karbala, where the canals had survived; to small areas on the Euphrates, between 'Ana and Hit; and to the rain-fed zone between Arbil, Kirkuk, Mosul, and Diyarbakr, which was protected by Turkish garrisons. The rest of the country was under shifting cultivation by the tribes, who practiced a simple form of irrigation by damming river channels with rolls of reed matting reinforced with branches and mud. The bulk of the land was under winter crops, almost solely wheat and barley.[84] The southern part of the country did not meet its needs of wheat and barley but had a surplus of rice and dates (II,22).

A description written in 1866 shows little change[85]:

> The low marshy districts on either side of the Euphrates supply rice. At Hilleh, and throughout the inhabited parts of Mesopotamia, wheat, barley, millet and idreh are

[78]Sousa, *Fayadanat*, vol. 2, pp. 402–410.

[79]Dispatch of 7 May 1851, FO 195/367.

[80]Delaporte to Drouyn, 1 August 1863, CC Baghdad, vol. 12.

[81]A and P 1878/79, vol. 72, "Baghdad"; Sousa, *Fayadanat*, vol. 2, pp. 389–401.

[82]A and P 1867, vol. 67, "Basra."

[83]Lynch to Consul, 22 September 1886, FO 195/1546.

[84]Haider, "Land Problems," p. 223; Owen, *Middle East*, p. 32; see also Batatu, *Old Classes*, pp. 63–67 and map.

[85]A and P 1867, vol. 67, "Baghdad."

cultivated; as also in the track of land to the east of the Tigris, up to the base of the mountains from Arbil to the Dialeh. Below Koot, on either bank of the Tigris, there is little or no cultivation until the marshes are reached above Kurneh, inhabited by the Albu-Mahomed Arabs, who raise rice in considerable quantities. The lands below Kurneh to the sea, on either side of the Shat-el-Arab, are almost exclusively devoted to the cultivation of the date. Exportation being limited, the supply of grain is necessarily regulated by local consumption; and as bad seasons seldom recur consecutively, prices, taken one year with another, maintain a pretty equable rate. They are affected chiefly by the inadequate rise of the waters of the rivers, by the inundations, or by periods of unusual disorder. . . .

At present, cultivation, like the fixed population, is restricted to the neighborhood of towns and villages situated on the great trunk roads, and to canal-irrigated districts, which are very limited in extent. The intermediate country is occupied by the great nomad tribes, who never engage in agriculture, and by the half-settled Arab communities, who shift their place of abode annually within certain limits, and raise only sufficient grain for their own consumption.

However, by 1878 Geary was reporting that in the last 15–20 years "the Arabs have been brought into something like subordination and cultivation is gradually extending," and at the same time the British consul stated that nomads, especially the *Muntafiq,* were putting waterlifting devices on the Tigris, above ʿAmara, and settling down.[86] In 1888 the British consul reported "the substitution of wheat cultivation for that of rice in the country," around Basra, with a consequent reduction in malaria.[87] In 1893 the consul estimated the amount of dates and grains shipped from Basra by native craft at the unprecedented high figure of 100,000 tons, worth some £500,000.[88] In 1908 a British official who traveled from Istanbul to Basra stated that "since 1872 cultivation has much increased"; data on the price of palm groves near Baghdad and along the Shatt al-ʿArab show a sharp increase after 1880.[89]

A few estimates by Hasan may be quoted. In the 1860s and 1870s, annual output of dates was about 30,000 tons, and exports 10,000. By 1887 output had risen to 60,000 and exports to 44,000 tons, and by 1909–1913 to 91,500 and 65,700 tons, respectively; in other words, the export rate had risen from 33 to 70 percent. In 1890, Cuinet put the grain production of the three *vilayets* of Baghdad, Mosul, and Basra at 319,000 tons of wheat, 514,000 tons of barley, and 118,000 tons of rice, a total of 951,000 tons; exports of wheat amounted to 35,000 tons, or about 10 percent of output, of barley 34,000, or 6 percent, and of rice 1300 tons, or 1 percent.[90] For 1911, the Ottoman Bank gave a total grain harvest for Basra of 274,000 and for 1912 of 240,000 tons, worth about £T. 1.25 million; exports of wheat averaged 20,000 tons in 1910–1912, of barley 77,000, of paddy and rice 37,000, and of seeds 14,000. The bank estimated that of the total value, £T. 645,000 remained in the hands of the agriculturists; transport and handling absorbed £T. 160,000, government tithes and leases £T. 375,000, and £T. 70,000 was realized in profits in Basra.[91]

[86]Geary, *Through Asiatic Turkey,* vol. 1., p. 114; A and P 1878/79, vol. 72, "Baghdad."

[87]A and P 1888, vol. 103, "Basra."

[88]A and P 1893/94, vol. 97, "Baghdad and Basra."

[89]Ramsay to Board of Trade, 28 May 1908, FO 195/2274; Cuinet, cited by Batatu, *Old Classes,* p. 241.

[90]Hasan, *Al-tatawwur,* pp. 169–173.

[91]A and P 1913, vol. 73, "Basra."

Total acreage has been estimated by Hasan at 1 million acres or 400,000 hectares.[92] This, however, seems much too low, since—if Cuinet's figures are accurate—it implies a yield of nearly 2.5 tons per hectare. A careful calculation made by British experts in Hilla in 1917 gave the following yields: wheat, $\frac{1}{4}$ ton per acre and barley $\frac{5}{8}$ of a ton (i.e., 625 and 1563 kilograms per hectare, respectively); the yield/seed ratio was 11-fold.[93] In 1918 the yield/seed ratio in Kirkuk was six- or sevenfold.[94] In 1908 the average yield/seed ratio was put at fivefold; however, outside the villages it was nearly twice as high, "owing to the flocks which in winter months manure the land and to the general richness of the soil."[95] In 1918 the total cropped area in the irrigation zone was only 937,000 acres, but this probably reflects the disruption caused by the war[96]; to it must be added perhaps another 500,000 acres in the rainfall zone, giving a total cropped area of perhaps 600,000 hectares or more.

The substantial increase in output was achieved by extending cultivation, with practically no improvement in methods. In 1869 a model farm was set up under a Polish agronomist,[97] but it had no impact, and there is no sign of improved seeds or tools being used. In 1891 it was reported that "Several Pashas fertilize their lands by means of machinery imported from Europe. One of them (Kadhim Pasha) has even imported with his European apparatus a European to put it together and work it. But such cases are exceptional."[98] In 1911 Lynch imported 35 pieces of British and American machinery, of which he sold 20; they were light machines, suitable for weak animals.[99] "From Meskene down to Nahaya (between Abu Kamal and El Kaim) all cultivation is done by means of water lifts worked by animals. From Nahaya to Hit the cultivation is mostly done by means of waterwheels. Below Hit there are again large numbers of water lifts, which continue below Ramadi, where the first canal takes off from the right bank of the Euphrates."[100] In 1866 Lynch introduced a 20-horsepower steam pump on the Tigris, costing £2000, in the face of stiff opposition from the governor. By 1907, 10 pumps, aggregating 63 horsepower, were working, and a further 14 (147 horsepower) were on order, in spite of difficulties "for lack of technical skills."[101] By 1912, 400 oil pumps "are said to be in regular operation on the Tigris and Euphrates. The larger sizes of plant, being more economical, are now in favour."[102]

There were also no signs of crop diversification. In the 1860s attempts were made in Iraq, as in Syria and elsewhere (see above), to grow cotton, and American seeds dis-

[92]Hasan, *Al-tatawwur,* p. 178.

[93]"Administrative Report," Revenue Board, Baghdad, 1918, FO 371/4150.

[94]"Land Revenue Note on Kurdistan," 1918, FO 371/4148; in 1934–1938 wheat yields averaged 720 kilograms and barley 770 (FAO *Yearbook*).

[95]"Report Upon the Conditions and Prospects of British Trade," by George Lloyd, 1908, Confidential, p. 114.

[96]Warriner, *Land Reform,* pp. 99–101.

[97]Rogier to La Valotte, 4 January 1870, CC Baghdad, vol. 13.

[98]Tweedie to White, 14 January 1891, FO 195/1721.

[99]Political Resident, "Summary," July 1911, FO 195/2368.

[100]Ramsay to Board of Trade, 28 May 1908, FO 195/2274.

[101]Kendall to Bulwer, 13 April 1864, FO 195/367 and 23 June 1866, FO 195/803A; Diary, 25 February 1907, FO 195/2242; Ramsay to Board of Trade, 12 October 1906, FO 195/2215.

[102]A and P 1914, vol. 95, "Baghdad."

tributed to farmers in Baghdad produced cotton "little inferior" to American. However, falling prices and locust ravages soon put an end to that experiment.[103] A 1918 British report stated that, although cotton yields were very high, prewar attempts, both public and private, to grow cotton with Egyptian seeds had met with no success. The reasons were several: lack of security of tenure, irregularity and unreliability of irrigation, lack of marketing facilities, high cost of transport, high cost of growing under lift irrigation, and "a corrupt and suicidal system of taxing the crop."[104] In 1920 output of cotton was only 60 bales of 400 pounds each.[105] Tobacco was grown in the northern regions. In 1869 the output of the *vilayet* of Mosul—mainly the Ruwandiz, Koy Sanjaq, Karadar, and Sulaimaniya areas—was put at 15,000 bales of 79 kilograms each; half of the output was consumed within Iraq and the rest exported to Iran and Syria. However, partly because of the efforts of Rashid pasha, from the 1850s on fruit and vegetable gardens became more and more common in the vicinity of Baghdad.[106]

Midhat pasha's attempt to encourage the planting of sugarcane by exempting its seed from duty produced no results.[107] Liquorice, which grew wild on the riverbanks, was dug up, sent to Basra, and pressed for exporting; in 1891 the cost per ton in Basra was £2.5, and freight to London added another £1.5.[108] Of the pastoral products, an important item was wool (selection 24). In 1891 wool presses were set up at ʿAmara by Lynch, cutting export costs.[109] However, the high tariff imposed by the United States, which was the chief market, in 1897 and increasing Australian competition hampered exports.[110]

A new chapter in Iraq's agricultural history opened in 1905, with the presentation of a comprehensive report on irrigation by Sir William Willcocks, an engineer who had distinguished himself in India and Egypt (selections 30 and 31). This scheme had to be modified because "there is a depression between the two rivers lower than the beds of either," that prevented the running of canals between the two rivers.[111] It was therefore changed to include an escape, near Ramadi, for the excess waters of the Euphrates into Lake Habbaniyya and the Abu Dibis depression, and another, near Samarra, for the excess Tigris waters into the Tharthar depression. Regulator dams, to raise the water level and feed canals, were to be built at Balad and Kut on the Tigris and at Hindiyya, to replace the old dam, on the Euphrates. This plan, revised and improved—notably by the Haigh Commission in 1946–1949 and with the addition of storage dams on the Tigris and some

[103]"Reply to Questions," 23 January 1863, and Kemball to Bulwer, 25 February 1863, FO 195/752; A and P 1867, vol. 67, "Baghdad."

[104]*Report on Cotton Experimental Farms,* Baghdad, 1919, FO 371/4150; whereas in Mosul in 1845 cotton accounted for 12 percent of tithes (wheat and barley 74 and rice 5), by 1919 it was insignificant, 87 percent coming from winter grains, 9 from summer, and 4 from fruit and vegetables (see Shields, "Economic History," pp. 113–114).

[105]Himadeh, *Iraq,* p. 179.

[106]Reply to Circular, 1869, CC Baghdad, vol. 13.

[107]A and P 1872, vol. 57, "Baghdad"; Chiha, *Baghdad,* pp. 95–96.

[108]See "Report on Liquorice Plant," A and P 1890/91, vol. 84, "Basra."

[109]A and P 1893/94, vol. 97, "Baghdad."

[110]A and P 1898, vol. 99, "Baghdad"; for exports of wool from Mosul, see Shields "Economic History," pp. 145–151.

[111]"Memorandum on the Present State of Irrigation Works in Iraq," 16 May 1910, FO 424/223.

of its tributaries—was finally implemented in the 1950s and 1960s. Selection 30 shows the anticipated costs and benefits and selection 31 the state of affairs just before the outbreak of the First World War. The only major project actually implemented was the new Hindiyya barrage, officially opened on 12 December 1913, with immediate benefit to cultivators.[112]

Land Tenure

Underlying a great diversity over time and space, Middle Eastern Islamic land tenure shows a basic pattern, involving the state, the farmer, and an intermediary. The ownership of the land (*raqaba*) was vested in the state or ruler, with minor exceptions such as *mulk* (*milk*) or freehold land (which prevailed in the towns, in the center of villages, and in certain areas such as Lebanon), and *waqf* (mortmain), where ownership was regarded as transferred to God, its income being earmarked for specified religious or charitable purposes, or entailed within the family, the religious or charitable beneficiary having only a reversionary right. The peasant who tilled the land enjoyed usufructuary rights (*tasarruf*). In practice, provided it met its tax and other obligations, the village was left free to allocate land among its members and decide which crops should be grown, and where and when. The intermediaries collected rent or taxes from the farmers and transferred part of the proceeds to the central treasury, keeping the balance as payment for the military or administrative services they performed.

In the Ottoman Empire during the 17th and 18th centuries, the land on which the state claimed ownership (which came to be known as *arazi-amiriye*, or *miri*) was divided into two categories: *has* (*khass*), the private property of the sultan or members of the imperial family, or land the revenues of which were assigned to holders of certain offices; and *timar*, or fiefs, assigned to *sipahis* or *timariots*, who collected revenue (rent or taxes) from the farmers. They administered the countryside and provided the cavalry of the Ottoman army, and were subject to strict control by the central government. In addition to raising taxes, they were usually assigned a portion of the village land, which was cultivated for them by the peasants as part of their labor obligations. The nomads lived outside this system, raising their herds and cultivating their traditional tribal area (*dira*) with little outside interference. They paid a tax on livestock whose amount was determined mainly by their power relative to the nearest center of authority.

From the 17th century on, the government's growing need for cash, which was connected with the change in the structure (decline of cavalry) and weaponry (increased use of firearms) of the army and was aggravated by inflation (VII, Introduction), led to increasing conversion of *timar* land to *has* when its owner died. This land was then assigned to tax farmers, who acquired the right to collect taxes from a specified area. By the 18th century such tax farms (*iltizam*, *malikane*, also known in Syria as *muqata'a*) had become both saleable and hereditary.[113] Or else the land was leased as a *chiftlik* (*mazra'a*) to individuals, who became responsible for the *miri* tax due on it.[114]

[112]A and P 1914–1916, vol. 75, "Baghdad."

[113]For details, see *EHMENA*, pp. 134–137 and sources cited; Owen, *Middle East*, pp. 10–21, 43–44.

[114]Rafeq, in T. Khalidi (ed.), *Land Tenure*, pp. 374–376.

Syria

Studies of the records show that in Ottoman Syria *iltizam* was widespread, for example, in the Biqaʿ, where it was given to tribal chiefs; in northern Palestine, where it was sometimes held by the *amirs* of Lebanon or by local chiefs; and in the countryside around Damascus, Aleppo, and Homs, where it was in the hands of local notables.[115] The main taxes were the tithe (*ʿushr*)—usually a tenth of the crop, paid in kind—and the *iʿana,* or *farda,* a graduated head tax, but there were also many vexatious impositions. In 1845, if the villagers paid the tithe directly to the government, the *multazim* took a quarter of their crops; if he paid the tithe he took one-third[116] (see also II,1).

City-dwelling landlords did not farm their land directly but leased it to sharecroppers, a system known as *muzaraʿa* or *murabaʿa.* Usually, the landlord supplied a house, tools, seed, and livestock, and—if subsequent practice is any guide—took the greater part of the crop.[117] For their part, owner-cultivators usually had to contract loans, or to sell their crops in advance, in either case paying high interest rates.[118]

One more aspect of land tenure needs mention: *mushaʿ* or collective property. Under this system the village land was periodically reallocated among its families, according to the number of males, or under other criteria. Thus each family received noncontiguous plots in those parts of the village land that were planted in the particular year, following the rotation adopted by the *shaykh* or village elders. The plots were farmed individually.[119]

In the period under review, land tenure was deeply transformed by two sets of forces. First, there was the increasing commercialization of agriculture, which raised land values and greatly increased the desire to hold land in private, unconditional ownership. Second, there was the government's attempt to increase revenue from land by abolishing intermediaries between the state and the farmer and making the latter responsible for taxes by assigning him property rights. As a result, the old communal ties were loosened and private property became more general. At the same time, much land was alienated from its original holders, and passed into the hands of tribal or local chiefs, city merchants, moneylenders, government officials, or other powerful individuals.

In 1831 Mahmud II took over the remaining *timars* and in 1839 *iltizam* was officially abolished; however, it had to be reintroduced in 1842 and was once more abolished, in 1856. An attempt by Ibrahim pasha to do away with *iltizam* in Syria was also unsuccessful. In fact, tax farming seems to have continued until the beginning of this century.[120]

[115]See papers by Abu-Husayn, Bakhit, Pascual, and Rafeq in ibid.; Owen, *Middle East,* pp. 17–20.

[116]Rafeq, in T. Khalidi (ed.), *Land Tenure,* pp. 383–388.

[117]A and P 1859, vol. 30, "Aleppo"; Pascual, in T. Khalidi, *Land Tenure,* pp. 361–365; Weulersse, *Paysans,* pp. 121–132; Hannoyer, in Raymond (ed.), *Syrie,* pp. 286–287; Hanna, *Al-qadiya,* vol. 1, pp. 119–125; in 1856, sharecroppers near Jaffa bore all expenses and surrendered a quarter to a half of their produce (Reply to Questionnaire, FO 781/419).

[118]Rafeq, in Udovitch (ed.), *Islamic Middle East,* pp. 663, 674–675.

[119]Weulersse, *Paysans,* pp. 99–109; Warriner, in *EHME,* pp. 74–76; Latron, *La vie rurale,* pp. 14–18; Granott, *Land System,* pp. 174–179; Yakov Firestone, "Faddan and Musha," paper presented to Conference on the Economic History of the Middle East, Princeton, N.J., 1974; Wilson, *Peasant,* p. 189.

[120]See Baer, in *EHME;* Sluglett, in T. Khalidi (ed.), *Land Tenure,* pp. 410–412. In 1851 the British consul in Aleppo reported: "The principal reform undertaken for the benefit of Agriculture is having taken from the

The Land Code of 1858 had more momentous consequences. It sought primarily to "tax every piece of land, and therefore to establish clearly the title to it by registering its legal owner as a *miri* owner," that is, one who enjoyed hereditary possession and use of land, confirmed by a deed, the *tapu temesseku* or *tapu sanad,* while ownership continued to belong to the state. In pursuit of this aim, the code forbade collective ownership or the registration of a whole village as an estate by an individual. In Anatolia, the code facilitated the spread of small peasant farms, which was also probably one of the consequences desired by its framers.[121] But in the Arab provinces it ran counter to village and tribal practice. Moreover, records were poor, the administration was understaffed, untrained, and corrupt, and peasants, distrusting the government and its purposes, and often unable to establish their occupancy, did not press their claims and sometimes supported the local notable in registering the whole village in his name. This resulted in the loss to the state of vast areas, some of which were taken over by Sultan Abd al-Hamid (e.g., near Hama and in northern Palestine); in all the sultan is said to have owned 1114 villages in Syria, a figure that seems too high.[122] It also led to the emergence of a whole body of large landowners, a development that was not necessarily viewed with disfavor by the authorities, since it could facilitate the collection of taxes. Other large estates were built up with land acquired in foreclosures for debt.[123] Rough estimates for 1913 show that 25 percent of Syria's total area was in small holdings (under 10 hectares), 15 percent in medium holdings (10–100 hectares), and 60 percent in large holdings (over 100 hectares); more accurate figures for the Syrian Republic in 1945 are 15, 33, and 29 percent, with 23 percent in state lands. Small holdings were most widespread in Hauran and Jabal al-Druze and large holdings in Damascus, Aleppo, Jazira, Latakia, and Homs.[124] More generally, small ownership was prevalent in the neighborhood of towns, where there was more security, and in humid or irrigated areas, where yields did not fluctuate widely from year to year, putting an intolerable strain on small farmers. At the same time *musha*ʿ survived in many areas, for example, in Palestine where, in the 1930s, it covered 70 percent of the total area.[125]

As regards the price of land, in 1895 Cuinet gave the following estimates: fertile, irrigable land, 350 piasters per *dunum* (880 francs per hectare); mediocre, irrigable land, 175 piasters (440 francs); nonirrigable land, 75 piasters (188 francs). The gross return of land was put at 15.5 percent; of this 6.5 percent was absorbed by labor and other costs, leaving a net return of 9 percent.[126]

Two areas require more detailed treatment: Lebanon and Palestine. Lebanon had a

Malekanes, or proprietors of the villages the receipt by them of the Tithe or Tenth, by making them a compensation calculated on the receipts of the average of five years, which they have rendered, thereby preventing the Proprietors from interfering with the Peasants, who are henceforward to account direct with the Government, the latter furnishing the Peasants, when required, with cash and seed." Werry to Palmerston, 28 February 1851, FO 78/871.

[121]*EHT*, pp. 202–210.

[122]Hanna, *Al-qadiya*, vol. 1, p. 99.

[123]Sluglett, in T. Khalidi (ed.), *Land Tenure*, pp. 413–421; Baer, in *EHME*, pp. 83–90; Warriner, in *EHME*, pp. 72–78; Klat, "Origins"; Schölch, in Owen, *Palestine*, pp. 21–26; Gilsenan, in T. Khalidi (ed.), *Land Tenure;* Hanna, *Al-qadiya*, vol. 1, pp. 100–104.

[124]Hannoyer, in Raymond (ed.), *Syrie*, p. 288; see also Hanna, *Al-qadiya*, vol. 1, p. 103 and 133–143.

[125]Hannoyer, in Raymond (ed.), *Syrie*, p. 292; Baer, *Fellah*, p. 136; Hanna, *Al-qadiya*, vol. 2, pp. 37–39.

[126]Cuinet, *Syrie*, pp. 334–335.

political and social system that was closer to European feudalism than was that of any other Middle Eastern country.[127] Property was widespread: according to Bowring, "In Mount Lebanon almost every male inhabitant is a small proprietor of land. In the neighbourhood of Beyrout there are also a great number of landholders who, for the most part, cultivate the wild mulberry tree. Large proprietors there are few, except among the emirs of Mount Lebanon, some of whom have extensive lands, which they either cultivate for their own account, or let out to farming tenants." Volney also remarked that, "Unlike Turks every man lives in a perfect security of his life and property," and attributed to this the extensive terracing and other improvements made by the peasants.[128]

Population growth (II, Introduction), the expansion in silk production (see above), and the commercialization of the economy put an increasing strain on Lebanon's scarce land. At the same time the growth of an urban bourgeoisie and education began to spread ideas of liberation among large numbers of Christians (II,3). A further complicating factor was that, in southern Lebanon, many Maronite peasants worked the lands of Druze *muqata'jis* (feudal chiefs). Agrarian unrest led to four uprisings between 1820 and 1860, of which the last was the most violent and led to peasant seizure of land; all of them were soon transformed into bloody clashes (II,2 and 3).[129] The Règlement of 1861 (II, Introduction) abolished the remnants of feudalism and gave Lebanon a political and administrative structure conducive to development. Much land was purchased by peasants with funds sent by emigrants (III, Introduction) or acquired through *mugharasa,* under which a tenant planted and tended a plot bearing trees and after 10–20 years received a quarter or a half of the land. Mount Lebanon became an area where small ownership overwhelmingly prevailed, but in the areas added to it to form the republic—'Akkar, Biqa', and, to a lesser extent, South Lebanon—there were large estates.

Regarding Palestine, the most important development was the founding of German and Jewish colonies and the acquisition of land by various Christian churches. Although foreigners were forbidden to own real estate, a very small amount of urban and rural property was acquired by association (VI, Introduction) or other subterfuges. The 1867 law removed this restriction, but the Ottoman authorities, fearful of foreign settlement, repeatedly thwarted its application, and as often had to retreat under pressure from the consuls. The Christian churches—Orthodox, Catholic, Protestant, and Eastern—acquired substantial properties.[130] The Templars, a German Protestant group, started buying land in the 1860s and established colonies around Haifa, Jaffa, and Jerusalem (selection 13).[131] By 1890 they had some 4000 hectares worth £400,000, and by 1913 the land was

[127]See Harik, *Politics and Change,* pp. 3–73; Chevallier, *La société,* pp. 80–105; Swedenburg, *Capitalism,* pp. 88–98.

[128]Bowring, *Report,* p. 102; Volney, *Travels,* vol. 2, p. 73.

[129]The literature on this subject is extensive. See the works by Baer, Buheiry, Chevallier, Hanna, Kerr, Khalaf, Khuri, Porath, Smilyanskaya, and Touma in Bibliography, and Owen, *Middle East,* pp. 160–166. For other peasant uprisings (e.g., in Palestine, the Ansariyya Mountains, and Jabal al-Druze in the 1830s–1880s), see Hanna, *Al-qadiya,* vol. 1, pp. 160–162, 175–190. For the 1835 uprising against the local Derebeys in the Jisr al-Shughur area of Aleppo and the very oppressive conditions prevailing in 1880, see dispatches by Goschen of 20 July and 14 August 1880, in FO 195/1305.

[130]For details see Kark, "Changing Patterns."

[131]As early as 1850, the British consul in Jaffa had reported: "Two Prussian families (eleven persons) arrived here lately from Germany and I hear their object is to settle in this land as agriculturists." More were expected to follow (Kayat to Palmerston, 15 February 1850, FO 78/839). It is not clear, however, whether these settlers were Templars.

worth twice as much; in all, they had 624 colonists in the villages and 1400 in the cities. Their farming methods were good (selection 15).[132]

Jewish agricultural settlement began in the 1870s. Several organizations gave the necessary support, the most important being the Palestine Jewish Colonization Association (PICA), sponsored by Baron Rothschild who, by 1914, had invested £1.6 million. The settlers, lacking previous experience, tended to adopt local crop patterns, and some employed Arab labor but used better equipment and methods. This development was frowned on by the socialist wing of the Zionist movement, which, fearing the emergence of a "planter class," in 1909 founded the first *kibbutz*, in Dagania. By 1914 there were 12,000 rural settlers, occupying 41,000 hectares.[133] With regard to Arab property, in 1907 Auhagen, a reliable observer, estimated that in Galilee about 20 percent of the land was held by peasants, in Judea about 50 percent, and in Transjordan about 15.[134]

Iraq

For many centuries Iraq was more tribal than Syria, a fact reflected in its land tenure. The greater part of the irrigated zone was controlled by various tribal confederations, such as the Shammar, Banu Lam, Albu Muhammad, Muntafiq, and others. The area over which the tribe claimed sovereignty, the *dira*, was vast, tribesmen often alternating agriculture with livestock raising and shifting to new plots of land where salination or exhaustion rendered unfit the land previously cultivated. Over the lands they occupied, the tribes claimed the right of *lazma* (holding), acquired through conquest or the "vivifaction" of "dead" lands by irrigation works.[135] The land chosen for cultivation each year was allocated among the various subdivisions of the tribe, down to a *qit'a* under a *sarkal* (subchief), who parceled it out in plots (*faddan*) to groups (*joks*) or individuals, but retained the managerial decisions, such as fixing dates of sowing and harvesting, supervising irrigation works, and advancing seed and money. In the northern raid-fed zones Kurdish farmers were more settled, cultivated a specific piece of land year after year, and paid to their chiefs rents that seem to have been relatively low.[136]

This system ran counter to the basic principles of Ottoman land tenure, but the government, which seems to have introduced the *timar* system to only a limited extent when it was at the height of its power, was not able to do more than assert its position as overall landowner and accordingly claim a share in the land revenue. This it did by granting *iltizams* to the *shaykhs*, who passed on to it some of the surplus they took from the cultivators. According to a British consul writing in 1867, and cited by Haider, 82 percent of the land in the irrigation zone was in *miri* tenure and only 12 percent in *mulk*. In 1869–1872, however, the reforming governor Midhat pasha (II,31 and 32, and VII,23) attempted to apply the 1858 Land Code. Under Article 78, anyone proving 10 years of undisputed occupancy could register his rights and obtain a *tapu* title deed; however, there

[132]Kark, "Changing Patterns"; Carmel, *Siedlungen*, passim; Schölch, in Owen, *Palestine*, pp. 42–45.

[133]Ruppin, *Syrien*, pp. 81–88; for details see Giladi, "Agronomic Development," in Maʿoz (ed.), *Studies*, pp. 175–189.

[134]Auhagen, *Beiträge*, p. 52.

[135]Jwaideh, "Aspects," in T. Khalidi (ed.) *Land Tenure;* see also her *Land and Tribal Administration* and "Midhat Pasha"; Batatu, *Old Classes*, pp. 63–152.

[136]Haider, in *EHME*, pp. 163–178; see also Nieuwenhuis, pp. 115–117.

were certain exceptions.[137] But the application of the code raised even greater problems than in Syria. Some tribal *shaykhs,* in both the rain-fed and irrigated zones, notably Nasir pasha al-Sa'dun, the chieftain of the Muntafiq confederation, registered the greater part of the tribal land in their names or that of their relatives or employees.[138] Most *shaykhs,* however, refused the government's offer, distrusting its motives and being fearful of taxes and especially conscription, which had just been introduced. On the other hand, many townspeople put in claims on tribal land, attracted by its increasing commercial value. These claims were ignored by the tribesmen and the ensuing conflict was settled by the relative power of the government and tribe. Near the towns, the new owners were upheld and the tribesmen became tenants; in the remoter areas the tribe kept outsiders away. In addition, a large part of Iraq was taken over by Sultan Abd al-Hamid and became known as *aradi saniyyah* or *mudawwara.* Finally, many *sarkals* were charged by the government with collecting revenues and took advantage of this to acquire land, or take a larger share of the crop.[139]

Some minor improvements and modifications were made in the 1870s, but they were ineffective. Hence—and in order to increase land revenue—in 1880 and again in 1892 decrees were issued suspending the application of article 78 (which granted *tasarruf* rights under *haqq al-qarar,* or establishment of occupancy) in the irrigated zone. This created a new class of land, which, strictly speaking, was extra legal, since in it both *raqaba* and *tasarruf* belonged to the state, although it was occupied. To increase confusion further, this became known as *aradi amiriyya,* or *miri* (note the new meaning of the term), whereas land that had been registered was termed *tapu.* (This corresponded to *amiriye* or *miri* in the Ottoman Code; (see selection 33.)[140] The new *miri* was regarded as state land held by occupiers on a short lease, as tenants at will, who could be evicted at any time and from whom the state could demand any rent it chose. Here again actual conditions were determined by the relative power of the state. In the more remote areas the *shaykhs* remained the only possible tenants, but near the towns they were often dispossessed or charged high rents. A rough estimate by Cuinet for Baghdad province in the early 1890s was that the sultan owned 30 percent of cultivated land, 20 percent was *waqf* (mortmain), 30 percent was *aradi amiriyya,* and only 20 percent *mulk* or *tapu.*[141] After the sultan's downfall, his lands were added to *aradi amiriyya.*

The most important disadvantage of the system was that it did not give occupants any security and therefore deprived them of incentive to improve. After the First World War the British authorities, relying heavily on the chiefs and landlords for political support, maintained the Ottoman system with some modifications drawn from Indian experience. Hence, in spite of various mild reforms such as the Miri Sirf Settlement scheme, right up to the 1958 revolution, Iraq continued to be a country of large landownership in which the bulk of the rural population worked as tenants: only 37 percent of the privately held land was in properties under 125 hectares, held by some 250,000 owners, and 4500 owners held the rest of the land.[142]

[137]Jwaideh, "Aspects," pp. 340–343.

[138]Ibid., pp. 345–347; Haider, "Land Problems," p. 167; Owen, *Middle East,* pp. 183–188.

[139]Jwaideh, "Aspects," pp. 346–351.

[140]Haider, in *EHME,* pp. 169–170.

[141]Cited by Owen, *Middle East,* p. 280.

[142]Sluglett, *Britain*; Sluglett and Sluglett, "Transformation"; Warriner, *Land and Poverty,* pp. 53–152, and table on p. 54; Owen, *Middle East,* pp. 279–285; Batatu, *Old Classes,* pp. 53–62.

1

Lebanese Agriculture, 1850s

The pattern of agricultural production and land tenure in Lebanon is strikingly different from that prevailing in the rest of the Fertile Crescent. . . . The object of this article is to present some additional, primarily economic, information drawn from a report presented by the British Consul in Beirut. This was in response to a circular sent in 1858 by the Consul General in Constantinople to all the consulates in the Ottoman Empire, requesting statistical and economic information on their districts. The replies are available in two unpublished volumes at the Public Record Office in London (FO 78/1418 and 78/1419) and contain extremely valuable data on Iraq, Syria, and Egypt, as well as on parts of Anatolia and some of the European provinces. In the following pages, the questions and replies pertaining to agriculture in Lebanon have been reproduced and a few comments added. Some words that are not clear in the photocopy have been put in square brackets, and three words in Arabic script have been transliterated and italicized.

I. What are the principal articles of agricultural produce in your district, whether obtained from arable land, pasture, gardens, orchards or fruit trees?

> The principal articles of produce in the Lebanon and the plains near Tripoli, Beyrout and Sidon are silk, olive oil and a superior quality of Tobacco. The several kinds of grain are wheat, barley, indian corn, millet seed, peas, beans, two kinds of sweet peas and a grain called "*suwais*—Swaiss"—as well as a great variety of vegetables. The vine and fig tree are extensively cultivated, but the former has more or less suffered from the blight during the last three years, except in the higher ranges of the mountain. Almost every kind of fruit, such as almonds, apples, apricots, black-berries, black and white mulberries, plums, prunes, pomegranates, peaches, quinces, pears, bananas, citron, lemons, oranges and prickly pear and small nuts, carrub, *kharrub*, etc. etc. grow in this district, especially near Ehden, and at the foot of the mountain near Beyrout, Tripoli and Sidon. The corn, fruits and vegetables above mentioned are consumed in the country. There are some pasture lands on the top of the mountains called "Djurd" which, besides providing food for cattle, are also frequented during summer by the Bedouins who feed their flocks of sheep and camels and upon whom the feudal chiefs, in their respective districts, levy a contribution either in kind or in money.

II. Exhibit in a tabular form, as far as is possible, the annual yield of each of these articles during the last ten years, and the average price of each at the place of its growth? [Table 1.1]

> The sharp rise in prices, accelerated by the outbreak of the Crimean War in 1853, has its counterpart in other parts of the Ottoman Empire. Using these figures, Table 1.2 may be constructed, showing the value of gross output, at the farm, of the main crops in 1846 and 1855.

> Thus, the gross value at the farm of the main crops was nearly £500,000 in 1846 and £1 million in 1855. Of this, silk accounted for over half—the relatively low price for 1855 should be contrasted with those for 1854 and 1856. Grains added up to less than a fifth of

From Charles Issawi, "Lebanese Agriculture in the 1850's: A British Consular Report," *American Journal of Arabic Studies*, vol. 1, 1973.

Table 1.1

Names of articles	Average annual yield during 10 years	1846	1857	1848	1849	1850	1851	1852	1853	1854	1855	1856
Silk[a]	260,000 okes[b]	P. 100	100	120	110	115	125	1855[c]	160	180	160	250
Oil	10,000 Crs.	650	650	700	700	750	800	900	900	1000	1400	—
Tobacco	2,000 Crs.	1800	1800	1900	2000	2000	2200	2200	2300	2400	2500	—
Wheat	500,000 Kilos	10	10	12	13	14	18	30	25	24	38	to 40
Barley		6	8	9	10	11	11	13	19	19	20	to 23
Raisins	5,000 Crs.	200	200	220	250	275	300	350	350	450	600	—
Figs	4,000 Crs.	130	150	150	150	175	250	275	300	350	400	—

[a]Native reeled silk. But cocoons reeled by European machinery introduced into Mt. Lebanon, first by French merchants in 1836, sells at double the price of the silk reeled by the native machinery. Independent of the success or failure of the crop, the state of affairs in France always exercises a great influence on the prices of Silk in Syria. The quantity of Silk produced in every other part of Syria does not exceed the half of that produced in Lebanon and its neighbourhood. In a fair crop Syria yields 500,000 okes. The olive yields one crop every second year, with some exceptions.

[b]Presumably the oke referred to was the *uqqa* equal to 1.28 kilograms; the cantar, the *Qintar*, equal to 256–288 kilograms, and the kilo, the *kaila* of 36–37 litres.

[c]*Sic.*

the total in 1846 and, even with the sharp rise in their price caused by the Crimean War, to under a third in 1855. In other words, Lebanon's concentration on high-quality crops, and its reliance on other parts of Syria for its grain requirements, which had begun in the 17th century, was already far advanced by the 1840s.[1]

III. Distinguish which are articles of export and what has been the amount exported in each year?

3. Silk, Tobacco, olive oil and dry fruits are exported from Beyrout. The amount of the export during the last ten years is calculated as follows:

Silk, from 1846 to 1856 —200,000 okes exported annually to France, Egypt and the Morocco ports; supplies the native manufactories

Oil " " —1,200,000 okes to Greece, Egypt and (?)

Tobacco " " —100,000 to Egypt principally

Raisins and dry figs, the produce of Lebanon have become articles of export to Foreign Countries

In 1849 20,000 okes of figs and 30,000 okes raisins
" 1850 20,000 " " 30,000 " " ⎫
" 1851 40,000 " " 60,000 " " ⎪
" 1952 50,000 " " 60,000 " " ⎬ for Europe
" 1853 50,000 " " 60,000 " " ⎪
" 1854 10,000 " " 20,000 " " ⎭ for the U.S.A.

Lebanon Tobacco is extensively used in Syria and is also exported to Egypt and Turkey as above, and some packages are sent to England and France every year. Oil has hitherto been all consumed in the Country and in supplying [native] manufactories. But from 1852 to 1855, owing to the injury sustained by the olive tree in the Archipelago, and the usual demand from France, the oil has been exported as above stated. . . .

[Based on Table 1.1, Table 1.2 may be constructed.—ED.]

[1]For details see *EHME*, pp. 226–247 and Chevallier, ''origines.''

Table 1.2

| | Value of gross output (in millions of piastres) | |
Product	1846	1855
Silk	26.0	41.6
Oil	6.5	14.0
Tobacco	3.6	5.0
Wheat	5.0	20.0
Barley[a]	3.0	10.0
Raisins	1.0	3.0
Figs	0.5	1.6
	45.6	95.2

[a] Assuming the barley crop was the same size as the wheat crop.

IV. Compare the average price of the several articles exported, at the place of their growth and at the place of exportation; specify the mode of conveyance to the place of exportation, the time thus occupied and the several charges incident on this transport?

4. The difference in price between the place of growth and that of exportation as regards the produce of Mt. Lebanon is inconsiderable. The silk pays 70 to 90 Piastres the Cantar. Oil and Tobacco are carried to Beyrout or to the ports of Tripoli at the average rate of 40 Piastres the Cantar. But a very great difference exists in regard to the several kinds of grain that form the sole produce of the plains of Balbeck, Bekâ, and the rich country round and beyond Anti-Lebanon and the Hauran. Owing to the bad state of the Roads and the use of camels, mules and donkeys in conveying the produce, which only travel upon an average 15 miles a day, the kilo of barley bought in the Country round [Damascus] at 9 Piastres costs at Beyrout 18 to 20 Ps. The transport of corn from the [country] to this place in winter, which sets in shortly after the gathering of the harvest, costs as much as the freight from the port of shipment to Syria to Europe. The calculations of the Merchants in regard to time are not [infrequently] frustrated by the detention of the muleteers on the road by the mud in the Bekâ and the snow in certain passes of the Lebanon and during the summer by the forcible seizure of the animals by the Authorities for Government Service. . . .

V. Describe the geographical distribution of the several kinds of agricultural produce, and specify what are the causes, physical, political, or social, by which productiveness and prices have been affected in the case of each article?

5. The narrow plains at the foot of the mountain are peculiarly adapted to the cultivation of the olive and fig trees, the middle ranges for the silk, and the higher ranges for the vine and corn. In the case of the Lebanon there are no political causes affecting agriculture, but beyond it, where grain is cultivated, the chief impediments to agriculture are want of security, the extortions practised upon the Peasantry by the Irregular Cavalry and the exorbitant usury which the authorities allow certain Capitalists to exact upon anticipation, which the villagers, in their pecuniary distress undertake to pay at the time of their crop.

The knowledge of agriculture of the peasants is very limited and only acquired by tradition, because there are neither works nor Societies nor schools for its amelioration or encouragement. There are various physical causes which affect the several crops above mentioned—the principal one is generally insufficiency of rain during the winter. The south easterly winds, called Scirocco, are fatal to the silk worm, if they prevail in May, the time of the formation of the cocoons. . . .

VI. State in what respect the mode of cultivation in the several branches of agriculture is defective, and in what manner it might be improved?

 6. As regards this district the use of the thermometer for regulating the temperature in the early stages of the silkworm is wanted, as well as works upon agriculture and the implements of modern invention. Although the supply of water for irrigation is plentiful, the principal streams crossing the Lebanon are wasted from the absence of canals and aqueducts. The traces of those made in ancient times are still visible in some localities and could be repaired if encouraged by the Government. The present state of things does not provide the necessary protection to Capital; and even were provisions to be made with that view, the native capital would be inadequate for similar undertakings, especially as there are no banking establishments, and that even at the present rate of interest of 12 percent considerable sums of money cannot easily be procured. Were these deficiencies to be supplied there is no doubt that agriculture might be considerably improved. But the land belonging to the State can never be expected to be used to the best advantage unless it be sold to private individuals or Companies. . . .

VII. What are the implements employed for agricultural purposes, to what extent has machinery been substituted for human or animal labour, and what additional machinery might be employed with advantage?

 7. The implements at present in use are the ordinary plough drawn by oxen, and the *mi'wal* for tilling the ground with the hand. These are considered as the best adapted and most economical for cultivation in the mountainous districts and plains where corn is cultivated. The use of modern machinery is altogether unknown—everything is accomplished by animal or manual labour. But so long as the land is under the control of the Government and the present system of farming the villages is continued the roads remaining in their actual state no improvement whatever can be expected. The peasants are so much discouraged and disheartened that they allow the manure to accumulate near the houses, and instead of removing it to the fields for the benefit of the crops get rid of it by setting fire to it. When asked about such indifference the answer is ''Why should we take so much trouble when we have but a transitory interest in the land?''

VIII. What are the usual terms on which money is advanced on land? Are mortgages common, and are they often foreclosed?

 8. No such advances are made in the Lebanon because the land is free-hold.[2] The tenants enjoy one fourth of the crop for their trouble in gathering it in, and taking care of the property. Mortgages are not uncommon, the lender of money enjoys the rent [until he] is reimbursed, but are not transferable. . . .

IX. Is land usually cultivated by the landlord or tenant, and what different forms of tenancy exist?

 9. The Inhabitants of the Lebanon mostly own land which they cultivate for their own account. Another portion of landed property belonging to the Aristocracy and Clergy is given to the tenants with whom they conclude contracts of different modes of tenancy on the following terms. For instance, the tenant of mulberry plantations receives the fourth of the produce for his trouble in rearing and nursing the silk worms and the landlord paying all expenses of cultivation, lodging, implements and repairs. Another mode is to give the tenant the third of the produce, requiring him to pay the expense of cultivation; and a third

[2]That is, *mulk,* not *miri.*—Ed.

mode is to give the tenant the half of the produce rendering him responsible for all the expenses as well as for any deficiency in the produce of the leaves, which should he increase by his care, he receives a compensation varying from 5 to 10 per cent. In the cultivation of land, which is not planted with trees, the tenant receives the half, himself providing one half of the seed and all other expenses. In some locality [*sic*] the landlord gives the two thirds of the produce, requiring the peasant to provide all the seed and defray every other expense. . . .

X. What is generally the nature of the engagement between employers and agricultural labourers?

10. The conditions vary according to the supply of labourers; in some places, a man ploughing with two oxen receives 10 Piastres. The rate of hire also varies in proportion to the ability and capability of the men and animals employed. The wages also vary in winter and summer according to demand. A workman employed by the day receives from 4 to 6 Ps. a day. Those employed by the year to take care of oxen and drive them in the field are fed by the landlord and are paid from 200 to 300 Ps. a year; In the plain from [900] to 1000 Ps., inclusive of his food.

XI. To what extent is serfdom or any kind of compulsory labour still in existence?

11. In the Lebanon and at Beyrout no compulsory labour exists. The feudal chiefs, however, still continue to treat their tenants in an arbitrary manner with very slight chances of redress.

XII. What is the present rate of agricultural wages, how far has it varied during the last ten years, and to what causes may its fluctuations be properly attributed?

12. The rate of wages for a common workman varies at present, as stated in reply X, from four to six Ps. a day. In town it has increased about 30 per cent during the last ten years; but this change has not been felt in that part of the Lebanon where the peasants do not enjoy the necessary freedom.

XIII. What is the social condition of the agricultural labourer generally? What races or classes supply the best labourers? Is there any excess or deficiency of indigenous labour, and, if the latter, from what countries is it supplied?

13. The workman generally live comfortably. In late years their condition has improved owing to the demand arising from the unusual attention paid to Agriculture provoked by an increase in the prices of produce as shewn in the table annexed to these queries; as well as to the erection of numerous private buildings. No foreign workmen are employed but one district supplies the deficiency in the other, a great portion of the workmen at Beyrout are Christians from the mountain and some Egyptians.

The information on wages may be supplemented by data from other sections of the reply from Beirut and from replies by other consulates. Regarding the first, it is stated that Mount Lebanon "unlike the other districts of Syria could supply a considerable number of robust labourers at a moderate rate of wages varying from 8d. to 1/- a day." Average daily wages in Beirut were: carpenters 8–14 piasters, plasterers 8–12, and common workmen 4–6. In the "mountain wages are at the same rate." [See II,19 and *EHT*, pp. 37–43.]

These rates were only slightly above those in other parts of geographical Syria, somewhat higher than in Iraq, and somewhat lower than in the islands and European

provinces, . . . In the absence of comparable information on prices, it is impossible to say whether these differences represent variations in real wages. [See II,19 and *EHT*, pp. 37–43.]

XIV. Is there much outlay for the ultimate improvement of the land in such operations as drainage, irrigation, manuring etc.?

14. There is no considerable outlay for operations of this kind. Some outlay is however made occasionally on a limited scale for irrigation in the plain of Beyrout.

XV. What public works are most urgently required for the development of agriculture? And which of them could be best executed by grants from the Government, by local, or by trading companies?

15. The greatest desideratum in this part of Syria is to render the high way between Beyrout and Damascus thro' the Lebanon practicable for carriages. This project is favorably viewed by the Merchants at those two places: but they are waiting for encouragement. The next step required is the cession of land in the valley of the Bekaa and Balbec and beyond anti-Lebanon to [private] individuals, in which case the Government would meet with advantageous tenders, and the benefit to the Treasury and the Custom house would be immensely increased, the temptation to corruption greatly diminished and the Authorities as well as the peasants relieved from the constant depredations of lawless [men] who frequently descend from the wild fastnesses of Lebanon and anti-Lebanon to prey upon the defenceless peasants of the plain, thereby providing themselves with the means of subsistence which enables them to persevere in their defiance to the legitimate authorities; so long as the present state of things exists every measure or step taken on behalf of the Govt. or any Company native or foreign would be unavailing nay more than idle. The root of the evil lies in the two above stated main causes of the discouragement of Agriculture and the want of common security.

XVI. What is the present average value of land and through what causes has it increased or diminished, if either, within the last ten years?

16. At Beyrout the value of land is high, as it is required for building purposes, the Government standard being twelve Piastres the square pike. In the suburbs it costs half that amount. But in this district generally the value of property is reckoned by the income it gives—for instance the mulberry from 200 to 500 Piastres the load of leaves weighing 25 okes, varying according to climate favoring the silk worms. A piece of land sufficient for sowing a kilo of corn is worth from 4000 to 6000 Ps. according to locality. But these prices form a very remarkable contrast with those in adjoining districts where land is worth a fourth thereof. The value of property in this district generally has increased more than twofold during the last 10 years, which is attributed to a greater security and prosperity, to the development of European Commerce with this Coast and to the increase in value of produce already alluded to.

XVII. Has any survey and valuation of landed property been made by the Government, and what is the local mode of measuring land and calculating its value?

17. The property in Lebanon and at this place being freehold, and the Government receiving only a fixed tribute of 3,500 Purses [a purse equaled 500 piasters] a year thereon, no valuation or Survey of property has been made. A mode of measurement for an equal assessment of taxation among the Inhabitants had been attempted in 1847, but was not completed owing to the recall of the Commissioner Emin Effendi. The mode of measuring or valuing landed property is mentioned in answer to preceding query. It is different

however, in the plains beyond Lebanon, where property being Crown land is measured by the "Feddan", that is such an extent of land as can be ploughshed by a yoke of oxen in a day.

XVIII. What usage prevails in your district as to leaving lands in fallow?

18. In some localities the land is only sown every second year. In others where the ground is rich and can be irrigated the kind of seed only is changed, and the land sown every year.

CONCLUSION

In conclusion, the reply to the 1858 questionnaire provides a landmark for measuring the path traced by Lebanese agriculture in the last hundred years.

First, it shows that some of the characteristic features of present-day Lebanese agriculture were already clear by 1858. There was a marked concentration on cash crops, for export—this has continued, but the composition of these crops has changed, in response to shifts in world demand and prices. A high density of rural population already prevailed, a condition not appreciably affected by large emigration overseas and the rapid growth of Beirut and the other towns. And the value of land was already much higher than in surrounding countries, and has since increased severalfold as a result of the rise in incomes and the increasing inflow of funds generated in commerce and the services.

Second, Lebanon was already a country in which small-scale landownership was prevalent. This has since spread, as a result of the 1858–1860 revolts, the purchase of land by returning emigrants and their families, and the breakup of estates through the extension of *mugharasa*.

Third, irrigation, which was then restricted to very small areas, expanded very slowly until the Second World War, after which it spread more rapidly.

Fourth, poor transport was still a great obstacle to agricultural development; however, improvements were already under way, and were greatly to increase in the following decades.

Finally, techniques showed practically no change until the Second World War. Since then, there has been a rapidly increasing application of chemical fertilizers and growing use of machinery, pesticides, and selected seeds.

2

Sponge Fishing, 1839

Sponge fishing is carried on by Greek and Arab divers. The former are the better divers, plunging to a depth of 29 fathoms, whereas the local divers go only to 19–20 fathoms; however, some of the latter are as bold as the Greeks.

Some Greek boats fish with tridents. However, they can operate only in perfectly calm weather, using a drop of oil, which they drop into the water and which spreads on the

From "Report on Sponge Fisheries," 28 August 1839, CC Alep 1830–1837, vol. 29.

surface, enabling them to see the sponges at the bottom and to fish them out with tridents; sponges fished in this way are worth 30 percent less than those picked by divers, for almost all get torn by the tridents.

All the Greeks who pursue this occupation come from the archipelago of Castel Rosso. In an average year some 290–300 Greek divers come to Tripoli, scattering from there all over the Syrian coast. At Tripoli, Batrun, and Latakia they hire boats suitable for fishing, each carrying 3–6 divers. The boats (*sacolives*) that the Greeks bring with them not being suitable for fishing, they lay them up at Tripoli and use them only for the journey and for carrying back the sponges they have fished out.

Almost all the divers of Castel Rosso work under the management of M. Bigliotti, a Tuscan subject established at Rhodes, who advances them money in winter and draws a contract obliging them to sell to him all the sponges they fish during the season at an agreed-upon price that is always below the sale price in this country, thus covering the value of his advances. M. Bigliotti used to carry on these diving operations on behalf of a British firm in Rhodes. For two years, he has done it on behalf of a business house in Marseilles, which supplies him with the required funds.

Sponge diving is practiced only between Beirut and Alexandretta; the coast of Caramania supplies very few sponges because the seabed is generally sandy, whereas that between Beirut and Alexandretta is everywhere rocky and it is here that good-quality and abundant sponges are to be found. The coasts of the island of Cyprus also supply sponges, but almost all of common quality—one seldom finds there fine sponges.

In addition to the boats manned by Greek divers, there are in Tripoli some 10–15 boats manned by local divers, in Beirut 2, in Batrun 8–10, and in Ruwad 4–6 (almost all the inhabitants of that island are divers, and in those years when they are not engaged in navigation or when sponges are very much in demand they are more numerous; at a pinch they can man 25–30 boats). In Latakia there are 6–7 boats, each carrying five or six divers.

There are three qualities of sponges, viz.:

Fine white sponges with small grain;
Venises—thick sponges for household use;
Hard, fine sponges, with yellowish grain.

It is very difficult to ascertain the exact amount of sponges that each boat can take in during the fishing season, since that depends on the prevailing weather. In a calm year a boat carrying four to six divers can gather 150–200 *okes* of sponges, and even more, of which one-third are fine and two-thirds *Venises* or hard-fine sponges. The boats with Greek divers do not fish a greater quantity than those with local divers, but their diving season is one month shorter, to allow them the time to go back home before bad weather sets in. One can therefore reckon the amount harvested by each boat at 150–250 *okes* of sponges, on average. Local divers fish on their own account. However, in winter the various European merchants advance them funds; they are obligated by contract to hand over to those merchants, at an agreed-upon price, the sponges they fish. Here one must never pay by the month or for the journey.

Last year fine sponges were sold locally for 50–100 piasters an *oke*, delivered on board ship (*rendue à bord*) and *Venises* and hard-fine sponges at 15–20 piasters. Merchants who had advanced funds obtained sponges at lower prices. Last year sponges were

very expensive because of great competition among buyers. In previous years fine sponges were bought at 50–60 piastres and *Venises* and hard-fine sponges at 10–12. However, I do not believe they will ever be available again at such prices, whether because of the increase in the currency supply (*augmentation des monnaies*) or because of the greater competition among buyers, which grows every year.

In an average year, 14,000–16,000 *okes* of sponges are fished off the Syrian coast; of these one-third are fine sponges and two-thirds *Venises* and hard-fine sponges. This kind of fishing could become much more extensive if it were well managed.

Local people start fishing for sponges in June and end in September. Greek divers arrive in mid-June and leave at the end of August.

Before sponges came into demand divers were less numerous and the sea threw on the shore many sponges that were picked up by anyone who found them. Nowadays very few get thrown up and one seldom comes across more than a few pieces on the beach.

It is only in the last 15 years that Greek divers started working off the Syrian coast; local divers were few and not skillful. Today some of them can match the Greeks. Formerly only French merchants had the right to buy sponges, and manage sponge diving, in Syria. Since the Egyptian campaign our merchants have lost this lucrative privilege. However, a few years ago M. Charles Guys, vice-consul of France in Tripoli, obtained from ʿAbdallah pasha a *buyurdi* [*sic*] that granted M. Thoumin, a French merchant, the exclusive right of fishing [sponges] in the whole of Syria. He also had the sole right of purchase. This merchant sold his privilege to M. Bigliotti.

Under Ottoman rule each Greek or Arab diver paid the government dues of 100 piasters for every 10 *Venise* sponges, plus 6 piasters in customs duty. . . . The Egyptian government has not yet cast its eyes on this branch of trade; so far it has not passed any regulations either abolishing or preserving these dues.

3

Tobacco Cultivation, 1843

(1) Kinds and varieties of Tobacco

(2) Soil, Climate, and Manure Suitable for Tobacco

In the whole of Syria, only tobacco needed for local consumption is grown. It is only on the western slopes of Lebanon, above Latakia, Saida, and Tyre, that tobacco plantation is more extensive and gives rise to a fairly active export trade with Egypt. In the neighborhood of the two above-mentioned towns cultivation began only after Djazzar pasha established a monopoly and very high duties on cotton, leading to its being given up and replaced by tobacco.

On the eastern slopes of Lebanon, and in the Anti-Lebanon, very little tobacco is grown and sometimes the crop does not even meet the consumption of Damascus and other inland towns. Christians do not grow this crop as well as do Metwalis, and it is the latter who supply the largest crops and the finest qualities.

From "Report on Tobacco Cultivation in Syria," CC Damas, vol. 2, 1845–1848.

Tobacco is normally grown on hillsides and mountain slopes of medium elevation. In the plains bordering the Mountain, cereals and leguminous plants required for feeding the country are grown; they would not thrive at a great height. On the high peaks it would be too difficult and too costly to work the soil, and the flocks that are usually left in the fields would not be able to stay so long in winter. One should not, however, conclude from this that tobacco does not do well on high plateaus, for the village of Sadjad, which is located on the summit of the mountain overlooking Djazzin, and which is covered with snow for several months, supplies tobacco that sells at twice as much as that of other villages. However, if it is wished to grow tobacco in cold places, it is necessary to replant seedlings grown in other districts with a higher temperature; otherwise germination would take place too late. . . .

Generally speaking, in Syria cow and horse dung are never used for manure, only that of sheep and goats being used. For tobacco the latter alone are applied. Whenever possible, flocks are stationed in the fields where tobacco is to be grown, or better still on an adjacent field which is higher up so that the winter rains can flow down into the planted field, carrying with them the animal and salty substances deposited by the flocks during their stay.

(3) Preparation of the Soil

When a plot of land is to be planted to tobacco, if that crop has not been grown on it before, it has to be broken, cleared of stones, and cleaned of weeds. For three consecutive years it must be manured and ploughed three times. The deeper the soil (i.e., the thicker the layer of vegetable soil), the more years are required for preparation; thus, the minimum is three years and the maximum six or seven. First a 2-inch layer of sheep or goat dung is spread on the surface of the field, which is then ploughed with the ordinary plough—the only one in use in Syria—that is, a piece of wood with an iron ploughshare. In order not to leave the land completely idle during the years of preparation, those plants can be grown in it that can be harvested before complete maturity, for example, barley (which can be cut when green to feed horses), cucumbers, squash, watermelons, etc. . . . After the fields have been prepared for three to seven years, they are ploughed six to seven times more in the spring, and the soil is then ready to receive the transplanted seedlings.

(4) Sowing and Thinning out

From the beginning of September to mid-November, squares of black and heavy soil, which has been carefully passed through a sieve, are prepared inside the villages, at the foot of the walls of the houses and sheltered from the wind. These squares are covered with chopped straw on which a layer of goat dung is spread and burned by setting fire to the straw. After the ashes have been mixed with the soil, by hand, the squares are covered with 2 inches of thoroughly pulverized dung, which is then left to rest until the beginning of December or, at the latest, the 15th of January. At this time the seed, mixed with two-thirds of its weight of ashes of common wood, is inserted in the soil (*au plat*) or sown broadcast. After that the soil is cultivated (*remué*) by hand and covered with brush to prevent the birds—which have a great liking for them—from digging out the seeds and hail from harming the young plants when they begin to emerge. This operation must be undertaken in very dry weather and if it has rained during the preceding days the soil must be left to dry for several days until it can be pulverized by rubbing and the clods that have been formed during the rain broken up. Every 15 or 20 days the seed lots must be inspected, and if the seeds have not yet germinated resowing is necessary. When the first

three leaves have appeared the brush is removed and the plant is no longer in danger. If the weather is dry and no rain has fallen the seedplots must be watered with watering vessels each two or three days at least. When at last the plant has reached the height of half a foot at the most, it is fit for transplanting.

In April, in the fields that have been prepared as we said before, furrows, spaced 2½ feet apart, are made with a plough; at the bottom of these furrows tobacco is replanted, leaving between the plants the same distance as that between the furrows. Until the plants have taken root, if the weather should be warm and dry, they must be watered every day, not by irrigation but each in turn by means of a jug with a spout, care being taken not to pour out the water too violently for fear of uprooting the plants. The plants must also be examined every day, to pluck out caterpillars and pull out weeds and as long as the tobacco has to be watered—that is, until they are firmly rooted and have reached a height of 1 foot—weeding is done several times by hand. When it is clear that the plant is well rooted, it is left to itself and care is taken not to water it, for at that stage water would be harmful. Those plants that are to be kept for seed are lopped, leaving only the corymbose of flowers, from which the central and terminal flower is removed if it towers over the others, and also those branches that are in the axils of the leaves. As for the other plants, which will provide the tobacco, they require no further care or operation, neither pinching nor lopping nor pollarding—they are left entirely to themselves until picking time.

(5) Animals Harmful to Tobacco

(6) Tobacco Picking

Tobacco picking begins at a season that varies according to the district where it grows and the atmospheric conditions it has experienced. Usually this is done in the morning, preferably in dry weather. Tobacco is picked at four successive times, constituting four crops distinguished not only by the time of harvest but also by the quality of tobacco produced. Usually they begin in June and terminate at the end of October. . . .

(7) Preparation of Tobacco

Each time tobacco is picked, as I have described, the leaves are stacked in bunches of 8 or 10, tied by the stalk. These bunches are laid out in concentric circles, stalks outside, in a field that has been carefully cleaned and left for four days and nights exposed to sun and dew. If it should rain, they are carried indoors. When the midribs (*côtes*) have wilted, the leaves are strung together by the stalks, with string or straw, forming a kind of file, which is left in the field for another four days and nights exposed to sun and dew—first on one side and then, for the same period, on the other. Finally, when it is judged that sun and dew have had the desired effect—which is indicated by the red tinge the tobacco acquires—one morning, when it is still damp with dew, it is picked up and deposited in a hole dug in the ground, its size depending on that of the crop, and lined at the bottom and on the sides with a layer of straw. The tobacco is then covered with mats, held down by large stones. It is then taken out and once more exposed to sun and dew for two days and nights on either side, then put back in the hole and pressed for two more days and finally taken out again and put for sale.

(8) Various Qualities of Tobacco

. . . Three qualities of tobacco are distinguished. The first, *djedar,* is all tobacco produced in the fields that have been chosen and planted as described above. It is also grown in the artificial fields set up in the neighborhood of monasteries.

The second, *ksar,* is the first crop picked on newly prepared fields that have not been previously planted to tobacco. It is worth 8–12 percent less than the first quality.

Finally, the third quality, *barrawi,* is tobacco planted in the first available field, and grown without all the care I have described. It is light, lacks substance and is worth only a half, sometimes a third, as much as *djedar.*

4

Sheep Raising, Damascus Region, 1851

. . . The people of Damascus carry out their business in the following way:

We have already seen that, on average, 100 ewes give birth to 50 lambs; that of these 50 lambs 25 are males and 25 females; we have also seen that each ewe provides $1\frac{1}{2}$ *ratls* of butter. All newborn lambs belong to the owner of the flock, who also gets half the fleeces and a third of the butter, that is, 23 *ratls,* because for every 45 ewes that have had their young the total amount of butter produced is 68–70 *ratls.* The beduin therefore receives 37 fleeces and about 48 *ratls* of butter.

The owner's profit may be reckoned thus:

For every 100 ewes, costing	5000	piasters
25 male lambs at 20 piasters	500	"
25 female lambs at 30 piasters	750	"
23 *ratls* of butter at 14 piasters	322	"
38 fleeces (because of a 25 percent mortality rate) at 5 piasters	190	"
	1762	piasters

This would represent 35 percent, but a 10 percent deduction must be made from capital, to take mortality into account; deducting 500 piasters from 1762 leaves a profit of only 1262, that is, 25 percent of the capital invested; this is very close to the rate of return on money in the Damascus market. The raising of livestock peculiar to the inhabitants of Hauran is effected as follows:

For every 100 ewes that are consigned to a beduin he receives 25 measures of maize (850 liters) which, at 5 piasters a measure (average price), represent an advance of 125 piasters. The beduin, for his part, gives up 63 of the 75 fleeces produced by 100 ewes and keeps only 9 [*sic*] for himself; however, he also keeps a quarter of the lambs, returning to the owner not 50, as in the preceding case, but only 38. But, instead of keeping 50 *ratls* of butter, as in the preceding case, he retains only 23 and hands over to the owner 46 instead of 23.

From Ségur to Minister of Foreign Affairs, 26 November 1851, CC Damas, vol. 3, 1849–1855.

Each side therefore receives the following:

The beduin gets 9 fleeces, 12 lambs, and 25 *ratls* of butter, not counting the 25 measures of maize;

The owner gets from his flock:

19 male lambs at 20 piasters	380	piasters
19 female lambs at 30 piasters	570	"
46 *ratls* of butter at 14 piasters	644	"
63 fleeces (because of a 25 percent mortality rate) at 5 piasters	315	"
	1909	piasters
Deduct the value of the maize	125	piasters
	1784	piasters

which would represent 35 percent; but because of mortality there is a further loss of 10 percent of capital, leaving a return of only 25 percent on invested funds. The rates of return are therefore equal under both systems.

5

Potential for Agricultural Development in Syria, 1855

DISTRICT OF AGELOON

This district has extensive arable lands on which every kind of produce could be raised. Mines of various metals likewise exist in it. Owing to its remoteness from Damascus, the roving Arabs have laid it almost completely waste, and for a number of years no attempt has been made to restore it to its former state of prosperity. With the view to bring the waste lands under cultivation a wealthy and influential person, named Sheikh Berakat, who is there, should be summoned here by the Government, and he would, provided the protection of the District were confided to his management, in a short time bring about a change for the better. The Treasury would assuredly derive much additional revenue in consequence. None of the Governors hitherto sent thither have been able to do anything without the assistance of Sheikh Berakat.

DISTRICT OF ERBID

This district likewise possesses extensive lands equal to those of Ageloon, and the Arabs have in the same manner been the cause of its ruin. There is an opulent Sheikh there who is able to do much good, and should the Government employ him he would greatly

From Wood to Clarendon. Damascus, 12 February, 1855 FO 78/1118.

contribute towards the improvement so desirable in the matter of public protection as well as in that of the revenues.

THE DISTRICTS OF GEBEL HAURAN [JABAL AL-DURUZ] AND THE HAURAN

The fertility of these two Districts is well known. The Hauran, on account of its greater exposure to the incursions of the Arabs, is subjected to large losses, as the Arabs levy contributions in kind from the cultivators. Were it to be efficiently protected against such causes of impoverishment, sufficient grain could be raised in the Hauran alone to supply the whole of Syria, and such are its resources that were the agricultural population to be increased ten fold they would still find land enough to cultivate. It would be an easy matter to render these Districts prosperous and to add very considerably to their revenues. The most effectual method of repelling the Arabs would be to appoint some of the Druse Chiefs, and Hauranese Sheikhs to the command of a mounted Irregular force in the pay of the Government. These Chieftains would cheerfully enter into engagements to keep the country clear of Arabs with even a smaller number of horsemen than is now employed for that purpose. In this manner these Districts would flourish, a larger amount of revenue would accrue to the Treasury, the inhabitants would enjoy greater tranquillity, and the expense now incurred for the rural Police force would be considerably reduced.

DISTRICTS OF HASBEYA AND RASHEYA

It is true that these Districts are mountainous and to all appearance in a flourishing condition. The inhabitants were almost wild and under no control, and not a thought was ever bestowed upon their improvement, so much so that, under the Egyptian rule, troops used to be sent to levy the taxes. At that period the Government satisfied itself with collecting the Miri which was levied in the aggregate sum. The same system of taxation was adopted by the present Government; but should the attention of the Turkish functionaries be directed towards the condition of these Districts it would be considerably benefited in every way. The people might be allowed to farm out their villages, as practised in other parts of the country, with advantage to themselves and to the public Treasury.

THE DISTRICT OF THE BAKAA

This fine and fertile District has been neglected by the Government, and is gradually falling into decay. The chief causes of its ruin are the continual change of its Governors, and the interference by some of the notables of Damascus in the villages, whither they send their agents who exercise every species of oppression over the peasants. To the above may be added the vexations practised by the inhabitants of the Lebanon, which are notorious. The imposition likewise of the grievous burden of One hundred thousand Piastres over and above the assessed taxes (regulated by the average of five years) has opened the door to much tyranny. The way to restore this District to a prosperous condition would be: (1) That the Government officials should cease to have personal interests in the villages; (2) that the inhabitants of the Lebanon be prevented from exercising their control over the villages; (3) that the extra-imposition of the Hundred Thousand Piastres be taken off; and (4) that the inhabitants be allowed to follow their ancient system of farming out their produce to private individuals by private contract.

DISTRICT OF BAALBECK

This district is, on the whole, in a flourishing condition. There are only three villages which are known to be in a ruinous state. On ascertaining, by a reference to the Register of Arrears, the amount of taxes due by these three places, they could be farmed out to some one for a period of several years, and their restoration would certainly follow.

DISTRICTS OF HAMAH, HOMS AND MUARRAH

These three districts have extensive and exceedingly fertile lands, but they have been turned to wastes by the Bedouins who overrun them and rule paramount over the land and its inhabitants. Up to the present moment the Tanzimat has not been introduced in those districts; and the Governors conspire with the notables against the people. There has long existed enmity between the Denatshee and Ansayris and the people to the prejudice of the latter. By protecting the peasants against the incursions of the Bedouins, by summoning the Chiefs of the Denatshee and of the Ansayris to the seat of local Government with the view of effecting a better understanding between them and those whom they now oppress, and employing them in certain places in the service of the Government for the protection of the country, by introducing the Tanzimat and the Imperial ordinances; by organizing the local Medjlisses on a more equitable footing so as to ensure due attention to affairs brought under their notice; and by causing registers to be kept of all public acts and every proceeding relating to the Revenue Department, the same to be submitted once a month to the scrutiny of the central Medjlis at Damascus, a better state of things would be necessarily ensue [sic] from the adoption of such preliminary measures.

DISTRICT OF DAMASCUS OR THE GHOOTA

The district of the city of Damascus is divided into four Communes, which with their respective villages extend over a distance of ten hours from the city. Whenever any dispute arises between the inhabitants, or any other affair occurs which requires the personal attendance of the parties concerned before a Magistrate, they are obliged to come to Damascus, and thus lose a considerable portion of their time in coming and going and in waiting. Whenever it is requisite to summon one of the peasants a special officer is deputed to fetch him. The collection of the revenue is similarly managed by the dispatch of special officers to the spots where the taxes are to be levied, and these officers invariably extort money for their trouble. It would be far preferable to adopt the system practised by the Egyptian Government, which consisted in appointing a Superintendant over each of the four Parishes or Communes, who was empowered to hear and decide all petty suits brought before him. Through such superintendants too the revenue could be collected expeditiously and without difficulty or annoyance to the people, who would thus derive all the advantages which a constant application to their own affairs, and the saving of much unnecessary loss of time and expense incurred under the present system would be certain to bring with them.

6

Silk in Lebanon and Syria, 1852, 1879, 1900

("Report on Silk," 16 September 1852, CC Beyrouth, vol. 6, 1848–1853)

This year transactions in cocoons and raw silk have been very large. Purchases—almost all by Frenchmen—have been put at about 14 million piasters. The greater part of the cocoons has been sent to Marseilles; that which remains in the country is used by the silk-reeling plants established in Lebanon, of which there are seven, five being managed by Frenchmen working on their own or on behalf of firms in southern France.

The considerable profits of the previous campaign resulted in an increase in speculation and an attempt to buy at any price, but I am afraid profit expectations will not be fulfilled. Hence, in spite of the downward trend on the Marseilles market, the *oke* of cocoons at harvest time was bought for 20 and even 24 piasters. It is true that for many buyers the *oke* of cocoons cost on average 13–15 piasters, because of advance buying; the peasants conclude contracts with the merchants by which they undertake to deliver at harvest time so many *okes* of cocoons, at an agreed-upon price that is paid on the spot. The peasants who resort to this kind of sale generally need cash, and the buyers take advantage of this situation to obtain as low a price as possible. But this is what happens only too often, and has led to interminable complaints at harvest time: prices, as we have said, rise to 20 piasters—what does the farmer, who has sold, let us say, at 12 do? Ignoring his obligations to the merchant, he sells at 20, making a profit of 8 piasters an *oke*. When asked to implement the contract he made in advance, he maintains that his crop was poor and that he cannot deliver the stipulated amount. In such a case the merchant must either come to some agreement with his debtor or sue him in a Court; but in the latter case it is still difficult, even if judgment has been given in favor of the merchant, for him to get back all the money he advanced. [This situation has led to jurisdictional conflicts between the pasha and the Druze Qaimmaqam of Lebanon]. . . .

The cocoons and silk will be transported to Marseilles by some 10–12 sailing ships. The new process, which consists in choking the worm by means of steam, makes it possible to press the cocoons and reduce their bulk very considerably. The trade seems decided to use, for the transport of next year's crop, the steamships of the Messageries Nationales. The speed of the journey, the security provided, and the lower insurance premiums charged—these three factors together outweigh the higher freight rates, which anyway will, it is said, be brought down. This will be the final blow to sail navigation on the Syrian coast, for imports are not sufficiently large to make it possible for ships arriving laden to Beirut to do without return cargoes. Unfortunately, they will find only cereals and oil, when their prices make exports possible.

(Dispatch to Minister of Foreign Affairs, 24 February 1853, CC Beyrouth, vol. 6, 1848–1853)

. . . It should be noted that the further one goes from Beirut the lower is the price of cocoons. Three or four years ago, the plain of Beirut and part of Lebanon supplied for

From CC Beyrouth 1848–1853, vol. 6; idem 1868–1888, vol. 9; idem 1897–1901, vol. 12.

export sufficient quantities and at prices that left a profit to both buyers and sellers; now one must go much further afield to find prices that yield a profit. I have been assured that the purchases made at all sorts of prices in 1852, at harvest time, would have caused losses had it not been for the fact that advance transactions, concluded at low prices, had brought down the average and established a balance.

In contrast the merchants who bought large amounts of cocoons, for delivery at harvest time, at Hasbayya in the south and in the Antioch plain in the north, have made very large profits because they were operating in new territories, unspoilt by competition. . . .

("Report on Silk," 10 September 1879, CC Beyrouth, vol. 9, 1868–1888)

As is well known, Syria is an important center of silk production. From Tripoli to Saida, and from the coast to the Anti-Lebanon chain of mountains, the Mountain is covered with factories for the raising of silkworms and the reeling of cocoons. These factories are an important source of income for the people of this country, who thanks to this industry grow large mulberry groves on land of low fertility which would otherwise have remained untilled and unproductive.

It is especially since 1850 that the raising of silkworms and reeling of cocoons have remarkably developed; today there are 67 factories, almost all in the hands of natives, whereas between 1840 and 1850 there were only 5, of which 3 belonged to Frenchmen. This rapid expansion is due to various causes. First of all I would mention the undoubted security that the new Administration has introduced in the Mountain and that, by giving the people the assurance that they will not be disturbed in their undertakings, has encouraged them to risk in such enterprises capital which during the previous state of turbulence they were forced to hide.

Second, the low cost of labor leaves a large margin of profits. Daily wages for men do not exceed 7 piasters (1 franc 40) and those for women never go beyond 3 or 4 piasters; this makes it possible for exporters effectively to compete with similar industries in Lombardy and the south of France where workers demand a much higher remuneration.

Finally, one should take into account the almost certain regularity of the harvest which, taking bad years with good, always works out at a remunerative average; it is not exposed to those climatic variations which we see in other countries and which only too often wipe out their crops. Hence Western markets turn willingly to Syria, knowing that it can almost certainly meet their supply needs.

In Lebanon, there are in all some 5800 pans, employing 10,000 workers for nine months of the year and producing 140,000–160,000 kilograms of silk. . . .
[The report goes on to state that the 1879 crop was put at 1.6 million *okes* (2 million kilograms), compared to 1.8 million in 1878. Pasteur eggs played a very minor part, Corsican eggs being mainly used. Japanese varieties were also in use, but 96–97 percent of them had been reproduced in Syria. The average price paid by filatures was $28\frac{1}{2}$–29 piasters per *oke* (4.40–4.50 francs per kilogram)].

(Sercey to Delcassé, 25 February 1900, CC Beyrouth, vol. 12, 1897–1901)

. . . In the Biqaʿ plain, in the neighborhood of Damascus, the growing of mulberries, unknown 25 years ago, is developing considerably day by day At the expense of vines and olives. In 1875 there were in all of Syria 4700 pans, of which 880 were

inoperative, in 1899 at least 9000. [The present cocoon crop amounts to 5,128,000 kilograms, producing 456,000 kilograms of silk, against 465,000 last year.]

Syrian factories, of which the largest are in the hands of Frenchmen, reel at both ends and knot the ends (*filent à deux bouts et à bouts noués*). Their equipment, in the way of fitting out and outbuildings, leaves much to be desired and cleanliness is almost unknown. Contrary to what has been done in Bursa, the improvements that have been introduced elsewhere are not applied here. Nevertheless, Syrian products compete favorably with those of Bursa and Italy, as is shown by the following figures:

First Class, Syria 55 (percent?), Bursa 53 Italy 56.

[Exports, including waste floss and inferior and superior *bassinés* amount to 22–25 million francs.]

7

Cotton in Aleppo Region, 1864

In the province of Aleppo cotton growing has always received much attention, but it is only recently that it has gained considerable importance and that its products feature among leading exports. Some 10 years ago, cotton growing was confined to national needs and merely supplied internal consumption. During the Eastern [Crimean] War it was completely given up in favor of cereals, to which the supply of the Allied Armies offered a large and profitable outlet. But after 1856, cereals not being in such demand in the Levant and market prices in Europe not offering profits to Syrian producers, grain cultivation returned to its previous limits and, as in the past, was confined to meeting the needs of the native population. Farmers therefore began to grow cotton, but it was only after the dearth resulting from the Civil War in the United States that its cultivation in Aleppo province—as in the rest of Syria, Anatolia, Kurdistan, and Mesopotamia—assumed such a development that the 1863 crop was ten times as large as those of 1857 and 1858. The 1864 crop promises to be even larger, but it is not yet safely in. . . . It is estimated that the province of Aleppo by itself will offer for export—after supplying local consumption—4000–5000 bales, that is, 400,000–500,000 kilograms of cotton.

Not only is the town of Aleppo the market where the cotton of the province is sold, it is also the entrepôt of transit for the cotton of Urfa, Mardin, Diyarbakr, Kharput, Kadiyemen, and other districts of Asia Minor. It is reckoned that the Aleppo market will be able to add, for export, some 3000 bales (300,000 kilograms) to the above-mentioned 4000–5000.

This cotton is classified, in the trade, in three qualities, viz:

First quality, originating in Latakia or Idlib;
Second quality, originating in Urfa or Mardin;
Third quality, originating in Kharput, Killis, etc.

From "Report on Aleppo Cotton," 9 June 1864, CC Alep, vol. 33, 1863–1866.

These qualities are determined by the length and toughness of the fiber and by the extent to which the cotton has been cleaned. In general, cotton supplied by the Aleppo market is badly cleaned and contains a large amount of fragments of pods. This is partly because cleaning is undertaken in winter, when the humidity of the atmosphere makes the fragments of pods stick more closely to the lint than in dry weather; it is also a result of the poor methods and bad tools employed. Attempts have been made to introduce into this country the machines used in Europe; but whether because people here did not know how to work them or whether, as is claimed, they are not suited to local cotton varieties, they were unsuccessful; it is affirmed that these machines, having been designed to treat cotton with a longer and tougher lint than native cotton, break Syrian cotton and appreciably damage it. Hence in the countryside people stick to the tools and methods with which the peasants are familiar.

Present cotton prices on the Aleppo market, which vary only in response to the fluctuations in the French and English markets, are for a bale of 100 kilograms f.o.b.:

First quality	440–450 francs
Second quality	425–435 francs
Third quality	410–420 francs

These prices include the following charges:

(1) 10 percent—for the tithe levied on all produce of the soil;

(2) 25–30 francs per bale of 100 kilograms for weighing and packing costs and cost of transport from Aleppo to Alexandretta;

(3) An export duty, which this year, under the [1861] Treaty of Commerce, should amount to only 6 percent but that in fact is often as high as 12 percent. For the Ottoman customs levy on farmers bringing their cotton to market an internal duty, collected on entering the city, on all produce intended for local consumption; but when this cotton is bought for export and changes its destination, the customs refuse to rebate the duty and insist that our merchants pay, in addition, the export duty. In vain have our merchants sought, through their Consulates and the Embassy of France in Constantinople, tax relief on the cotton bought in towns for export. . . .

[This report is followed by one on Cotton in Tarsus Province.]

8

Agriculture, 1871

. . . The produce of the rich vast plains, such as those of Hamah, Hauran, Beka, Samaria, &c., little more than suffice at present, under favourable circumstances, for the support of the scanty population. Large tracts of great fertility lie waste and depopulated, but presenting traces everywhere of former prosperity, and of a teeming population.

Agriculture knowledge is everywhere in a backward state. The old Roman plough,

From A and P 1872, vol. 58, "Syria."

drawn by bullocks is employed, while the rest of the tiller's implements owe their origin to still remoter ages. The "feddan," or admeasurement of land in Syria, is of various dimensions. It is popularly held to be that quantity capable of being ploughed by a pair of oxen throughout the year. It of course varies in extent, according to the fertility of the soil, and the nature of the land.

In hilly districts, where the soil is light, an average pair of oxen may keep under cultivation from 36 to 40 acres; while, in the plains, from 28 to 36 acres is the ordinary size. The quantity of seed sown varies also according to the nature of the ground, and its richness, averaging from 25 to 60 kilog. of Constantinople per feddan. The seed is sown broad-cast. The majority of portions of land are of 1 feddan only. The next most numerous are of $2\frac{1}{2}$, and few are found of more than 6 or 7.

The yield per feddan may be calculated at a very rough estimate at about 200 bushels of wheat, 50 of barley, 75 of millet, and 40 of sesame.

The proportion in which the cultivated lands are devoted to the various kinds of crops differ, of course, according to locality; but the following estimate of an average of five years in the fertile districts of Acre and Nablous, will give an approximate idea of the whole, save perhaps that of cotton and tobacco:

	Percent
Wheat	40
Barley	9
Millet	7
Sesame	13
Cotton	6
Lentils, beans, and peas	5
Tobacco	2
Water melons }	4
Vines and fig trees }	
Olive trees	14
	100

Crops are classed under two heads, viz., the summer and winter crop. The former consists of millet, Indian corn, tobacco, cotton, and sesame; and the latter, of wheat, barley, lentils, beans, chick-peas, and vegetables.

Rotation of crops is confined to the change in alternate years of the species of produce cultivated; thus, the land which this year is devoted to cotton, will next year be planted with wheat, and so on.

Manure is not used, and indeed, is seldom obtainable, save in pastoral districts, where, however, the unsettled state of the country, reduces cultivators to narrow limits.

No capital is laid out in agricultural enterprise in face of the system of taxation, vexations, and abuses to which the cultivator is exposed. In the less settled districts, by far the most fertile, such as the Hauran, for instance, the quality and yield of the wheat and barley, which are renowned throughout Syria, these impediments do not exist in the same degree, owing to the semi-independent state of the inhabitants preventing the introduction of the system of administration which obtains elsewhere; but capital is there totally wanting. In the settled districts, on the other hand, the farmer is happy who is able to clear a small profit by the result of his labours—a thing, however, of rare occurrence. The obligation to pay fixed tithes upon his produce, whether the yield is good or bad, taxation unfairly assessed, and illegal exactions of all who possess authority over him, from

the tithe-gatherer and tax-collector, to the rural police, to say nothing of the usurer, from whose clutches he is seldom free; all these circumstances combine to prevent his reaping beyond a miserable pittance from his toil. When to these impediments to prosperity are added those of bad harvests, involving recourse to the money-lender for the purchase of seed, and for payment of taxes, with money borrowed at rates from 25 percent to 40 percent, the condition of the Syrian fellah becomes a hard one, and he is soon hopelessly involved. This is the general position of the Syrian peasant throughout the country. Large fortunes are made out of the fruits of his labours, by the usurer and tithe-farmer, while he is left with barely enough to subsist upon. Protection he has none. Governmental action seems to have been limited so far to seeking fresh methods of taxation, and no thought is given to the prosperity of the country, or the improvement of the position of him whose labours create the source whence springs the national support. It is not, therefore, surprising that all energy, desire for improvement, and emulation, should be crushed out of him, and that his state should be that of the grossest ignorance and apathy.

The relations between him and those in authority over him are, as may be imagined, strictly inimical; and ages of misrule and oppression have stamped on his mind the belief that change in anything that concerns him must be resisted, as it can only conceal some covert scheme of adding to the exactions already wrung out of him. . . .

9

Problems of Agricultural Development, 1878

. . . 1. There is no want of labourers, despite the late heavy conscription, for the present primitive mode of cultivation which the poverty and ignorance of the fellah entails upon the land, and which is limited to scratching the ground and throwing in the seed, leaving all else to nature. Abundance of unskilled labour, at prices between 10*d*. and 1*s*. per diem, is available in all large towns, proceeding from that numerous body of the lower classes of the population which prefers the precariousness of livelihood with occasional glimpses of comparative plenty afforded by the cities to the poverty and hardships inseparably connected with agriculture. And the fact that this class forms no inconsiderable portion of the population of a country so thinly peopled as Syria carries with it its own tale. Again, no portion of the settled districts, still less the greater part of the land, is in the hands of wandering tribes.

2. The condition of the peasant obliging him to live a hand-to-mouth existence of the most wretched description, frees him from the charge of short-sightedness in not cultivating beyond what is needed for his own sustenance. He is utterly without means for such extension. The extent of his means may be judged from the fact of the French Damascus and Beyrout Road Company having offered the peasants along their line their large accumulations of manure if they would take it away; the offer remains without effect, because the peasants are too poor to provide transport by horse or donkey to their

From Report by Jago, FO 78/3070.

neighbouring fields. Even with the exceedingly sparse population of the agricultural districts of Syria and Palestine, the want of any constant remunerative employment at home or abroad obliges the peasant to remain in idleness during many months of the year. In the mountainous regions, where winter crops are chiefly raised, the means of cultivation at his command restrict his efforts to ploughing and sowing in the autumn, and to reaping and threshing in the summer: operations which occupy at most four to five months. When the situation permits also the raising of summer crops, his time is more generally occupied, but still with a considerable period of enforced idleness. No doubt ages of oppression and misrule have had their natural effects in crushing energy, desire for improvement and spirit of emulation besides inducing apathy to a great extent; but even if it were far otherwise such characteristics would be valueless under the present system. That idleness is voluntary is again negativated by the fact that throughout the entire country, peopled after a fashion by races possessing far different characteristics, the condition of agriculture and of the peasantry is everywhere the same. Their poverty and toils are again shown by the distances many of them travel on foot and under a burning Syrian sun, often 10 and 20 miles to carry to the markets of the neighbouring towns their little produce in the shape of leben, grass, vegetables, and for the sake of a very few pence.

3. Heavy taxation, or rather the insatiable greed of the tax-collector, form two only of the manifold exactions which oppress agriculture.

4. Exposure to danger from robbers. With the exception of the villages on the eastern borders liable to Bedouin incursions, the people are generally able and manage to protect themselves. They have, however, little or nothing worth robbing, and, besides, the poor in Syria do not prey upon their kind.

5. The wretched state of the roads. Properly speaking there are no roads in Syria and Palestine besides those made by traffic.

6. Regulations for forest conservancy exist, but are defeated by corruption, as is the case with the magnificent woods in the Aleppo district, which are being destroyed by charcoal burners and oak-bark strippers, despite Governmental prohibition, and under the eyes of the officials.

In Syria and Palestine forests no longer exist. . . .

10

Hauran Wheat, 1897

. . . The Hauran plateau is the main wheat producer in Syria. The crop, which on average is 250,000 tons,[1] could be tripled by using improved farming methods. The export of this wheat has been greatly helped, in the last few years, by the building of the railway.

From "Note sur la situation économique de la Syrie," August 1897, CC Beyrouth, vol. 12, 1897–1901.

[1] According to the report by M. de Petiteville, received on 25 July 1896, the annual crop is some 3 to 4 million hectoliters, of which about half is sent to Egypt and The [Greek] Archipelago, 200,000 are consumed in Damascus and 200,000 exported to Europe through Beirut. On average, Syria exports 100,000 tons of wheat, worth about 10 million francs.

However, because of the enormous American production (whose quality is also superior to that of Syrian wheat) and also because of the raising of customs tariffs in most European countries—notably in France, which was formerly the main buyer of Syrian wheat—it is becoming more and more difficult to market the wheat produced in Syria. The result has been a real economic crisis in Syria in the last few years.

For the time being, struggling against American wheat would be vain, for a hectoliter of Hauran wheat fetches 7.20 francs in the local market and if it is to sell in France for 10 francs that would leave only 2.80 francs for cost of transport to Beirut, freight, insurance, etc. This situation could, however, be changed by introducing improved farming methods, which, by greatly increasing yields, would diminish production costs. . . .

11

Winemaking in Central Syria, 1898

. . . The winter has been unusually severe in the South of Asia Minor and the loss of sheep and cattle very great in consequence. The zaptiehs at Marrah [Ma'arrat al-Nu'man] employed in collecting the sheep tax stated, that only 12,000 sheep had been registered this year as against 52,000 last. The village of Sheikhun [Khan al-Shaykhun] alone lost over 1000. . . .

I took the opportunity while at Stoura [Shtura] of visiting the wine factory, vaults and distillery of Selim Boulad, a wealthy Arab proprietor who owns a property at Stoura of 200 acres, of which 50 acres are planted with vine and the remainder reserved for the production of cereals and for sericulture. The value of the Estate including plant machinery and wine in stock is roughly estimated by him at £30,000. The cultivation of the vines which are largely imported from France and the manufacture and storage of the wine are entirely conducted on European lines. The vaults are extensive and contain in stock 300,000 litres (66,666 gallons) of wine in the wood up to 10 years old and 10,000 litres (2222 gallons) of older wine in bottles.

Mr. Boulad's chief sale is in Egypt where the Khedive deals with him largely. He has agents in New York, Paris, and Madagascar and does a considerable trade with France.

Some of the better wines are exceedingly good; the white wines comparing very favourably with the best Rhine productions. The prices vary from 35 centimes a litre for the common Syrian table wine to francs 2.25 the bottle for the best qualities. He also manufactures cognac and raki. The quantity of wine produced yearly on the estate is approximately 200,000 litres (44,444 gallons).

I reached Beirut on the 5th of April on the 39th day after leaving Bitlis.

From "Journey from Bitlis to Beirut," FO 195/2024.

12

Grain Production of Southern Syria, 1901

Grain Production of the Hauran, the Jebel Druse, the Ajlun Caza and The Southern Part of the Central Caza of Damascus

Name of district	Population	Total area (acres)	Total area of cultivated land (acres)	Total annual wheat crop (bushels)	Total annual barley crop (bushels)	Total annual crop of other grain (bushels)	Observations
Hauran	53,540	751,875	297,175	1,063,741	447,708	1,165,150	Consisting of *122* principal villages of which the nearest is ⅝ miles from the railway line and the farthest 24 miles.
Jebel Druse	33,090	529,000	245,140	791,700	416,967	769,767	Consisting of *95* principal villages of which the nearest to the Line is 15 miles distant and the farthest off 48 miles.
Ajlun caza	30,000	531,250	225,000	1,680,000	420,000	1,050,000	Consisting of *133* principal villages of which the nearest to the Railway is 7 miles and the farthest off is 25 miles.
Southern part of central caza of Damascus	Not known	Not known	Not known	155,517	147,350	144,583	Only *10 villages* treated of here, the others *not being affected* by the Line. The total annual fruit crop of this District is put at *3410* tons.
Totals	116,630	1,812,125	767,315	3,690,958	1,432,025	3,129,500	

Therefore the total annual Grain Crop of these Districts is *8,252,483 bushels.*

N.B. These figures are not to be taken as *exhaustive,* but only as relating to those districts of which the produce is, or is likely to be, affected by the Railways.

From Richards to O'Conor, 3 October 1901, FO 195/2097.

13

German Settlements in Palestine, 1902

The largest and most flourishing is the Colony at Haifa, numbering some 500 souls, which was founded by a certain Dr. Hoffman, who emigrated to Palestine about 40 years ago at the head of a sect consisting principally of Wurtembergers, and in response to religious conviction which determined him and his followers to settle in the Holy Land.

The second is the German Colony of Jaffa, founded by a Mr. Hardegg, a companion of Dr. Hoffman, and consists of about 230 individuals, most of them engaged in trade.

The third is an agricultural Colony at a place called Sarona situated somewhat over a

From Dickson to O'Conor, 3 November 1902, FO 195/2127.

mile to the north of Jaffa, and numbers 360 souls. With the exception of a few of its members who are engaged in the manufacture of wine, these Colonists are agriculturists, and since the creation of the Colony have wrought great changes and improvements in the surrounding country.

The fourth is the German Colony near Jerusalem, containing some 300 individuals, also followers of Dr. Hoffman above mentioned. They are mainly occupied in earning a living as small traders and shopkeepers in Jerusalem.

A fifth Colony, however, is now being founded in the district of Jaffa, and has received the encouragement and support of the German Emperor, the King of Wurtemberg, and members of the German aristocracy. I am informed that the Emperor has contributed 10,000 marks towards its establishment, out of his private purse, the whole cost of founding the Colony being estimated at from £8000 to £10,000.

The situation of the new Colony is in the plain of Jaffa about 9 miles to the east of that town, and comprises lands purchased from the villages of Yahudiyeh, Et-Tireh, and Rantieh, 5500 "donnums" (a donnum—.224 acre) were bought from the inhabitants of the first of these villages; 1684 "donnums" from those of the second village; and 1700 from those of Rantieh—in all 8884 "donnums" or 1995 acres.

In order to avoid paying high prices, competition, and attracting public attention, the Germans purchased the above mentioned lands quietly through two influential natives of Jaffa, who acquired the property in their own names and afterwards transferred it to a Commission of Germans, whose president is a certain Christo Hoffman. The average price paid was about 16/- per "donnum.". . .

14

Latakia Region, 1903

. . . As regards the tobacco for which this district is famous it would appear that owing to the English market being overstocked at present with this article, the native merchants are not purchasing just now. Moreover they are creating difficulties for and putting obstacles in the way of the Régie which, as Your Excellency is aware, is charged with the purchase of this article on behalf of the Imperial Tobacco Company of Great Britain and Ireland. Their method consists in urging the cultivators to insist on the employees of the Régie buying the whole of the crop of the district—or none at all. In the latter case, say they to the fellaheen, we will buy your whole crop and at higher prices than those paid by the Régie. If, however, they (the peasants) refrain from taking this insidious advice, they, the said merchants, will buy no tobacco of theirs whatsoever! Many of these foolish dupes are, it appears, already refusing to bring their tobacco to the depots and matters begin to look serious. It is said to be probable that the central authorities of the Villages will ultimately have to intervene in order to arrange a modus vivendi between the Régie, the tobacco growers and the native merchants with a view to the collection of the tithe, if not in the interests of order. . . .

From "Quarterly Report," Beirut, Richards to O'Conor, 1903, FO 195/2140.

15

Two Farms in Palestine, 1905

AN ARAB FARM NEAR HEBRON

. . . The farm chosen as an illustration includes:

300 *dunums* of land in Zif (12 kilometers from Hebron) at 15 francs	4500 francs
15 *dunums* of vineyards " " 200 francs	3000
A fairly good house, with a stable, made of limestone with a vaulted roof	3600
Total capital	11,100

In addition, the owners rent another 60 *dunums* of land, one-third of the produce of which they give to the owner, in kind. The rest accrues to them, and is not included in the following reckoning of produce.

This farm belongs to three brothers, aged 41, 48, and 53 years. They inherited from their father only a small house in Hebron, which was later enlarged. The three brothers are married. In addition to two grown-up sons, who work permanently on the farm, there are seven children, aged 2–14, of whom the eldest occasionally also help. One of the three brothers is concerned exclusively with the management of the farm and the sale of the produce; his hands betray the fact that he has not carried out hard manual work. He administers the till and is generally acknowledged as head of the family.

The livestock inventory consists of:

6 Oxen at 140 francs	840	francs
1 Camel	200	
1 Small donkey	40	
150 Goats at 10 francs	1500	
50 Sheep at 12 francs	600	
3 Chickens at 1 franc	3	
Total	3183	

The inventory of tools and implements is:

2 ploughs with accessories at 10 francs	20
2 sieves at 2 francs	4
2 pitchforks at 1½ francs	3
3 picks (*Hacken*) at 2 francs	6
Camel saddle and cord	8
Total	41

Total value of farm	14,324 francs

From Hubert Auhagen, *Beiträge zur Kenntnis der Landesnatur und der Landwirtschaft Syriens*, Berlin, 1907, pp. 73–79.

The following was sown (1904/05 is taken as an illustration):

Wheat. 68 *Tabbeh* (24 kilograms each), yielding 57 camel loads of 12 *tabbeh* each. Of this, 7 camel loads were used for seed (the sowing ratio varies somewhat from year to year). Twenty-five camel loads were used for making bread for consumption by the household. The other 25 (of 12 *tabbehs* each, or a total of 300) were sold at 4 francs, or 1200 francs: 1200 francs

Barley. 68 *Tabbehs* (22 kilograms each) were sown. Thirty camel loads were reaped; of these, 7 were used to feed the draught animals, 3 for seed, and 20 were sold at 20 francs (barley was very cheap): 400 francs

Durra [millet]. 3 *Tabbehs* were sown and 10 camel loads harvested; of these 3 [*tabbehs*] were sown, 57 were made into bread, and 60 were sold, at 2 francs: 120 francs

'Adas [lentils]. 12 *Tabbehs* (of 24 kilograms) were sown and 36 harvested—the crop was poor. Of these, 2 *tabbehs* were used for household consumption, 6 for seed, and 28 were sold at 4 francs: 112 francs

Kersanneh [vetch]. 24 *Tabbehs* were sown and 10 camel loads harvested; of these 24 *tabbehs* were used for seed, 16 were fed to the camel, and 80 were sold at 2.50 francs: 200 francs

Of the produce of the vineyard 400 *ratls* (of 2.5 kilograms) of raisins were sold at 1.10 francs: 440 francs

Livestock raising yielded:

30 *ratls* of butter at 6 francs		180 francs	
50 " " *laban* [yogurt] (dried) at 1.50		75 francs	
20 " " lambs at 8 francs		160 francs	
30 " " he-goats at 6 francs		180 francs	
		595 francs	

On average, the camel carries 10 loads to Jaffa each year, at 12 francs: 120 francs

Ploughing for other farmers (*lohnpflügen*): 140 francs

Total income 3327 francs

Expenditure

(1) *Taxes*

Land tax on house 12 francs, on vineyard 10, on 300 *dunums* of land 34, total:	56	francs
Sheep and goats, 200 at 1 franc	200	francs
1 camel 2 francs, 1 horse[1] 2, 1 donkey 0.50	4.5	francs
Road tax 16.50 francs, school tax 2.75	19.25	francs

The tithe was taken into account when calculating the yields of the various crops.

Total taxes, excluding tithe: 279.75 francs

[1] The horse does not figure in the livestock inventory given earlier.—Ed.

(2) *Wages*

The shepherd receives each year 20 goats, which he raises for himself
and in addition receives 2 shirts at 2 francs each, 1 cloak at 8 francs,
headgear and cap 6 francs, a leather belt 4 francs, 2 pairs of shoes at 2
francs each, total: 26 francs
 Two reapers receive wheat during the harvest.

(3) *Upkeep of Inventory*

5 new ploughshares at 2 francs each, 1 camel saddle 5 francs, rope,
string, and twine for binding and carrying, 23 francs: 38 francs
 [Total farm expenses] 343.75 francs
 For shoeing the oxen the smith receives 5 *tabbehs* of wheat and
the wheelwright 2 *tabbehs* of wheat, 2 of *durra,* and 2 of barley, at
harvest time.

(4) *Household Expenses*

 (a) Clothing: 5 men receive each year 2 shirts at 2 francs each, 1
cloak at 8, 2 pairs of shoes at 3, a headgear and cap with turban 6
francs, or 24.50 francs: 120 francs
 3 women receive each year 1 pair of shoes at 2 francs, 1 vest at 3
francs, headgear and veil 1 franc—6 francs: 18 francs
 Clothing for 7 children at 4 francs each: 28 francs
 (b) For food not produced on the farm: meat 40 francs, oil 24,
olives 6, vegetables 40, rice 16, sugar 6, salt 10, coffee 6: 148 francs
 (c) Sundries: only one man smokes, 6 francs worth; 1 camel load
of charcoal 8 francs; 1 crate of petroleum 3 francs; matches $1\frac{1}{2}$ francs;
sewing things, etc. 2 francs: 20.50 francs
The women do not smoke or drink coffee.
 Total household expenses: 334.50 francs
 Extraordinary expenses include the marriage of sons and payment
for exemption from military service, the latter costing 1000 francs.
According to Hebron custom, a wife costs 560 francs; this sum should
not, however, normally be taken into account, for on average the
daughters of the house bring in an equivalent amount. The military
exemption fee of 1,000 francs should be spread out over 5 years, giving
an annual amount of: 200 francs

Add farm expenses 343.75 francs
Add household expenses 334.50 francs
 Total expenses 878.25 francs
Income amounts to 3,327.50 francs
Leaving an annual surplus of 2,448.75 francs

produced by 5 men, 3 women, and some of the elder children. This result is relatively
good, and surpasses the usual average.

A GERMAN FARM IN SARONA, ABOUT 6 KILOMETERS NORTH
OF JAFFA

25 hectares of farmland at 1000 francs	25,000 francs
0.5 hectares of gardens at 2000 francs	1,000 francs
4 hectares vineyards at 2500 francs	10,000 francs
1.25 hectares orange groves (with irrigation installations)	15,000 francs
1 hectare of woods (formerly waste)	600 francs
Irrigation installations with capstan (*Göpel*)	600 francs
Buildings	8,000 francs
	60,200 francs
[Livestock Inventory, including 5 horses and 7 cross-bred cows]	4,700 francs
[Tools and implements, including a motor run on oil]	8,525 francs
Value of farm	73,425 francs

In addition to the owner, the following work on the farm: 1 orange grove tender, 2 grooms, 1 day laborer, 1 woman day laborer, 1 stable boy, and 1 vegetable gardener. Draft power is provided by 5 horses. . . .

Income

[Oranges 5500 francs, milk 4200, vegetables 3500, grapes 2880, potatoes 1280, watermelons 1000, other 1930]	20,290 francs

Expenditure

In addition to the usual tithe ($\frac{1}{8}$), which is paid in kind, taxes. . . amount to:

	720 francs
Other expenditures:	370 francs
Wages of servants and laborers	

1 groom	480	francs
1 stable hand	400	"
1 day laborer	400	"
1 stable boy	200	"
1 woman day laborer	200	"
1 orange grove tender (shared with neighbor)	300	"
Other wages	150	francs
Share of vegetable gardener ($\frac{1}{3}$ of crop)	1100	francs
	3430	francs [*sic*]

Other farm expenses
[Increase and replacement of livestock and implements, upkeep of buildings, etc.] 4400 francs
Household expenditure 3000 francs

Total expenditure	11,920 francs
Income	20,290 francs
Surplus	8,370 francs

16

Olives in the Haifa Region, 1910

Olives are here not pickled for export. Although the olive tree grows wild on Mount Carmel, very few new olive orchards are cultivated, the most olive orchards are from the time of the Crusaders and not much more as are destroyed by storms or old trees cut, to avoid the payment of the duty, are new planted.

The natives have the opinion that an olive tree wants to least 30 years to bear enough to pay the expences and that is one of the reasons why so few trees are planted.

But with a careful treatment the [German] colonists here have already in 12 years a crop big enough to pay the expenses.

The wild olives contain only very little oil but as the wild trees grow better such are planted and when some years old, graft.

In the low land the summer olives (green or blue) are cultivated and in the valleys of the mountains the winter or black olives.

If the summer olives are watered or have a heavy rain at the time of their ripeness they get a nice appearance but they lose their oil.

The winter olives become not good before they have not had a good rain.

No green olives are pickled here for trade, and every family pickles only as much olives as needed for own use.

When picked the olives are soaked in fresh water for 24 hours and then put in a jar and covered with salt, water, heavy enough to swim an egg; after two or three months the olives lose the bitter taste.

Care has to be taken that no wild olives or such which were grown in a wet orchard are pickled as those get quite soft and only the stone and the peel remains and are no more pulpous like olives which contain oil.

When not quite ripe it is very difficult to distinguish the good fruit from the wild.

The riper the less bitter is the taste of the olives but the appearance is not so good as they get then very easily black spots.

The black olive are left on the tree until they are overripe and fall off. Every day they are gathered from below the trees; as most of them fall off by bad weather and when the soil is wet they have to be washed.

Then they are salted with a good deal of salt and conserved in jars.

Very few Europeans eat here the black olives as they have no own olive orchards yet and the treatment of the black olives is not clean enough.

This year no black olives have been exported, they were all consumed in the inland.

The olive crop could very easily be increased if the natives would take care of the trees; but there are several reasons which make them neglect the trees.

The owner of a tree is often not the owner of the land on which the tree grows. So is the village Emrar [*Mghar?*] which has a large old olive orchard but the land on which it grows belongs to the village Staidy [*Jdayde?*] and I have seen that. The owner of the land

From Struve to Memminger, 14 June 1910, US GR 84, Miscellaneous Correspondence, Beirut, April–June 1910.

319

approached to 6 inches to the trunk of the tree with planting beans, of course none of both have a good crop.

One and the same orchard has also often several owners but none of them wants to spend money for the other.

For example a German farmer bought several years ago $\frac{16}{24}$ of an orchard of 120 trees from 3 owners and the remainder of $\frac{8}{24}$ belong to 2 other owners. As the trees were very neglected the German farmer took care of them and in 2 years the trees had quite another appearance. Now the two other owners do not want neither to sell, buy, divide nor to attend to the orchard and always hoping the other part will attend to it and the German farmer does not know which are his 80 trees.

Similar cases are a great many. Since thirty years the Turkish farmers became from year to year poorer and poorer and were obliged to sell their olive trees to the merchants of the towns to which they were indebted. Usually they sold part by part.

The merchant leases his part and of course the tenant does not care much if the tree is ruined or not he looks only to get out the rent, for the two years that he has the trees, without any expense.

That is the chief reason why the olive crop diminishes here from year to year.

17

Silk in Lebanon, 1914

. . . The cocoon crop in Mount Lebanon is estimated at approximately 4 million kilograms; if we assume the average price per kilogram to be 15 piasters, the income from cocoons is 60 million piasters. If, however, [all] the silk were reeled, its value would rise to 80 million, a figure equal to 60 percent of the total income in the Mountain. It is clear from these figures that silk is among the most important economic factors in the Mountain.

Unfortunately, for some time now, a certain deterioration has become noticeable in both silkworm raising and silk reeling. Some people believe that the growing of mulberries in the Mountain will have to be gradually decreased because it can be easily replaced by other plants that yield a higher profit to landowners. The owners of silk-reeling factories attribute the decline in their industry to continued imports from the Far East; they believe that the special favorable conditions for breeding silkworms there, the fact that more than one crop can be raised each year and the lowness of wages render the costs of their silk lower than in Europe or the Near East. We notice that silk crops in the Far East increase each year, which has caused a general fall in silk prices, compelling the factory owners to accept reduced profits and to offer lower prices for cocoons than before.

Many people in Lebanon believe that the decline of the silk industry is due solely to the above-mentioned causes, which cannot be countered. This belief is false; for if the above-mentioned causes have in the past had a great impact on growers and reelers, this is

From Isma'il Haqqi Bey (ed.), *Lubnan, Mabahith 'ilmiyya wa ijtima 'iyya*, Beirut, 1918 (reprinted Beirut, 1970), pp. 487–491, 499–504, 517–518.

Table 17.1 Average Output of Cocoons in Syria over 10-Year Periods[a]

1861	960	1871	2100	1881	2800	1891	3492	1901	4650
1862	1900	1872	2000	1882	2050	1892	4102	1902	5670
1863	1500	1873	2300	1883	3300	1893	5900	1903	5380
1864	1200	1874	1800	1884	3070	1894	5290	1904	4965
1865	2000	1875	1795	1885	3075	1895	4311	1905	5330
1866	3400	1876	1667	1886	3200	1896	4710	1906	5081
1867	2400	1877	1500	1887	3642	1897	5490	1907	5840
1868	1700	1878	2250	1888	3600	1898	5210	1908	5476
1869	1350	1879	2000	1889	3725	1899	5050	1909	4875
1870	1152	1880	2368	1890	4636	1900	5000	1910	6100
10-year	1661	10-year	1988	10-year	3409	10-year	4865	10-year	5336
average	[sic,	average	[sic,	average	[sic,	average	[sic,	average	[sic,
	read		read		read		read		read
	1756]		1978]		3310]		4855]		5337]

[a]In thousands of kilograms.

no longer true at present, and we see in Europe and the Near East a new, firmly based industrial and economic equilibrium. If the art of silk growing, and still more that of reeling, are still depressed in the Mountain that is due to particular causes that can be overcome.

The reader may be surprised to learn that the state of silk growing is now as satisfactory as in the past, nay indeed has been progressive and successful, not declining as some say. Table 17.1 supports our statement.

If we deduct from the last figure 1 million kilograms of cocoons that were produced by regions adjacent to the Mountain, we get an average of 4 million for Lebanon. These figures show clearly that the output of cocoons is increasing. If some landowners have pulled out mulberry trees in their properties, this has taken place in the fertile coastal region where the land can be easily irrigated and mulberries replaced by lemons and vegetables. In the Mountain, however, conditions are very different, for the land is poor and infertile. Since the mulberry is a strong tree that grows in poor soils, we see the inhabitants of the Mountain increasingly taking to planting it and it will inevitably come to play a leading part in Lebanon similar to the one it is playing in Savines, Var, Corsica, Piedmont, Lombardy, Calabria, and other mountain regions with thin soil.

The fact that there has been some decline in our planting of mulberries and raising of silkworms is due solely to the ignorance of the farmers and raisers. It is indeed strange that our yield of cocoons per box of eggs is the lowest recorded, and that in spite of the temperateness of the weather and the favorable natural conditions for raising cocoons. Tables 17.2 and 17.3 give some figures showing average yields per box of 25 grams over 6 years in the main producing centers. These tables show that yield per box in France is twice as high as in our country. Nevertheless, one need not fear that this industry will die out in the Mountain but, on the contrary, one can hope that it will grow and progress because of the favorable climate it enjoys. Its progress would become certain and tangible

Table 17.2 Lebanon (in kilograms)

1906	23.300	1909	20.730
1907	20.080	1910	24.940
1908	22.050	1911	25.300

a total of 136.400 or average of 22.733

Table 17.3 Other Countries (in kilograms)

Hungary, 1890–1905	25.400	France, 1906	42.174
Brusa Vilayet, 1890–1905	34.400	France, 1907	44.575
Italy, 1890–1905	39.110	France, 1908	44.400
France, 1890–1905	39.340		

if effective measures were taken to encourage that craft and if the right principles were implanted in the minds of growers.

The condition of the owners of silk-reeling factories is more difficult and gives grounds for greater apprehension than that of silk growers, for many closed down part of their plant and dismissed their workers when they saw that their work brought them nothing but toil. There used to be 9000 pans in the Mountains, capable of reeling an estimated 6 million kilograms and employing 12,000 workers; today there are only 5000 pans, reeling 3 million kilograms and employing only 6000 workers, and a large part of the country's cocoons is exported unreeled. Two things follow from this:

(1) When purchases of cocoons came to be made by agents rather than factory owners, prices fell, injuring growers.

(2) The reeling of cocoons is equivalent to 30 percent of their value, and the difference is distributed in the form of workers' wages and factory owner's profits. The export of cocoons therefore deprives the Mountain of this large gain. . . .

Costs of Reeling. Using the technique at present prevalent in Lebanon, by means of two reels—that is, the French Chambon method—a working woman reels 20 grams of 9/10 grade in one hour. Let us take as a standard in our study a largish factory with 80 pans reeling medium-quality silk, as is the case with 85 percent of Lebanese factories. We shall use for price the average of silk prices in 1913/14:

80 reelers (women), at a wage of 4 piasters	320	piasters
4 supervisors (men), at a wage of 8 piasters	32	"
6 twisters (men), at a wage of 5 piasters	30	"
2 combers (women), at a wage of 4 piasters	8	"
2 assistants (men), at a wage of 3 piasters	6	"
0.5 ton of coal, at a price of 250 piasters	125	"
	521	"
Unforeseen costs, approximately 5 percent	29	"
	550	"

If we estimate the number of hours worked by a woman at 11 per day, the amount of silk reeled is 11 × 20 × 80 = 18.600 kilograms, giving an average cost per kilogram of 31.25 piasters. These costs can be slightly reduced if special favorable circumstances exist, such as the proximity of the factory to a forest, making it possible to buy fuel at a lower price; or in the upper reaches of the mountains, where wages are lower, etc. In the coastal plain the reverse situation prevails, hence we have taken 31.25 piasters, or say 31, as the average cost per kilogram in the Mountain.

An Economic Survey of Silk Reeling in The Mountain. The price of silk varies with its quality: Excellent, First class, Second class. It also varies according to the size of the output of factories in Europe and the Far East and to the demand for the particular variety in the markets of Europe and North America. . . .

Table 17.4

Country	Quality of Silk	Grade	Price, in francs
France	Excellent	9/10–11/13	53
Italy	Excellent	11/13	52–53
Switzerland	Excellent	9/10	52
Syria	First Class	9/10	49
Syria	Second Class	9/10	47
Bursa	First Class	14/30	47
Bursa	Second Class	14/30	46

As for the price of cocoons in our country, it varies with

(1) Changes in the price of silk
(2) The size of the crop and consumption
(3) The size of Italian, and especially French, output
(4) The state of the reeling factory in France.

Let us take a numerical example. In 1914, for instance, prices per kilogram of silk were [as in Table 17.4]. At the same time, Syrian cocoons were sold at the following prices: Alexandretta, Excellent, 11.25 francs; Lebanon, 15–21 piasters per *oke,* depending on distance from place of sale. As for silk—or the amount of cocoons needed to reel a kilogram of silk—its price in Lebanon was 37 francs and in Marseilles 39.

The factory owner buys cocoons and transforms them into silk. The difference between the sale price of a kilogram of silk and the purchase price of the cocoons needed to make it is known as "the margin." To it should be added the value of the by-products of reeling, such as floss and others, which is equal to 4–6 percent of the value of silk and, in terms of the prices given above, equals 2.50 francs per kilogram. The margin, in francs, is therefore as shown in Table 17.5. . . . The margin may be divided into three parts: "costs of reeling"; "interest" on capital invested, brokerage, transport, freight to Europe, "profit" (i.e., difference between margin and "costs of reeling") *plus* "interest" . . . "Costs of reeling" with the methods used in Lebanon (except for the factory belonging to Guérin in Qrayya) are: Excellent silk 7.10 francs, First Class 6.70, Second Class 6.30. "Interest" amounts to about 10 percent of the value of the silk. Economically powerful owners and those who have representatives in Europe who sell the silk gradually, as it is produced, can keep interest below 10 percent, but in our country there are few such persons and we will therefore use the figure of 10 percent as representative of the mass of producers. Interest per kilogram of silk is therefore 4.90 francs for Excellent silk,

Table 17.5

Quality of silk	Price of silk (per kilogram)	Price of cocoons needed per kilogram of silk	Price of by-products	Margin
Excellent	52	37	2.50	17.50
First Class	49	37	2.50	14.50
Second Class	47	37	2.50	12.50

4.80 for First Class, and 4.70 for Second Class. . . . Profits are . . . 5.50 francs, 3.00, and 1.50, respectively.

Capital. Factory owners buy the necessary cocoons at the beginning of the season (i.e., at the time of picking) at prevailing prices, and need much capital for this purpose. For those who wish to reel 5000 kilograms of silk, the following capital is required:

Factory	35,000 francs
Purchase of cocoons	180,000 francs
Cash	5,000 francs
	220,000 francs

If, therefore, the price of silk does not change and the quantity of cocoons used is the one estimated by the buyer, profits on the above-mentioned 5000 kilograms are [as in Table 17.6].

Fluctuations in Price. . . . To avoid such fluctuations some factory owners sell their silk "on delivery" (*bay' taslim*); that is, at the beginning of the season they agree with brokers in Europe to deliver a specified quantity of silk at a specified time and at an agreed-upon price. The price is usually the one prevailing at the time of the transaction. Should prices rise the factory owner cannot take advantage of them, since he is bound by the transactions, and should they fall he will suffer no loss. In this way, he can safeguard his industrial profit. Generally speaking, such transactions are made only for Excellent silk. For First Class silk, the transaction is usually made only for a short period and it is very difficult indeed to make one for Second Class silk, and if it does occur it is for a very short time. For example, at the beginning of the season the broker buys, at the prevailing price, all the Excellent silk that can be reeled by the factory owner in the course of the year and buys only the amount of First Class silk that can be reeled in five or six months at most. As for Second Class silk, it is seldom sold in advance for more than a three months' output.

It is clear from this that reelers of Excellent silk are in a very good position; unfortunately there are only two factories in the Mountain that reel such silk, and both belong to Europeans. Of the Mountain's factories, 85 percent reel Second Class and only 13 percent First Class. Because of this, we see many factories closing down and depriving the country of a very beneficial and profitable industry. It follows that the resurgence of the industry depends mainly on improving the silk and shifting to the reeling of Excellent silk. This is not easy, since it also demands knowledge of the various factors that affect reeling and the introduction of modern equipment that makes it possible easily to produce Excellent silk. Such equipment is general in Italy and is also spreading fast in France and Japan. It not only reels Excellent silk but also saves time and labor and greatly reduces wage costs, providing the owner with a net industrial profit of 8 francs per kilogram of silk. We have already stated that the Mountain can produce 400,000 kilograms of silk a

Table 17.6

Quality of silk	Annual industrial profit	Profit as % of capital after deduction of interest
Excellent	5000 × 5.50 = 27,000 francs	12.5
First Class	5000 × 3.00 = 15,000 francs	6.8
Second Class	5000 × 1.50 = 7,500 francs	3.4

year, an astonishingly large amount that could provide factory owners with an annual profit of 3.2 million francs. To this should be added the wages earned by workmen. . . .

Economic Characteristics of Modern Reeling Factories. Let us examine the costs of production of one kilogram of silk, taking as standard a factory with 24 pans, each having 8 reels:

24	Reelers (women) with a wage of 4 piasters	96
16	Boilers (women) with a wage of under 2 piastres	30
6	Drainers (women) with a wage of 3 piastres	18
6	Knotters (women) with a wage of 4 piastres	24
2	Combers (women) with a wage of 4 piastres	8
2	Men servants with a wage of 3 piastres	6
3	Supervisors [male] with a wage of 8 piastres	24
55		206
	Extraordinary expenses, about 5 percent	14
		220
	Half a *qintar* of coal for the pans and motor	125
		345

Average daily output of silk is 750 grams per reeler, working 11 hours a day and using medium-quality Syrian cocoons of 9/10 grade—we have taken these figures from experiments carried out in Italy. The total amount reeled per day is therefore $750 \times 24 = 18$ kilograms. In other words, a factory with modern equipment employing 55 persons produces more than an old-fashioned factory with 80 pans and 94 workers. The costs of reeling one kilogram are 18.345 piasters (say 19), that is, 4.50 francs, compared with 31 piasters for old-fashioned factories. This applies to Excellent silk. For First or Second Class silk, the cost falls to 4 francs or 3.50—since daily production is larger and some costs can be eliminated.

[This gives a net profit, after deductions of interest, for an output of 5000 kilograms a year, of 18.4 percent for Excellent, 12.5 for First Class, and 9.76 for Second Class.]

The cost per pan for modern equipment, with its accessories, is 1000 francs. A person wishing to install 24 pans in his factory would therefore need 24,000 francs. This sum can be amortized in one year. . . .

18

Trade with the Beduins, 1914

. . . The trade relations that take place with the beduins at the edge of the cultivated areas are very interesting. The centers of this trade are Aleppo, Homs, Hama, and Damascus; Zahleh, Tiberias, Safad, Hebron, and Bersheba also participate in it to a lesser extent. The beduins bring to the markets the products of animal husbandry: livestock (camels, sheep, goats, horses), wool, hides, butter, and also eggs, and take back grain, petroleum, sugar,

From A. Ruppin, *Syrien als Wirtschaftsgebiet*, Berlin, 1916, pp. 258–262.

tobacco, other colonial goods, guns and ammunition, cloth, and saddlery. The turnover is not insignificant and may be estimated at:

600,000 Sheep	worth	10,000,000	francs
100,000 camels	"	25,000,000	"
A few thousand			
horses	"	1,000,000	"
30,000 goats	"	200,000	"
Wool	"	5,000,000	"
Hides	"	500,000	"
Sheep butter	"	3,000,000	"
Eggs	"	300,000	"
	Total	45,000,000	

Trade takes place in the following way: beduins, singly or in groups, enter into standing relations with a given merchant in Aleppo, Homs, or Hama. In spring, when lack of water drives them out of the desert to the edge of the sown, they bring to that merchant the animals that are ready for sale and other products and in return take from him the goods they need. Very often the merchant gives them more goods than the value of the products they have brought warrants. He does so without hesitation, although the beduins return to the desert in autumn, as soon as the first abundant rains fall there, and once there are beyond the reach of any court or public prosecutor. But the beduin never betrays the trust put in him—as the proverb says: "The beduin robs, but he pays his debts." The following spring he returns and delivers his produce to cover his debt.

For many beduins who are not already in partnership with a capitalist in the producing zone (e.g., Mosul), these standing trade relations with a merchant in the sales market lead to an association. The merchant gives the beduins money or goods, as an investment, and becomes thereby part-owner of the flocks. On the other hand, there are beduins who do not have a steady trading friend and who make the best sales decision only when they reach the neighborhood of a town. Recently it has often happened that the cattle merchants have not waited until the beduins brought to them their herds in the spring but have gone into the desert and bought the animals there. About a quarter to a third of the animals have been bought thus. In this way, the merchants get them cheaper but on the other hand must bear the risk of transport, which is very great. Because of epidemics or unfavorable fodder conditions, a large part of the animals may be lost in transport.

Trade in Sheep. The main markets for sheep are Aleppo and Homs. By the time they reach those two towns the sheep, which are usually two and a half to three years old, have made a three- to four-months' journey from their place of origin. There are two kinds: white sheep from the region of Mosul and Dayr al-Zur (and Diyarbakr) and red sheep from the region of Erzerum. Of the total arrivals of 600,000, some 60 percent are red sheep, 30 percent are white sheep from Mosul and Dayr al-Zur, and, in addition, there are 10 percent consisting of white sheep from the neighborhood of Diyarbakr. In Aleppo the price of a white sheep from Mosul weighing 15–25 kilograms is 10–15 francs, and that of a red sheep weighing 20–35 kilograms is 20–30 francs. The sheep serve to meet Syria's internal consumption, but part is exported to Egypt and Constantinople. Internal consumption is very large, for in Syria no meat other than mutton is used. In Damascus alone, between the months of May and June when sheep arrive from Asia Minor and Mosul, 300 sheep and 1000 lambs are slaughtered each day. In all, the city of Damascus

consumes each year not less than 100,000 sheep and 150,000 lambs; most of the latter are raised in Syria itself. When market conditions are unfavorable the owners of the sheep hold them back for many months or even till the following spring and put them to pasture in the neighborhood of lake Amuk ['Amq] (Antioch).

Trade in Camels. Camels are brought from Dayr al-Zur and the Syrian desert. Of the yearly arrivals of about 100,000 animals, 40,000 remain in Syria as beasts of burden and 30,000 take the land route to Egypt, either to be used as pack animals or for slaughter. In summer, in the neighborhood of Gaza, one can see during the whole day caravans of camels destined for Egypt passing by. The main trading places for camels are Damascus and Gaza.[1] The price of a camel ranges between 250 and 500 francs.

Trade in Horses. [It] is confined to a few thousand beasts, for the breeding of Arabian horses by the beduins has greatly retrogressed.

Goats. [They] are brought in smaller numbers from Mosul to Aleppo.

Wool. [Wool] is brought to Aleppo, Homs, and Hama, mainly from Urfa and Mardin but also from northern Syria. There part of the wool is washed in the Quwayq and Orontes rivers, losing an average 50 percent of its weight in the process. The wool is packed in bales of 120 kilograms and, except for a small part that remains in the country, exported in a washed or unwashed state. The price is 1.25 francs for a kilogram of unwashed wool and 2.50 francs for washed. Exports go to Marseilles, Liverpool, and Italy, and more recently in increasing quantities also to Germany and particularly to the United States, where they are used for making carpets. According to the report of the American consul in Aleppo, wool exports from the *vilayet* of Aleppo to the United States were[2]:

1912—$534,280 (about 2,700,000 francs)
1913—$272,674 (" 1,400,000 ")

The total yearly wool trade of Aleppo, Homs, and Hama may amount to an average of 5 million francs, of which Aleppo's share is 60 percent, Hama's 25 percent, and that of Homs 15 percent. In addition, there is a not insignificant wool trade in Damascus, to which the beduins of Hauran and Transjordan bring their wool and wash it in the Barada river.

Butter. [Butter] is made, in a very primitive way, by beduins from sheep milk, being smelted to preserve it from becoming rancid and to rid it of the numerous inherent impurities. It is brought by the beduins to Aleppo, Homs, and Hama in two qualities. The better one known as *samneh hadideh* and the inferior one as *samneh gharib;* there it is bought by merchants, packed in old petroleum crates, and sent to Egypt, Constantinople, and America (for the Syrians living there). Of the total volume of 2–3 million francs, the share of Aleppo and Hama is 40 percent each and that of Homs 20 percent. The price is about 500 francs per *qintar* of 256 kilograms.

Hides. These consist mainly of sheep and goat hides, not cattle hides, for the beduins do not raise cattle. Part of the hides is transformed into leather in the country and the rest, mainly lamb hides, exported to Austria, Germany, and the United States. Weakley states that each year the beduins bring 2,122,500 *okes* of wool to the Aleppo market and some 1.6 million *okes* to Homs, Hama, and Zahleh, for a total value of 5 million

[1]Report of the British Consul in Jerusalem for 1912, p. 16.
[2]Daily Consular and Trade Reports (Washington), 6 June 1914.

Table 18.1

	Raw wool		Raw sheep and goat hides		Other raw hides		Butter	
	kg	piasters	kg	piasters	kg	piasters	kg	piasters
From the ports under the Alexandretta customs	736	5,152	263	1,092	10	64	221	2,738
From Beyrut	2,135	15,658	533	2,550	29	202	544	5,873
From other Syrian ports	58	426	105	491	6	41	16	182
Total	2,929	21,236	901	4,133	45	307	781	8,793
	or about 4.7 million francs		or about 900,000 francs		or about 70,000 francs		or about 2 million francs	

francs.[3] The same author estimates the amount of sheep butter brought for sale to Aleppo, Homs, and Hama at 1 million *okes,* worth 2.5 million francs.[4]

According to the official Turkish trade statistics for the year 1326 (1910/11), Syria's exports were [as in Table 18.1, figures in thousands]:

Wool about 4.7 million francs
Sheep and goat hides " 900,000 "
Other raw hides " 70,000 "
Butter " 2 million "

The value of exports of wool and butter corresponds approximately to the value of the amounts of wool and butter brought by the beduins to market, and leads to the conclusion that exports are totally provided by the beduins.

In addition to the raw hides exported, some hides are cured for export. In 1326 these amounted to [Table 18.2, figures in thousands]:

Table 18.2

	Kilograms	Piasters
From the ports under the direction of the Alexandretta customs	159	2,486
From Beyrut	104	1,465
From other Syrian ports	6	84
	269	4,636
	or about 900,000 francs	

A kind of peddling trade with the beduins also takes place from places on the edge of the cultivated zone, like Hebron and Safad. Some merchants take their goods into the desert, to exchange them with the beduins. The Hebron merchants have large stores in Tafileh, southeast of the Dead Sea, for trade with the beduins camping in the neighborhood. . . .[5]

[3]"Report on the Conditions and Prospects of British Trade in Syria," A and P 1911, vol. 87, p. 204.—ED.
[4]Ibid., p. 200.—ED.
[5]Baedeker, *Palestina und Syrien* (Leipzig, 1910) p. 163.

19

Changes in Landownership in the Ghuta of Damascus, 19th and 20th Centuries

. . . The gist of the matter is that tyrants usually desired to convert the whole Ghuta into an *iqta'* (fief) or to own it wholly or in large part. This is what the Ottoman governor Kiwan did: he took over most of the orchards of Rabweh and Mazzeh, seizing the property of the *fallahin* (peasants) and extracting what they owned by purchase or *mugharasa* (coplantation). In the last century the Jewish *sarrafs* (moneylenders) of Damascus also nearly came to own an important part of the Ghuta through the accumulated exorbitant interest they charged large and small farmers. But a Turkish lawyer, As'ad Effendi, saved the peasants from the *sarrafs*, forcing the Jews to sell the lands they had acquired in order to avoid the pressure of their neighbors the large landlords.

As regards the transfer of some land from the original owners to rich men and persons of influence, a friend[1] has told me that the reason for the transfer of land from the *fallahin* to the *effendis* (gentlemen) is that all debts and exactions were thrown "into the lap of the village" (*hijr al-day'a*), that is, debited to the village as a whole. The accumulation of such debts would force the villagers to sell their land at the lowest prices, in one transaction. Some peasants would therefore migrate to other villages while others accepted to work for the new owners. In the last century the village of Duma was almost overwhelmed by debts, causing its inhabitants to consider ceding half the village to their creditors and keeping the other half for themselves. If the practice of *hijr al-day'a* had not been abolished, some Ghuta land would have left the hands of its original owners. We believe that the alienation of the land of the villages of Zibdin, Bala, al-Haditha, al-Muhammadiya, and al-Aftiris was caused only by this evil practice or regulation— unless it was due to the accumulation of taxes, which forced the *fallahin* to sell by auction; and it should be remembered that some notables would agree to buy a village only as a whole unit. . . .

But when the condition of the *fallahin* of the Ghuta improved somewhat and its crops rose in price and were produced in an economic way, it became possible for them to purchase land from landlords who were forced to sell. I have heard of peasants whose grandfathers had given up the ownership of land, preferring to live peacefully on the estates of rich men as farmers or laborers, who now form associations for the purchase of land which that rich man, or his son or grandson, desires to sell; they divide such land between themselves, each one adding a piece of newly bought land to his adjacent property. In this way the *fallahin* have begun to own what they alone should rightfully have owned for centuries. . . .

From Muhammad Kurd-'Ali, *Ghutat Dimashq*, Damascus, 1952, pp. 126–128.
[1]Al-Sayyid Hikmat, a headman among the farmers, who got his information from Shaykh Mu'ammar, an inhabitant of al-Marj, who remembered the rule of Ibrahim pasha in Syria (1831–1840).—ED.

20

Land Tenure in Syria

Modes of Land Tenure

We would not be exaggerating if we stated that over 60 percent of the inhabitants of [geographical] Syria work in agriculture, directly or indirectly. Nor would it be an exaggeration to say that many of the inhabitants of the large and medium towns, whose number approaches half the total, have no work except farming. Syrians have dealt with land in an unjust way; by this we mean that a small number of wealthy or powerful men dispose of vast areas in many regions, whereas the *fallahin* (peasants) work on lands in which they have no share. Thus around Hama there are 124 villages, 80 percent of which belong to powerful members of families that can be counted on one's fingers; the remaining 20 percent belong to peasants or middle-class owners. And around Homs there are 176 villages, 80 percent of which belong to the notables alone, and 20 percent are shared by them and the peasants—except for a few villages that have remained untouched by the large owners and belong to peasants alone. The same may be said of many other regions of Syria, such as the villages of Ma'arrat al-Nu'man and others in the Aleppo region.

In Hauran the situation is different, for 95 percent of the soil is equitably distributed among the inhabitants. The same is true of Jabal Hauran, 'Ajlun, al-Balqa, Karak, Wadi al-Taym, and the Bilan region. In the Ghouta [see selection 19], every one of the great families of Damascus owns large estates; nevertheless half the land is in the hands of medium owners, one-quarter belongs to small owners, and one-quarter to the notables of Damascus.

This is an appropriate place to mention the large estates belonging to *Bayt al-Mal* (Treasury) and administered in the name of the Syrian government. Sultan 'Abd al-Hamid II was one of the ablest sultans in acquiring land and gathering wealth. He appropriated about 1 million hectares east of Homs and Salamiyeh, including Jabal al-Bal'as and al-Shumariyeh, and stretching close to Palmyra. In this he built about 120 villages and estates, cultivating about 100,000 hectares. In the Aleppo region he acquired about 500,000 hectares, which now contain 567 prosperous villages and estates, in the vicinity of Manbij and al-Bab, on the west bank of the Euphrates from the mouth of the Sajur to Maskaneh, and including most of Jabal-al-Has and large stretches south of Aleppo near the mouth of the Quyayq. He also acquired seven villages in Hauran, including that of Masmiyeh and also Baysan and some nearby villages. He enforced security in this vast private kingdom, exempted his farmers from military service, protected them from the depredations of the notables, and lent some money free of interest; the result was that those regions became prosperous whereas previously they had been the abode of predatory nomads. When the 1908 revolution broke out, the Sultan was forced to cede these estates to *Bayt al-Mal;* the farmers therefore now became renters from the new owner, *Bayt al-Mal* (i.e., the government). They pay the government 20 percent of their produce in some regions and 22.5 percent in others, in lieu of 'ushr (tax) and rent. Although they do not formally own the land but are only tenants, they do in fact pass it on by inheritance as though they were owners; the government does not evict a peasant from his village except

From Muhammad Kurd-'Ali, *Khitat al-Sham*, vol. 3, Damascus, 1925, pp. 214–216.

if he commits some grave offense such as starting a riot or injuring others. Since the government lends such farmers money free of interest and takes a smaller share of the produce than did the notables, the condition of peasants on state lands is in every way better than that of farmers in villages owned by landlords. . . .

Returning to the subject of land tenure in Syria today, except in al-Ghuta, al-Marj, some irrigated land, and farms around cities (where some owners farm their land directly, paying their workers monthly or annual wages), land in Syria is exploited under different kinds of share-cropping. In Homs and Hama the landlord takes a quarter of the produce and pays the *ushr* (tax), leaving the tenant three-quarters; in such cases the tenant has to meet all expenses and supply all the work, but the landlord generally advances him seed, charging interest and recovering it from the threshing floor. In some villages in Hauran landowners take a quarter of the crop and pay the *ushr* and the land tax, leaving the rest to the farmer to cover his work and expenses. But the most prevalent method in Hauran is the leasing of land for a specified quantity of grain; for instance, the *rub'a* is leased for 50–60 *mudds* [90–108 liters] of wheat; and since the *rub'a* land can be sown with 50–60 *mudds* of seed, if the grain/yield ratio is four or five the landlord will have obtained a quarter or a fifth of the crop.[1]

The thicker the population and the less available the land in a village, the greater is the landlord's share in the crop, and vice versa. Thus in Biqa' the landlord takes half the crop, paying the *ushr* to the government. In Huleh, where land is irrigated, the landlord's share is one-third of the crop and he pays the *ushr*. But in al-Ghuta and al-Marj the landlord takes a third and pays *ushr* only on that one-third, the other two-thirds being borne by the tenant.

These are the main ways of farming land; in all of them all work and expenses are supplied by the tenant. If, however, the landlord wishes to lay out the necessary working capital, the *fallah* who works on his land is known as a *murabi'* and is obligated to work a *faddan* of oxen, that is, to sow about 8 hectares to grain and prepare an equal amount for the following year. The *fallah* generally receives a quarter or a fifth of the crop after deduction of the *ushr*. . . .

[1]The *rub'a*, or "quarter," is a unit of measurement that varies in different regions, like the *faddan* or *qirat*.—ED.

21

A European-Owned Farm in Palestine, 1869–1923

THE BERGHEIM FAMILY AND THE FARM OF ABU SHUSHA

. . . In order to understand the work of the Bergheim family with regard to the farm of Abu Shusha—one of the most modern farms in Palestine in the last century—we must first refer briefly to the history of the family.

Melville Peter Bergheim was born in 1815 in a small town in the district of Posnan. According to some sources he was a Jew, and even the son of a rabbi. In 1833 he moved to England and there lived for eight years, during which he may have converted. In the early 1840s he came to Jerusalem via Malta under the auspices of the London Society for Promoting Christianity among the Jews. Although he had a British passport, he declared himself to be a Prussian citizen and took the protection of the Prussian Consulate in Jersualem. He made his living as a pharmacist.

In 1851 he went into banking, opening the Bergheim and Co. Bank in Jerusalem. Thereafter he launched a series of economic enterprises. first by himself and later aided by his sons Sam, Timothy, Christopher, and Peter. He opened in Jerusalem a large modern store, which among other things supplied all the necessary equipment for construction on the Russian compound. He traded in wines and in English beer and built in Jerusalem the first mill in Palestine to be operated by steam and equipped with modern German machinery. The high-quality white flour produced for the first time in the country was much in demand, and the whole enterprise turned out to be very profitable. Bergheim also engaged in purchasing land, part of which was designed for speculation and another part earmarked for the establishment of a modern farm. He brought the lands of Talbiya in Jerusalem and 10,000 *dunams* of the land of Sur Bahr, south of the city, as well as large areas near Jericho and in Ramla. The site chosen for the establishment of the farm was that of ancient Gezer, above and adjacent to the Arab village of Abu Shusha [on the way from the coastal plain to the Judean Mountains, close to the Jerusalem–Jaffa–Gaza road]. In a report of 1887, the secretary of the German Consulate in Jerusalem describes Bergheim as a wealthy man, the owner of a big house in Jerusalem and of real estate, a steam-mill and a windmill worth in all about 200,000 francs (some £8000). He estimates the annual turnover of the Bergheim Bank at 1.5 million francs. And all this, he says, is in addition to the Abu Shusha farm.

In 1869 the Jerusalem-based German banking family purchased Tel Gezer [the archeological site of Gezer] and the surrounding area. The background for the transaction was the promulgation of the Ottoman Land Law of 1858, the land surveys conducted by the government since the late 1860s, and the granting to foreigners of the right to purchase land. The timing of the purchase may have also been connected with the identification,

From Ruth Kark and Tsvi Shiloni, "Hidush ha-yishuv be-Gezer" [The Resettlement of Gezer], in E. Schiller (ed.), *Zev Vilnay's Jubilee Volume* (Jerusalem, 1984), pp. 331–342 (in Hebrew). Reproduced with kind permission of Ariel Publishing House, Jerusalem (footnotes omitted). Bergheim's activities as banker and merchant in al-Salt, Transjordan, were credited by the British consul with spreading vine cultivation for "miles around," Finn to Clarendon, 26 May 1855, FO 78/1121. — ED.

earlier that year, of the archaeological site as the old city of Gezer. We have no details concerning the transaction other than the fact that it was made by Bergheim and that it included the archaeological site as well as some, or possibly all, of the lands of the village of Abu Shusha. According to the different sources, the area purchased from the Ottoman government amounted to between 7500 and 20,000 *dunams*. How the transfer of ownership was arranged is not clear. Some contemporary evidence, backed by later developments, suggests that the procedure may have been somewhat irregular. According to Schölch, the property was acquired in 1872 for the sum of tax arrears owed by the inhabitants of the village (46,000 piasters). Bergheim acquired 153 title deeds from 51 peasants who became his tenants. The purchase gave rise to a dispute with the villagers, which was brought to court and became a matter of some public attention. At any rate, in 1882 the land was registered in the name of the Bergheim family and title deeds were acquired.

Once established, the farm was partly cultivated by the company and partly leased out to local *fellahin* for a quarter of the produce. For its part, the company introduced modern agricultural methods. As early as the 1870s it employed English harvesting machines. It was, in fact, the only company in Palestine to launch an extensive agricultural project. A two-story complex with walls up to 1 meter wide was built on the site, consisting of residential quarters, storage areas, stables, a large courtyard, and numerous other facilities. The main crops grown were wheat and barley for export and for grinding in the Bergheim mill in Jerusalem. In order to facilitate their sale to Jewish customers, the company abided by the Jewish law of tithe. A map appended to a contemporary report by C. R. Conder and E. R. Kitchener shows that a group of mulberry trees was also planted west of the farm buildings, perhaps with the aim of growing silkworms.

Although it turned out to be a profitable venture, in 1882 the farm is reported by several sources to have been offered for sale. This was perhaps connected with the acquisition of title deeds earlier that year. Given the work already done on the farm, it could now be sold for a considerable profit. Zalman David Levontin, who was then visiting Palestine looking for lands suitable for the establishment of a new colony (*moshava*), came to Abu Shusha and was impressed with ''its produce and climate,'' but his group could not afford the £20,000 demanded.

In 1882 or 1883 other negotiations were conducted with a missionary by the name of Friedlander of the Anglican Mission in Jerusalem. According to Brill, the price was now set at £11,200. The potential buyer promised to settle on the land some 200 Jewish converts. It was perhaps the interest shown in the transaction by some Jewish organizations that caused the Anglican Mission to make vague promises to the effect that it intended to transfer the land purchased to Jewish hands. This is implied in a letter of 23 October 1882 from the chairman of the Jerusalem-based Jewish company ''Yishuv Ha'aretz,'' Aryeh Leob Frumkin. Frumkin adds:

> According to oral information acquired by my agent, the site has 25,000 dunams of land, 25 buildings and cowsheds, 100 bulls, camels and mules, 24 donkeys, 40 horses, 20 sheep, 2 threshing machines, 2 harvest machines, 2 ploughs and 7 springs of water.

He, however, warns his addressee of the ''missionary network'' and doubts whether the transaction will be realized. Indeed, for the time being the farm remained in the hands of Bergheim, who continued making large profits on it.

In the winter of 1885, against the background of fierce disputes between landowners

and the *fellahin* of Abu Shusha, Bergheim's son Peter was murdered along with his coachman. One newspaper reported: "It is rumoured that the murder was a matter of revenge. It has been some time now since Mr. Bergheim purchased the farm of Abu Shusha, having dispossessed the villagers of their land."

In 1887, the farm was again put up for sale. According to a report by the secretary of the German Consulate, it amounted to 7500 *dunams* and was offered at £14,000. Again the transaction was not completed and the dispute between the Bergheim company and the *Fellahin* continued. The *qaimaqam* of Jaffa apparently tried to take advantage of the situation in order to pick on the foreigners-Christians. The latter, for their part, sought to bring about his dismissal. A member of the German Consulate in Jaffa writes in 1891 that "the fellahin were about to let the matter rest, but the *qaimaqam* incited them not to forsake their rights." The *fellahin* then appealed to the Jaffa court, but their appeal was rejected and Bergheim's ownership was declared legal.

At that time the Bergheim bank suffered financial difficulties. As the Ottomans had shortly before banned the sale of land to Jews, there was no hope of saving the bank by selling some of the family-owned land. At the end of 1891, circumstances brought the bank to bankruptcy, Serapion Murad of Jaffa being appointed official receiver.

Henceforth the cultivation of the Abu Shusha farm was managed by S. Murad in cooperation with Bergheim in Jerusalem. There is some evidence from the mid-1890s that the Ottoman authorities continued to support the villagers. The Governor of Jaffa declared at one point that "the land should be given to the inhabitants of the village, the Shaykhs of Abu Shusha, and not to Mr. Bergheim." Until 1908, nevertheless, the atmosphere on the farm remained more or less quiet.

IMPLICATIONS OF THE YOUNG TURK REVOLUTION

The intensive correspondence of the German Consulate with regard to the lands of Abu Shusha resumed in 1908, and not by accident. The resumption was apparently the result of the Young Turk revolution of July 1908 and of the ensuing promulgation of a new constitution. In the new circumstances, the *fellahin* of Abu Shusha believed that the time was opportune for advancing their interests, and they proceeded to file a claim first with the Jaffa court and afterwards with the court of appeals. This having failed, they turned to illegal measures. They would not sign the lease contracts, nor would they agree to give a quarter of the produce to the manager of the farm. They took to cultivating land by force and to preventing the owners of the farm from cultivating their own land. The secretary of the German Consulate in Jaffa, George Murad, made a series of requests to the Governor of the town and to the *mudir* of Ramla to dispatch policemen to the site and take measures in defence of the legal owners and the farm workers supervised by his brother S. Murad. The addressees responded with intentional procrastination.

On 20 December 1909, the Administrative Council of Jaffa decided, under instructions from the Governor in Jerusalem, that action should be taken to protect the rights of the legal owner in Abu Shusha and to restrain the *fellahin*. The Council demanded that the heads (*mukhtars*) of the village undertake in writing to avoid violating the law. When the latter refused and declared their intention to continue cultivating the lands in question by force, legal action was launched by the Public Prosecutor. An emissary accompanied by policemen was dispatched to the village to enforce implementation of the Council's decision. But there was too little they could do in face of the villagers' opposition.

For the German Consul in Jerusalem, Mr. Schmidt, the Abu Shusha case now

became a matter of principle, or of honoring German property rights, warranting an appeal to the embassy in Istanbul. For another few months the dispute continued unabated, with further instances of violence by the *fellahin,* of complaints by the German consular officials in Jaffa, and of dispatching *tapu* officials and policemen to the village. Finally, in April 1910 S. Murad reported that the dispute had been resolved. The *fellahin* had reportedly received a newly dispatched group of policemen and *tapu* officials with no recourse to violence. At the same time, they rejected the leasing arrangement, nor would they undertake under contract to give a quarter of the produce to the owner of the land. The farm work had thus to be turned over to hired labour. In October of the same year, acting as official receiver and as the Bergheim's family accredited representative, S. Murad sold part of the farm to the Abu Shusha villagers.

THE PURCHASE OF THE BERGHEIM LANDS BY JEWS

The part of the farm not transferred to the villagers of Abu Shusha attracted the attention of a number of Zionist organizations, including the Joint Zionist Council of Great Britain which in 1911 decided to set up a land purchasing fund and to establish a colony in Palestine. The fund was named the Maccabean Land Company after the central body of British Zionism in those days, the Order of Ancient Maccabeans, from among whose ranks the new settlers were expected to come. It was perhaps on behalf of this movement that the Palestine Office was negotiating a purchase of land in Gezer at a time when Yehoshu'a Hankin was doing the same on behalf of "Hakhsharat Hayishuv" (The Palestine Land Development Company).

In January 1912 Arthur Ruppin wrote to Hankin:

> . . . As you know, I have instructed 'Antabi to purchase Abu Shusha. However, he complains that the transaction cannot be effected pending your reply to S. Murad. In view of this complaint, I urge you to write to Murad that you have failed to find a customer for the farm and that you therefore withdraw from the negotiations.

Three days later Hankin answered that he had already written to Murad. At the end of January 1913 the transaction was completed, and at the beginning of February it was reported in a letter from S. Murad to the German Consulate in Jaffa:

> Two weeks ago, the Jewish Colonization Association purchased the farm of Abu Shusha formerly owned by the Bergheim family and administered by S. Murad. 3,600 dunams out of the total of 10,000 were purchased for the villagers of Abu Shusha, who had for long been engaged in lawsuits against the farm owners. In return, the fellahin withdrew their suits.

During the first half of 1914, there were some reports in the Jewish press to the effect that Baron de Rothschild, the main benefactor of JCA, had offered to give a house and land in Gezer to Mendel Beilis, the immigrant Russian Jew who had been shortly before acquitted of a blood libel which had caused a storm in the Jewish world. Beilis turned down the generous offer, perhaps because of the poor security and living conditions awaiting the foreign settlers in Gezer. With no alternative, Rothschild leased the land temporarily to Arab sharecroppers. Part of the land was purchased eight years later by the president of the Maccabean Land Company, Norman Bentwich. Interestingly, from the moment it was transferred to Jewish hands, the place was called Gezer.

PLAN FOR A FIRST ANGLO-JEWISH SETTLEMENT

A 12-page pamphlet published by the Maccabean Land Company in 1924 sets out a plan for the establishment of an Anglo-Jewish settlement in Gezer. Beginning with a historical account of Gezer and a survey of the excavations previously done in the site, the pamphlet goes on to announce that the site has been chosen for the establishment of the first Anglo-Jewish settlement in Palestine. The advantages of the site are then enumerated. It is situated high above the surrounding area and not far from Ramla, the Jerusalem–Jaffa road, and the railway junction of Lydda, which branches out to Syria, Egypt, and Haifa. It is close enough to the Na'na rail station, which will serve as an outlet for its produce. And it enjoys a healthy and pleasant climate and excellent soil. The company intended to distribute the land purchased among its stockholders, who would come to work and live on the farm. A first experiment showed the site to be suitable both for a dairy farm and for growing vegetables, tobacco, and fruits such as almonds, oranges, peaches, and grapes. The idea was for the settlers to engage in highly profitable enterprises.

Numerous dignitaries, including the High Commissioner Sir Herbert Samuel, participated in the inauguration of the new settlement in May 1923, on the occasion of the "first harvest of fodder." Part of the farm was then still cultivated by Jewish hired labour. Some £2000 worth of crops proved easy to sell, and experimental plots planted primarily with tobacco also yielded excellent crops amounting to £1000 in value. Also undertaken during this first year were the beginning of an approach road, the laying down of pipelines from the Bergheim farm well, fertilizing work, and the planting of a 1.5-kilometer long row of ornamental trees and eucalyptus and other fast-growing trees in groups and along the borders of the farm.

At the end of the year it was realized that the original plan would have to be changed, as very few of the stockholders intended actually to settle on the land. As a compromise, it was decided to lease land out to "experienced workers from among the immigrants," at the same time keeping the residential plots for those among the stockholders who might wish later to come to live on the site. Another plan considered at the time proposed to settle on the land Jewish veterans who had fought on the Palestine front during the First World War and who wished to remain in the country as immigrants. Yet another envisaged the establishment of a settlement of Yemenite immigrant-workers, of the kind already in existence in Rehovot and other neighboring colonies. The company appointed an experienced manager from one of the colonies as an adviser and assistant to future settlers. A council of local experts was set up to advise on matters of land allocation and utilization. Engineers and surveyors were hired to plan the allocation of land for public buildings. It was believed that some 100 families would come to live in Gezer, and would lay the foundation for a "genuine Maccabean settlement."

THE ESTABLISHMENT OF KIBBUTZ GEZER

The plan of the order of Ancient Maccabeans for the establishment of a Jewish settlement in Gezer apparently never materialized; the land was cultivated by an adjacent *kibbutz* and was settled by Kibbutz Bezer in 1945

22

An Early Jewish Settlement: Petah Tikva, 1878–1918

The first lands of Petah Tikva, on the banks of the Yarkon, were purchased from an Arab moneylender from Jaffa named *Kassar*. *Kassar* himself had acquired these lands from debtors who could not pay off their debts. He first set up on it a farm of irrigated crops and a plantation of sugarcane, but was shortly afterwards disappointed with the results and decided to get rid of the land. The remains of the Kassar farm, with a well drawing its water from the Yarkon and the fence, can still be seen on the northeastern part of the Petah Tikva, near the Baptist Village.

The new settlers of Petah Tikva were ultimately to show that something could be done with the "valley of Achor" they had found when they had first arrived on the site. But this was to take many efforts, sacrifices, and struggles. In their search for solutions for the various problems they encountered on the site, they introduced agrotechnical and technological innovations in areas such as cultivation methods, improvement of existing crops and introduction of new ones, harvesting, processing of agricultural products, and above all, drilling wells and pumping water.

We will show below in which areas Petah Tikva—during its first 40 years—was a pioneer, and which projects were tried in it but failed. These developments will be described and analyzed with a view to establishing in what ways the first steps of Petah Tikva in agriculture and in the processing of agricultural products influenced the development of agriculture and of agricultural industry in the country in general. We will show briefly what was the nature of Petah Tikva's contribution to the development of agriculture (and of agricultural industry) in the country as a whole. One should remember that some of the innovations and achievements that originated in Petah Tikva had implications outside Palestine, too, In some respects, notably the introduction of new tools and devices and the organization of production, Petah Tikva may be considered a pioneer on the international as well as the local level.

EXPERIMENTS AND BEGINNINGS IN AGRICULTURE

Of the various agricultural experiments carried out by the first settlers of Petah Tikva, and even more so by the Rothschild administration, some never passed the experimental stage, or proved unsuccessful or lacking any economic rationale under the existing circumstances. However, the lands of Petah Tikva served as a proving ground for many crops, some of which did strike roots within a few years. One should note the attempt to grow field crops such as flax, hemp, and a kind of thistle the prickly heads of which were to serve for beating wool. *Tumbak* (waterpipe tobacco) was also introduced under the guidance of an expert brought for this purpose from Syria. These crops met with considerable success, but were not continued for long. The farmers of Petah Tikva were also pioneers

From Shmuel Avitsur, "Trumata shel Petah Tikva . . . ["The Contribution of Early Petah Tikva to the Agricultural and Industrial Development of Eretz Yisrael, 1878–1917"], *Cathedra* 10 (January 1970), pp. 129–141. Reproduced by kind permission of the publisher (footnotes omitted).

in growing mangel, and conducted some successful experiments with sugar beets. Samples of the latter crop were sent to Paris, where they won praise. Other experiments involved the growing of tea, roses, and even opium poppies.

In the first years of the century Noah Naftuski of the second 'aliya [wave of Jewish immigration] tried with the help of Berl Katzenelson, who was then a laborer in Petah Tikva, to obtain better yields by adopting a Chinese method of growing wheat in garden beds. Naftulski later carried on his experiments in Degania in the Jordan Valley, etc., in which cotton was grown on the bank of the Yarkon but had to be discontinued for lack of a mechanical gin and due to some other economic and social reasons. The growing of acacia trees was to serve a double purpose: the trees would form hedges and their flowers would be used in the perfume industry. There were, of course, the eucalyptus trees, which played an important role in fighting the tributary swamps of the Yarkon and set a model for similar projects throughout the country. One should also note the many successes in growing irrigated fodder, which had not existed in Palestine before, and especially the tremendous achievements of Aryeh Lipkes in growing irrigated trefoil in Mir. And last, but most important for Petah Tikva's prosperity, was citrus growing. Ironically, the first citrus orchard to be planted in the colony, to be precise on the Lachman estate, proved unsuccessful and ultimately degenerated. It should be noted, in this regard, that before this crop was taken up by the farmers of Petah Tikva, the Rothschild administration had done a lot to develop it. A contemporary survey conducted by Menashe Meirowitz shows that in 1900 there were 923 *dunams* of citrus orchards in Petah Tikva, more than a third of which (350 *dunams*) had been planted for, and were owned by, Baron de Rothschild. On the eve of the First World War the area of citrus orchards amounted to 6000 *dunams*. The total area of orchards grew, then, 7 times, while that of orchards owned by the local farmers grew 10 times. We will return to the subject of citrus growing in our discussion of Petah Tikva's contribution to the mechanization of irrigation.

THE BAHRIYYA ORCHARD

The largest Jewish-owned orchard in Palestine (650 *dunams*) was the Bahriyya orchard north of the Yarkon, just outside Petah Tikva's area of jurisdiction. It was owned jointly by five partners from Petah Tikva and Jaffa. Thanks to its size, the Bahriyya orchard was the site of experiments and innovative practices that could not be carried out on a smaller scale. For one thing, it received its water not from wells but directly from the Yarkon, on which it actually bordered. In this respect, it played a pioneering role among Petah Tikva's orchards. The pumping plant of Mir, upstream, was used for irrigating field crops rather than orchards, and the central pumping project of Betzal'el Jaffe was not yet started.

MECHANIZATION OF AGRICULTURE

On 21 December 1878, Yehuda Raab made the first furrows in Petah Tikva's land, in what may be taken to mark the beginning of the new Jewish settlement in Palestine. Having little confidence in, or information about, the local plough, the new settlers made the error of introducing heavy Hungarian ploughs that turned the soil over, causing it to lose its moisture. These ploughs also required three times as much effort as the local furrow-making plough, and were the cause of a fall in yields, especially in summer crops. At the same time, a European harvester, despite its heavy weight and awkwardness, made

it possible to speed up and finish the harvest before the grains fell from their spikes—and all this without outside help.

The first harvest of Petah Tikva was also the first in the new Jewish settlement as a whole. In Mikve Yisra'el, which had been established earlier, field crops were left to Arab sharecroppers from the neighboring Arab village of Ya'zur. Already in this harvest, the traditional sickle of the Arab *fellah* was replaced by a machine—to be precise, it was a horse-drawn device, not a mechanical or a steam engine. (The internal combustion engine had not yet been introduced, even in Europe.) Threshing was also done by horse-drawn machines that were rented from the German colony of Sarona until one was bought by the farmers themselves. But these machines turned out to be of little help, and many times the farmers were forced to go back to the traditional threshing floor. A short while afterwards, the Rothschild administration introduced a heavy plough operated by the *manège,* which was designed to prepare the soil for planting trees. The *manège* would be turned by horses and a steel cable would be wound around it, at the same time pulling the 80-centimeter-deep plough. These three devices—the harvester, the threshing machine, and the *manège*—represent the premechanical phase of the Jewish settlement, in which some mechanization was introduced, but not one based on mechanical power.

The beginning of the 1890s saw the introduction, by the Rothschild administration, of the first locomobiles. The *manège* would be henceforth operated by steam, thus beginning the era of real mechanization in agriculture. Deep ploughing made the notorious and exhausting *bahr* (preparation of the soil for planting by hoes) unnecessary, as animals or steam power (and later tractors) could now do the work. This was a spark of hope, portending not only an easing of the physical effort involved in farming but also an increase in production. Although these beginnings were still very modest, some people began already this early to think of their future implications. Yehoshu'a Barzilai, a well-known public figure at the time, writes that the replacement of the hoe by "deep ploughing" (still very partial at the time!) causes the dispossession of the workers, as an area hoed by 100 workers in a day calls for only 5 workers using the new method—a 20-fold increase in production. Barzilai failed, of course, to take into account the horses or locomobiles that operate the *manège.*

But mechanization had its most important impact in the field of acquiring and transferring water. Here were involved new elements that had not been applied yet anywhere else. This subject warrants going into more detail.

THE WIND-OPERATED PUMP

Until the last years of the 19th century only animal or manpower was used for drawing water from wells in Palestine. For drinking water a rope and a bucket would be used, and for irrigation as well as drinking there was the water hoist (Ar. *shaduf* or *shalaf*) or the waterwheel. For drawing reasonable amounts of water, even just for drinking purposes, these devices were effective only in shallow wells. The water hoist (pumping wheel), operated by animal power, would raise a series of clay jugs, and later wooden boxes cast in a framework of iron bars. When full of water, a 1-meter-long row of such jugs or boxes would weigh up to 70 kilograms. This limited the capability of the animal (usually a mule), so that water could not be drawn from more than 10, or at the most 12, meters deep. In a deeper well the water hoist was useless and only miniscule amounts could be obtained in waterskins, which could be raised by animals going down a specially installed

slope. The amount of water that could be raised in this way, using one or a pair of animals, was 1 cubic meter per hour or less, as compared with 5–8 cubic meters when using the waterwheel.

In 1883 the settlers of Petah Tikva were driven by malaria to move temporarily to Yehud. There they were astounded to find water only 46 or 47 meters deep, while the well of the neighbouring Arab village Yahuddiya was only 18 meters deep. The cost of digging the well amounted to 8000 francs, a fantastic sum for those days. It should be remembered that the internal combustion engine was not in use yet and that the steam engine, of which there was one sample in Palestine in a flour mill [see selection 21], had no suitable fuel or spare parts in addition to being very expensive and impossible to repair locally.

The situation in Yehud seemed hopeless. But it turned out that a similar problem had already been solved by the German Templars of Sarona who, for several years, had been using a wind-operated pump to draw water from their well (which was, however, not as deep). With funds obtained from Rothschild, a similar device was built in Yehud. It was a hollow iron tower, with a round wind turbine of metal blades installed at the top. The idea was to use the pump for operating a flour mill, too, but this did not materialize at the time. Nor do we know whether there was a water reservoir built near the pump, which could have made it possible to maintain the reserve of water when the wind was not strong enough.

For some time the pump supplied the needs of the inhabitants of Yehud. But meanwhile the sanitary situation in Petah Tikva improved and Yehud was gradually deserted. As there was no more need for water, the pump was shut down and a few years later it was removed from the grounds. The new settlers who came to Yehud at the beginning of the second 'aliya had to go back to using a rope and a bucket, with the help of a hand crank. From the days in which it had still been in use we have a description of the pump by Hayim Chissim, a member of Bilu. It is likened to a huge bird spreading its wings in the air.

Both the first settlers of Petah Tikva and those of Rishon le-Tziyon had expressed wishes or had dreamt of being able to acquire water by means of a device operated by wind. But as it were, it fell to the lot of the temporary residents of Yehud to have been one of the first in Palestine to have installed a modern wind turbine and to have used wind power for pumping water.

TECHNOLOGY OF PUMPING AND TRANSFERRING WATER

The first well of Petah Tikva supplied water for drinking only. At 24 meters deep, a waterwheel would have been useless, and the water had to be raised by hand.

When a "fever" of planting citrus began in the vicinity of Jaffa, orchards were first planted anywhere that water could be found at a depth of up to 10–12 meters. As will be remembered, the only pumping device with an output sufficient for irrigating the orchards was the waterwheel. However, the amount of water that the mule or camel operating the wheel could raise was limited, so that the wheel could not be used in wells over 12 meters deep. This was the so-called "depth barrier," which limited the expansion of the citrus area despite the increasing demand for "Jaffa" oranges in Europe. The matter was taken up by the concessionaire of the Jaffa–Jerusalem railroad, Y. Navon, who requested the municipal engineer of Jerusalem, Mr. Faranjiyya, to prepare a plan for transferring the water of the Yarkon springs to Jaffa by the power of gravitation. The plan was submitted

and was translated into English and published as a parliamentary document, and Navon for his part received the concession for using the Yarkon water. But the necessary funds could not be raised, and fortunately so. As it turns out, Faranjiyya was gravely mistaken in his calculations, measuring the level of Yarkon springs in Rosh ha-ʿAyin at 50 meters instead of at 50 feet. With the hills around Jaffa being actually higher than the Yarkon springs, the plan—had it been attempted—would have met with total failure.

When the Rothschild administration had started planting citrus, the small size of the orchards, combined with relatively shallow wells, made it possible to use waterwheels for pumping water. Then a continuous area of 101 dunams was planted and a simple steam engine called "locomobile," which could be operated with any available fuel, had to be introduced. Shortly afterwards the first kerosene engines were brought to Palestine and were purchased, among others, by the Rothschild administration. But the wooden water-wheels could not move fast enough to be matched with either the steam or the internal combustion engine. To solve this problem, Jewish blacksmiths in Jaffa were assigned the manufacturing of iron waterwheels, modeled after Italian, French, and Spanish examples, which were smaller and more solid than the wooden ones. The first such waterwheel was installed in Petah Tikva, apparently after having been tried on one of the Rothschild orchards by Yaʿakov Papo, the builder and first mechanic of the Rishon le-Tziyon winery. This, too, proved to be insufficient. The use of an engine made it possible to pump water from deeper than before, but the pipes were soon clogged with sand. In addition, the engines could not be used at their full power as at such speed some of the water would spill. Despite its advantages, then, mechanical pumping was introduced at first only on a limited scale.

Such was the situation in 1900, four years after the introduction of the kerosene engines into Palestine. In Petah Tikva there were at this time 28 wells. Two were used exclusively for drinking water—one equipped with a pump operated by hand and the other (the wind pump in Yehud) inoperative by then. Of the other 26 wells, 23 irrigated orchards of a total area of 923 *dunams*. The Rothschild orchards amounted to 348 *dunams*, with another 70 *dunams* being then prepared for planting. They were irrigated by one waterwheel, one locomobile, and three internal combustion engines. Another 18 orchards with a total area of 575 *dunams* were irrigated by 20 wells equipped with 17 waterwheels, one hand pump, and two engines. In general, the farmers were in no hurry to introduce the new engines, as they had not yet been convinced of their advantages. At the time, it should be noted, the orchards of Petah Tikva already represented 40 percent of all the citrus area owned by Jews.

The technical difficulties involved in pumping water for irrigation were now taken up by Leon Stein, an engineer by profession and the owner of the first modern mechanical workshop in Jaffa. Apparently in 1904 he developed a filter that prevented the infiltration of sand into the pipe of the pump. It was a fine, dense copper net that was installed on the pipe and allowed the passage of water but not of sand. This simple device facilitated the use of mechanical pumps instead of the water-pumping wheels. As a result, an intensive planting activity was launched in the orange plantations in general, but most of all in Petah Tikva.

The filter was distributed all over the country only after it had been tried successful-ly in one of the orchards of Petah Tikva. But it proved to be a mixed blessing. The fast and intensive pumping quickly exhausted the wells, so that they would take many hours to refill. To overcome this problem the wells had to be dug even deeper so that more

abundant groundwater could be reached. This led to the introduction of another innovation. Instead of digging deep in the water-carrying level, the well would be dug up to the top of the water-carrying level and from there drilling would start into the groundwater.

A new type of well thus developed: deeper, more abundant in water and dug only in its upper part. It was designated a "Jewish" or "dry" well, as opposed to the "Arab" or "wet" well, with water visible on its bottom. There was also a technical reason for the new practice of digging the well up to the water level. As the piston pump, which was then in use, could raise the water only 10 meters (in practice only 8.5–9 meters), it had to be installed at the bottom of the well, close to the water level. Only with the introduction of vertical–centrifugal pumps that allowed for pumping from very deep, did it become possible to start pumping from ground level. But this occurred in Petah Tikva only after the establishment of the British Mandate.

An important project in the area of water technology involved the pumping and transferring of the Yarkon water to the lands of Petah Tikva. Rather than applying to the Ottoman government, the planners had this project carried out under concession from the local committee (va'ad). The concession was given to Betzal'el Jaffe, the man who had conceived the idea, through a stock company named "Palestine," which was later incorporated in the Rutenberg concession company under the name "Yarkon."

A similar pumping and irrigation project had been previously launched in Heftziba, near the Hadera stream; but unlike the Yarkon project it served only one company, Agudat Neta'im. The Jaffe project was set up in Mir, not far from the Yarkon springs. The actual building housing the pump was the first in Palestine to have been built of concrete. At the end of the summer of 1914 the broad-minded and devoted Jaffe bought from Rishon le Tziyon Winery a gasogenerator internal combustion engine operated by solid fuel (originally by anthracite). At the end of the spring of 1914 the pumping station was equipped with the first diesel engine to be seen in Palestine. A few weeks later, because of the outbreak of the First World War, the diesel stopped operating till the end of 1918 for lack of mineral fuel. The gasogenerator came again to use, but now fed by charcoal and even by pieces of wood for "instant" carbonization in a locally made device coupled to the gasogenerator. The gasogenerators saved the inhabitants of Petah Tikva and the whole population from thirst and destruction.

In England, the high point of the great Industrial Revolution of the 18th century was the development of the steam engine. In Palestine, it was the introduction of the internal combustion engine and the invention of the filter that started a revolution, not so much in industry as in agriculture and especially in irrigation. Only with the introduction of mechanical water pumping did it become feasible to plant extensive citrus orchards and give them a firm economic and technological basis. Petah Tikva, which with its vicinity had over 20,000 dunams of citrus orchards on the eve of the Second World War, was the pioneer of this revolution.

PROCESSING OF AGRICULTURAL PRODUCTS

[Winery, citrus by-products, weaving, ice making, tool shed, use of concrete and irrigation plans]

23
Agriculture in Kurdistan, 1820

. . . This afternoon I had some discourse with Omar Aga and Mahmood Aga about the agriculture of Koordistan. The usual increase of grain is about five to ten, to one of seed; fifteen is an extraordinarily good crop. Last year the crops of grain were bad, and yielded only two. Wheat and barley are sown alternately in the same ground. They depend on the rain, which mode of agriculture is called *dem*. There is a kind of corn called *bahara*, which is sown in the spring, and requires artificial irrigation. In the plains the land is not allowed to lie fallow; but it is relieved by alternating the crops of wheat and barley. In the hilly country the land must rest every other year. Cotton must never be sown twice running in the same ground; some crops of tobacco generally intervene.

The cotton is all of the annual kind, and generally requires watering, though in the hilly grounds some is grown by means of rain. Manure is applied only to vines and tobacco. Rice should not be sown for several years running in the same ground, which, however, may be employed for other grain. The rice is chiefly grown in the district of Shehrizoor. No hemp or flax is grown in Koordistan. Omar Aga told me that this year he has thrown into the ground a small quantity of flax seed, which he procured from a *Hadgee* who had brought it from Egypt. Much Indian corn, millet, lentiles, gram, and one or two other species of pulse, are grown. The plough is drawn by two bullocks.

No trees of the orange or lemon genus will flourish in Koordistan. The summer heat is indeed more than adequate; but the winter is too severe for them. The Pasha lately procured some Seville oranges and sweet lime-plants from Baghdad, for his new garden; but the first winter killed them. The ricinus, or castor-oil plant, is cultivated all over Koordistan; sometimes in separate fields, sometimes mixed with cotton. . . .

From Claudius James Rich, *Narrative of a Residence in Koordistan*, London, 1836, vol. 1, pp. 133–135.

24
Wool Trade of Iraq, 1860

. . . Because of its fineness, the wool supplied by the sheep that graze in the plains of Iraq and Sawad (Mesopotamia and surrounding zone) enjoys a marked preference over those coming from Syria. Hence, in spite of the disadvantage of distance, which entails considerable transport costs, it is in constant demand. Annual exports of this product amount to about 5000 bales, of which 2500 are exported from Baghdad and 2500 from Mosul; each bale weighs about 100 Constantinople *okes* (128 kilograms) and two bales constitute a camel load. France is the country in which Iraqi wool is most highly prized, and almost all

From "Report on Wool," 10 October 1860, CC Baghdad 1856–1867, vol. 12.

these 5000 bales are sent to Marseilles, by way of Aleppo and Alexandretta; a small amount is shipped to Livorno.

This wool consists of three [*sic*] main qualities:

Shafal—black, brown, reddish, or white wool. This wool is very fine and much used in the country for weaving of overcoats (*'aba*) and other garments of natural color worn by Arabs. It is gathered between Baghdad and Kut al-ʿAmarah, 45 leagues to the south.

Bazzuni—black wool, as fine as the preceding one, also employed for local uses. It is gathered in the Shatra, below Baghdad.

Awusi—wool that is predominantly white, less fine than the preceding ones but longer, sought for export. It is found between Baghdad and Kirkuk, 70 leagues to the north.

Halasseh—wool of any color, bought from butchers and tanners, an inferior quality. It is sold at a price one-third below that of the other qualities and accounts for only one-eighth of total exports.

The price of the first three qualities is approximately the same; variations are due to the greater or lesser care given by the Arabs in washing their flocks, an operation that takes place three or four days before shearing.

It is reckoned that about half the wool from Baghdad and $\frac{17}{20}$ of that of the Mosul region is white.

Kurdistan wool is very inferior to that of Iraq, and accounts for only one-third of the quantities bought in the Kirkuk and Mosul regions.

Purchases are made locally, either directly by European houses (French and Swiss) in Baghdad or through the intermediary of local traders on behalf of business houses in Aleppo or Beirut. British traders in Baghdad play no part in this trade. This year ten firms in Baghdad bought wool: one Swiss and nine Arab.

The operation starts in April. At that time of year the agents of the Baghdad merchants go out among the tribes, buy wool, and, as it is gathered, send it to their principals in Baghdad, so that the latter may take advantage, in sending it to Aleppo, of the caravan that usually leaves Baghdad in June, arriving in Alexandretta after a journey that lasts not less than 70–80 days. However several merchants prefer to delay their shipments by a month or two so that they may receive, before arrival, the first dews of autumn. They claim that this humidity, by moistening the wool, gives it a better appearance and makes it heavier, which produces a profit; but it also happens that, because of this delay, rain sometimes falls on the wool and, by wetting it more than required, makes it lose up to 6–7 percent of its value.

The operation begins in April and ends in August, lasting five months, after which the only outstanding item is the balances due; these are usually less the result of the bad faith of the Arabs than of the fact that the agents hold on to these arrears so as to use them, later, for their own benefit.

In their rounds among the Arabs these agents do not run any personal risks. It does sometimes happen that tribes other than those with whom they are dealing rob them of the money they carry; such accidents are rare, however, and anyway, since the thieves are known to them, they generally manage to recover the sums that have been taken from them.

The last wool that comes in—that is, at the end of the summer—is dispatched from Baghdad only the following spring.

Among Arabs the purchase of wool is done on the basis of the fleece (*djazzeh*). After the agent has discussed and fixed with the *shaykh* the price of the fleece, all the ones

from the flocks of the tribe are delivered to him at the same price. For every 10 fleeces the buyer is entitled to an additional one, or even two if buyers are few. This right is called *ushr* (tenth). Sales are in cash, and in base coinage—pieces of 5 or 6 piasters, occasionally half-piasters—which, unlike gold and silver coins, are not subject to continual variations in rates. The Arabs' preference for this kind of money gives it a premium of 2–3 percent at the beginning of the season.

Advances (*salaf*) of two or three months are often made to the Arabs, in return for which buyers get a discount of 20, 30, and sometimes 50 *paras* (10, 15, and 25 centimes) per fleece, depending on the degree of competition. These advances do not usually exceed half the value of the wool that can be supplied by the seller's flock. This year fleeces cost $4\frac{1}{2}$–6 piasters (90 centimes to 1.30 franc), but most fetched 5 piasters (1 franc), and I will therefore take the last figure as a basis for my calculation.

In Baghdad wool is sold by the *mann*, a *mann* of wool weighing 11 Constantinople *okes* (14 kilograms 80 grams). This is the current price in Baghdad, and not the one of fleeces outside it, and it is the one charged to the principals at Aleppo.

A *mann* equals 16 or 17 fleeces, or an average of 16.5 but as the tithe, which is 1.5 fleeces per *mann,* must be deducted, the gross price for the initial buyers is equivalent to only 15 fleeces, that is, 75 piasters (15 francs).

The difference between the purchase price of the fleeces and the sale price in *manns* covers the cost of transport to the town, tolls on bridges, if there are any on the road, and entry duties levied by the Baghdad Customs House. After deduction of these costs, the surplus of the difference is shared in half by the buyer and his agent, the latter finding in his share a remuneration for the effort he has exerted.

Here is an account of these expenses for one *mann* of wool:

Price of 15 fleeces	75 piasters
Transport to Baghdad	4 "
Toll on bridge	—
Entry duty	2
	81 piasters (16.20 francs)

This year the *mann* of wool was sold on the Baghdad market at 80–95 piasters (16–19 francs), that is, an average of $87\frac{1}{2}$ (17.50); the difference between the cost and sale price that the initial buyers had to share with their agents was therefore $6\frac{1}{2}$ piasters (1.30 francs)

Cost of transport to Alexandretta per camel load—two bales weighing together 200 Constantinople okes (250 kilograms)

(1) Most Baghdad merchants buy wool from the Arabs, but since this operation is carried out, except in special cases, at their own risk they are supposed by their principals, to have bought it on the Baghdad market; hence a brokerage fee of 0.5 percent of the value of the wool.

(2) When the wool is baled it has to be cleaned, separated by color, pressed, and weighed. This work costs 5 piasters per bale.

(3) Each bale is wrapped in cloth made of goat hair and tied with rope; the price of the wrapping and ropes is 35 piasters.

(4) Since the camel drivers live in the western part of Baghdad and start their

journey from there, the bales of wool must be carried from the warehouses on the east bank to the opposite bank. This transfer costs 2 piasters a bale.

(5) The cost of transport from Baghdad to Aleppo or Alexandretta varies each year, according to the needs of trade, the dearness of the means of subsistence, the number of camels etc. It is reckoned by the *qantar* or *mann*. This year the cost per load to Aleppo is 530 piasters and to Alexandretta 570.

(6) The brokerage charged by the Baghdad merchants is based on the value of the wool and of the costs incurred. There are two kinds: 5 percent with guarantee of losses that may result from outside purchases (*achats faits au dehors*) and 3 percent without such guarantee—the latter being seldom used.

Here is a recapitulation:

Price of 2 bales of wool, constituting a camel load and weighing 200 Constantinople *okes* (i.e., 18 Baghdad *manns*), at

87.5 piasters per *mann*	1575	piasters
Brokerage 0.5 percent	7.35	piasters
Cleaning and baling	10	"
Wrapping and ropes	70	"
Crossing of river	4	"
Transport to Alexandretta	570	"
	2236.35	
Commission, 5 percent	111	
Export duty Alexandretta	10	
	2357.35	

On this basis (i.e., 471 francs 57 centimes), the sale of wool in Marseilles would result in losses rather than profits for the consignees; transactions in this commodity make sense only because of the relative advantage it offers as a means of reimbursement of funds, compared to specie or paper.

It is only in the last four years that Iraqi wool has become an export item to Europe. It was the Mosul correspondent of the Maison Rostand of Marseilles who first experimented with it. Before that time, the price of fleeces had been nearly constant, at 2 piasters 10 *para* (45 centimes). Since then it has steadily risen and it looks as though the upward trend will persist, not only because of the demand of trade but also because of the decision taken, a few months ago, by the Baghdad Military administration, to manufacture here the woolen cloth needed for the army uniforms. This year the amount required for this purpose was 80,000 Constantinople *okes* (102,000 kilograms), and it is intended as a test.

In concluding this report on the wool of Iraq, I should add that wool derived from the region of Basra and Najd is exported to Bombay, through Basra, and Kuwait, on the Persian Gulf. This export does not exceed 1500 bales a year.

25

Prospects for Cotton Cultivation, 1863

[An area] for half a mile—capable of almost illimitable extension—on either bank of the rivers and canals, whether in the date groves or in the open, from the mouth of the Shat El Arab to the junction of the Euphrates and Tigris and for a very considerable distance up those rivers is capable of producing the cotton plant with very little labor to the cultivator. The flow of the tide into the canals and watercourses almost does away with the necessity of the expense of raising water for irrigating it. The climate apparently suits the plant admirably, and the soil in general is rich and strong. The few trees lately raised here have received no particular attention.

The obstacles that exist to the extended cultivation of cotton in this district are firstly the insecurity of property and of property in crops which, though it does not influence the cultivation of cotton in particular, is antagonistic to agricultural improvement generally and causes vast tracts of cultivable land to be left fallow. Monied men, even had they the desire to cultivate and the enterprise to embark capital in agriculture, would hardly venture to do so while there is a prospect of their crop being destroyed by Arabs and while there is a chance of their different rulers, Turkish and Arab, imposing arbitrarily—as the Turks have lately done here—increased taxation upon land. The land tax, its different assessors, varied rates, and attendant grievances is another obstacle, and the removal of all imposts from cotton—which I am informed is contemplated by the Government— would only affect such cultivators and landowners as hold what were originally "Maaf" lands and would give no particular encouragement for its culture to the mass of land-holders where property or holdings are assessed at so much per Jerreeb. [See VII, 23.] If it be the intention or desire of Government to foster its cultivation and they do away with the dues on cotton for a time, they would do well to reduce the taxes on cotton cultivators of the latter class, and the Sheikh of the Montefik should, I think, be invited to aid their endeavors by waiving the quarter or third of the gross produce to which he would be entitled were this article cultivated, he having a great deal of property in this district of which the richest portions are alone cultivated with cereals, etc., his tenants fearing to cultivate the less productive lands lest a bad harvest should beggar them. Another obstacle to the cultivation of cotton is the apathy of cultivators and the general objection to innovation of any kind; this latter, however, would be overcome if the profitableness of its culture were demonstrated by the better class of landowners.

An extensive distribution of American and Egyptian cottonseed to the poorer classes of cultivators and landholders would doubtless be productive of good; a guaranteed minimum price too might do some good but I anticipate that the pretty general want of confidence in the good faith of Government would go far to render even this extreme measure useless if it were guaranteed by them—but a guaranteed price and some judicious advances from a source the cultivators could rely upon would ensure the more extended cultivation of cotton and be productive of much good to the district. . . .

From Kemball to Bulwer, 22 April 1863, FO 195/752.

26

Agriculture in Iraq, 1865

. . . Of the above produce it will be seen, from the Report of Her Majesty's Vice-Consul at Bussorah, that dates and wheat are alone worthy of mention as articles of export; the exportation of beans, cotton, dholl, and millet being exceptional, and extremely limited. Leaving aside the shipment of wheat to the ports of the Red Sea, which is purely a Government speculation dating from the year 1863, and having for its object to supersede the supply from Egypt, the trade in this cereal is of a fluctuating character, though specially stimulated by the demand which arose in Bombay in 1865–1866. Its destination is usually restricted to the ports of the Persian Gulf, and in more limited quantities to Mauritius and Batavia. When indeed the harvest is abundant in the south of Persia, wheat is even imported into Bussorah, the charges of transit down the rivers of Mesopotamia having been hitherto greater than the expense of transport from Bushire and other ports on the northern coast of the Gulf. Scarcely any wheat is cultivated at or on the banks of the Shat-el-Arab, within Turkish limits.

Prices at the place of growth depend upon quality, and upon distance from town or intermediate depots.

Bagdad on the Tigris, Hilleh and Semaweh and Suk-esh-Shiookh on the Euphrates, may be regarded as the entrepôts.

At Bagdad the average price of wheat, in the last five years, has been 40 piastres per 134½ lbs. At the present date it is 55 piastres.

At Hilleh, Semaweh, and Suk-esh-Shiookh, the average price of wheat, in the past five years, has been 30 piastres per 134½ lbs. At the present date it is 50 piastres.

The average cost of transit on the Tigris is 150 piastres per taghar of 2690 lbs. On the Euphrates, the average cost of transit is 200 piastres per taghar.

The blackmail and other arbitrary exactions formerly levied from boats at different points on the banks of the two rivers, have for some years entirely ceased.

All the grains enumerated may be raised indifferently in every part of this pashalic, the only conditions being the supply of water and the means of irrigation. The low marshy districts on either side of the Euphrates supply rice. At Hilleh, and throughout the inhabited parts of Mesopotamia, wheat, barley, millet, and idreh are cultivated; as also in the track of land to the east of the Tigris, up to the base of the mountains from Arbil to the Dialeh. Below Koot, on either bank of the Tigris, there is little or no cultivation until the marshes are reached above Kurneh, inhabited by the Albu-Mahomed Arabs, who raise rice in considerable quantities. The lands below Kurneh to the sea, on either side of the Shat-el-Arab, are almost exclusively devoted to the cultivation of the date. Exportation being limited, the supply of grain is necessarily regulated by local consumption; and as bad seasons seldom recur consecutively, prices, taken one year with another, maintain a pretty equable rate. They are affected chiefly by the inadequate rise of the waters of the rivers, by inundation, or by periods of unusual disorder. The social condition of the inhabitants, as illustrated by the peculiar government of the Arab tribes, the delegation of authority to irresponsible chiefs, their constant internal dissensions, engendered by the

From "Report on Baghdad," A and P 1867, vol. 67, pp, 272–274.

weakness of the local administration, the general insecurity and consequent stoppage of the main channels of trade, are among the chief obstacles of the extension of cultivation. A detailed statement of the terms on which money is advanced for the cultivation of lands, of the relations of landlord and tenant, and of the general conditions of agricultural labor, would occupy too much space, and perhaps be out of place in this paper; but the occasion of reform may be predicated, from the universal indebtedness of the fillah or peasant cultivator, which is one of the worst features of the existing system. The mode of cultivation, in every branch of agriculture, is of the most primitive character. The implements are limited to the plough, with a share of 8 inches; the spade, differing from the English spade in being smaller in the blade, and in having a handle (without grip) 5 feet long; a rude wooden hoe; and a machine for chopping or cutting straw, consisting of a roller armed with blades fitted both transversely and longitudinally, and working the whole on wheels drawn by mules. In lieu of thrashing, corn is trodden by cattle. Machines for irrigation, and adapted to a river in which the rise and fall of water averages in the year 18 or 20 feet, would supersede with advantage the present plan of raising water in skins, which are drawn over a roller by horses or bullocks working up and down a ramp.

At present cultivation, like the fixed population, is restricted to the neighbourhood of town and villages situated on the great trunk roads, and to canal-irrigated districts, which are very limited in extent. The intermediate country is occupied by the great nomad tribes, who never engage in agriculture, and by the half-settled Arab communities, who shift their place of abode annually within certain limits, and raise only sufficient grain for their own consumption. Yet Turkish Arabia, in ancient times, comprised the seats of the most flourishing empires; and to judge from the existing remains in every direction, the surface of the country, reticulated with canals, must have teemed with a thriving population; and the alluvial soil and genial climate of Mesopotamia are adapted not less to the cultivation of the rich products of the tropics than to those of more northern regions. Were security established, encouragement might with advantage be afforded to the substitution of more valuable articles of produce for the ordinary grains; and one gradual but natural consequence of security would be to afford an ample supply of labour by converting the half-settled tribes into a fixed and industrious peasantry.

Cotton. Although the soil and climate of Turkish Arabia are eminently suited to the cultivation of cotton, there has been no appreciable increase of production subsequent to the outbreak of the American [C]ivil [W]ar. The supply, as before, continues inadequate to the local demand, and is supplemented by importation from Persia. The indigenous seed is very inferior, and unhappily the results of various attempts to introduce Egyptian and American seed have been intercepted by the ravages of locusts during the past five years. In the absence of direct encouragement and example (agricultural speculations being closed to foreign enterprise and capital), the apprehension of loss from the depreciation of value in the European markets is generally alleged to militate against the extended cultivation of the plant. . . .

27

Hindiyya Dam, 1888–1890

. . . The Hindiyya canal received its name because it was dug at the expense of an Indian princess who visited Najaf and saw the shortage of water there. With the passage of time, the canal widened and its flow increased, drawing the water of the Euphrates into it, and it became known as the Hindiyya river, after the princess. This caused a diminution of water in the Hilla branch, with great adverse consequences and complaints on the part of the inhabitants of Hilla. The *walis* tried to remedy the situation but without success and, although expenditure was high, no advantage resulted.

The greatest concern of this *wali* [Sirry pasha] was to complete the Hindiyya Dam; he spent most of his time on this and showed much care and energy.

The Ottoman Embassy in Paris had signed a contract with the engineer Schoendorfer and his assistant Dieuvivant; they came to Baghdad at the request made by the *wilaya* of the Ministries of the Privy Purse and Public Works. Their task was to make the survey for the removal of obstacles in the Tigris and Euphrates and to study the Hindiyya dam project. They reached Baghdad on 19 September 1305 Rumiyya [1888], studied the need for the dam, and made a survey of the flow and navigability of the Euphrates near Hindiyya and Hilla in all seasons, returned to Baghdad, and drew up a map and report that they presented to the *wilaya,* which forwarded them to the Ministry of Public Works.

It became clear that the engineer was convinced that changes were necessary in the plans drawn up by M. Galland, the technical adviser in the Ministry of Public Works; it therefore became necessary to await the ministry's reply. On 1 *Jumada al-akhira,* 1307, the engineer and his assistant left Baghdad by land, to survey the Euphrates, and reached Maskana to study the navigation of boats and inspect the rocks in the river at Hit, returning to Baghdad by river.

Total expenses since the constitution of the Hindiyya Dam Committee until the end of November amounted to 1,733,998 piasters and 33 *paras;* they were incurred by orders issued either by the Treasury of the *wilaya* or by the Treasury of the *saniyya* [Sultan's estates] or by landowners. But the breakdown of these expenditures has not been ascertained by the accounts department of the *wilaya;* however, the supplies brought over are nowhere near commensurate with this amount. It is therefore of the greatest urgency that the *wilaya* should always be cognizant of the details of expenditure and that it should follow financial regulations in matters of expenditure. The *wilaya* therefore issued the appropriate orders to the committee, asking that orders and expenditures be entered in the proper ledgers and that clear information be shown regarding purchases and expenditures. It was learned that expenditures by the treasury until the end of October 1888 were 1,350,885 piasters and 13 *paras,* by the *saniyya* 200,665 piasters, and by landowners 182,444 piasters. This explains the vizier's activity since he took over the governorship of Baghdad.[1]

The Ministry of Public Works' orders were that work should proceed according to the technical report of the engineer, M. Schoendorfer, which agreed essentially with the

From Abbas al-ʿAzzawi, *Tarikh al-Iraq bayn ihtilalayn,* Baghdad, 8 vols., 1935–56, vol. 8, pp. 99–102.
[1]*Al-Zawra,* No. 1417, 8 *Jumada al-thania* 1307.

opinion of M. Galland, the technical adviser, and that the necessary measures should be taken to avoid further expenses; it declared that further operations would require £T. 15,300. Until now about £T. 15,180 have been spent, and further clarification was requested. The vizier's answer was as follows:

> What has been spent so far amounts to 1,922,000 piasters, of which 779,539 were spent with the knowledge of the first Committee, in the days of Taqial-din pasha, and 1,142,461 with the knowledge of the second Committee, in the days of Mustafa ʿAsim pasha. The work undertaken by the first Committee was abandoned, following the arrival of M. Galland, and the expenditure was wasted, only a small amount being turned over to the second Committee and included in its expenditure. The second Committee's expenses were devoted to excavation, two large and two small boats for transport and some equipment. In addition, 70,000 piasters remain due to the contractors carrying out excavations and transport. . . . The *Wali* declared that he would carry out an inspection and gave preliminary estimates.[2]

[The dam was officially inaugurated on 11 *Rabi'al-awwal* 1308/1890; Ibid., p. 104.]

[2]Ibid., No. 1420, 29 *Jumada al-akhira* 1307.

28

Date Trade in Basra, 1897

. . . The date season in Bussorah begins, according to the earliness or lateness of the crop, in the early or middle part of September, and lasts six or eight weeks. The crop was ready for packing this year about the usual time, viz., the middle of September.

The price is usually fixed at a meeting of the growers and buyers. This meeting or conference is generally held as soon as the dates are ready for packing, but this year it was considerably postponed with a view to obtaining reasonable terms with the owners of the dates by showing them that exporters were in no hurry, and were not eager to obtain dates at very high prices. Nevertheless, the smaller shippers and some even of the leading exporters in their great anxiety to secure their requirements and commence packing paid high prices for their dates. The first prices demanded were 340 shamis[1] (about 20*l.*) for "Hellawis" (the best packing date); 280 shamis (about 16*l.* 9*s.*) for "khedrawis" (the second quality); and 180 shamis (about 10*l.* 12*s.*) for "sáyers" (the inferior description) per 1 kara of 2000 okes[2] (about 50 cwts.). These prices, however, do not represent the limit of rise for 400, 300, and 200 shamis (about 23*l.* 10*s.*, 17*l.* 13*s.*, and 11*l.* 15*s.*, respectively) are said to have been given for the three qualities, respectively.

These high prices, it is feared, must result in loss to some shippers, for it is said that a large quantity of dates of last year still remains unsold in London and elsewhere. To

Report by Forbes, A and P 1898, vol. 93.

[1]17 shamis are equal to about 1*l.* sterling.

[2]1 oke equal to about 2¾ lbs. avoirdupois.

maintain prices at a level necessary to obviate great loss it has been thought advisable to institute a combination in London without which it is believed that prices would have descended disastrously low without sales being effected, owing to the flooding of the market by this year's importations of dates. The packing of the dates and the departures of the steamers were also delayed for the purpose of clearing last season's unsold stock in London and America, as well as for the object above alluded to, but buyers would seem not to have come forward, so that the stock has been little reduced. . . .

The quality of dates this season is said to have been exceptionally good, although the quantity was somewhat less than last season, owing to excessive heat about the time the crop was entering into the ripening stage which caused the fruit to dry up and fall. Some gardens were also affected by blight which caused much fruit to drop off before being matured. It is said that about 750,000 cases of $\frac{1}{2}$ cwt. each were shipped from Bussorah for London, New York, and other places. Maskat is said to have exported 60,000 cases. Besides the shipment of dates in boxes a large quantity is exported in baskets to India and its dependencies. These dates are generally of the inferior qualities and are transported in native sailing craft.

It would seem that the packers of dates were more or less obliged to ship as many cases as they possibly could, seeing that there were at the beginning of the season 1,000,000 empty boxes which had been paid for, the smaller packers not being in a position to be able to hold over empty paid-for boxes to the next season; and seeing also that considerable advances of money had been made to packers who were thus enabled to pack more dates than their own limited capital, without such advances, would have permitted them to pack; large advances to the growers against their dates when ready for packing had also been made. It must also be observed that packers had incurred sundry not inconsiderable expenses in the erection of packing sheds, and were presumably induced to make these preparations for packing as many dates as possible by the comparatively fair prices which were obtained last year for the first arrivals of dates in London, while they seemed either to forget, or fail to take into consideration, the considerable quantity remaining unsold from last year's shipments. So eager and impetuous were some of the minor native shippers to obtain as many dates as they could that, it is related, they have parted with their wives' jewellery even in their hot haste to secure as much profit as possible. But looking at the state of the date market in London, which has already been adverted to above, there would seem to be very little room for doubt that many will repent their rash and ill-judged speculation.

It may be generally said that the culture of the date palm in the Turkish province of Bussorah has steadily increased since the packing of dates in boxes for export to the United Kingdom and America was started, which is about 15 years ago. In the year 1896 the greater part of the country was inundated by unprecedented floods in which it is reported over a million date palms were destroyed; these trees it is believed have been all replaced by young ones, but still it will take 6 to 10 years before the latter produce fruit in any quantity. The high prices which are now obtained by the growers for their dates have rendered the possession of date gardens most valuable property, and the culture of the date palm receives from the Arabs great care, attention, and expenditure of capital in manuring and irrigation, which is not the case with land under any other form of produce. . . .

29

Irrigation in Iraq, 1907

SAKLAWYA CANAL

The existence of the Saklawya [Saqlawiyya] Canal seems to go back to the most remote antiquity. According to certain old documents it was the northern boundary of the earthly Paradise of the Chaldeans. It is conceivable, besides, that at a certain time this canal was a branch (*faux bras*) of the Euphrates. Everything tends even to show that, in prehistoric times, when the floodwaters hollowed out the valley of the Euphrates the wide bed of Saklawya, which crosses tracts of gypsum-bearing marl, was made before the narrower and less direct bed in which the whole course of the Euphrates is today concentrated: that is to say, that originally the whole river Euphrates occupied the Saklawya bed, and flowed into the Tigris near Baghdad.

However that may be, the Saklawya canal formerly had a considerable importance in view of the intercourse which it promoted between the middle region of the Tigris and that of the Euphrates: and one may fairly attribute to the importance of this intercourse the choice of the site of the town of Baghdad, at the very point where this canal debouched into the Tigris. It was the waters of this canal which quickened into life the plains on the right bank of the Tigris near Baghdad, plains formerly so fertile, but which are today nothing but a desert.

As late as 1838 this canal was in working order, and a steamer is reported at this time to have passed by this channel from the Tigris to the Euphrates.[1] It is permissible to think that, little by little, the entrance to the canal became larger, and that the dykes which formerly protected the sides ceased to control the waters of the river. Certain it is, that at the time of the great floods the discharge of the canal became so large that the whole plain round Baghdad was inundated, and that the low-lying portions of the town suffered considerable damage. Instead of seeking to remedy this situation by raising and strengthening the dykes and by reducing the entrance to the canal to the necessary size the only idea was to dam it. This senseless decision was carried out about 1847–1848. The work was done by means of "sausages" and fascines, according to the local custom: the banks of the canal were raised and Baghdad could now breathe freely, having nothing more to fear from the Euphrates' floods.

But the inconvenience of such a radical solution was soon felt. There was no longer any direct intercourse between the valleys of the Tigris and Euphrates, and no more irrigation of the plain or of the gardens on the right bank. In 1869 a wish began to be felt to go back to the old state of affairs. But instead of finding for the head of the canal a place near the old one, or better still, a little lower down, the unhappy idea was hit on of placing the head six kilometres above the first one, in the general direction of the valley, in a concave part of the bank, and moreover in soil recently deposited and eminently unsuitable. A combination of all these unfavourable conditions led to failure.

First of all they opened the new feeder canal (the Kananieh canal in the direction B.B): then they attempted to build a lock eight metres wide without troubling themselves

From a report from L. Cugnin, 12 October 1907, Baghdad, FO 195/2243.

[1]*Note:* The steamer passed from the Euphrates to the Tigris. (signed) J.R.

about the consistency of the soil on which the foundations of the work were placed. In using pumps, in order to facilitate the work of the masons, they raised, according to some witnesses, as much sand as water, thereby undermining the very ground on which the work rested. On the occurrence of the first flood and before the masonry was even finished, everything disappeared and was swallowed up in the sand, and the canal, which had been opened to its full width before the completion of the lock which was to protect the entrance, being eaten away by the water, soon became 80 instead of 10 metres wide. Nevertheless the erosion of the bed of the canal disclosed a fairly solid bank, some way below the head of the canal. In 1871 a new lock of 8 metres was raised upon this solid foundation. But no precautions were taken to protect the unsubstantial banks against which the work rested, and nothing was done to make the lock itself and the approaches safe from submersion. At the first flood the works were covered by the water, and the two banks washed away each to a width of 30 to 40 metres, while the unhappy lock was left on its foundation in the middle of the inordinately enlarged canal.

Not being able to understand the cause of these failures the authors of the project thought of nothing more than to shut up this new canal, as had happened to the first. They were doubtless pushed to this extreme measure by the cries of the population of Baghdad who, on each false move, were exposed to fresh inundations.

The earthen barrier which was constructed with this object at the entrance of the new canal, at C, was not defended any more than the preceding works, by raised banks above flood level, and the river overflowing in every direction took no time in wearing away a new passage in the direction d.d' and swamped the canal as if nothing had been done. The floods of the next years completed the destruction, and in 1879 no trace was to be seen of the work which had been carried out, except the Kananiyeh canal with its yawning mouth 80 metres wide, through which every flood found an easy passage to set in alarm the people of Baghdad. To put an end to this state of affairs, an attempt was made to find a new bed for the Euphrates in the direction of e.e' and to dam the river completely at E, to a width of 150 metres. This operation was all the more difficult because the new bed of the river e.e' had only been dug 4 metres wide and one metre below the level of low water. Happily for the success of the enterprise the soil was loose and the bed of the new cut could be enlarged as the progress of the barrage advanced. This barrage was executed in fascines according to the method in use for "barrages volants." Instead of "bardi" (a kind of marsh grass) and straw, which are not forthcoming in the locality, tamarisk branches were used for the construction of fascines and the thorny brushwood of "astralaga" and mimosa were used for the filling up. The "sausages" made for this work were not less than 50 metres long, and 3.50 metres in diameter. Hundreds of men were employed both to make and to move them. At the moment of closing the dam the wash produced upstream was so great that the noise of the water falling could be heard more than 10 kilometres off, and when the dam was actually closed, it could be seen that a hole more than 15 metres deep had been hollowed out lower down, in the dammed bed of the river. There is no doubt that to the length of the "sausages" and the great resistance of this method of making fascines must be attributed the success of a work carried out in such unfavourable conditions. Behind the dam of fascines, for greater security, a second dam was made of earth above flood level at F. and a second similar dam at F'. An insubmersible dyke was built between these two works, and two similar dykes connected them with the dykes constructed by the cultivators to protect their fields against inundation. Finally, through excess of precaution, the Kananiyeh canal was closed by a third dam made of earth, at F" and this dam was, like the others, connected by dykes raised above flood level

to the dykes of the cultivators. It is estimated that the barrage of fascines cost £T. 18,000, the earthen barrages £T 6000, and the connecting dykes £T 3000, a total of £T 37,000 [*sic*] or about 850,000 francs. Adding to these sums, what had previously been spent, since the opening of the Kananiyeh canal, there is no doubt that a million and a half francs were spent.

At the beginning of this year (1907) the dykes were broken and a new canal formed near Kananiyeh: in a little time the opening was 200 metres wide and the depth at low water is actually 3 metres. It is this opening which they are at the present moment trying to close by a dam made of fascines.

If it is wished to establish a navigation service on the Euphrates, it will be absolutely necessary to re-establish communication between the two rivers by means of the Saklawya canal. The usefulness of this communication is felt so strongly that in the course of this year a fairly large number of boats have profited by it to bring lime and bitumen from Hit to Baghdad. This canal will render possible a steam navigation service between Baghdad and Meskeneh on the Euphrates, 90 kilometres from Aleppo: consequently there is no doubt that merchandise and travellers will always use this waterway in order to go from Baghdad to Constantinople, and it will thus become an important highway.

The canal is 75 kilometres long from Saklawya village to the bridge at Khur, near the Tigris: a level taken in olden times gave a difference in level of 9 metres between the two ends, the canal has therefore a fall of .12 metres in the kilometre. It would be enough in the beginning to make only one barrage regulated with a lock at the intake of Saklawya, to re-establish communication at all seasons. The flow of the Euphrates being extremely regular, without any sudden floods, it is possible to employ small sluice gates and consequently the opening and shutting of the dam can be performed without mechanical means. The width of the barrage ought to be 20 metres and the lock to be 8 metres wide and to have 50 metres of available length. The cost of construction would be about 500,000 francs to which should be added an expenditure of 100,000 francs for strengthening the existing dykes.

There is no doubt that the income made by the passage of boats through the lock and the utilisation of land which could be irrigated by this canal would be extremely remunerative in proportion to the capital engaged in this work.

A contoured plan (*un plan coté tachéometrique*) covering a considerable area would be necessary, to show what area of land is irrigable from the canal.

30

Irrigation Schemes, 1911

Consul-General Lorimer to Sir G. Lowther.

(No. 14. Very Confidential.) *Bagdad, March* 31, 1911.

Your Excellency,

SIR WILLIAM WILLCOCKS is now about to submit to the Turkish Government in final form a complete set of projects for the irrigation of Mesopotamia, and, in consonance with the happy and confidential character of our relations from the first, he has handed me in advance a table of financial results, showing what he hopes will be achieved if his proposals are adopted. I hasten to transmit to your Excellency a copy of this important document, which is so clearly drawn that it seems to require no explanation or comment on my part. [Table 30.1]

I will only remark that, in setting down the cost of the schemes, Sir William has not only, so he informs me, added 33 percent. to the estimated expenditure according to Egyptian practice, but has doubled the result so obtained; and that the enormous margin of 166 percent. has thus been allowed to cover interest charges during construction of the works and development of the country.

The expenditure shown in column 2 of the statement (cost of irrigation works) is such as properly might, and in India would, be met by Government itself.

The expenditure shown in column 3 of the statement (cost of agricultural works) is that involved in levelling fields, constructing distributory channels, extirpating weeds, &c.; and this secondary expenditure might either be borne by owners and occupiers of land, or undertaken by a land development company, agricultural bank, or other similar body, or met partly in the one way and partly in the other.

The profit on the undertaking is calculated by the percentage of net rents on the total cost of the Irrigation and Agricultural Works, and is 24.9. Profit to the Government is calculated by the percentage of tithes minus maintenance on the cost of the Irrigation Works, and is 9.0. In addition to the direct gain on the Irrigation Works expenditure, the Government will profit by increased import duties and all other sources of revenue which accompany increased wealth among the people.

March 30, 1911. W. WILLCOCKS.

From Lowther to Grey 2 May 1911, FO 424/227.

Table 30.1 Table of Financial Results

Name of system (1)	Cost of irrigation works (2) £T.	Cost of agricultural works (3) £T.	Total cost of irrigation and agricultural works (4) £T.	Area commanded (5) Hectares.	Net rents, per annum[a] (6) £T.	Percentage of column 6 on column 4 (7)	Tithes, per annum (8) £T.	Maintenance, per annum (9) £T.	Tithes, less maintenance, per annum (10) £T.	Percentage of column 10 on column 2 (11)	Value of land at fourteen years (12) £T.
Feluja Hindia	5,084,580	5,500,000	10,584,580	550,000	3,080,000	30.0	770,000	165,000	605,000	11.9	42,900,000
Hai	2,757,980	2,500,000	5,257,980	250,000	1,400,000	26.7	350,000	75,000	275,000	10.0	19,500,000
Bussorah	1,996,960	900,000	2,896,960	90,000	504,000	17.4	126,000	27,000	99,000	5.0	7,020,000
Euphrates over-flow	425,000	250,000	675,000	50,000	280,000	41.4	70,000	30,000	40,000	9.4	3,900,000
Beled	2,118,240	1,700,000	3,818,240	170,000	952,000	24.9	238,000	51,000	187,000	8.8	13,260,000
Nahrwan	1,817,120	2,000,000	3,817,120	200,000	480,000	12.5	120,000	60,000	60,000	3.3	6,600,000
East Tigris tail	1,006,760	1,000,000	2,006,760	100,000	560,000	28.0	140,000	30,000	110,000	10.9	7,800,000
Navigation	48,380	..	48,380	5,000
Total	15,255,020	13,850,000	29,105,020	1,410,000	7,256,000	24.9	1,814,000	443,000	1,371,000	9.0	100,980,000

[a]Net rents are the rents with the tithes deducted from them.

357

31

Irrigation Projects, Iraq, 1914

Mesopotamia Irrigation: Sir W. Willcocks's Scheme

Paragraph in Sir W. Willcocks's Report	Works included	Sir W. Willcocks's Estimate	
	Work already in Hand	£T.	£T.
8	Hindiah barrage works, including Hilla branch works	669,480	669,480
	Works reported as to be Adjudicated on in 1914 . . .		
9	Habbaniah escape	791,00	
10	Dam along the right bank of the Tigris, Sakhlawieh regulator, Bagdad dyke, &c.	214,940	
11	Feluja barrage, diversion of the Euphrates thereat, &c.	711,620	
12	Right Tigris canal system, including Upper and Lower Sakhlawieh regulators, Akkar Kouf dam, Right Tigris, Lower Melcha, Harrea and Bagela canals, bridges, &c.	1,889,480	
13	Left Euphrates canal system, including Left Euphrates, Abou Goraib, Right Goraib, and Left Goraib, Upper Melcha, Koutha, Iskanderieh, Mahmoudieh, Radwanieh, Latafieh and Babylon canals, &c.	1,192,660	
14	Akkar Kouf drain and drains Nos. 1 to 10, regulators, bridges, &c.	554,220	
	Subsidiary Works on the Hindieh Branch.		
19	Two canals, regulators, &c.	67,940	
		5,421,860	
	Less paragraph 12—Right Tigris canal system below kilometre 69	1,006,760	4,415,100
12	Right Tigris canal system below kilometre 69		1,006,760
	Other Works.		
16	Tigris navigation, including Chala, Majar Kebir, and Machera barrages	48,380	
17	Kout barrage and Hai system, including Kout barrage, diversion of the Tigris, diversion of the Hai branch. Hai escape, drains, canals, &c.	2,757,980	
18	Basra system, including the Basra barrage, repair of the old Euphrates bank, canals, and drains	1,996,960	

(continued)

From communication by Messrs. Pearson, 31 January, 1914, FO 424/251.

Mesopotamia Irrigation: Sir W. Willcocks's Scheme (*Continued*)

Paragraph in Sir W. Willcocks's Report	Works included	Sir W. Willcocks's Estimate	
20	Beled barrage, including barrages at Beled, the Ashik dyke and diversion of the Tigris, Didjail escape, canals, drains, &c.	2,118,240	
21	The Nahrouan irrigation, including the diversion of the Dyala, the Lower Nahrouan, and other canals, &c.	1,817,120	
Page 52	Euphrates overflow	425,000	
			9,163,680
	Grand total	..	15,255,020

32

Agricultural Production and Potential, 1919

The Tigris, while retaining a clearly defined bed, waters the plains on either side through great branches, such as the Micheriya, Chahala, Misharra, Majar-el-Kabir, Batera, Dujailah and innumerable smaller canals. These branches curve sharply to the south after leaving the Tigris and run almost parallel with it, splitting into lesser branches, until their tail waters coalesce in great swamps, which form a barrier between the cultivated lands and the desert. The swamps on the east are expanded by torrents from the Persian mountains. The silt brought down during the annual floods has raised the Tigris and its branches above the surrounding country, so that there is a gradual descent from the borders of all the rivers and canals down to the swamps. The central plateau built up by the Tigris and its main branches is only irrigated at the time of the full flood during the late spring and is always dry during the cold weather. The intermediate slopes are irrigable during most of the spring and summer, while the low land at the tail of the subsidiary streams is always wet. Thus, round every channel there is a gradation of slopes, the higher being fitted for barley and wheat, the lower land for millet after the floods have somewhat subsided, and the lowest land of all for rice. The rice land is again sub-divided into two classes—the higher land well commanded by water throughout the rice season, but not always under water, and the lower land, which is always under a certain amount of water. In the higher land, rice is cultivated broadcast and in the lower it is transplanted. Beyond the lower rice land, is the unreclaimed swamp full of reeds. The swamps contract and expand with the volume of water in the Tigris and its channels, and have to be restrained by a system of dykes from flooding the comparatively narrow rim of cultivated land round them. When they contract after the summer floods, excellent crops of millet are grown in the damp soil left bare. Rice cannot be cultivated in them, because their waters do not hold

From "The Prospects of British Trade in Mesopotamia and the Persian Gulf," 1919, FO 371/4152.

enough silt. At least that is the local theory. Much damage is caused to cultivation by the breaking of the dykes at high flood. The tribes are divided into cultivators of wheat, barley and millet, and cultivators of rice.

The date plantations, which require regular irrigation, are located along the banks of the Shatt-al-Arab and along the Euphrates from Nasiriyah to Qurna. The accompanying map indicates roughly the extent of the grain producing areas.

25. The main products of the Vilayat are dates, rice, wheat, barley, millet, melons, vegetables and fruit. Dates have hitherto formed the most valuable item of export and may be considered to be the staple article of food in the country. The annual revenue actually collected on date areas, under present conditions, approximates roughly about 12 lakhs [1.2 million rupees], and another 3 lakhs should be collected in the Suk-esh-Sheyukh district under more settled conditions. A revision of the existing settlement would probably enable the date revenue to be raised to 20 lakhs, and, assuming this to represent one-fifth of the total average annual value of the date crop, the total value of the crop may be estimated at rupees one crore per annum. If the average selling price of dates is taken at Rs. 5 per Basrah maund, the total weight of dates would be about two million maunds, of which output about half may be regarded as available for foreign markets, the remainder being consumed locally and in the countries bordering on Lower Mesopotamia. Or, taking one rupee of revenue to represent roughly the annual tax on five trees, there should be 10 million trees in existence in Lower Mesopotamia and about 100,000 acres or more under dates, which, on an average of one quarter maund per tree, would produce 2,500,000 maunds. . . .

26. After dates, rice is the most important crop in Lower Mesopotamia. The main rice growing centres are the southern portion of the Amarah district at the tails of the large canals issuing from the Tigris on both sides and the Sukesh-Sheyukh district at the point where the Euphrates empties itself into the Hammar and Sannaf Lakes. Though primarily grown for home consumption rice is increasingly exported and 67,000 tons were loaded at Basrah in 1912, but fluctuations in the water-supply affect the crops seriously. It is difficult to form any accurate estimate of the area under rice until a regular survey is undertaken. The Turkish system of large lump sum revenue demands on tracts producing both barley and rice renders it difficult to apportion the amount of revenue derived from each crop. Again, the outturn of an acre of rice or barley is unknown and the people themselves have the vaguest ideas of units and measurements and crop yields, estimates given by them showing yields of as much as 4 tons of rice per acre and 2 tons of barley. In any case the yield of rice is very heavy, and the rice tribes are by far the wealthiest. At a very rough estimate based on assessment under Turkish rule, the area under rice might be put at 100,000 acres in the Basrah Vilayat, the total yield being about 195,000 tons. The estimate must, however, be accepted with the greatest caution. The demand for rice and paddy is likely to increase and the export should form an increasingly valuable item in the trade of Basrah.

27. The total area under wheat and millet within the Basrah Vilayat may be put down roughly at 50,000 acres, of which at least three-fifths would be under millet, the latter being grown mostly on the open lands on the banks of the river where the floods reach far enough to moisten the earth and recede early enough to allow of sowing, while wheat is grown both on open lands which are dry enough to admit of sowing before the advent of rain and which remain clear of floods sufficiently long to admit of harvesting, and under the shade of the date palms along the Euphrates and the Shatt-al-Arab. The greater part of the wheat exported from Basrah came from beyond the borders of the

Vilayat and the wheat trade may be said to have been mainly in the hands of the Baghdad firms. The rival claims of rice and dates and the uncertainty of canal irrigation and the scanty rainfall militated against the growing of wheat to any great extent in the Basrah Vilayat, though if the Tib and Dawairij areas were once more brought under irrigation as proposed below, a great increase in produce would result. It may be assumed that about 20,000 acres were under wheat cultivation in the Basrah Vilayat before the war. Barley probably accounted for 70,000 acres, millet for 30,000 and vegetables for 20,000, the total cultivation being about 349,000 acres. The wheat was not, generally speaking, of first class quality and was used mainly for mixing with softer wheat. The barley was of better quality, but its reputation in the market suffered badly from the high percentage of dirt which it contained and which was deliberately added by the growers. The export of grain was handicapped by the fact that, owing to the lowness of water in the Tigris and Hai rivers in summer and autumn, much of the newly harvested crop could not be brought down to Basrah in native boats until the following spring. Careless storage during the autumn months was responsible for deterioration of the grain which gave it a bad name in European markets. The grain growing capabilities of Upper Mesopotamia are described in Mr. Lloyd's report, and the Commissioners have not, in the circumstances, been able to obtain any fresh information on the subject. . . .

29. The method of cultivation of the spring crops, barley and wheat, is capable of considerable improvement. There is only one very light ploughing, the ground is never properly broken up and the upturned soil is never exposed to the sun and air for any length of time, although such exposure is a most important factor in the fertility of the soil. Moreover, the practice of waiting for the first fall of rain before sowing must often result in the seed being put into the ground much later than is proper thus missing a great part of the effects of the first rain. Wheat and barley are often sown as late as the 1st of March. If the ploughing and sowing could take place without fail say, in the third week of October, the seed would begin to germinate immediately the first rain fell. The reason why this is not done in many places seems to be that the population is not sufficient to look after both the rice crops and the spring crops. The wheat and barley tribes migrate to the rice tracts at harvest with their cattle and do the work of reaping and threshing and go on afterwards with their cattle to plough their spring crop. Thus, until reaping and threshing of the rice is concluded about the end of December, there are no means of preparing the wheat and barley lands. If motor ploughs could be utilized, the soil would be much more thoroughly turned up quite early in the season, its fertility being much increased thereby. It would be ready for sowing at the very first shower of rain and the seed would probably gain two or three weeks of cool weather. With a view to the improvement of existing methods generally, there is urgent need for the institution of an Agricultural Department. The rice grown is of a coarse quality and only one crop is raised each year. Experimentation might produce valuable results in regard to this and many other crops which are suitable to Mesopotamia. One of the first requirements of the country is to devise a system for getting rid of the salt which occurs in many places and which renders otherwise arable land uncultivable, and the Agricultural Department should devote careful study to this point.

30. In the second place, agriculture has suffered heavily hitherto from the uncertainty of the cultivators' tenure. Under former conditions the Sheikhs themselves held most of the land from the Crown on leases for not more than five years while those beneath them were usually tenants-at-will and were ruthlessly exploited, so that all concerned with the land took what they could out of it and put nothing into it. There was a chain of excessive and purely nominal values and rents, arrears and extortion, from the

Sheikh down to the lowest cultivator. When tenants do not remain more than a year in one place there is no proper system of fallowing, the ground is badly cultivated, no trees are planted and wild trees are not even permitted to grow. This general statement does not, however, apply to the narrow strips of palm groves and gardens near the towns.

31. The handling and financing of the grain crops might be greatly improved. The bulk of the purchases of grain destined for shipment are made in Basrah, but after the war conditions should be such as to permit British firms to purchase at the centres of growing and to carry out the processes of cleaning, packing, etc., near such centres. Efforts should be directed to the improvement of the quality of crops raised and to the prohibition of adulteration of the grain with dirt.

32. But our greatest hopes for the future of Mesopotamia are founded upon its possibilities as a cotton producing country. Hitherto cotton has been cultivated chiefly in the plains irrigated by several small streams forming the river Dyala in the Khorasan Sanjaq and the Baghdad Vilayat. The approximate area was estimated at from 500 to 1000 acres in small patches. Cotton was also grown at Anah on the Euphrates. Mr. Lloyd stated that Mesopotamian cotton had short staple but good strength and results showed the absence of proper cultivation. An attempt was made by a Jew near Baghdad to introduce a different quality of cotton from Egypt and India, but the experiment was not a success owing to the fact that the local cultivators were unable or unwilling to tend the plants in the manner required to grow on an extensive scale. . . .

33. The Agricultural future of Mesopotamia is entirely dependent upon three conditions:

> (1) the possibility of enormously extending the area under cultivation by creating irrigation systems on a scale analogous to those which in ancient times made the land so productive;
> (2) the capacity of the inhabitants to undertake the heavy burden of work which the development of the country will involve; and
> (3) the improvement of means of communication.

34. The question of irrigation will be dealt with first. Sir William Willcocks in his report on the subject describes the Tigris–Euphrates delta as an arid region of some 12,500,000 acres, the only adequately irrigated portions of the area being—

> (1) the Delta of the Diyala;
> (2) the Lower Euphrates from Nasiriyah to Suk-esh-Sheyukh; and
> (3) The Shatt-al-Arab.

Sir William Willcocks' investigations led him to believe that if the water-supply available can be properly utilised it will permit of the irrigation of 7,150,000 acres of winter crops, and of summer crops 1,000,000 acres of rice or 3,125,000 of millet, sesame, cotton, etc. Sir William selects six[1] tracts as specially favourable for irrigation schemes. [See selection 31].

[1](a) Between Feluja and Baghdad, Babylon and Baghaila.
 (b) The Hai Branch of the Tigris.
 (c) The country between Basrah and Jubair.
 (d) The country round the Hindia Branch of the Euphrates.
 (e) The country between Beled and Baghdad on the right bank of the Tigris.
 (f) The Nahrwan Canal. . . .

36. The restoration of the régime of the rivers appears to involve a threefold problem. Firstly, the successful but economical application of their waters for irrigation purposes; secondly, their preservation for navigation, which is and will be for a long time to come essential, and, thirdly, the drainage of the swamps now in existence. In the case of the larger Indian rivers which are canalised, we see that the irrigation, drainage and the maintenance of the river are in harmonious relationship. The river is not permitted to flow along the line of the canals and no vast marshes spelling widespread disaster, are created, the reason being that irrigation, drainage and the régime of the river are considered as mutually dependent and not as independent problems. In Mesopotamia, the phenomena suggest that irrigation has been permitted to exploit the river and drainage has been left to look after itself.

37. The Trade Commissioners do not presume to offer any opinion as to the lines on which it may eventually be considered desirable to find a solution of the difficulties which has to be faced and they merely venture at present to offer a warning as to the dangers involved in the hasty adoption of any large schemes of irrigation before a body of information has been collected which may enable sound conclusions to be drawn. Irrigation projects only too often suffer from narrowness in the first conception and when once a scheme is decided on, it is extremely difficult to pass beyond its limits or to modify its character in order that it may harmonise with later conceptions. . . .

33

Land Tenure

NOTE ON LAND POLICY

. . . Before any problem can be solved it must be stated. The main conditions of this question are, however, already familiar. With the possible exception of the survival known as "Uqar", all acknowledged rights in the land are subordinate to those of the Turkish Conquerors. The Turkish Government, presumably by right of conquest, was in theory the sole owner of the soil save in so far as it had divested itself of its rights by a specific act of alienation in favour of individual proprietors or possessors. We may for the present leave out of account land which has been made "Waqf" or devoted to an endowment of a religious nature. A special Department exists to look after Waqf properties and their management needs no detailed consideration here. There remain four classes of lands:

(1) *Sirf Mulk,* being land in which absolute rights of private ownership have been recognised. *Mulk* land however as a rule continues to pay land revenue, if used for agricultural purposes.
(2) *Aradhi Sanniyah,* or *Mudawwarah,* or lands formerly comprised in the domains of the Crown and afterwards transferred to general revenues.

"REVENUE CIRCULAR," Baghdad, 29 May 1919, FO 371/4150.

(3) *Aradhi Amiriyah*, or State lands in respect of which the Government had by a deed known as a Tapu *sanad*, given rights of occupancy to private persons on certain general conditions. Such lands are commonly known as Tapu lands or, more rarely, are referred to as *Mulk*.

(4) *Aradhi Amiriyah* or State lands in respect of which no act of alienation had ever taken place.

Lands of the third and fourth class are often called *Miri*. It thus comes about that lands of the third class may be referred to either as *Mulk*, *Tapu* or *Miri* according to the point of view of the speaker.

The Department of Government which dealt with alienation of land by the State and the transfer of immovable property between private persons was known as the Tapu Department. This Department aimed at providing a system of registration of title. How far it succeeded in a country wholly unsurveyed and unmapped and nearly devoid of natural landmarks, while its operations were conducted by a set of functionaries as ignorant, inert and inefficient as they were dishonest, can be imagined.

Each class of land presents its own difficulties.

Sirf Mulk

Here the chief difficulty is that according to the existing law all inheritance of Sirf Mulk is governed by Shara' Law. This law was intended for a people whose wealth consisted in flocks and herds. It prescribes division into multitudinous shares of impossible fractions. However, with a few doubtful exceptions, this class of land is confined to building sites and gardens in urban and suburban areas, and it has no great importance in a statement of agrarian policy.

Aradhi Sanniyah, or Mudawwarah

These properties were for the most part acquired by Sultan Abdul Hamid, sometimes in rather dubious ways. When once he had got them, however, he looked after them well and his memory is highly venerated in Iraq, as the model landlord and father of his people. So differently do the same men appear in different aspects. Since the establishment of the constitution the Sanniyah lands have been managed for the benefit of the public revenues and have apparently not profited by the change. The proportion which the State takes of their produce is sometimes as high as 60 percent, and the whole management strikes the impartial observer as a curious blend of benevolence and rapacity. There would seem to be no real ground for maintaining any difference between these lands and those of the fourth class. But the change cannot be introduced all at once.

Aradhi Amiriyah (3rd Class)

This is the source of all or nearly all our woe. It was Midhat Pasha, Wali of Baghdad, who in or about the year 1870, extended to the area under his administration the Tapu system long established elsewhere in the Ottoman Dominions. Needless to add, he acted with the best intentions. He saw that the tribes of Mesopotamia lacked security of tenure and had no motive for cultivating properly. He tried to benefit them, but the Arabs had good cause for looking on the Turks and the gifts of the Turks with suspicion. They feared conscription or some other plan for their undoing, and with very few exceptions rejected the proffered boon. What followed is instructive. The tribesman held aloof from the Tapu Department and its deeds. But others were not so backward. The Turkish Government and

its local representatives were generally ready to part with Government land, for a consideration, and the consideration was not always for the sole benefit of the fisc. So rich merchants and men of influence of all kinds obtained deeds for large tracts of agricultural land with boundaries and areas filled in pretty much at the discretion of the purchaser, regardless of the tribesmen who all the time remained in actual possession of the soil. The class of Tapu tenant thus created has always been the object of the tribesmens' bitterest hostility. But the tribes were not always ready to be openly defiant of authority. Their leaders were often bought with the land, and the purchaser was very often content at first to bide his time. When the authorities were complacent and powerful enough to enable him to recover the share due according to custom to the landlord, he recovered it or something less. When times were adverse, he would come to terms with the tribal Shaikh, to whom very often he would lease his rights for a fraction of their nominal value. For it is a feature of the Turkish fiscal system that everyone, from the Government downwards, leased out his rights, and passed on his liabilities to someone else. Hence arose the large and pernicious class of middlemen and tax-farmers who throve as parasites on the Government's impotence and ineptitude. In some areas such as Basrah and Baghdad, where the tribal system had degenerated, as it does in the neighbourhood of large towns, and in Ba'qubah, where the tribal system had never been strong, the Tapu tenant was able to consolidate his position. Here we find existing a large class of absentee ''landlords,'' very few of whom have ever visited their properties. They have been content simply to lease their rights from year to year to middlemen and enjoy the proceeds. Elsewhere, as in Hillah, the tribal element remained strong, and the Tapu tenant, save a few who laid themselves out to be good landlords, and develop their estates, has mainly existed on sufferance. Elsewhere again, as in Nasiriyah and on the Lower Euphrates, those who took out the Tapu *sanads* were of a different class. These were members of the Sadun family or persons immediately dependent on them. The Sadun family are the hereditary heads of the local tribal confederacy and the tribesmen at first raised no objection to the acquisition by them of Tapu papers. It was only when the Sadun began, on the strength of these papers, to enlarge their old customary dues into a demand for the landlord's full share of $\frac{1}{5}$th or upwards, that the tribes rose against them and drove them from their lands. This rising was not universal and did not affect all the Sadun. Those whose good sense outweighed their rapacity—a temperament rare amongst Arabs—still live on their lands and get enough out of their tribal tenants to keep them in considerable state. The rest are living in exile, a thankless, thriftless unamiable crew. Enough has been said to show that Midhat's reform brought not security but confusion. Here it is that we have our greatest difficulties to face. Hitherto our Political Officers and Assistant Political Officers have been guided almost entirely by possession and have made some sort of summary settlement to provide for immediate necessities, *viz.*, the cultivation of the land, the maintenance of flood protection banks and the payment of Government dues. But mere possession alone, though the best guide we had to follow, cannot be considered as a final criterion, and in any case we have to provide for the further adjudication of conflicting claims and the revision, where necessary, of temporary decisions.

Aradhi Amiriyah (4th Class)

This class comprises by far the largest part of the land capable of cultivation. It might be thought that it would offer fewer and simpler problems than the others. But the facts do not justify this expectation. It seems to have been a feature of Turkish policy, although as a matter of fact, in many parts of the country, they actually realised little or nothing from

lands of this class, to be fiercely solicitous of maintaining the fiction that it was theirs to do with as they chose. They avoided every act which could be construed as a recognition of any tribe's rights to any particular tract. Where such a tribal right was too patent to be blinked, as for example in the 'Amarah Division, they took a delight in shifting tribal Shaikhs and sections about from place to place within the tribal area. Elsewhere, as in the middle Euphrates, they brought in Saiyids and strange tribes from outside, to counteract the preponderance of powerful confederacies such as the Khazail, of whom they were afraid. In spite of this, if long continued occupation for periods of centuries can give rights, many of the tribes would seem to have prescriptive rights to the lands on which they dwell. This appears to be their view although they readily admit that the lands are State lands. In Fellujah the tribes call their right, if right it is, by the name of "Sakaniyah," which we may perhaps call "squatters' right." But whatever the right may be, the tribesmen certainly bequeath and mortgage it. Apparently they have also been known to sell it, but only among themselves. Whether they would countenance alienation to an outsider or not has not yet been ascertained. Probably some form of pre-emption would be brought into play to redress the situation.

Then again apart from the rights of the tribes as a whole to a particular tract of State land, there are the rights of the tribesmen *inter se,* as demonstrated by the shares into which they divide the produce of the soil. It seems to be a rule that the actual cultivator, the fellah, who is protected from the more gross forms of oppression by his mobility and the scantiness of his numbers in relation to the large area of land available, as well as by mutual rivalries and jealousies between claimants for tribal leadership, takes everywhere a fairly generous proportion of the fruit of his toil. In some areas he gets a "nusf barid" (a cold half), in others 40 percent, but apparently nowhere less than a third. Between him and the Shaikh, the head of the tribe, there exists generally a class of middleman known as *Sarkar,* commonly pronounced *Sarkal,* who represents the brain, energy and capital without which the labour of the fellah would be misapplied or not applied at all. His share too varies from place to place. It is commonly 20 percent, but in some areas, especially those apparently where silt clearance charges are heavy, he takes as much as 36 percent, leaving little for the Shaikh. The Shaikh again takes a share apparently calculated mainly according to the measure of his power to exact. Where he is strong he takes a good deal; where he is weak he has to be content with little or nothing.

These are the four classes of land divided according to the extent to which private rights have been recognised. The objects of our land policy have been stated as justice and the common benefit. The difficulties with which we shall have to contend in attempting to attain those objects in our dealings with each class of land have been explained. We now come to a consideration of the measures which we must employ in contending with those difficulties. . . .

VI

Industry

Mining

Except for oil and bitumen, phosphates in Jordan and Syria, Dead Sea potash, and copper and sulfur in Iraq, all of which have been exploited only recently, the Fertile Crescent is poor in minerals. Iron, silver, boracite, and other mineral deposits were to be found north of Aleppo, and some were worked but most lay in what is now Turkey (selection 7). In Lebanon, under Egyptian rule, small coal, sulfur, and iron mines were worked (II,1)[1] but abandoned soon after, and attempts to use the coal for silk factories were unsuccessful. In 1902 a detailed report on mineral deposits in the Damascus *vilayet* listed bitumen, gypsum, lignite, iron, coal, and marble.[2] In the Mosul area, according to Geary,[3] writing in 1878, "some coal mines exist, the produce of which is not, however, equal to English coal. [See II,33.] A mine of lignite has been worked by the Turkish government, and some of the coal deposits were at one time utilized to supply steamers on the Tigris; but the primitive and inefficient methods of working made the out-turn so dear that coal from England has superseded the native article." Similarly, the silver and iron mines that had been worked in the Mosul *vilayet* in the 1870s were abandoned because the silver content was low and the iron could not compete with Russian.[4] In 1904 phosphate deposits near al-Salt drew the interest of a British mining enterprise, which asked the Hijaz railway if it could transport 5000 tons of ore a month for shipment through Haifa, and offered to help

[1]Bowring, *Report*, p. 20; see also Ruppin, *Syrien*, p. 127.
[2]Report for 1902, FO 195/2117; Ducousso, *L'industrie*, pp. 153–154; Moore to Bulwer, 23 January 1862, FO 78/1670; "Mines and Forests in the Vilayet of Syria," FO 618/3.
[3]Geary, *Through Asiatic Turkey*, vol. 2, p. 98.
[4]Newmarch to O'Conor, 23 June 1902, FO 195/2118.

with the rolling stock, but the project was not carried through.[5] In 1911 a concession was granted to an Italian company, but the outbreak of war prevented exploitation.[6] Chromium mines near Latakia were worked from 1904 to 1907, and a very small quantity was exported, and then abandoned. In Lebanon gypsum was also gradually given up, because of foreign competition.[7] Ruppin put the value of the whole of Syria's mineral output at 200,000 frances (£8000) a year.[8]

Seepages of bitumen and petroleum have been known in various parts of Syria (e.g., in the Latakia, Hasbayya, and Dead Sea areas) for thousands of years, and at various times have been exploited on a very small scale and by primitive methods. The traditional Ottoman mining regulations, however, discouraged production, and the mining laws of 1861, 1869, and 1886, though successively more liberal, failed to attract much capital to mining in general in the Empire and petroleum extraction in particular.[9] A German company took a concession near Alexandretta but, having "bored assiduously for a period of 3 years without success," suspended operations.[10] However, the law of 1906, promulgated at the urging of the foreign powers, was regarded as much more satisfactory; under it—and with the growing worldwide interest in and increasing use of oil—some concessions were sought in Syria.

The Syria Exploration Company, registered in London in 1912, "held licences in Syria and conducted some shallow drilling there" but did not pursue the matter further. Another British concern, Jaffa Oilfields, an offshoot of Eastern Petroleum, which was operating in Egypt, leased "seven plots west of the Dead Sea." The Consolidated Oilfields of Syria, registered in 1913, "was short-lived and failed to develop the bituminous property which it was founded to exploit."[11]

More important was the taking over, in May 1914, by Standard Oil (New Jersey), of licences granted to Ottoman subjects in Palestine. Preparations to drill near Beersheba were interrupted by the outbreak of war, and obstruction by the British military authorities prevented their resumption in 1918–1920. At this point Standard became interested in the Iraqi concession being negotiated by Turkish Petroleum Company, and when it took a share in the latter it had to relinquish its claim to a concession in Palestine, under the Red Line Agreement (see below).[12]

In the interwar period the Iraq Petroleum Company obtained concessions over most of geographical Syria; it located traces of gas in the Jazira area, but no development took place. Another company, the Palestine Mining Syndicate, prospected on the shores of the Dead Sea.[13] However, it was not till the 1960s that oil production began in the Qarachuq area in Syria, and in 1955 in Israel. Asphalt was produced in the Latakia area in the interwar period.

It was the development of the Iraqi oil industry, and the building of pipelines from

[5]"Report on Damascus," 7 January 1904, FO 195/2165.

[6]Ruppin, *Syrien*, p. 129.

[7]Haqqi, *Lubnan*, vol. 2, p. 446.

[8]Ruppin, *Syrien*, p. 127.

[9]See *EHT*, pp. 273–274. and VI, 7.

[10]A and P 1897, vol. 94, "Aleppo."

[11]Longrigg, *Oil*, p. 25; for other contracts made in 1911–1913, see "Memorandum by Mr. Weakley on Syrian Oilfields," 30 August 1913, FO 424/239.

[12]Ibid.; Shwadran, *Middle East*, pp. 403–408.

[13]Longrigg, *Oil*, pp. 90–94; Shwadran, *Middle East*, pp. 409–418.

Iraq and Saudi Arabia to the Mediterranean and of refineries at the terminals, that gave Syria its importance in the world petroleum industry.

The history of the oil industry in Iraq is exceptionally complex. Not only was there a large number of competing businesses—each supported, to a greater or lesser extent, by its government; there were also many different government departments concerned (e.g., in Britain the Foreign Office, Admiralty, Board of Trade, India Office, Government of India, and Colonial Office); in addition, there were the political upheavals that interrupted and diverted the flow of negotiations, most notably the Young Turk Revolution and the First World War. The most recent and fullest study is that by Marion Kent, on which this account is largely based.[14] The intent here is merely to disentangle the main threads and elucidate the reading of the documents included in this section.

Oil seepages have been observed, and utilized, in Iraq since remote antiquity. In the 19th century several deposits were worked, in a primitive way, by the local inhabitants (see selections 11 and 12). By the 1870s these and other deposits had begun to attract the attention of both Ottoman subjects and foreigners, Midhat Pasha had built a small refinery at Ba'quba, which soon fell into disuse, and a French expert introduced some improvements in the wells at Qayyara.[15] An attempt was made to use this oil as fuel in the Turkish river steamers, but its poor quality and high cost (£6 per ton compared with £2 for coal at Basra) rendered this unsuccessful. For the same reason, it was unable to compete with imported American kerosene.[16] In the 1890s several reports were made on oil including one by the Armenian businessman C. S. Gulbenkian. This prompted Sultan Abd al-Hamid to put the oil properties of the Baghdad and Mosul *vilayets* under the control of the Civil List. The French consul in Mosul judged that, because of its low cost of extraction, Mosul oil if refined locally could easily compete with Russian.[17] In 1908 a British official put the cost of Mandali oil at two-thirds that of the cheapest foreign imports. Its output was 20,000 tons but could be raised to 400,000.[18]

The concessions granted to the Anatolian and Baghdad Railway Companies in 1888 and 1903 (see IV, Introduction) gave them a preferential right over minerals along the lines, including oil. In July 1904 the Anatolian Railway, acting for Deutsche Bank, received a one-year exploration contract; however, its investigations seem to have been cursory, it did not report the results of its findings, and the Ottoman government declared that the concession had lapsed and that it could be granted to another party. Tentative approaches were made to various British firms, including the D'Arcy group that was operating in Iran,[19] but the outbreak of the 1908 revolution changed the situation.

The new government transferred the oilfields to the Ministry of Finance, to whom all applications were to be submitted. In the course of the next three years interest was expressed by the D'Arcy group; by the Germans; by Admiral Chester of the United States, as part of his railway scheme;[20] by the Anglo-Saxon Petroleum Company, representing

[14]See also the works by Longrigg (*Oil*), Shwadran, and Issawi and Yeganeh, listed in the Bibliography; Kent (*Oil and Empire*) reproduces the relevant documents.

[15]Longrigg *Oil*, pp. 13–14; see also A and P 1867, vol. 67, "Baghdad," and dispatch from Basra of May 1873, FO 195/996.

[16]Geary, *Through Asiatic Turkey*, vol. 2, pp. 16–17.

[17]"Report on Mosul," 30 April 1895, CC Mossoul, vol. 2.

[18]"Report upon the Conditions . . ." by George Lloyd, 1908, IOPS 3/446, p. 96.

[19]See *EHI*, chap. VII.

[20]See *EHT*, p. 196.

Royal Dutch-Shell and Gulbenkian's interests; by the Eastern Petroleum Syndicate, representing the Lynch (see IV, Introduction) interests; and by other groups.[21]

The years 1912–1914 saw intense competition for an oil concession. The protagonists were as listed below.

1. Anglo-Persian Oil Company, the name adopted by the D'Arcy group in 1909; in 1914 the British government acquired a 51 percent interest in this firm, but even before that it had backed it against other groups as being purely British and less likely to join an oil cartel than was Shell.
2. Royal-Dutch Shell, then owned 60 percent by Dutch interests and 40 percent by British; it acted through the Anglo-Saxon Company.
3. The National Bank of Turkey, an Anglo-Turkish group that had been founded in 1909, on Turkish initiative and with the encouragement of the British Foreign Office.
4. The Deutsche Bank group, backed by the German government.

In 1912, under the sponsorship of Sir Ernest Cassel, a German-born British banker, the Anglo-Saxon Company, the National Bank of Turkey, and the Deutsche Bank group combined to form the National Petroleum Company, which was to take over the oil rights of the German railway companies and to search for petroleum in any part of the Ottoman Empire. It will thus be seen that the German government was willing to accept a large British share in the projected oil company, and later showed no reluctance in conceding that British interests should form a majority. However, for a long time, negotiations were stalled by the insistence of Anglo-Persian that it have at least a half-share, and a controlling voice, in the new company.

In July 1913, the British and German governments began direct negotiations and found that their positions were quite close. At one moment a partnership between Anglo-Persian and the Deutsche Bank group—eliminating both the National Bank and Shell—was envisaged, but it was decided that this was not possible. Eventually, agreement was reached on the following basis: 50 percent to Anglo-Persian and 50 percent to Turkish Petroleum Company (TPC), the latter being equally divided between the Deutsche Bank and Anglo-Saxon Company (Shell).[22]

At this point, however, Gulbenkian revealed that he owned a substantial interest in the National Bank of Turkey's holdings in TPC, and insisted on a share in the proposed concession. This led to renewed negotiations resulting in a final agreement on 19 March 1914, under which Anglo-Saxon and Anglo-Persian would each concede a 2.5 percent shareholding to Gulbenkian, without voting rights, thus making him "Mr. Five Per cent."[23] At the same time it was decided that the capital of the TPC, to which the new concession would be granted, would be doubled. The participants also agreed (paragraph 10) that neither they nor companies associated with them would seek to extract or refine oil otherwise than through the TPC in any part of the Ottoman Empire except for Egypt, Kuwait, and the "transferred territories" on the Turco-Persian frontier.[24] This stipulation, designed both to create a common front and to prevent any participant from

[21]Kent, *Oil and Empire*, pp. 15–30.

[22]Ibid., pp. 33–79.

[23]See Hewins, *Mr. Five Per Cent;* for the text of the March 19, 1914 agreement see Hurewitz, *Middle East,* vol. 1, pp. 574–576.

[24]Shwadran, *Middle East,* pp. 195–196.

stealing a march on the others, was to constitute the basis for the 1928 Red Line Agreement.

It will thus be seen that British interests were a clear majority in the reconstituted company. Britain owed its success to its strong bargaining position: the Germans were prepared to pay a price to remove British opposition to the Baghdad Railway, and the Turkish government was willing to make concessions in return for British consent to raising their customs duties to 15 percent.[25] The next round of negotiations was between the Turkish Petroleum Company and the Ottoman government, regarding the latter's royalties and share in profits. Talks were still proceeding when war broke out.[26]

During the war existing seepages continued to be exploited, those of Qayyara being developed by the Germans.[27] But British armies slowly and painfully occupied Iraq and British diplomats engaged in tortuous negotiations with their Allied counterparts and colleagues in other departments on the future of the country and its oil. Under the Sykes–Picot Agreement of 1916 the *vilayet* of Mosul was included, along with Syria, in the French zone of influence; apparently the desire to have a buffer zone between Russia and the British zone in Iraq proved stronger than that to acquire the country's major oil territory and induced acquiescence in the French claim. After that, however, the withdrawal of Russia, the collapse of Turkey and Germany, and the negotiations between the British government and Shell aimed at making the latter a predominantly British firm, brought about a change of attitude. In 1918 the D'Arcy Exploration Company examined oilfields in the neighborhood of Baghdad, was favorably impressed, and recommended that exploration wells be drilled at Abu Jir, Hit, or both.[28] Finally, in 1920, at the San Remo conference, Anglo-French agreement was reached. France renounced claims on Mosul in return for a 25 percent interest—at the expense of Germany—in the oil company that was to be formed. It also agreed to the building of a railway and pipeline from Iraq to the Mediterranean across Syria.[29]

At this point a new actor stepped on the stage, the United States. The appetite of Standard Oil (New Jersey) and other American companies had been whetted by the oil prospects of Iraq. Simultaneously, and not just by coincidence, fears of exhaustion of U.S. domestic supplies swept the country. The U.S. government proclaimed the Open Door Policy and began to put pressure on the British. Meanwhile, the latter managed to secure, on March 14, 1925, from the Iraqi government a 75-year concession for the TPC covering the whole country except for the Basra *vilayet*.[30] They also concluded, on 5 June 1926, with Turkey and Iraq, a frontier agreement under which Turkey renounced all claims to its former provinces in return for a 10 percent interest on all royalties received by the Iraqi government from TPC or other concessionaries for a period of 25 years.[31] Exploration and drilling began immediately and on June 27, 1927, a gusher was struck at Baba Gurgur, near Kirkuk, followed by an almost equally important discovery at Qayyara. This put pressure on all concerned to settle outstanding disputes, and on July 31,

[25]See *EHT*, pp. 74–76.

[26]For details, Kent, *Oil and Empire*, pp. 103–112.

[27]Longrigg, *Oil*, p. 43.

[28]D'Arcy Company to USS Foreign Affairs, 16 May 1918, FO 371/3402; this file contains much information on oil.

[29]Kent, *Oil and Empire*, pp. 120–178.

[30]For the text see Hurewitz, *Middle East*, vol. 2, pp. 355–365.

[31]For text, Ibid., vol. 2, pp. 372–374.

1928, a new agreement was reached under which the D'Arcy group surrendered half its holdings to an American group in return for an overriding royalty of 10 percent on all TPC oil. Thus the final distribution of shares was as follows: D'Arcy (Anglo-Persian), 23.75 percent; Anglo-Saxon (Shell), 23.75 percent; French (Compagnie Française des Pétroles), 23.75 percent; American (eventually Standard Oil of New Jersey and Socony Mobil, with equal shares), 23.75 percent; and C. S. Gulbenkian, 5 percent. The participants reaffirmed the Red Line Agreement, which remained in effect until November 1948.[32] The TPC (after 1929 called the Iraq Petroleum Company) acquired, through the Mosul Petroleum Company concession of 1938, the right to prospect for and exploit oil in the whole of Iraq. In January 1935 the pipeline carrying Kirkuk oil to the Mediterranean, through branches terminating at Haifa and Tripoli, was inaugurated, and large-scale production of oil in Iraq began.[33]

Manufacturing

The Fertile Crescent's ancient preeminence in handicrafts, particularly textiles, is shown by such loan words in European languages as damask, damascene, gauze, muslin, and baldaquin. By the end of the Middle Ages Europe had forged well ahead, and glass, paper, silks, and other products that had formerly been exported by the region to Europe were now imported from it, as was a large quantity of woolen cloth. However, in the 18th century cotton yarn and a small amount of cloth were still exported from Aleppo to France, until they were stopped by both increased Indian competition and a sharp rise in French duties in 1761. After that, Syria exported its cotton, like its silk, in raw form, but continued to meet its own needs, and those of adjacent areas, in cotton cloth.

Mechanization gave the textile industry of Britain—and subsequently that of other European countries—an enormous advantage, but for many years the Revolutionary and Napoleonic wars shielded the Middle East from such competition (III, Introduction). Writing in 1816 about Urfa, Buckingham noted: "The bazar is amply furnished with the manufactures of India, Persia and Asiatic Turkey, and with some few Cashmeer shawls and Angora shalloons; but English articles, which are held in the highest estimation, are extremely rare." He then describes the local cotton and woolen handicrafts, which had a rather primitive technology.[34]

Syria

In the 1820s, however, imports began to enter in increasing quantities. In the 1830s Egyptian textiles, produced by Muhammad Ali's factories, began to compete in Syrian markets and—much more serious—British and Swiss goods poured in. They were helped by greatly reduced prices (III, Introduction, Table III.6), lower freights (IV, Introduction), and, after the application of the 1838 Treaty (III, Introduction) following Egyptian withdrawal, minimal import duties; later on there was also a shift to European dress. Local textiles, on the other hand, continued for a long time to be subjected to several duties at various stages. As a British consul said, "European competition has much to

[32]Shwadran, *Middle East,* pp. 195–196.

[33]Longrigg, *Oil,* pp. 76–78.

[34]Buckingham, *Mesopotamia,* vol. 1, pp. 139–148.

answer for, but not all. The present vicious system of taxation upon raw products when manufactured in the country, created, it might be supposed, for the purpose of crushing all industrial enterprise, is at the bottom of the general decay."[35] Some craftsmen also had difficulty in obtaining raw materials locally, such as cotton (V, Introduction). Observers are unanimous in stating that a steep decline in handicrafts ensued; their estimates—which are far from consistent—are shown in Table VI.1.[36]

The figures are too heterogeneous and shaky for quantitative analysis, but they do reflect a clear trend: the sharp decline and subsequent recovery. The recovery was due to several factors.[37] First, there was the increase in population and, possibly, also in the level of living (II, Introduction), coupled with the fact that most people continued to prefer some local to foreign goods. Production became more concentrated and efficient. Some handicraftsmen successfully imitated foreign designs. The repeal of most internal duties in 1874 also helped (III, Introduction). Craftsmen increasingly relied on cheaper and stronger foreign yarn: Syria's imports of cotton yarn (from Britain and elsewhere) rose from an average of £60,000–70,000 a year in 1888–1892 to £400,000 in 1903–1907 and £900,000 in 1913, and of silk thread (Chinese and other) from £95,000 in 1888–1897 to £250,000 on the eve of the First World War;[38] in other words, as in Europe, weavers won a reprieve at the expense of domestic spinners. They also shifted to the production of cheaper varieties (e.g., *dima* cloth, made only of cotton, instead of *alaja*, which contained silk) and improved methods. In 1854 the French consul reported that imitations of French silks were being made and that two Jacquard looms had been installed at Dayr al-Qamar; their products were both better and cheaper than those of the old looms.[39] Soon after, three such looms were operating in Damascus (selection 2). Most of the looms in both places were destroyed during the 1860 disturbances, but by 1911 there were 30–40 Jacquard looms, some of an improved type, in Damascus and in Aleppo.[40] Finally, wages seem to have remained low (II,19). And even while suffering from foreign competition at home Syrian craftsmen continued to supply foreign markets. In 1861 it was estimated that one-third of Syrian cloth was sent to Asia Minor and Istanbul and a little under a third to Egypt.[41]

In 1872, of Aleppo's production of 9 million meters of cotton cloth, 7 million were exported to Egypt and Turkey.[42] Similarly, in 1879, 8 million francs worth of textile products in Homs and Hama, out of 12 million, were sent abroad through Tripoli.[43]

[35]A and P 1872, vol. 58, "Syria"; see also Schatkowski-Schilcher, *Families,* p. 71, citing French consul in Damascus, and a list of duties in Aleppo in 1857 in A and P 1859, vol. 30, "Aleppo." In 1845 an American stated: "The power looms of the Christians are silencing the handlooms of the Moslems. The consequence is that the population of the city is decreasing and its character is changing from manufacturing to commercial." This would, however, be eventually changed by the utilization of local water power and cheap labor and raw materials (Durbin, *Observations,* vol. 2, pp. 62–63).

[36]See also Owen, *Middle East,* pp. 93–95, 172–173, 261–262; Himadeh, *Organization of Syria,* p. 124.

[37]See also Owen, *Middle East,* pp. 94–95; Kalla, "Foreign Trade," pp. 198–207; Swedenburg, "Development of Capitalism," pp. 56–59.

[38]Kalla, "Foreign Trade," p. 203.

[39]Rafeq, *Buhuth,* p. 186; "Report on Trade," 29 May 1854, CC Beyrouth, vol. 7.

[40]Weakley, in *EHME,* pp. 282–283.

[41]"Report on Agriculture and Industry," 12 August 1862, CC Beyrouth, vol. 7.

[42]"Report on Trade," 1872, CC Alep, vol. 35.

[43]Report of 31 July 1879, CC Damas, vol. 6.

Table VI.1 Handlooms in Syria

Time period	Aleppo	Damascus	Homs	Hama	Beirut	Lebanon	All Syria
18th Century[a]	40,000	34,000					
1825[b]		12,000					
1820s[c]		12,000					
1820s[d]	25,000						
1829[e]	6,000						
1838[e]	4,000	4,400				1,200	
1845[c]	1,500	1,000					
1840s[f]							50,000
1847[f]							2,500
1848[g]	5,000						
1850[h]	10,000	1,666					
1853[d]		4,500					
1855[i]	5,560						
1856[j]	10,000						
1856[k]	5,500	2,800					
1858[g]	1,400						
1859	10,000[k]	3,436[h]					
1859[l]		3,156					
1850s[m]	3,500	3,000			0	600	
1860[n]		2,000					
1861	10,000[o]	550[l]					
1862[m]	4,000	1,500			100	150	
1864[l]		3,156					
1871[o]	5,000						
1872	6,000[p]	1,300[q]					
1874[n]	5,000		2,500				
1875[n]	2,400	5,250					
1879	3,000[r]	4,000[s]	4,000	700[t]			
1884[u]				1,800			
1891[n]	5,884	3,000	4,000	700			
1892		2,000[v]					
1897	3,000[w]	5,000[x]					
1902[y]		2,000	5,000	1,000			
1907[z]	14,000	1,200					
1908[n]			8,500				
1909[aa]	10,000	2,500	10,000	1,000	2,500		31,100

[a]Date unspecified; for Aleppo the figure shows "the past record," for Damascus "recent past"; Ma'oz, *Ottoman Reform*, p. 179.

[b]De Bocage, p. 242, cited in Owen, *Middle East*, p. 94.

[c]Earlier date unspecified; dispatch 10 September 1845, CC Beyrouth, vol. 5.

[d]Earlier date unspecified; "Trade Report," 1853, CC Beyrouth, vol. 7.

[e]Bowring, *Report*, pp. 20–21, 84.

[f]Bazili, p. 243.

[g]"Report on Aleppo," 1858, FO 198/13.

[h]Aleppo: J. L. Farley, *Turkey*, pp. 199, 212, cited in Owen, *Middle East*, p. 94. Damascus: CC Damas, vol. 3, cited in Rafeq, "Impact," p. 427.

[i]A and P 1856, vol. 57, "Aleppo," cited in Rafeq, "Impact," p. 427.

[j]A and P 1859, vol. 30, "Aleppo"; also 300 looms in Mar'ash, idem, "Mar'ash."

[k]Aleppo: Ma'oz, *Ottoman Reform*, p. 179. Damascus: CC Damas, vol. 4, cited in Rafeq, "Impact," p. 427.

[l]Rogers to Bulwer, 20 August 1861, FO 78/1586.

[m]Report, 12 August 1862, CC Beyrouth, vol. 7; a figure of 2000 in Damascus is suggested by CC Damas, vol. 4, cited in Rafeq, "Impact," p. 427.

Notes for Table VI.1 (*Continued*)

[n]Aleppo, Owen, *Middle East*, p. 172; Damascus, Qasatli, p. 123, who gives breakdown.

[o]A and P 1872, vol. 57, "Aleppo."

[p]"Report on Trade," CC Alep, vol. 35.

[q]A and P 1872, vol. 58, "Syria."

[r]Destrées to Waddington, 25 February 1879, CC Alep, vol. 36.

[s]A and P 1880, vol. 74, "Damascus."

[t]Dispatch 31 July 1879, CC Damas, vol. 6.

[u]Report for 1884, US GR 84, T367.15.

[v]A and P 1893/94, vol. 91, "Damascus."

[w]A and P 1898, vol. 99, "Aleppo"; also 2500 in 'Aintab, 2000 in Urfa.

[x]1898; A and P 1899, vol. 103, "Damascus."

[y]A and P 1903, vol. 79, "Damascus."

[z]A and P 1907, vol. 93, "Aleppo"; includes 'Aintab, Mar'ash, Urfa, and Antioch; A and P 1908, vol. 117, "Damascus."

[aa]Weakley, A and P 1911, vol. 87, "Report"; see breakdown in *EHME*, p. 275.

Exports to the Balkans and Russia were substantial and were hurt by the imposition of a 75 percent duty on Turkish goods entering Russian ports following the Russo-Turkish war, by the annexation of Bosnia–Herzegovina by Austria, and by the Bulgarian revolt.[44] In 1884 an American consul reported that the products of Zuq were improving and that they were supplying markets in Syria, Europe, and even America; also that three-quarters of the output of Beirut's looms was exported to Smyrna, Istanbul, and Egypt.[45] The Armenian massacres in the 1890s caused many artisans from the Aleppo region to emigrate; some went to Egypt, setting up their industry there and causing a loss of that market to Aleppo.[46] (See also II, 13 and 14.) However, by 1901 the British consul in Damascus was reporting: "Trade with Egypt in silk and cotton fabrics is improving . . . exports to European and Asiatic Turkey . . . also doing fairly well"; but profit margins were small because of the rise in costs[47] (see also selection 2). In 1901 half of Aleppo's output was exported.[48]

There was considerable displacement of weavers during this period. The 1822 earthquake and subsequent disturbances in Aleppo caused many weavers to move to Damascus. Conversely, the 1860 massacres in Damascus led to an exodus of Christian weavers (who owned practically all the looms) to Aleppo, Beirut, and Lebanon; by 1864 the number of looms in Damascus had almost regained its pre-1860 level, but two-thirds now belonged to Muslims.[49] In the 1870s, 'Aintab, Urfa, Birejik, and Mar'ash, which had previously bought cloth in Aleppo, set up their own looms because labor was cheaper there.[50] The number of looms in Homs and Hama seems to have increased (Table VI.1),

[44]"Report on Aleppo," 24 September 1887, CC Alep, vol. 37; see also Answer to Questions, 21 July 1880, US GR 84, T367.14.

[45]Report for 1884, US GR 84, T 367.15.

[46]"Trade Report," 1889, CC Alep, vol. 37.

[47]Richards to Bunsen, 7 January 1901, FO 195/2097.

[48]A and P 1902, vol. 110, "Aleppo"; for village looms in Palestine, see Wilson, *Peasant*, pp. 259–260.

[49]"Report on Agriculture and Industry," 12 August 1862, CC Beyrouth, vol. 7; A and P 1864, vol. 53, "Damascus."

[50]Destrées to Waddington, 25 February 1879, CC Alep, vol. 36.

and in 1880 the American consul reported: "There are thousands of handlooms through-out the country, often in the house of the operator."[51]

It is impossible to give precise figures on quantity and value of output. Boislecomte gives a figure of 6 million francs (£240,000) for Damascus and puts total exports of silk fabrics at 13 million francs (£520,000).[52] From the data given by Bowring, one can estimate the gross value of the silk and cotton fabrics of Damascus in 1838 at about £820,000 and of its cotton fabrics at £16,000; wages paid amounted to £84,000 and £2300, respectively. Applying the same coefficients to Lebanon gives a gross output of about £180,000. Bowring also quotes a figure of £250,000 for Aleppo.[53] Allowing for Homs, Hama, and other centers, total Syrian output may have been about £1–1.5 million.

In 1856 the gross value of the products of Aleppo's looms was estimated at 69 million piasters, or about £600,000, and in 1872 at 9 million francs, or £360,000.[54] In 1879, the gross value of the looms of Homs was put at 11,230,000 francs and that of Hama at 760,000 francs, or £480,000 for both towns.[55]

For 1898, the details given in the consular report on Damascus make it possible to give a very rough estimate of £500,000 for the gross value of fabrics. For 1901 the British consul in Aleppo computed the total value of "native manufactures of all kinds at about £400,000 which is below the average, for it was a bad year for trade and many looms stopped work."[56] In 1902 the cloth output of Homs was estimated at "a minimum value of £150,000."[57] For 1909, Weakley put value of output in Damascus at £400,000 and his data make it possible to give a rough estimate of £350,000 for 'Aintab.[58] Ruppin put the value of silk, cotton, and mixed fabrics at 30–40 million francs (£1.2–1.6 million), of which 10–15 million francs came from each of Aleppo and Homs, 3–5 million from Damascus, and 2–3 million from Hama and Lebanon. Some 30,000–40,000 workers were employed, earning 6–8 million francs a year.[59] Considering the fall in textile prices (III, Introduction, Table III.6), this probably represents a distinctly larger volume of output than in the 1830s.

The fixed capital invested in the industry was small, since a loom cost only 2–3 *majidiyas* (6s8d–10s), and even the Jacquard looms (which were made locally) £5–8,[60] but the working capital, in the form of raw materials, must have been quite considerable. The latter were bought by a master entrepreneur and distributed to craftsmen, each of whom carried out a specified operation.[61]

Data on other handicrafts are much sparser. Several branches catering to traditional tastes (e.g., makers of slippers, turbans, waterpipes) were hurt by the shift to Western styles (selection 5). But others survived because they enjoyed a natural protection like tanning and pottery, or catered to peculiar needs, like soap. Syrian soap was made from

[51]Answer to Questions, 21 July 1880, US GR 84, T367.14.

[52]Douin, *Boislecomte*, pp. 266–267.

[53]Bowring, *Report*, pp. 20–21, 84.

[54]"Report on Trade," 1872, CC Alep, vol. 35.

[55]Gilbert to Waddington, 31 July 1879, CC Damas, vol. 6.

[56]A and P 1899, vol. 103, "Damascus"; idem, 1902, vol. 110, "Aleppo."

[57]Ibid., 1903, vol. 79, "Damascus."

[58]Weakley, in *EHME*, pp. 283–284.

[59]Ruppin, *Syrien*, p. 138.

[60]Weakley, in *EHME*, p. 289.

[61]Chevallier, "A Damas," and "Techniques."

olive oil and therefore had a ritual purity that imports—which contained all sorts of fats—did not enjoy. In 1833 Boislecomte put Syria's output at 45,000 *qantars* (about 12,000 metric tons) worth 5,175,000 francs (£257,000).[62] For 1838 Bowring gave the following figures: Palestine, 1.6 million *okes;* Aleppo, Idlib, Killis, 1.2 million *okes;* Dayr al-Qamar, 640,000 *okes;* Damascus, 320,000 *okes;* that makes a total of 3,760,000 *okes* or about 4800 metric tons, with a gross value that may be estimated at £250,000.[63] In 1850 the output of Jaffa's seven workshops was put at 7200 kilograms, much of which was sent to Egypt.[64] In 1871 the output of Aleppo, Killis, Urfa, and 'Aintab was put at about 2500 tons worth some £125,000; increased use of petroleum for lighting had made more olive oil available for soap.[65] In 1909 Weakley put total Syrian output of soap at 16,630,000 *okes,* or about 20,000 tons; the main producing areas were Nablus with 4 million *okes,* Jaffa 3 million, Lebanon 2 million, Tripoli district 2 million, Aleppo 1.4 million, and Aleppo region 2.5 million; Palestinian soap found ready markets in Egypt, Hijaz, and Yemen.[66] Finally, Ruppin gave a figure of 20,000 tons, worth 15 million francs (£600,000) and employing 2000–3000 men, who received 1–2 million francs a year in wages.[67] About one-third of the output was exported. It seems clear that overall output rose during the period under review.

Olive oil pressing continued to be done in a primitive way. In 1914, out of 600–800 workshops, only 114 (mostly in Lebanon) had hydraulic presses, installed during the previous 20 years. Annual output was about 22,000 metric tons, worth some 25 million francs (£1 million). Some 6000–10,000 persons were employed in this industry.[68] Other crafts that prospered were rugmaking and copperware, woodwork, and other items brought by tourists.

The decline of the handicrafts weakened the position of the guilds. In Syria guilds seem to have been introduced by the Ottomans but to have been more comprehensive than in other parts of the Empire, including not only craftsmen but merchants and people engaged in services. However, as in other provinces, their main function was to serve as an administrative link between the government and the urban population, helping to implement regulations and representing their members before the authorities. They controlled weights and measures and the quality of products, fixed prices and wages, collected taxes, supplied services and goods to the government, and occasionally supervised the distribution of raw materials and products. They arbitrated disputes between their members and helped them in case of need. All this was encouraged by the government, since it facilitated control of the potentially dangerous urban population. In Damascus, as in Egypt, in some guilds members were all of the same religious denomination, while in others the masters (*ustadh, mu'allim, usta*), journeymen (*sani'*), and apprentices (*ajir*) belonged to different sects.[69]

[62]Douin, *Boislecomte,* p. 266.

[63]Bowring, *Report,* pp. 19, 83.

[64]Report of 26 July 1851, CC Beyrouth, vol. 5.

[65]A and P 1872, vol. 57, "Aleppo."

[66]Weakley, in *EHME,* p. 281.

[67]Ruppin, *Syrien,* p. 151; figures of 6000–8000 workers and an annual income of £1.25 million are given by Swedenburg, "Development of Capitalism," p. 60.

[68]Ruppin, *Syrien,* pp. 145–146.

[69]For details see *EHT,* pp. 303–305; Baer, *Fellah and Townsman,* pp. 149–222; Rafeq, "Law Court Registers"; idem, *Buhuth,* pp. 160–192; Qoudsi, "Notices."

While these changes were taking place in the handicrafts, two small modern industries were developing, silk reeling and tobacco. The Régie des Tabacs, which had a monopoly (see V, Introduction), had two cigarette factories, in Aleppo and Damascus. The latter, established around 1883, went on using hand methods and employed only 40–50 workers; in 1908, however, it introduced modern machinery at a cost of £7000, raised its employment to 300 (mostly Jewish young women, paid 1 franc a day) and processed about 430 tons of tobacco, producing 72 million cigarettes a year.[70]

Silk reeling, by primitive methods in peasant houses, was practiced in Lebanon for many centuries.[71] A modern factory was established by a Frenchman in 1810 at Qrayye, and by 1845 there were five French factories, two English (one acquired in foreclosure of debt and the other, at Shimlan, having installed the first steam engine in the industry in 1846), and five Lebanese (whose products were of inferior quality); among them they contained some 360 wheels.[72] Although already in 1850 an increasing tendency to export cocoons rather than reeled silk is noted (V, Introduction), by 1862 the number of factories had risen to 44, with some 1800 wheels and 2200 pans; of those, 10 were French (770 pans), one British (80), and 33 Lebanese (1350). The latter were improving their methods, but the product of the French factories was better and commanded a premium; of the 1.2 million *okes* of cocoons reeled in Syria, more than two-thirds were by modern methods.[73] By 1885 the French owned 5 out of 105 factories and by 1913 only 7 out of 195, containing 735 pans out of nearly 11,000. On the eve of the First World War, over 90 percent of factories were in Mount Lebanon and the bulk of these in the Matn *qada;* over 90 percent of Lebanese factories were owned by Christians, mostly Maronites. The bulk were of medium size (25–99 pans), but the 28 large ones contained 32 percent of pans. The total working force fluctuated between 10,000 and 20,000; of these, 85 percent were women, overwhelmingly Christian and mainly Maronite. The working day averaged 13 hours in winter and 9–10 in summer, and the daily wage for an experienced woman was 5–6 piasters in summer and 3.5–4 in winter.

The capital invested was not large. In 1858, two British factories were sold for 156,100 piasters (about £1400) and £1250, respectively.[74] In 1909 fixed capital per pan was put at 200–250 francs, that is, a total of about 2.5 million francs (£100,000) for the whole industry. However, here too the working capital was much larger—some 3500–5000 francs per year.[75] To the French and a few of the larger Lebanese factories this was supplied directly through advances from importers in Lyon. The others received theirs from local banks, many of which had connections with Lyon.

Few other attempts were made to set up modern industries in Syria, and fewer succeeded. In 1835 the French consul in Beirut reported that a ship from Alexandria had

[70]A and P 1908, vol. 98, "Damascus"; idem, 1910, vol. 103, "Damascus"; Ruppin, *Syrien,* p. 265.

[71]The following account draws heavily on Ducousso (*L'industrie*), Chevallier, *Sociéte,* and especially Labaki (*Introduction*), pp. 32–171, which has an excellent and detailed analysis.

[72]Labaki, *Introduction,* pp. 79–84; Report for 1846, CC Beyrouth, vol. 5; Scott to Moore, 24 May 1852, FO 78/911.

[73]Reply to Questions, 1857, FO 78/1298; Report 1850, CC Beyrouth, vol. 6; Moore to Bulwer, 23 January 1862, FO 78/1670; Report, 12 August 1862, CC Beyrouth, vol. 7. Until 1856 foreigners were not allowed to own land in the Ottoman Empire, but they got around this by entering into partnership with a local notable; the Hatti Humayun removed this disability.

[74]Documents of 9 January 1858 and 19 October 1858, FO 616/4.

[75]Labaki, *Introduction,* p. 106.

landed 30 European workmen and "a large quantity of machinery" to set up factories, near the Dog River, for broadcloth, capes, and cotton yarn, but no more is heard about the project. In 1851 a Frenchman put an olive oil-refining plant in Tripoli, and a cloth factory was also reported in that town.[76] In 1863 a cotton-spinning mill in Beirut was reported "in course of construction" by a Syrian Muslim emigrant to Manchester, but it does not seem as though the project was completed.[77] In 1870 a cotton mill, costing £40,000, was built at Antioch, using the water power of the Orontes. English workers installed the machinery; however, the skepticism of the British consul regarding its success was borne out (selection 3).[78] In Beirut in 1878 an attempt by a Lebanese under British protection to set up a tannery, worked by machinery, and a tile factory were reported.[79] The following year the German colony at Haifa was reported to have wind-powered gristmills and an olive oil mill.[80] In 1881 a paper mill was built in Beirut, at a cost of £25,000; by 1896 it had closed, but a leather factory is mentioned.[81]

In the 1900s, however, industrial activity quickened, especially in Damascus. In 1901 a group of Muslims seriously considered setting up a sugar refinery, and experimented with imported beets, but in fact none was built until after the Second World War; at that time Damascus was reported to have a cotton-spinning mill—founded in the 1860s, using water power and producing 5000 bundles of yarn a year—and glue and starch factories.[82] In 1904 five flour mills, run by petroleum, are reported, and in 1905 a hydroelectric plant—the first of its kind in the Middle East—with a capacity of 1200 horsepower, was installed by a Belgian company for illumination and to run the streetcars.[83] In 1909 an ice factory, with a capital of £6500, was set up, as was a glass factory with a share capital of £16,000, which had to struggle hard against Austrian competition; a leather company with a nominal capital of £T. 10,000 had also been founded, but the attempt to float one for making fezzes had failed. There were also dyeing plants and factories making knitwear. Finally, mention should be made of the railway workshop, which was very well run and employed 180 men.[84]

Much less was done in Aleppo, but in 1902 a manufactory making silk rugs for the American market was reported, as were petroleum-driven flour mills in Aleppo, Urfa, ʿAintab, and Dayr al-Zur.[85] By 1910 the carpet manufactory employed 600–700 women and girls and 1000 by 1911.[86] Mention should also be made of several small industries established by Jewish immigrants in Palestine, including olive oil, sesame oil, wine, tapestry, and repair shops and workshops making simple machinery. The overall situation in 1914 is described thus by Ruppin: "In the whole of Syria one may estimate the number of enterprises that employ, in one factory, over 50 workers at less than 100; hardly a

[76]Dispatch of 18 February 1835, CC Beyrouth, vol. 1, ter.; Report of 26 July 1851, idem, vol. 6.

[77]Eldridge to Russell, 30 September 1863, FO 78/1769.

[78]A and P 1872, vol. 57, "Aleppo."

[79]Ibid., 1878/79, vol. 72, "Beirut."

[80]Ibid., 1880, vol. 73, "Caiffa."

[81]Ibid., 1882, vol. 71, "Beirut"; idem, 1897, vol. 94, "Beirut."

[82]Ibid., 1902, vol. 110, "Damascus."

[83]Ibid., 1905, vol. 93, "Damascus"; idem, 1906, vol. 129, "Damascus."

[84]Ibid., 1910, vol. 103, "Damascus"; idem, 1911, vol. 97, "Damascus."

[85]Ibid., 1903, vol. 79, "Aleppo"; idem, 1904, vol. 101, "Aleppo."

[86]Ibid., 1911, vol. 96, "Aleppo"; idem, 1912/13, vol. 100, "Aleppo."

dozen employ over 100 workers and not a single one over 300."[87] The fact is that, like other parts of the Middle East, Syria carried heavy handicaps in its industrializing efforts. The market was small, demand was shifting to foreign goods, fuel was expensive, most raw materials were lacking, transport was costly (IV, Introduction), skilled labor was unavailable and unskilled not very cheap, capital was scarce and timid, and the government gave almost no protection or encouragement until near the very end of the period.[88] No significant industrialization took place until the late 1940s.

Iraq

Much less information is available on Iraq, but the course of events there was similar to that in Syria. In the 1830s textile handicrafts were active, as may be seen from the fact that Baghdad and Basra (mainly the former) consumed 100,000 drams of gold thread— compared to 150,000 in Aleppo and 100,000 in Damascus, Homs, and Hama combined; another 25,000 were consumed in "Mesopotamia."[89] In 1842 Baghdad had a fairly flourishing textile industry, though heavily burdened by taxes (selection 8). In 1845 Mosul had nearly 1000 looms distributed as follows: 500 for cotton (four-fifths owned by Muslims); 400 for woolens (all Muslims); 30 for silk scarves (all Christian); 20 for ribbons; and 5 for silk cloth.[90] In 1866 the number of handlooms of every kind in Baghdad was put at 3500.[91] The large increase in Iraq's imports of textiles that accompanied the upsurge in its trade following the opening of the Suez Canal (III, Introduction) hurt textile production, especially that of cotton fabrics. In the 1880s, Baghdad's total output of textiles was put at £T. 312,000 for woolens, £T. 91,000 for silks, and £T. 55,000 for cottons.[92] By 1907 the number of handlooms in Baghdad had fallen to 900, producing 5 million yards of cotton cloth and 500,000 yards of silks and woolens (see details in selection 10). As for Mosul, in 1907 there were about 1000 handlooms in the city (and a similar number in the villages of the *vilayet;* selection 10), but in 1911 only 500.[93] In both cities handlooms almost disappeared after the First World War, but other crafts survived till much later, such as shoemaking, soapmaking, and cigarettes.[94]

Two industries processing raw materials for export developed: wool pressing and the making of boxes for dates. In 1889 there were two British firms that pressed wool. Lynch and Company, which had two steam presses capable of processing 14,284 bales a year, and Darby, Andrewes and Weir, which had two hydraulic presses with a capacity of 15,000 bales. In addition, there were numerous hand presses.[95] The wood for the date-

[87]Ruppin, *Syrien,* pp. 131–132.

[88]For a more detailed general discussion see *EHMENA,* pp. 156–159.

[89]Bowring, *Report,* p. 21.

[90]Report of 31 January 1845, CC Mossoul, vol. 1; the report also gives a list of the other crafts, of which the only significant ones were shoemakers, 120; tanners, 95; saddlers and makers of leather bags, 35; smiths (all Christian), 40; makers of copper utensils, 15 (12 Muslims, 3 Christians); goldsmiths, 24 (9 Christian, 8 Jewish, 7 Muslim); and swordsmiths, 13.

[91]A and P 1867, vol. 67, "Baghdad"; the figure of 12,000 looms in Baghdad during the first half of the 19th century given in selection 9 is probably greatly exaggerated.

[92]Hasan, *Al-tatawwur,* p. 282, citing Cuinet; see also Chiha, *Baghdad,* pp. 123–126.

[93]Hasan, *Al-tatawwur,* p. 283, citing British Consular Report; note, however, the increase in imports of yarn both in value and as a percentage of textile imports—see table in Shields, "Economic History", p. 72.

[94]Hasan, *Al-tatawwur,* pp. 284–285.

[95]Ibid., pp. 287–288, citing British Consular Report.

packing crates was imported in bundles from Austria-Hungary, Norway, and Russia; in 1911 the price of 1000 bundles was £32, c.i.f., and the cost of nailing the boxes in Basra was only 11s.8d. per 1000.[96]

Very few industries catering to the internal market were established. In the 1820s Dawud pasha, perhaps inspired by the example of Muhammed Ali of Egypt, set up small cotton and woolen textile factories serving the needs of his army (II, 26). In 1864 Namiq pasha built the ʿAbakhana textile plant in Baghdad, which was enlarged by his successor Midhat pasha in 1869; its daily output was 300 meters of woolen cloth and 4000 meters of canvas, also for army needs; the factory continued to function until 1950. Midhat also ordered a mechanical flour mill; however, it arrived after his departure, remained unassembled, and rusted. In 1870 he established a vocational school, for training in the different crafts; this too survived until 1917, but remained unsatisfactory.[97] Little more was done after that. In 1912 the British consul reported that in Baghdad there were, in addition to the military factory, 5 ice machines, 3 large and 21 small flour mills, 6 rice mills, and a small foundry and workshop fitted with machine tools; several of these had been established by British firms (see also Selection 9).[98]

[96]A and P 1910, vol. 103, "Basra"; idem, 1912/13, vol. 100, "Basra."

[97]Moosa, "General Reforms"; see also II, 32.

[98]A and P 1912/13, vol. 100, "Baghdad"; idem, 1914, vol. 95, "Baghdad."

1

Handicrafts in Lebanon, 1835

Nature of products	Number of looms, workshops, workers	Quantity of materials consumed[a]	Value of materials or funds used[b]	Cost of manufacture[b]	Value of products[b]	Profits[b]
Beirut						
Silk belts	120 Looms	36	882	360	1,323	228 [*sic*]
Fabrics for shirts and crepe	40 Looms	16	392	66	504	46
Cord, ribbons, silk for sewing and em-broidering	100 Shops	100	2,000	1,000	4,000	1,000
Skins and hides	200 Workers		300	150	600	150
Common earthenware	120 Workers		100	50	200	50
Sesame oil and *halva*	12 Shops		300	150	600	150
Horsehair bags	1 Workshop		50	25	90	15
Ships and boats	1 Shipyard		250	200	600	150
Lime	2 Kilns		10	8	36	18
Dayr al-Qamar						
Silk and cotton fab-rics	120 Looms	60	1,200	900	2,400	900 [*sic*]
Woolen and silk *'abas*	40 Looms	10	200	100	400	100
Ba'abda						
Silk and cotton fab-rics	40 Looms	20	400	200	800	200
Zuq Mikhail						
Silk and woolen *'abas,* gold thread and cotton yarn, fine	10 Looms	40 *ratls* of silk 20,000 piasters worth gold thread	50	3	65	12
Gold thread and cot-ton yarn, semifine	15 Looms	1 *quintal* silk 8 ½ quintals wool 175 *ratls* cotton yarn 50,000 piasters gold thread	135	66	241	40
Gold thread and cot-ton yarn, ordinary	75 Looms	75 *ratls* silk 13 quintals wool 260 *ratls* cotton yarn 52,500 piasters worth gold thread	132	98	270	40

[a]*Quintals* [i.e., *qintar*].
[b]Thousands of piasters.

"Tableau de l'industrie des habitans de Beyrouth et des principaux Bourgs qui en dependent," 1 March 1835, CC Beyrouth, vol. 1-ter.

2

Weaving Industry in Damascus, 1850, 1863

("Report on Weaving," 20 January 1850, CC Damas, vol. 3, 1849–1855)

MANUFACTURING OF SILKS

Cloth Known as *Qutni*

. . . Damascus makes various kinds of silk fabrics, but the most important with respect to quantity are *qutni* and *alaja*. For a few years the handicrafts of this city suffered greatly from the competition of lustred cotton cloth (*lustréen*), imitating Damascus patterns and made in Switzerland. But the population of the Levant, who had been at first attracted by the cheapness of the latter, changed their minds when they realized that their low price did not offset their lack of durability.

Qutni is a striped cloth with a silk warp and cotton woof. The threads constituting the woof are not dyed but remain white. There are two kinds of *qutni*: simple and rich (in Arabic, *manqusheh*). The latter usually has a plain satinlike stripe and a stripe decorated with patterns which the warp forms on the woof; here the woof constitutes the foundation and the warp the pattern.

Both simple and *manqusheh qutnis* are made with the same qualities and amounts of silk and cotton. The pieces have the same length and width when they are made for the same market, for the countries that get their supplies from Damascus do not order goods with identical dimensions. *Qutni* pieces designed for consumption in Syria, Baghdad, Constantinople, Smyrna, or Persia must be 8.75 *pics* (6.13 meters) in length and 1 *pic* (0.70 meter) in width. For those made for Egypt the length is 9.75 *pics* (6.83 meters), the width remaining the same.

The warps are stretched over a length that makes it possible to weave 15, 18, or even 20 pieces on the same loom, as is most convenient to the weaver. Thus a warp made for Egypt will be 136.66 meters long, plus the spaces in the warp between each two pieces, giving a total of 140 meters, whereas the warp for 20 pieces intended for the other above-mentioned countries will be 125 meters long in all. . . .

It follows from this that for 20 pieces of first-quality products the weight of the silk will be 7.722 kilograms and of the cotton 9.06, hence each piece will weigh 0.839 kilograms. For second-quality products the total weight is 13.507 kilograms and each piece weighs 0.675 kilograms. For third-quality products each piece weighs only 0.621 kilograms.

The cotton yarn used for making *qutni* is a number 12–18 (English);[1] in a very few cases up to number 20 is used. The fineness of the yarn used depends less on the desired fineness of the cloth than on the complexity of the pattern; this indicates that the finer yarns are used more particularly for *manqusheh*.

In Damascus there are 25 workshops where warps for *qutni* and *alaja* are available, employing about 100 workers. Work is paid for as follows:

From CC Damas, vol. 3, 1849–1855; vol. 4, 1856–1869.

[1] All cotton yarn consumed in Damascus is English.

(1) When 6 *okes* of silk (7.722 kilograms) are used for a warp of 20 pieces, the manufacturer pays the owner of the workshop 50 piasters (12 francs) for each warp and the owner, in turn, pays the two workers who spend a whole day on this operation 20 piasters (4.80 francs); each worker therefore earns 2.40 francs a day. Thus the making of the warp of a piece of first-quality *qutni* costs 0.60 francs.

(2) When 4½ *okes* (5.577 kilograms) of silk are used for a warp of 20 pieces, the manufacturer pays the owner of the workshop 35 piasters [7.40 francs (*sic,* read 8.40)] per warp; the owner in turn pays each of the two workers required for this task 7 piasters (1.68 francs). Since these workers spend only eight hours on this job they can make one and one-half warps a day, which brings their daily wage to 2.52 francs. The making of the warp for a *qutni* piece of second-quality therefore costs 0.42 francs.

(3) When only 3½ *okes* of silk (4.504 kilograms) are used for the warp of 20 pieces, the manufacturer pays the owner of the workshop 25 piasters (6 francs) per warp; the latter in turn pays each of the two workers required for this job 6 piasters (1.44 francs). But since the making of a warp of 3½ *okes* of silk takes only eight hours, and since two workers can make one and one-half warps a day, their wages amount to 2.16 francs. The making of the warp for a *qutni* piece of third quality therefore costs 0.30 francs.

Cloth weaving is almost wholly concentrated in *khans* belonging to mosques, *waqfs,* and private individuals. These *khans* are divided into rooms where several looms working at the same time can be placed. The number of looms making *qutni* is put at 653 and they employ 613 [*sic*] men and about 300 children. They produce 110,000–115,000 pieces of cloth.

Weaving is paid for as follows for each 10 *pics* (7 meters), a length known as *dorra:*

First quality—52.80 francs for the 20 pieces (220 piasters)
Second quality—48.00 francs for the 20 pieces (200 piasters)
Third quality—43.20 francs for the 20 pieces (180 piasters)

However, to these costs should be added 2 piasters for each piece for starch and other sundries. Workers who do not own a loom can hire one for 40 piasters (9.60 francs) a year.

One can sum up as [in Table 2.1].

Cloth Known as *Alaja*

Like *qutni, alaja* is divided into simple and *manqusheh. Alaja* is a cloth whose warp is made of silk and woof of cotton, the woof being usually dyed. The cloth produced by the

Table 2.1 Costs of Labor for Weaving *Qutni* (in Francs)

	6 okes *or* 3 ratls	4 1/3 okes *or* 2 1/6 ratls	3 1/2 okes *or* 1 3/4 ratls
Reelings at 4.56 per *ratl*	13.65	9.88	8.00
Division of yarn according to length of warp	2.34	1.69	1.38
Weaving 20 pieces	52.80	48.00	43.20
Starch, etc., of 20 pieces	0.48	0.48	0.48
Payment to owner[a]	12.00	8.43	6.00
Total	81.30	68.45	59.06
Labor per piece	4.06	3.42	2.99

[a]Line omitted in original.—ED.

Table 2.2 Cost of Labor for Weaving *Alaja* (in francs)

	Warp of 3 ratls *silk*	Warp of 2 ratls *silk*	Warp of 1 1/4 ratls *silk*
Reeling at 4.56 per *ratl*	13.68	9.12	6.70
Division of warp	2.34	1.56	0.97
Weaving 17 pieces	40.20	34.72	25.67
Total per warp	56.22	47.40 [*sic*]	33.34
Labor per piece	3.30	2.79	1.96

crossing of the warp and woof has stripes of different colors, along the length; however, in *manqusheh* cloth some of the stripes are decorated with designs.

Alaja produced for consumption in Syria, Arabia, Persia, and Turkey are 10.75 *pics* long (7.53 meters); those for Egypt 11.75 *pics* (8.23 meters). The width, which for *qutni* is 1 *pic*, is here only 0.75 *pic* (0.525 meters). The warp is stretched for only 17 pieces. . . .

It follows from what has been said that for first-quality *alaja*, for 17 pieces, the silk weighs 7.722 kilograms and the cotton 8.15 kilograms, hence each piece weighs 923 grams; for second quality, the silk weighs 5.148 kilograms and the cotton 7.55, hence each piece weighs 747 grams; and for third quality, the silk weighs 3.212 kilograms and the cotton 7.55, hence each piece weighs 633 grams.

For setting up the warp for the first quality, the owner of the workshop receives from the manufacturer 32 piasters (7.68 francs) and pays each of the two workers required for the job 5 piasters (1.20 francs). Two men can set up two warps in a 12-hour day; therefore, each worker earns 2.40 francs.

For the second quality the owner receives 27 piasters (6.48 francs) and pays the workers 4 piasters (0.96 francs); since the men can set up two and one-half warps a day, each earns 2.40 francs.

For the third quality the owner receives 20 piasters (4.80 francs) and pays the workers 3 piasters (0.72 francs); since the men can set up three warps a day, each earns 2.16 francs.

In Damascus there are 1013 looms for weaving *alajas*, employing 1013 men and about 5000 children. They produce 220,000–230,000 pieces a year—that is, twice as many as *qutnis*.

The costs for weaving *alajas*, including starch and other expenses, are as follows:

First quality—*osmanieh*, 10 piasters (2.40 francs); this is estimated at one-quarter of the total amount of *alaja* made.

Second quality—*tefarieh*, 9 piasters (2.16 francs); this is also put at one-quarter of the total.

Third quality—*kesawieh*, 7 piasters (1.68 francs); also one-quarter.

Fourth quality—*najajieh*, 6 piasters (1.44 francs).

Other Silk Fabrics

[*Kaffiyehs*, striped scarves, about 10,000–11,000 pieces a year, each of 16–32 *pics* (11.216–22.432 meters), 0.75 *pic* (0.525) in width]

COTTON FABRICS

. . . Damascus borrowed this industry from Aleppo, which alone had it in the past. But since Damascus is closer to some of the markets where these fabrics are sold than is

Aleppo, and since it consumes a certain amount, it is natural that it should have sought to acquire this industry, and also natural that it should have attempted to develop it.

At present the capital of Syria makes some 40,000 pieces of cotton cloth, each 9⅓ *pics* (6.560 meters) long and 1 pic less one-sixth (0.583) wide. This handicraft has 200 looms, employing 300 workers of whom 100 are children.

The 40,000 pieces produced by these 80 [*sic*] looms are sold as follows: 18,000 are consumed within the city and its neighborhood; 10,000 are sent to Baghdad; 3000 are sent to Mecca with the great caravan; 2500 go to northern Syria (Latakia, ʿAintab, Antioch); and 5000 go to Nablus, Jerusalem, and Hebron

You may have noticed, Mr. Minister, that in this piece of research I have not mentioned the sale price of the various fabrics. This omission is intentional: sale prices vary with the price of silk, whereas labor costs are always the same.

("Report on Industries of Damascus," 5 March 1863, CC Damas, vol. 4, 1856–1869)

[Before the events of 1860 Damascus consumed 300 *qintars* of silk (8000 kilograms) from Lebanon, Bursa, Persia, and Georgia. Today barely half that amount is consumed, because of the forced emigration of Christians to Aleppo and the competition of Aleppo. Exports to Cairo have fallen off from 100,000 pieces per annum to 25,000.

Last year 24,000 silk pieces (each 5.60 meters by 70 centimeters) were produced; 10,000 were consumed locally and the rest exported to Egypt, Anatolia, and the Mediterranean coast.

There are 1700 looms. Before 1860 ʿAbdallah Boulad had introduced a Jacquard loom, then two more, all of which worked satisfactorily. All were burned in 1860.

The report continues with a description of the other handicrafts.]

3

Handicrafts in Aleppo, 1870

. . . Forty years ago Aleppo's industry was still very active; its gold and silk, or silver and silk, fabrics were widely used in the East and were bought not only in Turkey but in Persia and India. Its cotton cloth also supplied a large population in Turkey and its muslins, for example, could compete with Indian products in most markets in the Ottoman Empire.

Imitations produced in Lyon struck the first blow at the Aleppo crafts; although they did not have the vividness of color and originality of design which for so long made people in the East prefer Aleppo fabrics, the cheapness of these imitations eventually brought them into general use. Later on the gradual adoption of European dress and fashions led to the giving up, little by little, of the use of gold or silver and silk fabrics. Since then only French and Swiss silks are used in Aleppo and not one of the looms that formerly employed 3000–4000 weavers in the city of Aleppo is still active. The fate of cotton fabrics was not quite the same. By imitating Aleppo products and delivering them

From "Report on Trade of Alexandretta," 20 May 1871, CC Alep, vol. 35, 1871–1878.

more cheaply to consumers English, French, Swiss, Belgian, and German factories have accustomed the townspeople to use inexpensive European cotton textiles; but the country people and the lower classes in the towns continue until now to use the strong cotton fabrics that the native looms supply to them cheaply. However, this industry is in decay; European factories have managed to imitate some of its products, notably the vividly striped cotton cloth which is used for certain essential parts of the dress of men and women among the common people. Some ten years ago, there were about 10,000 looms in Aleppo that made the cloth I speak of; today hardly 4000 are still active.

Three years ago some Aleppo merchants formed a partnership to establish, at Antioch on the Orontes, a factory powered by the river for ginning, spinning and weaving native cotton. The machines, bought in England, were set up and worked perfectly, producing yarn that could be used by Aleppo weavers and cotton cloth appropriate for local needs. Since they entered the market without being burdened by customs duties, transport costs and middlemen's profits, these products could stand up to foreign competition. However the business did not succeed and the firm is at present in liquidation. Its failure is attributed to the errors committed by a poor management and it is believed that once the liquidation has been accomplished the present owners will find it easy to sell the factory in this country, to industrialists willing to work it again. [The only other industries mentioned were: grain mills, cotton presses, tanneries, dyeing plants, and soap plants; all of them used horse or water power.]

4

Innovations in Damascus Weaving, 1850s–1870s

. . . Now however, the crafts of Damascus, and especially weaving, have suffered a great calamity because of the dearness of silk and the widespread use of European goods, even though the latter are less durable. This led the able al-Sayyid[1] ʿAbd al-Majid al-Asfar to imitate alaja using [only] cotton yarn, making it possible for the masses to buy it. Since his means were insufficient, he joined hands with al-Sayyid Hasan al-Khanji, who supplied him [with funds]. After much effort he was successful, and his products were used by both the upper classes and the masses; other craftsmen followed his example and improved on it, and now dima constitutes an important industry in which thousands earn their livelihood.

Some 20 years ago a member of the Murtada family designed a new kind of beautiful patterned (manqush) cloth, which sold widely. He was followed by al-Sayyid Darwish al-Rumani who, with the help of Khawaja Jurji Mashta, imitated the thin-striped European cloth (al-qalawuz al-muʿarraq); however, women refused to wear it because it did not have a European trademark, so he had to give it up. A short time ago, the able Khawaja Yusif al-Khawwam noticed how inclined people were to wear trousers, and their

From Nuʿman al-Qasatli, *Al-rawda al-ghannaʾfi Dimashq al-fayha*ʾ (Beirut, 1879), p. 123.

[1]The author uses *al-Sayyid* for Muslims and *Khawaja* for Christians.—ED.

need for a light cloth suitable for summer so he changed the looms used for *dima* and came up with cloth both better and cheaper than European weaves, thus earning general praise; if only other artisans would show his concern in improving their crafts they would match his success and soon rid the country of the need for European cloth. . . .

5

Effect of Westernization on Crafts and Trades in Damascus, 1891

9—*Antikji* (i.e., seller of antiques). This word is Latin and means old works, and the *antikji* is one who sells old works. This occupation is now flourishing because Franks are very interested in it and eager to buy its wares, especially very old ones going back to distant generations and times and with historical associations; in such cases, they pay severalfold. This came about when Frankish tourists entered the country in larger numbers, to visit old ruins and great monuments like Baalbak and Palmyra and other places; if in the course of their visit they come across an old piece of any kind or nature (e.g., an item of clothing like an old cloak, or a rug or carpet, even if torn, or a stone, especially porcelain, or a piece of copperwork or a sword or gun or anything else), they buy it at a very high price, because they value such objects greatly. I have been told of a man who bought an old copper bowl at Mecca for a rupee, which is equivalent to half a *riyal;* in Beirut a man who buys antiques to resell them to tourists saw him carrying it and started bargaining; the owner was greedy and asked for 20 French gold pieces [Napoleons], but the buyer beat him down to 13 French gold pounds and paid him cash. The seller was delighted, because each piaster he had paid got him a French gold piece, and said: ''I have paid for my pilgrimage with the profits on this bowl.'' He then heard that the man who had bought it from him had sold it to a Frankish tourist for 150 French gold pieces, so he started to wail and lament. And there are innumerable similar stories.

Many people have grown very wealthy in this business, which has become very profitable, especially during the pilgrimage season in Jerusalem when many visitors and tourists come from Europe. In our city of Damascus there are now many shops dealing in antiques, full of such objects. Some are old and some are imitations of old things and some are the products of current handicrafts but with beautiful designs and forms, and all are eagerly sought for by Franks. Some have made of it a trade, and appointed an agent abroad, to whom they send such objects. And if it had not been a source of great profit and large incomes it would not have multiplied in our country after having been nonexistent. Other people also earn their livelihood in this business such as the first buyer, and the seller, and the broker, and the intermediary, and the interpreter, and the buyer, who is a Frank and who resells it in his own country at great profit. . . .

21—*Bawabiji* (slipper maker). This is a maker of *bawabij* (plural of *babuj*), which is not an Arabic word [Turkish *pabuch* or *papuch*] and indicates a yellow shoe without a border,

From Muhammad Sa'id al-Qasimi, *Qamus al-sina'at al-Shamiyya,* Damascus.

worn by scholars, most poor students, and a few old women. It comes in many kinds, among them the ones worn by peasant women, which are of various types and go along with their traditional kind of dress, each village having its own particular fashion. Another kind is known as "Islanbuly" [Istanbuly], which is delicate and open and is lined with broadcloth of beautiful color. Some 30 years ago all the women of Damascus wore *bawabij* with *mast* [Turkish], that is, slippers, the upper-class ones wearing *mast* with Islanbuly *bawabij*. Then they gradually became civilized (*yatamadanna*) and took to wearing European-type shoes such as *kanadir* [Turkish *kundura*], *kawalish* [French *galoche*], *skarbinat* [Italian *scarpino*], all of which are high-priced, down to our own time, that is, 1309 A.H. (1891 A.D.).

People who pursued this craft, along with slipper workers (*musawaty*, . . .), did a very good business, since both men and women in Damascus and elsewhere wore *masts* and *bawabij*. Now, however, it has almost disappeared, only a few craftsmen remaining who live at a subsistence level; they produce for villagers and peasants, according to demand, since, as we stated earlier, peasants still keep their old styles and traditional dress. . . .

73—*Hammar.* The name is used for those who have donkeys, saddled and equipped, which they hire for riding from place to place, charging a fee that depends on the distance fixed by the customer. Before the appearance of carriages, this trade was pursued by many people, and was very prosperous. For most people had to travel, for pleasure or to a village or to a distant place, especially those who were unable to walk; such a person would go to a donkey owner and hire a donkey to take him to his village, or his orchard for an excursion, or to a distant place he had to visit, for a specified fee. The customer would ride the donkey and its owner would send with him a barefooted boy carrying a stick who would drive the donkey to its destination and take it back to its owner, and so on. But when carriages appeared people gave up donkeys and started hiring carriages to various places, since they were swifter and more comfortable. But there is still a remnant of donkey owners, resorted to by those who want cheapness even if it means discomfort, for a donkey is hired at 20 or 30 silver [*paras*]—or up to 1 piaster—per hour. . . .

98—*Khayyat* [tailor]. . . . [T]he tailor needs some tools, which can generally not be dispensed with: first, scissors; second, a measure [cubit, 65.6 centimeters long]; third, a needle; fourth, a thimble; fifth, a smooth board on which the clothes are sewn; sixth, a pressing iron made of iron, which is heated on a fire and used to press clothes, rendering them as smooth as if they were made of one piece; seventh, thread made of silk, cotton, or linen according to the kind of clothes. Some of these tools are natural (i.e., they cannot be dispensed with), such as scissors, needles, and thread; others are not natural and can be dispensed with (i.e., the other tools mentioned).

Among the tools that have recently appeared and spread is one called *makina* [machine]; it is now widely used by tailors. It is made by Franks and consists of a wheel and various instruments that dazzle the mind. It is possible to do without it, using hand labor, but it is far swifter. Hence all Christian tailors, especially those who make clothes for the government—both military and civilian—and other objects such as pants (?) (*banati*) do not work without such a machine; for it helps them with close and wide-spaced sewing [*darz wa tanbit*], etc., as is well known. Many Muslim women have learned to sew with such machines. . . .

252—*Ghalayiniy,* or maker of waterpipes (hubble-bubble). Waterpipes are made of earth that has been ground, passed through a sieve, left to ferment during the night, and worked

when congealed. A specially made mold is then used to produce waterpipes, which are then baked in a kiln prepared for them. After baking in the kiln, they are painted the desired color: black, red, golden, or other.

This craft used to be very prosperous, because of the great use made of waterpipes by the inhabitants of Damascus, for inhaling tobacco, known as *tutun*. . . . But now, generally speaking, the inhabitants of Damascus do not care for waterpipes. Only beduins use them, since they do not know how to roll cigarettes and continue to smoke tobacco through waterpipes. . . .

298—*Qumisiyunji* [broker]. This is a new trade in Damascus. The broker has agents and partners in foreign lands and elsewhere and merchants come to him, ask him for samples of the merchandise used in their particular trade, sign papers of agreement, and pay him for bringing them what they desire. He takes a fee, known as a "brokerage," of $2\frac{1}{2}$ piasters in every 100 piasters. If the merchandise is of great value, they agree upon a sum that suits both sides. All this makes it unnecessary for merchants to go abroad to bring back goods, which saves them time and expense and great trouble by land and by sea.

This is an important trade, which brings commensurate earnings, but those who would follow it must have many sterling qualities, such as good management, ability (*siyasa*) in dealing with merchants, complete honesty and responsibility (*siyana*), and avoidance of lying. There are examples of people who became rich and prosperous in this trade, whereas they had not previously had a penny to their name. . . .

299—*Qunturanji*. This is the name given to those who contract to supply the troops with such items as rice, clarified butter, meat, wheat, barley, sugar, onions, and other goods eaten or worn by soldiers. They undertake to do this at a specified price, after an auction in which all the contractors participate and in which each commodity is assigned to one person, or all commodites are assigned to one person. Documents are then drawn up stating that the person in question is charged, from the beginning of the contract to the end of the year, to provide, day by day, the products specified by number, weight, or measure, according to demand and at the price stipulated in the contract. After that profits or losses depend on the contractor's luck: if prices fall he makes a large profit and if the contrary occurs he has a heavy loss. If in times of high prices he delays providing the quantities agreed upon, they are bought [by the authorities] and the costs are deducted from the sum due to him. We have seen some become rich in this trade and others lose every penny they had. . . .

303—*Qawuqji*. This refers to maker of *qawawiq* [plural of *qawuq*, a cap made of felt or broadcloth], which disappeared around the middle of the last century [A.H., or around 1840]; those who made them have also disappeared; only the design (*rasm*) remains, and we mention it only because there are still some who carry on their father's business in this trade. . . .

There were some people who did not know how to wrap their turban around a *qawuq* or a *lubbada* [skullcap]; they sent it to people who were experts in wrapping turbans and made a livelihood out of this, in accordance with the wishes and appearance of the customer, and depending on his learning and taste. Some people wrapped their turbans around a *qawuq*, which was round like the large tambourine known as *mizhar*. Many *'ulama* wrapped a turban of white muslin around their *qawuq*. Others had turbans made of embroidered silk known as *Aziz Khan* or *aghabani*, which is the turban used by merchants and other people down to this day. Such a turban was expensive, costing 500 piasters or less, and it was large and required much material; and because of their value

turbans were often snatched, at night, from people's heads, and the next day there would be much talk of so-and-so's turban having been snatched from his head.

Fezzes [*tarbush*] were few, and were of the North African [i.e., soft] type.

Most people had two turbans or more, known as *'imma li al-riyasa* and *'imma li al-siyasa*—that is, one turban for meeting people and another to be worn at home or when practicing one's craft; the first would be carefully put away lest it get dirty and deteriorate.

When fezzes came more and more into use and their popularity began to spread, during the time of Sultan Mahmud [the Second], last century [A.H.], *qawuqs* became less common and fezzes were imported from abroad. Their fashion spread until it became general, replacing previous headgear such as the *qawuq*, *'urf*, *tabza*, and *lubbada*, except for some *shaykhs* belonging to fraternities who continued to dress like their predecessors, for purposes of gain. And people began wrapping turbans around their fez, and then, finding the turban rather gross, made it a point of delicacy to reduce it in size until things reached their present state.

Sultan Mahmud Khan was the first Muslim king to wear a fez; he gave up the turban in order to keep up with European civilization and to encourage his soldiers to follow their new regulations (*nizamiha al-madani al-jadid*), which were required by prevailing contemporary fashions.

Some people still believe that wearing the turban is a regulation required by religion and attack those who have given up turbans, referring to *hadiths* [sayings of the Prophet] concerning turbans; but all these *hadiths* are spurious, and falsely attributed to the Prophet, peace be upon him—as has been shown by scholars who are experts in *hadith*. Besides, religion is too exalted for such matters to be articles of faith. The same is true of dress in general, which follows conditions in every century, and is determined by what people are accustomed to in every age. Countless indeed are the common people's follies in matters of religion—truly we are God's and to him is our return.

As for the white turban wrapped around a fez, it was not the headgear of all *'ulamas* in Damascus. *Sharifs* [descendants of the Prophet] used to wear an embroidered silk turban around their fez, and very old men, and many whom we remember, wore only such turbans. The white turban, in the precise form we know it, was peculiar only to Turkish judges in Damascus; then the *'ulama* started imitating them, until it became extremely common among them and those who wished to seem learned.

An old jurist told me that in 1244 [1828/29] he saw 'Abd al-Rauf pasha, the governor of Damascus, wearing a *qawuq* as he set out to lead the pilgrimage caravan from Damascus. Then an order reached him to take off his turban and put on a fez and—continues my informant—when I saw him on the return of the caravan he wore a fez, without a turban. . . .

319—*Kunduraji*. This is a maker of the well-known shoes, including those called *kundura* [Turkish *kundura*], *subbat* [French *savate*], *kalush* [French *caloche*], and *jazma*, as well as women's shoes. All these are made by the *kunduraji*, from various kinds of leather known as *lamma'* (shiny) and "*kashi darsy*"? and "*duda dirisy*"? and *boya* [Turkish *boya*] and yellow or red leather and *klaseh* [French *glacé*], all of which are imported from abroad: some *kundurajis* use this leather to make the articles described above, which they hang up in their shops for sale; others have a shop for making special items for those who want the better qualities and are willing to wait. Thus a man will order a pair of shoes, for example, and the measurements of his foot will be taken and shoes made to suit his taste. The latter kind are stronger and more durable than those made for sale in shops.

This craft has greatly spread in Damascus; its profits have multiplied and it has

reached numerous markets because of greater demand for its products and people's inability to do without them and the spread of civilization. Around the middle of the last century this craft was nonexistent; people wore only yellow *bawabij* [see above], slippers, and red shoes. We have been told that when *kunduras* began to spread, around 1280 [1863/64], some pigheaded people regarded them as Frankish apparel that should not be adopted, and refused to wear them. But the truth of the matter is that they were strange items, with which people were not familiar. When they did become familiar with them, their use spread among pious people and others. Obstinacy in matters of dress, and the mixing of religion and its laws in such questions, is pure ignorance. For religion is a natural matter. . . .

6

Silk Handlooms in Damascus, 1902

. . . The depression in the silk manufacturing industry, the cause of which, curiously enough, is the fall in the price of raw silk, shows few if any signs of abatement, and the strike among the weavers engaged in it still continues. Raw silk, which is imported from China (Shanghai) though as often as not it reaches this country through importing houses established in France, has fallen in price from 19½ *mejidiehs* (£3.5.6) the *rotl* (5.65 lbs) to 17 *mejidiehs* (£2.17.1) for the same amount. At the first blush it would be natural to suppose that a fall in the price of the raw material would be a considerable advantage to the manufacturers, but unfortunately for them they have on hand a large stock of silk bought at the higher rate and therefore cannot afford to lower their prices until this is exhausted. But the Egyptian buyers of these goods, their best customers, who, of course, are perfectly well aware of the fall in the price refuse to pay the old prices so that the manufacturers have been reduced, as the only alternative, to lower the wages of the weavers—hence the strike.

The manufacturers instead of selling their goods in Egypt, whither practically the whole of these fabrics are exported (they are known as *"missriyeh"* from the word Missr = Egypt) at 110 piastres (15 shillings 4 pence) per piece of 9 *pics* (6⅔ yards), i.e., with a net profit of 10 piastres per piece, the cost of manufacturing being 100 piastres, they can only get 88 piastres in cash or 100 piastres payable in a year. Most of the Damascus manufacturers preferred the latter method of payment, but unfortunately the buyers declared bankruptcy soon after taking delivery of the goods to the great loss of the manufacturers who, I understand, lost on half of their consignments.

Moreover these goods are very largely disposed of at Tantah, during the fairs which are held there every three or four months, each of which known as Mowled-es-Seyid generally lasts a fortnight. Owing to an outbreak of plague in that town the Egyptian Government has, it would appear, forbidden the holding of these fairs and so the Damascus "Missriyehs" have lost their best market.

From Richardson to O'Conor, 6 January 1902, FO 195/2122.

It is feared by some who are well acquainted with the conditions of labour in this country and in Egypt that in a few years' time the silk-weaving industry will be transferred from Damascus to the latter country where one Damascene informs me he has already thirty looms at work. He points out that the silk fabrics made in Egypt have a superior lustre and gloss to those woven here, which is to be attributed to some difference in the method of manufacture. Moreover, if wages are no higher there than they are here (there seems some uncertainty on this point) and the article produced is as good as, if not better than that made here, the fact that the 8 percent import duty will have been paid only *once* instead of *twice* (once on the raw silk when entering Syria and once on the manufactured goods when coming into Egypt from that country) will give the Egyptian article a considerable advantage over its rival from Syria.

The manufacturers here having been unable to induce their workmen, who are paid by the piece, to accept a reduction of 16–18 percent on the payments hitherto made on one kind of fabric and of 30–46 percent on another kind, have in many cases closed their looms so that work is at a standstill with very serious results both to themselves and their men. . . .

7

Mines in Aleppo *Vilayet,* 1902

It is no grateful task to write of Mines and Mining operations in this district for although the mineral wealth is great I do not remember that any concession worth mentioning has ever been granted.

FORMALITIES TO OBTAIN CONCESSION

Those who desire to obtain a permit prospect must, in the first instance, present a petition to the local Government stating the limits of the land they wish to prospect. Their petition is referred, in the first instance, to the *Mukhtars* of the neighboring villages, who must report whether the proposed excavations will in any way injure the cultivation of the district, then to the Engineer of the *Vilayet,* and lastly to a military commission who will report whether they will involve the levelling of ground which is required for strategic purposes. If all this is satisfactory, the *Vilayet* can grant a permit to prospect with leave to export up to 2000 tons, but must, at the same time, report the fact to Constantinople. The further stage, the grant of a concession is negotiated at the Porte and can never be brought to a successful issue without ruinous expenditure. At the time of writing I learn that new Mining regulations have been promulgated of a nature to seriously affect the existing rights of foreigners in Turkey.

From ''Report upon the Mines of the Aleppo Vilayet,'' Aleppo, 13 January 1902, FO 195/2115.

MINES OF ALEPPO *VILAYET*

There are mines in parts of this *Vilayet* far from the coast where the inaccessible nature of the country, distance, and difficulty of transport render it futile for me to give them more than a passing notice. There are others near the coast, perhaps equally valuable and which present no such difficulties, and of these I will write more freely as they are of greater practical interest. The minerals of which the locality is more or less defined are coal, iron, silver, copper, chrome, boracite, antimony, sulphur, fullers' earth, and petroleum.

At Beirut-dagh four hours north of Zeitoun, 4200 feet above the sea and about 45 camel hours from the nearest port, there is an iron mine of which the iron is of excellent quality and the supply practically inexhaustible. The government however takes no interest in it, allowing it to be worked in primitive fashion by the Zeitounlies. As there is no wood on Beirut-dagh, the ore has to be carried on horseback to Chermegendj (a day's journey) to be smelted. It is said that it takes 2000 piastres worth of wood to smelt 100 piastres worth of iron. Yet I have it on the authority of those who have seen the coal, that there are large deposits of that mineral quite near the iron mine. I much wish that this fact could be verified by European experts, for, if it be so, the iron mine would certainly pay, in spite of the distance and difficulty of transport.

Coal of inferior quality has also been found at Abou-el-Fiad, seventy miles southeast of Aleppo.

Copper exists on Sheikh Mohsin Dagh, twenty minutes ride from Aleppo. It has been analyzed at Constantinople, but the result was not sufficiently encouraging to justify an attempt to work it.

Silver is found at Fundajak six hours to the southwest of Marash, and near Antioch, but little is known about them [*sic*].

The whole country verging upon the Gulf of Alexandretta is rich in chrome, and it is much to be regretted that it cannot be turned to account at a time when the market value of this article is enormously increasing. In the district of Beilan, alone, there are twelve distinct mines, at or near Ghynk-deré, AlaiDey, Jeylan, Deli-Bekirli, Koortlu-Boroonon, Sophook-olook, and Narghijlik, also two in the Amanus (Giaour Dagh) three hours from Alexandretta, and 2000 feet above sea level and another near Kessab in the neighbourhood of Mount Cassius.

A permit to prospect and export up to 2000 tons was given in the case last mentioned to a certain Dourian Effendi acting for the Imperial Ottoman Bank. This was about fifteen years ago when the price of chrome was low, and I believe the mineral did not yield a percentage sufficient to promise good results.

Boracite and antimony are found near Antioch. In the Caza of Killis there is a mine of fuller's earth which has been worked for many years. The earth is exported to all parts of Syria and Anatolia.

At Tchengel-Keni, between Arsous and Alexandretta, at one hour's distance from the sea, there is petroleum of excellent quality. About six years ago a German company obtained a concession to work it, and after spending all their capital in trying to find the source, became bankrupt and left the country.

Mines of sulphur and salt-petre are found in various places, but distant from the coast.

8

Textile Handicrafts in Baghdad, 1842

. . . There are few countries where silk and woolen textiles, as well as some other consumer goods, can be made at as low a price as in the land of Baghdad; Your Excellency will see, by examining the prices of the samples sent from this consulate to the Minister of Commerce, that were it not for the arbitrary prices and numerous taxes to which industry in this part of Arabistan is subjected, it would be impossible to compete with it.

First of all, the country's situation is very favorable for various kinds of industries, which would greatly expand if this industrious people did not have the misfortune to be governed by Turks. Gilan silk, imported from Persia to Baghdad, is abundant, and the raising of silkworms requires almost no care; the latter is practiced in all the villages along the Diyala River, a few hours from Baghdad, particularly in those of Samarra and Ba'quba. As soon as it is hatched, the worm is left in large enclosures in the middle of a mulberry grove, the *fallahs* merely cutting the branches and throwing them in the enclosures where they keep their worms. The excellence of the climate—it never rains during the silkworm fecundation season—makes possible this easy kind of raising. Cocoons are spun by hand in villages, by the women, and wages are extremely low. Thick silk thread is particularly valued, beind used to make kerchieves, which all Arabs wear on their heads.

The fine wools of Kurdistan, which could supply a perfect material for cloth, are hardly used in this country, and only for coarse products. They are sent to France, England, and, in the last few years, Bombay.

Cotton could be easily grown in the Baghdad region, between the two rivers; instead it is imported from India.

Good-quality flax is produced in the country; it is spun by men, who weave it into cheap cloth. . . .

In Baghdad, monopolies and arbitrary dues are imposed first of all on those raw materials, then on the materials used in the processing of the manufactured goods, such as cochineal, sandalwood, indigo, and finally, on the finished products themselves. I have the honor to give Your Excellency on account of the different taxes on textile manufacturing.

(1) *Damgha*—a stamp tax on dyeing. The dyeing monopoly was farmed out for 1842/43 (October to October) for 1,058,750 Constantinople piasters. Each manufacturer is obliged to send to the privileged dyeing plant the cloth he wishes to have dyed or the materials he wishes to use for his cloth and to pay various taxes, according to the colors he has chosen. . . .

(2) *Madar Khaneh*—a tax on grinding. The tax applies to all nonliquid dyestuffs like Kurdistan gallnuts or vitriol. It is paid at the same time as the customs duty and was farmed for 40,000 Constantinople piasters in 1842/43.

(3) *Daqqaq Khaneh*—a glazing tax on goods manufactured in Baghdad. . . .

(4) *Shaykh Takhtalik*—monopoly of sale of silk or tax on that product. . . .

(5) *Ihtisab*—this duty is levied on all produce as well as manufactured goods entering the town; it is an entry tax, but variable and arbitrary. It is farmed out.

From "Reply to Circular," 1 December 1842, CC Baghdad, vol. 10, 1831–1846.

(6) *Na-ma'lum*—literally, unknown, or tax without a name. It is levied at customs, after the customs duty has been paid, on European merchandise imported by subjects of the Grand Signior.

(7) *Ma'sar Khaneh*—a monopoly on the making of sesame oil and on fuels

[To all of which, says the author, must be added *Bakhshish* to various officials. The report describes the accompanying samples, of which the following are of interest:

(1) *Qazz*—silk; a workman makes 1¾ pieces a day, earning 1 franc 20 centimes. . . .
(5) *Kham Muthallath*—a workman makes 12–15 *pics* (presumably *dira'* of 75–80 centimeters each) earning 1 Baghdad piaster a *pic*, the exchange rate being 17 piasters to a franc. [*sic*] . . .
(7) *Bisht*—a woolen cloth. . . .
(36) *Izar*—described as "a silk covering for women, of white silk checked with red; indispensable dress when going out of the harem." The cost of production of a piece is estimated at 1135 piasters, broken down as follows: 2½ ounces of silk (531¼), dyestuffs (210), wages of workman (200), *damgha* (62½), dyeing duty (132), to which should be added the *raftiyah* of 3 percent on the estimated price of 1000 piasters. These figures suggest that taxes accounted for over 20 percent of costs.].

9

Handicrafts, Industry, and Working-Class Conditions

The Iraqi Town and the Birth of Capitalist Production in the Country

(a) *The Crisis of the Handicrafts*. Because of the domination of the feudal structure in the Iraqi countryside, dependence on the backward Ottoman Empire, and, particularly, as a consequence of the economic expansion of foreign capital, industrial production in Iraqi towns was at an extremely low level and, moreover, experienced a decline. The great poverty of the Iraqi peasantry narrowed the internal market and impeded the development of industry. The data in the trade statistics show the insignificance of the purchasing power of Iraqi peasants. In the period 1890–1913 each inhabitant of Iraq (reckoned at 3 million) bought 85 kopeks—rising to 4 rubles 30 kopeks—worth of imported goods; the figure for Italy in 1913 was 36 rubles, for Egypt 22, and for the Ottoman Empire as a whole 14 rubles 90 kopeks.[1] Sugar consumption in the peak year 1910 did not exceed 4.5 kilograms per capita, against 6.8 in Turkey.[2]

Domination by the Ottoman Empire directly impeded the development of trade,

From L. N. Kotlov, *Natsionalno-osvoboditelnoe Vosstanie 1920 goda v Irake* (Moscow, 1958), pp. 49–56.

[1]D.C.R. [British Diplomatic and Consular Reports], 1890–1913; A. D. Novichev, *Ocherki ekonomiki Turtsii* (Moscow—Leningrad), 1937, p. 179.

[2]D.C.R., No. 4513, p. 16; idem, No. 4730, p. 14; Novichev, *Ocherki*, p. 86.

handicrafts, and industry because of the large sums it pumped out of Iraq in the form of taxes. In addition, one cannot fail to note the baneful influence of the feudal anarchy prevailing in Iraq. Until the outbreak of the World War, there were customs barriers all over Iraq. On bridges and crossings tolls were levied by the government, local landlords, and tribal shaikhs.[3] Finally, the development of the Iraqi town was greatly impeded by the guilds and other medieval institutions that survived until recent times.

However, the fundamental obstacle to the development of the Iraqi town was the strong position of imperialism, which transformed the country into a raw material appendage of the capitalist countries, into a market for sales, and a sphere for capital investment.

Figures on foreign trade show the uninterrupted growth of imports of manufactured goods, capturing the local market, and the decline of semimanufactures and raw materials used by local crafts producing widely consumed goods—particularly yarn and indigo.[4] It is enough to state that, at the outbreak of the World War, imports of fabrics into the country accounted for 43–45 percent of the total.[5] At that time imports of machines were insignificant, particularly those for enterprises producing for the local market. It is not for nothing that the British consul mentioned as particularly noteworthy the delivery to Baghdad of one (!) handloom.[6] The rise of imports of machines in the last prewar years is explained by the intensification of construction on the Baghdad Railway and other transport enterprises as well as those processing local raw materials for export. Capitalist Europe used Iraq, as indeed the whole Ottoman Empire, as a market for the products of light industry, supplying low-quality goods. "Europe sends to Turkey second and third rate kinds of goods, being concerned not with their quality but with their external appearance. It gets rid here of all its unsaleable and defective goods."[7]

Under the impact of imports of cheap manufactured goods, local handicraft production decayed. Whereas in the first half of the 19th century in Baghdad alone there were 12,000 looms,[8] by the beginning of the 20th their number had shrunk to a few hundred [see selection 10]. In Basra, where at the beginning of the 19th century there were flourishing handicrafts producing calicoes and muslins, in the course of the century weaving practically disappeared.[9] The once famous Mosul weaving industry was in complete decline. In Adamov's words: "Cheap European manufactures gradually destroyed local weaving production, which had already greatly declined in the second half of the 19th century; even the dyeing of imported bleached goods, which was carried out until recently, is now a legendary memory, for it became less profitable than bringing printed goods into the market."[10] Under the impact of rising imports of enameled Austrian goods, local handicraft production of copper vessels folded up; European goods

[3]E. G. Soane, *To Mesopotamia and Kurdistan in Disguise,* London, 1926, p. 113; B. Thomas, *Alarms and Excursions in Arabia,* London, 1931; I. Sh.K.V.O. [Newsletter of the Staff of the Caucasian Military District], No. 31, p. 13.

[4]D.C.R., 1891–1913; A. Adamov, *Irak Arabskii,* St. Petersburg, 1912, p. 513 and following.

[5]Adamov, *Irak,* p. 513.

[6]D.C.R., No. 4482, p. 1.

[7]I. I. Goloborodko, *Staraya i novaya Turtsii,* Moscow, 1908, p. 150; see H. V. Geere, *By Nile and Euphrates,* Edinburgh, 1904, p. 108.

[8]Khursid-Effendi, *Siyahat Name-i-hudud,* St. Petersburg, 1877, p. 67.

[9]Ibid., p. 3.

[10]Adamov, *Irak,* p. 511; H. C. Luke, *Mosul and Its Minorities,* London, 1925, p. 15.

replaced the products of local shoemakers, and so on.[11] The artisanal production of petroleum and asphalt at Mandali, Hit, and other places [see selection 11] experienced a severe crisis.[12] Unable to sustain the competition of Baku and American petroleum, production in the oil wells at Mandali, for example, ceased in 1901; previously its output had been sent to Baghdad.[13]

Only a few branches of Iraq's handicrafts maintained their positions, and in the first place those that met the specific needs of the local market—producing national clothing, earthenware, arms, etc.—and only by extraordinary intensification of the craftsmen's labor. "The town worker, even if highly skilled, usually works ten to eleven hours a day, and sometimes more. One bookbinder, for example, starts work in the winter at 7 a.m. and, having had dinner, does not leave his house until 7 or 8 p.m."[14] However, even with such intensive work, many craftsmen were not in a position to buy the usual raw materials and were obliged to use substitutes; for example, coppersmiths made lamps out of the discarded tin cans in which kerosene was brought to Iraq.[15]

The surviving crafts retained their medieval character. The mainstay of the craft was the craftsman working for the immediate market. The majority of craftsmen were connected neither with industrial production nor with manufactories and, naturally, sold their goods without any intermediary. In towns with developed craft production the *suqs* or bazaars were at one and the same time places of production and places of sale of handicraft goods.[16] Craftsmen were grouped in guilds, not infrequently subdivided according to national or religious differences.[17]

Goldsmithery was mainly in the hands of Jews and silverwork in that of Arab-Sabeans (Christians). [*sic*—Sabeans are not Christians but have their own religion.] Like other corporations, the various crafts had their trade secrets, handed down from generation to generation.[18]

The master craftsman worked alone or with the help of family members or a few apprentices. The tools were extremely primitive and could not be improved because of the lack of funds of the majority of craftsmen. The extraction of asphalt, for example, was done by means of palm branches with which the workers collected the melted asphalt in the hot wells.

(b) *The Birth of Capitalist Production and the Penetration of Foreign Capital.* Those large enterprises that went beyond the framework of handicraft production could be counted in units and were, essentially, not the product of the organic development of capitalism in the country but introduced from outside.[19] They belonged mainly to

[11]Adamov, *Irak*, p. 508; Geere, *Nile*, p. 108.

[12]E. Shultse, *Borba za persidsko-mesopatamskiyu neft*, Moscow, 1924, p. 56.

[13]Iwan Kirchner, *Der Nahe Osten*, Brünn, 1943, p. 574; *The Geographical Journal*, 1897, vol. 9, p. 53.

[14]R. Coke, *Baghdad, The City of Peace*, London, 1927, p. 286.

[15]Geere, *Nile*, pp. 105–106.

[16]E. S. Stevens, *By Tigris and Euphrates*, London, 1923, pp. 34, 130; E. Sachau, *Am Euphrate und Tigris*, Leipzig, 1900, p. 124.

[17]Ali Sidu al-Gurani, *Min Amman ila al-Amadiya*, Amman, 1939, pp. 24, 137; Coke, *Baghdad*, p. 123.

[18]Gurani, *Min Amman*, p. 153; Stevens, *Tigris*, pp. 134, 245; Luke, *Mosul*, p. 31.

[19]In view of the insufficiency of capital, the formation of capitalist enterprises was greatly hampered, such as the unsuccessful projects in the 1880s and 1890s to build a Baghdad–Khaniqin railway with local capital; see S. H. Longrigg, *Iraq, 1900 to 1950*, London, 1953, pp. 32–33.

foreign capital or to the Ottoman government. The state owned mechanical workshops, working for the army and navy: a military factory, *abakhane* in Baghdad, which manufactured cloth, cotton fabrics, and had a smithery and a carpentry and wheelwright workshop, etc.[20] Baghdad also had a shipyard, evidently also belonging to the state.[21] In Basra there was an arsenal with repair shops for naval engines, guns, and rifles.[22] The government-owned Oman Ottoman Company had a dock in Basra.[23] Most of the workers in these enterprises consisted of military recruits, but convict labor was also used.

The development of private capitalist enterprises was feeble. The most noticeable changes were in those branches that met the specific needs of the local market, for example, the production of cloth for national costumes, shawls, construction, rugs, and jewelry; in branches related to the preparation of agricultural products for export; and in smithery, harness-making, baking, and transport. There is evidence that in these enterprises hired labor was employed.[24]

A significant number of small workshops in these branches were scattered all over the country. In Baghdad, for instance, there were nine private tanneries for the preparation of hides, in Mosul a factory for cigarette paper, in Basra a shipyard for making wooden riverboats, etc. The number of hired workers employed in the boats belonging to local merchants was significant, as also in the transport companies carrying mails and passengers between Baghdad, Karbala, and Najaf, and in the horse-tramway between Baghdad and Kazimayn. The largest number was employed in seasonal work, packing dates for export, and amounted (in Basra) to some 20,000–25,000 persons.[25]

However, even the few branches of the national economy of Iraq in which the development of capitalist production had occurred were doomed to vegetate and did not rise above the level of the primary forms of capitalism. Only those enterprises that were fit for the needs of the world capitalist market survived, for example those that carried out the first stages of processing raw materials for export. These branches were gradually subjected to foreign capital, and sometimes passed into its hands. In spite of the extreme exploitation of the fledgling working class, national industry in Iraq could not sustain the competition of foreign factory production.

The lopsided, lame development of national economic capitalist relations in Iraq went along the lines of penetration of foreign capital into the country, which adapted one or other branches of the Iraqi economy to meet its own needs. Along with the rest of the Ottoman Empire, Iraq was a sphere of investment of capital by imperialist monopolies. However, until the outbreak of the First World War, this process was still very weak; but the important thing is that it had already begun. The enterprises founded by foreign capital in this period served mainly foreign trade. The export of capital to Iraq began in the 19th century, and attained a significant level at the beginning of the 20th century.

The organization of transport companies by foreign capital began in the middle of the 19th century. . . . [See IV, Introduction.]

[20]S.S.S. [Compendium of Information on Adjacent Countries, Tiflis, 1911–1913], Nos. 21–22, pp. 13–15; S.K.D. [Collection of Consular Reports], 1904, No. 1, pp. 28–29; Sachau, *Euphrate*, pp. 28–29.

[21]Longrigg, *Iraq*, p. 34.

[22]Adamov, *Irak*, p. 32.

[23]S.K.D., 1902, No. 4, p. 302.

[24]D.C.R., No. 4999, pp. 22–23; Oppenheim, *Vom Mittelmeer*, vol. 2, p. 250.

[25]S.K.D., 1902, No. 5, p. 368.

(c) The Situation of the Working Masses in Iraqi Towns. The number of hired workers in Iraq did not exceed a few tens of thousands, including seasonal workers. The pressure of a huge number of landless *fallahs,* ready to hire themselves for any work, and the ever stronger impact of foreign capital led to enormous exploitation of the workers.

Even compared to wages in other parts of the Ottoman Empire the level of wages of Iraqi workers was extremely low. Whereas in the textile industry in Turkey the average wage was 8.4 piasters a day, in Iraq it was 7; leather workers in Turkey earned 13.6 piasters, a shoemaker in Iraq 11.5.[26] Day laborers received 2–5 piasters a day.[27] The labor of children and women was widely used and was paid much less than that of men. Women sorting out gum-arabic, wool, etc., received two to three times less than men.

Particularly hard was the condition of seasonal workers hired for the construction of roads and dams. Adamov gives a striking picture of the misery, lack of rights, and oppression of such workers in his description of the packing of dates for export. The workers, mainly women who had come to Basra with their children, lived during the packing season in huts made of reeds and mats. In the best of circumstances, their wages were about 2.5 piasters a day. This dense population was expected to bring its own food from home, and to eat waste dates.[28] "In these circumstances," wrote Adamov, "it is not surprising that most of the cholera, plague, smallpox epidemics, and especially the eye diseases maiming over half the local population, flare up during the *chardak* (packing season)". . . .[29]

[26]Novichev, *Ocherki,* p. 113; D.C.R., No. 4999, p. 23.
[27]I.Sh.K.V.O., No. 31, p. 14.
[28]S.K.D., 1902, No. 5, p. 367–368.
[29]Adamov, *Irak,* p. 369.

10
Handlooms in Baghdad, 1907

The local authorities appear to have no authentic record of the number of hand looms at work in this district, but from enquiries made by my staff and the information supplied to me by the local Government I understand that there are over 900 hand looms in the city of Baghdad engaged in weaving coarse striped cotton *Lunkas* varying from 16¾ to 20 inches in width, Cotton Loin cloths from 30 to 39 inches wide, Cotton *Yashmaghs* from 28 to 45 inches square, fine silks from 27 to 40 inches wide, and woollen cloths for *Abbas* from 24 to 32 inches in breadth.

The exact quantity of each kind of material manufactured in Baghdad is unascertainable. But from careful enquiries made from the principal factory owners, I gather that of cotton goods about 598,000 pieces of *Lunkas* measuring 4,310,000 yards, 52000 Loin cloths measuring 80,850 yards and 80,600 *Yashmaghs* measuring 89,550 (lineal) yards

From "Hand Looms in Baghdad and Surrounding Country," (FO 195/2243.)

are annually turned out by the Baghdad hand looms. The out turn of Silk and woollen goods is estimated at half a million yards. Besides the above about 90,000 pieces of *Lunka* measuring 660,000 yards are yearly imported from Aleppo and Damascus.

Three fourths of the cotton and woollen goods woven here are sent to Kerkouk, Sulaimania and across the Persian border for sale.

My Commercial Assistant who recently passed through the country as far as the northern limits of the Mosul *Vilayat* reports that in the town of Mosul there are about 1000 hand looms busy turning out cloths woven from locally spun and imported yarns and twist of 12, 14, 16, 18, and 22 counts, and varying in breadth from $15\frac{3}{4}$ to 36 inches, and that there is a similar number scattered throughout the numerous villages in that *vilayat*.

About £35,000 of cotton goods are manufactured by the hand looms in Mosul for the Kurdistan and Van markets, also a large number of ladies' *Izars* in cotton find their way as far north as Turkestan.

Weavers in Baghdad, Kerkouk and Mosul have been approached on the subject of securing high speed hand looms. They are quite alive to the economy of using modern appliances in their craft and are keen to obtain suitable machines, but hesitate to invest in them before seeing their capabilities.

The subject has also been discussed with merchants at the localities indicated above, and it has been found that they too are chary about investing in a machine that may prove unsuitable for the market and perhaps too dear for the class of people to whom it is intended to sell it.

The local hand looms are crude wooden structures and cost from 12 shillings to 60 shillings each according to size and workmanship. A weaver will weave from $16\frac{1}{2}$ to $24\frac{3}{4}$ yards and earns from 8 pence to 1 shilling 3 pence a day according to his ability.

The looms are run for 260 days a year on the average. The men work usually eight hours a day during the summer and twelve hours in winter.

The factory owners everywhere are anxious to improve their earnings and they say they are ready to consider suitable high speed hand looms if they prove to be simple in design, durable and of prices suitable to their means.

It will be observed from the above figures that in Baghdad alone over five millions of yards of various materials are woven yearly; while another 660,000 yards are imported which could be manufactured locally if facilities were available. These figures taken with the number of hand looms in the Mosul district speak for themselves.

With this note I am sending samples of the cotton cloths woven in the hand mills of Baghdad. These are docketted and numbered, and small patterns have been retained in the Consulate, similarly numbered.

The Consulate can of course distribute catalogues of looms and samples of work done by them, but I am not sanguine that such a course will lead to satisfactory and speedy results. People with no technical knowledge are likely to get confused with a number of samples, all of which are probably not turned out by the same machine or if they are turned out by the machine, only after alterations in the machine have been made.

Any instructions for working the machines should, if possible be sent out both in French and English, unless by chance Arabic or Persian instructions are available.

There are more people in and about Baghdad who know French than who know English, and this is especially the case in Mosul.

The Governor General of Baghdad informed me that a French Engineer had recently ordered a French hand loom for the use of the Baghdad Industrial School. If the French

makers have a sample of their machine on the spot, and it is a good machine, it seems unlikely that local buyers will care to risk their money on machines of which they only know the advertised merits.

Several methods occur to me for pushing the sale of hand looms in Baghdad, which is undoubtedly the place where a start should be made. . . .

11

Petroleum Production, 1871

. . . The petroleum springs of Mendeli are fairly numerous, amounting to over 30. . . . Around the places where there are shows of petroleum, cavities a few meters deep have been dug and every three or four days the oil is collected in waterskins, for dispatch to Mendeli. The oil is generally of a dirty-green color, but one of the springs, that of Om Ba, supplies a blackish oil. The two qualities probably do not originate from the same underground deposit.

There are two roads between Mendeli and the springs. They are rugged, especially two or three hours away from Mendeli, and in their present state can provide only for transport by pack animals: Donkeys are used, laden with 3 *thulums* (waterskins). The driver gets as wages 4 piasters plus half a *thulum*. Two waterskins of crude petroleum are sold for 25–55 piasters, depending on the season, or an average of about 40 piasters. This means that the cost of transport for 2½ skins is 14 piasters. Since it is not collected with much care, the crude petroleum almost always contains a certain amount of water. In addition, the capacity of the *thulums* varies greatly. For these two reasons, the donkey load is considered as weighing only 50 *okes*.

The oil issuing from these springs is the property of the Turkish government, which refines it in a workshop at Mendeli. The crude oil is exposed to moderate heat in copper stills or cauldrons. In this way a certain amount of hydrocarbons that can be used for lighting is distilled. The residue, which has a higher specific gravity and a blackish color, is used partly for lighting, partly for heating the stills.

The residual oil is sold to the Arabs for 18 piasters a *yuk* (2 *thulums*), or 50 *okes*, that is, 0.375 per *oke*. It is burned in earthenware bowls, rags being used as wicks. It goes without saying that combustion is very inefficient: the burning oil produces much smoke and a very foul smell.

The other part of the residual oil is used for heating the stills. Cow dung, dried in the sun, is impregnated with oil for several days. This provides a very good fuel but only a small part of the calorific power is utilized because of the defective methods of burning; there is an imbalance between the entry vents and the air in the hearths and the vents designed to let out the products of combustion. The stills are made of copper, and usually have the following dimensions: 0.55 meter diameter at the top; 0.80 meter diameter at the bottom; depth of 0.50 meter. They are only 1½–2 millimeters thick, and are therefore soon out of commission.

From "Report by Guyot on the Petroleum of Mendeli and Kifri," 30 August 1871, CC Baghdad, vol. 13, 1868– 1877.

The workshop has eight stills, each of which takes 32–35 *thulums*, or 800–875 *okes*, reckoning at 25 *okes* a *thulum*. The operation lasts 5 hours but, taking into account the time needed for filling and emptying, starting the fire, and repairs, only three operations are carried out in 24 hours.

Each still usually yields 4 *gumgums* of refined oil (i.e., about 36 *okes*). The *gumgums* are vessels of tinned copper in which the oil is transported for sale from Mendeli to Baghdad. Transport costs are 50–55 piasters per *yuk*, each *yuk* consisting of 6 gumgums with a total weight, when empty, of 26 *okes* and containing 54 *okes* of oil.

Output from February 1870 to the end of February 1871 was 15,252 *okes* of refined petroleum; this was obtained by the refining of 794 *yuks*, that is, at 50 *okes* per *yuk* of 39,725 *okes*, a yield of 38.3 percent. The output of all the springs in the preceding 12 months had been 6744 *thulums* or 167,500 *okes* (i.e., 458 *okes* per day).

I will end this report with a few words on the petroleum springs of Kifri and Tuz-Shurmati. In that region there are 14 springs, in geological conditions identical to those of Mendeli. . . . Total output of the springs is put at 500,000 *okes* per annum. Hence this region would seem to be richer than that of Mendeli, but I believe the figures to be exaggerated.

12

Oil Showings, 1914

. . . To conclude this memorandum, I should like to jot a few notes on oil deposits in Mesopotamia. Paul Rohrbach, who has several times visited these regions, compares them to the oil areas of Baku before the Russians had started exploitation. He also goes as far as to compare the gas emanations to those of America, which are put to various uses estimated at several million francs.

Within 25 kilometers of Mosul, not far from the place known as Hamman [Hammam?]-Ali, traces of petroleum are to be found; 60 kilometers south of Mosul, near Qayara, there are petroleum sources that are already being exploited, but naturally in a very primitive way. These wells produce about 1000 kilograms a day, sold at 30 centimes per kilogram. About eight hours north of Mosul there is another deposit, with an oil jet of 39 centimeters. Within a radius of two or three hours there are other deposits, but so far these have not been systematically exploited.

On the southern slopes of Yurgur, near Kirkuk, there are also some oil sources, belonging to the *Waqf*. I believe it is necessary to draw attention to these sources, which do not belong to the government and are not included in the agreements made with the Germans.

Southeast of Kirkuk there is the *Naft Dagh* (Petroleum Mountain), the wells of which are farmed out at £T 200 a year. Also noteworthy are the oil deposits in the northern part of the province of Baghdad. Traces of petroleum extend southeast to Mandali [see selection 11]. Some 30 years ago, an entrepreneur made profits of £T. 800–1000 a year

From R. Seefelder, ''Rapport à la Standard Oil Company,'' January 1914, IOPS/10/301.

from this region, but because of difficulties met at Constantinople regarding a concession he had requested, he gave up the business, destroying all his installations.

Rudimentary exploitation is also to be found around Hit, on the Euphrates, about 150 kilometers west of Baghdad. Judging from the efforts made by the German group, the petroleum business in Asia Minor looks promising; nevertheless, one should not forget—especially concerning the various holders of new exploration permits for Mesopotamian petroleum—that petroleum matters in general are subject to great disappointments, especially in a country where deposits of asphalt and similar substances are often taken for infallible indications of the existence of petroleum. It is, however, certain that, in addition to the known deposits in Mesopotamia, there are others, closer to the sea, but which are included in the zone of the French railways; I reserve the right to discuss them soon.

13

Prospects of Petroleum in Baghdad *Vilayet,* 1918

. . . Considering the great interest shown today by the international capitalists toward any unopened new source of naphtha, it is more than remarkable that the Mesopotamian deposits have so far remained unexploited. It may even be said that a serious attempt to create an up-to-date naphtha industry there was only made during the last four years. The sole reason for the delay was of a political nature; until quite recently the prevailing internal conditions of Turkey were such as to render extremely difficult the organization of any large business on modern lines.

As already stated, attempts have been made to obtain the right of exploiting these deposits. In 1904 the Anatolian Railway Company secured by an option agreement with the Civil List Administration the right of having these naphtha deposits examined by experts. The main lines of the said agreement were as follows: a one year's option for examining the deposits; if the result is satisfactory the company is to have the right of exploitation for a term of 40 years; the consideration payable to the Civil List was not a fixed sum of money, but only a certain percentage (royalty) of the net profits of the undertaking. Should the oilfields be given during the term of the option to another company on terms less favorable than those of the Anatolian Railway Company, the latter was to be entitled to be reimbursed in full by the Civil List for all the expenses in this matter.

The examination was carried out from January 1905 until the beginning of May of the same year—a remarkably short time considering that the journey from Constantinople to the oilfields takes 36 days by the shortest route.

The Civil List Administration unsuccessfully applied to the Railway Company for the result of the examination—which information the company was, under the agreement, bound to give, but although the application for the information was made several times,

From ''The Naphtha and Asphalt Deposits in Mesopotamia'' (translated from German), 11 March 1918, FO 371/3402.

no written answer was even given whilst a verbal reply was to the effect that the result of the examination was not encouraging; nor could a definite answer be obtained from the company, as to its intentions with reference to any continuation of the business.

In view of the uncertain attitude taken up in this matter by the Railway Company, the Civil List Administration applied to the Sultan for powers to grant the naphtha concession to another company. These powers were granted by an Irade but subject to a previous determination of the question whether the Anatolian Railway Company still had any claim to the rights granted to it under the agreement of option.

The consideration of that question was entrusted to a concession (= "group") of lawyers here (under the chairmanship of Barozi), which found that no prolongation of the option had been either granted to the Anatolian Railway Company or applied for by the latter, further that notwithstanding repeated requests made by the Civil List Administration to the Anatolian Railway Company to definitely state whether it intends or not to proceed with the exploitation of the oilfields, no definite answer to that question could be obtained from the Railway Company; therefore, any preferential right ("first refusal" = *Verrecht*) the company may have possessed has expired without involving any claim for compensation of damages.

It must here be observed that the Railway Company was quite desirous to do the business, but it did not suit them to immediately begin the exploitation of the oilfield as stipulated by the agreement of option, they wished to wait the beginning until the continuation of the construction of the Baghdad Railway was secure, since the company would lose all interest in the oil business if the railway were not built.

The Anatolian Railway Company would have carried out its plan, notwithstanding all the claims of complaints made, if it had not been deprived of its strongest protection owing to the change of the political regime.

14

Memorandum on Reported Oilfields of Mesopotamia and Part of Persia, 1918

The following remarks are based on German reports in the earlier part of the present century and recent reports by geologists sent to examine some of the oil occurrences by the Anglo-Persian Oil Company on behalf of the Military Authorities.

The Petroleum Zone of Mesopotamia extends over a distance of about 650 miles North and South with a minimum width of 80 miles, giving an area of about 50,000 square miles. Over this vast region oil is worked in a large number of hand dug pits and there are countless seepages and other signs of the presence of Petroleum.

All deposits of Petroleum in Mesopotamia belong to the "Civil List" properties of the Sultan and when they are worked are leased by that Department to the Lessees.

The most northern indication of oil with which this paper deals is that at Zakha,

From memorandum, 2 August 1918, FO 371/3402.

about 60 miles N.N.W of Mossul. It is an important seepage worked by natives and there are said to be 30 hand dug pits from which an oil of good quality of about .9 specific gravity is obtained.

The group of seepages in the neighborhood of El Gayara about 50 miles south of the Mossul are reported to be the most important of all in this region. They are leased to natives from the Turkish crown at a rental of £T. 250 a year. Oil is being produced in moderate quantities and has been so produced for ages. It is of good quality with about .8 specific gravity.

Oil indications occur on both banks of the Tigris between this place and El Fatha, 50 miles further down the river. The seepages are stated to be very important.

There are strong indications of oil at Kirkuk, while at Guil the present output from the seepages is 3 barrels a day and from Tuz Kermatie it is 4 barrels. Between both these places there are numerous oil shows. This region is reported to be very rich in oil.

At Kifri there is, in addition to an important oil seepage, a large outcrop of natural gas. Coal is also found in this neighborhood.

The oil is refined in rough native stills.

The group in the Mendali–Khanikin district is extremely important and promises to give several very prolific oilfields. They are mostly within the existing concession of the Anglo-Persian Oil Company Ltd. and have been examined more or less in detail by their geologists. At Chia Surk a field has been opened, but when the field at Maidan-i-Naftun was discovered, the former was abandoned on account of the greater accessibility of the wells of the latter to the Coast.

A report dated March 1918 on Naft Khana by one of the Company's geologists states that ''The Naft Khana oil field so nearly approached ideal conditions that it must be regarded as an area of greatest promise. The dome is said to be 10 miles long so that the reservoir of oil is probably very large. At the request of the Military Authorities, the Company is arranging to drill on this area as soon as the plant can be transported to the spot.

The field at Abi Ghilan is also reported to be of great promise.

The two fields marked in the Pasht-i-Kuh district at Deh Luran and Dalpari also show very favourable indications and it is intended to drill on them as soon as other development work permits. There are besides these, other favourable indications between Deh Luran and Naft Khana.

The group of oil occurrences in the Ramadi-Hit district on the Euphrates have been examined by the Anglo-Persian Oil Company geologist, who reports as follows:

> There is, therefore, three parts of a dome whose sides dip at a few feet to the mile only. Big productions have been obtained from similar structure in the United States. The gas pressure and large extent of the seepages though not necessarily implying a good production of asphaltic oil from drilled wells, must be taken as exceedingly favourable evidence.
>
> A considerable amount of oil is being obtained from hand dug wells and there is a lake of bitumen containing 60,000 tons of this material. It is probable that this region also will develop into a prolific field. . . .

VII

Finance
and Public Finance

Finance

In the 18th and much of the 19th century, the Ottoman monetary system had two outstanding characteristics: the currency was constantly being debased and depreciated, with an accompanying rise in prices; and the amount of local currency fell far short of needs, with a consequent use of foreign coins on a large scale.

The successive coins minted by the Ottomans (the *akche* in 1327, known to Europeans as the *asper* or *aspra;* the *para* in 1620; and the *qurush* or groschen or piaster in 1690) had all been debased, and the rate of the *qurush* had fallen from 5–6 francs in the mid-17th century to 2.6 francs in 1774 and 1 franc in 1811. Naturally, prices soared; a rough index of staple products in Istanbul rose from 83 in 1756 to 338 in 1800.[1] The scanty available data on Syria indicate a similar steep rise in prices in the 18th century (selection 1), and one may presume a parallel development in Iraq. The scarcity and poor quality of Ottoman coins meant that they were supplemented by a wide variety of foreign coins. In Syria in the 18th century, the main coin in use was, in principle, the *qurush* or piaster (divided into 40 *paras*), but since it was very scarce the Dutch rix dollar, or a debased copy of it called the Lion Dollar (*qurush asadi*) because of the Lion of Zealand on its face, which was minted specially for the Ottoman lands, became the standard currency. It was supplemented by the Maria Theresa dollar, the Spanish piece of eight, and other European coins. These were acquired through the export surplus normally registered in trade with Europe.[2] The relative values of all these coins fluctuated according to supply

[1]For a more detailed account of these developments, see *EHT,* pp. 326–337; Gibb and Bowen, *Islamic Society,* vol. 1, Part 1, pp. 49–59.

[2]*EHME,* pp. 30–37.

and demand, including such factors as the progress of the Spanish treasure fleets from the Americas and the demand for coins from Iran.[3] In Iraq, the Indian rupee and Iranian *tuman* and *kran* were also important. For official purposes the unit of account was the *kise* (*kis*) or purse of 500 piasters.

These trends continued during the greater part of the 19th century. New coins, notably the *beshlik* (5 piasters) and *altilik* (6 piasters), were minted in 1810, 1829, and 1833, but this did not help much because they too were short in weight and heavily alloyed (see II,1). In 1839, 25-piaster Treasury bonds, bearing 12 percent interest, the *kaime*, were issued, and were soon at a heavy discount. In 1844 a bimetallic gold and silver standard was adopted, at the ratio of 1 : 15.909, the new Turkish pound (*lira*) being worth 100 *qurush* or 18 shillings, but this arrangement was soon wrecked by the government's financial deficit, the import surplus, and the worldwide fall in the price of silver. Following the bankruptcy crisis, a new attempt was made in 1881. The Turkish gold *lira* of 7.216 grams, 91.65 fineness, equivalent to 18 shillings or $4.40, was the basic unit. It was subdivided into 100 gold *qurush sagh,* or sound piasters, known in the Arab provinces as *qurush sahih.* The main silver coin was the *majidiya,* originally intended to be worth 20 *qurush sagh* but, since silver had depreciated, officially fixed at 19, giving an implicit ratio of 105.26 piasters to the *lira.* The subsidiary coins constituted a further complication, the old silver ones being debased and the copper issued in excess of demand. Hence their market value fell well below par, and a new modified unit came into being, the *qurush churuk* (in Arabic *shuruk* or *mu'ib*) or defective piaster. This meant that there were two different kinds of money: first gold, and silver *majidiyas,* whose metallic value was more or less equal to their monetary face value, and which were used as units of account in government transactions. The second was token money whose face value was much higher than its intrinsic value, and which was used in everyday transactions. The latter had three sets of value: the legal one of 19 *qurush* to the *majidiya* or 105.26 to the *lira;* a conventional one for retail trade, mainly in Istanbul, of 108 to the *lira;* and a commercial one that varied according to place, to supply and demand, and to the nature of the product being bought and sold, and that ranged between the official value and the intrinsic value. Thus around 1905 the commercial rate was 108–109 in Istanbul, 102–178 in Izmir, 124–125 in Beirut, and 103–153 in Baghdad. In 1914, the rates in Syria were, for Tripoli, 123, Homs 124, Beirut 124.6, Saida 125, and Damascus 130.8. Moreover, different regions used different coins as their basic unit of trade: in Istanbul the *lira,* in Izmir the *majidiya,* in Armenia the *altilik,* and in Syria and Iraq the *qurush.* And, as before, large amounts of European, Russian, Indian, and Iranian coins continued to circulate. In addition, a small amount of bank notes was issued by the Ottoman bank, but except in Istanbul they stood at a discount and only very small amounts circulated in Syria and Iraq.[4] Needless to say, constant issuing of debased local currency led to a monetary inflation and a sharp fall in the exchange rate. In 1800, the piaster was worth 1.37 francs, but by 1900 only 22 centimes or less.[5] Naturally, prices rose sharply (see below).

[3]Davis, pp. 189–193; for exchange rates in 1838, see Bowring, *Report,* pp. 95–96.

[4]For details, see *EHT,* pp. 326–337; Young, *Corps.,* vol. 5, pp. 1–12; Gerber and Gross, "Inflation"; Himadeh, *Monetary,* pp. 24–28; idem, *'Iraq,* pp. 433–434; Verney and Dambmann (*Les puissances,* pp. 156–165) give lists of local and foreign coins and their rates.

[5]Verney and Dambmann, *Les puissances,* p. 156; for sterling exchange rates in 1740–1844, see *EHT,* pp. 329–331.

In addition, trade was constantly hampered by a shortage of coins and by repeated government attempts to regulate rates. In 1842 it was reported that, because of the shortage, coins with holes—indicating that they had been taken from women's jewelry—were being used.[6] In other words, previously accumulated coins were being dishoarded. In 1852 old coins were withdrawn but an insufficient amount of new ones put in their place; consequently, half the currency in circulation consisted of French, British, or Russian coins, one-quarter of coins whose intrinsic value was equal to their face value and another quarter whose intrinsic value was half their face value.[7] In 1859 the British consul in Aleppo stated that, because of the drain of currency abroad through the import surplus, commerce relied extensively on orders on *sarrafs* (see below), who manipulated rates and often failed, ruining merchants.[8] In 1860 the government decreed a reduction of 20 percent in the rate (in *shuruk* piasters) at which foreign and sound Turkish coins should pass; the result was great confusion and hardship in all the main commercial towns.[9] In 1871, the export of gold and silver reduced the currency in circulation in Aleppo so drastically that transactions had to be made by means of bills, carrying a monthly discount of 4–5 percent.[10] A decree of 11 March 1880 "lowered the current rate of exchange in metallic money 50 percent."[11] In 1882 it was reported that the intrinsic value of the *majidiya* was 15 piasters and the current 18.5; the government accepted it at 19, which sustained the current value. Hence *majidiyas* were being minted abroad and imported, yielding a profit of 15 percent.[12] After that, however, government interference seems to have decreased and fewer complaints are voiced.

The situation in Iraq was similar. In addition to numerous European, Indian, and Iranian coins, two kinds of *qurush* circulated. '*Ayn* piasters or *shami* (a coin that had not been minted since the 18th century but continued to be the nominal medium of transactions) were worth 10–11 ordinary Grand Signor piasters in the 1860s.[13] On April 3, 1888 the government decreed that the piaster value of all coins current in Baghdad be reduced by one-third; thus the *majidiya* fell from 28.75 Grand Signor piasters to 19 and the sovereign from 170 to 111. As the British consul pointed out, this stimulated imports.[14] A few years later the British consul in Basra pointed out that coinage was "a very difficult matter to deal with. It is hard to understand oneself on the spot, and still harder to explain to others." After listing the main coins in circulation, he points out that there were three kinds of piaster: "The government piastre, 100 of which = 1 lira; the local piastre, $153\frac{3}{4}$

[6]"Report on Trade," 17 September 1842, CC Beyrouth, vol. 3; see Chevallier, in Polk and Chambers (ed.), *Beginnings of Modernization.*

[7]Dispatch of 14 November 1852, CC Beyrouth, vol. 6.

[8]Skene to Bulwer, 28 May 1859, FO 78/1452.

[9]Brant to Bulwer, 8 April 1860, and Kayat to Russell, 2 February 1860, FO 78/1537; Skene to Bulwer, 1 May 1860, FO 78/1538; Rogers to Bulwer, 10 June 1861, FO 78/1586; Sandwith to Bulwer, 31 March 1862, FO 78/1670.

[10]A and P 1872, vol. 58, "Aleppo."

[11]A and P 1880, vol. 73, "Beirut."

[12]A and P 1883, vol. 73, "Beirut."

[13]A and P 1867, vol. 67, "Basra"; in the 1840s the rate was about 13.3 *shamis* to the pound sterling, and in the 1890s, 17.

[14]A and P 1889, "Baghdad."

of which = 1 lira; the piastre used for ordinary current expenses (i.e., small purchases of market or garden produce, etc.), 170¾ of which = 1 lira"[15] (see also selection 24).

How little silver currency was available is illustrated by an estimate for Baghdad in 1883: 142,000 rupees worth of Turkish coins and 186,000 of foreign, or about £43,000.[16] By 1907 the figure had risen to an estimated £250,000 and by 1909 to £500,000.[17]

The opening of branches of the Ottoman Bank (see below) improved matters somewhat. "The bank by accepting payments only in Turkish liras, mejidiehs, sterling and Napoleons, has succeeded in introducing the gold piastre (100 per Turkish lira) for purposes of exchange," but a variety of coins continued in use and the *kran*, "which predominates in this market, serves as a basis of exchange for sales and purchases effected in this money."[18]

With such a confused currency, the *sarrafs* (moneychangers)—in Syria at first mostly Jews, and later Christians, in Iraq mainly Jews—flourished, from those in small provincial towns to the Galata bankers of Istanbul. In addition to exchanging currencies, they transferred funds, advanced loans, and discounted bills. They also played a leading part in tax farming (see below), standing as surety for the farmer or taking the farms themselves.[19] Selection 3 shows the extent of the region's main money market, in Aleppo, in 1801 and selection 27 that methods had not changed significantly by 1908. In addition, some merchants lent money and a few small private banks were opened in Beirut and Jerusalem, such as the Valero bank in 1848, the first European establishment in the latter town.[20] Later, similar banks were founded in Aleppo and Damascus. In 1856 the Ottoman Bank, founded in London that year with a capital of £500,000, opened a branch in Beirut. It carried out the usual banking operations and offered 4–6 percent on time deposits, depending on the length of notice.[21] Until at least 1871 it was the only public bank operating in Syria.[22] However, by 1900 it had been joined by the Crédit Lyonnais, the Deutsche Palästina bank, and a small British bank, the Bank of Syria, in Haifa.[23] By 1914, the following banks operated in Syria: Ottoman Bank, with 12 branches; Deutsche Palästina Bank, with 9 branches; and Anglo-Palestine Company, with 8 branches, both mainly in Palestine; Crédit Lyonnais, with branches in Jaffa and Jerusalem; Banque de Salonique, with a branch in Beirut; Banque Commerciale de Palestine, in Jerusalem; and Deutsche Orient bank, with a branch in Aleppo.[24] These banks took deposits, discounted bills, made short-term advances, and made cheaper credit available. In 1860 the British consul had reported: "There is no bank in Jerusalem to which I could apply for an advance at a moderate interest—although I was willing to pay interest at the rate of 24 percent, which is now common in Jerusalem."[25] In the 1890s commercial loans were made in Beirut at 6–10 percent, and by 1910 the following rates were being charged: 6.5

[15]A and P 1893–1894, vol. 91, "Basra."

[16]25 January 1883, FO 195/1479.

[17]Ramsay, "Note," FO 195/3208.

[18]A and P 1907, vol. 93, "Basra"; for sterling–*kran* rates between 1809 and 1914, see *EHT*, pp. 343–345.

[19]For details see *EHT*, pp. 339–343.

[20]Gilbert, *Jerusalem*, p. 51.

[21]Copy of bank circular, 30 October 1856, FO 78/1219; see also Biliotti, *La Banque Ottomane*, passim.

[22]A and P vol. 58, "Syria."

[23]Verney and Dambmann, *Les puissances*, pp. 171–172.

[24]Ruppin, *Syrien*, pp. 267–277; Himadeh, *Monetary*, pp. 28–31.

[25]Finn to Russell, 24 May 1860, FO 78/1537.

percent for first-class bankers, 6.75 for second-class bankers, 7 for first-class merchants, and 7–8 for other merchants.[26]

An 1890 report gives an idea of returns on capital. Banks offered 5–6 percent on deposits and made profits of 15–25 percent. Agriculture yielded 5, 6, or even 7 percent. Buildings yielded only 7 percent in 1887, an abnormally low figure due to excessive construction in previous years.[27]

Insurance also became available. In 1854 the U.S. consul stated that there was "no insurance in this country, there being no companies or individuals who take such risks."[28] By 1900, however, 25 companies had offices in Beirut, providing life, fire, and maritime transport insurance.[29] In 1910 there were 19 companies in Beirut, 5 French, 4 British, 3 Austrian, 3 German, 2 American, one Canadian, and one Italian.[30]

These developments helped merchants and other townspeople, but almost nothing was done for farmers. In 1837 there was talk of establishing a bank to lend to small landowners at 10–12 percent, but the project did not materialize.[31] In 1852 a decree fixed the rate for rural loans at 8 percent; the British consul pointed out that the usual rates were 20–24 percent, which—given the risks attached and the fluctuation of exchange rates—represented real rates of about 14–18 percent.[32] The decree was naturally ineffective, as was another attempt in 1861 to reduce rates to 8–12 percent, and farmers continued to borrow from townsmen at 20–24 percent, repaying at harvest time.[33] The government-owned Agricultural Bank, founded in 1888, opened over 15 branches in Syria and advanced loans at 6 percent, but it met only a fraction of needs; in 1913 it had 71,000 outstanding loans, amounting to 58.7 million piasters.[34] (See also II,13.)

Developments in Iraq were similar, but slower and more restricted. A branch of the London and Baghdad Association was opened in Baghdad in 1864, but its operations were confined to exchange transactions with India.[35] In 1890 the Imperial Bank of Persia established a branch in Baghdad and in 1891 in Basra, but in 1893 both were closed down, as a result of the Ottoman Bank's intention to open branches. A branch was in fact opened in Baghdad in 1893 but in Basra not until 1904.[36] An attempt to introduce the bank's notes in Baghdad in 1895 had little success.[37] In 1907 a branch was opened in Mosul; in 1912 the Eastern Bank opened a branch in Baghdad.[38]

[26]Verney and Dambmann, *Les puissances*, p. 173; Ruppin, *Syrien*, p. 171; see also A and P 1909, vol. 98, "Jaffa"; idem 1910, vol. 103, "Damascus," and 1913, idem vol. 73, "Aleppo."

[27]"Notes on Trade," June 1890, CC Beyrouth, vol. 10.

[28]Reply to Circular, 15 July 1854, US GR 84, T367.2.

[29]See list in Verney and Dambmann, *Les puissances*, p. 200.

[30]Correspondence, October–December 1910, US GR 84, C8.5.

[31]Dispatch of 3 May 1837, CC Beyrouth, vol. 1.

[32]Wood to Canning, 28 January 1852, FO 78/910. In 1852 British firms in Damascus had $50,000 outstanding in loans to farmers, dispatch of 28 February 1852, FO 78/918.

[33]Finn to Alison, 19 June 1858, FO 78/1388; Rogers to Bulwer, 10 July 1862, FO 78/1670; Rogers to Elliot, 30 January 1868, FO 78/2051; "interest—ruinous to him and very few can recover from the load of debt laid on him" (Reply from Marash to Questionnaire, FO 78/1418).

[34]Himadeh, *Monetary*, pp. 31–33; Ruppin, *Syrien*, pp. 104–112.

[35]A and P 1867, vol. 67, "Baghdad."

[36]A and P 1893–1894, vol. 91, "Baghdad" and "Basra"; idem 1895, vol. 100, "Baghdad"; idem 1905, vol. 93, "Basra"; for the Imperial Bank, see Jones, *Banking*, pp. 64–66.

[37]A and P 1897, vol. 94, "Baghdad."

[38]Ramsay to O'Conor, 3 July 1907, FO 195/2243; A and P 1908, vol. 117, "Mosul"; Himadeh, *'Iraq*, p. 445.

Concerning prevailing interest rates, in 1911 "capital invested in local undertakings, which formerly could earn 9 percent, cannot now be reckoned to fetch more than 6 or 7 percent."[39]

Insurance was also very limited. In 1900 only one company is listed as operating in Baghdad, a Swiss firm that undertook maritime insurance.[40] In 1908 George Lloyd reported: "Life insurance in Baghdad is extremely uncommon among natives. Some 15 or 20 lives are insured with one or other of the American companies." Fire insurance was not common because it was "not encouraged by insurance firms. The better ones, as a rule, accept only first-class risks from Europeans."[41]

Agricultural credit was even scarcer than in Syria. In Mosul in 1845, "but few of the agriculturists possess money and to raise the necessary funds to carry on tillage, they are in the habit of purchasing goods from the merchants at a credit payable at harvest time, which they resell to a few capitalists at a discount of 20 or 25 percent for cash." Conditions in other parts were not better, and the Agricultural Bank does not seem to have operated in Iraq.[42]

In Syria, the sharp rise in prices continued until the 1850s (selection 1). At first the main factor was the debasing of the currency noted above. This continued under Egyptian occupation; for example, the Austrian dollar rose from 8 piasters in 1824 to 20 in 1838, and government demand for labor and produce also pushed up prices and wages (II, Introduction). The price of foodstuffs seems to have doubled, or more, and that of land tripled.[43] The restoration of Ottoman rule meant the application of the 1838 Commercial Convention and the removal of prohibitions on exports, hence a rise in grain prices to international levels.[44] On the other hand, imports became cheaper, the trend in world prices was downwards, and the currency gradually stabilized. The stability, or fall, in prices was interrupted by the very poor crops of 1845–1847 in Syria and Anatolia, accompanied by greater demand from Europe.[45] Prices fell again, but during the Crimean War grain prices reached unprecedented levels because of high demand from both Europe and Istanbul.[46] From the 1860s to the late 1890s prices seem to have been stable, thanks to good crops and falling world prices, but from then on to 1914 they rose sharply. Needless to say, the lack of storage and the high cost of transport (IV, Introduction) meant that both seasonal and annual price fluctuations were very sharp and that prices differed greatly from one locality to another.[47]

As regards the cost of living, available figures were studied for the periods when they were most abundant. In the 50 years or so preceding the 1840s the cost of living had risen sharply (selection 2). Between 1844–1856 and 1900–1912 the price of bread almost doubled, that of flour and rice showed no change, and that of meat rose three to fourfold (Table VII.1). The unweighted average suggests that the cost of living rose by 2.5 times,

[39]A and P 1912–1913, vol. 100, "Baghdad."

[40]Verney and Dambmann, Les puissances, p. 200.

[41]"Report upon the Conditions," IOPS/3/446, p. 47.

[42]Rassam to Canning, 9 August 1845, FO 195/228; Himadeh, 'Iraq, pp. 456–458; see also II, 33.

[43]Bowring, Report, pp. 118–124.

[44]Dispatch from Wood, May 1841, FO 406/7.

[45]See dispatch from HHS, in EHT, pp. 213–214; De Lesseps to Bastide 25 February 1848, CC Alep, vol. 31.

[46]Werry to Canning, 2 February 1850, FO 78/836; Finn to Clarendon, 27 February 1854, FO 78/1032; Kayat to Clarendon, 31 December 1855, FO 78/1122.

[47]For figures for Turkey see EHT, p. 332.

Table VII.1 Syria, Cost of Foodstuffs (1844–1846 = 100)

	Wheat bread	Wheat flour	Rice	Mutton	Beef	Unweighted average
1844–1846	100	100	100	100	100	100
1850–1856	78	—	—	146	189	138
1871–1878	—	108	253	358	483	301
1900–1912	167	94	104	415	553	267

Source: Selection 2.

but this gives an undue weight to meat. Furthermore, the price of sugar and coffee, which were imported, fell slightly, and that of kerosene and textiles dropped sharply (III, Introduction). On the whole, it seems likely that the cost of living at most doubled. This estimate is in line with a similar one for Turkey.[48]

It should be pointed out, however, that consular reports give the impression of a much greater increase in the cost of living. This is partly because of the sharp rise in the price of urban land, houses, and rents. In Beirut in the early 1830s the annual rent of a good house for a small family was put at £30 and that of a villa with garden for a larger family at £40; rents had risen because of the "many Frank residents lately settled." In 1887 the British consul reported: "The price of land and building sites both in and around Jaffa continues to rise steadily," as did that of buildings; in Jerusalem the price of land was six times what it had been "not very many years ago."[49] Jewish immigration and the proliferation of foreign religious and philanthropic establishments were largely responsible for this. In Damascus in 1891 "the cost of living has during the last 30 years been trebled. Rents also, although still low, except for Europeans, have more than doubled."[50] By 1899 it was thought that the cost of living was two or three times as high as 20 years earlier; the railway to Beirut was judged to have raised prices of agricultural produce.[51] By 1905, "the expenses of living have besides more than trebled since 1861."[52]

Information on Iraq is much scantier, but it may be presumed that the same general trends prevailed. In September 1831 the French consul in Baghdad reported that prices had risen steeply—wheat to 10.4 piasters an *oke* and meat to 20—but that is presumably attributable to the combined effects of the flood, epidemic, and siege.[53] Judging from the tone of the French consular reports, the Crimean War caused a sharp rise in prices of grain. There followed a slow rise until around 1870, succeeded by a stabilization or decline until 1908, when prices began to advance again rather briskly, because of quickening economic activity (selection 28). In Mosul, between 1855 and 1895, the price of bread, rice, meat, and butter rose appreciably.[54] Commenting on the sharp increase in wages of both skilled and unskilled labor in Baghdad (II, Introduction), the British consul stated: "The cost of living of all classes seems to have increased in a corresponding

[48]See *EHT* (pp. 332–337) for a further discussion.

[49]Carne, *Syria*, vol. 2, p. 10; A and P 1887, vol. 100, "Jaffa"; idem 1888, vol. 103, "Jerusalem."

[50]A and P 1893/94, vol. 97, "Damascus."

[51]Richards to Salisbury, 1 November 1899, FO 195/2056; see also list of prices for 1890 and 1906, showing a two- to threefold increase; A and P 1908, vol. 116, "Damascus."

[52]Craw to Hay, 4 October 1897, FO 195/1940; O'Conor to Lansdowne, 17 October 1905, FO 424/208.

[53]Beusches to Sebastiani, 19 September 1831, CC Baghdad, vol. 10; see also Longrigg, *Four Centuries*, p. 272.

[54]"Report on Mosul," 30 April 1985, CC Mossoul, vol. 2; see also selection 29; see also figures on grain prices in Mosul in Shields, "Economic History" (p. 138) and on food prices (p. 178).

degree—House rents have risen enormously, being in some cases double or even treble what they were a few years ago."[55] Nevertheless, judging from figures for around 1913 assembled by Eldem, the cost of living in Baghdad was lower than in Damascus, their indices (Istanbul = 100) standing at 86 and 113, respectively.[56]

Public Finance

The administrative structure of the Fertile Crescent changed during the period under review. From the Ottoman conquest to 1864 it was divided into large *eyalets,* also known as *pashaliks,* the number and boundaries of which were repeatedly changed. At the end of the 18th century Syria consisted of the provinces of Sham (Damascus), Aleppo, Tripoli, and Saida, and Iraq of Baghdad, Basra, Mosul, and Shahrizur.[57] In most places, however, power was exercised by local Ottoman rulers—for example, the Mamluks in Baghdad and Basra, the Jalilis in Mosul, the ʿAzms in Damascus, Jazzar in Acre, and the Shihabis in Lebanon.

The reconquest of Iraq in 1831 and the reoccupation of Syria in 1840, following Egyptian rule, did not change the administrative structure. In 1864, however, Lebanon was granted privileged status under Great Power supervision (*règlement organique*); also, a Provincial Reform Law was passed, and then amended in 1870 and 1880. *Eyalets* were replaced by what were generally smaller *vilayets,* subdivided into *sanjaqs.* Syria was now divided into two *vilayets,* Suriyya (Damascus) and Aleppo, and a third, Beirut, was added in 1888; earlier, an autonomous *mutasarriflik* of Jerusalem had been set up. Iraq consisted of Baghdad, Basra, and Mosul *vilayets.*[58] This system continued until the First World War.

"Each *eyalet* formed a separate and self-contained unit; out of its revenues were paid its own administrative and military expenses; and a fixed annual sum was laid down as the share of the Imperial Treasury . . . no instance appears to be recorded when the Porte made a contribution to the expenses of a provincial government from its other revenues."[59] For the early 1780s, Volney put the total revenue of Aleppo at 6–6.5 million piasters, of which 400,000 were sent to Istanbul; Tripoli and Saida sent 375,000 piasters each, and furnished provisions of equal value for the pilgrimage to Mecca; Damascus sent only 2250 piasters but had to cover the expenses of the pilgrimage and the safe conduct of the pilgrims to Arabia, amounting to 3 million (300,000?) and 900,000 (90,00?) piasters, respectively. The Palestinian plain, which was farmed separately, sent to Istanbul 170,000 piasters.[60] Formally, Lebanon was part of the *eyalet* of Saida, and it

[55]A and P 1912–13, vol. 100, "Baghdad."

[56]Eldem, *Osmanli,* pp. 203–204.

[57]For details see Husri, *al-Bilad,* pp. 128–136; Rafeq, *Al-ʿArab,* pp. 95–96; Gibb and Bowen, *Islamic Society,* vol. 1, pt. 1, pp. 142–144, 216–224.

[58]Shaw, *History,* vol. 2, pp. 88–90; Holt, *Egypt,* pp. 242–243; Lammens, *La Syrie,* pp. 191–92; Husri, *Al-Bilad,* pp. 138–143.

[59]Gibb and Bowen, *Islamic Society,* vol. 1, pt. 2, p. 37.

[60]Ibid., pp. 45–46; the figure of 6–6.5 million is not to be found in the 1825 edition of Volney's *Oeuvres* (vol. 3, p. 39). Gibb and Bowen (*Islamic Society*) find Volney's figures on pilgrimage expenditure (6000 and 1800 purses, respectively) "barely credible." Barbir (*Ottoman Rule,* pp. 184–190) puts the expenses of the pilgrimage in the 1730s–1760s at just over 300,000 piasters. It may be that Volney wrote 6000 and 1800 purses for 600 and 180. In 1858 the pilgrimage cost 6.3 million piasters. See IV,8, and selection 9 (this chapter).

was through the *pasha* of that province that the *amir* of Lebanon sent to the Sultan his tribute (*miri*), the amount of which seems to have varied greatly. The assessment and collection of taxes seems to have been left to the Lebanese *amirs* and the *muqata'jis*. At different times, attempts were made, with varying degrees of success, to subject Lebanon to further additional imposts, such as a poll tax.[61]

For the 19th century available figures, starting with the Egyptian occupation, are shown in selection 7. Between the mid-1830s and the early 1900s, the amount collected in Syria increased a little over twofold. This is about equal to the population growth and, given the doubling of prices and a probable small increase in per capita income (II, Introduction), suggests a considerable diminution of the tax burden.[62] The fact that under Egyptian rule taxation was distinctly heavier than either before or after it necessitates a modification of this judgment, but its basic validity stands. Taxation per capita in 1913 may have been about 50 piasters (say 8s.6d. or $2), which is low by international standards, and taxation may have amounted to 5 percent of national income, which compares with about 15 for Egypt and 10 for Turkey.[63]

In the early decades of the 19th century government revenues came from a multiplicity of taxes and duties, many of which were vexatious like the *batch* or road tax. Three main sources, however, stand out: taxes on agricultural land and its produce; customs duties on internal and external trade; and a poll tax on Christians and Jews.

Land revenue (*miri, 'ushr*) was collected from the villages by the holders of fiefs (*timar, zi'ama*), following ancient Ottoman practice. Increasingly, however, such holdings were replaced by tax farms (*iltizam*) assigned by the central government to a *multazim* for a period of one or more years or even for a lifetime (*malikane*).[64] The land tax was assessed on the various provinces,

> for instance, that the government of Aleppo has to pay 300,000 piastres of miri, or 300 kerats [*qirat*] of 1000 piastres each. This sum is then apportioned among the different villages according to their greater or less amount of population, or more or less extent of land . . . and it is the peasants themselves who make the repartition of the whole sum amongst the different villages.[65]

In addition to the regular taxes, many exactions were imposed on the villagers.[66]

Customs duties (*gumruk*) were paid on imports, exports, and goods transported from one town to another. "The charges imposed differed from place to place according to long-established usage and the kind of trade characteristic of each; and distinctions were often, but not always, made according to the status of the merchant concerned: whether he was a Moslem, a *Dhimmi* or a Harbi—that is an inhabitant of the Domain of

[61]Polk, *Opening*, pp. 32–49; Harik, *Politics and Change*, pp. 38–39.

[62]The sharp anticipated increase in the revenue of Beirut in 1914/15 is presumably due to the expected rise in customs duties following the raising of tariffs in 1914; see *EHT*, pp. 75–76, and III, Introduction (this volume).

[63]*EHME*, pp. 107–113; *EHT*, pp. 325, 353–355; Hansen, *National Product*."

[64]For the Ottoman practice see *EI2*, s.v. "Askari," "Ayan," "Ciftlik," and "Derebey"; Inalcik, *Ottoman Empire*, pp. 104–118; Gibb and Bowen, *Islamic Society*, pp. 235–275; for Syria, B. Lewis, "Ottoman Land Tenure"; Rafeq, in Udovitch (ed.), *Islamic Middle East*, pp. 666–669.

[65]Bowring, *Report*, p. 131.

[66]Rafeq, in Udovitch (ed.), *Islamic Middle East*, pp. 666–669; for imposts in Damascus, and the ensuing riots, see Douin, *Boislecomte*, pp. 221–224.

War."[67] In Syria, the capitulations subjected Europeans to only 3 percent duty on imports and exports, as against 5 percent paid by Ottoman subjects.[68]

Generally speaking, customs duties were light, but their multiplicity and unpredictability (and still more the monopolies and prohibitions on exports) made them seem very onerous to European merchants, who eventually succeeded in having them replaced by the uniform tarrif of the 1838 Anglo-Turkish Convention (III, Introduction, and references).

The poll tax on Christians and Jews (*jizya, kharaj*), in return for protection and exemption from military service, had been collected since the beginning of the Islamic state. Women, children, disabled and blind men, and the unemployed poor were exempt. The others were divided into three groups: high (*a'la*), middle (*awsat*), and low (*adna*); the rates paid by them were raised, along with the debasement of the currency (see above), from 3, 6, and 12 piasters (*qurush asadi*), respectively, in 1804 to 12, 24, and 48 in 1829, and 15, 30, and 60 in 1834.[69]

In fiscal matters Muhammad Ali's chief innovation—apart from much tighter control, stricter collection of revenue, and the introduction of some monopolies—was the imposition of a poll tax (*farda*) on all 16- to 60-year-old males; the poorest paid 15 piasters a year and the richest 500.[70] Christians and Jews continued to pay *jizya* as well, but this did not make the new tax more palatable to Muslims. Returns for 1834/35, which are slightly higher than those for the previous year, show that in Syria (excluding Mount Lebanon, Tarsus, and Adana), 297,000 inhabitants paid 14.7 million piasters in *farda*, or 21.6 percent of the total revenue collected, 67.9 million; in Lebanon 37,500 persons paid 1,875,000 piasters in *farda*.[71] Figures for 1835/36, which do not seem comparable with the previous ones, show that 35 percent of total revenue came from excise and Octroi (duty on goods entering a town) duties, 34 from *farda*, 19 from *miri* and other taxes, 10 from customs, and 2 from *jizya*.[72]

An evaluation is available for Lebanon. Before the Egyptian occupation, the *pashas* (Jazzar, Sulayman, 'Abdalla) levied 2500 purses, and Bashir took another 2500 purses, amounting to 2.5 million piasters in all. The Egyptian *farda*, at 15–500 piasters per capita, brought in 2.5 million piasters, to which was added the former *miri*, 1.25 million piasters. Bashir took another 5 million piasters—or 8.75 million in all.[73]

The revenue raised in Syria was almost wholly absorbed by the cost of maintaining the Egyptian army of some 40,000–50,000. It would seem that only part of the tribute (17.5 million piasters) to the Sultan due from Syria during the Egyptian occupation was covered by Syria's revenues. The rest was borne by Egypt, and observers agree that Syria constituted a heavy burden on the Egyptian treasury.[74]

Following the Egyptian withdrawal, the Ottomans abolished the *farda* but introduced a similar tax, the *i'ana,*

imposed on persons, not property, [which] was applied to all adult males irrespective of their religion in both the urban centers and the rural regions. It was paid once a year

[67]Gibb and Bowen, *Islamic Society,* vol. 1, pt. 2, p. 13, where examples are given.

[68]R. Haddad, *Syrian Christians,* pp. 34–35.

[69]*EI2,* s.v. "Djizya."

[70]Bazili, *Siriya,* p. 127; Bowring, *Report,* p. 131.

[71]See table in Bowring, *Report,* p. 22.

[72]See table in ibid., p. 131.

[73]Dispatch of 29 April 1841, CC Beyrouth, vol. 3.

[74]Bowring, *Report,* pp. 22–25, 132, 33; Bazili, *Siriya,* p. 129.

in the town or village of residence of the person and not where he worked. A tradesman who paid 500 piastres as *i'ana* for himself paid 100 piastres for each of his *mamluks* and black slaves.[75]

A tax on house rents in towns and land in villages, the *vergi* (*werko*) (selections 5 and 6) was also imposed.[76] Nevertheless, the amount collected seems to have been lower than under the Egyptians, In Damascus province in 1857 the *verghi* brought in about £10,000, compared to some £20,000 for the *farda* under the Egyptians, and total revenue dropped from 27.5 million piastres (£275,000) with no arrears, to 17.5 million (£143,500) with arrears of 5 million piasters. Although the number of troops was much smaller than under the Egyptians (selection 6), they cost the provincial government £42,000, to which should be added £70,000 for the pilgrimage (see also selection 9). Hence the budget showed a deficit, which was covered by the Imperial Trasury. Nevertheless, the British consul judged that taxation constituted a heavy burden, because of the prevailing insecurity that was causing an abandonment of many villages; moreover, the revenue was being "misapplied or plundered by employes."[77]

Another important change was the final abolition of the *timar* and *iltizam* (V, Introduction), the owners being compensated on the basis of their receipts during the previous five years. All peasants were now to pay taxes to the government.[78] However, because there was a shortage of trained personnel, taxes continued to be farmed out for most of the time in most places.[79] In 1841, the Ottomans decreed that the *miri* tax levied by the Egyptians be reduced by one-third. It seems to have been a light tax compared with the tithe (*'ushr*), which was also levied.[80] By 1867 there were two rural taxes: the *vergi* (4 percent of the value of land) and the *'ushr* on crops.[81] The incidence of the tithe obviously varied greatly over time and space. In 1859 the British consul maintained that in Damascus province it often equaled 25 percent or more of crops, and bore particularly hard on depopulated villages.[82] However, in a lengthy report in 1880, one of his successors stated: "In these eight Caimakamliks, at least, my experience goes to show that the tithe farmer has never been able to take more than a clear tenth of the crop."[83] In addition, villagers were subjected to a number of onerous exactions.[84]

[75]Rafeq, in T. Khalidi (ed.), *Land Tenure*, p. 384.

[76]A return for the years 1859 and 1864 shows that, in the city of Damascus, the house tax equaled some 11 percent of estimated annual rentals (A and P 1865, vol. 53, "Damascus"). In Aleppo, however, the *verghi* was estimated to equal 25 percent of rentals, causing great discontent (Werry to Rose, 19 January 1853, FO 78/960).

[77]"Report on Damascus," 14 June 1858, FO 78/1388.

[78]Werry to Palmerston, 28 February 1851, FO 78/871.

[79]For details see Shaw, "Tax Reforms"; Verney and Dambmann, *Les puissances*, pp. 173–176; Hasani, *Tarikh*, pp. 228–231; *EHT*, pp. 353–354.

[80]Rafeq, in T. Khalidi (ed.), *Land Tenure*.

[81]A and P 1872, vol. 58, "Syria." This figure may be erroneous; Shaw ("Tax Reforms") puts the *vergi* at 4 per mille. Himadeh (*Palestine*, pp. 353–361) states that the rate varied between 5 and 16 per mille.

[82]Brant to Bulwer, 12 June 1859, FO 78/1450.

[83]A and P 1880, vol. 73, Damascus; the report describes Midhat pasha's successful attempt to prevent the previous collusion between tax farmers, who agreed to low bids to the government; greater competition increased government revenue without imposing heavier burdens on peasants; he also describes the difficulty of direct collection by the government. A subsequent report (A and P 1884/85, vol. 78, "Damascus") describes the attempt to levy the tithe on the basis of the last five years' produce, and the consequent difficulties and abuses; see also Shamir, in W. Polk and R. Chambers, *Beginnings of Modernization*, passim.

[84]See Rafeq, in T. Khalidi (ed.), *Land Tenure*, pp. 384–388.

In 1883 a surtax of 1 percent was added to the tithe, to finance the Agricultural Bank (see above), and one of 0.5 percent for education. A further surtax of 0.5 percent was added in 1897—probably in connection with the Greek war—and one of 0.63 percent for armaments in 1900, raising the total to 12.63 which was reduced to 12.5 percent in 1906 to simplify calculations and protect cultivators.[85] The rate was applied to gross output and did not allow for seeds and other inputs. An example given by Ruppin shows the resulting anomalies: a wheat farmer with good land and low production costs would pay 16.8 percent of his net income, whereas another, with poor land and high costs, would pay 31.8 percent.[86] The cultivator's obligation to hold on to the produce until payment of tithe was particularly onerous, given the absence of storage (II,13). However, some of the worst abuses were gradually eliminated.[87] An animal tax was also levied.[88] Until 1863 this was in kind, 1 animal in 10 being taken. After that a tax of 3.5–5 piasters, depending on the locality, was imposed, and in 1903 the rate was raised to 10 piasters on all animals more than two years old, except donkeys, for which it was 3 piasters.[89] Lists of animals were prepared by village headmen and tribal chiefs and the tax paid by the latter was "related more to the degree of state authority over him than to the number of animals owned by his group."[90]

The ratio of the proceeds of the livestock tax to that of the tithe on cereals in the early 1890s, which may give an idea of the relative importance of crop raising and animal husbandry in the various provinces, was as follows: Aleppo 43.9 percent, Beirut 24.5, Damascus 7.9, and Jerusalem 23.3 percent.[91]

In the towns the main taxes were the *vergi* (*werko*) and the *tamattuʿ*. In 1861 the *vergi* (see above)—a tax on urban real estate (*amlak*), that is, buildings, and vacant or cultivated lands—amounted to 4 per mille of assessed value; gradually the rate was increased to 5 to 8 per mille. Here, too, assessment was uneven. In addition, a 4 percent tax was levied on house rents.[92]

The *tamattuʿ* (*patente*) replaced a tax on *asnaf* (guilds) that had been imposed by the Ottomans following Egyptian withdrawal under which members were divided into three classes, paying 5, 7.5, and 15 piasters a year, respectively.[93] In 1860 a 3 percent tax on business profits was imposed and raised to 4 in 1878 and 5 in 1886, at which date it was extended to salaries and wages. According to Abcarius, by 1914 it varied between 2 and 10 percent of the annual earnings.[94]

Customs duties were the most rapidly growing source of Ottoman revenue, except for tithes.[95] Changes in the tariff have been described earlier (III, Introduction). In 1873,

[85]Quataert, "Ottoman," pp. 28–30; Young, *Corps,* vol. 5, pp. 310–341.

[86]Ruppin, *Syrien,* p. 373.

[87]Verney and Dambmann, *Les puissances;* Quataert, "Ottoman," pp. 33–36.

[88]Brant to Bulwer, 12 June 1859, FO 78/1450.

[89]Texts in Young, *Corps,* vol. 5, pp. 292–301.

[90]Quataert, "Ottoman," p. 31.

[91]Cuinet, *Turquie,* vol. 2, p. 139; idem, *Syrie,* pp. 50, 383, 625.

[92]Shaw, "Tax Reforms"; Himadeh, *Organization of Syria,* pp. 353–361; Verney and Dambmann, *Les puissances,* p. 174; Himadeh, *Palestine,* p. 508.

[93]Brant to Bulwer, 12 June 1859, FO 78/1450.

[94]Himadeh, *Palestine.*

[95]See table in *EHT,* p. 354, taken from Shaw, "Tax Reforms."

the internal tax on goods transported by land, which was 2–8 percent, was abolished.[96] In 1900 the duty on goods seaborne from one Ottoman town to another was reduced to 2 percent and in 1903 was abolished except for a few goods.

Taken as a whole, Syria's tax burden was relatively light, but it was very unevenly distributed. First, the rural share was very large: tithes alone contributed some 40 percent of revenues (selection 7), to which should be added the other taxes mentioned above and the duties on silk and tobacco production that were paid to the Public Debt Administration. Conditions became particularly bad when crops were poor.[97] Aktan has calculated that in the 1890s farmers in Turkey (present borders) contributed 77 percent of total taxes more than proportionately, and this may also have been true of Syria.[98] Moreover, customs were levied at a flat rate and no other tax was significantly progressive. Upper and middle urban incomes seem to have been very lightly taxed, and the incidence on large landowners' incomes was also low. Lebanon paid very low taxes. What made the situation worse was the nature of government expenditure, practically all of which went to the army and bureaucracy (selections 5–10, 13 and 14). Conditions improved slightly in and after the 1890s, when expenditure on education and public works increased. In this respect, too, Syria's experience was similar to that of Turkey. Here, again, Lebanon was more fortunate, its taxes being used largely for internal improvements.

We can now ask whether, taken as a whole, the Syrian provinces had a budgetary surplus or deficit. As noted earlier, until 1831 Syria sent specified sums to Istanbul; under the Egyptians, part of Syria's tribute to the Sultan was paid for by Egypt; and after the Egyptian withdrawal there was a large deficit that was covered by the Imperial Treasury (selection 6). Lebanon had a deficit from 1862 to 1878 (II,15).

In 1858 it was reported that the Damascus government had borrowed "at least 11,000 purses (£45,000), at an annual rate of 24–30 percent," and in 1864 that "the whole military debt was paid off; but the Civil Treasury still owes about 30,000 purses, equal to about £150,000 sterling, subject to the uniform rate of 24 percent per annum, the bonds being held by foreigners, as well as native merchants, some of whom have made large sums of money by lending to the Treasuries capital borrowed by them in Europe at a lower rate of interest."[99] In 1879 the British consul put Damascus' local debt, issued in the form of sergis, at about £700,000, of which £170,000 was claimed by British subjects; in 1883 holdings by British subjects were put at £50,000 and in 1889 holdings of Austrian, Italian, French, and Russian subjects were put at £T. 86,000.[100] By 1899, however, the sergis had been paid off at a reduced rate.[101]

In Beirut, in 1854, "the local government, finding itself embarrassed for want of money, effected here in one day a loan of a million piasters. The European merchants were the first to subscribe and furnished 700,000 piasters; the Rayah merchants took up a

[96]A and P 1875, vol. 75, "Beirut"; Hasani, *Tarikh*, p. 232.

[97]"The taxes are not in reality very heavy but they become so by the manner in which they are collected. However bad the agricultural year may be, no leniency is shown to the population who are taxed at the same rate as in a prosperous year and if the money is not forthcoming it is extracted by force. As a result of this system of taxation, agriculture in the vilayet is in a very low state" ("Report on Beirut," 29 April 1900, FO 195/2075).

[98]*EHME*, pp. 108–113.

[99]Finn to Alison, 29 June 1858, FO 78/1388; A and P 1865, vol. 53, "Damascus."

[100]Dispatch by Jago, 1 March 1879, FO 1915/1262; Dickson to Wyndham, 3 May 1882, FO 195/1448; idem, 21 May 1889, FO 195/1648.

[101]Dispatch of March 1899, FO 195/2056.

large part of the remainder; and the Mahommedan merchants only came forward where there was but little more required."[102] (See also selections 8–10.)

By the 1870s the situation had changed and Syria was contributing considerable sums to the Imperial Treasury. In 1870, £T. 326,000 were sent by Damascus province to Istanbul and in 1871 £T. 324,000.[103] The following figures are available for subsequent years: 1880/81 £T. 123,000 and 1896/97 £T. 51,000.[104] In 1899/1900 £T. 84,000 was sent, in 1903/04 £T. 61,000, and in 1904/05 £T. 62,000.[105] In 1893/94 Aleppo sent £T. 40,000 and in 1894/95 £T. 150,000.[106] Between 1894/95 and 1904/05 Beirut sent an annual average of about £T. 104,000.[107] In 1894/95 through 1901/02, Jerusalem sent about £T. 40,000 a year.[108] Thus, around the turn of the century, Syria may have been contributing around £T. 300,000 a year to the Imperial Treasury, a significant item in its balance of payments (III, Introduction).

Most of what has been said about Syria holds for Iraq. At the end of the 18th century the revenues of the *pashalik* of Baghdad were estimated by Olivier at 2 million piasters; Rousseau gives a figure of 7.5 million, but this probably includes the neighboring *pashaliks* of Mardin and Shahrizur, then attached to Baghdad. Of this, 250,000 piasters were sent as tribute to Istanbul. The revenues were "derived from customs, ordinary taxes, produce of the farmed taxes, annual contributions of the governors and other officials, and the tribute due from the Arab tribes. Basra and Mosul, on the other hand, enjoyed very modest revenues and those of Basra were usually absorbed by the cost of defence, including subsidies to the neighboring tribes." Olivier put the net revenue of Mosul at 50,000 piasters, but Niebuhn gave a gross revenue of 17.5 million.[109]

Subsequent developments are shown in selection 15. Between the 1840s and the early 1900s Baghdad's revenue showed little increase, although population may have doubled and prices rose considerably (see above). Available figures for Basra and Mosul show a large increase. On the eve of the First World War, Iraq's taxes were about two-thirds of those of Syria, and the tax burden must have been about the same, whether reckoned per capita or as a proportion of GNP.

The main taxes levied were similar to those in Syria, but the difference in the economic structure of the two countries is reflected in their proportion. In Iraq urban taxes made a smaller, and taxes on livestock a larger, contribution than in Syria. A French consular report in Baghdad, which claims to have taken account of illicit as well as legal taxes, states that, in 1845, of a total of 23,338,000 piasters raised, 15,997,000 (68.5 percent) came from the taxes farmed out (presumably mainly tithes), 5,228,000 (22.4 percent) from monopolies and duties in the city, and 1,650,000 (7.1 percent) from taxes

[102]Calvert to Redcliffe, 7 January 1854, FO 78/1030.

[103]"Commercial Report on Syria," 30 September 1872, US GR 84, T367.8.

[104]Dickson to Wyndham, 3 May 1883, FO 195/1445; Richards to Currie, 3 April 1897, FO 195/1984.

[105]Quarterly Report, 26 April 1900, FO 195/2075; Report, FO 195/2075; Report, 7 January 1904, FO 195/2165; Report, FO 195/2187.

[106]Dispatch in FO 195/1883.

[107]Dispatches in FO 195/1843; Hay to Currie, 17 November 1897, FO 195/1980; FO 195/2056; FO 195/2075; FO 195/2097; FO 195/2117; FO 195/2140; FO 195/2165; FO 195/2187.

[108]Dispatches in FO 195/1895; FO 195/1940; FO 195/1984; FO 195/2061; FO 195/2127.

[109]Gibb and Bowen, *Islamic Society*, vol. 1, pt. 2, p. 46; Nieuwenhuis, *Politics and Society in Modern Iraq*, p. 10.

on beduins.[110] Cuinet's figures show that, around 1890, in Baghdad taxes on livestock (*kuda*) were 32 percent of tithes, and a further small amount was levied on beduins; in Basra the ratio was 21 percent and in Mosul it was 96 percent[111]; however, with the development of agriculture (V, Introduction) and the sedentarization of nomads, the proportion tended to decline. In 1911, for the country as a whole, tithes brought in 31.9 percent of revenue and animal taxes 10.9. Customs accounted for 23.0 percent, military exemption fees for 3.2, *vergi* (levied only in Mosul) 2.7, and *tamattu'* 1.8. The tithe was more complicated than in Syria, since additional amounts were imposed for flow irrigation and taxation varied according to the type of tenure of the land.[112]

Since Iraq was largely tribal, the collection of taxes often required military expeditions. A few examples are illustrative. The governor of Baghdad, Najib pasha, undertook, in return for the right to farm the taxes, to raise enough revenue to cover the expenses of the *pashalik,* which he estimated at 22.5 million piasters, and send 10 million to Istanbul. In 1846 he sent expeditions to collect higher taxes to the Muntafiq, Sulaymaniya, and Rawunduz, and raised a total of 35 million piasters. In the words of the French consul, Baghdad had to bear "the abuses of the old régime and charges imposed by the new one." At the same time, according to the British consul, "the subordinate officers of his government, whose emoluments did not depend upon the profits of Farms and to whom salaries were nominally assigned, were avowedly compelled to have recourse to bribery and extortion with a view to their personal remuneration."[113] (See also selections 17 and 18). In 1906 the government, having vainly tried for three years to get the tribes of the Muntafiq to pay their taxes—which, they claimed, were unfairly assessed—had to send in troops and engage in fighting.[114] Even the great reformer, Midhat pasha, had to start by leading an expedition to Hilla (selection 23).

The settled parts of the country were also subject to much extortion. A poor harvest in 1847 seems to have been used by the governor, Najib pasha, as a means to establish a monopoly and increase taxes (selections 17 and 18). Duties on the transport of grain were very high (selection 19). In 1861 the province of Mosul (already burdened by a multiplicity of taxes—see selection 16) was subjected to a forced loan of 1,415,000 piasters, of which 550,000 were imposed on the city and surrounding villages.[115] Furthermore, changes in taxes tended to be sharp and abrupt.

The arbitrary step taken last year by the Baghdad Government of doubling the tithes on dates and fruit produced on private property in this district [Basra], trebling them on wheat and barley, and quintupling them on rice (which is now liable to be charged 50 percent of the gross produce) . . . has put a stop to all improvements proposed or in progress. . . . The endeavor of each individual Governor is, not that the revenue shall receive any lasting benefit from his administration, but that he shall find out and

[110]Report of 19 April 1846, CC Baghdad, vol. 10; for a detailed breakdown of the 1845 budget in Mosul, see Selection 16 and Shields, "Economic History," pp. 180–205; for a breakdown of Baghdad budgets, see Nieuwenhuis, pp. 208–215.

[111]Cuinet, *Turquie,* vol. 3, pp. 85 and 253; vol. 2, p. 805.

[112]Himadeh, *'Iraq,* pp. 461–467, translated in *EHME,* pp. 187–190.

[113]Neimars to Lamartine, 9 May 1848, CC Baghdad, vol. 11; Kimball to Canning, 15 January 1850, FO 195/334.

[114]Crow to O'Conor, 12 May 1906, FO 195/2214.

[115]Rassam to Bulwer, 11 November 1861, FO 195/676.

Table VII.2

	Baghdad	Basra	Mosul
Civil List	61	22	
Gendarmerie	53	32	40
Magistrature	44	5	
Local expenses and salaries	30	7	36
Other	8	22	173[a]
Total	196	88	249

[a]*Havalés* (transfers)—that is, expenditure on soldiers and reserves.

suggest some alteration which will show some immediate though transient addition to the revenue which, however detrimental in its after-effect, will serve to bring him into note.[116]

However, matters, gradually improved. Some monopolies were abolished by Namiq pasha and certain river dues suppressed (selections 21 and 22). Midhat pasha attempted a thoroughgoing reform of taxes on land (selection 23). But until the end of Ottoman rule Iraq remained subject to a multiplicity of taxes, although, as mentioned before, their aggregate burden does not seem to have been very heavy (selection 26).[117]

As in Syria, expenditure was almost wholly absorbed by the military and bureaucracy. Expenditure in FY 1893/94, for example, was as shown in Table VII.2 (given in £000). To this should be added £550,000, from the three provinces, for the army.[118]

It is not clear whether Iraq, like Syria, also made a direct contribution to the Imperial Treasury. The proceeds of the Baghdad customs and Régie duties (averaging slightly over £100,000 a year) were sent to Istanbul, and this seems also to have been true of Basra and Mosul, whose expenditures always fell far short of their revenues.[119] These sums may have been wholly absorbed by the army expenditures mentioned earlier, but this does not seem probable.

In the decade preceding the First World War things began to improve. A large amount was spent by the Imperial Treasury on irrigation (V, Introduction), and the school system was expanded (II, Introduction). The first railway was built, with funds guaranteed by the Imperial Treasury (IV, Introduction). For the first time in centuries, Iraq was benefiting from government expenditure on development.

[116]A and P 1867, vol. 67, "Basra"; for details on taxes, see Nieuwenhuis, pp. 48–49.
[117]See also Himadeh, *'Iraq,* pp. 461–469.
[118]Report from Mockler, FO 195/1885.
[119]See, for example, Cuinet, *Turquie,* vol. 2, p. 805; vol. 3, pp. 85–86.

1

Price of Wheat in Syria, 1756–1913[a]

Year	Aleppo Price	Remarks	Source	Damascus Price	Remarks	Source	Mount Lebanon Price	Remarks	Source	Jaffa Price	Remarks	Source
1756/57	10 (7)[b]	Very dear	Ghazzi, Nahr, vol. 3, p. 301									
1758/59	11	Very dear	Ibid.									
1785	25	Exceptionally high	Ibid., p. 308									
1778/79				5	Very dear	Shihabi, Lubnan, p. 126						
1788/89				7		Ibid., p. 149						
1789/90				6		Ibid., p. 151						
1790/91				7		Ibid., p. 165						
1796/97				12		Ibid., p. 185						
1797/98				9		Ibid., p. 191						
1801/02				10	Very dear	Ibid., p. 355						
1802/03				4–30		Ibid., pp. 369–370						
1803/04				20–30		Ibid., p. 408						
1804/05				24		Ibid., p. 430						
1805/06				10		Ibid., p. 511						
1808/09				16		Ibid., p. 540						
1809/10				12		Ibid., p. 550						
1811/12							32		Shihabi, Lubnan, p. 575			
1813/14							24		Ibid., p. 599			
1814/15							28		Ibid., p. 627			
1824/15							28		Ibid., p. 641			
Late 1820s[c]				30		Bowring, Report, p. 50						
1838	75	Dear	Bowring, Report, p. 82	78		Ibid.						

(continued)

Price of Wheat in Syria, 1756–1913[a] (Continued)

Year	Aleppo Price	Aleppo Remarks	Aleppo Source	Damascus Price	Damascus Remarks	Damascus Source	Mount Lebanon Price	Mount Lebanon Remarks	Mount Lebanon Source	Jaffa Price	Jaffa Remarks	Jaffa Source
1845	25	Normal	Ghazzi, Nahr, vol. 3, p. 365									
1845	150	Disastrous harvest	Ibid.									
1846[d]	50–60 reached 80–100	crop very poor	CC Alep, vol. 31									
1847[d]	50–60	Poor crop										
1848[d]	30; fell to 20	Poor crop										
1849/50				18–30 (18–24)		Kremer, Mittel-syrien, p. 256						
1850	16	Good crop	FO 78/836							35–60		
1855	30		CC Alep, vol. 29							35–60[e] (30–36)		CC Beyrouth, vol. 3
1856	24		Ibid.							44–62[f] (27–42)		FO 78/1122
1857	40 (22)	Average crop	A and P 1859, vol. 30									Ibid.
1857	35–50 (16–20)		FO 198/13									
1859	95–130 (65–80)											
1860	Up to 170	Poor crop	CC Alep, vol. 32									
1861	50	Very good crop										
1863				44 (20)	Abundant crop	A and P 1864, vol. 61				44 (20)		A and P 1864, vol. 61
1866				40–56		A and P 1883, vol. 71						
1871	150 (75)	Very bad crop, usual price 50 (25)	A and P 1872, vol. 57	160	Very bad crop, usual 44	A and P 1872, vol. 58						
1872							60–78 (22–36)		A and P 1874			

(continued)

Year									
	Average crop	A and P 1873, vol. 75							
1874	56–60 (34)	A and P 1873, vol. 75							
1876			42 (24)		A and P 1877, vol. 3		A and P 1878/79, vol. 72	42 (24)	A and P 1877, vol. 83
1877						68–120 (36–48)			
1878			60–72 (28–32)		A and P 1878/79, vol. 72	48–60 (24–36)	Ibid.		
1879	56–60		120–140		A and P 1880, vol. 73		Ibid.	80 (36)[g]	A and P 1878/79, vol. 52
1880			58–70[h]			70–80 (30–40)		60 (26)	A and P 1880, vol. 73
1881									A and P 1882, vol. 71
1882			60–72		A and P 1883, vol. 71	50 (25)		40 (24)	Ibid.
1884			34–40 (18–28)		A and P 1884/85, vol. 78			36	A and P 1884/85, vol. 78
1885			66 (36)		A and P 1887, vol. 86				
1886			70 (40)	Poor crop					
1887			44 (22)		A and P 1889, vol. 81				
1888			40 (18)	Very good crop					
1889			32 (14)	Very good crop	A and P 1890, vol. 77				
1893	62 (31)	CC Alep, vol. 38	52 (24)[i]		A and P 1902, vol. 110				
Late 1890s									
1900			120–150[j] (53–80)	Exceptionally bad crop	A and P 1912/19, vol. 100				
1901			54–68[k]	Poor crop	A and P 1902, vol. 110				

Price of Wheat in Syria, 1756–1913ª *(Continued)*

Year	Aleppo			Damascus			Mount Lebanon			Jaffa		
	Price	Remarks	Source	Price	Remarks	Source	Price	Remarks	Source	Price	Remarks	Source
1902				(36)ˡ	Good crop	A and P 1903, vol. 79						
1900s	80	Normal price	Ghazzi, *Nahr*, vol. 3, p. 475	44–56 (22)								
1906				62–75 (30–36)		A and P 1912/13, vol. 100						
1908	110	Locust attack	Ibid.									
1909	150–180	Locust attack	Ibid., p. 476									
1910	110–150 (40–50)	Excellent crop	A and P. 1911, vol. 96									
1911	130–170 (60–70)	Fairly good crop	A and P 1912/13, vol. 100									
1912	150–190 (90–110)	Poor crop	A and P 1913, vol. 73				43–59 (20–23)		A and P 1914, vol. 95			
1913	75–110 (40–50)		A and P 1914, vol. 95				36–37 (24–31)		Ibid.			

ªIn piastres per *shumbul* of 45 *okes*, or about 60 kilograms or 132 pounds. Prices in Aleppo given in *shumbuls*; those in Damascus, Mount Lebanon, and Jaffa in *kayla* of 22 *okes* and therefore doubled to convert to *shumbuls*, except for 1900, 1906, and 1912, which are in *jift*, defined as 1⅛ bushels and assumed to be 0.56 of a *shumbul*.

ᵇPrice of barley given in parentheses.

ᶜ"Average former prices," that is, presumably before Egyptian occupation.

ᵈPrice of barley two-thirds that of wheat.

ᵉJune 1855.

ᶠSeptember 1855: "never has the price of grain been so high," because of large exports.

ᵍImport price.

ʰ"A succession of good harvests in Syria means wheat at 20 piastres per kilé [40 per *shumbul*] or 3s.3d. when little demand exists for export."

ⁱ"The average price is 26 piastres the kileh (3s. per bushel). Formerly, say 20 years ago, wheat was sold at 16 piastres the kileh, i.e. 1s. 10 per bushel."

ʲFor 1900 the "average" (i.e., normal) price was about 26 piastres per *jift* of wheat and 16 of barley (A and P 1912/13, vol. 100).

ᵏFormerly, say 20 years ago, wheat was sold at 16 piastres the kile (i.e., 1s.10d per bushel).

ˡThe average price being 12 piastres the kilé, i.e. 1s.5d per bushel.

2

Prices of Foodstuffs in Syria, 1756–1912[a]

Year	Place	Wheat bread	Wheat flour	Rice	Beef	Mutton	Butter	Coffee	Sugar	Source
1756/57	Aleppo[b,c]	0.16								Ghazzi, *Nahr*, vol. 3, p. 301
1785/86	Aleppo[b,c]	0.17–0.53			0.8[d]		0.13			Ibid., p. 308
1838	Aleppo	0.83[e]		3		4	8	10.6	8	Bowring, *Report*, p. 83
1844	Aleppo[c]	1.65	1.58							FO 78/621
1845	Aleppo[b]	1.5		1.63	3.8					Ghazzi, *Nahr*, vol. 3 p. 365
1846	Aleppo[b]	0.3								Ibid., p. 366
1820s[f]	Damascus		1	5		3.5	8	10–15		Bowring, *Report*, p. 50
1838	Damascus		2	5.5		4.5	11	10.5–15.5		Ibid.
1832/33	Jerusalem[b]			1.9–2.1			6.4–7.2			Tobler, *Lustreise*, p. 227
1846	Jerusalem[b]		2.67	2.67				9.6–12.8		Ibid.
1844	Beirut	1.87	1.2							FO 78/621
1846	Alexandretta	1.44			1.5	1.8				FO78/1419
1846	Damascus[c]	2	1.99							FO 78/621
1849/50	Damascus[b]	0.35–0.53			1.5[d]	1.87–2.4	6.9–10.7	7.5–10.7	5.6–7.5	Kremer, *Mittelsyrien*, p. 256
1854	Alexandretta	0.5			2.88	2.88	10		5	A and P 1859, vol. 30
1855	Beirut	1.44			1.4	1.6				CC Beyrouth, vol. 7
1855	Beirut	1.5								Ibid.
1855	Aleppo	1.12			3.2[d]	2.5				CC Alep, vol. 29
1855	Tripoli	0.92			2					CC Beyrouth, vol. 7
1855	Latakia	1.5								Ibid.
1855	Saida	1.32			2.65	3				Ibid.
1855	Haifa	1.56			2.42					Ibid.
1856	Beirut	2.07			6.6					Ibid.
1856	Diyarbakr				3.1	1–2				FO 78/1419
1856	Jaffa[g]				1.5–2[d]	2.1				FO 78/1419
1856	Mosul				3–3.5					FO 78/1419
1856	Tripoli					3–4				FO 78/1419

(continued)

Prices of Foodstuffs in Syria, 1756–1912[a] (Continued)

Year	Place	Wheat bread	Wheat flour	Rice	Beef	Mutton	Butter	Coffee	Sugar	Source
1856	Aleppo	1.25			4.5	5.7				CC Alep, vol. 29
1856	Urfa				1	1.5				FO 78/1419
1856	Alexandretta				4.5	5.5				FO 78/1419
1856	Antioch				1.5	2–2.5				FO 78/1419
1856	Latakia				1.8	2.9				FO 78/1419
1856	'Aintab					2.9				FO 78/1419
1856	Diyarbakr				1–2					FO 78/1419
1858	Alexandretta	1			4.5d	2.0				A and P 1859, vol. 30
1863	Diyarbakr								11	A and P 1865, vol. 53
1871	Beirut		2	2.8	6.5	6.8	16	12	9	A and P 1872, vol. 58
1873	Beirut		2.5	3	7	7.5	16.5	13.5	6.9	US GR 84, 1873
1878	Syria		1.5						7	FO 78/3070
1879	Damascus							14	7.25	CC Damas, vol. 6
1880	Jerusalem		3.4	3.6	9	6.4	15.4	14	6.8	Luncz, Jerusalem, p. 11
1891	Damascus				4.2d					A and P 1908, vol. 116
1900	Damascus	2.5	1.25	3.25	7	7.5	12.5	9	7	A and P 1912/13, vol. 100
1905	Aleppo		1.2	2.8		6	12	5.4	4	US GR 84, 1910
1905	Haifa		1.5	1.5	5.7d		11.5	9	2.5	Ibid.
1905	Damascus		1.2	1.8		5.2	11.2	5.2	2.1	Ibid.
1906	Damascus	3	1.8	3.5	8.5	9.5	14	11	7.5	A and P 1912/13, vol. 100
1910	Aleppo		2.8	3.2	10d	10	18	7.2	3	US GR 84, 1910
1910	Haifa		2.2	1.7			21	9.5	3.25	Ibid.
1910	Damascus		1.8	2.7		7.8	14	7.5	2.9	Ibid.
1912	Damascus	3	2	4.5	10.25	12	17.5	16.5	8	A and P 1912/13, vol. 100

Notes for Prices of Foodstuffs in Syria, 1756–1912ᵃ

aPrices given in piasters, decimalized per *oke* of 1.28 kilograms or 2.8 pounds.

bPrice given in *rotl*; assumed that *rotl* equaled 1.875 *okes*.

cExceptionally dear, because of drought.

dButcher's meat, unspecified.

eDear.

f"Average former prices," that is, presumably before Egyptian occupation.

gAverage of last 10 years.

3

Money Market in Aleppo, 1801

. . . The present commerce of Aleppo is principally with the Capital, the currency of money here being much higher than at Constantinople there exists a great scarcity of bills of exchange on the latter place; money therefore may be had at Aleppo for bills at Constantinople to the amount of, I imagine, at least 100 million piastres per month and for which the buyers pay about 10 percent agio, but this latter advantage sinks into nothing because the currency of money here is 10 percent higher than on the coast of Syria. I mention those particulars that in the possibility of hereafter our supplies from Constantinople proving deficient or tardy, you may avail of the little Aleppo can furnish.

Horses, mules and camels may be had here and in the vicinity—the first to the number of a thousand, the second to that of three or four hundred and camels about two hundred—each horse, mule or camel one with the other for the sum of piastres 200 to piastres 250 of Aleppo, that is of 10 percent less value than piastres of the Capital, owing to the difference in the currency above mentioned.

From J. Barker to Admiral Keith, Aleppo, 3 February 1801, IOPS Bombay, 381/20.

4

Cost of Living in Lebanon, 1820–1840

The personal account book kept by the historian Tannus al-Shidyaq (1794?–1861), brother of the more famous Ahmad Faris al-Shidyaq, is a document of considerable interest.

Shidyaq seems to have recorded all items of expenditure, however minute. He also has a statement of income during the various months; this consists mainly of gifts in cash and kind received from the various *amirs* and other notables with whom he was connected. Income seems generally to have been lower than expenditure, sometimes markedly so, but there is no suggestion of borrowing or debt. The figures are shown, rounded to the nearest piaster, in Table 4.1.

Expenditure shows a marked upward trend. Taking three-year averages, the figure rose from 641 in 1820–1822 to 839 in 1823–1826 and 1460 in 1827–1829; by 1833–1837 it stood at 1831 and in 1838–1840 at 2376, or 3.7 times its initial level. This represents an average annual compound rate of increase of 7.5 percent. Part of this may be due to a rise in Shidyaq's level of living, but most of it is probably accounted for by the rise in prices experienced by Syria, together with other parts of the Ottoman Empire, in this period.[1] My inability fully to decipher Shidyaq's notation makes it impossible to construct a price index. However, the unit price (probably per *uqiyah*) of one commodity for which a large number of reliable figures is available, tobacco (*tutun*), seems to have risen as follows: from about 20 *paras,* or half a piaster, in 1820 to around 1 piaster in 1827 and around 2 piasters in 1840—or, say, fourfold. The cost of a shave increased from 1 *para* in 1821 to 2 *paras* in 1836.

Shidyaq lived rather well. He bought a wide variety of fruits and vegetables, including grapes, figs, apricots, watermelons, sweet lemons, lemons, squash, cucumbers, onions, eggplants, and occasionally tomatoes; other staple items include rice, milk, yogurt, eggs, cheese, olives, and olive oil. His diet included chickens, mutton, and beef; for example, in 1827 he bought meat 36 times. He bought walnuts, *halawa,* cakes, sugar, ice, pepper, and coffee—but not tea—and drank wine and *araq;* he smoked a good deal, using waterpipes. He occasionally lunched or dined out and had himself shaven. He purchased soap, frequently paper, and at least once playing cards. He had his clothes washed and pressed; in 1820 he paid 25 piasters for a cloak (*'aba*), and in 1821 23 piasters and 183 piasters—large sums. He owned a watch, which he had repaired. He frequently gave small amounts in alms—for 1821 there are 22 entries, aggregating 33 *paras;* the average of 1.65 *paras* is slightly smaller than the lowest figure recorded for the purchase of bread in that year, 2 *paras.* With the rise in prices, the sums given in alms rise to 4–5 *paras* by the late 1830s. Another measure of purchasing power is the cost of a handkerchief, 3 *paras* in 1821.

From *Mufakkira al-Shaykh Tannus al-Shidyaq,* manuscript, American University of Beirut Library, MS 647.1 Sh.55.

[1]See Chapter II, selection 3. Shidyaq married and had two children, one of whom died in infancy. This undoubtedly increased his expenses. Unfortunately, the date of his marriage is unknown. See Salibi, *Maronite,* p. 164; and Introduction to Shidyaq's *Kitab al A'yan,* by Fouad Bustani (Beirut, 1970), vol. 1, pp. B–G.—ED.

Table 4.1 Expenditure and Income, 1820–1840 (in Piasters)

	Expenditure	Income
1820	389	855
1821	872	475
1822	662	454
1823	1508	1943
1824	351	366
1825	659	1022
1826	813	726 plus 361 in gifts
1827	1439	858
1828	1614	1590
1829	1326 (estimated)	1235 plus 240 in gifts
1830	364 (January–May)	1036
1831	1104 (January–June)	2133 plus 125 in gifts
1833	1391	971
1836	2172	1937
1837	1931	704 plus 89 in gifts
1838	2291	467 plus 151 in gifts
1839	2660	528
1840	2177	495 plus 168 in gifts

For items other than food and clothing, two figures are available. The daily wages recorded as paid to common laborers were 1 piaster in 1824 and slightly over 1 piaster in 1827 [see also selection II,19]. In July 1840 a monthly rent of 29 piasters was paid for a house.

5

Government Revenue and Expenditure, 1841

Under the Egyptian administration revenue in Syria amounted to 362,000 purses [of 500 piasters each], viz.

Miri	102,000
Ferdeh	60,000
Mubaya	200,000 approximately
	362,000

Now that the *mubaya, ferdeh,* and other taxes have been abolished by the ''Tanzimat Hairiyeh,'' the revenue is reduced to only 72,000 purses, while the expenditure and costs of the government in Syria, according to a rough count, amount to 140,000 a year, which means an annual deficit of 68,000 purses. In an interview I had the honor to have with their Excellencies Selim pasha and the Mustashar Effendi, it was decided not to levy

From Wood to Rifaat, 23 May 1841, FO 406/7 (original in French).

the *tahrire mal,* or 10 percent tax on property. The deep conviction that the collection of such a tax would cause great inconvenience in the country (an insurrection) made us adopt this decision. Since, however, expenditure is about twice as high as revenue, I take the liberty to suggest to Your Excellency that the Sublime Porte continue to levy half the *mubaya,* in lieu of the tax on property, which would produce an annual return of 100,000 purses.

This sum would raise total revenue to 172,000 purses and thus—in spite of the enormous expenditure, which, as mentioned above, amounts to 140,000 purses—a sum of 32,000 purses will remain for extraordinary expenses.

It is regrettable that the Sublime Porte should have judged it necessary to send such a large number of high officials to Syria. By increasing their number, one has merely increased proportionately the means of oppressing and vexing the people. Their salaries already amount to 1600 purses a month, or a quarter of Syria's revenue. It should not be difficult to reduce their number by adopting another form of administration. . . .[1]

[1]The figures in this selection are out of line with those in other sources (see Introduction and selection 7 of this chapter).—ED.

6

Fiscal Policy and the 1838 Anglo-Turkish Commercial Convention

. . . When there was no more money the Turks, contrary to their promises, began little by little to turn to the Egyptian fiscal system and, as in the past, to farm out many taxes. The *ferde* poll tax . . . was restored under the name of *vergi,* with a reduction on the part of the Treasury of one-third compared to Egyptian collections. [See Introduction to this chapter.] The people grumbled but, in spite of the increase in taxation, the government was unable to balance the revenues and expenditure of the Syrian administration and the upkeep of an army corps of 15,000–20,000 in the conquered territory. In seven years Syria absorbed more than 300,000 purses (about 9 million silver rubles) from the State [Central] Treasury. Moreover, because of the weakness of the administration, the amount of arrears increased yearly and in the present year (1847) has already reached 140,000 purses. Only customs duties show a significant rise in the new fiscal system compared to the Egyptian period; this, however, should not be attributed to an expansion of the country's trade and industry—on the contrary, both trade and industry have significantly declined—but solely to the introduction of a new tariff based on the 1838 Trade Convention, which destroyed all monopolies on export trade and all internal duties on imported goods.

This convention marks a new era in Ottoman trade with the European Powers and at the same time one of the most important governmental transformations; we must therefore explain here its basic features. In the original trade treaties that the Ottoman Empire

From K. M. Bazili, *Siriya i Palestina* (Reprint, Moscow, 1962), pp. 242–245.

concluded with the European states, it subjected foreign trade to a uniform 3 percent customs duty on all imported or exported goods. Thus in the East was established, at an early date, the boldest and newest theory of freedom of commerce now developed in English society under the name of free trade. The general impoverishment of the government, though endowed with the riches of soil and climate, the exhaustion and ruin of its ancient industry, which since time immemorial had made of Europe a tributary of Turkey, eloquently shows the falseness of these theories—like all absolute theories whose advocates and proponents lose sight of place and time and degree and direction of industrial development of society, passionately proclaiming their attractive learning.

We are not attributing the decline of agriculture in Turkey to the system of free trade, nor the fall in population nor the decrease in production, nor other inevitable consequences of the Turkish system of government, but to what else can we attribute the total collapse of manufacturing industry, to which the government was always favorably inclined and which, sheltered in towns, suffered less, or not at all, from the country's political perturbations? Some 40 years ago the Syrian towns, taken as a whole, had about 50,000 looms for silk, mixed silk, and brocade fabrics. Today there are hardly 2500. The solid and beautiful products of local manufacture have been replaced in the whole of Turkey by the worst Manchester cottons, with designs adapted to local tastes. If we assume, as a minimum, net income per loom for a working day to be 20 silver kopeks, with the decline of this industry Syria lost 33,000 silver rubles of net income per day; this sum would be doubled if we took into account the commercial turnover of local goods, the preparation of raw materials and dyes, and so on. Much cotton yarn was produced in the Judean mountains, in Nablus and Lebanon, and toward the end of the last century three or four loads of canvas were exported each year through Jaffa and Acre, which were used in the colonies for making shirts for Negroes. Today the *fallahin* sell their raw cotton, the total crop of which may be worth some 500,00 rubles, while Syria imports each year about 3 million rubles worth of English cotton yarn, canvas, and cotton fabrics. These simple figures strike us as more eloquent and intelligible than any theoretical discussions of inevitable equilibrium between the total production and consumption of each country and of periods of crisis in each industry. They become even more expressive in light of the misery of the families of the former handicraftsmen of Aleppo and Damascus, which increases each year. Proponents of unconditional free trade urge the ruined craftsmen to smash the looms they inherited from their fathers and take up a plough—but does this make sense in practice? Can they give us even one example of a population that has grown up in manufacturing industry and transformed itself into cultivators unless two or three generations have been reduced to misery?

On the unchanging basis of a general 3 percent duty, Turkey concluded with each power fixed term tariffs, which changed with price fluctuations and the value of money. Meanwhile, as government revenue in the country became exhausted, dooming it to progressive impoverishment and with growing internal and external troubles, the government's need for money increased. First tariffs on internal trade multiplied and, contrary to the spirit of the treaties, duties were levied on European goods moved from one port to another. The ambassadors protested, but the Porte persisted in its claim and held on to its own interpretation of the treaties. Second, it introduced monopolies on certain goods, and little by little that system spread, so that in the last years of Mahmud's reign almost all articles of export were bought by the government from producers at prices fixed by the former, to the detriment of production. Sometimes it allowed merchants to buy those products directly from the producers but only in virtue of special *firmans* and on payment

of duties exceeding the price of the goods, in addition to the ones fixed by the tariff. On this basis each *pasha* taxed, at his discretion, the export trade in his district. The government was impoverished, and farmers, forced to deliver their produce to the tax farmer or *pasha* for next to nothing and not receiving any recompense for their labor, left their fields untilled and were content with getting their daily bread. Just as the unrestricted freedom to import goods undermined manufacturing industry, prohibitive measures, tax farming, and monopoly on primary (*prostie*) goods destroyed production itself.

In no Ottoman region was the monopoloy system applied as generally and as strictly as in Egypt. The *pasha* was able to force the *fellahin* to cultivate the fertile Nile Valley. He multiplied its output tenfold and soon increased his revenues to the incredible sum of 800,000 Egyptian purses (27 million silver rubles).

European trade had already been wailing for a long time about monopolies and internal customs duties. The government began to perceive the fundamental viciousness of a system that ruined national industry and converted fertile fields into steppes, even if it provided a source of temporary gains to the Treasury. However, the most convincing argument against monopoly was the reckoning that with its destruction the main source of Muhammad Ali's wealth and power would run dry. This was in 1838, at a time when all Mahmud's aspirations were centered on Syria. A Convention was concluded first with England (5/17 August) at the time of the periodic renewal of the tariff, and then with the other Powers. This Convention abolished all monopolies and all internal customs duties in the Empire, and in their place added a duty of 9 percent on exported goods and of 2 percent on imports; however, with the proviso that goods that had once paid this additional duty could freely be sent from one market to another or be exported across the borders. Thus, instead of the basic 3 percent, imports paid 5 and exports 12 percent. This ratio must undoubtedly seem strange: every state strives as much as possible to encourage the sale of its own products and in the main burdens with duties the import of goods. This seems still stranger when we remember that at present Turkey supplies other states only with raw materials and receives manufactured goods in exchange. But the Turks have other economic notions and the 1838 Convention reveals rather a political idea, hostile to Muhammad Ali, and is marked by an external influence that made the Turks increasingly seek to inspire sympathy toward themselves and aggravate the anger of Europe against their Egyptian vassal. We should notice that, faced with bankruptcy at the time, Muhammad Ali was unable to submit to the *firman* destroying monopolies.

We have already mentioned that in Syria Muhammad Ali did not introduce monopolies; he even gave Syrian trade greater freedom by abolishing former restrictive measures. Introducing in that country the law of forced labor for the population in order to increase productivity, as in Egypt, was impossible for political reasons and because of the very nature of the Syrian soil. There remained only the privileges attracting people to agriculture. For this very reason the introduction of the new commercial system here did not encounter great obstacles. The Turks got four times as much in customs revenue as had been raised under the Egyptian administration (about 20,000 purses).

With regard to the organization of civil authority, we explained . . . the system of farming out the regional and district administrations. The fundamental practical reform of the present reign consists of the fact that *pashas* and *musallims* are not now at the head of either the economic departments or the armed forces. They receive salaries instead of disposing of government revenues after payment of an agreed-upon sum to the Treasury. In every *pashalik* there is a special official, the *daftardar*, designated by the Ministry of Finance for the superintendance of revenues and expenditures. In every district there is a

muhassil, who keeps accounts. But there are still many districts where, by necessity, the old tax-farming *iltizam* system continues. The efforts of the Porte to destroy the *iltizams* have been even less successful because its officials, from ministers to district officers, continue to derive from these *iltizams* significant benefits, entering into arrangements with the tax farmers and sharing their profits. At times the *pashas* buy *iltizam* farms under other names. It is easy to imagine what oppression the people suffer from when the governors of provinces participate in the farming of tithes, for example, for field crops that by their very nature and the methods used to collect them in Turkey, give much scope for corruption. . . .

7

Revenues and Tithes of Syrian Provinces, 1833–1914[a]

Year	Aleppo	Beirut	Damascus	Jerusalem	Source
1833/34	13.9		20.1[c]		Bowring, *Report*, p.22
	(2.7)[b]		(7.2)		
1834/35	15.2		21.1[c]		Ibid.
	(3.3)		(8.2)		
1836/37	20.9		35.9[c]		Rustum, *mahfuzat*, vol. 4, p. 15
1844			20.6		CC Damas, vol. 2
1847	(5.0)				A and P 1859, vol. 30
	approx.				
1857	16.8				Ibid.
	(10.7)				
1858	20.0	17.5	24.1		FO 198/13
	(6.7)	(7.5)			
1870			67.5[c]		*D.S.* 1289
1871			55.9[c]		Ibid.
1873			78.7[c]		A and P 1875, vol. 75
			25.5[c]		
1876	25.1[d]				A and P 1877, vol. 83
	(9.5)[d]				
1879			55.5[c]		FO 195/1263
			(24.9)[c]		A and P 1880, vol. 73
1880/81			58.8[c]		Ibid.
			(19.23)[c]		
1882/83			21.3		CC Damas, 6
1883/84			32.4		Ibid.
1884/85			20.7		Ibid.
1885/86			30.8		
1888/89	53.6				Cuinet, *Turquie*, vol. 2, p. 237
	(21.6)				
1889/90	45.9				A and P 1892, vol. 82
	(19.6)				
1891/92			33.2		*D.S.* 1308
			(11.6)		
1893/94	39.6	28.4		13.0	FO 195/1843, 1848, 1895
	(14.9)	(12.4)		(6.3)	

(*continued*)

Revenues and Tithes of Syrian Provinces, 1833–1914[a] (Continued)

Year	Aleppo	Beirut	Damascus	Jerusalem	Source
1890–95 average		36.1	104.3 [sic][e] 87.5 [sic][e]	16.1 (4.1)	Cuinet, Syrie, pp. 69, 383, 625
1894/95				9.2 (3.8)	FO 195/1895
1895/96			35.0[d] (12.6)[d]	8.4 (3.0)	FO 424/186, FO 195/1940
1896/97		34.7[d] (13.8)[d]	32.8[d] (11.7)[d]	8.6 (3.4)	FO 195/1984
1897/98				12.1 (3.6)	FO 195/2028
1898/99	40.4[d] (13.4)[d]	30.1 (14.0)	34.1 (13.4)	13.9 (5.3)	FO 195/2056, 2062, 2073
1899/1900		36.0 (16.0)	38.3[d] (16.0)[d]		FO 195/2075
1900/01		36.4[d] (16.0)[d]	38.6[d] (15.5)[d]	16.6 (5.9)	FO 195/2097, 2106
1901/02		15.2 [sic] (14.8)	39.9[d] (17.2)[d]	15.2 (4.1)	FO 195/2122, 2127
1902/03	38.6 (16.5)	37.2[d] (16.4)[d]	42.6[d] (18.7)[d]		FO 195/2137, 2140
1903/04			41.7[d] (18.2)[d]		FO 195/2165
1904/05	40.5 (18.0)	36.6[d] (15.3)[d]	38.4[d] (15.3)[d]	22.0 (5.7)	FO 195/2187, 2199
1908/09	(37.2)	(27.3)	(29.3)	(9.0)	Ruppin, Syrien, p. 358
1909/10	(24.8)	(30.7)	(18.8)	(10.7)	Ibid.
1910/11	(35.1)				A and P 1911, vol. 96
1911/12	(21.8)	(28.1)[f]	(28.0)[f]	(9.1)[f]	A and P 1912/13, vol. 100
1912/13	68.5 (28.2)				A and P 1913, vol. 73
1913/14	60.1 (23.4)				A and P 1914, vol. 95
1914/15[g]	89.2	140.4	68.5	20.4	FO Handbook, p. 137

[a]Given in millions of piasters.

[b]'ushr in parentheses.

[c]Probably includes Beirut and Jerusalem; totals for Syria, excluding Adana and Tarsus, were 62.1 and 21.8 million in 1833/34, 67.9 and 24.8 million in 1834/35, and 42.5 million in 1835/36 (Bowring, Report, p. 132); for 1836/37 the total for Syria, excluding Adana and Tarsus, was 93.0 million; Wood (see selection 5) gives a total of 362,000 purses (or 181 million piasters) for total annual revenue during the Egyptian occupation—a figure that seems erroneous.

[d]Sterling converted at 120 piasters.

[e]Perhaps these figures represent the total for five years.

[f]Estimated: one-eighth of value of crops assessed for tithe as given in Eldem, Osmanli, p. 272; see also Ruppin, Syrien, p. 358.

[g]Converted, at 1 franc = 4.4 piasters budgetable (Foreign Office Handbook, p. 137); for the whole of Syria, tithes equaled 92.4 million piasters.

　　　For Lebanon the following estimates of revenue are available: 1820s, 2.5 million piasters; 1835, 8.75 million (Report, 29 April 1841, CC Beyrouth, vol. 2), late 1890s, about 3.6 million (Verney et Dambmann, Les puissances, pp. 177–178); 1913, 4,461,000 (FO 424/239); and 1914/15, 4.4 million (Foreign Office, Handbook, p. 137).

8

Finances of Aleppo, 1858

The receipts of the Province of Aleppo are comprised under five heads, viz:

1st. Tax on Houses called Trabieh, in lieu of Verghi. It is assessed by Local Councils of the different Quarters of the town, and collected by Government Agents at the rate of about 15 percent on the rent. In villages it is a fixed tax on each, neither increased nor diminished by their annual prosperity. This tax is calculated to produce per annum an average revenue of Piastres 4,250,000.

2nd. Local dues called Rousoumat, levied on the following articles:

Tobacco, by weight according to quality at the rate of from 300 to 900 Piastres per Quintal of 200 okes, being nearly ⅓ of its value. The Tithe is also taken on Tobacco, and both taxes amount together to about 43 percent of the gross produce.

Honey, in a similar manner.

Animals, sold in the market, at 1 percent on their price.

Fisheries, near Antioch and Hama, farmed by the Govt.

Weights and Measures, at the public khans where a small fee is received on all goods weighed and measured by a Govt. Agent.

Saltworks, at Lake Malouka, farmed for a term of years.

These six items produce a gross annual sum averaging Piastres 1,750,000.

3rd. Ground rent on houses called Awarez, assessed at 1 Piastre per 5000 of the registered value of the ground covered by each house, vakouf property excepted.

Tribute levied from the Arab tribes under the title of Miri.

Tax on Trades.

These three items are assessed and levied by Govt. Agents, and produce annually an average amount of Piastres 1,250,000.

4th. Customs, which are farmed at Constantinople, together with the Excise duties on provisions paying 12 percent, and the Tithe on Silk. These at present produce per annum Piastres 6,000,000.

5th. Tithes of the gross amount of the produce of the soil, assessed and levied by the Farmer, who receives them in kind from the grower, and pays the price stipulated in money to the Govt. The average amount of revenue annually derived from the different districts is as follows:

Baba and Jiboul	Piastres	500,000
Gebel Seman		750,000
Beglieh		200,000
Raia		200,000
Edlib		100,000
Jisr Shogl [Shughur]		200,000
Maret Misrin		250,000
Sermin		250,000

From "Report on the Finances of Aleppo," FO 198/13.

437

Harem and Barisha	350,000
Amuk	250,000
Antioch	1,000,000
Killis	1,500,000
Aintab	750,000
Beilan	250,000
Mudik Kaleh	150,000
Zoar	50,000

Total 6,750,000

The total receipts on taxes farmed are thus—

Head 2nd	1,750,000
Head 4th	6,000,000
Head 5th	6,750,000

14,500,000

Those collected are:

| Head 1st | 4,250,000 |
| Head 3rd | 1,250,000 |

5,500,000

Total receipts of the province: 20,000,000

The expenditure of the Province of Aleppo is classed under two heads, viz: 1st. Pay of Civil Servants, as follows:

1 Governor General	Piastres	720,000
Treasurer		120,000
1 Chief Clerk		18,000
1 Chief Clerk for correspondence		18,000
Bookkeepers		24,000
2 Assistant Clerks		12,000
3 Assistant Clerks for correspondence		25,200
3 Assistant Clerks Provincial Council		43,200
1 Arabic Writer		9,000
1 Cashier		12,000
3 Clerks for Tribunals		18,000
Ecclesiastical expenses		84,000
Pensions		120,000
1 Cadi		24,000
1 Registrar General		60,000

Total 1,307,400

2nd. Pay of the Army, as follows:

| Irregulars, 2050 in summer, 1000 in winter | Piastres 2,400,000 |
| Policemen, 180 | 432,000 |

Pay of Officers of Irregulars & Police	108,000
Regulars, 2200	6,000,000
1 General of Division	264,000
1 General of Brigade	138,000
1 Colonel	60,000
1 Lieutenant Colonel	42,000
4 Majors	120,000
1 Paymaster	24,000
2 Adjutants	36,000
1 Chaplain	16,800
1 Surgeon	22,800
1 Apothecary	9,600
12 Captains	102,240
24 Lieutenants	162,480
24 Serjeants	67,680
96 Corporals	132,480

Total 10,138,080

Total Expenditure

	Piastres
For Civil Services	1,377,000
For Military Services	10,138,000
	11,475,000

From the Receipts stated at 20,000,000 should be deducted the amount paid at Constantinople for Customs, viz

6,000,000

Balance 14,000,000

This amount represents the whole revenue payable into the local chest at Aleppo, and available for local purposes. Deduct from it the total Expenditure as above detailed—

11,475,080

Excess of Receipts over Expenses 2,524,920

This apparent surplus has, however, no real existence, for, besides certain orders drawn at Constantinople on the local chest at Aleppo from time to time, remittances in cash are annually made to Damascus to the amount of from 3,000,000 to 5,000,000. Assuming the drafts from Constantinople to average annually 500,000, an approximate sum of 4,500,000 has to be met by the surplus, and a deficit is produced of, Piastres— 1,975,080.

The local Treasury is consequently at present in debt to the amount of 5,000,000, being 1,000,000 borrowed from Jews at rates of Interest varying from 36 to 72 percent per annum, and 4,000,000 due on orders issued but not paid, and the pay of the military establishment is a whole year in arrear with the exception of the Officers and Irregulars and Police, adding thus 6,000,000 to the debt which reaches in all the sum of 11,000,000.

As a set-off against this debt the Local Govt. has a claim of 15,000,000 against Farmers of Taxes whose payments are in arrear. A portion of this amount is now considered irrecoverable, say ⅓, leaving a credit of 10,000,000. To this may be added a new Tax on sheep computed at 1,000,000—Total 11,000,000.

The debts may therefore be gradually extinguished by rendering these claims available for the purpose.

9

Finances of Damascus, 1858

The receipts of the Province of Damascus are comprised under five heads, viz:

1st. Tax on Houses called Ferdeh, in lieu of Verghi. It is assessed and collected by Government, as at Aleppo. This Tax produces an average amount per annum of Piastres [figure missing].

2nd. Local dues, called Rousoumat, on provisions, weights and measures, etc., which are formed by the Govt for a gross annual sum of Piastres [figure missing].

This amount includes the Customs, which form part of the Contract, and produce annually Piastres 1,291,000. The Customs are thus received by the Local Government at Damascus and applied to meet the expenditure of the Province, which is not the case at Aleppo.

3rd. Tithes of the produce of the soil, farmed as at Aleppo, which produce an annual amount of Piastres 3,153,279.

This sum does not, however, represent the tenth part of the agricultural produce of the Province of Damascus, because a considerable portion of it is included in the assessment of the Tax called Ferdeh and collected by the Govt. It is impossible to calculate the exact proportions of that assessment which was fixed many years ago and is not liable to revision according to the change of circumstances in the villages.

4th. Auxiliary Tax called Muretebat Avnieh, which is an assessment on the villages, paid in kind to the Govt. by the Sheikh of each village and distributed by him amongst the villagers according to the quantity of grain produced by each.

This tax was instituted by the Egyptian Government when it held Syria, and the assessment has not been altered. A great amount of Arrears is therefore borne on the Treasury registers, as a village, though possibly deserted, is still recorded amongst those which pay. When a village, on the other hand, has increased in population and prosperity, no more is levied from it than the original rate of assessment.

The annual amount received by the Govt is Piastres 2,475,050.

5th. Commutation Tax for Military Service, called Bedelieh Askerieh, payable by the Christian population alone, has not yet been levied at Damascus.

The distribution of the receipts is as [in Table 9.1].

The detail of the Muretabat Avnieh or Auxiliary Tax is too voluminous for insertion in this Report, and it is also too vague to be relied upon inasmuch as many of the villages

From "Report on the Finances of Damascus," FO 198/13.

Table 9.1

Ferdeh	Rousoumat	Tithes	Commutation
Damascus			
1,051,600	3,262,530	0	167,250
Merjeghuta			
1,418,164	0	0	0
Wadi el Ajem			
655,936	0	0	0
Wadi Barrada			
286,450	0	2,973,244	75,000
Jebel Kalamun			
658,086	0	0	0
Baalbec			
1,127,709	81,500	0	67,500
Homs			
606,020	171,778	12,415	48,750
Hama			
2,422,602	339,495	0	78,750
Marra			
214,429	2,550	1,200	0
Husn el Akrad			
477,761	27,513	20,500	86,250
Hawran			
1,142,059	0	85,815	118,750
Ajelun			
658,942	0	19,457	7,500
Hasia			
79,772	0	0	27,250
Rasheyeh			
175,533	24,960	0	52,500
Hasbeyeh			
260,178	50,360	152,000	45,000
Jebel Druze Hawran			
150,220	0	28,470	11,250
Kunaitra			
310,833	0	185,000	3,750
Bukaa			
264,597	29,100	1,386,235	86,250
11,960,891	3,989,786	4,864,336	875,750

assessed have no separate existence, the more populous and better protected amongst them having absorbed the population of those in their neighbourhood which were weaker and more exposed to the oppression of Ayans and depredations of Bedouins, while the land, which they previously tilled, still remains under cultivation by them, although the tax on it is no longer collected.

The receipts on taxes farmed are thus:

Head 2nd	3,979,786½	
Head 3rd	4,864,336	
		8,844,122

Those collected are:

Head 1st	11,960,889	
Head 4th	2,475,050	
Head 5th	835,750	
		15,271,689
Nominal amount		24,115,811
Deduct annual arrears		3,213,643
Total actually received		20,902,168

The expenditure of the Province of Damascus is classed under two heads, viz:

1st Pay of Civil Servants in the City of Damascus, the establishment being nearly as at Aleppo	Piastres 1,375,534
Pay of Civil Servants in the other towns of the Province	867,938
Expense of collecting taxes, not farmed	1,346,861
Pensions	415,003
Expense of Wakuf establishment	244,561
Expenses of the annual Hadj, or Pilgrimage to Mecca	6,311,637
Divers expenses by order of the Governor Genl. of which the detail varies	900,993
Total	11,462,527
2nd Pay of the Army, as follows:	
Irregulars and Police, 1920	3,809,046
Regulars	6,000,000
Total	9,809,046

The sum of 6,000,000 allotted to the payment of the Regulars varies with the change of quarters, as each Province is required, in so far as possible, to defray the expenses of the troops stationed in it, and when there are more Regulars in the Province of Damascus than 6,000,000 can pay after deducting the expense of the Staff, arrears are accumulated. At present the Forces are distributed as follows: . . .

Total 11,39₄

Total Expenditure

For Civil Services	11,462,52⁻
For Military Services	9,809,04₆
	21,271,57₂

The total receipts being 20,902,168, an annual deficit of 369,404 appears.

A debt of 11,000,000 exists, for which interest is paid at the rate of 30 percent. Of this debt about one-third was capital borrowed, and two-thirds have been made up by compound interest.

Arrears of revenue are borne on the registers to the amount of no less than
4,000,000. An attempt to call these in has recently been made by means of the Military
Authorities, and the results are that 3,000,000 have been received, that 7,000,000 may be
realized during the lapse of ten years, and that the remaining 64,000,000 are considered
irrecoverable.

10

Finances of Beirut, 1858

The receipts of the Province of Beyrout are comprised under three heads, viz:
1st. Verghi or Tax upon income, which is not commuted as at Aleppo and
Damascus into a house tax, but is collected as in other provinces of Turkey. It produces a
revenue of Piastres 10,000,000.
2nd. Tithes on agricultural produce and the Local Dues called Rousoumat, which
are farmed together and yield an annual revenue of about Piastres 7,500,000.
3rd. Customs, which are farmed at Constantinople for Piastres 14,000,000.
The total Receipts available for local purposes are thus Piastres 17,500,000.

The expenditure of the province of Beyrout is classed under three heads, viz:

1st Pay of Civil Servants, which averages Piastres 7,500,000.
2nd Pay of the Army, forwarded to Damascus, Piastres 9,000,000.
3rd Pensions, Piastres 1,000,000.
 Total Expenditure—Piastres 17,500,000

There is no debt in this Province. The amount of Arrears of Revenue is Piastres
35,000,000.

From "Report on the Finances of Beyrout," FO 198/13.

11

Debt in Gaza, 1850

*The study from which the following passages are taken was based on the records of the shar'i courts
of Gaza, preserved in the Directorate of Historical Archives in Damascus (nu. 461) and covering
the years 1273–1277 A.H. (1857–1861).*
 Gaza, in the 1850s a town of some 15,000 inhabitants of whom 14,000 were Muslims and the

From 'Abd al-Karim Rafiq, *Ghazza,* pamphlet presented to 3rd Congress on History of Syria, Amman, 19–24
May 1980, pp. 66–70 (footnotes omitted).

rest Christians, was the capital of a sanjaq *attached to that of Jerusalem. Its economic importan(*
was based mainly on trade. The land route connecting Egypt with Syria and beyond passed throug
it, and its port was also linked with Alexandria, from which it imported grain, wool, and oth(
products. In addition, the Damascene Hajj caravan (see IV,8) often went to Gaza on its retu(
journey, causing a brisk traffic in the goods it had brought back with it; moreover, other pilgri(
passed through Gaza on their way to Aqaba, to join the Egyptian caravan.

Gaza was also the market town of a large agricultural district producing olives, oil, a(
other crops and livestock. It also contained a few simple crafts such as weaving, dyeing, potter
soapmaking, and leatherwork. Its population is estimated to have risen from 16,000 in 1882 (
40,000 in 1906 and then to have fallen back to 17,000 by 1932. (See EI2, *s.v. "Ghazza";* Baed(
ker, Palestine and Syria; *Meyer,* History; *Ben-Arieh,* Population.

. . . The largest among the estates in the registers of Gaza belonged to Husayn, son (
Hammuda al-Dabbagha. His main occupation was trade in textiles, but he also investe
money in the countryside. His estate amounted to 65,086 piasters. . . . It will be observe
that debts due to Dabbagha accounted for 44.5 percent of his estate. Comparing this wit
the corresponding proportion of debts due to Darwish al-Sirwan, ʿAbd al-Qadir al-Shaw
wa, and others who left estates, the capitalist character of most of the fortunes of the ric
people in Gaza whose names appear in the court registers becomes apparent. . . .

It will be noticed that in Gaza debts were individual; that is, the lender was a
individual and not a partnership or group. Most of the debtors were also individuals; in th
countryside, however, loans were made by people in Gaza to some or all the inhabitants o
a village collectively. The responsibility of the latter for repayment of the loan was als
collective; this shows the collective need of the rural population for loans, the collectiv
nature of their farmwork—probably because they did not own the land they cultivated–
and the inability of any one individual to borrow singly.

We have not found any cases of borrowing from the state. Some rich people, lik
ʿAbd al-Qadir al-Shawwa, delayed paying *miri* (agricultural) tax to the state, using th
money in their own business—a sort of forced, interest-free loan imposed on the state
There are examples of debts due to mosques in Gaza, e.g., . . . An important question i
raised by this: was this a loan made out of *waqf* (mortmain) revenue accruing to th
mosque? In other words, did the administrators of the *waqfs* lend money out of *waq*
funds, to increase the latter? Or did the debts of individuals to the mosques arise out of th
hikr (rent) due by them on mosque properties?

Most people both lent and borrowed. Most of the debts were very small, amountin
in one case to 1 piaster. This shows the high purchasing power of the piaster, the lownes
of incomes—which made even small sums significant—the attention paid by the court t
the least debts, and the obligation attached to financial rights, however small. The fre
quency of moneylending shows both people's need for it and the fact that debt was
common occurrence carrying no social stigma and that it was one way of placing mone
and earning an income with little effort. The fact that people felt obligated to repay debt
(except in cases of bankruptcy, when the estate was apportioned among creditors and heir
undertook to repay the debt) shows a high degree of social relations, a respect for financia
obligations, and the efficacy of the judiciary in making people honor their debt contracts
Hence creditors seldom resorted to courts to recover debts, except in such cases as th
settlement of an estate or bankruptcy of debtors.

We notice in the records of estates that moneylending was not confined to a few
individuals—in other words, it was not the profession of a few persons—nor was i
restricted to a certain number of families. The prevalence of moneylending shows tha

ıany people practiced it. Nor was it confined by denominational barriers: Christians ɔrrowed from Muslims, and vice versa. Christians resorted to the *shar'i* court to settle isputes arising out of debts due to each other. But the amounts of debts made by 'hristians were, judging by the records we studied, tiny compared to that made by ɹuslims. This may be due to lack of wealth, or to reluctance to risk money and content- ᴉent with what they had. Christians attended the public sales of the estates of Muslims, ᵣd bought there.

Women were well known as moneylenders and seldom borrowed from men, but ᵃther from each other. Studying records of estates, we find that a man borrowed, in the ᵢrst place, from his wife or wives, or from his daughters just as he borrowed from his ɔns. He also borrowed from other women. The wealth of women consisted mostly of ᵊwelry and of various kinds of coins. The sources of such wealth were, in the main, ᴉheritance or bequest or deferred *mahr* (bride money). They were also certainly engaged ᵢ some occupations, such as agriculture, dairy, and cotton picking and spinning. Women ᵢlaced their capital in loans, real estate, and occasionally the purchase of livestock.

From the records of the estates of eight women who died in Gaza, it appears that the ᵢchest among them, Zaynab al-Ramly, who apparently was not married, had an estate of ᵣ3,267 piasters; of this, 9352 represented the value of her jewelry and the coins she ᵥwned; 16,000 was a loan made to a single person; and 5000 her share in real estate. This ᵢves a total of 30,352 piasters, the balance consisting of household and personal goods. ᴉer debtor was Ahmad 'Auda, about whom we know nothing else; she had two manumit- ᵊd female slaves to whom she bequeathed some money, al-Hajja Halima and Mahbuba.

Moneylending by the people of Gaza took place beyond the limits of their town; ᵃrmers borrowed from them, but the reverse seldom occurred. This shows that capital lowed from the town to the countryside and that the latter was dependent on the former; it ᵢlso shows that the wealth of Gaza grew by the exploitation of the countryside. Loans ᵥere made to a whole village, or to a group within it. In addition to lending money, the ᴉhabitants of Gaza invested part of their capital in agriculture, or in raising livestock in he countryside.

The records describe debts as *shar'i* (legal); they were recorded in deeds. If neces- ₃ary, the validity of such deeds was attested by witnesses and the use of oaths. Sometimes ᵢ pledge was given for repayment of the loan, e.g., jewelry or real estate. Sometimes a hird person stood as guarantor for repayment. Loans were not always made in cash; ₃ometimes they took the form of the value of crops or livestock as other objects to be paid ᵥy a person or group, especially in the countryside. Such loans were regarded as ₃har'i. . . .

Repayment was specified for a given initial or deferred date, such as the first of the ɱonth, or a date within the month, determined by the appearance of the new moon of the ₃pecified month; this required witnesses who had seen the new moon. If a person failed to ᵣepay his debt and was proved to be indigent, the debt was stretched out in installments or ᵣeduced. Of course, if the debtor owned any real estate, it would be sold to meet the debt. ᴉn such cases resort was sometimes made to a method resembling mortgage or interest. The buyer of the piece of real estate would promise the seller, who had received its price, that if he came up with an equal sum within a specified period he could repurchase the property. In such cases the seller would authorize the buyer to enjoy the use of the property—whether to live in it, rent it, or take its produce—as long as payment remained due to him. Of course, such use is a form of interest. Such sales were known as ᵎ'*bay' wa'd bi al-ibaha*''. . . .

12

Tax Revenue of Damascus, 1882–1885

(in 0,000 piastres)[a]

	1300 (1882/83)	1301 (1883/84)	1302 (1884/85)	1303 (1885/86
Land tax (vergo)	1,131	1,267	1,320	1,514
Profession tax (Tamattuʿ)	284	277	232	320
Military exemption	168	177	165	164
Tax on sheep	90	126	158	96
Tax on camels	32	66	40	3
Farmed-out tithes	408	317	146	973
Dues on mines	NA[b]	NA	NA	NA
Rents	8	8	9	1
Sundry dues	2	0	1	4
Sundry revenues	6	6	6	4
Total	2,128	3,244[c]	2,073	3,075

[a]"Millions" in original.—ED.

[b]Not available.

[c]*sic*—Read 2,244.

From Dispatch to Minister of Foreign Affairs, 29 October 1889, CC Damas, vol. 6, 1878–1889.

13

Budget of Damascus, 1895–1896

I have the honour to transmit herewith the budget of the Vilayet of Damascus for the year 1895–1896. It will be observed that among the expenditure items that of "intérêts" has been suppressed while the item of "dépenses locales, traitements" has been divided into two. As I foreshadowed in my despatch No-22 of the 11th October 1893 the expenditure on account of salaries has increased since that date by some £3000, the expenses of the Sanjak of Maan being principally borne by the Damascus treasury, though the local government of the Sanjak has managed to collect a certain sum in taxes which partially defrays its expenditure.

It appears from the statement inclosed that there is a deficit of £60,000, but I am informed that actually the deficit amounts to £100,000 as the receipts are exaggerated and some items on the expenditure side are suppressed. At the present time the Vilayet is indebted to the Ottoman Bank to the amount of £29,000 and the instalments which have

From Eyres to Currie, February 1896, FO 195/1940.

446

allen due have not been paid for the last five months. The salaries of nearly all the officials are four months in arrear, and £15,000 is due to the contractors who furnish the troops with supplies. In addition to this the sum set down under the heading of "Guerre" has not been paid in full, though great efforts have been made since the beginning of October with the result that £50,000 have been handed over to the military chest.

The Defterdar now is engaged in forming a reserve for the Hadj, the incubus that weighs so heavily on the finances of this province.

The extra expense entailed on the Army chest by the Hauran expedition does not appear in the budget.

It is clear from the above that the financial position is desperate, and only a few days ago the Vali telegraphed to the Sublime Porte that he was in immediate need of £140,000, but His Excellency received an evasive reply.

The Defterdar resigned three times and at length his resignation was accepted and his successor has arrived.

Revenus du Vilayet	£E.	Observations
Impôt Foncier (Verghui) [Land Tax]	97,300	
Patente	10,000	
Exonération militaire des Chrétiens [Military Exemption]	12,700	
Moutons [Sheep]	49,100	
Dîmes [Tithes]	104,500	
Mines et forêts [Mines and Forests]	900	
Tapou et transferts [Tapu and Transfers]	6,370	
Revenus des propriétés de l'État [Revenue of State Property]	900	
Revenus des Tribunaux [Revenue of Law Courts]	3,700	
Divers [Sundry]	6,370	
Total	291,840	

Dépenses du Vilayet	£E.	
Magistrature (Cheri, Adlié) [Law Courts]	11,700	
Dépenses locales, traitement [local salaries]	36,400	
Traitements Spéciaux [Special salaries, pensions]	9,100	"Intérêts" are suppressed, some hav-
Liste Civile [Civil List]	3,700	ing been paid.
Guerre [Armed Forces]	163,640	
Gendarmerie	40,900	
Police	3,640	
Service	900	
Havalés [Transfers]	82,000	
	351,980	

14

Budget of Aleppo, 1902

The recent publication of an official Almanac containing a statement of the Budget of thi Vilayet for the last year induces me to submit a few remarks to your Excellency upon th financial situation. A very brief examination of this statement shows that it is utterl untrustworthy, that it resembles too nearly those published in former years to leave a doubt that its figures are improbable, if not purely imaginary. I have therefore sough elsewhere for reliable figures, from the officials of the Ottoman Bank and Public Debt an others, with the result that although I am left in doubt as what figure the revenue should b stated, I find there is a consensus of opinion that it is steadily falling off and that while thi is the case, the Vilayet has been so drained by incessant demands from the Ministry o Finance as to leave nothing to meet the barest local needs. In former times Aleppo wa one of the few Vilayets which yielded a surplus and was allowed to make use of it for loca improvements but since Raif Pacha left, the Vilayet has been given over to officia plunder. The Vali is a cypher, the local land-owners are unscrupulous brigands enjoying the title of Pasha, who are in league with the Subgovernor and Defterdar to defraud th revenue, especially in eluding the payment of tithe; the Defterdar takes bribes openly bu has the support of the Minister of Finance whose every demand he complies with. Th nearest estimate of Revenue I am able to give is shown in Table 14.1, and of expenditur in Table 14.2.

I have here only quoted the items which are published in the official budget. The Revenue from Posts Telegraphs and Customs is not shown nor that derived from the Stamp Tax fo the maintenance of the refugees. In no case, however, do the figures quoted represen anything like the average annual Revenue. The Sheep Tax, for instance, averages from £70,000 to £80,000, the excess shown in Table 14.1 arising from the collection of arrears. This tax is nominally reserved for the payment of the Russian War Indemnity of which Aleppo is called upon to pay £T. 40000 annually, although, apparently, it paid half as much again last year.

The collection of the Military Exemption tax is left to the Superintendence of the Head and Council of each Millet or Sect. The Vilayet forwards a notice to the Bishop that so much is due from his community and must be collected or entail heavy penalties. The incidence of the tax which is supposed to fall most heavily on those best able to pay, gives rise to constant complaint, and the Consulates are often asked to intervene.

Turning to the expenditure I have to point out that the charge of military Account

Table 14.1

Property and income tax £T.	Military exemption tax £T.	Tithes £T.	Sheep tax £T.	Sundries £T.	Turkish liras total £T.
102,000	20,000	135,000	102,000	43,000	402,000

From Barnham to O'Conor, 10 January 1902, FO 195/2115.

Table 14.2

Civil service account £T.	Military account £T.	Gendarme and police £T.	Russian war indemnity £T.	Salaries of exiles £T.	Havalés £T.	Sent to Ministry of Finance £T.	Sundries £T.	Turkish liras total £T.
75,000	136,000	20,000	60,000	15,000	20,000	40,000	36,000	402,000

includes £T. 36,000 paid to the Contractor for rations to about 7500 men and £T. 70,000 paid in salaries to the Military Staff. The amount paid to the troops was probably not more than £T. 2800—a dole of a medjidie per man twice in the year.

The large sum of £T. 15,000 was paid away in salaries to the numerous Pashas who live here in exile. The fact appeals to one's imagination, and suggests the very large number of those persons who must be living in the other towns of the Interior. The havale's were chiefly paid on naval account. The large sum of £T. 40,000 was sent [to Constantinople] in answer to repeated demands from the Ministry of Finance and was probably absorbed in Palace expenses. Here again one may well conjecture how much was sent by other Vilayets, and what a colossal amount of good money has been wasted.

A sum of £T. 20,000 has been assigned to the maintenance of the Cretan refugees, though probably not more than one half is expended upon them. Villages, neat and substantial, have been constructed for them in the plain of Alexandretta and in the neighbourhood of Antioch and Suedia.

I have referred at the commencement of this dispatch to the opinion generally held that the finances of the Vilayet are now in a bad way. Especially I would draw attention to the shameful abuses which prevail in connection with the tithe administration, and would strongly recommend that this branch of Revenue should be taken out of the hands of the local authorities, and handed over to the Administration of the Public Debt, which I understand, has taken it over with marked success in other Vilayets.

15

Revenues and Tithes of Iraqi Provinces, 1839–1911[a]

Year	Baghdad	Basra	Mosul	Source
1828	12*			Chapter II, selection 28
1839–1841 (average)	22.5–25.0			FO 195/334
1843/44	20.1	0.4		CC Baghdad, vol. 10
1845	23.3	0.3	11.3	CC Baghdad, vol. 10; FO 195/228
			(1.7)[b]	
1849	35.0			FO 195/334
1862			(3.1)	FO 195/752
1863			(3.8)	Ibid.
1889		19.3	16.2[c]	Cuinet, *Turquie*, vol. 3, p. 253;
		(13.6)	(4.3)	D.S. 1307
1890/91	24.6		22.5	Ibid., p. 85
	(13.7)		(6.8)	Ibid., vol. 2, p. 805
1892/93[d]	24.1	21.5	23.0	FO 195/1842
	(13.0)	(13.8)	(8.5)	
1893/94[d]	22.2	27.4	19.3	FO 195/1885
	(11.4)	(13.2)	(4.8)	
1894/95[d]	23.0	18.0	17.4	FO 424/191; CC Mossoul, vol. 2
			(4.5)	
1895/96[d]	23.3	22.1		FO 195/1885
	(11.3)	(9.2)		
1896/97[d]	25.9	24.2	19.3	FO 195/1885
	(13.3)		(4.8)	FO 195/1978
1897/98[d]	27.2	28.7		FO 195/2020
	(17.2)	(14.0)		
1898/99[d]	25.3			FO 195/2055
1899/1900	25.4			FO 195/2096
1901/02[d]	24.8			FO 195/2188
1902/03[d]	21.3			Ibid.
1903/04	25.7			Ibid.
1904/05[d]	22.0			Ibid.
1905/06	23.1[d]	17.5		FO 195/2214, FO 195/2215
1907/08	24.1			FO 195/2308
	(14.3)			
1909/10	(18.3)[e]	(14.8)[e]	(11.9)[e]	Eldem, *Osmanli*, p. 272
1911/12[f]	(21.1)[f]	(19.4)[f]	(14.1)[f]	Ibid.

*After deduction of expenses.

[a]Million piasters.

[b]*ushr*, in parentheses.

[c]Date uncertain.

[d]Sterling converted at 110 piasters.

[e]Estimated: one-eighth of value of crops assessed for tithe as given by Eldem.

[f]Total revenue in FY 1911/12 for the three provinces was £1,653,000, or, at 110 piasters to the pound, 181.8 million piasters; tithes amounted to £527,000, or 58 million piasters (breakdown in *EHME*, p. 186).

Note: Revenues of Baghdad from 1890 on do not include customs duties, which averaged slightly over £100,000, or 11 million piasters, a year.

16

Revenues and Economic Conditions in Mosul, 1845

I have the honor to transmit herewith to your Excellency, a List of Revenues of this Pashalik; such statistics are difficult to procure, and the present statement is at best but an approximation, perhaps a little underrated.

This Document is not so complete as I could have wished, for besides the items enumerated there are many small sources, such as "Yol Teskeres" (Road Passes), from which in the aggregate, Pashas derive considerable emolument, but the probable amount I have not been able to elicit.

Under the head of "Custom House" I have used the terms Import and Export, these merely apply to the entry into or exit from the Town of the Produce or Manufactures of this Province. Foreign Goods, and those from other Pashaliks, are almost invariably provided with Teskeres exempting them from further duty, and Exports to Europe pay according to the Tarifs. Goods manufactured in the Town pay on exit, both the Import and Export tax, amounting from 13 to 18 percent, according whether ad valorem or fixed sums.

With the exceptions of Salt and Grain, every article even though subject to a Mookataa (Monopoly or Farmed Tax) pays in addition these entry and exit dues, and even wheat, when leaving the Pashalik, pays an arbitrary tax at the discretion of the Pasha.

The Pasha can place a "Mookataa" on any Article or Trade, and in the latter case should the Esnafs [guilds] object to work, he can force them to do so, and pay him the amount he demands. Such is the case with the Printers and Dyers in Red.

There can be little doubt but that the Dyeing and Printing "Mookataa" restrict the consumption of British goods, for instance the enhanced prices of the Indigo used by the Dyers, and the Calicoes, Tanjibs etc. by the Printers; during the processes which fit them for the use of the people, place them beyond the means of a considerable number of the poorer classes. If they are hurtful to our interests they are equally so to the Natives, for the Trade has gradually dwindled away; and now the importation of our cottons printed at Aleppo at cheaper rates, must soon stop this once extensive branch of Moossul industry and will be a blow to the cotton growers and spinners.

Amongst other exactions not enumerated is the Tax on Laden Camels leaving the Town, omitted from its being an arbitrary impost varying each year, and of which the amount depends upon the fluctuating quantities of goods exported. This year the Cameleers are to pay per load "Kalbiti Jemal" p 20—"Badj" p 5—"Kerven Kiayah" p 2—"Sheikiyah" p 10—Gate p 2 and "Moobashir" p 2 together p 41, which must come out of the purse of the merchant sending the goods, and supposing the load of 20 Maunds to be Wool or Galls worth about p 350 and p 500, this addition to a carriage to the Sea Coast of p 175, amounts to $11\frac{3}{4}$ and $8\frac{1}{4}$ percent. The Duty alone of 9 and 3 percent is already too heavy, and almost prevents the exportation of these articles to Europe.

Besides the Tax on counting the Sheep as they cross the Tigris on their way to the

From Rassam to Canning, 27 April 1845, FO 195/228.

mountain pastures in summer, and on their return in autumn, every Flock whether small or large, gives to the "Ashair Aghasy" (Chief of the Tribes), and officer appointed by the Pasha to collect the Tax, one Sheep, and as much Butter etc as he may require, besides presents, indeed the Post is considered very lucrative.

The "Mookataas" of "Dyeing Blue," Rafts, and the toll on the Bridge, are the rights of individuals, granted by Firmans from some of the Sultans. Mohammed Pasha who was the first to usurp them, paid the owners annually p 5 or 6000 each, but lately they have received nothing at all.

The "Salian" of the Town is levied only on the Esnafs, thus the richer classes who do not trade are wholly exempt, and the whole brunt is borne by the working population already crushed by the heavy imposition that fall upon them.

Land is held by five Tenures called Milk, Melkiana, Vakouf, Timar, and Mahloula.

Milk—is the absolute right to the land itself with power to sell—and the Proprietors pay nothing to Government. The land on which houses stand, or Orchards, may be "Milk," but with the exception of three Villages with their fields, granted from Mecca in ancient times, no Corn land is "milk."

Melkiana—is only a life tenure charged with a rent, but the holder can during his life time bestow it on another, by which means it passes from Father to Son—should however the occupant die before transferring it, it reverts to the Sultan—though as every Melkiana has its fixed price, the next of Kin by paying it, can regain the land in preference to all others.

Vakouf—Either the absolute property of the Mosques, or held by individuals at a nominal rent—neither give anything to the Government. The first kind cannot be alienated, the second may be sold, provided other property, no matter how low the value, be substituted and charged with the same rent.

Timars—Bestowed for Military Service, and pays a trifling rent in token of its being held at the pleasure of the Sultan.

Mahloula—Without Proprietor. Anyone finding it waste may settle on it, by paying one tenth of the Produce to Government, nor can he be dispossessed so long as he continues to till it.

The Farmers on these various lands pay to the Proprietors from 10 to 13 percent of the Produce, according to old established usage in different villages. On Government land one-half is frequently taken by the Pasha, and that half taken in money at an exorbitant valuation. The Agriculturist is bound to the soil, and cannot leave his village, and at the same time can only be removed by the owner wishing himself to cultivate the land, or by the Farmer neglecting to do so—only the "Mahloula" may be left at pleasure, which is frequently done when the Pasha presses too hard.

The Farmers are also obliged to furnish the Pasha with any quantity of "Zahirah" or produce which he may require, and which he can demand whenever and as often as he pleases. Thus the quantity depends entirely on the moderation or avarice of the ruling Vezir. This alone must prevent all improvement and is a sufficient explanation why so large a proportion of the land remains a desert. Unfortunately this principle is based on the provisions of the Koran etc. with regard to land, and will be difficult to alter, so long as it continues no one will raise more than his necessities oblige.

The enclosed statement is no criterion to judge what the people actually pay, for besides what comes to the Pasha, are the heavy "Khizmets" of the collectors, and the petty governors scattered over the country have a host of little exactions of their own.

I endeavored to obtain the amount of the Population of the whole Pashalik, but only ucceeded in getting that of the immediate District of Moossul as per enclosed List.

Before the arrival of Mohammed the first Turkish Pasha, Moossul was the seat of an ctive Trade, inhabited by opulent merchants, who one by one deserted their native city, nd established themselves at Baghdad, Aleppo, and Diarbekir. Now most of the Khans re in ruins, and whole streets of stone shops untenanted, in every direction may be seen allen houses; formerly the Town was not large enough to contain its inhabitants, and quarters were built outside the gates, now it has shrunk from its walls, and green Barley to graze horses, is grown where in spite of the plough the foundations of houses are still discernible, and this is an increasing evil, wholly attributable to Turkish misrule, for there s no good reason why so fertile a country processing exportable Produce to pay for what s imported from Europe, should not prosper. Even granting that European Manufactures aave injured the native weavers, the effect would have been little else than diverting their exertion to other channels. As with the town so are the villages, the same misery, the same uin is everywhere perceptible, and this retrogression must continue, until security is issured to both Trader and Peasant, and until a moderate Taxation is made to bear fairly apon all classes. . . .

Approximated Amount of the Revenues of the Pasha of Moossul:

Duties

(Taken directly by the Pasha), viz:

Custom House, yields on an average on Imports 10% and
 Exports 3%, on many articles a fixed duty is laid
 equivalent to 18%, as will be seen hereafter. p 700,000

Sheep counting levied twice a year, each time p $1\frac{1}{4}$ per
 head—say p $2\frac{1}{2}$ on a value of p 21 = 12%. p 400,000

Irrigation Buckets, worked by one horse, for drawing water
 from the ditches to the level of the gardens, each p 250 p 25,000
 (Farmed to the highest bidder)

Damgah, or General Stamp
 The city of Moossul p 130,000
 5% on exports, on some articles a fixed duty equal to
 10% and on sales by Auction 5%
 The Villages of Moossul 12,000 142,000
 5% on Native calico

Wheat 100,000
 p $2\frac{1}{2}$ on the Camel load on entry
 p 4 on the Camel load on sale
 p $6\frac{1}{2}$ on a value of p 50 = 13%

Tobacco 20,000
 Besides p $2\frac{1}{2}$ per Batman of about p 14
 = 18% paid to Custom House, p $1\frac{1}{4}$ is taken
 = 9%

Sheep Skins 8,000
 4 paras on each worth p 4. = $2\frac{1}{2}$%

Wool 60,000
 4 paras on every Fleece worth p $2\frac{1}{4}$ = $4\frac{1}{2}$%

Precious Metals 18,000
 $2\frac{1}{2}$% on sale of worked metal

Copper	18,000
2½% on sale of worked metal	
Sale of Animals	30,000
2½% from both buyer and seller = 5%	
Auction	14,000
Besides the 5% to the Damgah, 2½% on sales	
Cotton Yarn	p 20,000
Spun in the Town p ¾ per oke of p 10 at 15.	
an average of 6½%	
Gardens	40,000
p 200 on ground worked by five men	
Irrigation Ditches cut from the river to water Cotton,	
Millet, gardens, etc	
The cultivator makes the best bargain he can with the	
Monopolist.	15,000
Slaughter House	85,000
on Sheep p 1. Cows p 7½ Camels p 15.	
Buffaloes p 40. = 1 to 5%	
Calico glazing, 5%	1,000
Toll on the Bridge	45,000
p 1 on each load entering or leaving	
on Timber p 2 on value of p 30 = 7%	
and on Firewood p ¼ value p 4 = 1½%	

Total of Duties	p 1,741,000

Perquisites of the Pasha

"Mouharremieh", at new year	p 65,000
Borne by the Rayahs and a few Mohammedan Esnafs	
Dahyak	
10% on all litigated suits	
Jerrems or fines:	850,000
Khelats or dresses of investiture	
charged to the receiver in the proportion	
of p 500 to real value of p 30 = 1,550%	
Attacking Arabs	p 800,000
sales of plunder taken from refractory Tribes.	

Total Perquisited	p 1,715,000

Contributions

Salian	p 1,120,000
Haradj	280,000
levied on the Districts of Moossul, Mardin, Jezirah, the	
mountains, and in the Baghdad territory of Arbeel and	
Kerkook—only one-third is demanded by the Porte, the	
other two-thirds being added by the Pasha. It is divided	
into three classes—the 1st pay p 62½, 2nd p 32½, and 3d	
p 18.	
Total	

	p 1,400,000

Tithes on Produce

Grain,	25,000 Taghars	at p 50	p 1,250,000
Cotton,	25,000 Batmans	at p 8	200,000
Rice,	10,000 "	at p 8	80,000
Sesame,	4,500 "	at p 10	45,000
Raisins,	20,000 Batmans	p 4	80,000
Tobacco,	2,000 "	at p 15	30,000
			p 1,685,000

Monopolies

Indigo dyeing

City of Moossul	p 105,000	
Villages of Moossul	85,000	
District of Nafkir	7,000	
District of Edhok	2,000	p 199,000

The Monopolist buys the oke of Indi-
go at p 100 and dyes with it for
p 500. a difference of 500%,
and yet can gain but little.

Calico Printing and Red Dyeing 30,000

This includes their Salian. The native
Calico first pays 5%; if dyed
Blue, the Printer loses 100% on
his Indigo, deducted by the Indi-
go Dyers, and it then pays 5%—
and then the 10% Import and
3% Export.

Publick Weighing 12,000

charge 1 para on the Batman; about
18 paras the Mule load, and 22
the Camel.

Presses for Sesame Oil 44,000

Six in the City of Moossul, and
Three in the Villages. This Mo-
nopoly raises the cost of the Oil
from p 25 to 30 and 36 per
Batman, say an average of 30
percent.

Mill Stones 2,000

Rafts 60,000

Freight on Manufactures etc. p 90 per
Cantar, on low goods such as
Fruit p 60—were the construc-
tion of Rafts free, goods might
be carried for p 25—a difference
of 360% and 240%.

Ferry

At Moossul when the stream is too		
strong for the Bridge of Boats	p 13,000	
At Wana, eight hours up the river	24,000	
At the Zab	12,000	49,000
Salt		35,000

The Monopolist purchases the oke at
5 paras and retails it at 20 to 30
enhancing the cost 400 to 600%.
Tallow Candles 10,000
The real value of the Batman is p 18,
whereas it is sold at p 27 = 50%

<div align="right">

total Monopolies p 432,000

</div>

<div align="center">

Summary

</div>

Duties	p 1,741,000.
Perquisites of the Pasha	1,715,000.
Salian and Haradj	1,400,000.
Tithes on Produce	1,685,000.
Monopolies	432,000.
District of Moossul	p 6,973,000.

<div align="center">

Pashalik of Moossul

</div>

Moossul	p 6,973,000.
Mardin	1,450,000.
Jezirah	860,000.
Badinan	750,000.
Zakho	300,000.
Telaffer	300,000.
Amadiah and Davudiah	300,000.
Acra	275,000.
Sinjar	100,000.
Total Revenue of the Pasha	p 11,308,000.

<div align="center">

Population of the District of Moossul

</div>

City of Moossul	Mahaleh	Houses	Adult males
Mohammedans	31	5,143	11,245
Christians	14	924	2,566
Jews	1	172	577
Total	46	6,239	14,388

Villages of Moossul	Villages	Houses	Adult males
Mohammedans	298	5,102	8,486
Rayahs	17	1,454	3,821
Total	315	6,556	12,307

17

Attempt to Control the Price of Grain in Baghdad, 1848

Translation of a letter from H. E. Nejib Pasha to the address of Major H. C. Rawlinson, H.M.'s Consul at Baghdad—Dated 13th Jemaz il Akhir 1264 (16 May 1848)

As the harvest this year promises to be abundant, and the time of reaping the crops is now close at hand, it might have been presumed that the market price of corn would lower from day to day—but such is not the case—within the last few days the price of corn has enormously advanced, owing as it would appear, to the capitalists, who succeeded last year in obtaining a monopoly of the market, having again come forward to buy up all the available grain.

The inhabitants of the town having in consequence addressed petitions to me representing their distressed condition, and the matter having been submitted by me to the Council, I have been advised to adopt measures which shall prevent the market from thus falling into the hands of monopolists and shall provide for the corn of the province being rendered available to the daily wants of the population. The measures which I have judged expedient for meeting this end and which I have accordingly ordered to be carried into execution are as follows:

1stly. The corn imported into Baghdad is to be taken directly to the corn market, and there disposed of, all other sales being prohibited.

2ndly. The authorities in the districts will take especial care that purchases are not made by any single party to a larger extent than 5 Taghars.

3rdly. Should this regulation be infringed the parties so purchasing will, after this notification, be compelled to dispose of their grain at a rate as low as may be.

In order that these regulations of the Govt of Baghdad for the relief of the suffering population may be duly respected, I have the honor hereby to give you official notice of the same, and request the favor of your promulgating the orders to the British merchants of the place and other parties enjoying your protection. . . .

Comment on Preceding Decree

(Rawlinson to Canning, 20 May 1848, FO 195/318)

. . . Your Excellency will observe, that Nejib Pasha proposes to meet the views of the inhabitants of Baghdad, who have petitioned for relief against the famine prices that have lately ruled in the corn market, by checking the further importation of grain into the city, except in small quantities, and by forced conditions of sale. His Excellency, you will see, affects to ascribe the existing pressure to the speculations of the corn dealers, and takes it for granted, that measures directed against monopoly will be remedial to the community.

Now to give His Excellency credit for good intentions in issuing these orders will be to convict him of ignorance of the first rudiments of civil Government; while if we suppose him cognizant of the natural consequences of the course he has adopted, some

From FO 195/318.

very strong motive of self-interest will alone explain his thus venturing to tamper with the comfort, I may almost say with the lives of the poorer classes of our thickly populated city.

To ascertain in which light His Excellency's conduct is to be viewed, I have taken some pains to trace the origin of the present scarcity in Baghdad and I trust Your Excellency will permit me, not only to state the result of these enquiries, but to draw from them their legitimate inference as to the meaning of the orders now under discussion.

The harvest, then, of last year, owing to an extraordinary drought, failed generally throughout the Pashalic. Hardly a fifth part of the usual cereal produce was realized, and the price of grain accordingly rose prodigiously in every quarter. The Government receiving a considerable portion of its revenues in corn, had always the means of affording relief by opening the public granaries—but in no instance was this course adopted—on the contrary the Government stores in the districts were hoarded on the pretext of the requirements of the troops, while at the same time very large speculations were entered into between the principal corn dealers of the city and Nejib Pasha's officers, so as to give the parties thus associated for a considerable period an absolute monopoly of the market, their interests being further supported by the issue of restrictive orders (very similar in spirit to those now promulgated and affecting the same philanthropic object) which, remaining inoperative in regard to the dealers in partnership with the Governor, effectually silenced all competitors. The most enormous profits were realized by the first speculation. Further gains accrued from the command retained over the market by the public stores being exclusively disposed of in small quantities by the favored dealers, and while Nejib Pasha never ceased ostensibly to condemn monopoly, the distress in consequence became so general, that the Consul General of France thought himself called upon, in the interests of humanity, to expose and denounce the whole proceeding, and even I believe to press the abuse on the notice of the French Embassy at Constantinople. As I was not invited to cooperate in the protest and imitation might have compromised my independent position, I did not think it necessary on that occasion to take an active part against the Government, but I entirely approved of the views and measures adopted by my colleague—and as I think I now perceive a design of reviving and perhaps extending the old abuse, I feel it my duty thus early to draw Your Excellency's attention to the subject.

The scarcity at present felt, is, in reality, partly owing to the effect of Nejib Pasha's former measures which have greatly reduced the numbers of the Baghdad corn dealers, and partly to the real exhaustion of the country at the close of a year, during which the supply has never nearly equalled the demand, and before the new crops can be made available. Relief might be afforded by throwing open the Government stores, which still contain a considerable quantity of last year's grain, and which cannot possibly be now required for the public service—or if matters were left to themselves, in the face of an immediately approaching harvest of singular abundance, the distress could not be other than temporary. The mere fact of issuing remedial orders at such a moment, is thus calculated to excite mistrust and when we come to examine these orders, the premises on which they rest are so manifestly opposed to truth—and the effects which it is proposed to derive from them, are so entirely irrational and contrary to the natural course of events, that no reasonable person can doubt the whole affair being a juggle, designed to cover some corrupt intention.

I will now briefly state to Your Excellency what I consider to be the true object of Nejib Pasha's interference with the state of the market. Owing to the extreme stringency with which the lessees of the Government farms were at the last harvest required to make

good their contracts, a stringency which threw a very large proportion of the capitalists of Baghdad into insolvency, and which deterred the remainder from again engaging in speculation, the agricultural districts have remained during the present year almost universally in the hands of the Government, and the crops promising favorably, it is feared the price of grain will necessarily fall, and that the Government share of produce instead of realizing 40,000 may thus bring in no more than 20,000 Purses—Nejib Pasha according-y, as I verily believe, wishes to excite the panic that he affects to deprecate.

By restricting to a limit of 5 Taghars the quantity of grain to be purchased by any single individual, by arbitrarily prohibiting the amassing of corn by any of the parties engaged in the trade, and by holding out the threat of a compulsory sale, he can only aim, I think, at driving the few remaining independent corn dealers out of the market—and thus retaining in his own hands the entire supply of the city, the prices at the same time being kept far above their natural rates, by his permitting no more corn to be brought in, than will suffice for current consumption, or possibly by suspending occasionally all importation. That infinite distress may be expected to ensue, unless His Excellency's restrictive measures are overruled by the central Government, I need not press on Your Excellency's attention. It is of more importance that I should cite the abuse which I have thus exposed, as one of the necessary evils of Nejib Pasha's having been granted a farm of the Government of Baghdad, an arrangement which he considers to absolve him from all control, which in fact makes him an irresponsible agent, and leaves him at liberty to defer all other considerations to the one sole object of filling his Treasury, reckless of the present welfare of the many millions of His Highness' subjects committed to his care, and indifferent to those difficulties of finance and legislation which he will bequeath to his successor in the Government.

P.S. Since writing the above despatch, I have received a letter from certain merchants of this place, protesting against Nejib Pasha's restrictions on the corn trade of Baghdad. . . .

18

Monopolies, Taxes, and Extortion in Baghdad, 1848

. . . And even now in the vicinity of Baghdad they are alone permitted to sell their grain to certain Jew capitalists who have been associated with Ahmed Beg, His Excellency's son, for the purpose of buying up all the available corn of the country, to the exclusion of all other parties.

The British trader to make any purchases of grain is obliged to send to a distance of 100 miles, and wheat and barley continue to command almost famine prices in the city although there is a plethora of grain in the districts. At the lowest calculation it is supposed

From Rawlinson to Malmesbury, 28 May 1848, FO 195/318.

that Nejib Pasha will gain £100,000 by his arbitrary restrictions on the corn trade, but this profit of course can be only realized at the expence of the consumers. . . .

Any return moreover, however authentic and elaborate, would convey but a very imperfect idea of the real pressure upon the laboring classes and the consumers, as the realization of every item of revenue is in the hands of contractors, who are permitted to put in practise all conceivable means of extortion, even to the infliction of personal torture, provided they fulfill their pecuniary obligations to the Government. The trade in corn since the last harvest has been a monopoly in the hands of the Government and the price to the consumer accordingly has been more than double that which was warranted by the abundant resources of the country. On animal food and fruit and vegetables the duties under a variety of denominations amount to an average of about 50 percent ad valorem, and dates, which to the Arab population constitute the real necessary of life, are hardly less extravagantly taxed. All the internal trades to which the wants of the community give extension or importance, are reserved as monopolies and farmed out to the highest bidder—among these monopolies I may instance the manufacture of soap; of spirits and of leather, the dyeing and printing of cloths, the cleaning of cotton, the storing and weighing of rice and grain, porterage, brokerage, etc., etc., etc. The transit duties also are enormous. On hides, wool, sheep skins, gallnuts, etc. the charges amount sometimes to 30 percent ad valorem before the goods reach the gates of Baghdad, and a further duty of 12 percent is levied on entrance into the town. New taxes too are being constantly added. Stamps are required for all public papers, whether bonds, acquittances, agreements, or even petitions. The Passport fees press heavily on the poorer classes and the exorbitant charges on conveyance of property, on the realization of money, on the mere passing of contracts, deter the rich from making any use of their capital. According to data which I have collected from various quarters and which furnish at any rate the means of approximately estimating the result of Nejib Pasha's financial operations during the last year, I find that His Excellency, who was granted a farm of the Baghdad Pashalic at the assumed gross annual valuation of 60,000 purses (£300,000) has raised, by ostensible means alone, above 120,000 purses (£600,000); and at the most moderate calculation for his extraordinary profits, those I mean which have accrued from his grain monopoly, from his Raziehs [raids] on the Arabs, from confiscations, fines, presents and above all from direct bribes, I should be disposed to assess the entire proceeds of his Government at not less than one million sterling—and when your Excellency considers that during the interval in question no single fresh source of legitimate revenue has been opened; that there has been no territorial acquisition; no barren lands reclaimed from the desert; no increased trade; or improved cultivation; no discovery of metallic treasure; no invention in manufactures, or extension of product; but that on the contrary every branch of agriculture, commerce, enterprise and industry has very essentially declined, you will understand that this immense sum, so entirely disproportioned to the present capabilities of the province, could not have been raised without entailing a terrible amount of individual suffering and without calling forth a general execration of the ruling power. . . .

19

Duties on Transport and Export of Grain, 1857

Note of the cost of 10 Taghars Barley forwarded from Hillah to Sookh es Shookh [Suq al-Shuyukh] with the duties paid thereon

10 Taghars Barley at 25 Ks	Cost	Ks 250

Duties paid on the same in transit

Hillah duty	Ks 30
Sheikh es Siffin at Hillah	1.4
Abdullah Pasha's people at Kuskushea	1.4
Diwanieh duty	17.10
Exacted by Customs' people	3.10
Samaweh duty	26.12
Exacted by Customs' people	2.
Aboo Tubr duty	31.10
Exacted by Customs' people	4.17
Koot duty	59.
Exacted by Customs' people	1.13

Kerans 179

or 71½%

[On transport to Basra for export the further additional duties were levied:

Garneh (Qurna) duty	4.10
Basra duty on boat	4.10
Basra duty	72

Grand Total 260 Kerans, or 104% of original cost]

No. 1 Note of the Purchase of 62½ Hillah Taghars of Wheat bought in the Neighbourhood of Hillah for exportation—

	Coms.
55½ Hillah Taghars bought at 75 com. per Tagh	4,162½
7 Hillah Taghars bought at 62 com. per Tagh	434
Comries	4,596½

No. 2 Note of the duties paid by us on the said Wheat until its arrival at Bassorah—

	Coms.		
		"	*"*
Duty paid at Hillah 62½ Tagh. at 6 coms.	375		
Paid to the Sheikh-es-Siffin at Hillah	7	12	30
Extorted by Abdullah Pasha's people at Kushkushiyeh	7	12	30
Reduced duty paid at Diwaniyeh	90	*"*	23

From Hector to Kemball, 26 March 1857, FO 195/577.

461

Extorted by Customs' people Diwaniyeh	23	"	"
Reduced duty paid at Semaweh	176	16	16
Extorted by Customs' people at Semaweh	13	1	17
Reduced duty paid at Aboo Tubr	209	"	"
Extorted by Customs' people at Tubr	32	7	28
Duty paid at Koot	392	2	"
Extorted by Customs' people at Koot	13	12	38
Duty paid at Takhta, Shamies 113 at p. 34 & 20	192	2	"
Extorted by Customs' people at Takhta	10	4	"
Gorna duty shamies 3¾	6	"	"
Jusheer in Bussorah 6 shamies	10	4	"
Taken in Aboo Tubr in addition to duty 10 Hillah Waznehs at 6 Coms.	60	"	"
Taken in Koot 10 Hillah Waznehs at 6 Coms.	60	"	"
Taken in Shook es Shookh 13 Kaylehs at the Sook price of 3 Coms. per Kayleh	39	"	"

or abt. 37½% on the Cost

	Coms.	1717	16	.22

No. 3 Note of the out turn of the said Wheat in Bassorah, in Bassorah Taghars and the internal duty demanded on same there—

85 Bassorah Taghs. valued at Shamies 70 per Taghar =	Shamies	5,950
9 percent duty on same =	Shamies	535½
deduct 16% allowed by the Tariff		85½
Shamies		450
or Comries		765

Memo: 30 Taghs. of above wheat were exported on which a duty of 3% or Shamies 52½ is leviable. This we offered to pay but the Customs Authorities declined receiving it pending the settlement of the question of the internal duties.

20

Tithes in Mosul Province, 1863

I have the honor to acquaint Your Excellency that the authorities of Moossul have terminated the sales of the Dime Tax of the whole of this Province which has realized as follows:

Sales of the Dime Tax of the villages round Moossul	2,435,735
" " of Talafer	207,500
" " of Duhak	55,000

From Rassam to Bulwer, 4 July 1863, FO 195/752.

"	"	of Sinjar	50,000
"	"	of Akra	453,000
"	"	of Dawoodia	126,000
"	"	of Mazoory	89,000
"	"	of Zakho	155,000
			3,571,235

The Sales of the Dime Tax of Amadiah have not yet been forwarded. Last year the "Dime Tax" brought to the Government an aggregate sum of Piastres 3,140,219. but the present year, the crops of wheat, barley and other grains are very prolific consequently the whole tithe of this province was sold for Piastres 3,571,235. which with Amadiah ought to realize 3,751,235.

This increase however must be in a great measure attributed to the vigilance and perseverance of Ranan Pasha who has the interests of his Government at heart. It is a long time since we have had such a Governor in Moossul, he is liked by all classes of the people and under his wise administration the inhabitants in the mountains and in the plains are well protected and the whole are enjoying the security of their property.

21

Abolition of Certain Monopolies, 1863

I have the honor to inform your Excellency that in the month of February last, His Excellency Namik Pasha, the Musheer of Irak, sent instructions to the authorities of Moossul to abolish certain Monopolies, as their rent would expire on the 12th of March, which is the first day of the new year in the Turkish Calendar.

This wise and benevolent step, gave great satisfaction to the people in general, and there is no doubt that the monetary loss to the treasury will be regained through another channel, as the labour will not be confined to a few, and the cultivation of Sesame, etc. will be vastly increased by possessors of land.

The following is a list of the Monopolies which have been abolished this year.

Indigo dying Establishment	p. 206,000
Pressing Oil from the Sesame seed	45,000
Making Candles	7,000
Making Sweet meats	3,100
Sale of Cotton Yarn	12,000
Sale of Fruits and the Steelyards	45,000
Making Catgut	400
	318,500

The following is a list of the Monopolies which the Government have not disposed of this year.

From Rassam to Bulwer, 11 April 1863, FO 195/752.

The Gold and Silver Stamp	p. 20,000
The General Stamp	50,000
The Slake lime	1,100
The Roasting of Coffee	13,500
The Horse Market	61,100
The Skins for Rafts	35,000
The Wheat Market	16,000
The Melons and Cucumber Gardens	30,000
The Slaughter House	81,500
Tithe on Vegetables	12,600
Garden buckets	8,000
Weighing by Steelyards	16,500
Tax on all production sold in the villages	80,000
Rent of Indigo Factory	45,500
	470,800

Last year the Government sold the Tax on the Counting of Sheep for p 766,000 with authority to the farmer to receive on each sheep p 1½, but this year the Government have lowered the rate to p 1 per Sheep, and are going to collect the tax on the part of the Government, that they may be able to know the real situation of the sheep within the province of Moossul

22

A Conservative and Nationalist Governor, 1866

. . . There is certainly nothing peculiar in the system of irrigation in the Province of Baghdad, save that, whereas the same supply of water [and] the same extent of arable land exist, as when, in ancient times, the country was reticulated by Canals, Cultivation is in the present day restricted to the Banks of Streams; and that irrigation, save in the low-lying districts of limited extent, is everywhere artificial and is practised by means of draught cattle only: Native Capital and enterprize are wanting nor, as experience testifies, could [they] be resuscitated under the existing Régime, to restore the old system of Canalization. The overflowing waters of the two Rivers, no longer restrained and regulated, have become agents of destruction, and the land, where it does not lie waste, is converted into scarcely more profitable marsh. But Namik Pasha openly avows his opinion that the surrounding desolation is preferable, in the sense of Turkish dominancy, to a prosperity which should have its source in European Agency; and though he be convinced by repeated failures of the impracticability of associating Turkish subjects alone on

From Kimball to Lyons, 26 December 1866, FO 195/803B.

speculations of Navigation, Trade or Agriculture[1]; nor can deny the salutary influence of a foreign element in supplying the one thing needful to growth and improvement viz. the confidence of the Governed in the good faith, probity and evenhandedness of their rulers.[2] Yet with characteristic tenacity His Excellency clings to the principle of exclusiveness that he has adopted for his guide, and points for its justification to the condition of Egypt as illustrating the predominance of European interests advancing hand in hand with material progress to the eventual extinction of Ottoman Supremacy. His Excellency apprehending justly that steam machinery could only be turned to profitable account in the hands of Europeans foresees that its employment by them must still be precarious unless they should acquire some sort of proprietary controul over the lands to be irrigated. It is herein he discovers the thin end of the wedge directed to subvert that fundamental law of the country which debars aliens from the purchase or tenure of land and under this conviction His Excellency is least disposed to favor English enterprize in a remote portion of the Empire where the foreign element is almost entirely restricted to ourselves and where referring to our position in India he betrays constantly his mistrust of our ultimate designs. In short, speaking generally, the manifest decadence of race and religion is ascribed by His Excellency not to inherent political weakness, or immobility, but to contact with a different form of civilization of which he does not, of course, argue the superiority from the effect; and his retrograde tendencies being the result of prepossessions or prejudices, intensely Ottoman and Mahomedan, He believes that the evil could now be stayed only as it should have been forestalled more notably in the case of the Capitulations by a course of Policy consisting in the rigid assertion of International rights. How far such a Policy as interpreted by His Excellency were practicable in the present day, it is not for me to discuss. I have ventured thus briefly to picture to your Lordship the workings of Namik Pasha's mind, as displayed in the freedom of private intercourse, on subjects which he is ever prone to discuss, in order to exemplify the only foundation that I can discover for the objections alleged by Aali Pasha to the measure under discussion. . . .

[1] His Excellency is at the present time engaged on a scheme for selling Crown Lands according to the Tapoo System and for encouraging the cultivation of waste lands under certain provided guarantees for the security of the proprietory rights of intending occupants. Public opinion encourages little hope of the success of this scheme.

[2] I may here instance the general suppression of the so-called River dues and the check given to the impressment of River Craft as being due solely to the urgency employed by H.M.'s Embassy in redressing the grievances resulting to British subjects.

23

Midhat Pasha's Land Tax Reforms, 1869–1872

. . . The amelioration of conditions through the development and organization of the affairs of Iraq was the first required measure. Therefore, after his return from Daghghara, Midhat Pasha gave precedence to this matter over all others. He issued a regulation

From Haidar Midhat, *Tabserei ibrat* (Istanbul, 1325) (1909), vol. 1, pp. 84–93.

handing over existing *miri* lands to their occupiers with title deeds (*tapu*), similar to state-owned lands. He attempted the execution [of this regulation] after presenting his remarks and resolutions on the matter to the Sublime Porte and obtaining an Imperial Rescrip (*irade*).

The summary of the detailed information is as follows. Because of the requirements of the natural disposition of their location, the lands of Iraq cannot be compared to those of Anatolia and Rumelia. Most of Iraqi lands are irrigated by rivers and canals. Even this cultivation entails many different methods as regards flow irrigation, waterlifts, and rain. Also, among those lands that are cultivated in various ways, some had been set up as *waqf*, while the revenue of other places was bound to certain parties under the name of *'uqr*. Because of this situation, the totality of the cultivated and uninhabited land was divided into various kinds and categories, according to their *muqata'at*, consisting of those lands that contained a river or a canal, and which paid from their produce a tax of one-third, one-half, or two-thirds to the state. These lands would have been too valuable to be handed over in accordance with the state land regulation of demanding only a tenth (*'ushr*) of their produce. Also, not everyone would have been capable of purchasing and paying the price in one payment. In order to facilitate business, various measures were taken. It was decided that two-tenths (i.e., 20 percent) should be taken from the produce of these lands. Yet, if the buyer gave, in addition to the required price, five years' worth of one-tenths (i.e. an amount equivalent to 10 percent of five years' produce), then the two-tenths he had to pay was to be lowered to one-tenth. Also [it was decided] that lands that had been left vacant for extended periods, thereby needing the reopening of rivers and water ditches, should be sold by auction. One-tenth was to be uniformly taken from the revenues of these lands. The title deeds of the lands watered by *kard* (i.e., a waterwheel), or lands watered by rainfall because of their location, were to be given permanently to those who had been cultivating them, on condition that no more than a tenth would be taken from them. It was also decided that places where cultivation of the land was reserved for its inhabitants, as in the *muqata'as* of Hindiyya and Amara, were to be separated in accordance with *dunum* and *jarib* measures.[1] They were then to be divided and distributed among the inhabitants in return for appropriate prices. During the first year, the adjudication of many places was made in accordance with this regulation.

During this year, an additional benefit of more than 100,000 *liras* accrued from the price of all the lands that were sold, distributed with a title deed (*tapu*), or adjudicated in this manner. Since the yearly state revenues had been lowered from 60 and 50 percent to the 10 and 20 percent level, it had been expected that this lowering would result in a proportional decrease in total revenues. Yet, on the contrary, total revenue did not decrease; the excess in the quantity of the produce amply made up for the deficiency. And in the following years, the good results of this activity and cash profits conceived for the state treasury started to emerge as the produce exceeded its former level. In addition to this, previously one could not see a single planted tree or any construction indicating some prosperity on the lands that were cultivated under the previous procedure in trust (*amanatan*) or at a fixed price. Yet, under the new procedure, the buyers of these sold lands were assured that, without any dispute, these lands were their own property. Therefore, they naturally started to improve their lands, and within one or two years signs such as buildings and trees indicating good conditions could be observed in most of these lands. The inhabitants, who had been heretofore worn out with conditions of poverty and

[1] That is, They were to be taxed according to area.—ED.

despair, and had been constantly weakened with revolts and rebellions, now personally and indirectly enjoyed the taste of land possession. Therefore, all the incidents and disturbances that used to follow one another every single year came to a full stop.

A striking proof of the state of affairs was the *muqata'a* of Hindiyya, one of the most important in Iraq. Although these *muqata'as* were previously adjudicated to their revenue farmers (*multazim*) at yearly fixed values of 8,000 or 10,000 purses of *akches,* these values could be obtained only once every three or four years [instead of once a year]. Moreover, most years the produce would rot away and lose its value due to the opposition and revolts of the inhabitants. Under 'Omar, 'Abdi, Rashid, and Namiq Pashas, all these revolts had also led to many financial losses incurred by sending soldiers against the inhabitants and much loss of lives. Midhat Pasha, in the second month of his arrival in Baghdad, personally went to Hindiyya to learn the real reasons [for these revolts]. The information he gathered was as follows: The crops of the above-mentioned inhabitants consisted of rice. Even though the seeds of the rice they cultivated were provided by them, 66 percent of their produce was taken away from them as the share belonging to the state. A large amount of the remainder of the produce was also retained for things such as the *mashayikh* fee, weighing fee, and the rent of the granary. The inhabitants were thus forced to revolt because, as a consequence of this unjust treatment, they had nothing left of the produce for themselves. It thus became clear that this situation was the source of all the incidents known as the "Hindiyya disturbances" in most years. Midhat Pasha immediately lowered the state's share to 50 percent and changed and abolished a number of fees and expenses. He also included in the rescript he gave those aforementioned inhabitants a promise that the state's share would be decreased the following year to 40 percent, and the year after that to 30, with further reductions in the future if these inhabitants showed good faith. Soon after this decision, the previously mentioned Daghghara incident occurred. There were more than 15,000 armed men in Hindiyya. It was anticipated that these men would provide the utmost assistance and support to the Daghghara rebels. Yet the inhabitants of Hindiyya remained steadily at their places and did not deviate from obedience. Moreover, they endeavored by consent to fulfill the state's share of the produce with utmost uprightness. That year, 6000 *taghars* (i.e., 6 million *qiyyes*) of rice were produced as the state's share. This amount was equivalent to the produce that had been obtained during the most prosperous years, when the previously applied 66 percent state's share had been collected in its entirety. According to the requirements of the promise mentioned above, even though the state's share was lowered to less than 50 percent the following year, the amount of the state revenue did not decrease. . . .

PARK, WATER MACHINES, PETROLEUM RESERVES, AND THE FIRST FACTORY

Among the many other activities of Midhat Pasha during this period, was the construction of a public park as a place of recreation by the municipality. The great bridge over the Tigris was also rebuilt. A factory was built for cleaning rice. As there were no fountains in the city of Baghdad, water for the basic necessities of the inhabitants was being transported from the Tigris River by water carriers. An easier way was found by placing steam-powered water pumps in numerous places. Attempts were made to benefit from the petroleum reserves in the vicinity of Mandali [see VI,11]. Pending the arrival of machinery that was to be imported from Europe, kerosene was distilled with locally obtained means and available tools. Since the circulation of this kerosene cost the municipality 70

paras per *qiyye*, it gradually replaced the customarily used olive oil at the markets, government offices, and other places. Hence, independence from American kerosene resulted, and every town was once more adorned with kerosene lanterns. . . .

24

Currency in Basra, 1892

. . . The currency in vogue at Bussorah, and throughout the vast district which is nominally included in the province of that name, is varied and complicated. The names and values alone of the different coins take some time to learn, while the rates of exchange are constantly varying. The standard coin is the Turkish pound ("lira") containing nominally 100 piastres, and worth approximately 18s. 2d. The number of coined silver piastres to the lira varies continually and averages about 108, but the Turkish government offices insist that any sum due in piastres means so many hundredths of a lira, and, for example, refuse to accept a silver 20-piastre piece ("mejidieh") in payment, say, of a 20-piastre telegram. But there are no piastres to be had at all. In over four years' residence I have not come across a dozen of them. The only silver Turkish coin to be met with in any numbers is the 20-piastre piece; 10 and 5 piastre pieces are occasionally current in the town, but not to any useful extent, while the 1 and 2 piastre pieces—the most essential of all in a poor community—are unknown. As the introduction of foreign silver into Turkey is prohibited, the population should, strictly speaking, do without small change at all, or restrict itself to the bronze ¼ piastre, known locally as the "metallic," of which there is a fair supply, though by no means a superabundance. Fortunately (in this instance) the law is not invariably respected in Turkey, and the Persian silver kran is universally used, almost all buying and selling on a small scale being done with it. But, again, as in the case of the piastre, an apparently useless complication has been introduced. The actual coin, the kran, goes about 54 to the lira on the average, though the exchange varies. All merchants' accounts, however, are kept in a fictitious kran, of which 34.4 go to the Turkish lira (which actually was the ratio of kran to lira 20 years or so ago). I am told that this imaginary kran is preserved in order to circumvent the rise and fall in value of the real kran; if so, the stratagem meets with very little success.

Another silver coin current in the port of Bussorah and along the Turkish coast of the Persian Gulf is the rupee. Local commercial relations with India are very important and are transacted in rupees, while the thousands of Indian pilgrims, who pass through on their way to the Shia shrines round Baghdad, provide themselves with Indian silver for their expenses. The British Indian post office at Bussorah too, through which passes all correspondence with the outer world, accepts only Indian silver or British gold in payment of stamps, &c.

Occasionally the custom-house authorities remember that the importation of foreign silver is forbidden, and when they do consider it necessary to vindicate the law, it is

From A and P 1893, vol. 79.

invariably a consignment of rupees which they select as a victim, krans being too neces-
sary to interfere with.

The only money used in transactions with the interior of Arabia, and recognised by its inhabitants, is the Maria Theresa dollar, of which antiquated coin there appears to be a perennial supply.

For the date trade the "shammi" alone is employed. This "shammi" is an obsolete Turkish coin, for which the Arabs in Mesopotamia have always manifested a great affection. It was rather smaller than a 5-shilling piece, and was made of silver with a large admixture of alloy. After the last Russo-Turkish war its nominal value (10 pias. gold or $\frac{1}{10}$ of a lira) was, by Government order, reduced 50 percent, in common with the rest of the debased Turkish coinage, and for the last 20 years "shammis" have disappeared. It was discovered by enterprising money-changers that the intrinsic value of the silver contained in it exceeded the reduced nominal value of 5 pias., and the obvious result followed. But, up to the present day, dates are still quoted at so many "shammis" per maund, though few of the younger generation have ever seen a specimen of the coin, and the cash payments are made in liras, mejidiehs or krans, the exchange operation involving a complicated evolution through the "book kran." . . .

25
Banking in Baghdad, 1907

I have the honour to invite the attention of the Board of Trade to the desirability of taking immediate steps to induce British Bankers to examine the possibility of opening a Branch at Baghdad. I regret that I am not in a position to give such detailed information on the prospects of success as would be of use to an expert. The trade of Baghdad is not only large but it is growing, and with the increased attention that is being directed to this part of the world the trade must grow very quickly in the future. In addition to the ordinary statistics which are already available to any inquirer in London I can only give the following information.

(1) The Deutsche Orient Bank has every intention of opening a Branch here before long, and a representative of the Bank, who is or was at Teheran (M. Gauthmann?) is expected here in a few weeks. This is a matter of common knowledge. I also hear that a powerful French Bank is making enquiries about the prospects of business here.

(2) The credit conveniences available at Baghdad are generally admitted to fall short of the demand. The result is that the ordinary rate for discounting bills varies from about ten to thirteen percent. These bills are locally known as "Compialas", they usually pass through the hands of a "Sarraf" (half broker half Banker) and are looked upon as good security.

(3) The amount of these Compialas is estimated at about £250,000. Of these about £100,000 are said to be in the hands of the Ottoman Bank, while the rest are in the hands of Jews and others.

From British Residency and Consulate General, Baghdad, 20 May 1907, FO 195/2242.

(4) Mr. Lloyd has interviewed some of the Sarrafs and he understands that they would welcome, and not oppose, the opening of a new Bank. A number of merchants have also expressed their desire for better Banking facilities.

(5) I enclose a list of these persons who are in England and who are likely to have at their disposal knowledge of Baghdad business which might serve as a basis for further enquiry by an expert.[1]

2. I have not been able to find out the reasons that led the Imperial Bank of Persia to withdraw from Baghdad in favour of the Imperial Ottoman Bank.

3. Though I can at present do no more than suggest enquiry by an expert, I should be glad to do my best to answer any direct questions, the answers to which would be useful to an expert. The one thing of which I am certain is that if an English Bank is to make a fair start it should lose no time in opening business here, otherwise it will find competitors in possession. At present the Imperial Ottoman Bank is alone and it is therefore master of the financial situation.

It is perhaps not understood in England that goods ordered by letter from Baghdad are seldom received in less than four months, while they often take much longer to reach Baghdad. In these circumstances there is ample scope for credit operations. . . .

[1]Paragraph missing in original.—ED.

26

Tax Collection on Land and Other Sources, 1908

How Taxes Are Collected from Land and Other Sources, in Baghdad

The toll taken from men who work with their hands in this part of Turkey is heavy, compared with the modest "poll tax" of American states. Sometimes as much as one-fifth of all a man makes is taken as a tithe by the government. When he rents government land, he often pays one-half of all he raises.

The method of collecting land and other government revenues in the Vilayet of Bagdad is unique and interesting. The "Daftar Khakani", or what corresponds to a Register of Deeds' office, is divided into two departments, the Tapu and the Imlak.

"Tapu" is an abbreviation of the Turkish word "Tapook", which means obedience [sic]. This department was established here in 1889; it sells government land to private persons; it deals with mortgages, transfers, restoration of lands, and records such transactions. It also rents out government lands, and when other tenants are not available, hands such lands over to neighboring Arab tribes and takes as revenue half of the produce. Sales, mortgages, and transfers of all kinds are taxed by the "Tapu"; after local costs of admin-

From US GR 84, Miscellaneous Correspondence, Baghdad, June 1908–December 1909.

stration are paid, the balance of such fees goes to Constantinople to meet government expenses.

The "Imlak" bureau, controlled by the "Mudir of Tapu", deals with sales, mortgages and transfers of House Property. On each such transaction an ad valorem tax of $1\frac{1}{2}\%$ is levied; sometimes orders from Constantinople raise or lower this rate. The "Daftar Khakani" at Constantinople gets what is left of this fund, after paying cost of local administration.

How Land Is Held about Bagdad

Men live on land here under four terms of tenure: The first is "Miri", or Crown lands: second, "Wakf", or pious foundation lands: third, as "Mulikanah", or Crown grants: and fourth, as "Mulk" or freehold property. The "Miri" lands, which in Abdul Hamid's time formed the largest part of the territory of the Sultan, were held direct from the crown. Fees were charged for cultivation, but title remained in the Crown, to which lands reverted if not [cultivated. Wakf][1] is designed to provide revenue for the erection of mosques and schools.

The "Mulikanah" was granted to Spahis, or the old feudal troops, in recompense for military service rendered by them, and is hereditary and exempt from tithes. The fourth form of tenure, the "Mulk," or freehold property, exists but to a small extent. Some house property in the towns and some land near the villages is "Mulk", which has been purchased by peasants.

Irrigated Land. That watered by lift (or pumps) is called "el Bakra"; when watered by a canal, "arazi-i-mirie". When watered by rain only it is called "Dem"; marshes and drying pools, when cultivated are called "El-Kibis".

There are two harvests, divided as follows:

From the class of lands known as "El Bakra", held by ordinary tenants, a winter harvest of wheat and barley is made and divided:

To the government	2/10ths
To the tenant	2/10ths
To the man who supplies the seed	3/10ths
To the Fellah, or cultivator	3/10ths

The other harvest of rice, or Millet, is called "El Saifi":

To the Government	1/10th
To the tenant	3/10ths
To the man supplying the seed	3/10ths
To the Fellah, or cultivator	3/10ths

When the "El Bakra" land is owned directly by the government the crop is divided this way:

To the Government	1/3
To the Seed Man	1/3
To the Fellah	1/3

[1]Line missing in document.—ED.

The distribution of cultivated land in the Vilayet of Bagdad has been estimated as follows:

30% the property of the government (arazi-i-mirie).
30% was, till his abdication, the private property of the Sultan. This is now also government property.
40% the property of private individuals.

The total area is estimated at 38,000 feddans. A "feddan" is an area of land which requires about 3384 pounds of wheat to sow it.

Taxes are levied on watered land as follows: if a cultivator must lift water onto his land from the river by means of a "Chard", or bullock-skin hoisted over a pulley and drawn up by horses walking down an incline plain [sic], he pays a tax of $\frac{1}{10}$th the crop. If the land is watered naturally by the river without special apparatus he . . .[2] channels, such as are used in rice fields, the government collects $\frac{1}{3}$ of what the man raises.

In the vicinity of Diwanieh and Hindieh, where the government owns the land, it collects $\frac{1}{2}$ the produce as rent. "Wakf" land is sometimes exempt from taxation. This is the case with the vast area owned and administered by the Nakib of Bagdad.

Strange to say, for some unknown reason, Honey is included in the land revenues, and a tax of $\frac{1}{10}$th the output of hives is collected by the Government.

TRADE AND OTHER TAXES

Tobacco and salt, being state monopolies, are not taxed, on importation.

An 8% ad valorum duty is levied on all imports, and 1% on all exports.

There is also a transit duty of 8% on all goods sent from one part of the Empire to another, and 1% is collected on all goods passing through Bagdad destined for Persia, or coming out of Persia via Bagdad.

From time to time various stamp duties are imposed, or repealed.

Cattle tax is collected at the rate of about 50 cents a year on each horse, camel, buffalo, mule, ox or pig; donkeys pay about 13 cts a year.

A "Thamgha" tax, levied at the rate of $\frac{1}{40}$th the value of cloth or woolen goods woven in Bagdad is also collected; it is a municipal tax.

An "Income Tax", called locally "Passwaniya", is also taken. It is graduated according to reputed incomes. It is levied monthly by the municipality, and is meant to defray cost of sweeping and lighting the streets, watchmen, etc. All Turkish subjects pay this, and all foreigners who own lands or houses.

An "Asnafiya" tax is levied on all traders, being from 20 to 40 cts a year. In the Sandjak of Karbala a second "trade tax" is also levied.

A Royalty of from 5% to 15% is levied on all minerals exported.

A *Conscription Tax* of 2 Medjidies ($1.76) per annum is levied on all non-Mohammedan Turkish subjects, over 15 or under 60 years of age. Only Mohammedans are allowed to serve in the Army, all others having to pay this tax.

Burial Taxes. These are charged on each corpse buried at the holy cities of Karbala, Nedjef and Kadhimain. They vary from $1.50 up to $175.00 per corpse, depending on the spot in the sacred enclosures where the interment is made.

[2]Line missing in document; the tax paid was generally $\frac{1}{8}$—see ʿAbbas al-ʿAzzawi, *Tarikh al-daraib fi al-ʾIraq* (Baghdad, 1959), p. 110.—ED.

Home-grown tobacco pays two taxes, a $\frac{1}{8}$th share of the crop to the government, and an extra tax of from 18 to 39 cts per kilo on the "leaf". About 250 tons a year is imported from Persia for use in waterpipes; a tax of about 17 cts per $2\frac{1}{2}$ lbs is levied on this.

Tax on Nomad Arabs is levied each year, and amounts to about $2.25 per tent (family); to this is added a surtax of 25 cts a tent, for public instruction and military purposes.

Sheep & Goats. This is an annual tax, payable in the Spring, at the rate of about 15 cts per animal.

In Irak province, from which buffaloes are exported to other parts of the Vilayet, a tax of 45 cts each, per annum, is levied. A similar tax is imposed on camels in Irak.

27

Commercial and Financial Practices in Iraq, 1908

. . . Trade in Turkey has, in some respects, changed its character in an extraordinary degree during the last 30 years. Up to 30 years ago the great trade centres of Turkey were the Yapruklu and Zileh fairs. To these places came the largest merchants of Mesopotamia, Damascus, and Bagdad, and from all the great centres of Turkey, bringing with them an important quantity of wares for sale, in some cases one man bringing as much as 25,000*l*. worth of goods himself. Tokat sent its copper; Angora its mohair; Damascus its silk; Kurdistan its cattle; and a great market of barter and exchange was thus established. The trade was thus done between principals; but the facilities given by railways and telegraphs in the way of communication has brought about appreciable changes—the rise of small native firms which have ousted the British traders from their position as buyers for export, and relegated them to the position of receiving agents at Smyrna or Constantinople, with results by no means beneficial to the export trade.

In many other respects, however, trade is done to-day in the same way as it has been done for centuries past. In Bagdad, Basra, and the majority of coast towns European methods have to a certain extent affected Oriental custom—and custom it is which rules, and is the excuse for everything understood or misunderstood by the Western mind—but inland, in the up country districts, little has changed. The bazaars are the same, the methods of dealing the same. Any inquiry as to the market price of goods in a given place will be met with a stare of astonishment. In Europe any trader would be able to give accurately the day's market price of any commodity within his ken. Not so in Turkey; nay more, the train of thought even suggesting the inquiry will not be appreciated. . . .

Large sums of money change hands daily, yet the general system of trading is a credit one. For the purchase of produce, ready money must be given out in the first instance at some risk, and the buyer often makes large profits by shipping direct.

When a merchant wishes to bring out goods he enters into a contract with one of the

From George Lloyd, "Report Upon the Condition and Prospects of British Trade in Mesopotamia," 1908, OPS/3/446, pp. 36, 17–18.

commission houses, paying a small deposit and the balance on arrival, which works satisfactorily, but ordering direct is attended with some risk to home manufacturers, for should the goods when sent out vary from sample, however slightly, the native customer, if the market be unfavourable, is apt to reject them or demand a great reduction. The risk of trading on these lines has been the means of creating the many native commission houses in Bagdad; orders are gathered from all quarters and trade facilitated: the practice for payment being to send the documentary drafts through a European house. The small trader who orders a bale of piece-goods makes a deposit and pays the balance by instalments (giving as security a Kompiala bond), and, in his turn, collects a weekly sum from the small shopkeepers. The Kompiala bond, introduced about 18 years ago, is a promissory note payable at date, and can be discounted at rates from 6 to 12 percent; it is an undoubted security in the hands of the Imperial Ottoman Bank, which can use its legal machinery to protest and recover, but in some other hands it may be a source of expense.

Continental merchants have tried to open up trade by sending an agent or partner of their own, and have been obliged to withdraw, but the Bagdad-born merchant who goes to Europe usually succeeds in building up a good business for his firm.

Saraf Methods. The Saraf as a changer of money in the ordinary acceptation of the term does a flourishing business with the general public. His charge varies between two and four small piastres for changing a lira's worth of coins, according to the currency tendered and the coins demanded; but the Bagdad Saraf proper fills a far more important office than that of a simple broker of coins. He is of a different grade, having an office or shop in Khan Pasha or Khan Zaroor, which may be termed the money market of Bagdad.

The Sarafs number about 50, each having a limited clientèle among the 200 (approximately) merchants. They are employed in a two-fold capacity—

1.—(*a*) To assay the liras and medjidiehs (brought in from all parts of the country) in a professional manner, at a fixed salary, for the leading merchants and the Imperial Ottoman Bank before the coins are put into circulation; this assay is not only as to weight but as to their currency in Bagdad at the time, and they indicate for what Vilayet the rejected medjidiehs are eligible. It should be explained that medjidiehs that would not be accepted in Bagdad would be accepted, say, in Basra or Aleppo. By arrangement the Saraf adjusts and replaces light-weight coins, and, without his office, ready-money transactions would be blocked altogether.

(*b*) To act as collectors of bills and payments.

2. As private bankers pure and simple. A merchant will deposit cash or bonds against which he draws simply by chit in piastres, leaving the Saraf to arrange in what currency the amount shall be paid. It is not necessary for the merchant to keep books in which the various coins figure; the Saraf, for a moderate charge, sometimes as low as two paras a lira, relieves him of this. The large amounts passing directly through the hands of the Sarafs make them a power. Acting together, they practically fix the rates of the trade bills for the merchants, which rates, when issued to the bill brokers, are put on the market. The broker visits his clients and buyers. British merchants especially are required to pay cash, that is, on settlement day; but if sellers (of their own bills) at these rates, they find difficulty in securing reciprocal terms. Their alternative is to sell to the Imperial Ottoman Bank for cash at an arbitrary rate.

Viewed closely, the Saraf is the soul of trade. He divines needs, supplies wants, and wards off catastrophes; he can be a friend to the merchant in that he can stave off a pressing creditor, while the debtor can refer the claimant to his Saraf and preserve his dignity. . . .

28

Price of Grain in Baghdad, 1855–1914[a]

Year	Wheat (1st quality)	Rice (negazeh)	Rice (shumba)	Barley	Source
Dec. 1855	454	990	619	277	CC Baghdad, vol. 12
July 1856	470	990	578	332	Ibid.
Dec. 1856	578	908	619	367	Ibid.
June 1857	578	990	660	474	Ibid.
Dec. 1857	743	908	660	474	Ibid.
June 1858	660	1238	825	395	Ibid.
Nov. 1858	681	1138	660	474	Ibid.
1860–1865 (average)	660				A and P 1867, vol. 67
1866	908				Ibid.
June 1867	1238	1650	1155	632	A and P 1870, vol. 64
Dec. 1867	957	990	908	474	Ibid.
June 1868	710	1238	1242	300	Ibid.
Dec. 1868	627	1238	825	284	Ibid.
June 1870	1238	1865	1155	474	A and P 1872, vol. 57
Dec. 1870	1865	2475	1320	869	Ibid.
June 1876	413			221	A and P 1877, vol. 83
Dec. 1876	429			221	Ibid.
June 1878	495			363	A and P 1878/79, vol. 76
Dec. 1878	908			585	Ibid.
1884/85[b]	657			440	A and P 1886, vol. 65
1890/91[b]	790			535	A and P 1893/94, vol. 91
1891/92[b]	582				Ibid.
1894	(400)			(200)	A and P 1897, vol. 94
1895	302			165	Ibid.
1896[c]	(330–800)			(175–400)	Ibid.
1897[c]	880			350	A and P 1898, vol. 99
1898[c]	550				A and P 1899, vol. 103
1902	580–840			250–410	A and P 1903, vol. 79
1903	370–460			180–210	A and P 1904, vol. 101
1904	400–600			200–350	A and P 1905, vol. 93
1905	370–430			250–300	A and P 1906, vol. 129
1906	470–640			275–400	A and P 1907, vol. 93
1907	500–720			280–400	A and P 1908, vol. 117
1908	510–930			280–560	A and P 1909, vol. 98
1909	870–1090			520–640	A and P 1910, vol. 103
1910	650–790			260–330	A and P 1911, vol. 96
1911	600–720			320–370	A and P 1912/13, vol. 100
1912	550–1210			440–880	A and P 1914, vol. 95
1913	1200–1830[d]			600–740	A and P 1914–1916, vol 75
1914[e]	700	1300		350	FO 371/4148

[a] In piasters per metric ton.

[b] Average price of exports of Baghdad province to Basra.

[c] Crop failure; 1897 and 1898 figures are average export price from Basra.

[d] Crop failure, record price.

[e] Average prewar prices, Kirkuk.

Note: The original quotations were in wazna (of 61, 63, and 102 kilograms), taghar (992 kilograms), hundredweight (50 kilograms), and avoirdupois tons. Sterling prices have been converted at £1 = 110 piasters.

29

Price of Foodstuffs in Iraq, 1855–1865 [a]

Year	Bread (1st quality)	Bread (2nd quality)	Rice (1st quality) [b]	Buffalo	Beef	Mutton	Dates [c]	Source
Baghdad								
End 1855	1	0.75	30	2	2	2.5	21.5	CC Baghdad, vol. 12
July 1856	1	0.88	28.5	1	1	2	21	Ibid.
Dec. 1856	1.12	1	35	1.25	1.1	2	23.5	Ibid.
June 1857	1.12	1	35	2	2	2.5	30	Ibid.
Dec. 1857	1.40	1.25	45	2	2	3	30	Ibid.
June 1858	1.5	1.25	40	1.5	1.5	2	25	Ibid.
Nov. 1858	1.25	1.12	41.25	1.5	1.75	2.5	30	Ibid.
1908	1.24 [d]		87.9				4.5	Eldem, Osman; p. 203
Mosul								
Nov.–Dec. 1855	0.75	0.6			1	1.5		CC Mossoul, vol. 1
Feb.–March 1850	1.25	1.6			1.5	2		Ibid.
1855	0.25 [d]		0.5–0.6 [e]					CC Mossoul, vol. 2
1895	1.25 [d]		2–2.5 [e]					Ibid.
Basra								
1861	2.3				2.4		22	A and P 1867, vol. 6
1862	1.6				2.4		19	Ibid.
1863	1.6				2.4		14	Ibid.
1864	1.4		58		2.3		13	Ibid.
1865	1.4		60		3.1		11	Ibid.

[a] In piasters, decimalized, per *oke* of 1.28 kilograms.

[b] Per *wazna* of 60.6 kilograms.

[c] Per *wazna* of 43.7 kilograms.

[d] Quality unspecified.

[e] Per *oke*.

Appendix: Weights and Measures

As in other preindustrial countries, weights and measures in Syria and Iraq were extremely confused. Each region had its own units, or its own name for a given unit, while the same term often covered units of greatly varying size. In 1869, and again in 1886 and 1897, the Ottoman government tried to standardize weights and measures and to encourage the use of the metric system, but had almost no success.[1]

Weights

Syria

For precious metals and valuable goods like silk, the standard unit was the *dirham* (dram) equal to 3.17 grams in Aleppo and 3.09 in Damascus. Theoretically, it consisted of 16 *qirat* (carats) of 4 *habba,* or *qamha* (grain) each. The *mithqal* equaled 1.5 *dirham.*

For merchandise the basic unit was the *uqqa* (*oke*) of 400 *dirham* or 1.283 kilograms. It was in principle divided into 6 *uqiya* (ounce) of 66.6 *dirham* or 214 grams each. However, there were local variations; for example, in Damascus the *uqiya* equaled 50 *dirham* or 154.2 grams, in Aleppo 60 or 190 grams, in Hama 55 or 171.9 grams, and in Homs 71 or 225 grams.

The *ratl* (rottoli) varied between 800 and 1017 *dirham,* or 2.564 to 3.255 kilograms. In northern Syria it was generally equal to 2 *uqqa,* or 2.564 kilograms and in southern Syria to 2.25 *uqqa* or 2.884 kilograms. There were also local variants; for

[1] For details and local variations see Hinz, *Islamische Masse;* Latron, *La vie rurale,* Cuinet, *Syrie;* idem, *Turquie;* Verney and Dambmann, *Les puissances;* Great Britain, Admiralty, *Handbook;* Great Britain, Naval Intelligence, *Iraq and the Persian Gulf; EHME; EHI; EHT.*

example, for oil the *ratl* was equal to 13.5 *uqiya* in Shuwayfat, 15 in Saida and Antioch and 18.5 in Jazzin; for dry figs, tobacco, and carobs in South Lebanon it was equal to 4.5 *uqiya*.[2]

The *qintar* (cantar, quintal) was equal to 100 *ratl*, or 288.4 kilograms, in Damascus in Hauran it was equal to 180 *uqqa*, or 230 kilograms and in Aleppo 200 or 256.8 kilograms.

Iraq

The *dirham* and *mithqal* were about the same as the Syrian; the *mithqal 'ajami*, used for pearls, equaled 22.5 *qirat* instead of 24.[3]

The Istanbul *uqqa*, or *huqqa*, equaled 400 *dirham*, or 1.282 kilograms; it was used in retail trade, for sugar, coffee, and other items. The big *uqqa* or *huqqa* was equal to 2.5 Istanbul *uqqa* or 3.2 kilograms; it was used for foodstuffs such as bread, meat, fruits, and vegetables; it was divided into 4 *uqiya*.[4]

There were also several kinds of *mann* (maund); the small *mann*, used in petty trade, equaled 6 Istanbul *uqqa* and the large *mann*, more widely used, 12 *uqqa*, but there were other values; for example, in Basra 4 for soap, 10 for spices and meat, and 60 for vegetables, fruits, rice, flour, wool, and skins.

The *wazna* equaled, in principle, 4 large *mann*, or 48 Istanbul *uqqa*, and in practice generally 50. However, it also varied widely; for example, in Kirkuk and Sulaymaniya it equaled about 100 kilograms but in Baghdad it depended on the commodity weighed— thus for tea, coffee, and metals it equaled 7.7 kilograms, for charcoal about 63 kilograms, and for grain and vegetables 99.[5]

The *taghar* was equal to 20 *wazna* or 1000 *okes* (1282 kilograms) but also varied widely. Thus in Baghdad it was sometimes equal to 2036 kilograms; in Basra it equaled 1534 kilograms for grain and 1278 for sand and gypsum. In Mosul it equaled 208 Istanbul *uqqa* or 260 kilograms, and was used for grain, fruits, vegetables, wool, etc.; the *qintar* of 208 *uqqa*, or 270 kilograms, was also used in Mosul for iron, copper, indigo, sugar, and groceries.[6]

For dates the *mann* of 69 kilograms was used. The small *kara* was equal to 20 *mann* and the large *kara* to 40 *mann*.[7]

Capacity

Syria

The basic unit for grain, olives, and other solids was the bushel, called in various regions *kayla, tabba*, etc., which was equal to 36–37 liters. The *mudd*, used mainly in southern

[2]Latron, *La vie rurale*, pp. 8–9; Verney and Dambmann, *Les puissances*, pp. 150–152; Cuinet, *Syrie*, p. 371.
[3]Great Britain, Admiralty, *Handbook*, vol. 1, p. 154.
[4]Ibid.; Cuinet, *Turquie*, vol. 3, p. 110; A and P 1911, vol. 96, "Basra"; Great Britain, Naval Intelligence, *Iraq*, pp. 640–642.
[5]Great Britain, Naval Intelligence, *Iraq*, p. 640.
[6]A and P 1899, vol. 103, "Mosul"; For further details see Great Britain, Admiralty, *Handbook*, pp. 153–156.
[7]A and P 1909, vol. 98, "Basra."

Syria, was equal to half a *kayla*. In the larger plains, where sown areas were bigger and the camel rather than the donkey or mule were used for transport, another unit was also used—the *jift* in Hauran, *rib'a* in Latakia, and *olchak* in Jazira—which was twice as large as the *mudd*. In addition, there was the *shumbul*, which was widespread in northern Syria; the small *shumbul*, equal to half a camel load, varied between 100 and 150 kilograms of wheat and the large *shumbul*, or camel load, between 200 and 260 (i.e. approximately a *qintar*). However, a *shumbul* of 45 *okes*, or about 60 kilograms, was also widely used. In Akkar, onions were measured in *quffa* (basket), equal to 18 *ratl*. For olive oil the *jarra* (jar), containing 5–6.5 *ratl* of oil was used. Other liquids were sold by weight.[8]

Iraq

In Iraq grain, dates, and other produce seem to have been sold by weight, as were liquids. I have not seen any references to measures of capacity.

Length

Syria

The basic unit was the *dira'* or ell (also referred to by Europeans as *pic*). Its most common value was 75–76 centimeters, with local variations of 63 in Damascus, 68 in Aleppo, and 65 in Jerusalem.[9] It was subdivided into 24 *qirat* or *usba'* (finger) of about 3 centimeters each.

For long distances, the *mil* (mile) of 1000 *dira'* or 700 meters, and the *farsakh* (Persian *parasang*) of 3 *mil* were used.[10]

Iraq

Here too the unit was the *dira'*, but its value varied. In Baghdad the *dira' Baghdad* of 76 centimeters was used; it was divided into 4 *charak* of 4 *'aqd* each. The *dira' Halab*, of 68 centimeters, similarly subdivided, was used for silks and woolens. The *dira' shah*, of 107 centimeters, was used for carpets or other dealings with Iranians.[11] In Basra the *dira'* equaled 48 centimeters, in Mosul 81 centimeters, and in Diyarbakr, where it was also called *arshin*, 76.[12]

[8]Latron, *La vie rurale*, pp. 9–11, 25–27; Verney and Dambmann, *Les puissances*, pp. 154–155; and Cuinet, *Syrie*, p. 372.

[9]Hinz, *Islamische Masse*, pp. 56–57.

[10]Cuinet, *Syrie*, pp. 372–373.

[11]Great Britain, Admiralty, *Handbook*, pp. 156–157; Cuinet (*Turquie*, vol. 3, p. 111) gives a value of 81 centimeters.

[12]Great Britain, Admiralty, *Handbook*, pp. 156–157; A and P 1889, vol. 103, "Mosul"; A and P 1908, vol. 98, "Basra"; Cuinet (*Turquie*) gives a figure of 71 for Diyarbakr.

Area

Syria

The *faddan* varied widely. In some regions it was defined as the area that could b
ploughed in one day by a team, or about 0.25 to 0.33 hectare.[13] In others it designated th
area that could be seeded with 500 *okes* of wheat plus 700 *okes* of barley or, say, 27.
hectares, depending on the terrain and soil.[14] Other values, ranging from 11 to 18 hectare
are also given.[15]

The square *dira'* equaled 0.49 square meters; the *qasaba* equaled 7.33 *dira* or abou
3.6 square meters.[16] A more uniform measure was the *dunum*, standardized at 919 squar
meters.

Iraq

The *faddan* was defined as "the area which two men can cultivate," or "a surface whic
can be completely sown with 500 Istanbul *huqqa* of wheat and 700 *huqqa* of barley," o
about 18 hectares.

The *dunum*, also known as *mishara*, was equal to 0.25 hectare. Another measure
peculiar to southern Iraq, was the *jarib*, which designated the area covered by 100 palm
trees, or about 0.23 hectare. The *jarib* was divided into 10 *qafiz*.[17]

[13]Latron, *La vie rurale*, p. 12.
[14]Cuinet, *Turquie*, vol. 3, p. 44.
[15]Verney and Dambmann, *Les puissances*, p. 154.
[16]Ibid.
[17]Great Britain, Admiralty, *Handbook*, p. 158.

Bibliography

GENERAL

Abraham, Sameer and Nabil Abraham, *Arabs in the New World*, Detroit, 1983.
Akrawi, Matta and R. Matthews, *Education in Arab Countries of the Near East*, Washington, D.C., 1949.
American School of Classical Studies at Athens, *Voyages and Travels in the Near East Made during the XIXth Century*, Princeton, N.J., 1952.
_____, *Voyages and Travels in Greece and the Near East and Adjacent Regions Made Previous to the Year 1801*, Princeton, N.J., 1953.
American University of Beirut, *A Post-War Bibliography of the Near Eastern Mandates*, Beirut, 1933–1935.
Bacqué-Grammont, J-L and P. Dumont, *Economie et sociétés dans l'Empire Ottoman*, Paris, 1983.
Baedeker, Karl, *Palestine and Syria, with Routes through Mesopotamia and Babylon*, Leipzig, 1912.
Bailey, Frank, *British Policy and the Turkish Reform Movement*, Cambridge, Mass., 1942.
Berque, Jacques and D. Chevallier (eds.), *Les Arabes par leurs archives*, Paris, 1976.
Biliotti, A., *La Banque Ottomane*, Paris, 1909.
Blunt, Lady Anne, *Beduin Tribes of the Euphrates*, London, 1879.
Bonné, Alfred. *The Economic Development of the Middle East*, London, 1945.
_____, *State and Economics in the Middle East*, London, 1955.
Boratav, K. et al., "Ottoman Wages and the World Economy," *Review* 8(3), 1985.
Braude, Benjamin and Bernard Lewis (eds.), *Christians and Jews in the Ottoman Empire*, New York, 1982.
Brice, William (ed.), *The Environmental History of the Near and Middle East since the Last Ice Age*, London, 1978.
Brown, L. Carl (ed.), *From Medina to Metropolis*, Princeton, N.J., 1973.
Buheiry, Marwan (ed.), *Intellectual Life in the Arab East, 1890–1939*, Beirut, 1981.
Bulliet, Richard, *The Camel and the Wheel*, Cambridge, Mass., 1975.
Caponera, Dante, *Water Laws in Moslem Countries*, Rome, Food and Agricultural Organization of the United Nations, 1954.
Chapman, Maybelle, *Great Britain and the Bagdad Railway*, Northampton, Mass., 1948.
Clawson, Marion et al., *The Agricultural Development of the Middle East*, New York, 1971.
Cohen, Hayyim, *The Jews of the Middle East*, New York, 1973.

Cuinet, Vital, *La Turquie d'Asie*, 4 vols., Paris, 1890–1894.

Devlet Salnameh (Official Handbook)

Dunne, J. Heyworth, *Introduction to the History of Modern Education in Egypt*, London, 1938.

Earle, Edward, *Turkey, the Great Powers and the Baghdad Railway*, New York, 1923.

Eldem, Vedat, *Osmanli Imperatorlugunun iktisadi . . .*, Ankara, 1970.

Encyclopaedia of Islam.

———, 2nd Edition (A–M).

Farnie, D. A., *East and West of Suez: The Suez Canal in History*, Oxford, 1969.

Field, Henry, *Bibliography on Southwestern Asia*, Coral Gables, Fla., 1953.

Fisher, S. (ed.), *Ottoman Land Laws*, London, 1919.

Fletcher, Max, "The Suez Canal and World Shipping," *JEH*, December 1958.

Geary, G., *Through Asiatic Turkey*, 2 vols., London, 1878.

Gibb, H. A. R. and H. Bowen, *Islamic Society and the West*, 2 vols., London, 1950–1957.

Goloborodko, I. I., *Staraya i novaya Turtsiya*, Moscow, 1908.

Guide Bleu, *Syrie–Palestine–Irak–Transjordanie*, Paris, 1932.

Hansen, Bent, "National Product and Income for Egypt ca. 1880 to 1913," University of California, Berkeley, March 5, 1974.

Hecker, M. "Die Eisenbahnen in der asiatischen Türkei," *Archiv für Eisenbahnwesen*, Berlin, 1914 (see also *EHME*, pp. 248–257).

Hershlag, Z. Y., *Introduction to the Modern Economic History of the Middle East*, 2nd Edition, Leiden, 1980.

Hewins, R., *Mr. Five Per Cent*, London, 1957.

Hijab, Wasfi, "Al-fikr al-ʿarabi fi maah sana—al-fikr al-ʿilmi," *Al-fikr al-ʿarabi*, Beirut, American University, 1967.

Hinz, Walther, *Islamische Masse und Gewichte*, Leiden, 1955.

Holt, P. M., *Egypt and the Fertile Crescent, 1516–1922*, London, 1966.

Hoskins, H. L., *British Routes to India*, London, 1928.

Hourani, Albert, *Minorities in the Arab World*, London, 1947.

———, *Arabic Thought in the Liberal Age*, London, 1962.

———, *The Emergence of the Modern Middle East*, London, 1981.

Hurewitz, J. C., *The Middle East and North Africa in World Politics: A Documentary Record*, 4 vols., New Haven, Conn., 1975–.

Imlah, Albert, *Economic Elements in the Pax Britannica*, Cambridge, Mass., 1958.

Inalcik, Halil, *The Ottoman Empire*, London, 1973.

Issawi, Charles, *The Arab Legacy*, Princeton, N.J., 1981.

———, *Economic History of the Middle East and North Africa*, New York, 1982.

——— and Mohammed Yeganeh, *The Economics of Middle Eastern Oil*, New York, 1963.

Karkar, Yaqub, *Railway Development in the Ottoman Empire*, New York, 1972.

Karpat, Kemal, "The Ottoman Emigration to America," *IJMES*, May 1985.

———, *Ottoman Population, 1830–1914*, Madison, Wis., 1985.

Kazamias, Andreas, *Education and the Quest for Modernity in Turkey*, London, 1966.

Khalidi, Tarif (ed.), *Land Tenure and Social Transformation in the Middle East*, Beirut, 1983.

Khuri, Raif, *Modern Arab Thought* (ed. Charles Issawi), Princeton, N.J., 1983.

Kryazhin, B. A., *Natzionalno-osvoboditelnoe dvizhenie na Blizhnem Vostoke*, Moscow, 1923.

Landau, Jacob M., *The Hejaz Railway and the Muslim Pilgrimage*, Detroit, 1971.

Lewis, Bernard and P. M. Holt (eds), *Historians of the Middle East*, London, 1962.

Longrigg, Stephen, *Oil in the Middle East*, 3rd Edition, London, 1968.

Lutfi, Ahmad, *Tarikh-i Lutfi*, Istanbul, 1290–1328 AH, 8 vols.

MacGregor, John, *Commercial Statistics*, 5 vols., London, 1844–1850.

McCarthy, Justin, "The Population of Ottoman Syria and Iraq, 1878–1914," *Asian and African Studies*, March 1981.

_____, *The Arab World, Turkey and the Balkans (1878–1914): A Handbook of Historical Statistics*, Boston, 1982.

Mears, Eliot, *Modern Turkey*, New York, 1924.

Milburn, William, *Oriental Commerce*, 2 vols., London, 1813.

Mommsen, Wolfgang (ed.), *"Imperialismus im Nahen und Mittleren Osten," Geschichte und Gesellschaft* 1(4), Göttingen, 1975.

Musrey, Alfred, *An Arab Common Market: a Study in Inter-Arab Trade Relations*, New York, 1969.

Naff, Thomas and Roger Owen (eds.), *Studies in Eighteenth Century History*, Carbondale, Ill., 1977.

Ochsenwald, William, *Religion, Society and the State in Arabia*, Columbus, Ohio, 1984.

Okyar, Osman and Halil Inalcik, *Social and Economic History of Turkey, 1071–1920*, Ankara, 1980.

Olivier, G. A., *Voyage dans l'Empire Ottoman, L'Egypte et la Perse*, 4 vols., Paris, 1804, An 12.

Oppenheim, Max, *Vom Mittelmeer zum Persischen Golf*, 2 vols., Berlin, 1899.

Owen, Roger, *The Middle East in the World Economy*, London, 1981.

Pamuk, S., "The Decline and Resistance of Ottoman Cotton Textiles, 1820–1913," in *Explorations in Economic History*, 1986.

_____, *Osmanli Ekonomisi ve Dunya Kapitalizmi*, Ankara, 1984.

Panzac, Daniel, *La peste dans l'empire ottoman*, Louvain, 1985.

Parfit, C. J. T., *Twenty Years in Baghdad and Syria*, London, 1917.

Pernot, Maurice, *Rapport sur un voyage d'études*, Paris, n.d.

Polk, William and Richard Chambers (eds.), *The Beginnings of Modernization in the Middle East*, Chicago, 1968.

Quataert, Donald, "Ottoman Reform and Agriculture in Anatolia," Ph.D. dissertation, University of California, Los Angeles, 1973.

Rafeq, Abd al-Karim, *Al-Arab wa al-Uthmaniyyun, 1516–1916*, Damascus, 1974.

Raymond, André, *Grandes villes arabes à l'époque ottomane*, Paris, 1985.

Rohrbach, P., *Die Bagdadbahn*, Berlin, 1902.

Shaw, Stanford, "The Nineteenth Century Ottoman Tax Reforms," *IJMES*, October 1975.

_____ and Ezel Shaw, *History of the Ottoman Empire and Modern Turkey*, 2 vols., Cambridge, 1977.

Shwadran, Benjamin, *The Middle East, Oil and the Great Powers*, 3rd Edition, New York, 1973.

Tarrazi, Filib, *Tarikh al-sihafa al-'arabiya*, 4 vols., Beirut, 1913–1937.

Thobie, Jacques, *Intérêts et impérialisme français dans l'empire Ottoman*, Paris, 1977.

Thomsen, Peter, *Die Palästina Literatur: eine internationale Bibliographie*, Leipzig, 1911–1938; Berlin, 1954–1958.

Udovitch, A. L. (ed.), *The Islamic Middle East, 700–1900*, Princeton, N.J., 1981.

Warriner, Doreen, *Land and Poverty in the Middle East*, London, 1948.

_____, *Land Reform and Development in the Middle East*, London, 1962.

White, K. D., *Greek and Roman Technology*, London, 1984.

Williamson, John, *Karl Helfferich*, Princeton, N.J., 1971.

Wirth, Albrecht, *Vorderasien und Aegypten*, Stuttgart, 1916.

Wolf, John B., *The Diplomatic History of the Baghdad Railroad*, Columbia, Mo., 1936.

Wood, Alfred, *A History of the Levant Company*, London, 1935.

Young, George, *Corps de droit Ottoman*, 6 vols., Oxford, 1905–1906.

IRAQ

Abu Hakima, Ahmad, *Tarikh al-Kuwait*, 2 vols., Kuwait, 1967–1970.

_____, *History of Eastern Arabia*, Beirut, 1965.

Adamov, Aleksandr, *Irak arabskii,* St. Petersburg, 1912.

Adams, Doris, *Iraq's People and Resources,* Berkeley, Calif., 1958.

Adams, Robert McC., *Land behind Baghdad,* Chicago, 1965.

Aichison, C., *A Collection of Treaties Relating to India and Neighbouring Countries,* 12 vols., Calcutta, 1892.

Ainsworth, W. F., *Personal Narrative of the Euphrates Expedition,* London, 1888.

Akrawi, Matta, "Curriculum Construction in the Public and Primary School of Iraq," Ph.D. dissertation, Columbia University, 1942.

Ali, Hassan Mohammad, *Land Reclamation and Settlement in Iraq,* Baghdad, 1955.

Alwan, Abdul Salih, "The Process of Economic Development in Iraq with Special References to Land Problems and Policies," Ph.D. dissertation, University of Wisconsin, 1956.

Andrew, W. P., *The Euphrates Valley Railway,* London, 1840.

————, *Memoir of the Euphrates Valley Route to India,* London, 1857.

ʿAtiya, Wadi al-, *Tarikh al-Diwaniya,* Najaf, 1954.

ʿAtiyyah, Ghassan, *Iraq, 1908–1921, A Political Study,* Beirut, 1973.

ʿAzzawi, Abbas al-, *Tarikh al-ʿIraq bayn ihtilalayn,* Baghdad, 8 vols., 1935–1956.

————, *ʿAshair al-ʿIraq,* Baghdad, 2 vols., 1937–1947.

————, *Tarikh al-nuqud al-ʿIraqiyya,* Baghdad, 1958.

————, *Tarikh al-daraib fi al-ʿIraq,* Baghdad, 1959.

Batatu, Hanna, *The Old Classes and The Revolutionary Movements of Iraq,* Princeton, N.J. 1978.

Bell, Gertrude, *Amurath to Amurath,* London, 1911.

———— , *Letters of Gertrude Bell,* London, 2 vols., 1927.

Bidawid, Rufail, *Al-Musul fi al-jil al-thamin ʿashar,* Mosul, 1951.

Binder, H., *Au Kurdistan, en Mespotamie et en Perse,* Paris, 1887.

Blunt, Anne, *Bedouin Tribes of the Euphrates,* London, 1879.

Buckingham, J. S. *Travels in Mesopotamia,* London, 1827.

————, *Travels in Assyria and Persia,* London, 1830.

Buckley, A. B., *Mesopotamia as a Country of Future Development,* Cairo, 1919.

Chesney, F. R., *The Expedition for the Survey of the Rivers Euphrates and Tigris,* London, 1850.

————, *Narrative of the Euphrates Expedition,* London, 1868.

Chiha, H., *La Province de Baghdad,* Cairo, 1908.

Cohen, Stuart, *British Policy in Mesopotamia 1903–1914,* London, 1976.

Coke, R., *The Heart of the Middle East,* London, 1925.

————, *Bagdad The City of Peace,* London, 1927.

De Warren, Count Edward, *European Interests in Railways in the Valley of the Euphrates,* London, 1857.

Dieulafoy, *La Perse, la Chaldée, et la Suziane,* Paris, 1887.

Dowson, E., *Enquiry into Land Tenure,* Letchworth, 1931.

Dowson, V. H., *Dates and Date Cultivation in Iraq,* Cambridge, 1921.

Dupré, Adrien, *Voyage en Perse,* Paris, 1819.

Faiq, Sulayman, *Baghdad Kuleh,* Istanbul, 1292.

Fami, Ahmad, *A Report on Iraq,* Baghdad, 1926.

Fernea, Robert, "Land Reform and Ecology in Post-revolutionary Iraq," *Economic Development and Cultural Change,* April 1969.

————, *Shaikh and Effendi,* Cambridge, Mass., 1970.

Fontanier, V., *Voyage dans l'Inde,* Paris, 2 vols., 1844.

Foster, Sir William, *The English Factories in India,* London, 1906–1907.

Fraser, David, *The Short Cut to India,* London, 1909.

Fraser, J. S., *Mesopotamia and Assyria,* Edinburgh, 1840.

————, *Travels in Koordistan, Mesopotamia,* 2 vols., London, 1840.

Garnier, H., *Voyage en Perse,* Tours, 1845.

Geere, H. V., *By Nile and Euphrates,* Edinburgh, 1904.

Gharaybeh, Abd al-Karim, *Al-'Iraq wa al-jazira al-'Arabiya fi al-'ahd al-'Uthmani*, Damascus, 1960.

Ghunayma, Yusuf Rizqallah, *Tijarat al-Iraq*, Baghdad, 1922.

Great Britain, Admiralty, Intelligence Division, *Handbook of Mesopotamia*, London, 4 vols., 1916–1917.

_____, Foreign Office, Historical Section, "Peace Handbooks," *Mesopotamia*, London, 1919.

_____, Colonial Office, *Report to the League of Nations*, 1922–1932.

_____, Naval Intelligence, Geographical Handbook Series, *Iraq and the Persian Gulf*, London, September 1944.

Groves, A. N., *Journal of a Residence in Baghdad*, London, 1832.

Gurani, 'Ali Sidu al-, *Min 'Amman ila al 'Amadiya: Jawlah fi Kurdistan al-janubiya*, Amman, 1939.

Haddad, Ezra S. and Priscilla Fishman, *History Round the Clock: The Jews of Iraq*, Tel Aviv, 1952.

Haider, Saleh, "Land Problems of Iraq," Thesis, London University, 1942 (see also *EHME*, pp. 163–178).

Haigh, F. F., *Report on the Control of the Rivers of Iraq*, Baghdad, 1952.

Hall, L. J., *Inland Water Transport in Mesopotamia*, London, 1921.

Hammond, F. D., *Report on the Railways of Iraq*, London, 1927.

Hasan, Muhammad Salman, *Al-tatawwur al-iqtisadi fi al-'Iraq*, Saida-Beirut, n.d.

Hay, W. R., *Two Years in Kurdistan*, London, 1921.

Helfferich, Karl, *Georg von Siemens*, Leipzig, 1923.

Heude, W., *A Voyage up the Persian Gulf*, London, 1819.

Hilali, 'Abd al-Razzaq al-, *Tarikh al-ta'lim fi al-'Iraq fi al 'ahd al-'Uthmaniy*, Baghdad, 1959.

Himadeh, Sa'id, *Al-nizam al-iqtisadi fi al'Iraq*, Beirut, 1938.

Huart, C., *Histoire de Bagdad dans les temps modernes*, Paris, 1909.

I.B.R.D. (International Bank for Reconstruction and Development), *The Economic Development of Iraq*, Baltimore, 1952.

Ionides, Michael, *The Régime of the Rivers Euphrates and Tigris*, London, 1937.

Iraq Government, Directorate General of Irrigation, *Report on the Control of the Rivers of Iraq* ("Haigh Report"), Baghdad, 1951.

Jackson, J., *Journey from India*, London, 1799.

Jackson, Stanley, *The Sassoons*, London, 1968.

Jamil, M. Husayn, *Siyasat al-'Iraq al-tijariya*, Cairo, 1949.

Jones, Geoffrey et al. *Banking and Empire in Iran*, Vol. I, Cambridge, 1986.

Jones, James Felix, *Memoirs*, Bombay, 1857.

Jwaideh, A., "Midhat Pasha and the Land System of Lower Iraq," *St. Antony's Papers* 3, 1963.

_____, "Aspects of Land Tenure and Social Change in Lower Iraq," in *Land and Tribal Administration* (ed. T. Khalidi).

_____, *Land and Tribal Administration of Lower Iraq under the Ottomans, 1869–1914*, forthcoming.

Kalidar, Abd al-Jawad al-, *Tarikh Karbala*, Baghdad, 1368.

Karmali, Anastas al-, *Khulasat tarikh al-Iraq*, Basra, 1337.

Kemball, Sir A., "Reports on the Trade of Baghdad and Basrah," *Parliamentary Papers*, Great Britain, Vol. 67, 1867.

Kent, Marian, *Oil and Empire*, London, 1976.

Keppel, G., *Travels in Babylonia*, London, 1827.

Khayyat, Ja'far al-, *Suwar min tarikh al-Iraq fi al-'usur al-muzlimah*, Beirut, 1971.

Kinneir, J., *Journey Through Asia Minor*, London, 1818.

Kotlov, L. N., *Natsionalno-osvoboditelnoe vosstanie 1920 goda v Irake*, Moscow, 1958.

Lanzoni, A., *Il Nuovo regime turco e l'avvenire della mesopotamia*, Rome, 1912.

Layard, A. H., *Nineveh and Babylon*, London, 1853.

Lloyd, Seton, *Twin Rivers*, Oxford, 1943.

_____, *Foundations in the Dust*, London, 1947.

Loftus, W. K., *Travels and Researches*, London, 1857.

Longrigg, S. H., *Four Centuries of Modern Iraq*, Oxford, 1925.

——, *Iraq 1900 to 1950*, Oxford, 1953.

Lorimer, J. G., *Gazeteer of the Persian Gulf*, Calcutta, 4 vols., 1908.

Luke, H. C., *Mosul and Its Minorities*, London, 1925.

Mahmud, Abd al-Majid, *Al-masarif fi al-ʿIraq*, Baghdad, 1942.

Marr, Phoebe, *The Modern History of Iraq*, London, 1985.

Midhat, Ali Haidar, *Tabserai ibrat*, Istanbul, 2 vols., 1325. (1909)

——, *Life of Midhat Pasha*, London, 1903.

Mignon, R., *Travels in Chaldaea*, London, 1829.

Mitford, *A Land March from England to Ceylon*, London, 1884.

Moosa, Matti, "General Reforms of Midhat Pasha in Iraq," *Islamic Literature*, January 1966.

——, "The Land Policy of Midhat Pasha in Iraq," *Islamic Quarterly* 12, 1968.

Morier, J., *A Journey through Persia*, London, 1812.

——, *A Second Journey through Persia*, London, 1818.

Mottahedeh, Roy, *The Mantle of the Prophet*, New York, 1985.

Munshi al-Baghdadi al-, *Rihlat al-Munshi al-Baghdadi*, Baghdad, 1948.

Nawwar, ʿAbd al-ʿAziz, *Dawud basha, wali Baghdad*, Cairo, 1967.

——, *Al-Masalih al-Britaniya fi anhar al ʿIraq*, Cairo, 1968.

Nieuwenhuis, T., *Politics and Society in Modern Iraq*, The Hague, 1981.

Penrose, Edith, *Iraq*, London, 1978.

Porter, R. K., *Travels in Georgia*, London, 1822.

Rasheed, G. A. K., "Development of Land Taxation in Modern Iraq," *Bulletin of the School of Oriental and African Studies*, 1962.

Rich, C. J., *Narrative of a Residence in Koordistan*, London, 1836.

Rousseau, J. B., *Description du Pachalik de Baghdad*, Paris, 1809.

——, *Voyage de Bagdad à Alep, 1808*, Paris, 1899.

Rzoska, J., *Euphrates and Tigris, Mesopotamian Ecology and Destiny*, The Hague, 1980.

Sachau, E., *Am Euphrate und Tigris*, Leipzig, 1900.

Saleh, Zaki, *Tarikh al-ʿIraq*, Baghdad, 1948.

——, *Mesopotamia (Iraq) 1600–1914*, Baghdad, 1957.

Salter, Lord, *The Development of Iraq*, Baghdad, 1955.

Sarkis, Yaʿqub, *Mabahith Iraqiya*, 2 vols., Baghdad, 1948.

Sassoon, David, *A History of the Jews in Baghdad*, Letchworth, England, 1949.

Sayigh, Sulayman, *Tarikh al-Musil*, Cairo, 1923.

Shields, Sarah, "An Economic History of Nineteenth-Century Mosul," Ph.D. dissertation, Chicago University, 1986.

Sluglett, Peter, *Britain in Iraq*, Oxford, 1976.

—— and M. F. Sluglett, "Transformation of Land Tenure in Iraq, c. 1870–1958," *IJMES*, November 1983.

Soane, Ely, *To Mesopotamia and Kurdistan in Disguise*, London, 1912.

Sousa, Ahmad, *Fayadanat Baghdad fi al-tarikh*, 2 vols., Baghdad, 1965.

——, and J. D. Atkinson, *Iraq Irrigation Handbook*, Baghdad, 1944–1946.

Southgate, H., *Narrative of a Tour*, London, 1840.

Stevens, E. S., *By Tigris and Euphrates*, London, 1923.

Stivers, William, *Supremacy and Oil*, Ithaca, N.Y., 1983.

Sufi, Ahmad al-, *Al-Mamalik fi al Iraq*, Mosul, 1952.

Sykes, Mark, *Through Five Turkish Provinces*, London, 1900.

——, *Dar ul Islam*, London, 1904.

——, *The Caliph's Last Heritage*, London, 1915.

ʿUmari, Suʿad al-, *Baghdad Kama wasafaha al-suyyah*, Baghdad, 1954.

Ussher, John, *London to Persepolis*, London, 1865.

Vaucelles, P., *La vie en Irak il y a un siècle*, Paris, 1963.

Wellsted, J. R., *Travels to the City of the Caliphs*, London, 1840.

Willocks, Sir William, *The Irrigation of Mesopotamia*, London, 1911.

———, *The Irrigation of Mesopotamia*, 2nd Edition, London, 1917.

Wirth, E., *Agrargeographie der Irak*, Hamburg, 1962.

Wratislaw, A. C., *A Consul in the East*, Edinburgh, 1924.

Zaki, Muhammad Amin, *Tarikh al-Sulaymaniya*, Baghdad, 1951.

Zeigler, H. Conway, "A Brief Flowering in the Desert, Protestant Missionary Activity in the Arabian Gulf, 1889–1978," M.A. thesis, 1977, Princeton University.

SYRIA

Abdel Nour, Antoine, *Introduction à l'histoire urbaine de la syrie ottomane*, Beirut, 1982.

Abkarius, Iskandar, *The Lebanon in Turmoil, Syria and the Powers in 1860* (trans. J. F. Scheltema), New Haven, Conn., 1920.

Abraham, A. J., *Lebanon at Mid-Century, Maronite–Druze Relations in Lebanon 1840–1860*, Washington, D.C., 1981.

Abu-Husayn, A., "The Iltizam of Mansur Furaykh," in *Land and Tribal Administration* (ed. T. Khalidi), Beirut, 1983.

Abu Shaqra, Husayn, *Al-Harakat fi Lubnan*, 1952.

Addison, Charles, *Damascus and Palmyra*, Philadelphia, 1838.

Ajami, Fouad, *The Vanished Imam*, New York, 1986.

Aouad, Ibrahim, *Le droit privé des Maronites au temps des Emirs Chihab, 1607–1841*, Paris, 1933.

'Arif, 'Arif al-, *Al-mufassal fi tarikh al-Quds*, Jerusalem, 1961.

Amiran, David, "The Pattern of Settlement in Palestine," *Israel Exploration Journal* 3, 1953.

Andrew, Christopher and A. S. Kanya-Forstner, *The Climax of French Imperial Expansion, 1914–1924*, Stanford, Calif., 1981.

Aswad, Ibrahim al-, *Dalil Lubnan*, Ba'abda, 1906.

Auhagen, Hubert, *Beiträge zur Kenntnis der Landesnatur und der Landwirtschaft Syriens*, Berlin, 1907.

'Azm, Khalid al-, *Mudhakkarat*, 3 vols., Beirut, 1972.

Baer, Gabriel, *Fellah and Townsman in the Middle East*, London, 1982.

Bahjat, Muhammad and Muhammad Rafiq, *Wilayat Beirut*, 2 vols., Beirut, 1334–36. A. H.

Bakhit, M. A., *The Ottoman Province of Damascus in the 16th Century*, Beirut.

———, "The Role of the Hanash Family," in *Land and Tribal Administration* (ed. T. Khalidi).

Barakat, Awad, *Le probleme budgétaire en Syrie (1920–39)*, Beirut, 1948.

Barbir, Karl, *Ottoman Rule in Damascus, 1708–1758*, Princeton, N.J., 1980.

Barker, Edward B. (ed.), *Syria and Egypt under the last Five Sultans of Turkey*, London, 1876.

Bazantay, P., *L'artisannat à Antioche*, Beirut, 1932.

Bazili, Konstantin, *Siriya i Palestina*, Moscow, 1962 (reprinted).

Béchara, E., *Les industries en Syrie et au Liban*, Cairo, 1922.

Bell, Gertrude, *Syria: The Desert and the Sown*, London, 1908.

Ben-Arieh, Y., *The Population of the Large Towns in Palestine*, Jerusalem, 1970.

Berkengeim, A. M., *Sovremennoe ekonomicheskoe polozhenie Sirii i Palestiny*, Moscow, 1897.

Bin Yahya, Salim, *Kitab Tarikh Bayrut Wa Akhbar Al Umara Al Buhturiyin Min Bani Al Gharb* (ed. Louis Shaykho), Beirut, 1898.

Blumberg, Arnold, *Zion before Zionism, 1838–80*, Syracuse, N.Y., 1986.

Bodman, Herbert, *Political Factions in Aleppo, 1760–1826*, Chapel Hill, N.C., 1963.

de Boucheman, A., "Note sur la rivalité de deux tribus moutonnières," *Revue des Etudes Islamiques* 8, 1934.

———, *Une petite cité caravanière: Sukhné*, Damascus, 1939.

Bowring, John, *Report on the Commercial Statistics of Syria*, Reprint, New York, 1972 (Originally published, London, 1840).

Buheiry, Marwan, "The Peasant Revolt of 1858 in Mount Lebanon", in *Land and Tribal Administration* (ed. T. Khalidi).

Burckhardt, J. L., *Travels in Syria and the Holy Land*, London, 1822.

Burns, Norman, *The Tariff of Syria*, Beirut, 1933.

Cardon, Louis, *Le régime de la propriété foncière en Syrie et au Liban*, Paris, 1932.

Carmel, Alex, *Die Siedlungen der Württembergischen Templer*, Stuttgart, 1973.

———, *Geschichte Haifas in der türkischen Zeit, 1516–1918*, Wiesbaden, 1975.

Carne, John, *Syria, The Holy Land, Asia Minor*, 3 vols., London, 1836 (illus.).

Carruthers, Douglas, *The Desert Route to India*, London, 1929.

Charles, H., *Tribus moutonnières du Moyen-Euphrate*, Damascus, 1938.

Charles-Roux, F., *Les Echelles de Syrie et de la Palestine au XVIIIe siècle*, Paris, 1928.

Chevallier, Dominique, "Aux origines des troubles agraires libanais en 1858," *Annales*, January 1956.

———, *La société du Mont Liban à l'époque de la révolution industrielle en Europe*, Paris, 1971.

———, "Un exemple de résistance technique de l'artisanant syrien," *Syria*, 1962.

———, "A Damas, Production et Société à la fin du XIXe siècle," *Annales*, 1964.

———, "Techniques et Société en Syrie," *Bulletin d'Etudes Orientales de l'Institut Français de Damas*, 1963–64.

———, "De la production lente à l'économie dynamique en Syrie," *Annales*, 1966.

———, "Western Development and Eastern Crisis in the Mid-Nineteenth Century," in *Beginnings of Modernization* (eds. W. Polk and R. Chambers).

Churchill, Charles H., *Mount Lebanon: A Ten Years' Residence from 1842–1852*, London, 1853.

———, *The Druzes and the Maronites under Turkish Rule from 1840 to 1860*, London, 1862.

Cohen, Amnon, *Palestine in the 18th Century*, Jerusalem, 1973.

Conder, Claude, *Tent Work in Palestine*, 2 vols., New York, 1878.

Cuinet, Vital, *Syrie, Liban et Palestine*, Paris, 1896.

Cunningham, A. (ed.), *The Early Correspondence of Richard Wood*, London, 1966.

Davis, Ralph, *Aleppo and Devonshire Square*, London, 1967.

Dibs, Yusuf, al-, *Al-Jami 'al-Mufassal Fi Tarikh al-Mawarina al-Muassal*, Beirut, 1905.

Ducousso, Gaston, *L'industrie de la soie en Syrie*, Paris, 1913.

Douin, Georges, *La mission du Baron de Boislecomte*, Cairo, 1927.

Durbin, John, *Observations in the East*, 2 vols., New York, 1845.

Elefteriades, Eleuthère, *Les chemins de fer en Syrie et au Liban*, Beirut, 1944.

Eliav, Mordechai, *Ahaavat Tziyon ve-anshei Hod*, Tel Aviv, 1970.

Farah, Caesar, E., "The Problem of the Ottoman Administration in the Lebanon: 1840–1861," Ph.D. dissertation, Princeton University, 1957.

Farley, J. L., *Two Years in Syria*, London, 1858.

——— , *The Resources of Turkey*, London, 1862.

Fawaz, Leila, *Merchants and Migrants in Nineteenth Century Beirut*, Cambridge, Mass., 1983.

Firestone, Y., "Faddan and Musha," in *Islamic Middle East* (ed. A. L. Udovitch).

Fischer, H., *Wirtschaftsgeographie von Syrien*, Leipzig, 1919.

Fitzner, R. *Aus Kleinasien und Syrien*, Rostock, 1904.

Frayha, Anis, *Hadara fi tariq al-zawal: al-qariya al-lubnaniya*, Beirut, 1957.

———, *Isma' ya Rida*, Beirut, 1956.

Friedman, Isaiah, *Germany, Turkey and Zionism, 1897–1918*, Oxford, 1977.

Gaulmier, Jean, *Notes sur le mouvement syndicaliste à Hama*, Paris, 1932.

Gerber, Haim, "The Population of Syria and Palestine in the Nineteenth Century", *Asian and African Studies*, 1979.

———, and Nachum Gross, "Inflation or Deflation in Nineteenth Century Syria and Palestine," *JEH*, June 1980.

Gharaybeh, Abd al-Karim, *Suriya fi al-qarn al-tasi' 'ashar*, Damascus, 1962.

Ghazzi, Kamil al-, *Nahr al-dhahab fi tarikh Halab*, 3 vols., Aleppo, 1923–1926.

Gilbert, Martin, *Jerusalem: Rebirth of a City*, London, 1985.

Gilsenan, Michael, "A Modern Feudality? Land and Labour in North Lebanon, 1858–1950," in *Land and Tribal Administration* (ed. T. Khalidi).

Granott, A., *The Land System in Palestine*, London, 1952.

Grant, Christina Phelps, *The Syrian Desert*, London, 1937.

Great Britain, Naval Intelligence Division, Handbook of Syria, London, 1920.

———, Geographical Handbook Series, *Syria*, April 1943.

———, *Palestine and Transjordan*, December 1943.

Gulick, John, *Social Structure and Culture Change in a Lebanese Village*, New York, 1955.

Guys, Henri, *Beyrout et le Liban*, 2 vols., Paris, 1850.

———, *Statistique du Pachalik d'Alep*, Marseilles, 1853.

———, *Esquisse de l'état politique et commercial de la Syrie*, Paris, 1862.

Haddad, Robert, *Syrian Christians in Muslim Society*, Princeton, N.J., 1970.

Haddad, William and William Ochsenwald, *Nationalism in a Non-National State: The Dissolution of the Ottoman Empire*, Columbus, Ohio, 1977.

Hanf, T., *Erziehungwesen in Gesellschaft und Politik des Libanon*, Bielefeld, 1969.

Hanna, 'Abdullah, *Al-qadiya al-zira'iya wa harakat al-fallahin fi Suriyya wa Lubnan*, 2 vols., Beirut, 1975–1978.

———, *Al-haraka al 'ummaliya fi Suriyya wa Lubnan, 1900–1945*, Damascus, 1973.

Haqqi Bey, Isma'il (ed.), *Lubnan Mabahith 'ilmiyya wa ijtima'iyya*, Beirut, 1918 (reprinted, Beirut, 1970).

Harik, Iliya F., "The Iqta' System in Lebanon: A Comparative Political View," *MEJ* 19(4), Autumn 1965.

———, *Politics and Change in a Traditional Society, Lebanon, 1711–1845*, Princeton, N.J., 1968.

Hasani, Ali al-, *Tarikh Suriya al-iqtisadi*, Damascus, 1924.

Himadeh, Sa'id, *The Economic Organization of Palestine*, Beirut, 1938.

———, *The Economic Organization of Syria and Lebanon*, Beirut, 1936.

———, *Monetary and Banking System of Syria*, Beirut, 1935.

Hitti, Philip, *History of Syria*, New York, 1951.

———, *Lebanon in History*, London, 1957.

Hopwood, Derek, *The Russian Presence in Syria and Palestine, 1843–1914*, Oxford, 1969.

Hourani, A. H., *Syria and Lebanon*, London, 1946.

———, "Ottoman Reform and the Politics of Notables," in *Beginnings of Modernization* (ed. W. Polk and R. Chambers).

Houry, C. B., *De la Syrie considérée sous le rapport commercial*, Paris, 1842.

Husri, Sati' al-, *al-Bilad al-'Arabiya wa al-Dawlah al-'Uthmaniya*, Cairo, 1957.

Hütteroth, W. D. and K. Abdul Fattah, *Historical Geography of Palestine*, Erlangen, 1977.

Huvelin, Paul, "Que vaut la Syrie?," *L'Asie française*, Paris, 1921.

Ibish, Yusif, "Elias Qudsi's Sketch of the Guilds of Damascus in the Nineteenth Century," *MEEP*, Beirut, 1967.

Imam, Chafiq, "L'artisannat du verre en Syrie," *Bulletin d'Etudes Orientales* 27, 1974.

I.B.R.D. (International Bank for Reconstruction and Development), *The Economic Development of Syria*, Baltimore, 1955.

Isma'il, Adel, *Histoire du Liban*, vol. 1, Paris, 1955; Vol. 4, Beirut, 1958.

Issawi, Charles, "British Consular Views on Syria's Economy in the 1850's–1860's," *American University of Beirut Festival Book*, (eds. Fuad Sarruf and Suha Tamim), Beirut, 1967.

Jabir, Muhammad, *Tarikh Jabal 'Amil*, Beirut, 1981.

Jessup, Henry H., *Fifty-three Years in Syria*, New York, 1910.

Jouplain, M., *La Question du Liban, étude d' histoire diplomatique et de droit international*, Paris, 1908.

Kalla, M. S., "Role of Foreign Trade in the Economic Development of Syria, 1831–1914," Ph.D. dissertation, American University, Washington, D.C.

Kark, Ruth, "Changing Patterns of Landownership in Nineteenth Century Palestine," *Journal of Historical Geography*, 1984.

Karmon, Y., "The Settlement of the Northern Huleh Valley since 1838," *Israel Exploration Journal*, 1953.

Karpat, Kemal, "The Ottoman Emigration to America, 1860–1914," *IJMES*, May 1985.

Kayat, As'ad Y., *A Voice from Lebanon, with Life and Travels of Assad Kayat*, London, 1847.

Kazziha, Walid, *The Social History of Southern Syria (Transjordan)*, Beirut, 1972.

Kerr, Malcolm, *Lebanon in the Last Years of Feudalism*, Beirut, 1959.

Khalaf, Samir, *Persistence and Change in 19th Century Lebanon*, Beirut, 1979.

Khalidi, Rashid, *British Policy towards Syria and Palestine, 1906–1914*, Oxford, 1980.

Khatir, Lahd, *'Ahd al-mutasarrifiyyin fi Lubnan*, Beirut, 1967.

Khazin, Philip al- and Farid al-Khazin (eds.), *Majmuat al-Muharrarat al-Siyasiyya*, 3 vols., Beirut, 1910.

Khouri, Philip, *Urban Notables and Arab Nationalism*, Cambridge, 1983.

———, *The Politics of Nationalism: Syria and the French Mandate*, Princeton, N.J., 1986.

Klat, Paul, "Musha Holdings and Land Fragmentation in Syria," *MEEP*, Beirut, 1957.

———, "The Origins of Landownership in Syria," *MEEP*, Beirut, 1958.

Kremer, Alfred von, *Mittelsyrien und Damaskus*, Vienna, 1853.

Kurd-'Ali, Muhammad, *Ghutat Dimashq*, Damascus, 1953.

Kushner, David (ed.), *Palestine in the Late Ottoman Period*, Leiden, 1985.

Labaki, B., "La filature de la soie dans le Sanjak du Mont Liban," *Arabica*, February 1982.

———, *Introduction à l'histoire économique du Liban*, Beirut, 1984.

Lamartine, Alphonse de, *Souvenirs, impressions, pensée et paysages pendant un voyage en Orient, 1832–1833*, Paris, 1835.

Lammens, H., *La Syrie*, Beirut, 1921.

Latron, André, *La vie rurale en Syrie et au Liban*, Beirut, 1936.

Lewis, Bernard, "Ottoman Land Tenure and Taxation in the Syrian Lands," unpublished paper, 1974.

Lewis, Norman, "The Frontier of Settlement in Syria, 1800–1950," *International Affairs* 31, 1955 (see also *EHME*, pp. 258–268).

———, *Nomads and Settlers in Syria and Jordan*, Cambridge, 1987.

Lortet, Louis, *La Syrie d'aujourd 'hui*, Paris, 1884.

Luncz, A. M., *Jerusalem Yearbook*, Vienna, 1882.

Mantran, R. and J. Sauvaget, *Règlements fiscaux ottomans: les provinces syriennes*, Paris, 1951.

Ma'oz, Moshe, "The Impact of Modernization on Syrian Politics and Society during the *Tanzimat* Period," in *Beginnings of modernization* (eds. W. Polk and R. Chambers).

———, *Ottoman Reform in Syria and Palestine, 1840–1861*, Oxford, 1968.

——— (ed.), *Studies on Palestine during the Ottoman Period*, Jerusalem, 1975.

Maqdisi, Anis al-Khuri al-, *Ma'al-zaman*, Beirut, n.d.

Maqdisi, Jurjus al-Khuri al-, *A'zam harb fi al-tarikh*, Beirut, 1921.

Marcus, Abraham, *Social Realities in the Premodern Middle East*, forthcoming.

———, "Men, Women and Property," *JESHO*, 1983.

Marsot, Afaf Lutfi al-Sayyid, *Egypt in the reign of Muhammad Ali*, Cambridge, 1984.

Masson, Paul, *Histoire du commerce français dans le Levant au XVIIe siècle*, Paris, 1896.

———, *Histoire du commerce français dans le Levant au XVIIIe siècle*, Paris, 1911.

———, *Marseille et la colonisation française*, Paris, 1912.

McGowan, Bruce, *Economic Life in Ottoman Europe, 1600–1800*, Cambridge, 1981.

Mears, Eliot, *Modern Turkey*, New York, 1924.

Medawar, Wady, *La Syrie agricole*, Beauvais and Paris, 1903.

Meriwether, Margaret, "The Notable Families of Aleppo," Ph.D. dissertation, University of Pennsylvania, 1981.

Meyer, M. A., *History of the City of Gaza*, New York, 1907.

Michaud, Joseph and Jean Poujoulat, *Correspondance d'Orient*, Brussels, 1841.

Monicault, Jacques de, *Le Port de Beyrouth et l'économie des pays du Levant sous mandat français*, Paris, 1936.

Morcos, Michel, *La culture du tabac au Liban*, Beirut, 1974.

Moussly, Nazim, *Le problème de l'eau en Syrie*, Paris, 1951.

Musil, Alois, *Manners and Customs of the Rwala Beduin*, New York, 1928.

al-Mutamar al-dawli al-thani li-tarikh bilad al-Sham, Damascus, 1980.

Naff, Alixa, "A Social History of Zahle," Ph.D. dissertation, University of California, Los Angeles, 1972.

Neale, F. A., *Eight Years in Syria, Palestine and Asia Minor*, 2nd Edition, London, 1952.

Nimr, Ihsan al-, *Tarikh Jabal Nablus wa al-Balqa*, Damascus, 1938.

Oliphant, Laurence, *Haifa or Life in Modern Palestine*, New York, 1887.

Owen, Roger (ed.), *Essays on the Crisis in Lebanon*, London, 1976.

———, *Studies in the Economic and Social History of Palestine in the Nineteenth and Twentieth Centuries*, Carbondale, Ill., 1982.

———, "A Study of Middle Eastern Industrial History," *IJMES*, November 1984.

Paris, Robert, *Histoire du commerce de Marseille de 1660 à 1789 le Levant*, Paris, 1957.

Pascual, Jean-Paul, "The Janissaries and the Damascus Countryside at the Beginning of the Seventeenth Century", in *Land and Tribal Administration* (ed. T. Khalidi).

Peake, Frederick, *A History of Jordan and its Tribes*, Baltimore, 1958.

Penrose, Stephen, *That They May Have Life: The Story of the American University of Beirut*, New York, 1941.

Philipp, Thomas, *The Syrians in Egypt, 1725–1975*, Stuttgart, 1985.

Poliak, A. N., *Feudalism in Egypt, Syria, Palestine and the Lebanon*, London, 1939.

Polk, William, "Document: Rural Syria in 1845," *MEJ* 16(4), 1962.

———, *The Opening of South Lebanon*, Cambridge, Mass., 1963.

——— and Richard Chambers, *Beginnings of Modernization in the Middle East*, Chicago, 1968.

Porath, Y., "Peasant Revolt of 1858–61 in Kisrawan," *Asian and African Studies* 2, 1966.

Poujade, Eugène, *Le Liban et la Syrie, 1845–1860*, Paris, 1867.

Qasatli, Nu'man al-, *Kitab al-rawdah al-ghanna' fi Dimashq al-Fayha'*, Beirut, 1879.

Qoudsi, Elia, "Notices sur les Corporations de Damas," *Actes du Sixième Congrès international des Orientalistes*, Leiden, 1884.

Rabinowitz, Dan, "Themes in the Economy of the Bedouin of South Sinai," *IJMES*, May 1985.

Rafeq, Abdul-Karim, *Buhuth fi al-tarikh al-iqtisadi*, Damascus, 1985.

———, "The Law Court Registers of Damascus," in *Les Arabes par leurs archivs* (eds. J. Berque and D. Chevallier).

———, "Economic Relations between Damascus and the Dependent Countryside," in *Islamic Middle East* (ed. A. L. Udovitch).

———, "The Impact of Europe on a Traditional Economy: The Case of Damascus, 1840–1870," in Bacqué-Grammont and Dumont (eds.), *Economie et sociétés*.

———, Land Tenure Problems and their Social Impact in Syria around the Middle of the Nineteenth Century", in *Land and Tribal Administration* (ed. T. Khalidi).

———, *Al-'Arab wa al-'Uthmaniyun*, Damascus, 1974.

Raymond, André (ed.), *La Syrie d'aujourd'hui*, Paris, 1980.

———, "The Population of Aleppo in the Sixteenth and Seventeenth Centuries," *IJMES*, November 1984.

Ruppin, A., *Syrien als Wirtschaftsgebiet*, Beihefte zum Tropenpflanzen, vol. 16, no. 3/5, Berlin, 1916.

Rustum, Asad, *Materials for a Corpus . . .* (in Arabic), Beirut, 1930–1934.

———, *A Calendar of State Papers . . .* (in Arabic), Beirut, 1940–1943.

——— (ed.), *Lubnan fi 'ahd al-mutasarrifiyya*, Beirut, 1973.

Saadé, Toufick, *Essai sur l'agriculture à Lattaquié*, Beauvais, 1905.

Sabah, Husni, "Taʿrib ʿulum al tibb," *Revue de l'Académie arabe de Damas,* October 1985.

Safa, Elie, *L'émigration libanaise,* Beirut, 1960.

Saliba, Najib, "Wilayat Suriyya," Ph.D. dissertation, University of Michigan, Ann Arbor, 1971.

Salibi, Kamal, *Maronite Historians of Mediaeval Lebanon,* Beirut, 1959.

————, *The Modern History of Lebanon,* London, 1965.

Samné, Georges, *La Syrie,* Paris, 1921.

Sanjian, Avedis, *The Armenian Communities in Syria under Ottoman Rule,* Cambridge, Mass., 1964.

Saulcy, L. F. de, *Carnets de voyage en Orient (1845–69),* Paris, 1955.

Sauvaget, Jean, "Esquisse d'une historie de la ville de Damas," *Revue des Etudes de l'Islam,* 1934.

————, *Alep,* Paris, 1941.

Schatkowski-Schilcher, L., "Ein Modellfall indirekter wirtschaftlicher Durchdringung: Das Beispiel Syriens, *Geschichte und Gesellschaft* 1, 1975.

————, "The Hauran Conflicts of the 1860's," *IJMES* 13, May 1981.

————, *Families in Politics,* Stuttgart, 1985.

Schölch, Alexander, "European Penetration and the Economic Development of Palestine, 1856–82", in *Studies in Economic and Social History* (ed. Roger Owen).

————, "The Demographic Development of Palestine, 1850–1882," *IJMES* 17, November 1985.

Schulmann. *Zur türkischen Agrarfrage, Palästina und die Fellachenwirtschaft,* Weimar, 1916.

Schumacher, G., *The Jaulan,* Jerusalem, 1976.

Seetzen, U., *Reise durch Syria . . . ,* 4 vols., Berlin, 1954.

Seikaly, Samir, "Land Tenure in Seventeenth Century Palestine," in *Land and Tribal Administration* (ed. T. Khalidi).

Shidyaq, Tannus al-, *Akhbar al-aʿyan fi jabal Lubnan,* Beirut, 1970.

Shihabi, Amir Haydar al-, in *Lubnan fi ʿahd al-umara al-shihabiyyin* (eds. A. A. Rustum and F. E. Bustani), 3 vols., Beirut, 1933.

Shorrock, William, *French Imperialism in the Middle East,* Madison, Wis., 1976.

Siba'i, Badr al-Din al-, *Adwa ʿala al-rasmal al-ajnabi fi Suriyya, 1850–1958,* Damascus, 1968.

Sluglett, Peter and Marion Farouk-Sluglett, "The Application of the 1858 Land Code in Greater Syria," in *Land and Tribal Administration* (ed. T. Khalidi).

Smilyanskaya, I. M., "Razlozhenie feodalnikh otnoshenii," *Peredneaziatskii Etnografi-cheskii Sbornik,* Moscow, I, 1958 (see also *EHME,* pp. 226–247).

————, *Krestyanskoe dvizhenie v Livane,* Moscow, 1965.

Spagnolo, John, *France and Mount Lebanon, 1861–1914,* Oxford, 1977.

Stanhope, Lady Hester, *Memories of the Lady Hester Stanhope,* 2nd Edition, London, 1846.

Stein, Kenneth, *The Land Question in Palestine, 1917–1939,* Chapel Hill, N.C., 1984.

Stephens, John L., *Incidents of Travel in Egypt, Arabia Petraea and the Holy Land,* Norman, Okla., 1970.

A Survey of Palestine, prepared by the Government of Palestine, 4 vols., Jerusalem, 1946.

Swedenburg, Theodore, "The Development of Capitalism in Greater Syria, 1830–1914," M.A. thesis, University of Texas, Austin, 1980.

Tannous, Afif, "Emigration: A Force in Social Change in an Arab Village," *Rural Sociology* 7, 1942.

Thompson, Charles, *Travels . . . ,* Glasgow, 1810.

Thomson, William M., *Lebanon, Damascus and Beyond Jordan,* London, 1886.

Thoumin, Richard, *Géographie humaine de la Syrie centrale,* Paris, 1936.

Tibawi, A. L., *American Interests in Syria,* Oxford, 1961.

————, *British Interests in Palestine,* Oxford, 1961.

————, *A Modern History of Syria,* Edinburgh, 1969.

————, *Islamic Education,* London, 1972.

Tobler, T., *Lustreise ins Morgenland,* 2 vols., Zurich, 1839.

_____, *Dankblatter aus Jerusalem*, Konstanz, 1853.

'ouma, T., *Paysans et institutions féodales*, Beirut, 1971.

'ower, Allen, *The Oasis of Damascus*, Beirut, 1935.

'resse, R., "L'irrigation dans la Ghouta de Damas," *Revue des Etudes Islamiques* 3, 1929.

_____, "Histoire de la route de Beyrouth à Damas," *La Géographie* 6, 1936.

'ristram, Henry, *The Land of Israel*, London, 1865.

'u'meh, George, *Al-mughtaribun al-'arab fi Amerika al-Shimaliyya*, Damascus, n.d.

Jdovitch, A. L. (ed.), *The Islamic Middle East: 700–1900*, Princeton, N.J., 1981.

Jrquhart, D., *The Lebanon (Mount Souria): A History and a Diary*, London, 1860.

√erney, Noel and Georges Dambmann, *Les puissances étrangeres dans le Levant en Syrie et en Palestine*, Paris, 1900.

√olney, C. F., *Travels through Syria and Egypt*, 2 vols. London, 1787.

√ogüé, Eugène De, *Syrie, Palestine, Mont Athos*, Paris, 1876.

√alpole, Frederick, *The Ansayri (or Assassins)*, 3 vols., London, 1851.

√arburg, Gabriel and Gad Gilbar (eds.), *Studies in Islamic Society*, Haifa, 1984.

√arburton, Eliot, *The Crescent and the Cross*, London, n.d.

√eakley, E., "Report on the Conditions and Prospects of British Trade in Syria," A and P vol. 87, 1911 (see also *EHME*, pp. 275–290).

√eulersse, Jacques, "La primauté des cités dans l'économie syrienne," *Congrès International de Géographie*, Amsterdam, 1938, Section IIIa.

_____, *Le pays des Alaouites*, Tours, 1940.

_____, *Paysans de Syrie et du Proche Orient*, Paris, 1946.

√ilson, C. T., *Peasant Life in the Holy Land*, New York, 1906.

√inder, R. Bayly, "The Lebanese in West Africa," *Comparative Studies in Society and History*, vol. 4, no. 3, 1962.

_____, "Syrian Deputies and Cabinet Ministers," *MEJ*, Autumn 1962.

√irth, Eugen, *Syrien: Eine Geographische Landeskunde*, Darmstadt, W. Germany, 1971.

ʿaziji, Nasif al-, in *Risala tarikhyiyya fi ahwal Lubnan* (ed. Q. al-Basha), Harisa, 1936.

ʿayn, Ahmad Arif al-, *Tarikh Sayda*, Sayda, 1913.

Index of Subjects

Agriculture
 Iraq, 95, 279–84, 347–49, 359–63
 Syria, 10, 12, 56–57, 61–63, 65, 75–77, 79–80,
 169, 172, 269–79, 290–96, 302–4, 310–11,
 313, 315–18

Balance of payments
 Iraq, 134–36, 191–92, 373–74
 Syria, 72, 81, 133–34
Banking
 Iraq, 121, 411–12, 469–70, 473–74
 Syria, 76–77, 310, 410–11, 429, 444–45
Barley
 Iraq, 98, 146, 150, 199–200, 281–82, 316, 343,
 361, 461
 Syria, 143, 273, 309, 313, 316

Caravans. *See* Road Transport
Coal
 Iraq, 121
 Syria, 40, 394
Coffee
 Iraq, 36
 Syria, 35, 427–28, 430
Cotton
 Iraq, 194, 283, 343, 347, 349, 362, 395
 Syria, 6, 57, 75, 276–77, 307–8
Customs. *See* Tariffs

Dates
 Iraq, 146, 200, 281, 351–52, 360

Education
 Iraq, 33, 117, 124–25
 Syria, 30–32, 49, 54, 67–70, 81, 87–88
Electricity
 Syria, 30, 379

Fisheries
 Syria, 278, 296–98
Foreign Investment
 Iraq, 136
 Syria, 135
Foreign Trade
 Iraq, 3–5, 93, 95–96, 107–9, 120–21, 132–33
 Syria, 3–5, 56, 57, 127–31
Forestry
 Syria, 278

Health
 Iraq, 18–19, 99–104, 111–13
 Syria, 19, 51–54

Industry and handicrafts
 Iraq, 4, 107, 120, 380–81, 395–96, 398–402,
 467

Index of Places and Peoples